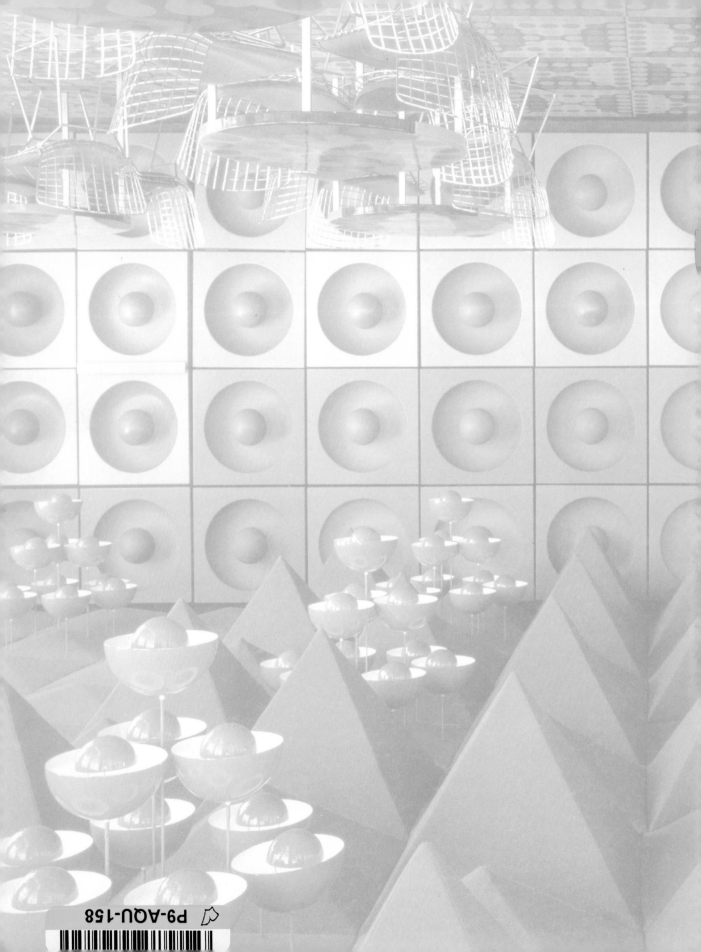

02 Decorative Art

© 2000 Benedikt Taschen Verlag GmbH
Hohenzollernring 53, D–50672 Köln
www.taschen.com

© 2000 for the works by Charles & Ray Eames:
Eames Office, Venice, Ca, www.eamesoffice.com
© 2000 for the works by Le Corbusier:
FLC/VG-Bild-Kunst, Bonn
© 2000 for the works by Gunnar Aagaard Andersen,
Barbara Brown, Gunnar Cyrén, Paul Hoff, Stig Lindberg,
Etienne Martin, Bengt Orup, Eduardo Paolozzi, Sigurd
Persson, Georg-Karl Pfahler, Frank Stella, Victor Vasarely,
Göran Wärff, Yan Zoritchak: VG-Bild-Kunst, Bonn

Design: UNA (London) designers
Production: Martina Ciborowius, Cologne
Editorial coordination: Susanne Husemann, Cologne
© for the introduction: Charlotte and Peter Fiell, London
German translation by Uta Hoffmann, Cologne
French translation by Philippe Safavi, Paris

Printed in Italy
ISBN 3-8228-6406-4

TASCHEN

KÖLN LONDON MADRID NEW YORK PARIS TOKYO

A source book edited by Charlotte & Peter Fiell

Decorative Art

02

S

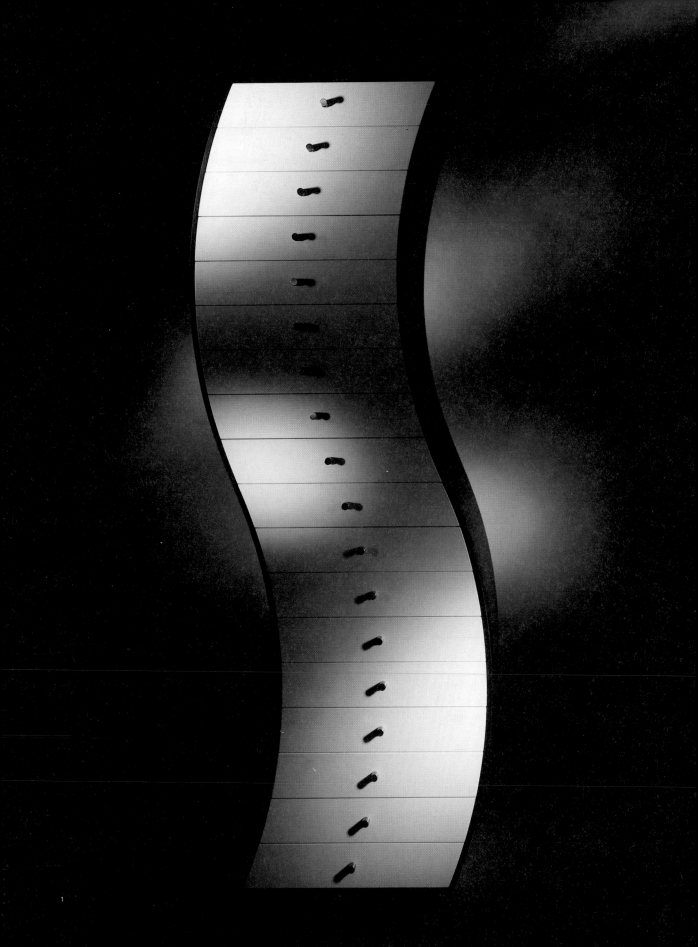

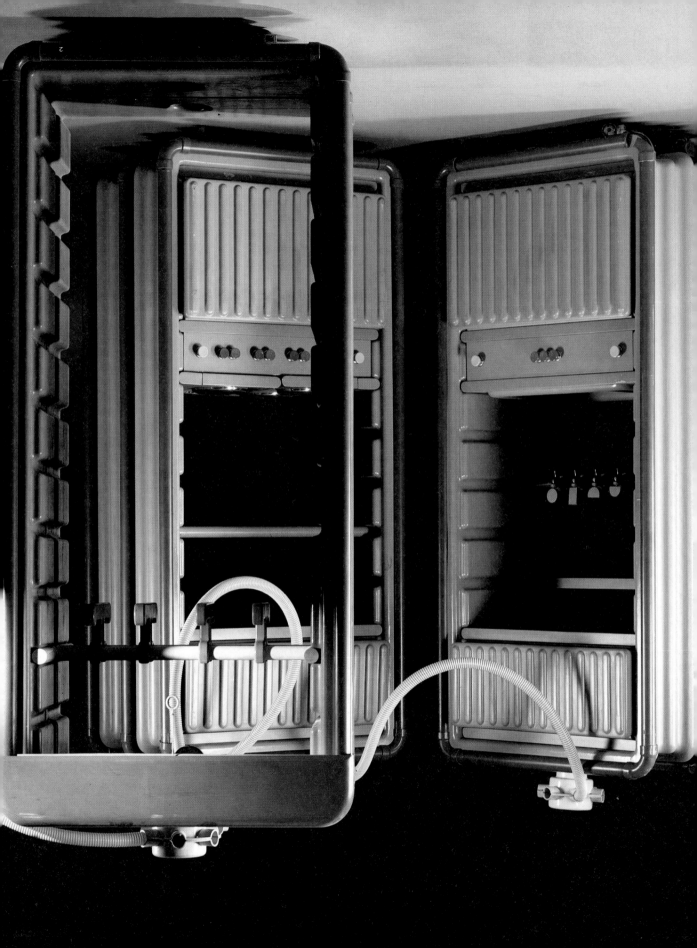

CONTENTS
INHALT
SOMMAIRE

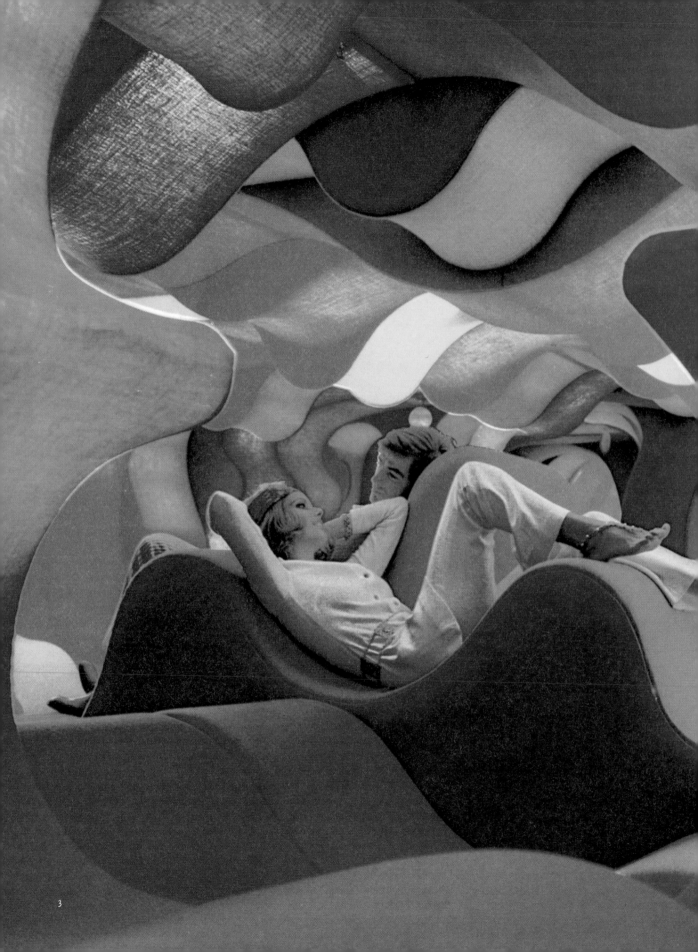

PREFACE

1. Shiro Kuramata, *Furniture in Irregular Forms* chest-of-drawers for Fujiko, 1972
2. Ettore Sottsass, Modular habitat-style units designed for the Museum of Modern Art's "Italy; New Domestic Landscape" exhibition, 1972
3. Verner Panton, Room Installation for Bayer's "Visiona II" exhibition, Cologne, 1970
4. Hans Coper, Vessel, c. 1972
5. Yonel Lébovici, *Soucoupe* lamp, 1970

The "Decorative Art" Yearbooks

The Studio Magazine was founded in Britain in 1893 and featured both the fine and the decorative arts. It initially promoted the work of progressive designers such as Charles Rennie Mackintosh and Charles Voysey to a wide audience both at home and abroad, and was especially influential in Continental Europe. Later, in 1906, *The Studio* began publishing the *Decorative Art* yearbook to "meet the needs of that ever-increasing section of the public who take interest in the application of art to the decoration and general equipment of their homes". This annual survey, which became increasingly international in its outlook, was dedicated to the latest currents in architecture, interiors, furniture, lighting, glassware, textiles, metalware and ceramics. From its outset, *Decorative Art* advanced the "New Art" that had been pioneered by William Morris and his followers, and attempted to exclude designs which showed any "excess in ornamentation and extreme eccentricities of form".

In the 1920s, *Decorative Art* began promoting Modernism and was in later years a prominent champion of "Good Design". Published from the 1950s onwards by Studio Vista, the yearbooks continued to provide a remarkable overview of each decade, featuring avant-garde and often experimental designs alongside more mainstream products. Increasing prominence was also lent to architecture and interior design, and in the mid-1960s the title of the series was changed to *Decorative Art in Modern Interiors* to reflect this shift in emphasis. Eventually, in 1980, Studio Vista ceased publication of these unique annuals, and over the succeeding years volumes from the series became highly prized by collectors and dealers as excellent period reference sources.

The fascinating history of design traced by *Decorative Art* can now be accessed once again in this new series reprinted, in somewhat revised form, from the original yearbooks. In line with the layout of *Decorative Art*, the various disciplines are grouped separately, whereby great care has been taken in selecting the best and most interesting pages while ensuring that the corresponding dates have been given due prominence for ease of reference. It is hoped that these volumes of highlights from *Decorative Art* will at long last bring the yearbooks to a wider audience, who will find in them well-known favourites as well as fascinating and previously unknown designs.

4

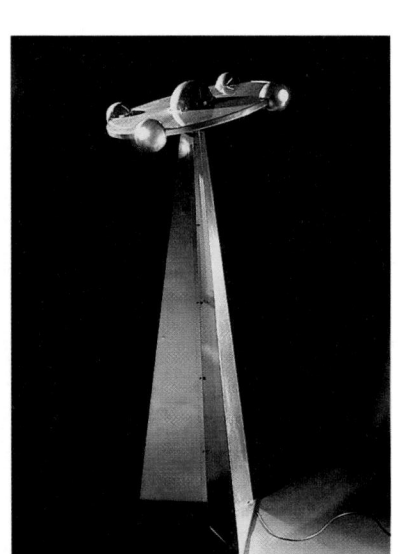
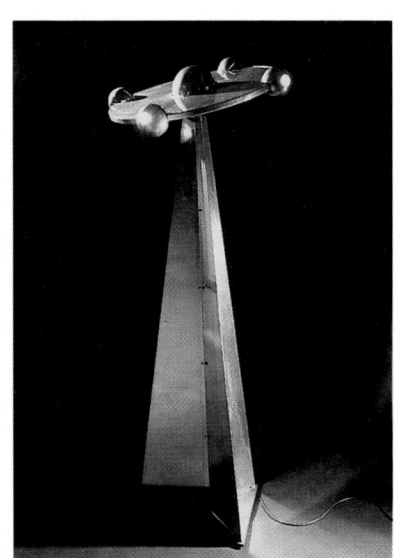

5

VORWORT

Die »Decorative« Art Jahrbücher

Die Zeitschrift *The Studio Magazine* wurde 1893 in England gegründet und war sowohl der Kunst als auch dem Kunsthandwerk gewidmet. In den Anfängen stellte sie einer breiten Öffentlichkeit in England und in Übersee die Arbeiten progressiver Designer wie Charles Rennie Mackintosh und Charles Voysey vor. Ihr Einfluss war groß und nahm auch auf dem europäischen Festland zu. 1906 begann *The Studio* zusätzlich mit der Herausgabe des *Decorative Art Yearbook*, um »den Bedürfnissen einer ständig wachsenden Öffentlichkeit gerecht zu werden, die sich zunehmend dafür interessierte, Kunst in die Dekoration und Ausstattung ihrer Wohnungen einzubeziehen.« Diese jährlichen Überblicke unterrichteten über die neuesten internationalen Tendenzen in der Architektur und Innenraumgestaltung, bei Möbeln, Lampen, Glas und Keramik, Metall und Textilien. Von Anfang an förderte *Decorative Art* die von William Morris und seinen Anhängern entwickelte »Neue Kunst« und versuchte, Entwürfe auszuschließen, die »in Mustern und Formen zu überladen und exzentrisch waren.«

In den zwanziger Jahren hatte sich *Decorative Art* für modernistische Strömungen eingesetzt und wurde in der Folgezeit zu einer prominenten Befürworterin des »guten Designs«. Die seit 1950 von englischen Verlag Studio Vista veröffentlichten Jahrbücher stellten für jedes Jahrzehnt ausgezeichnete Überblicke der vorherrschenden avangardistischen und experimentellen Trends im Design einerseits und des bereits in der breiteren Öffentlichkeit etablierten Alltagsdesigns andererseits zusammen. Als Architektur und Interior Design Mitte der sechziger Jahre ständig an Bedeutung gewannen, wurde die Serie in *Decorative Art in Modern Interiors* umbenannt, um diesem Bedeutungswandel gerecht zu werden. Im Jahre 1981 stellte Studio Vista die Veröffentlichung dieser einzigartigen Jahrbücher ein. Sie wurden in den folgenden Jahren als wertvolle Sammelobjekte und hervorragende Nachschlagewerke hochgeschätzt.

Die faszinierende Geschichte des Designs, die *Decorative Art* dokumentierte, erscheint jetzt als leicht veränderter Nachdruck der originalen Jahrbücher. Dem ursprünglichen Layout von *Decorative Art* folgend, werden die einzelnen Disziplinen getrennt vorgestellt. Mit großer Sorgfalt wurden die besten und interessantesten Seiten ausgewählt. Die entsprechenden Jahreszahlen sind jeweils angegeben, um die zeitliche Einordung zu ermöglichen. Mit diesen Bänden soll einer breiten Leserschaft der Zugang zu den *Decorative Art* Jahrbüchern und seinen international berühmt gewordenen, aber auch den weniger bekannten und dennoch faszinierenden Entwürfen ermöglicht werden.

6

7

PRÉFACE

Les annuaires « Decorative Art »

Fondé en 1893 en Grande-Bretagne, *The Studio Magazine* traitait à la fois des beaux-arts et des arts décoratifs. Sa vocation première était de promouvoir le travail de créateurs qui innovaient, tels que Charles Rennie Mackintosh ou Charles Voysey, auprès d'un vaste public d'amateurs tant en Grande-Bretagne qu'à l'étranger, notamment en Europe où son influence était particulièrement forte. En 1906, *The Studio* lança *The Decorative Art Yearbook*, un annuaire destiné à répondre à « la demande de cette part toujours croissante du public qui s'intéresse à l'application de l'art à la décoration et à l'aménagement général de la maison ». Ce rapport annuel, qui prit une ampleur de plus en plus internationale, était consacré aux dernières tendances en matière d'architecture, de décoration d'intérieur, de mobilier, de luminaires, de verrerie, de textiles, d'orfèvrerie et de céramique. D'emblée, *Decorative Art* mit en avant « l'Art nouveau » dont William Morris et ses disciples avaient posé les jalons, et tenta d'exclure tout style marqué par « une ornementation surchargée et des formes d'une excentricité excessive ».

Dès les années 20, *Decorative Art* commença à promouvoir le modernisme, avant de se faire le chantre du « bon design ». Publiés à partir des années 50 par Studio Vista, les annuaires continuèrent à présenter un remarquable panorama de chaque décennie, faisant se côtoyer les créations avant-gardistes et souvent expérimentales et les produits plus « grand public ». Ses pages accordèrent également une part de plus en plus grande à l'architecture et à la décoration d'intérieur. Ce changement de politique éditoriale se refléta dans le nouveau titre adopté vers le milieu des années 60 : *Decorative Art in Modern Interiors*. En 1980, Studio Vista arrêta la parution de ces volumes uniques en leur genre qui, au fil des années qui suivirent, devinrent très recherchés par les collectionneurs et les marchands car ils constituaient d'excellents ouvrages de référence pour les objets d'époque.

Grâce à cette réédition sous une forme légèrement modifiée, la fascinante histoire du design retracée par *Decorative Art* est de nouveau disponible. Conformément à la maquette originale des annuaires, les différentes disciplines sont présentées séparément, classées par date afin de faciliter les recherches. Les pages les plus belles et les plus intéressantes ont été sélectionnées avec un soin méticuleux et on ne peut qu'espérer que ces volumes feront connaître *Decorative Art* à un plus vaste public, qui y retrouvera des pièces de design devenues célèbres et en découvrira d'autres inconnues auparavant et tout aussi fascinantes.

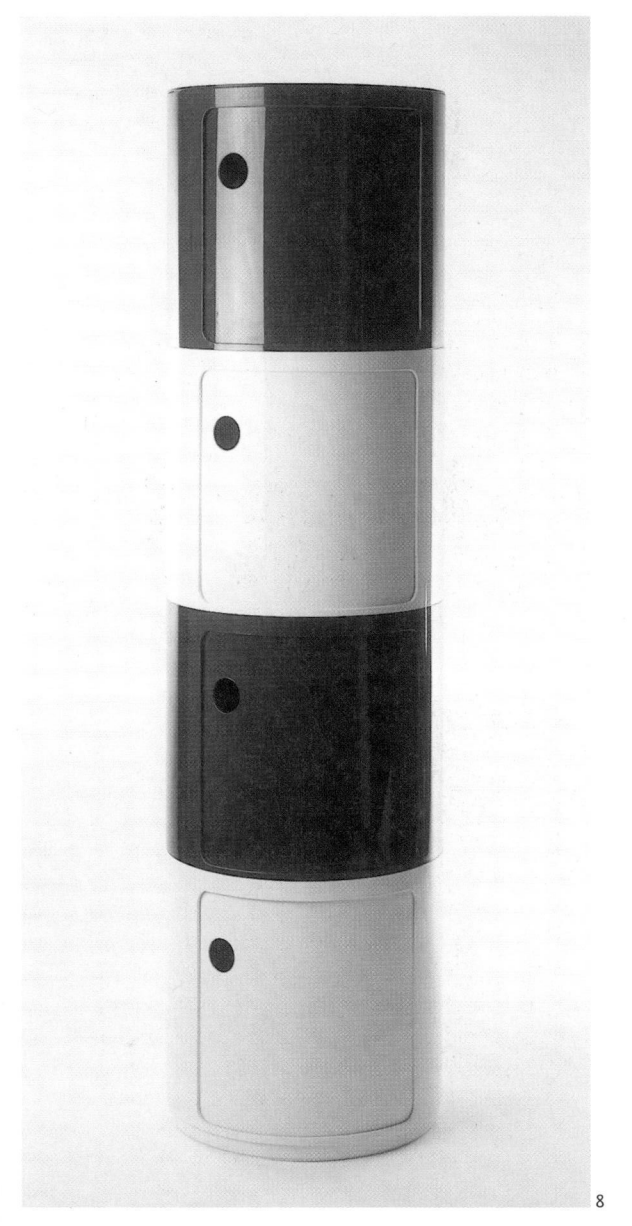

8

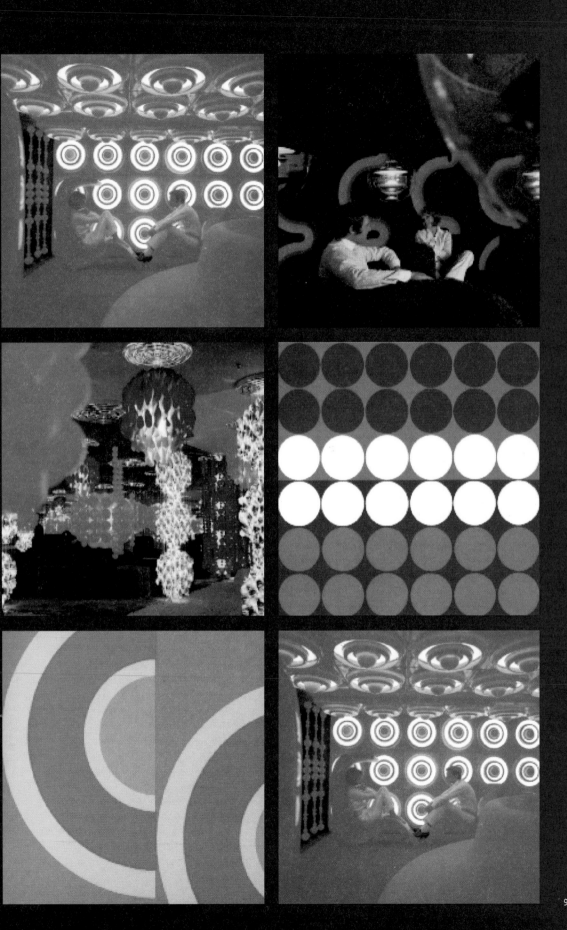

INTRODUCTION
THE 1970s

Economics, Environment and New Directions

The spirit of 1960s counterculture continued into the early 1970s and became, if anything, more extreme. The psychedelic Age of Aquarius was, however, abruptly cut short by the general energy crisis in 1973 and the subsequent economic slow-down, which effectively lasted until the end of the decade. The naïve optimism of the swinging sixties had been replaced by a sober scepticism and the dawning of radical feminism and the environmental movement. Germaine Greer published her influential book, *The Female Eunuch*, in 1970, and the following year Greenpeace was founded at the University of British Columbia to oppose US nuclear testing in Alaska. Within the decorative arts there was ever greater diversity: while America and Britain saw a renewed emphasis upon the crafts, with the World's Craft Council promoting a more artistic *modus operandi*, manufacturers of industrially-produced consumer products were embracing ever greater rationalism in an effort to reduce costs. The *Decorative Art* yearbooks continued to feature crafted and industrially manufactured goods alongside each other, but increasingly the emphasis was placed on contemporary trends in architecture and interior design.

Architectural practice in the 1970s was divided into three quite distinct camps: the Radical Design groups, the Brutalists and the "Eco-architects". Practitioners of Radical Design, which emerged during the mid to late 1960s, relied

10

upon state-of-the-art materials such as injection-moulded plastics, and created either modular "space age" environments that had little practical application or proposed unrealisable environments. This vision of architecture generally fell out of favour with the onset of the recession, which necessitated a more rational and realistic approach to building and design. The Brutalists were essentially urbanists who favoured the use of unclad concrete and bold unrelenting geometry. Their architectural legacy is still much in evidence in our cities today, with various interest groups either fighting to save these fundamentally alienating buildings, such as the Hayward Gallery in London, or campaigning to get rid of them. The Brutalists took industrial rationalism to such extremes that it became yet another stylistic device. The Eco-architects, whose work is perhaps most relevant to our own times, were spurred on by the environmental debate and attempted to get back to nature through the design of either primitive structures or experimental, forward-looking dune houses that were exceptionally ecologically efficient. Importantly, all three architectural camps were fundamentally connected by their pursuit of experimentation and their quest for new ways of building.

This spirit of investigation and research also manifested itself in the staging of several exhibitions, most notably the "Experiments for Living" exhibition held in London in 1970 by the mainstream furniture retailer, Maples, and the series of landmark "Visiona" exhibitions sponsored by Bayer in Cologne. These latter exhibitions displayed futuristic synthetic domestic landscapes in which furniture such as the chair was no longer a recognisable form, having been transmuted into a "Living Tower" or waves of foam blocks upholstered in psychedelic colours. In 1972, the Museum of Modern Art in New York also held a groundbreaking exhibition; entitled "Italy: New Domestic Landscape – Achievements and Problems of Italian Design", it illustrated the diverse nature of design, categorized as either "conformist, reformist or contesting" by the show's organiser, Emilio Ambasz. This exhibition also brought to light the two opposing currents in Italian design: engineering-orientated design with its goal of large-scale mass production, and semantic counter-design, which happily announced the demise of Modern design.

Anti-Design was certainly an attitude which pervaded the 1970s, as the arguments of what constituted "Good

Design" no longer seemed relevant. Although the recently developed thermoplastic ABS offered designers a cheaper material than earlier plastics, injection-moulded products that required expensive tooling, such as those manufactured by Artemide, needed a mass market to be at all profitable. It was an extremely difficult time for designers – lack of money meant a lack of jobs, and the few jobs that did exist with established manufacturers required previously unknown design professionalism. Too many designers and manufacturers were chasing too few customers, while inflation meant that the demand for cheaper goods could no longer be satisfied by the high-wage economies of Western Europe.

Anti-Style and Pro-Craft

The overwhelming cost constraints of the 1970s resulted in the proliferation of cheap copies of high-style designs. This culture of "knock-off" furnishings devalued and debased much public understanding of Modern design, while magazine editors exacerbated the situation through their continued promotion of ephemeral here-today-gone-tomorrow trends in design. In reaction to this decline in quality, the craft revival offered a return to better-made, higher value and longer-lasting products, albeit for the small minority who could afford them. Craft revivalists such as John Makepeace in Great Britain also attempted to preserve the tradi-

tions of craftsmanship being eroded by modern industrial production, and sought to produce luxury products that would bring "joy" to both maker and user. The increasing demand for handcrafted wares paralleled the ascendancy of ecological awareness and the rejection of "high-style".

This repudiation of "style" also became apparent in the work of architects such as Norman Foster and Richard and Su Rogers. Having historically been obliged to conform to particular styles, by the 1970s architecure had become virtually free of such constraints. "Positive" buildings were erected that, according to Su Rogers, were "enclosure[s] within which people can create their own style and pattern of life". A symposium on *The Family and its Future*, staged by the Ciba Foundation in 1970, defined the house as "a general purpose shell" that could allow personal expression in terms of "fabric, form and use". Sentiments such as these were strongly influenced by the study of Japanese architecture and its inherent adaptability and functional flexibility through, among other things, the use of screens.

By the mid-1970s, the high-rise tower blocks of the previous decade were generally perceived to have failed in fulfilling their earlier expectations, and planners were now mooting the idea of low-rise (2 or 3-floor) cluster developments, which would provide village-like units that would promote a better sense of community. The idea of product architecture continued to be given currency, especially in the work of the Finnish architect Matti Suuronen, who

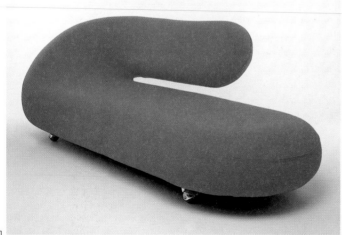

11

12

developed a series of moveable buildings from high-insulated, fibreglass-polyester, factory-made elements. The Rogers' also designed a transportable housing system that was adaptable and extendable.

High-Tech architects such as Michael Hopkins also furthered the acceptance of industrial components in buildings. In architecture during the 1970s much emphasis was placed on the relationship between internal and external space, and plate-glass became to the decade what plastic had been to the 1960s. By the mid-1970s the *Decorative Art* yearbooks were including public as well as private buildings, since architects of the former, having greater resources at their disposal, were in general more innovative in their planning. Projects such as the Hall of Wedding Ceremonies by Yasutaka Yamazaki & Associates in Nagoya, with its sculptural modelling of functional space, revealed how light and colour could be used to determine the shape of buildings. During this time, many architects also produced sensitive conversions of historic buildings in order to preserve the past in the face of a "modern world marked by transience and mechanization" (Schofield, Maria: *Decorative Art & Modern Interiors*, London 1978, p.vii).

Art and Nature

The late 1970s saw emphasis placed on the creativity of the architect or designer, and especially on the artistic quality of buildings. Many architectural projects were the outcome of collaborations between artists and architects, such as the Concert Hall in Helsinki and the Museum of Modern Art in Takasaki. The idea of aesthetics over function was also taken up by the crafts revival, which in America was becoming ever more influenced by contemporary currents in the fine arts – Conceptual Art, Minimalism, Abstract Expressionism – and the folk arts. The idea of design multiples was also borrowed from the fine arts. The vitality of America's craft scene was expressed through publications such as *Craft Horizons*, which urged glassware and ceramics to become more "artistic" and less "crafted". High-quality craftsmanship, which had always been non-democratic and expensive, now became increasingly divorced from any functionality. As well as being influenced by a growing ecological awareness, the return to craft can also be seen as an attempt to create greater cultural and social cohesion,

which was felt to be threatened by industrialisation. In stark opposition to the crafts revival and "artistic" architecture, High-Tech architects advocated a return to functionalism and Modern Movement rationalism.

The constraints placed on both architects and designers by the economic recession which dominated the 1970s served only to spur on their creativity. While inventiveness characterised the work of the avant-garde during these years, that of the mainstream – bar a few notable exceptions – was typically bland, boring and dull. By the end of the decade, however, the public was generally more aesthetically aware and receptive to new architecture and design. Projects such as Tadao Ando's Azuma Residence reflected a shift towards "themes in nature", as did the remarkable dune houses by William Morgan and Claus Bonderup, which synthesised naturally occurring forms with architecture. It was now understood that environmental quality affected well-being, and there was a move in architecture and design to relate to the human scale and human needs. For the avant-garde, the spiritual had once again become an important factor in the design of buildings and objects for everyday use. The apathy of mainstream design, however, provided fertile ground for the re-emergence of Anti-Design in the last years of the 1970s and the subsequent flowering of Post-Modernism in the 1980s.

13

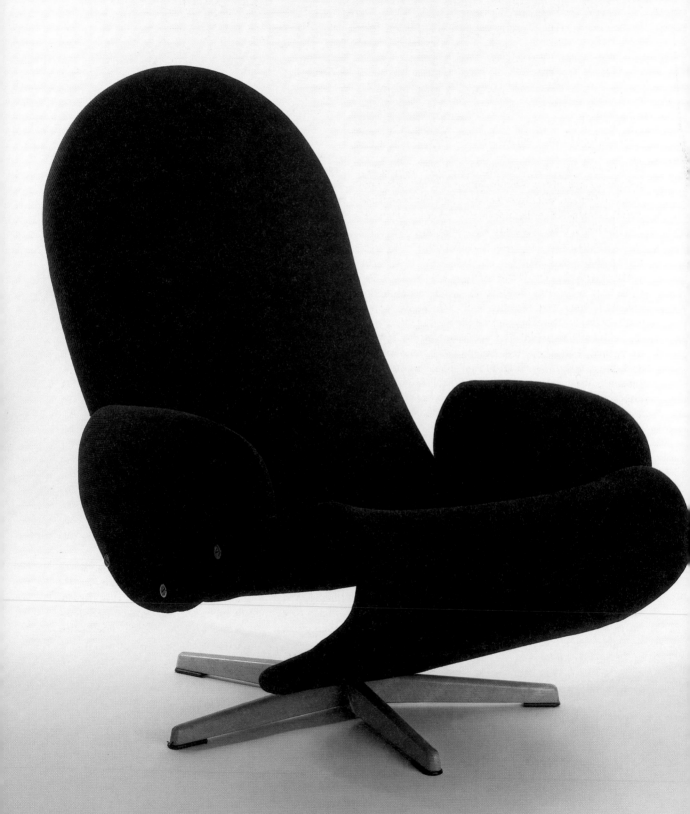

EINLEITUNG
DIE SIEBZIGER JAHRE

14. Verner Panton, *1-2-3* lounge chair for Fritz Hansen, 1973
15. Etienne-Henri Martin, *Chaffeuse 1500* chairs for C. S. T. N. Mangau Atal, 1970–1971

Wirtschaft, Umwelt und neue Ausrichtungen

Mit Ausbruch der Weltwirtschaftskrise wurde das psychedelische »Zeitalter des Wassermanns« 1973 abrupt unterbrochen. Die Antikultur der sechziger Jahre hatte sich bis in die frühen siebziger Jahre fortgesetzt, wurde jedoch zunehmend extremer. Nüchterner Skeptizismus löste den naiven Optimismus der »Swinging Sixties« ab. Radikaler Feminismus und Bewegungen zum Schutz der Umwelt entwickelten sich. 1970 erschien Germaine Greers einflussreiches Buch *Der weibliche Eunuch*. Aus Protest gegen die nuklearen Versuche der USA in Alaska wurde an der University of British Columbia Greenpeace gegründet.

In den dekorativen Künsten gab es eine enorme Vielfalt: während die USA und Großbritannien durch das entschiedene Eintreten des World Craft Council für einen betont künstlerischen *modus operandi* eine Wiederbelebung des Kunsthandwerks erlebte, forcierten die Hersteller industrieller Verbrauchsgüter eine zunehmende Rationalisierung, um die Kosten zu senken. Zwar bemühten sich die *Decorative Art* Jahrbücher weiterhin um die Förderung kunsthandwerklicher und formschöner industrieller Designs, aber Berichte über zeitgenössische Trends in der Architektur und Interior Design nahmen einen größeren Raum ein.

In den siebziger Jahren war die Architektur in drei recht unterschiedliche Lager geteilt: die Radical Design-Anhänger, die sogenannten Brutalisten und die »Öko-Architekten«. Die Radical Design-Anhänger hatten sich seit Mitte

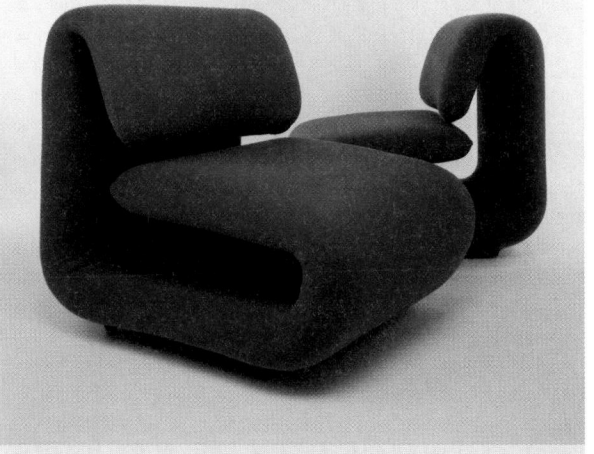

der sechziger Jahre formiert und verbauten neueste Materialien, etwa spritzgussgeformten Kunststoff. Sie schufen modulare »Weltraum«-Landschaften von geringer Praktikabilität und entwarfen nicht realisierbare Environments. Derartig kühne Visionen von Architektur verloren infolge der einsetzenden Wirtschaftsrezession, die rationalere und realistischere Bauentwürfe erforderlich machte, an Popularität. Die Brutalisten waren in ihrem Ansatz Urbanisten, die eine Vorliebe für die Verwendung von Rohbeton und strenger Geometrie hatten. Sie hinterließen in unseren Städten ein nicht zu übersehendes architektonisches Vermächtnis, an dem sich die Geister scheiden sollten: die einen, wie z. B. die Hayward Gallery in London, versuchten später, diese zutiefst entfremdeten Gebäude zu retten, die anderen setzten sich für ihren Abriss ein. Die Brutalisten führten den industriellen Rationalismus ad absurdum, so dass er zum reinen Stilmittel verflachte. Die Öko-Architekten, deren Baukonzepte vielleicht für die heutige Zeit am bedeutendsten sind, formierten sich als Reaktion auf die Umweltdebatte. Sie versuchten, zu einer natürlichen Architektur mit vereinfachten Strukturen oder experimentellen, zukunftsorientierten Projekten mit hoher ökologischer Effizienz, wie z. B. Dünenhäusern, zurückzufinden. Einen sehr relevanten Punkt haben die drei Lager allerdings gemeinsam: sie waren alle experimentell und auf der Suche nach neuen Baukonzepten.

Dieses Suchen und Forschen kam auch in Ausstellungen zum Ausdruck, allen voran der viel beachteten Ausstellung »Experiments for Living« des Möbelhauses Maples in London 1970, und den zukunftsweisenden »Visiona«-Ausstellungen, die von der Firma Bayer in Köln veranstaltet wurden. In diesen Ausstellungen wurden futuristische synthetische Wohnlandschaften gezeigt, in denen Sitzmöbel keine scharf abgegrenzten Formen hatten, sondern in »Living Towers« oder Wellen aus Schaumstoffblöcken transformiert und mit psychedelischen Farbtextilien ausgepolstert waren. 1972 zeigte das Museum of Modern Art in New York die bahnbrechende Ausstellung »Italy: New Domestic Landscape – Achievement and Problems of Italian Design« (Italien: Neue Wohnlandschaften – Errungenschaften und Probleme des italienischen Designs). Diese Ausstellung stellte ein breites Spektrum zeitgenössischer Entwürfe vor, die von dem Kurator der Ausstellung, Emilio Ambasz, in die Kategorien »konformistisch, reformistisch oder kämp-

15

ferisch« unterteilt wurden. Die Ausstellung verdeutlichte die beiden gegensätzlichen Positionen des zeitgenössischen Stilempfindens in Italien: gutes Industriedesign, dessen Ziel seriengefertigte Massenproduktion war, und semantisches Anti-Design, das triumphierend das Ende des Modern Design verkündete.

In den siebziger Jahren setzte sich das Anti-Design durch, und ein Stilverhalten, das sich an den geltenden Maßstäben des »gutem Design« orientiert, begann an Bedeutung zu verlieren. Zwar war der neue wärmegeformter ABS-Kunststoff für Designer preisgünstiger als frühere Kunststoffmaterialien, konnte aber nur mit teuren Werkzeugen bearbeitet werden, wie es bei der Firma Artemide geschah, und war deshalb nur bei umfangreicher Serienproduktion profitabel. Für Designer waren extrem schwierige Zeiten angebrochen, denn aufgrund der schwierigen Produktionsbedingungen herrschte Kapitalknappheit, und die Arbeitsplätze für Designer waren rar. Für die wenigen guten Positionen bei den etablierten Herstellern wurde eine nie dagewesene Professionalität gefordert, denn zu viele Designer und Hersteller wetteiferten um zu wenige Verbraucher. Die steigende Inflationsrate hatte zur Folge, dass

die Nachfrage nach verbilligten Waren von den Hochlohnländern Westeuropas nicht mehr befriedigt werden konnte.

Anti-Stil und Pro-Kunsthandwerk

In den siebziger Jahren stieg die Nachfrage nach preiswerten Kopien hoch stilisierter Entwürfe. Die Kultur der »kopierten« Wohnungseinrichtungen entwertete bei den Verbrauchern nicht nur das Verständnis für modernes Design, sondern entzog ihm auch den Boden. Die Herausgeber der Wohnzeitschriften verschärften diesen Zustand, in dem sie ständig wechselnde Modetrends im Einrichtungsdesign propagierten. Die in Reaktion auf diesen Qualitätsverfall entstandenen Erneuerungsbewegungen im Kunsthandwerk boten eine Rückkehr zu sorgfältig hergestellten Produkten mit hochwertigem Design und dauerhafter Qualität an, die sich allerdings nur eine kleine Käuferschicht leisten konnte. Craft Revivalists wie John Makepeace in Großbritannien setzten sich für die Erhaltung traditioneller Handwerksmethoden ein, denen durch die moderne Massenherstellung die Basis entrissen worden war. Die Crafts Revivalists bemühten sich um die Anfertigung von Werkstücken, die ihnen und ihren Kunden »Freude« bereiteten. Die steigende Nachfrage nach handgefertigten Werkstücken ging einher mit einem gestiegenen ökologischen Bewusstsein, das »exklusiven Stil« ablehnte.

Diese Ablehnung kam auch in den Bauentwürfen der Architekten Norman Foster und Richard und Su Rogers zum Ausdruck. In den siebziger Jahren hatte sich auch die Architektur – historisch eher traditionsverbunden und stilistisch anpassungsfähig – gänzlich von traditionellen Zwängen befreit. Man baute »positive Gebäude«, laut Sue Rogers »Bereiche, in denen Menschen ihren eigenen Stil entwickeln und ihr Leben individuell gestalten können.« Ein Symposium mit dem Titel *Die Familie und ihre Zukunft* der Ciba Foundation im Jahre 1970 definierte das Haus als »eine Hülle allgemeiner Zweckbestimmung«, die Raum für persönlichen Ausdruck in Bezug auf »Textilien, Formen und Zweckbestimmung« ließ. Derartige Konzepte waren vom Studium der japanischen Architektur beeinflusst, die ihre Anpassungsfähigkeit und funktionale Flexibilität nicht nur der Verwendung von Wandschirmen verdankte.

Um die Mitte der siebziger Jahre setzte sich die Einsicht durch, daß die vielstöckigen Wohnsilos des vorangegan-

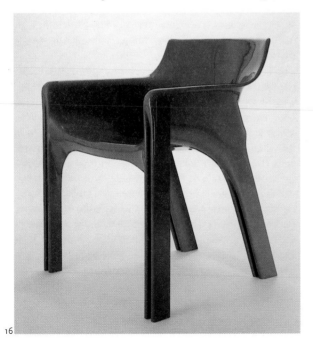

16

genen Jahrzehnts die in sie gesetzten Erwartungen nicht erfüllt hatten. Dagegen stellten die Planer Konzepte niedriger (2–3 Stockwerke) Wohnsiedlungen, die wie dörfliche Einheiten ein Nachbarschaftsgefühl erzeugen sollten. Dennoch war das Konzept der Produktarchitektur noch immer weit verbreitet, und war besonders deutlich im Werk des finnischen Architekten Matti Suuronen, der bewegliche Serienhäuser aus industriell gefertigten Elementen aus hochisoliertem Fiberglaspolyester entwickelte. Auch das Architektenehepaar Rogers entwarf ein System transportabler Häuser, die anpassungs- und erweiterungsfähig waren.

High-Tech-Architekten wie Michael Hopkins trugen zur Akzeptanz der Verwendung industrieller Komponenten beim Bau von Gebäuden bei. In der Architektur der siebziger Jahre wurde die Beziehung von Innen- und Außenräumen stark diskutiert. Flachglas hatte in diesem Jahrzehnt eine ähnliche Bedeutung wie Plastik in den sechziger Jahren. Seit Mitte der siebziger Jahre berichteten die *Decorative Art* Jahrbücher über private und öffentliche Bauprojekte, da die Architekten öffentlicher Gebäude nun über größere Finanzmittel verfügten und eine innovative Planung ermöglichte. Projekte, wie die Hall of Wedding Ceremonies (Halle der Hochzeitszeremonien) von Yasuta Yamazaki & Associates in Nagoya, mit ihrer skulpturellen Modellierung des sonst funktionalen Raum, verdeutlichen, wie die Form eines Gebäudes durch den Einsatz von Licht und Farbe gestaltet werden kann. Zu dieser Zeit bemühten sich viele Architekten, die Vergangenheit durch sensible Umwandlung historischer Gebäude in einer »modernen Welt, die durch Kurzlebigkeit und Mechanisierung charakterisiert war« (Maria Schofield: *Decorative Art in Modern Interiors*, London 1978, p. vii) zu erhalten.

Kunst und Natur

In den späten siebziger Jahren wurde sowohl auf die Kreativität der Architekten und Designer als auch auf die künstlerische Qualität der Gebäude großer Wert gelegt. Viele Bauprojekte waren das Ergebnis der Gemeinschaftsarbeit von Künstlern und Architekten, etwa die Konzerthalle in Helsinki und das Museum für Moderne Kunst in Takasaki. Das Konzept Ästhetik vor Funktionalität wurde von der Crafts Revival-Bewegung übernommen, die in den USA zunehmend von den neuesten Strömungen zeitgenössischer Kunst – der Conceptual Art, dem Minimalismus und dem Abstrakten Expressionismus – und der Folk Art beeinflusst wurde. Aus der Kunst wurde die Idee limitierter Editionen übernommen. Die Vitalität des amerikanischen Kunsthandwerks kam in Veröffentlichungen wie der Zeitschrift *Craft Horizon* zum Ausdruck, die Glas- und Keramikkünstlern dringend rieten, ihre Entwürfe mehr als Kunst statt als Kunsthandwerk zu vermarkten. Von hochqualifizierten Kunsthandwerkern geschaffene Artefakte, die niemals »demokratisch«, aber von je her teuer gewesen waren, lösten sich jetzt zunehmend von jeglicher Funktionalität. Unabhängig von dem Einfluss eines wachsenden Umweltbewusstseins, kann die Rückkehr zum traditionellen Handwerk auch als Versuch gewertet werden, wieder zu größerer kultureller und sozialer Kohäsion zurückzufinden, die man durch die zunehmende Industrialisierung bedroht sah. In scharfer Opposition zum Kunsthandwerk und der »künstlerischen« Architektur, forderten die High-Tech-Architekten eine Rückkehr zum Funktionalismus und Rationalismus der modernen Bewegung.

Die Einschränkungen, die Architekten und Designern durch die Wirtschaftsrezession der siebziger Jahre auferlegt worden waren, führten zu wachsender Kreativität. Und während die von der Avant-garde dieser Jahre gebauten Entwürfe durch Einfallsreichtum charakterisiert sind, blieben die allgemeinen Bauvorhaben, von wenigen Ausnahmen abgesehen, einfallslos, langweilig und fade. Am Ende des Jahrzehnts hatte sich in der breiten Öffentlichkeit ein verfeinertes ästhetisches Bewusstsein und eine Akzeptanz für neue Architektur und modernes Design durchgesetzt. Projekte wie Tadao Andos Azuma Residence und die ungewöhnlichen Dünenhäuser von William Morgan und Claus Bonderup, die natürliche Formen mit Architektur verbinden, zeigen eine Hinwendung zu »Themen der Natur«. Es begann sich die Einsicht durchzusetzen, dass die Qualität der Umwelt das Wohlbefinden des Menschen beeinflusst. In Architektur und Design versuchte man, menschliche Maßstäbe wieder mit menschlichen Bedürfnissen zu verbinden. Auch die Avant-garde berücksichtigte das Spirituelle als wichtigen Faktor beim Entwerfen von Gebäuden und Gegenständen des täglichen Lebens. Die in den späten siebziger Jahren verbreitete Apathie im herkömmlichen Design bereitete dem wieder auflebenden Anti-Design und der Postmoderne der achtziger Jahre einen fruchtbaren Nährboden.

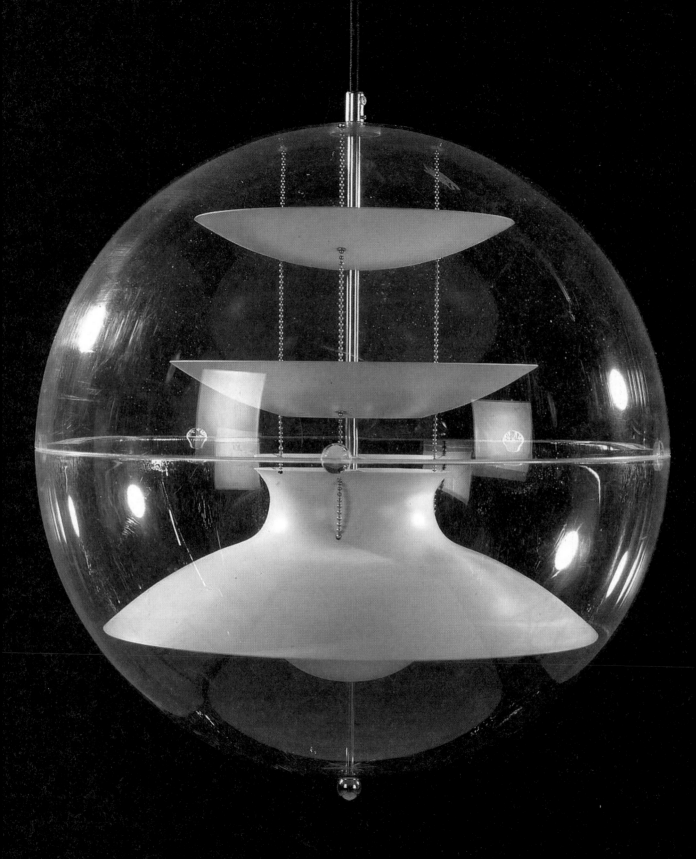

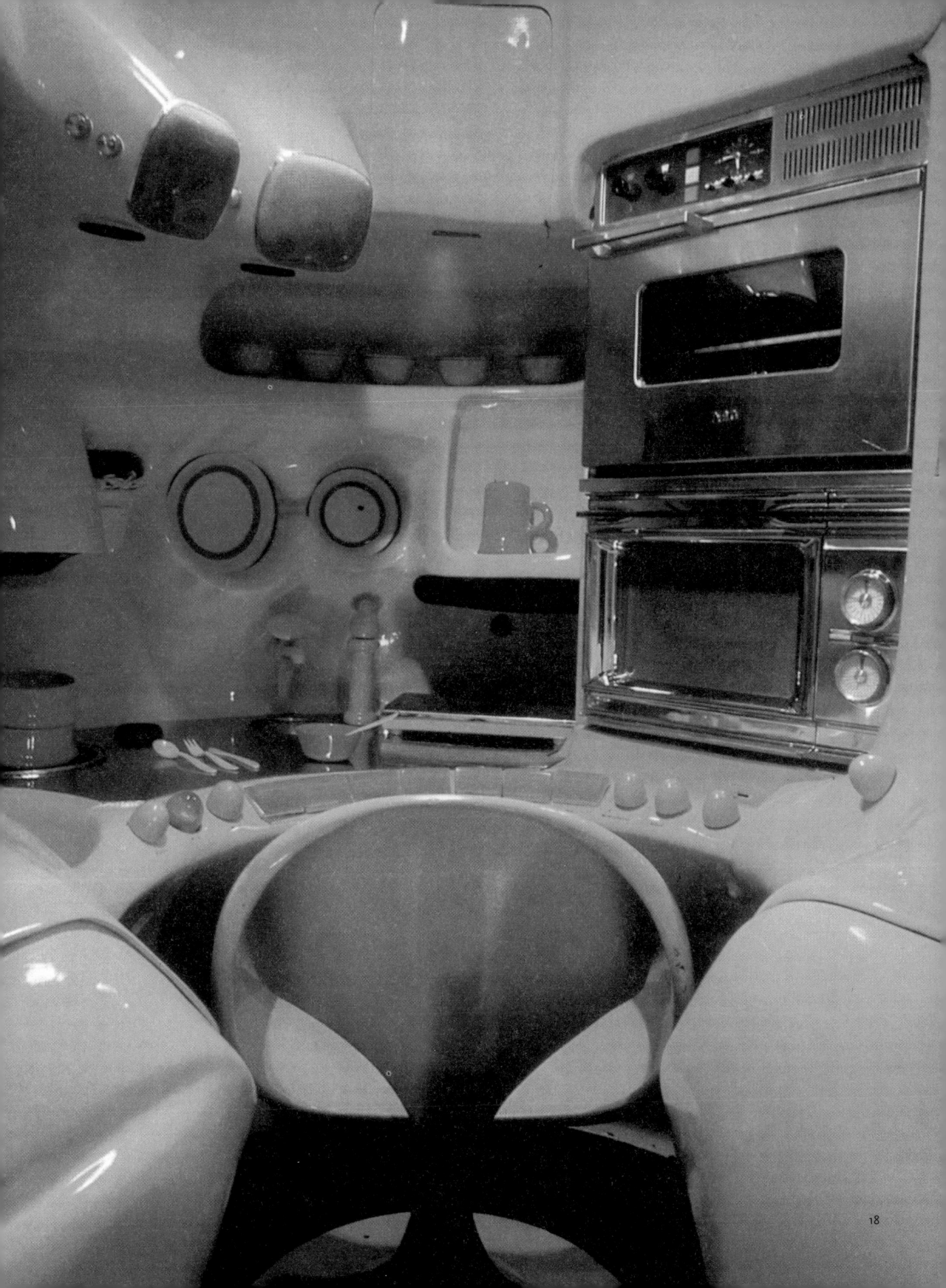

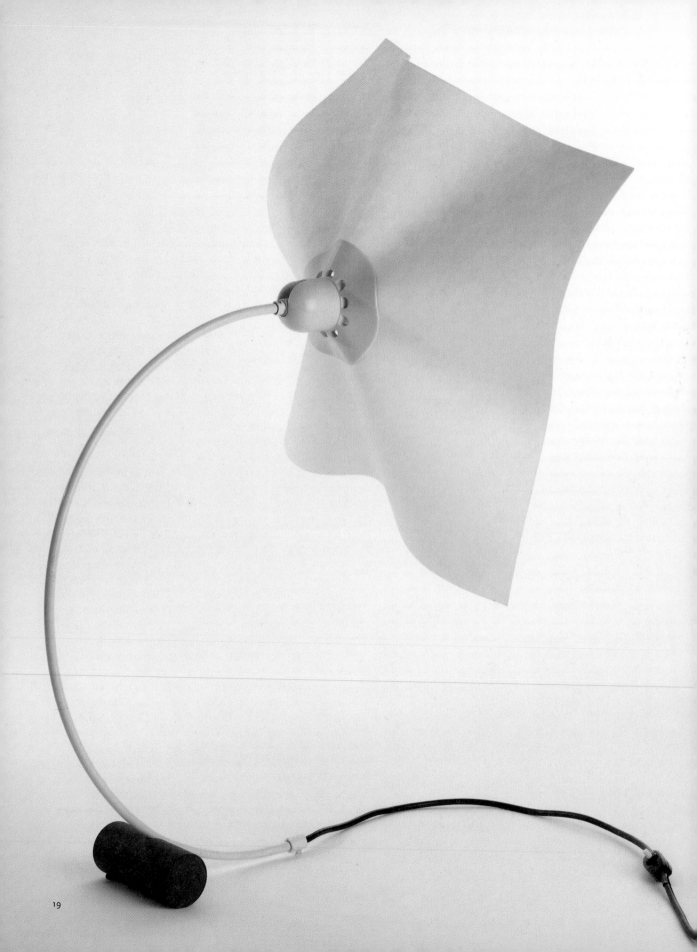

INTRODUCTION
LES ANNÉES 70

19. Mario Bellini, *Area* lamp for Artemide, 1974
20. Luigi Colani, *Sitzgerät Colani* sitting tools for Top System Burkhard Lübke, 1971–1972

Economie, environnement et nouvelles orientations

L'esprit des années 60 contre la culture perdura au début des années 70 pour devenir encore plus virulent, si c'était possible. Toutefois, l'ère psychédélique du Verseau fut brutalement interrompue en 1973 par la crise générale de l'énergie et par le ralentissement économique qui en résulta et qui persista jusqu'à la fin de la décennie. L'optimisme naïf des joyeuses années 60 s'effaça devant un scepticisme dégrisé, la naissance du mouvement féministe radical et le mouvement écologique. En 1970, Germaine Greer publiait *La Femme Eunuque*, qui devait marquer son époque. L'année suivante, l'Université de British Columbia fondait Greenpeace pour s'opposer aux essais nucléaires en Alaska. Les arts décoratifs se diversifièrent encore plus. Aux Etats-Unis et en Grande-Bretagne, l'artisanat connut un regain d'intérêt, le Conseil Mondial de l'Artisanat mettant en avant un *modus operandi* plus artistique. D'un autre côté, les fabricants de produits de consommation industriels firent preuve d'un rationalisme croissant afin de réduire leurs coûts de production. Les annuaires de *Decorative Art* continuèrent de faire figurer côte à côte objets artisanaux et produits manufacturés, mais en mettant de plus en plus l'accent sur les tendances contemporaines en architecture et en décoration d'intérieur.

Dans les années 70, les architectes se divisaient en trois camps bien distincts : les groupes de « design radical »,

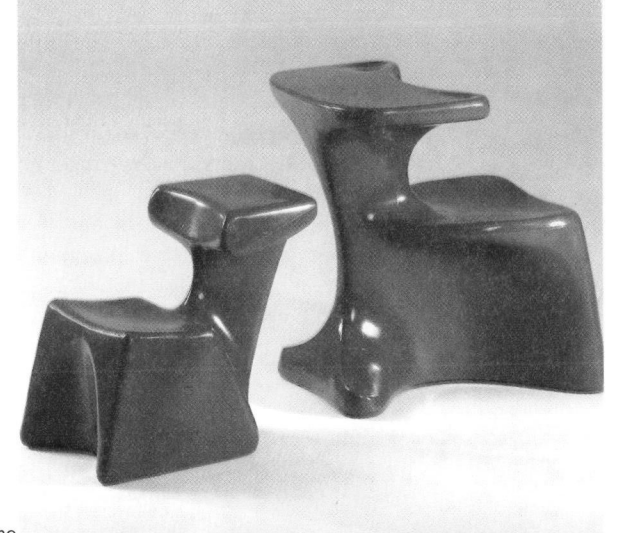

20

les « brutalistes » et les « éco-architectes ». Les adeptes du design radical, qui fit son apparition entre le milieu et la fin des années 60, utilisaient des matériaux issus des technologies de pointe, tels que les plastiques moulés par injection. Ils dessinaient des environnements modulaires inspirés de l'ère spatiale difficiles à mettre en pratique, voire irréalisables. Cette vision de l'architecture s'estompa dès le début de la récession qui exigeait une approche plus rationnelle et réaliste de la construction et du design. Les brutalistes étaient essentiellement des urbanistes qui privilégiaient le recours au béton brut et à une géométrie implacable. Leur legs architectural est encore très visible dans nos villes aujourd'hui, où différents groupes d'intérêts luttent pour sauver ces bâtiments fondamentalement aliénants, comme la Hayward Gallery à Londres, ou font campagne pour qu'on les rase. Les brutalistes menèrent le rationalisme industriel à de tels extrêmes que celui-ci devint un nouveau système stylistique. Les éco-architectes, dont le travail est peut-être plus en accord avec notre temps, étaient motivés par le débat sur l'environnement et tentaient un retour à la nature à travers la conception de structures primitives ou expérimentales, comme des maisons-dunes innovatrices et d'une efficacité exceptionnelle sur le plan écologique. Il est important de souligner que ces trois écoles d'architecture étaient fondamentalement reliées entre elles par leur recherche expérimentale et leur ambition pour trouver de nouvelles manières de bâtir.

Cet esprit d'investigation et de recherche se manifesta également par plusieurs expositions, dont notamment « Experiments for Living », organisée à Londres en 1970 par le marchand de meubles Maples, et la série d'expositions phares « Visiona », sponsorisées par Bayer à Cologne. Ces dernières présentaient des paysages domestiques synthétiques et futuristes où les meubles comme par exemple les chaises n'avaient plus de forme reconnaissable, s'étant métamorphosées en « tours vivantes » ou en vagues de blocs de polystyrène tapissées de couleurs psychédéliques. En 1972, le Musée d'Art Moderne de New York organisa une autre exposition fondamentale intitulée : « Nouveau paysage domestique – réussites et problèmes du design italien ». Elle visait à illustrer la nature contrastée du design, que l'organisateur de l'exposition, Emilio Ambasz, classait en trois catégories : « Conformiste, réformiste ou contestataire ». Cette exposition mit également en lumière deux

courants opposés du design italien : la création orientée vers l'ingénierie, avec ses objectifs de production à grande échelle, et l'anti-design sémantique, qui annonçait gaiement le déclin de la création moderniste.

L'anti-design était dans l'air du temps, les arguments défendant le « bon design » ne paraissant plus pertinents. Bien que l'ABS thermoplastique récemment mis au point offrît aux créateurs un matériau meilleur marché que les plastiques antérieurs, les produits moulés par injection, tels que ceux présentés par Artemide, nécessitaient un outillage coûteux et ne pouvaient être rentables que sur un marché de masse. Ce fut une époque extrêmement difficile pour les designers : le manque d'argent signifiait une pénurie d'emplois et les rares postes disponibles auprès de fabricants établis nécessitaient de nouvelles qualifications auxquelles peu étaient préparés. Trop de designers et trop de fabricants cherchaient les rares clients, tandis que l'inflation empêchait les économies à hauts salaires d'Europe occidentale de satisfaire à la demande de produits toujours moins chers.

Contre le style et pour l'artisanat

Les écrasantes restrictions budgétaires des années 70 entraînèrent la prolifération de copies bon marché du design de luxe. Cette culture d'ersatz nuisit considérablement à la compréhension que le public avait du design moderne. Les rédacteurs en chef des magazines exacerbaient la situation en promouvant constamment des modes éphémères. Face

à ce déclin de la qualité, l'artisanat proposait un retour aux produits mieux faits, de plus grande valeur et plus durables, même si seule une minorité pouvait se les offrir. Les partisans du retour à l'artisanat, tels que John Makepeace en Grande-Bretagne, tentaient également de préserver des traditions érodées par la production industrielle moderne et cherchaient à fabriquer des produits de luxe qui feraient « la joie » à la fois du fabricant et de l'utilisateur. En outre, la demande croissante d'objets faits à la main correspondait à une plus grande conscience écologique et à un certain rejet de la sophistication.

Cette répudiation du « style » devint également apparente dans le travail d'architectes tels que Norman Foster ou Richard et Su Rogers. Ayant toujours été obligée de se conformer à des styles imposés, l'architecture devint virtuellement libre de toute contrainte dans les années 70. On construisit des bâtiments « positifs » qui, selon Su Rogers, étaient des « enclos à l'intérieur desquels les gens créent leur style et leur mode de vie personnels ». Un symposium intitulé *Die Familie und ihre Zukunft* (La Famille et son avenir), qui se déroula à la Fondation Ciba en 1970, définit la maison comme « une coquille polyvalente » permettant l'expression personnelle en terme de « matière, forme et usage ». Ce genre d'idées était fortement influencé par l'étude de l'architecture japonaise, de son adaptabilité inhérente et de sa flexibilité fonctionnelle à travers, entre autres choses, le recours à des parois coulissantes.

Vers le milieu des années 70, les tours d'habitation de la décennie précédente étaient généralement perçues comme ayant échoué dans leur mission et les architectes envisageaient plutôt des lotissements de maisons basses (d'un ou deux étages) formant des unités rappelant des villages et promouvant davantage le sens de la communauté. L'idée d'un « produit architectural » continua de faire des émules, dont notamment l'architecte finlandais Matti Suuronen, qui développa une série de bâtiments transportables avec des éléments très isolants, en fibre de verre et polyester, fabriqués en usine. Les Rogers conçurent également un système d'habitation transportable, adaptable et que l'on pouvait agrandir à loisir.

Des architectes high-tech tels que Michael Hopkins poussèrent encore plus loin l'introduction d'éléments industriels dans le bâtiment. Dans les années 70, on insista beaucoup sur la relation entre les espaces intérieur et exté-

21

rieur. La vitre devint ce que le plastique avait été aux années 60. Vers le milieu des années 70, les annuaires de *Decorative Art* incluaient des bâtiments publics aussi bien que privés, dans la mesure où les architectes des premiers, ayant plus de ressources à leur disposition, se montraient généralement plus innovateurs dans leurs projets. Des projets tels que la salle des mariages de Yasutaka Yamazaki & Associés à Nagoya, avec son modelage sculptural de l'espace, révélèrent comment la lumière et la couleur pouvaient être utilisées pour déterminer la forme des bâtiments. Durant cette période, les architectes réalisèrent également d'intelligentes reconversions de bâtiments historiques afin de préserver le passé dans « un monde moderne marqué par le transitoire et la mécanisation » (Schofield, Maria : *Decorative Art & Modern Interiors*, Londres 1978, p. vii).

Art et Nature

A la fin des années 70, l'accent fut placé sur la créativité de l'architecte ou du designer, et notamment sur la qualité artistique des bâtiments. De nombreux projets architecturaux, fruits d'une collaboration entre des artistes et des architectes, virent le jour, comme la salle de concert d'Helsinki et le musée d'art moderne de Takasaki. L'idée de l'esthétique dominant la fonction se retrouva également dans le renouveau de l'artisanat, qui, en Amérique, était de plus en plus influencé par les courants contemporains dans les beaux-arts : art conceptuel, minimalisme, expressionnisme abstrait et arts populaires. Le concept des multiples en design était également emprunté aux beaux-arts. La vitalité de l'artisanat américain s'exprimait à travers des publications telles que *Craft Horizons*, qui incitaient les artisans du verre et de la céramique à se montrer plus « artistiques » et moins « artisanaux ». L'artisanat d'art de haute qualité, qui n'avait jamais été démocratique ni bon marché, s'éloigna de plus en plus de tout fonctionnalisme. Tout en étant influencé par une conscience écologique grandissante, le renouveau de l'artisanat était également une tentative de renforcer la cohésion sociale et culturelle, que l'on sentait menacée par l'industrialisation. Contrastant fortement avec ce renouveau de l'artisanat et de l'architecture « artistique », les architectes high-tech prônaient, quant à eux, un retour au fonctionnalisme et au rationalisme du mouvement moderniste.

Les contraintes imposées aux architectes et aux designers par la récession qui domina les années 70 ne firent que renforcer leur créativité. Toutefois, si l'inventivité caractérisa le travail de l'avant-garde durant ces années, la création plus grand public, à part quelques exceptions notables, fut généralement plate, ennuyeuse et sans grand intérêt. Malgré cela, vers la fin de la décennie, le public était généralement plus sensible et réceptif à l'esthétique des nouvelles créations en architecture et en design. Des projets tels que la Résidence Azuma de Tadao Ando reflétaient un virage vers les thèmes inspirés de la nature, tout comme les remarquables maisons-dunes de William Morgan et de Claus Bonderup, qui synthétisaient les formes naturelles et l'architecture. Il était désormais admis que la qualité de l'environnement influait sur le bien-être de l'individu. L'architecture et le design cherchaient à revenir à une échelle humaine et à répondre à des besoins. Pour l'avant-garde, le spirituel était redevenu un facteur important dans la conception des bâtiments et des objets quotidiens. Néanmoins, l'apathie du design grand public favorisa la réapparition de l'anti-design dans les dernières années de la décennie et l'épanouissement du postmodernisme des années 80.

22

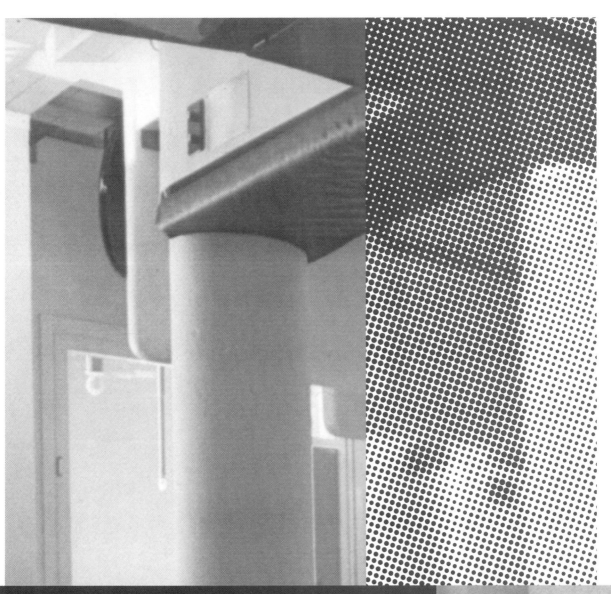

architecture and interiors | Architektur und Interieurs | Architecture et intérieurs

Mews House in Camden, London
architects R. Rogers and N. & W. Foster

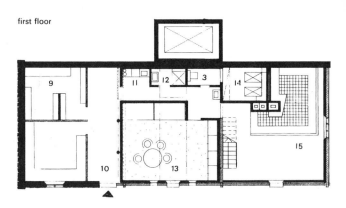

first floor

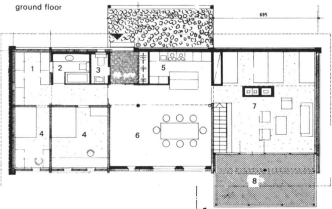

ground floor

plan key

1 cloakroom
2 bath
3 wc
4 bedrooms
5 kitchen
6 dining area
7 sitting room
8 balcony
9 wine cellar
10 entry
11 hotplates
12 shower
13 guestroom
14 heating installation
15 warm space

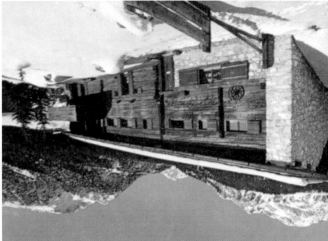

Weekend House at Lenzerheide
architect Edi Franz

Y Residence, Japan
architects T. Azuma & Associates

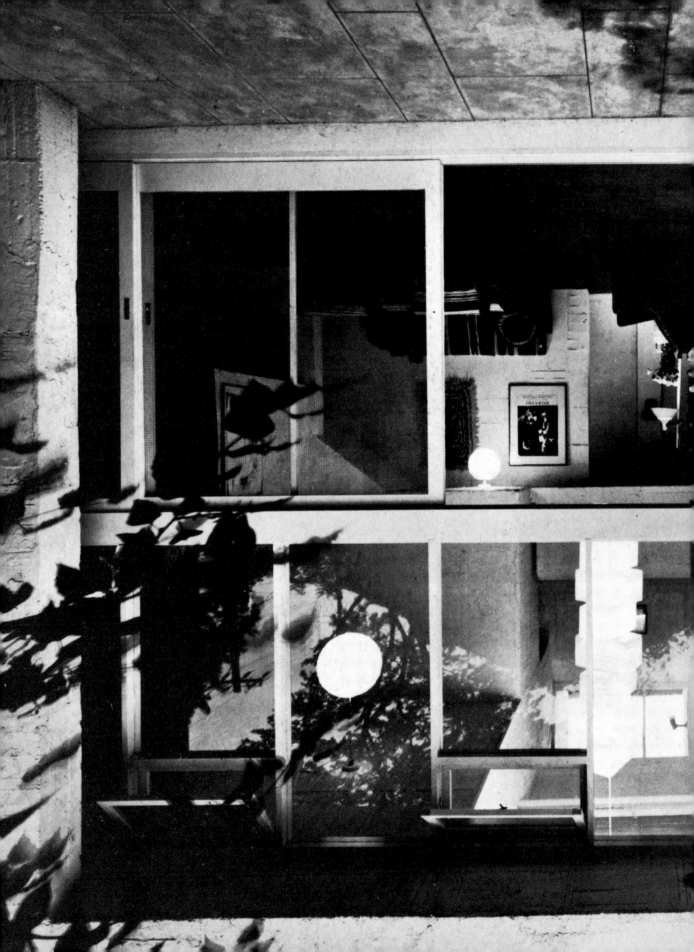

Y Residence, Japan
architects T. Azuma
& Associates

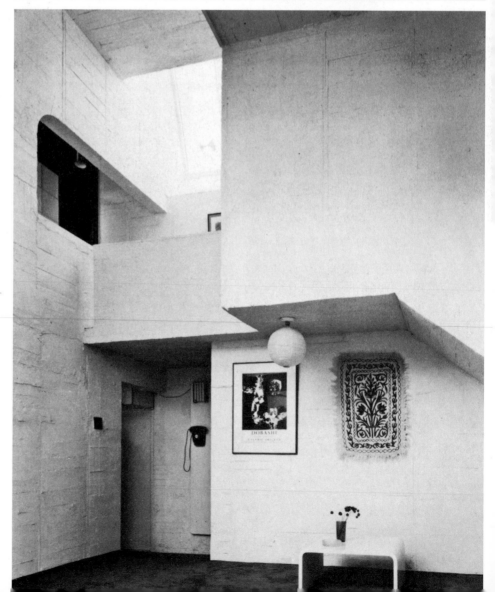

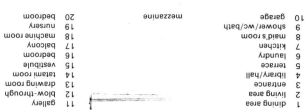

ground floor

1 dining area
2 living area
3 entrance
4 library/hall
5 terrace
6 laundry
7 kitchen
8 maid's room
9 shower/wc/bath
10 garage

mezzanine

11 gallery
12 blow-through
13 drawing room
14 tatami room
15 vestibule
16 bedroom
17 balcony
18 machine room
19 nursery
20 bedroom

first floor

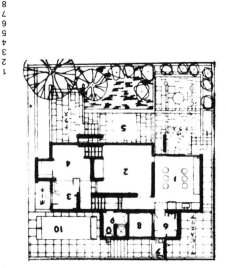

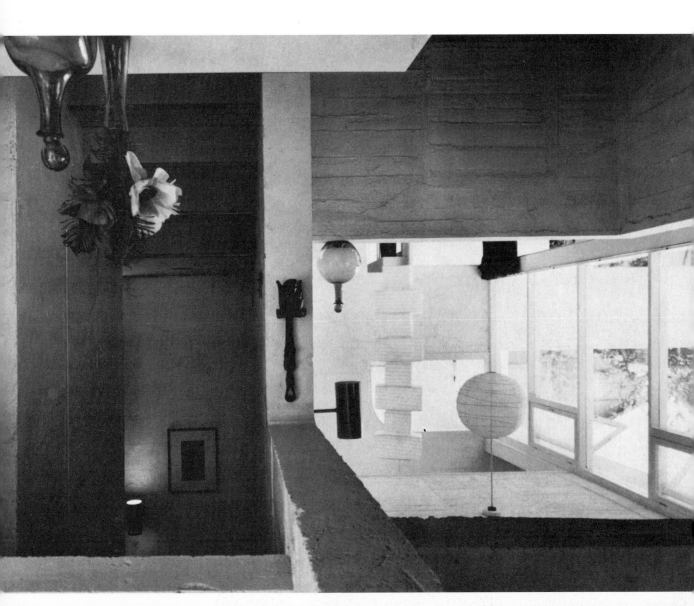

Y Residence, Japan
architects T. Azuma & Associates

1 view from terrace at night
2, 3 east side view
4 entrance
5 terrace and library from hall (mezzanine)
6 living room
7 living room and hall
8, 10 terrace with dining area from east
9 child's bedroom, second floor
11 tatami room

Six bedrooms provide undisturbed privacy for each member of the family and the domestic helper, contrasting completely with the informal freedom of the ground floor living areas where continuously connected spaces have some of the atmosphere of a coffee house or hotel, in this secluded residence in a Japanese suburban area.

Built of reinforced concrete, the house presents a strong plasticity, its walls, with undisguised shuttering marks, painted white both inside and out, its carefully planned floor levels and the doorless spaces of the lower level creating a flow of structure and activity.

Colours and details of the furnishings are emphasised against the white walls and the floors vinyl-covered or plain carpeted.

photographs Shigeo Okamoto
courtesy Kenchiki Bunka

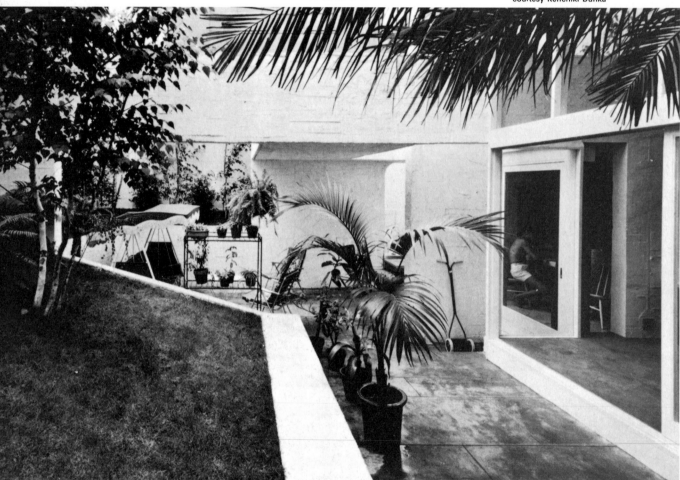

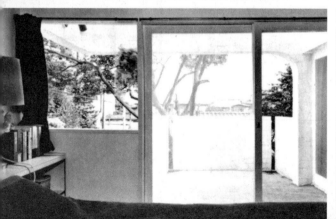

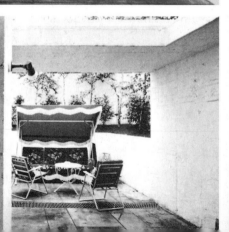

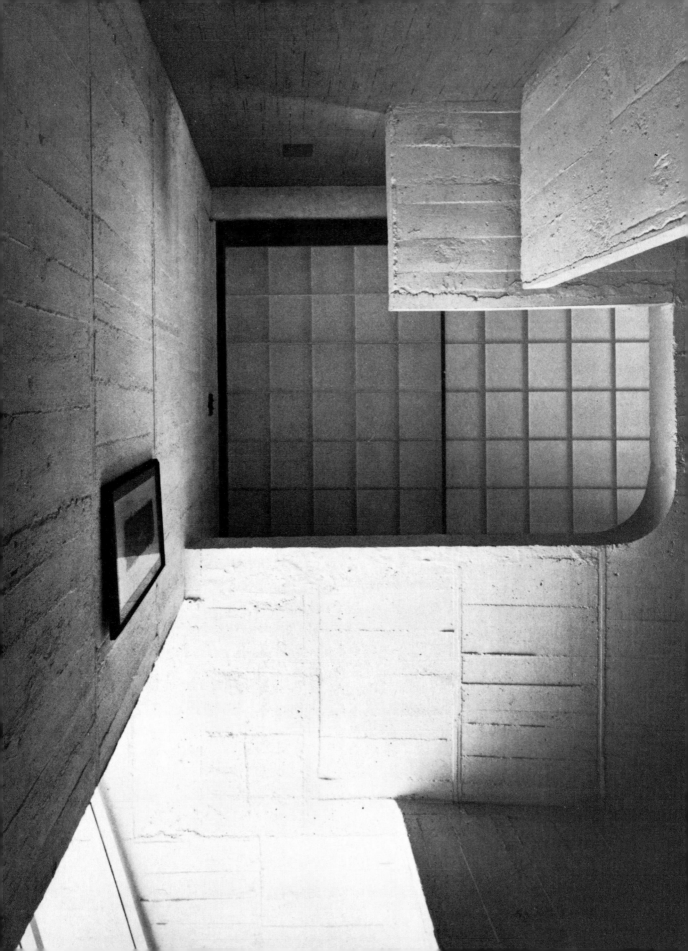

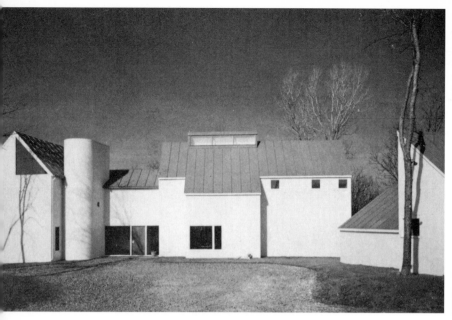

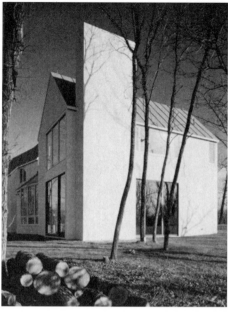

House at Des Moines, Iowa
architect John D. Bloodgood AIA

The clients, Mr and Mrs Frederick Weitz, wanted a family house 'a cross between an early European chateau and a midwestern farmhouse.

Achievement of these seemingly incompatible design concepts was aided by the site – the end of a long, sloping meadow at the edge of a wood bordering a river.

The design evolved as one providing privacy with a feeling of staunchness, appearing from the approach road through the fringes of the wood as a group of farm buildings rather than a single block.

The rear of the house is opened more fully to the view but the woods provide the same sense of enclosure as do the blank walls on the approach side.

The plan sorts itself into a parents' wing to the west and, for the four children, a play and sleeping wing to the east – the children's bedrooms are above kitchen and playroom and reached by a secondary stairway.

The dining room, open to the north roof lights is also the garden room with brick tile damage-proof floors: the balcony above the entrance hall looks out through the glazed roof to the trees and divides parents' area from the children's.

Materials and detail were kept to simple basics: exterior plaster is broken only by required expansion joints and painted a soft cream colour.

The terne metal roof is painted a soft green. There is no basement: the house is built on crawl space which contains heating/cooling units.

A garage/shop/storage structure is separate.

photographs Hedrich Blessing

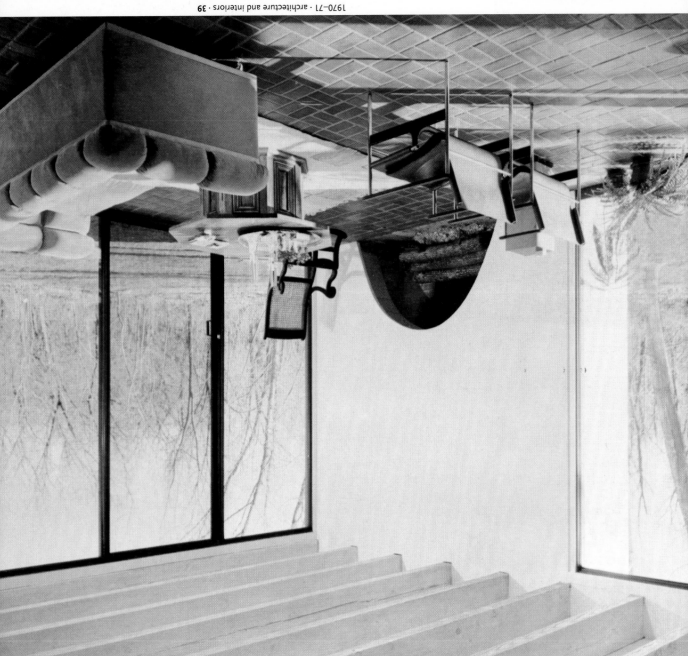

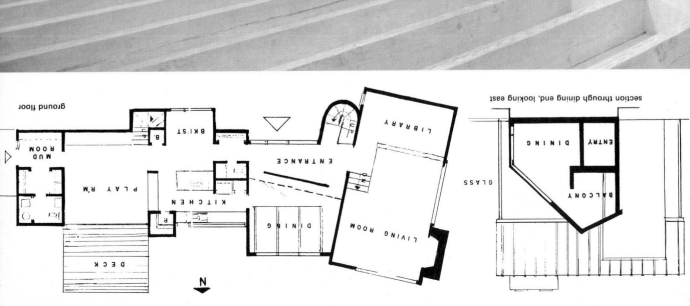

section through dining end, looking east

ground floor

DECK

MUD ROOM

PLAY R'M

KITCHEN

BKF'ST

B.

DINING

ENTRANCE

LIVING ROOM

LIBRARY

UP

N

GLASS

BALCONY

DINING

ENTRY

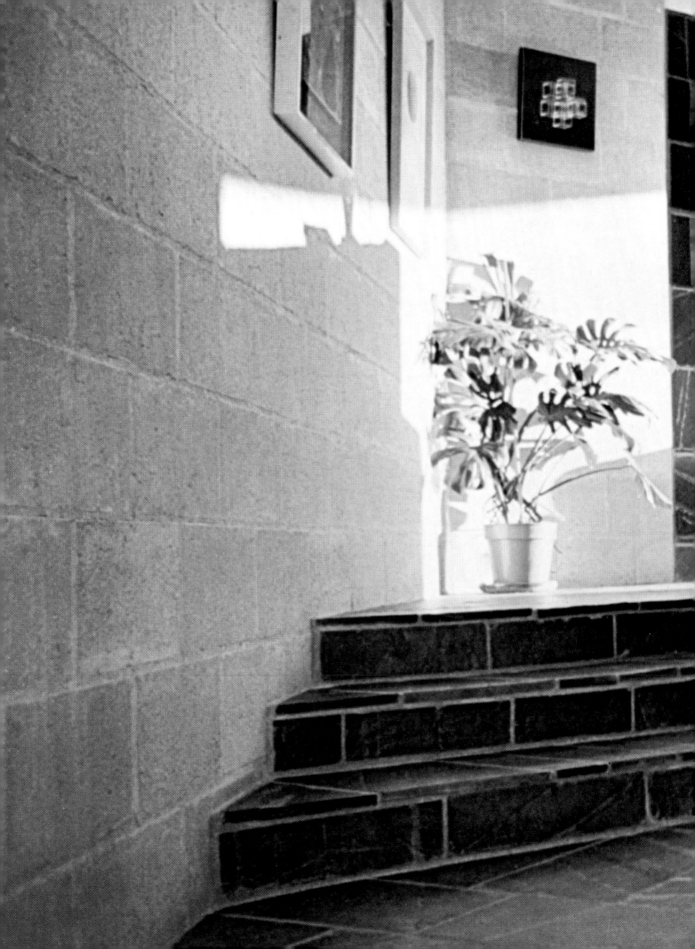

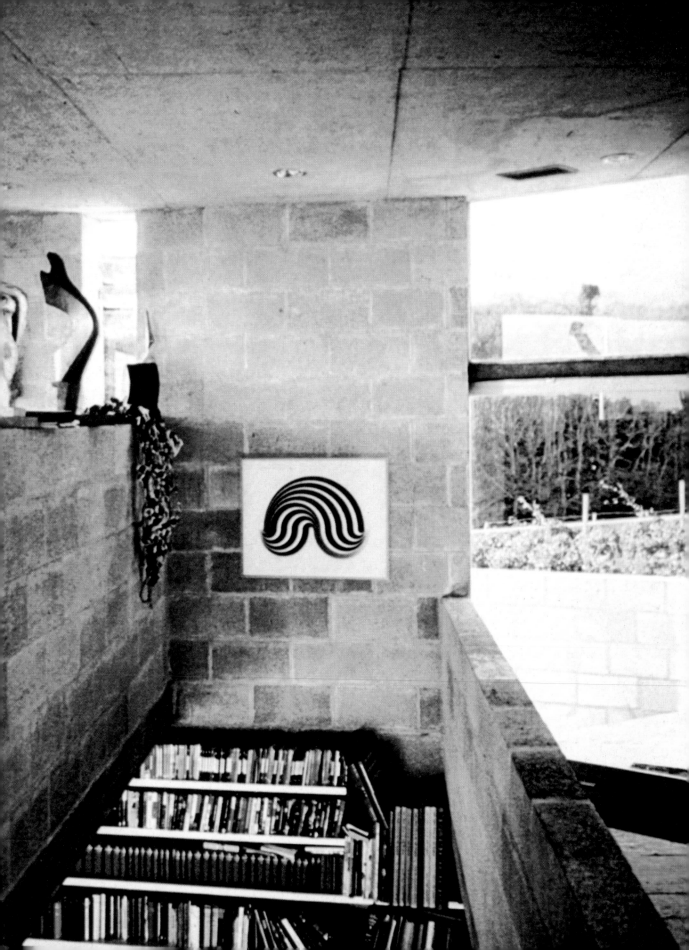

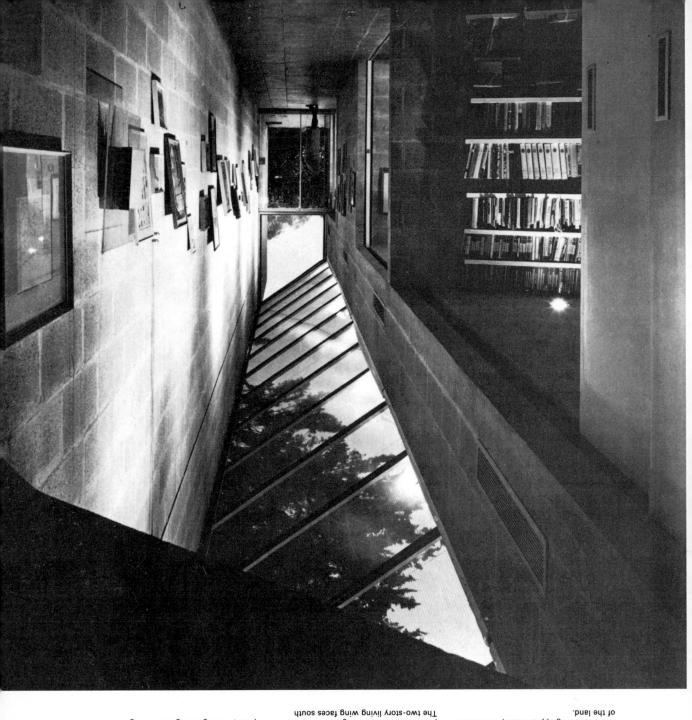

Creek Vean, Feock, Cornwall
architects R. Rogers, N. & W. Foster

The forms of this house grew from the needs which it fulfils.

The brief required the house to be integrated into its site; to take full advantage of the views seaward, up the valley to the north, and westward to the creek and wood, to have a scale visually and physically to accommodate large collections of modern painting, sculpture and books.

The site slopes steeply from a road down to a boathouse on the creek, less steeply from north to south and the house is built along two axes, with internal levels following approximately the contours of the land.

One axis is external and splits the house into two, leading from the road across a bridge to the front door, down a flight of steps to the boat-house.

The other is internal, in the form of a top-lit picture and sculpture gallery which at night is flood-lit from the outside. It connects all the rooms, starting at the highest roof terrace and ending as a path to the underground garage.

To the road the house presents a 5-4 metres high blank wall running the full 44 metres length of the house, broken only by the pedestrian entrance bridge.

The two-story living wing faces south towards the sea, the master bedroom west across the creek and the self-contained flat up the valley.

Every room can be connected to the gallery by sliding away the fourth wall.

The living room spans across the dining/kitchen area with voids at front and back.

Materials are left in their natural state. The walls are honey-coloured Forticrete blocks; floors are Dorothea blue Welsh slate. Windows are frameless and sliding and have anodised or aluminium stainless steel fittings. Heating is by means of a ducted hot air system, flowing through the ceiling.

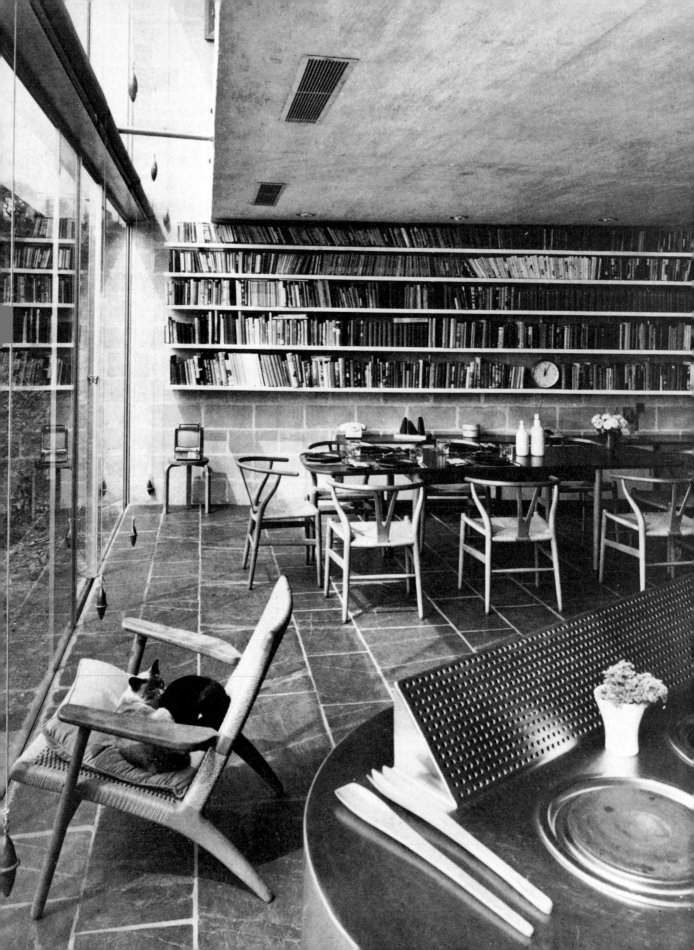

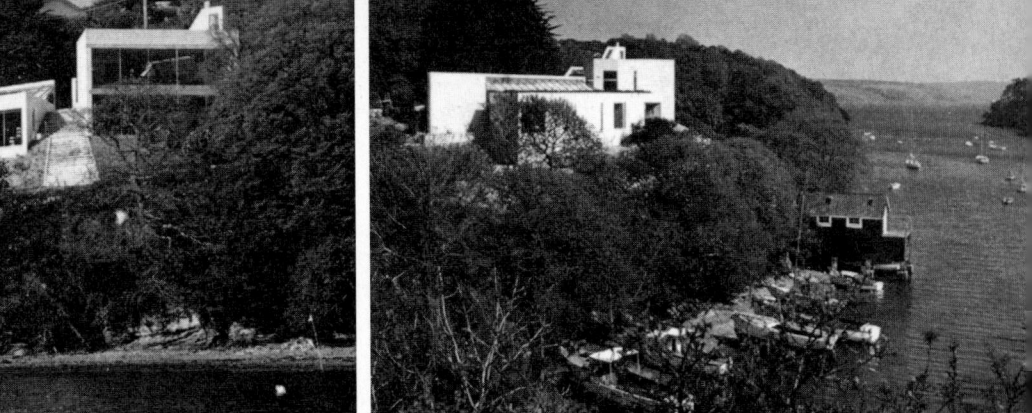

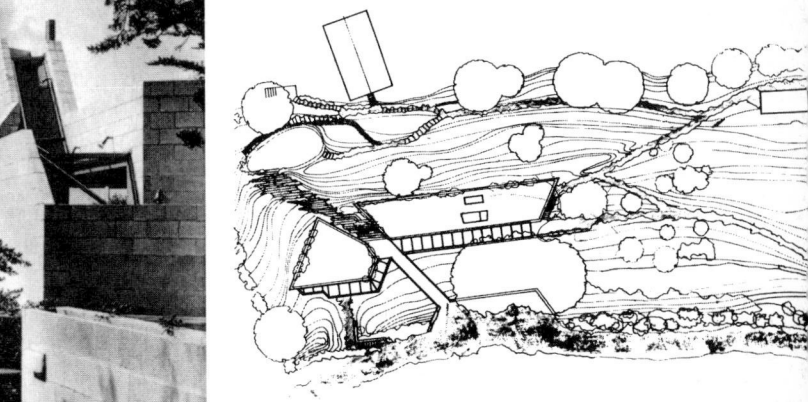

Creek Vean, Feock, Cornwall
architects R. Rogers, N. & W. Foster

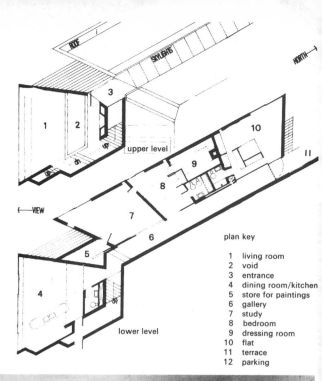

Creek Vean, Feock, Cornwall
architects R. Rogers, N. & W. Foster

1 stairs leading to roof garden
2 looking down to study from living room
3 the gallery—study to the left
4 the kitchen and dining room
5 the house seen across the creek
6 the house and the creek
7 skylight of the stairs leading to the roof
8 the living room
9 the kitchen
10 stairs to entrance floor; kitchen to
 the right

black/white photographs Brecht-Einzig

plan key

1 living room
2 void
3 entrance
4 dining room/kitchen
5 store for paintings
6 gallery
7 study
8 bedroom
9 dressing room
10 flat
11 terrace
12 parking

upper level

lower level

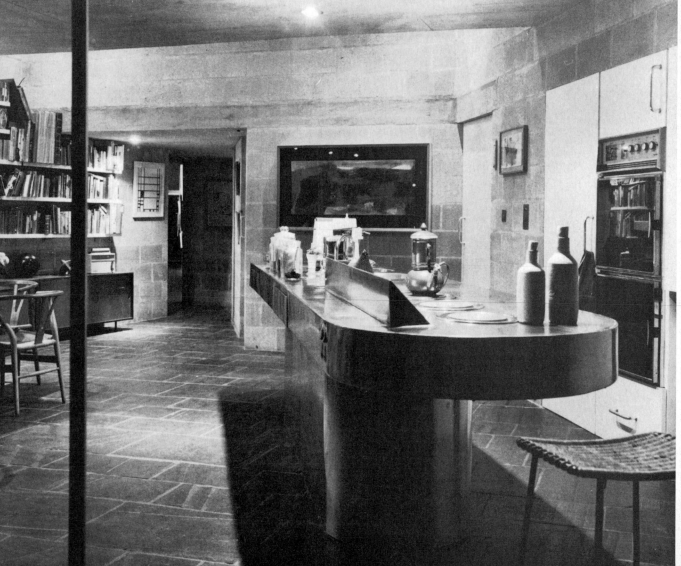

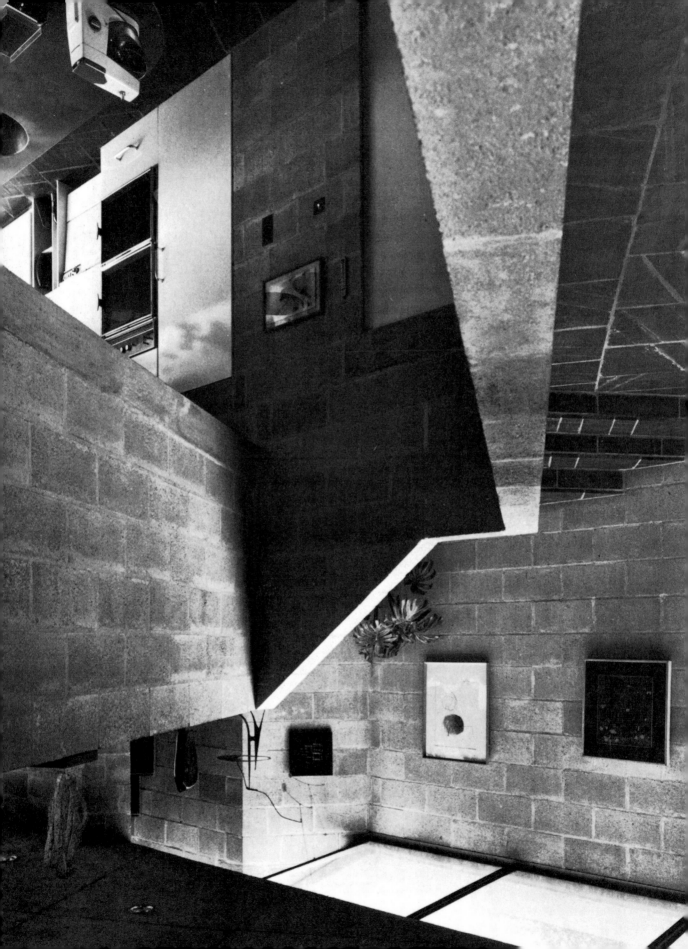

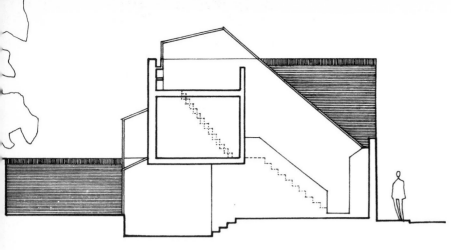

The home of a doctor who is also an art
collector, and his young family, this is one
of a block of three houses built into a
limited site on a cobbled mews.
The centre is lit from the east sky through
the three-storey-height glazed well above
the dining/kitchen area (page 13 and on
these pages), the back is open to the
fullest possible width of the site, on
to a paved court from the sitting room area
pages 60/61; above it, afternoon and evening
sun flood the bedrooms through large bays.
Reached by the higher flight of wood block
'stepping-stone-steps'

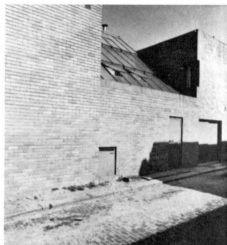

Mews House in Camden, London
architects R. Rogers and N. & W. Foster

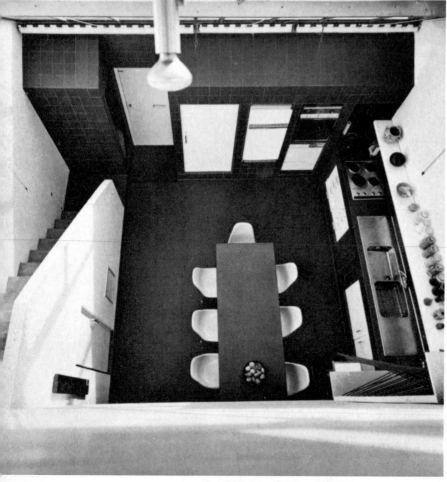

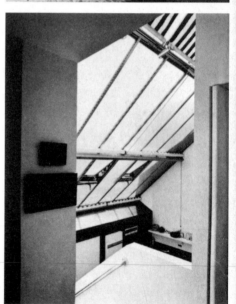

1
 3 5
2 4

1 section through one of the houses
2 looking down from the studio towards
 the entrance
3 the face presented to the mews
4 working end of the kitchen
5 view through the house: midway up
 the stairs a bathroom, right
6, 7 master bedroom and nursery
8 the sitting room with courtyard,
 foreground

photographs John Donat

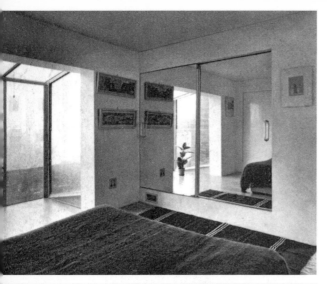

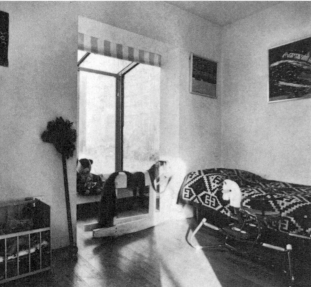

Mews House in Camden, London
architects R. Rogers and N. & W. Foster

studio with access to a tiny terrace having
views over central London.
The completely 'closed' elevation preserves
the character of the mews and gives the
house visual and aural privacy; access to
garage as well as house is through this
mews wall, 3.
Beside the entrance, 2, built on to the wall
are ovens and refrigerated storage units at
right angles to the dining table: this, with all
the fixed items of furniture, working surfaces
etc on the ground floor is a built-in part of
the structure—like the floors, faced in red
Dutch ceramic tiles.
The wall supporting one end of the dining
table is also part of the seat unit of the
sunken living area 6
 8
from the entrance, looking up through the
red-striped roller blinds of the roof lights. 7

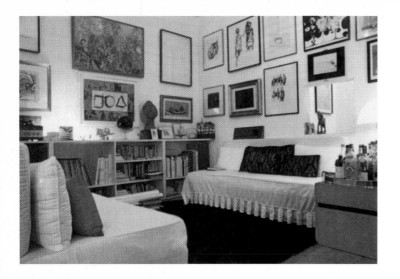

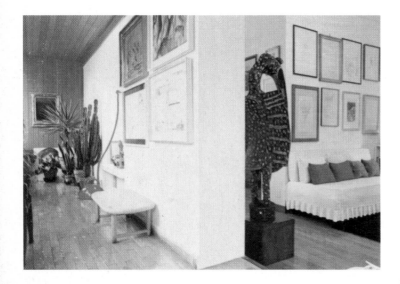

A writer's apartment in Milan

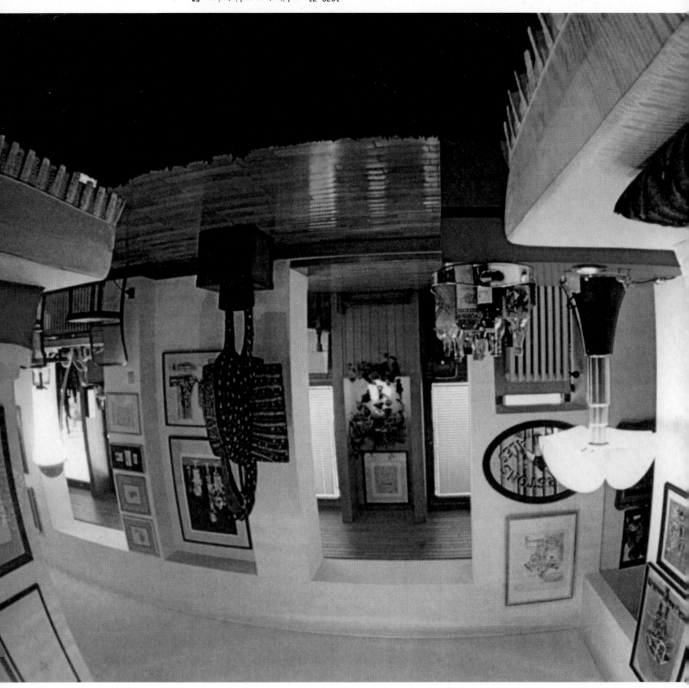

Giorgio Soavi has filled his apartment with sketches by Klimt, by Bidsier, Modigliani, Giacometti, by Graham Sutherland and many other famous names—although few of them have been bought in a gallery. Giorgio Soavi is a poet who also writes light-hearted novels and upon the subjects of travel, art, the theatre. His collection of art has cost practically no money but years of painstaking work, writing about artists who suddenly become not merely friends but an indispensable part of life.
Although otherwise furnished in an unexceptional way, his apartment is therefore a highly individual one, but one which many visitors feel they would like to have for themselves.

Home in Los Angeles

Collections of primitive art from Africa
and Indian America, early toys, early
advertising, circus memorabilia and other
interesting trivia mix with bright modern
things in another Californian house of the
1920's.
Jerry Braude, head of a design firm involved
in all areas of graphics, and his young
family, like to feel their home in a constant
state of change as new acquisitions add to
their collection: yet they strictly maintain
the essential original structure of their
house—the white Italian marble floor, the
high ceiling painted chrome, the stucco
exterior.

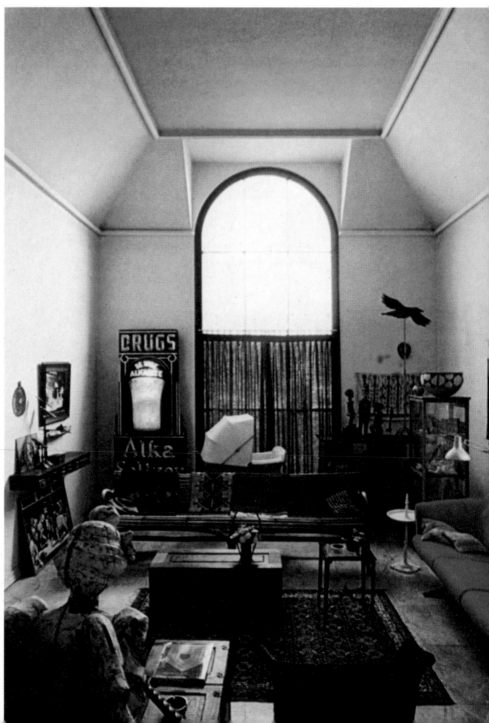

Houses with Ateliers at Järvenpää
architect *Kirmo Mikkola*

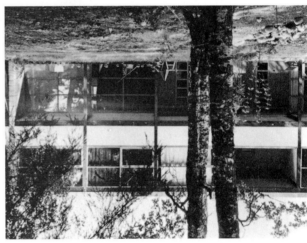

The group was built by four artists and an architect.
Construction is light concrete (Leca) in the transversal walls on a wooden frame. In each house there is a two-storeys-high atelier and an apartment.
The system allowed for individual arrangement of apartment and atelier and for the addition of an exhibition space

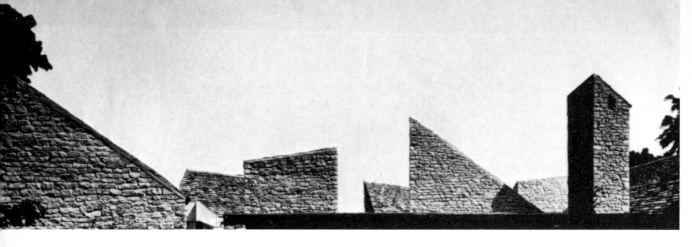

House at Shipton-under-Wychwood, England
architects Stout & Litchfield

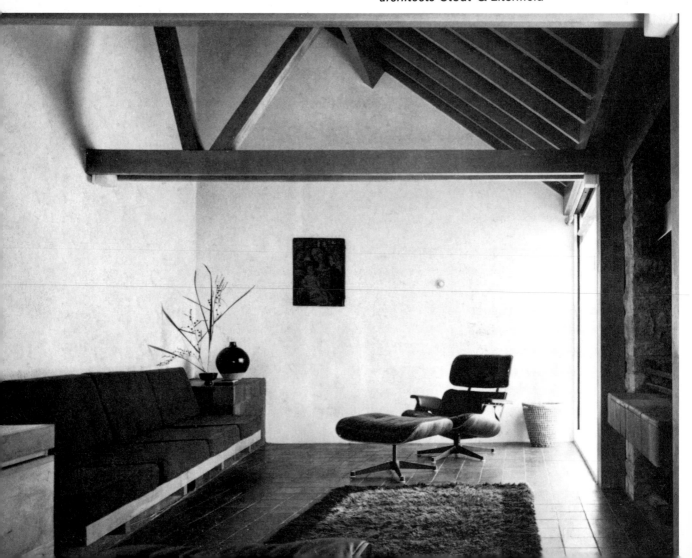

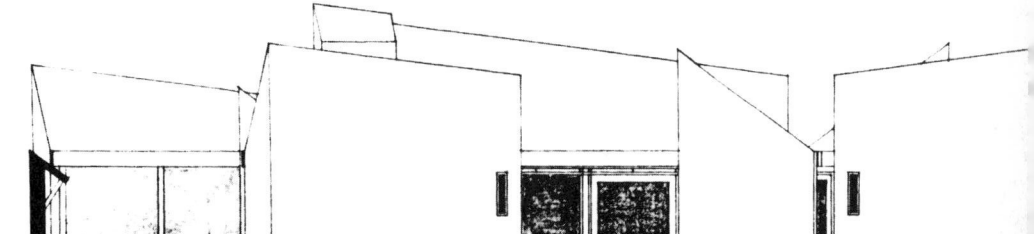

Eight separate but linked units make up this three-bedroomed week-end house on the edge of a Cotswold village.

The separate units mean a large total area of external wall which intensifies the apparent mass of stonework.

As in many farm buildings the line of the eaves gather is the same as that of the beam from which springs the roof of each unit.

Thus floor to ceiling windows could be fitted at the front of all units while the rear walls have only one or two small pierced openings — another feature which emphasises the mass of stonework.

The rear walls of the units are not at right-angles to the other three and the constant-pitch roofs have sloping ridges: together with the relative positions of the units this has produced a dramatic series of irregular, changing visual patterns. The stonework is backed with brickwork and white-painted plaster over insulation. Open timber roofs are boarded with Columbian pine, battened over insulation and counter-battened, felted and covered with Cotswold stone tiles.

Floors are brown quarry tiles with under-floor heating.

The built-in furniture is of polished beech and brown tile-covered concrete slabs.

Other woodwork is painted white.

Although the plan called for the use of local Cotswold stone and the roof lines integrate well into the farming countryside, planning permission was obtained for the house with difficulty.

photographs Brecht-Einzig

1, 2
Long chair, settee and chair, one-piece
mouldings of rigid expanded polyurethane
foam, covered stretched nylon with latex
cushions: the long chair cm 182·5/53 inches
deep overall
Designed by Frederick Scott for S. Hille
& Company Limited, *England*

3
Chair, oiled teak frame, upholstered green,
brown, red or grey fabric:
cm 63·5 × 77 × 79/25 × 30½ × 31 inches
Designed by Shogo Suzuki for Isetan
Company Limited, *Japan*

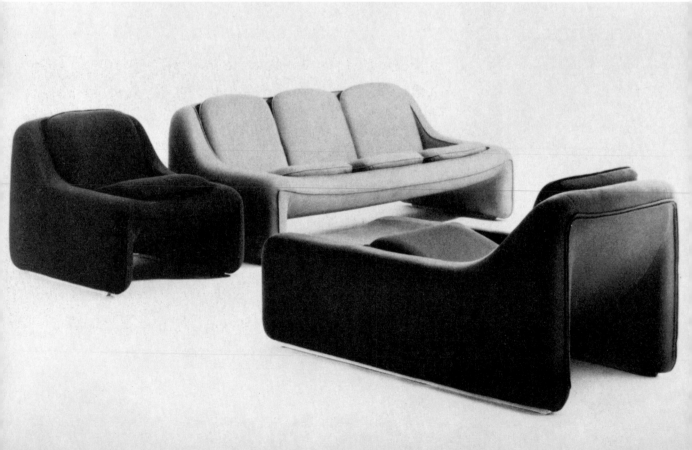

2 6
1 3 4 5

4
Flipper arm chair; seat and back element on
tube steel frame with rubber saddle-girth;
upholstered over polyether foam:
cm 98/38½ inches high
Designed by Mikael Björnstjerna for Bejra
Möbler i Tibro Ab, *Sweden*

5
Easy chair, upholstered velveteen or dacron
over polyether foam and pocket springs,
beige, brown, marine or red:
cm 77·5 × 77·5 × 56/30¾ × 30¾ × 22 inches
Designed by Hans Ehrlin for Alfred Ehrlin Ab
Sweden

6
Seat and stool units, wood frame upholstered
foam rubber and stretch nylon, orange, green,
blue and gold:
cm 150 × 75 × 65/59 × 29¾ × 22 inches
Designed by Kazuko Watanabe for Isetan
Company Limited, *Japan*

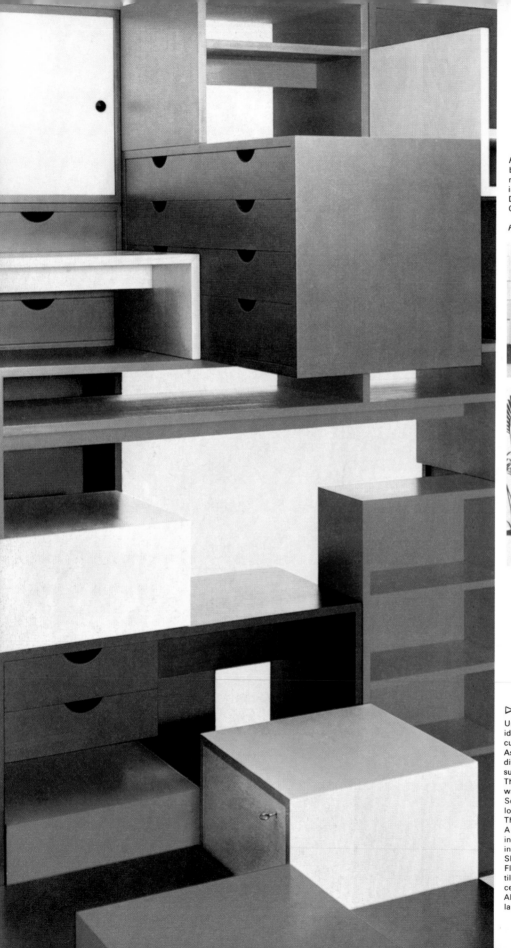

Pago Cubus and Pago Variant units
beech lacquered red, white, green or blue or
natural: basic cube cm 40×40×40/16
inches.
Designed by Hans Eichenberger and Marcel
Corthay for Progressa Ab, *Switzerland*

Peter Moeschlin

▷

Uniform height kitchen units may not be
ideal under all circumstances and this
custom built kitchen has 3 'working levels';
As the hausfrau is petite she finds it
difficult to lift heavy casseroles onto
surfaces at the normal height of 90-92 cms.
The plate warmer is inset into the left hand
wall, 4, at one level.
So the electric hotplates are on the same
low level as the breakfast/work table.
The sink and drop-shelves level is standard.
A tiny cupboard holds items,
including pepper, salt, oil, constantly
in use, closed with a silent vertical door.
Sliding drawers are for utensil storage.
Floor and walls are of grey-green ceramic
tiles, the upper walls white-painted, the
ceiling grape-green.
All built-in elements are white plastic-
laminate finished.

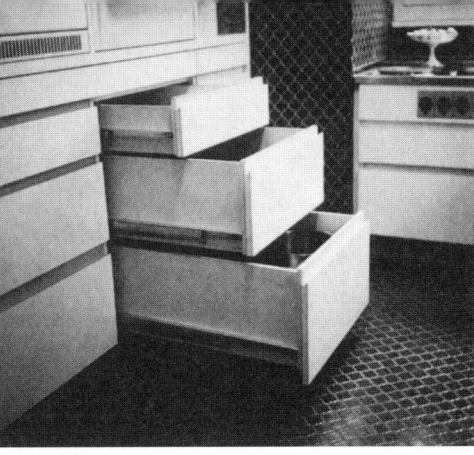

Small kitchen for
a Swiss family
interior architect
Lucy Scoob-Sandreuter

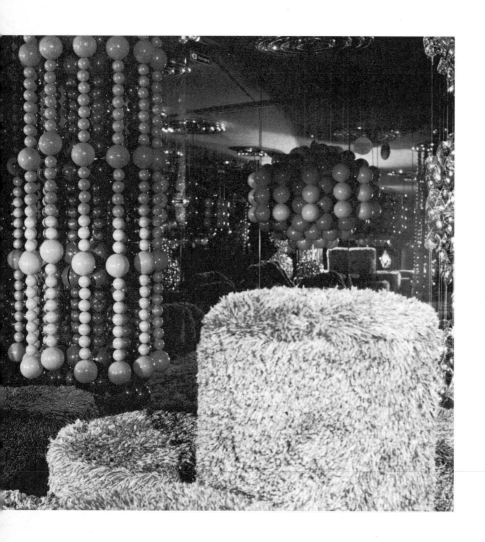

Both pages: interior of Visiona
designed by Verner Panton for Bayer
Fibres, *W. Germany*

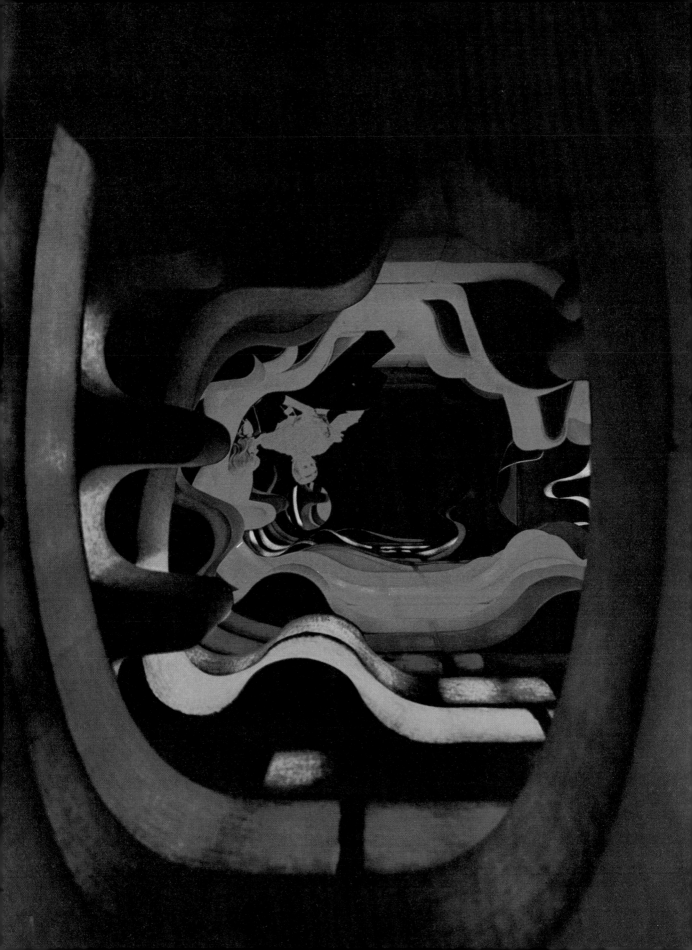

The Sitting Room, assembled for an
exhibition 'Ten Sitting Rooms'
plastic materials
Designed by Elizabeth Harrison
Institute of Contemporary Arts, London

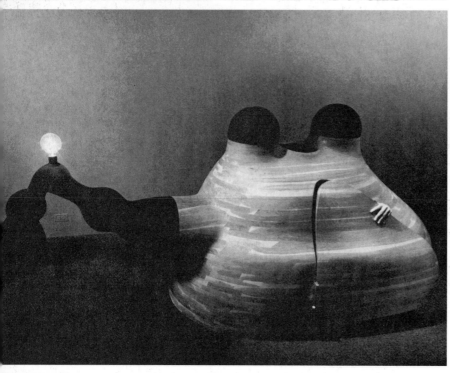

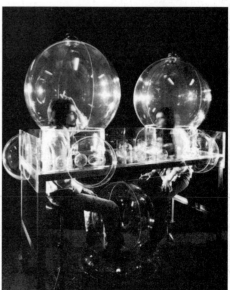

Laminated wood *Reclining Space for one*
by Wendell Castle.

Centering Environment acrylic fibres
woven on steel frame: cm 183/6 cubic feet
Designed and made by Ted Hallman jr,

Moon-Man-Fountain plastic structure
for two by Neke Carson
All for Contemplation Environments at the
Museum of Contemporary Crafts, New York

Sleeping block with retractable cover and, at head, built-in lighting, stereo equipment etc.
Living/dining block closed and opened to reveal the dining table; below is a cocktail cabinet, above radio and other equipment
Designed by Joe Colombo for Sormani spa, Italy

Hachinohe is a popular holiday region between Hokkaido and Honshu Islands and already has so high a density of building that in planning this villa any idea of opening it to a view could not be considered.

The architect therefore borrowed something from the squares of European towns and cities – the open space and meeting place – surrounded here by the three blocks which comprise the house. The space is a large elevated terrace and the three blocks which are open to it each serve a separate purpose: one is the salon and living-room, the second contains the bedrooms, the third is the lover's lounge.

Exterior walls and parapets are of rough, vertical wood siding but the interiors are vividly coloured – each area strictly monochromatic.

Thus the salon is rose-carpeted and rose-upholstered, with cushions in rosy hues: wall and table surfaces are also rose-red. The stairway and hall are deep green – but wholly green – a bedroom is all-blue, the kitchen, orange.

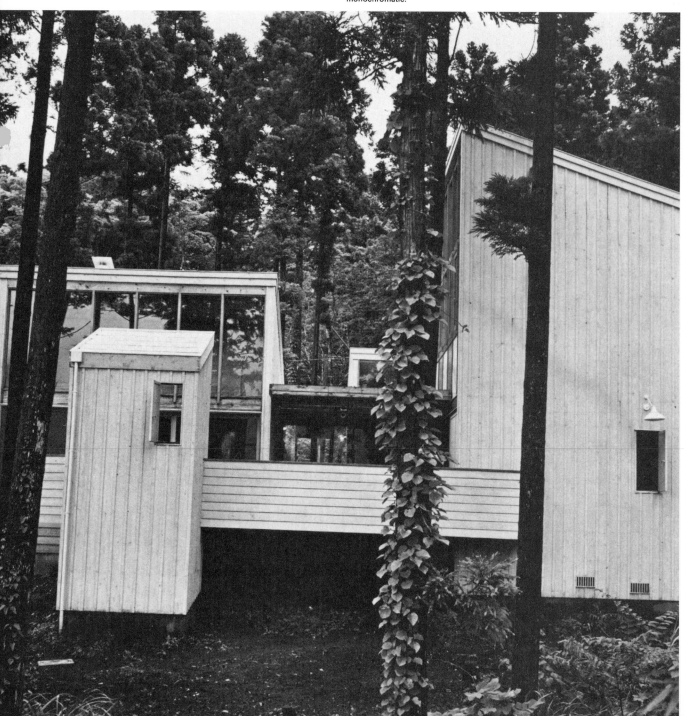

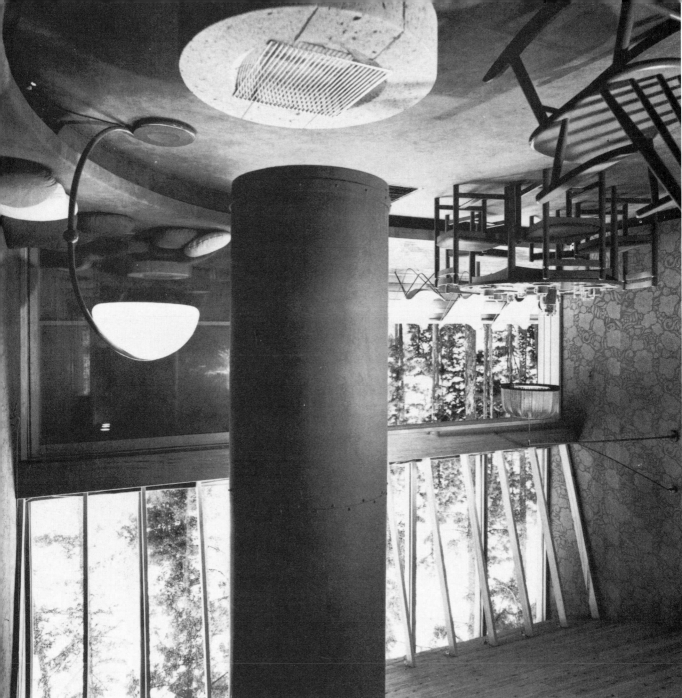

Plaza House, Hachinohe Myojindaira
architect M. Miyawaki and associates

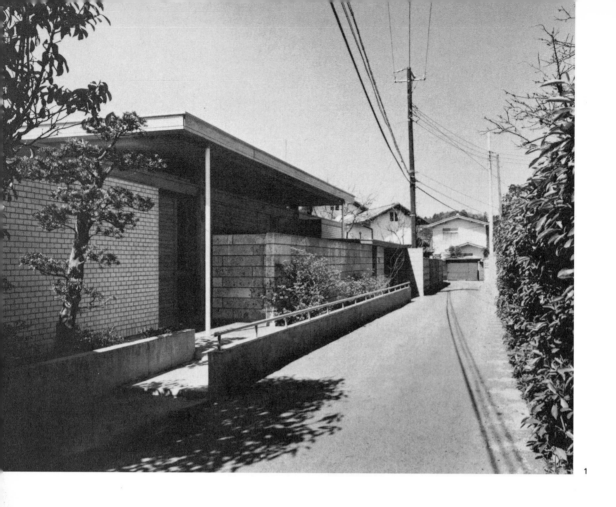

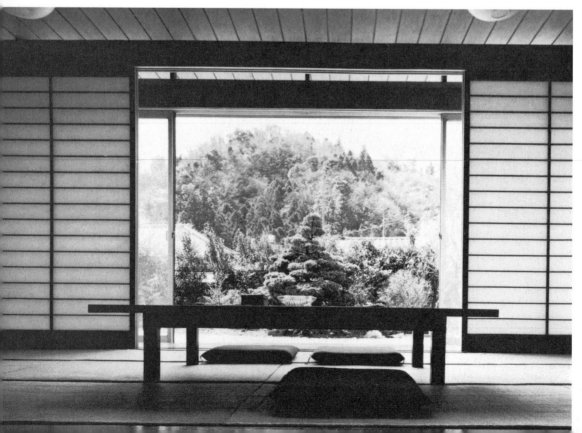

The Ta residence, Kamakura
architect Motoo Take

The Ta residence, Kamakura
architect Motoo Take

4

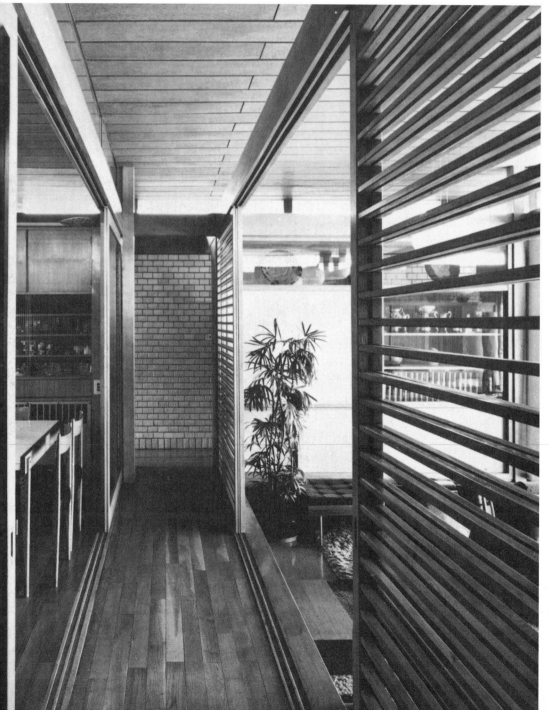

picture key

1 entrance
2 salon
3 among the woodcutters
4 between dining room and salon
5, 6 salon

photographs T. Waki
courtesy *Kenchiku Bunka*

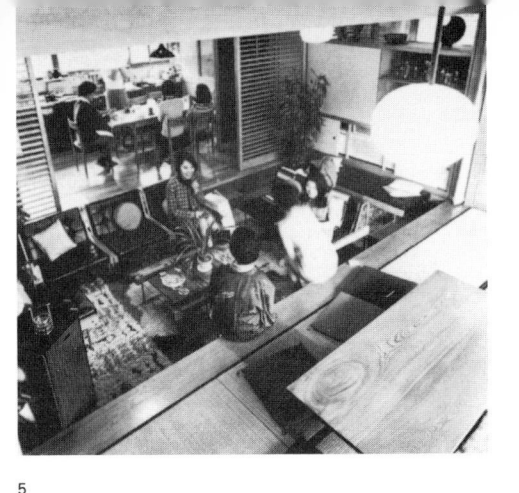

5

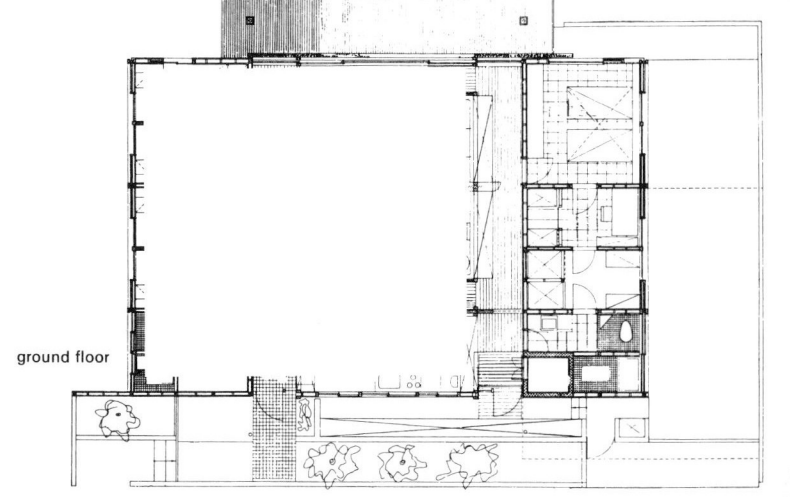

ground floor

The architect's own home, this house epitomises one of the changes which have developed in Japan in recent years. Traditionally the Japanese home consisted of the *zashiki* or formal room where guests were received and entertained and the *chanoma* or tea quarter where the family met. Influenced by western ideas which (not so very long ago) merged the front room, or parlour, into the middle, or sitting-room, by means of open-plan, Japan, too now tends to combine her *zashiki* and *chanoma* into one multi-purpose living room.

Motoo Take has therefore stretched his salon or living-area to the utmost while reducing the bedrooms to the minimum possible dimensions – all this without conflict with the characteristic style of Kamakura, the ancient capital of Japan.

6

This house is situated on a gentle slope overlooking the city of Kofu with the mountain in the background.
It is a two-storied reinforced concrete structure having a wide living room on the ground floor open to a south facing terrace and the view of mountain and city below. Above, the bedrooms on the first floor each face the void open to the living room. Pine boarding and other timbers have been used to furnish the surfaces of the living area. The architecture includes the seating and some other items.

Yg residence overlooking Mt. Fuji
architect Y. Hosaka

photographs S. Okamoto
courtesy *Kenchiku Bunka*

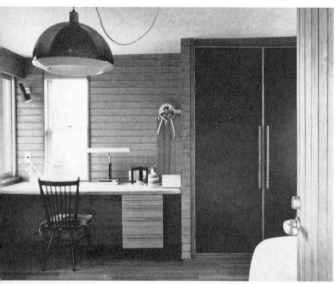

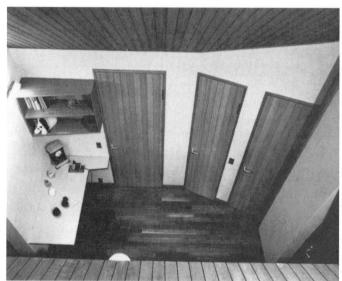

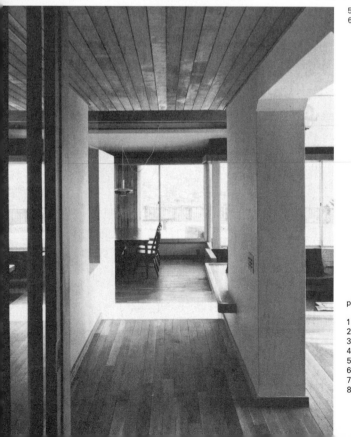

5 7 8
6

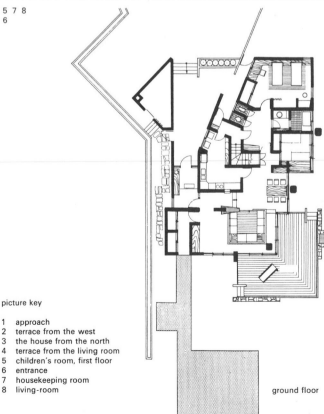

picture key

1 approach
2 terrace from the west
3 the house from the north
4 terrace from the living room
5 children's room, first floor
6 entrance
7 housekeeping room
8 living-room

ground floor

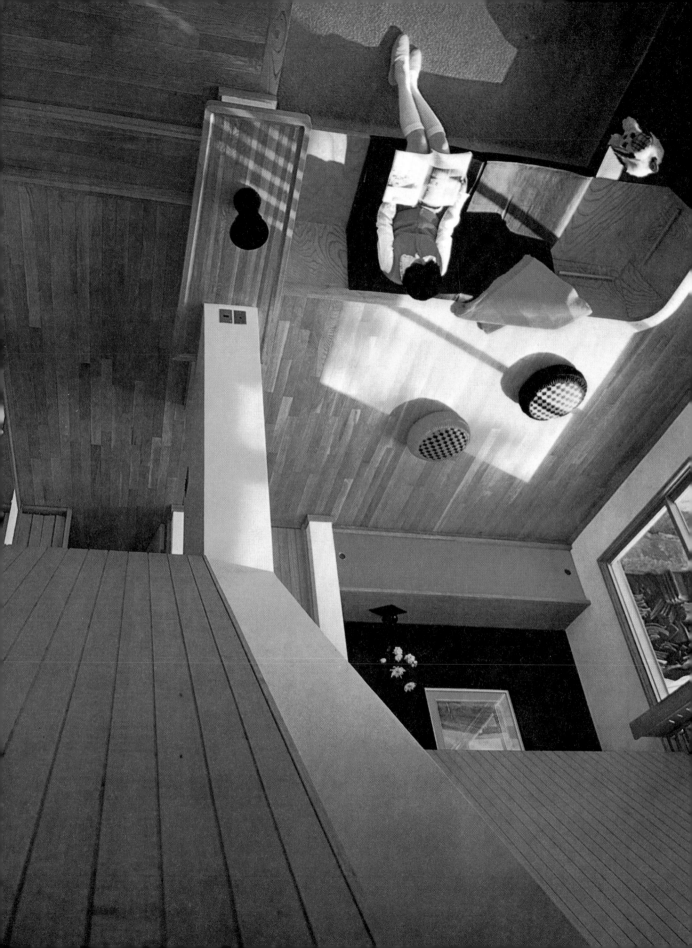

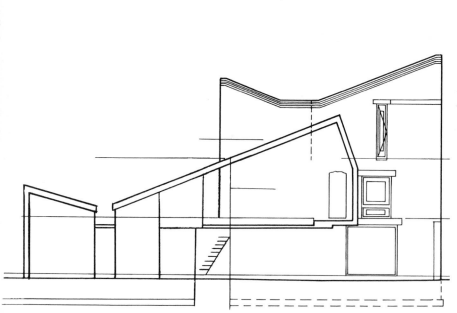

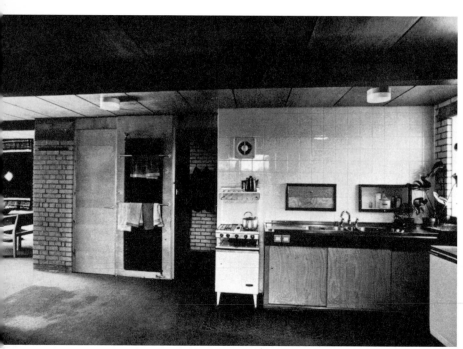

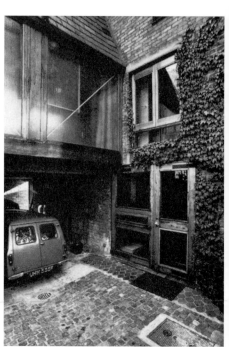

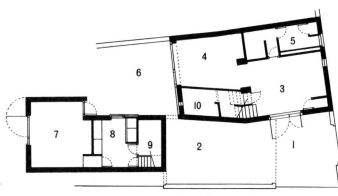

plan key

1 courtyard
2 garage
3 kitchen
4 dining room
5 WC, cloaks
6 terrace
7 sculptor's studio
8 lobby
9 shower
10 cellar

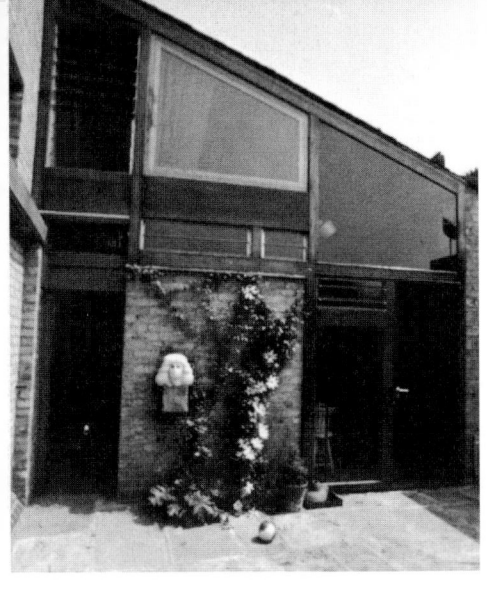
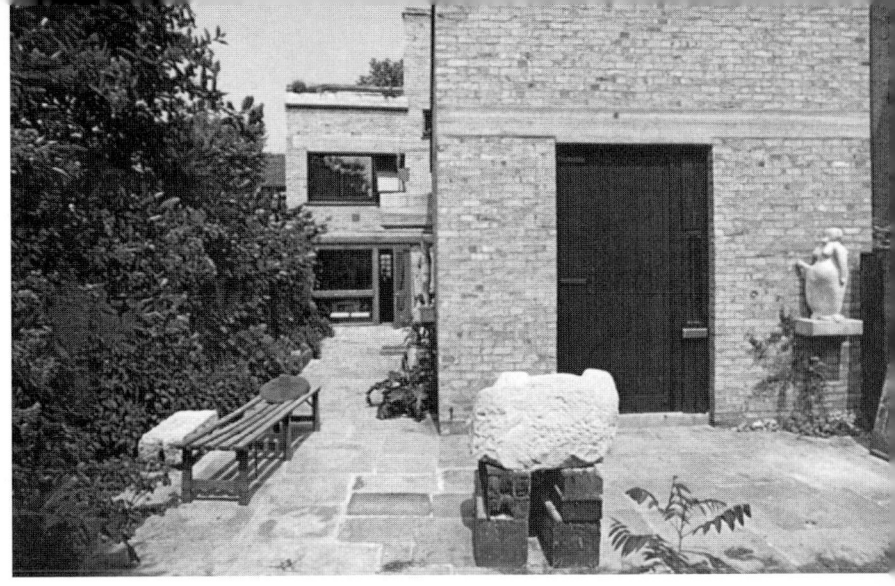

2 4 5
1 3 6

House with studios at Hammersmith, London
architect Theo Crosby

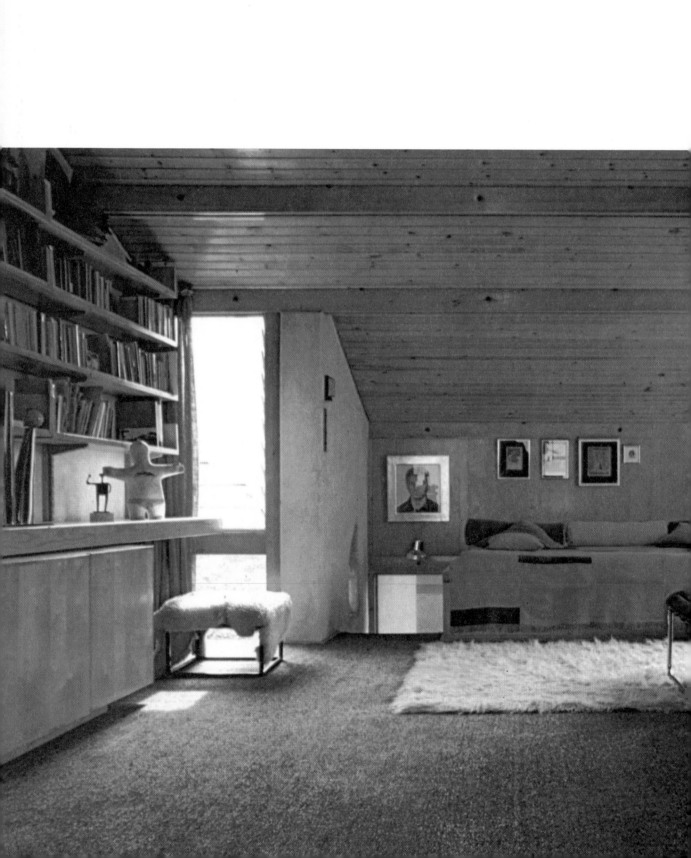

House with studios at Hammersmith, London
architect Theo Crosby

12, 13
14

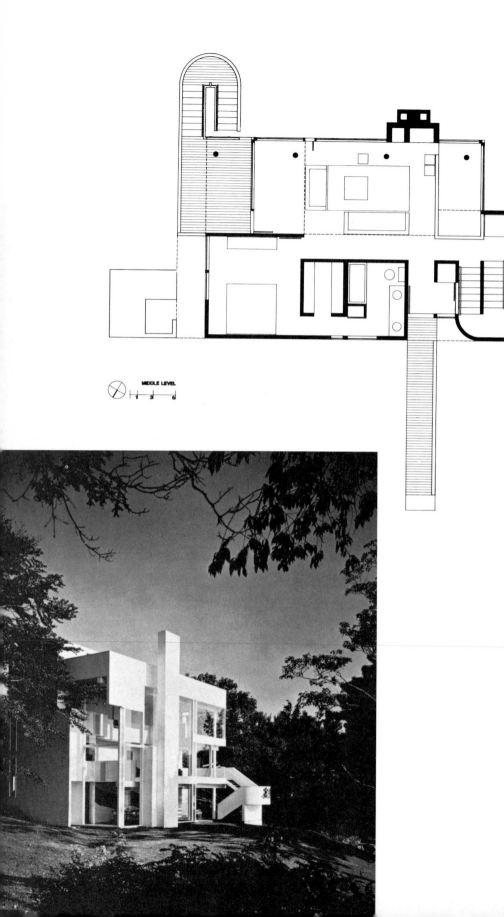

MIDDLE LEVEL

1 3 6

This family house for year-round use occupies a one-and-half acre site near the top of a rocky slope which descends towards the Sound on one side and inland on the approach side.

The house is basically a rectangular prism with accommodation on three levels. Entry is into the middle level, via a wide, terraced, gravel path leading up from the garage site some little distance from the house. Here is the interior staircase at the south-west corner: on this middle level are living-room, main bedroom, dressing room and bath. Below, on ground level, is the dining-room, kitchen and service areas: above are children's and guest rooms and, on a balcony open to the double-height living space, 1, a library and play area.

At the north east all three levels are open vertically to each other and toward the large diagonal views of the Sound, 1,2. An exterior stairway also connects ground and second floor, leading from a recessed terrace opening from the dining area to a porch off the living area on the second level.

The roof is a sun-deck providing a fourth and yet other perspective to the view. The external materials are vertical wood siding and glass with a brick chimney, on a structure of wood-bearing wall and round standard steel columns supporting wood beams on the 'open' side.

The two different structural systems create two different kinds of spatial volume; small, compact space within the bearing wall and large, open space where the structure is columnar. The bearing wall is a thick mass penetrated by a sculptural curving entry. Movement is through this entry into the single level service area, through the circulation spine under the third level balcony and into the large, two-level space of the living area. The compressed private area increases the sense of expanding space in the living area. Space is layered from entry to sea wall and also layered horizontally from dining level to ceiling.

A skin of glass on the sea side and the terrace off the living area, as well as a free-standing chimney and fireplace that are pulled out beyond the glass, visually continue the space beyond the wall. The house seems open to nature. This openness is increased by the white interior walls which reflect the changes in natural light. In elevation, the white exterior walls and glass also reflect nature. The inner planes can be seen through the glass walled exterior, and the sea side wall of the roof solarium continues the plane of the inner bearing walls. Horizontal planes are indicated by mullions.

photographs Ezra Stollar

photo key

1 north-east view
2 living area from the play room
3 middle and lower level from the
 balcony
4 living room: furniture designed by the
 architect

House overlooking Long Island Sound, Connecticut
architect Richard Meier

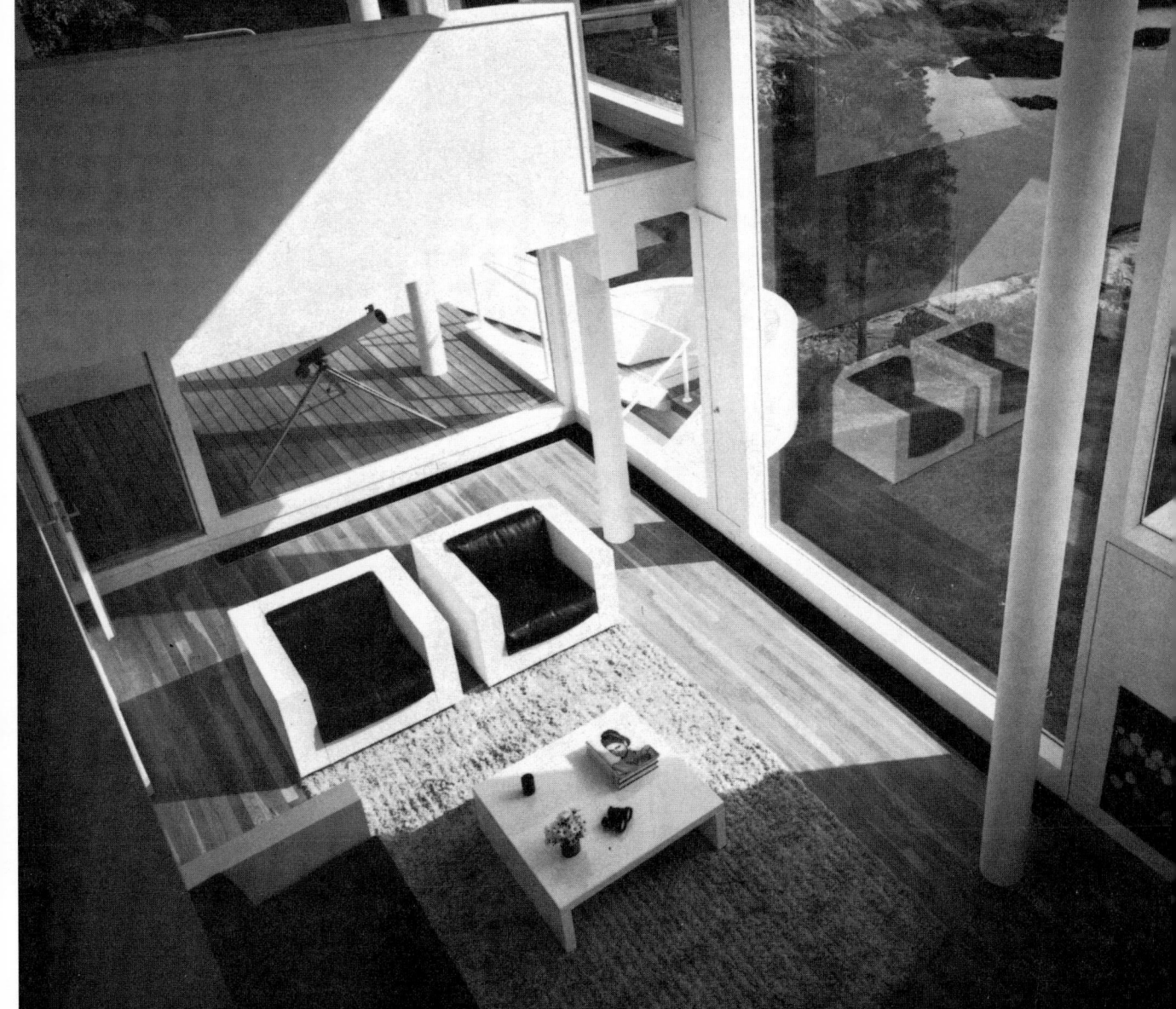

House overlooking Long Island Sound, Connecticut
architect Richard Meier

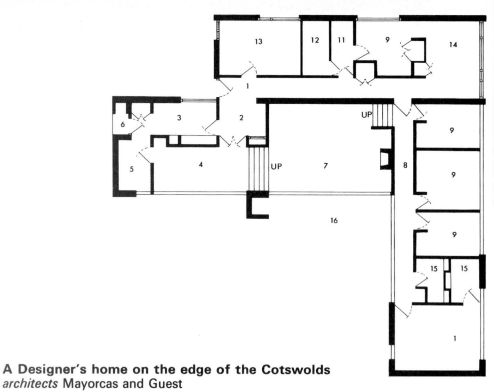

A Designer's home on the edge of the Cotswolds
architects Mayorcas and Guest

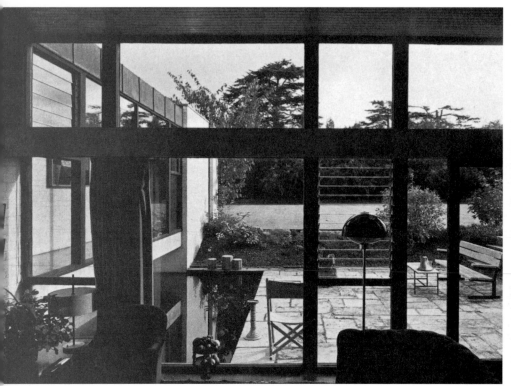

1 2
3 4

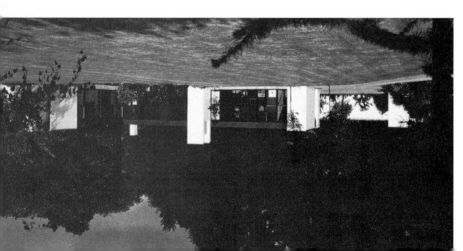

Robert Welch designs in silver, iron, steel and glass — cutlery, lamps, coffee pots. A craftsman and consultant designer to industry his headquarters are at Chipping Campden on the edge of the Cotswold Hills and this, his family home, is a few miles away at Alveston near Stratford-on-Avon.

The house realizes the planned development of an older too-small dwelling in which the working/playing area to the left of the entrance is now separate from the main living area by the extent of the main hall or corridor.

The large level site was ideal for such an extension of the one-storey building demanded by planning and aesthetic considerations.

The level of the living room/terrace areas has been deliberately lowered to improve the acoustics of the living room and give further shelter to the terrace and this has further improved the 'fit' of the house into its site. Nevertheless the structure is characterised and strongly accented, in part by the white painted brickwork of the main walls and screen walls.

Within, the house reveals a happy blend of old and new: mostly fine old sitting room furniture and modern shelving; modern under-floor electric heating and a chimney for an old-fashioned fire. The fair-faced brickwork is as good a surface as any for the collections of old treasures and newer examples of Robert Welch product design. In winter teak and pine strip surfaces of floor and ceiling glow pleasantly through the main living areas. In summer the same areas are open wide to the southerly aspect over the expanse of lawn: more immediately to the terrace sheltered by the bedroom wing of the house.

A Designer's home on the edge of the Cotswolds
architects Mayorcas and Guest

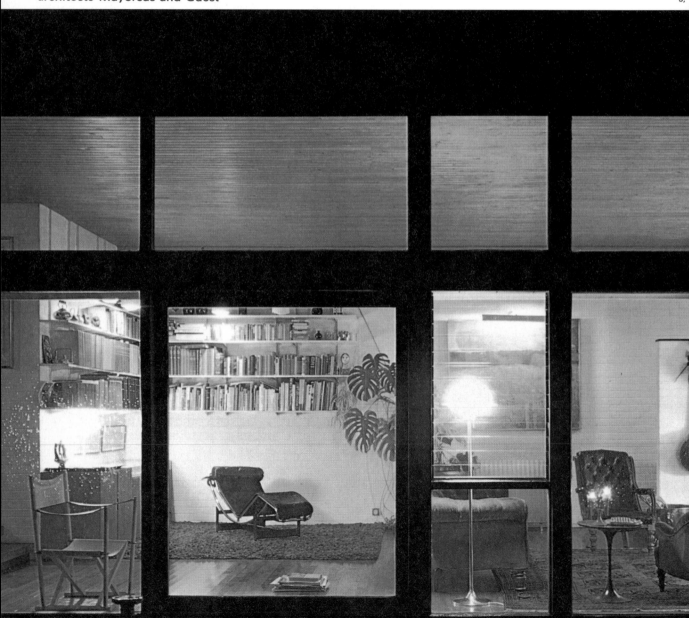

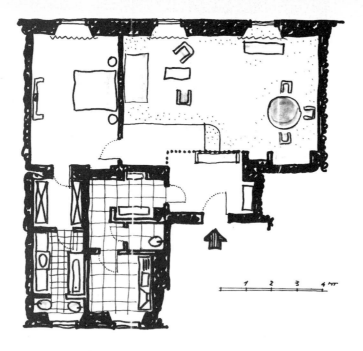

Apartment in Milan
interior design Franco Mazzucche

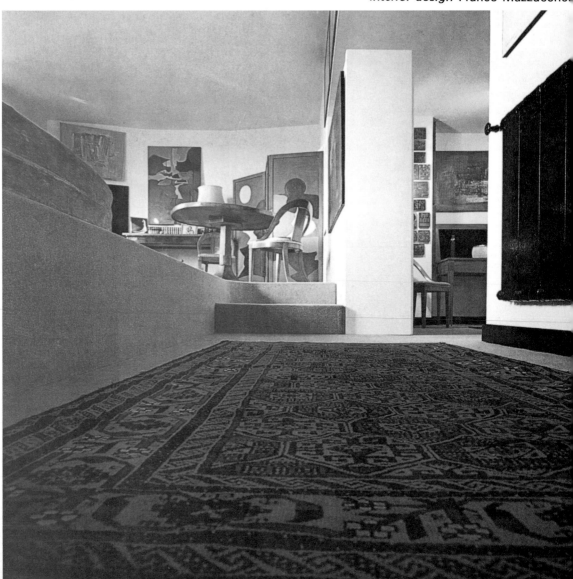

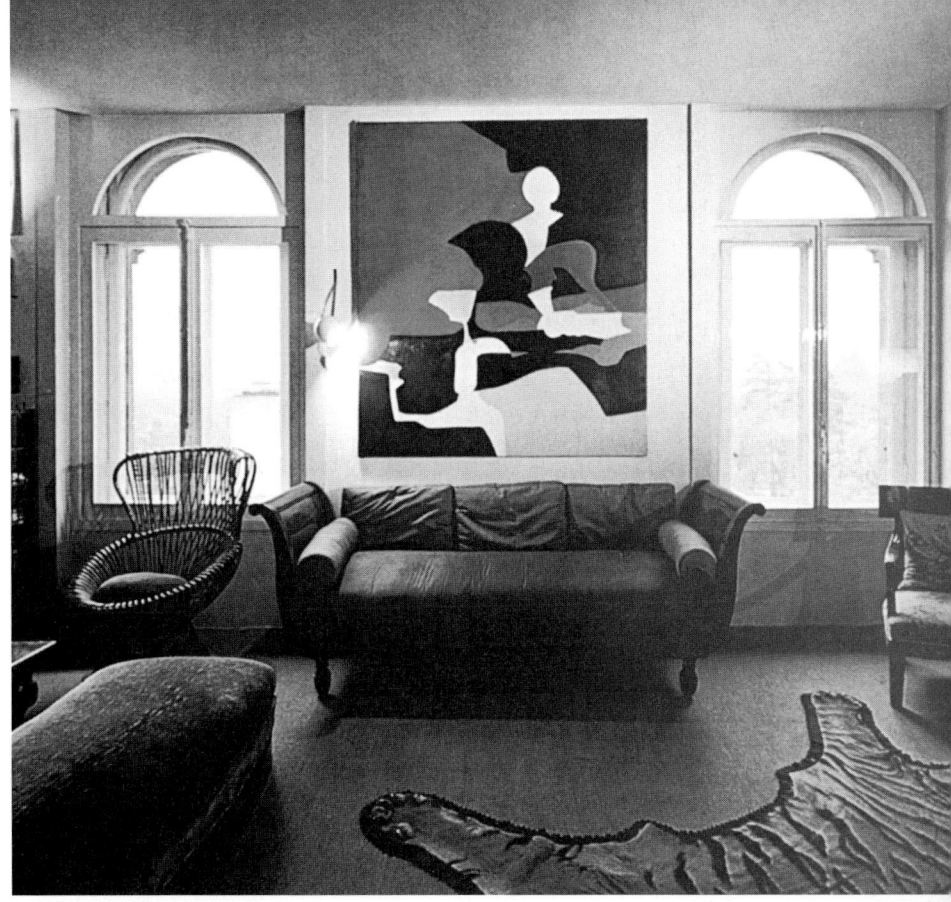

On the top floor of an older house over-
looking a park, this flat has recently been
remodelled to make it entirely self-
contained, functional and comfortable by
today's standards.
The owners are Alberto Papafava a
photographer and his wife, the Norwegian
painter Irmelin Slotfeldt, who has collab-
orated on the interior design and whose
paintings hang on the walls.
In a few square meters a large living/
dining room, bedroom, bathroom-with-
dressing-room and a kitchen have been
contrived.
Antique furniture and other family heirlooms
all contrast sharply with the white walls.
The level of the living area is raised but the
whole open floor area of the apartment is
covered by a grey moquette.
An extremely sophisticated atmosphere has
been created.

picture key

1–5 hall, kitchen, bathroom, bedroom
6 general view of living/dining area
7 dining end from bedroom
8 view to the park
9 the bookcase screens the living room
 from the entrance

8

9

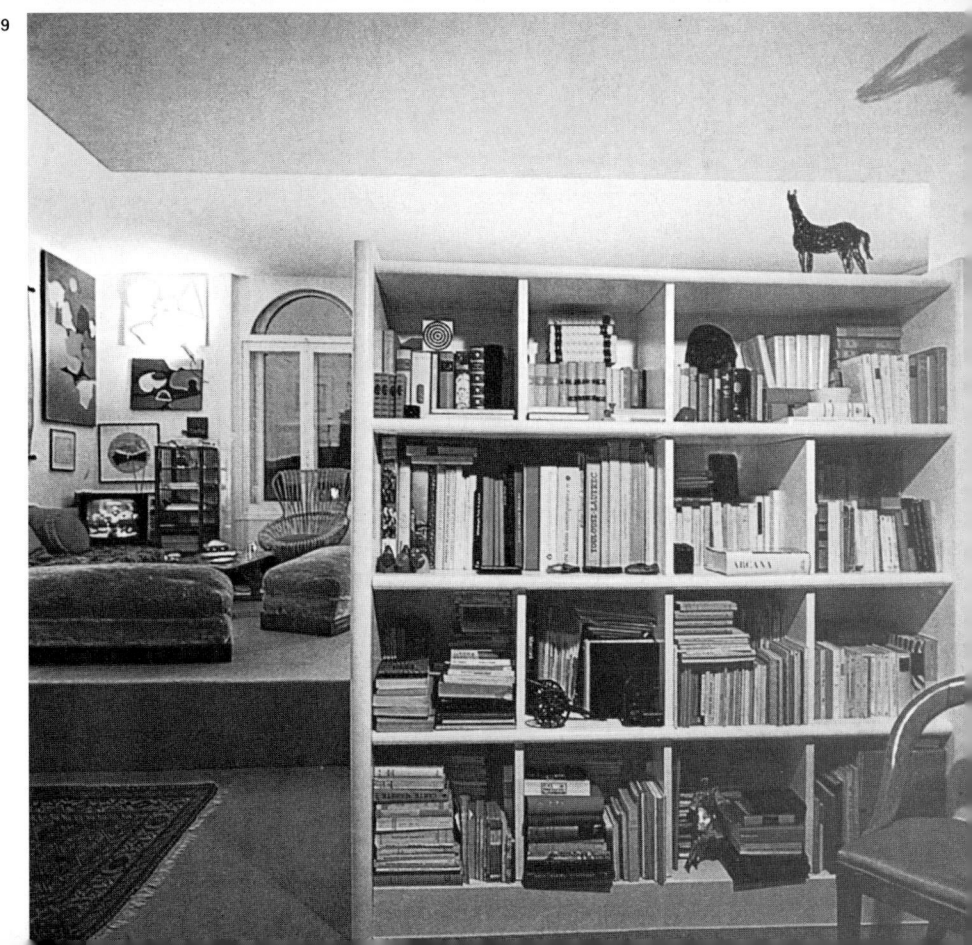

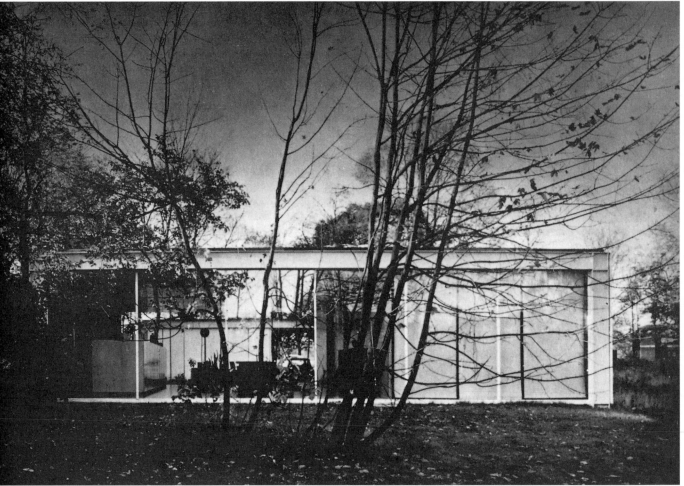

Rogers House, Wimbledon
architects Richard and Su Rogers in association with Design Research Unit
engineers Anthony Hunt and Partners

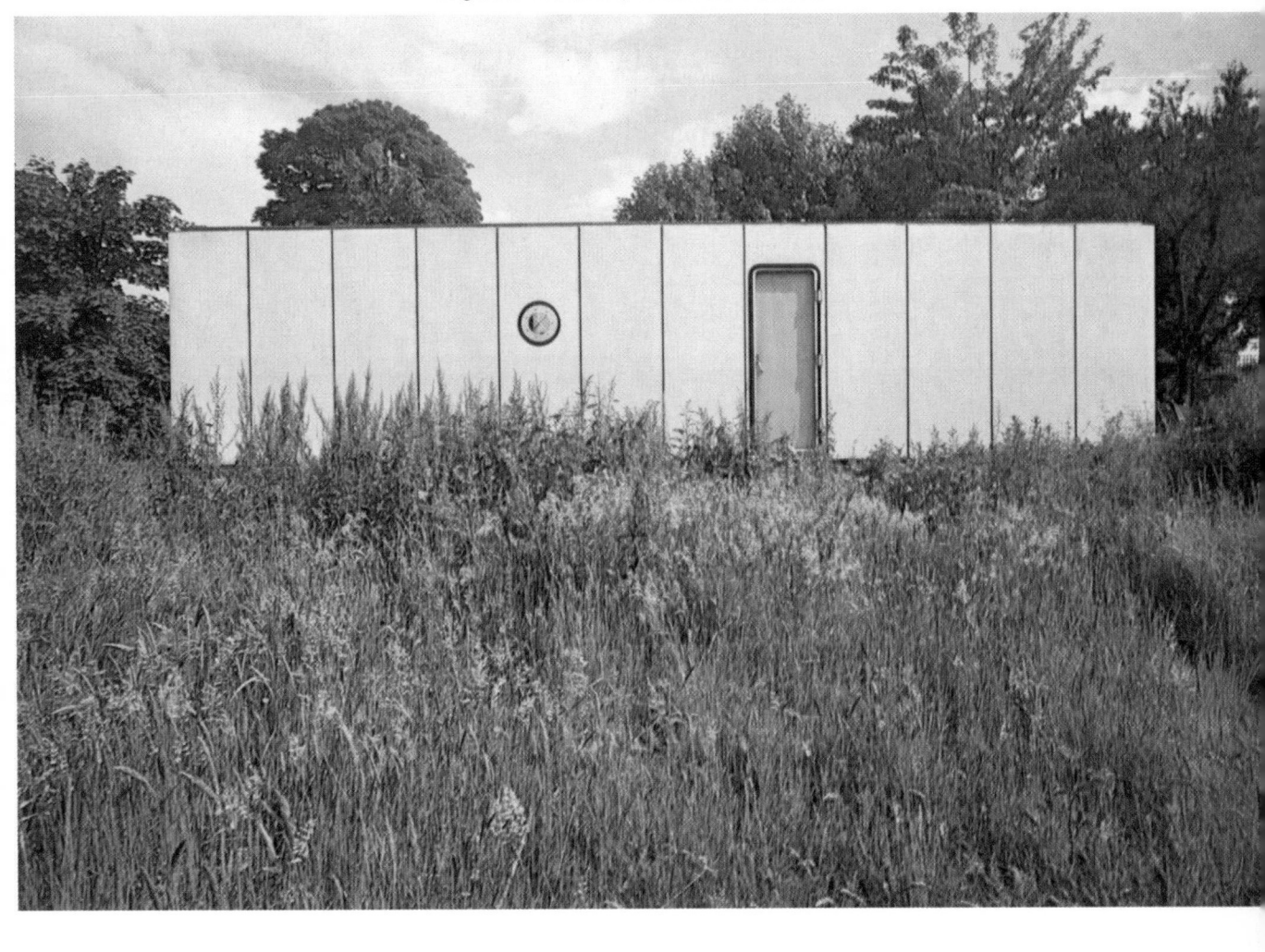

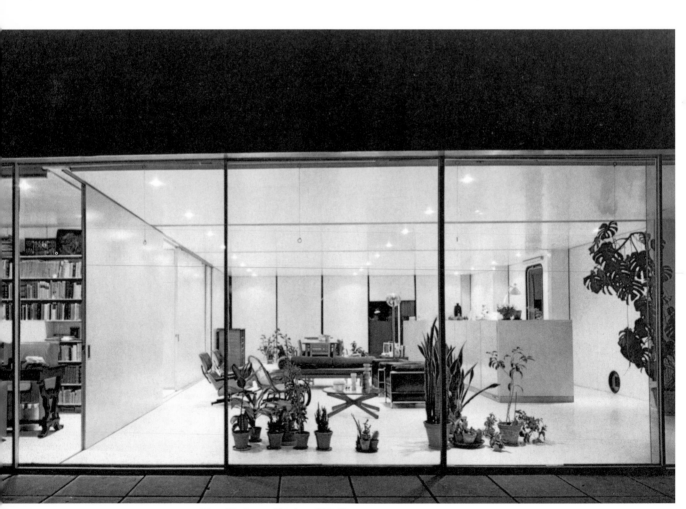

Rogers House, Wimbledon

architects Richard and Su Rogers in association with Design Research Unit
engineers Anthony Hunt and Partners

This house was designed by their son for a doctor and his wife.

One day they may move to the lodge, which at present houses a pottery kiln-room as well as living space: Mrs Rogers produces beautiful cream-glazed stoneware. The lodge also screens the main house from a major road.

Wimbledon is a residential district on the south-west edge of London.

It preserves a style composed of pleasantly-mixed, mostly nineteenth-century houses, shops and inns.

The Rogers' architectural practice is extremely modern in its approach whilst trying to satisfy both the sociological and technological requirements of today.

It happens that this startlingly different house occupies a site between the limit of the genuine older buildings and a mock-Georgian-detached development.

The intention was not to shock the champions of either style but to develop one of a series of prototypes for single and multiple application around the principle of maximum flexibility and extendibility.

Costs of building and maintenance were to be minimal.

Industrialized materials used in dimensions dictated by production techniques, with factory-applied finishes, fixed on site by skilled teams, resulted in minimum waste and maximum economies.

The portal frames span 12.19 metres/40 feet, thus eliminating columns in the middle of the building and freeing the internal spaces.

Walls are sandwich panels by Alcoa with aluminium faces and polyurethane cores hung on to the steel framework and joined with neoprene zips.

They are white pvc-finished inside and out, with bus doors closing into neoprene-sealed openings in the panels.

Internal space is divided by fixed but removable joinery partitions and sliding doors.

As all the exterior walls are also technically movable 100% flexibility is built-in.

Subsequent owners can remove the studio wall panels and turn it into a second house or link it to the main house. East and west elevations of the house are double-glazed with full height, full width

sliding units.

The suspended plaster ceiling contains the small-bore heating system of the house. In the lodge the ceiling is a stretched plastic membrane and heating is by convector radiators.

Floors are self-levelling white polyurethane over concrete.

Enamel—lemon yellow, lime green and chrome yellow—sprayed on to steelwork, sliding doors and partitions respectively, compose the flat areas into a colour harmony.

The owners' mid-30's dining suite was designed by Italian architect Ernesto Rogers; armchairs are by le Corbusier, Eames and Thonet.

photographs: Richard Einzig

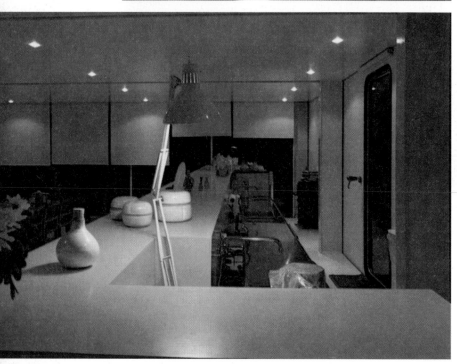

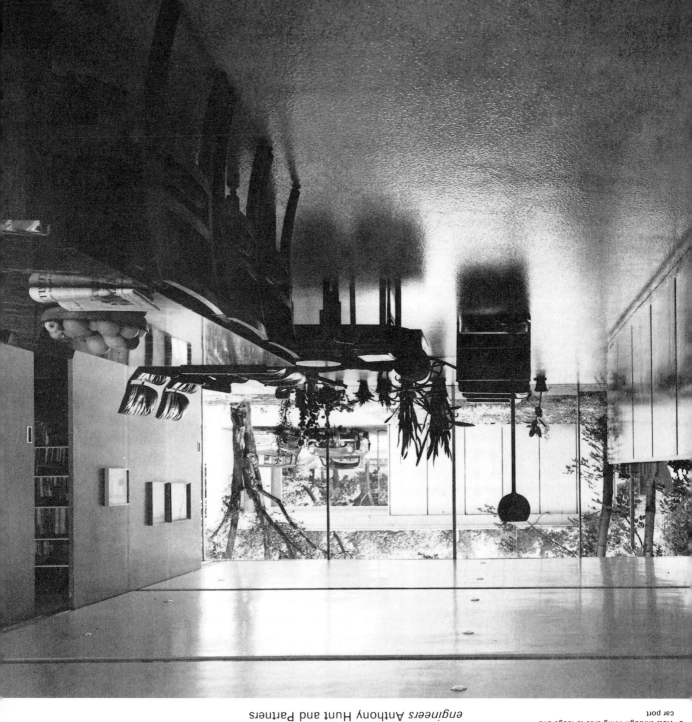

Rogers House, Wimbledon
architects Richard and Su Rogers in association with Design Research Unit
engineers Anthony Hunt and Partners

1 Rear view into main house
2 North-west wall with porthole to laundry/utility room and bus door to small bedroom
3 Through carport to house, lodge at right
4 The kiln room in the lodge
5 View from court to living area with, left foreground, doctor's study
 Background: yellow blinds over rear glazing
6 Sitting and dining space with, beyond, a partly-opened screen wall to the main bedroom
7 Laundry/utility room, like the bathroom lit by the roof light
8 Kitchen counter: pottery equipment alongside
9 View through living area to lodge and car port

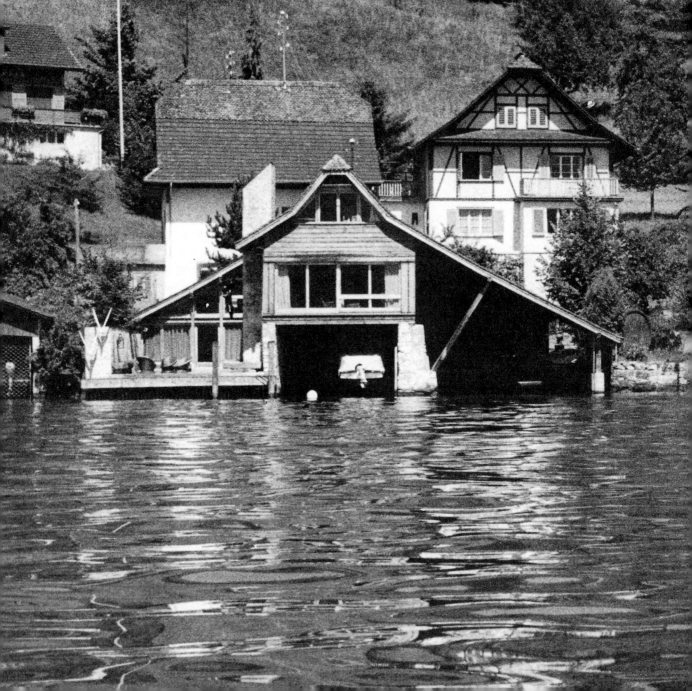

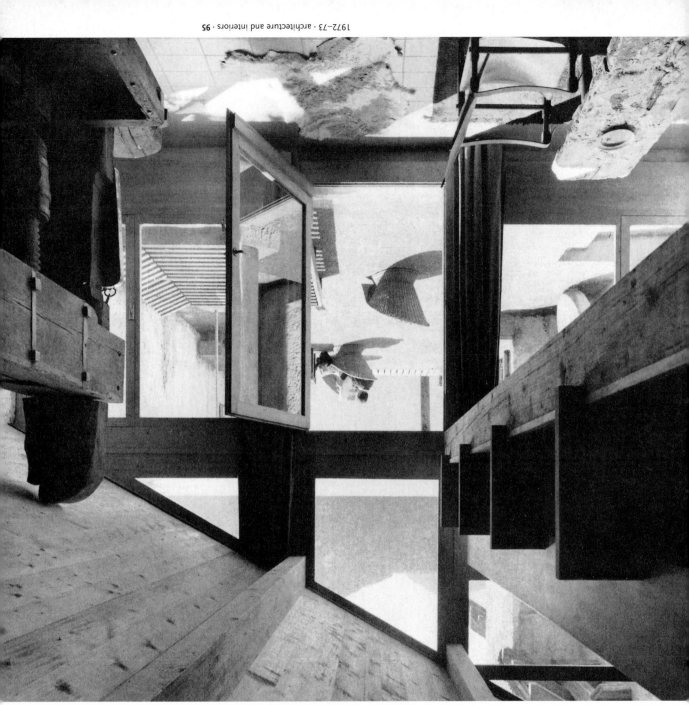

Holiday home on Lake Lucerne, Switzerland
architect Justus Dahinden

1 living room
2 kitchen
3 terrace
4 gallery
5 solarium
6 toilet/bathroom
7 exit

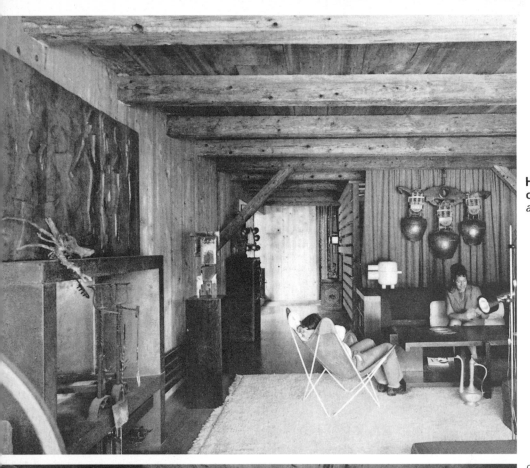

Holiday home on Lake Lucerne, *architect* Justus Dahinden

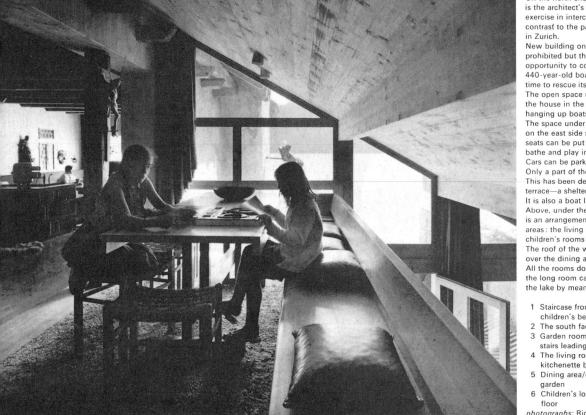

On the north shore of Lake Lucerne this is the architect's own holiday home and an exercise in intercommunicating space—in contrast to the pattern of the family house in Zurich.

New building on the lake shore is prohibited but there was a unique opportunity to convert and restore a 440-year-old boathouse, and, at the same time to rescue its basic concept from decay. The open space under the oldest part of the house in the middle is equipped for hanging up boats.

The space under the huge projecting roof on the east side serves as an area where seats can be put up, where the children bathe and play in the rain

Cars can be parked there as well. Only a part of the west 'wing' remained. This has been developed into a sunny terrace—a shelter from wind, and private. It is also a boat landing-stage.

Above, under the centre of the great roof is an arrangement of open rooms and areas: the living room and above children's rooms

The roof of the west wing sweeps down over the dining area/gallery

All the rooms double as sun rooms and the long room can be opened towards the lake by means of sliding glass doors.

1 Staircase from first floor leading to children's bedroom
2 The south facade from the lake
3 Garden room and sun terrace from the stairs leading to the first floor gallery
4 The living room (staircase and kitchenette behind curtain)
5 Dining area/gallery overlooking the garden
6 Children's long bedroom on the second floor

photographs: Richard Einzig

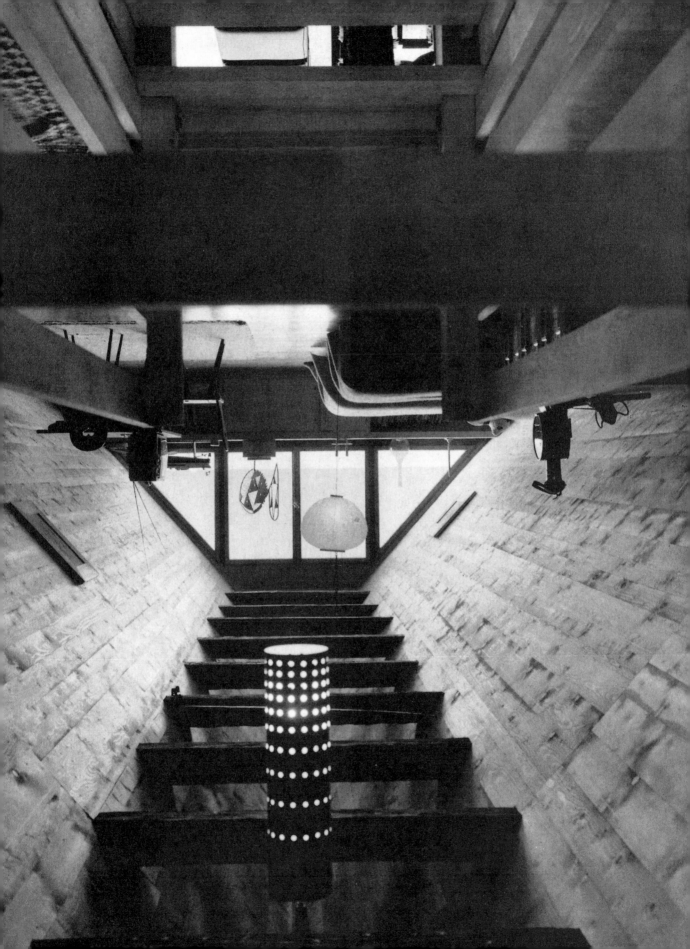

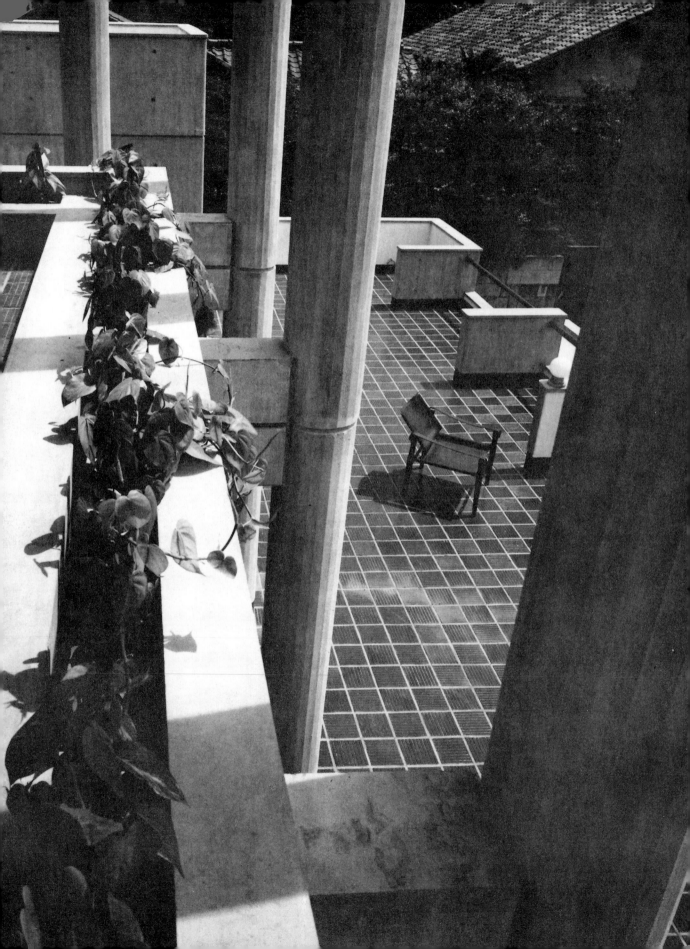

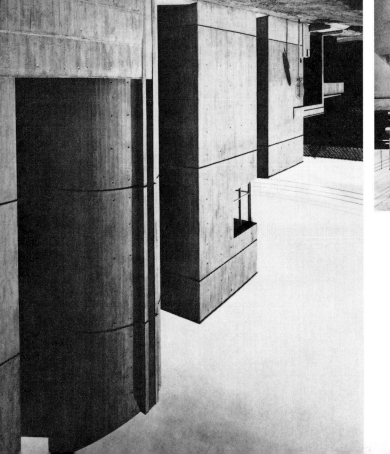

Built in a quiet residential area of the city for a famous actor of Kabuki the house is required to fulfil two different functions. The ground floor contains public space with a rehearsal room and the first and second floors are the family residence. In order to segregate the house from the street fair-faced concrete has been used for the walls and large open terraces are provided on the east and west.

1 First floor terrace from the
 second floor
2 South view
3 Living-room ground floor
4 North-east view
5 Terrace from the first floor

photographs: Tomio Ohashi
courtesy Kenchiku Bunka

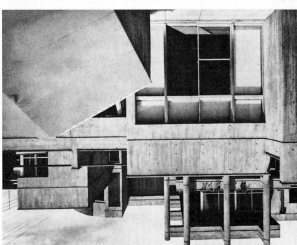

Baiko Residence, Tokyo
architects Sanwa Tatemono Co Ltd

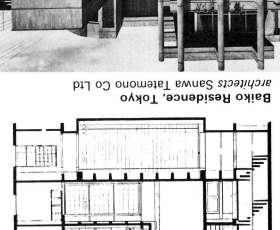

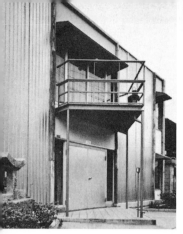

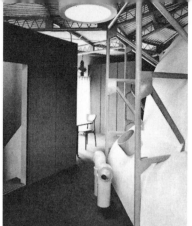

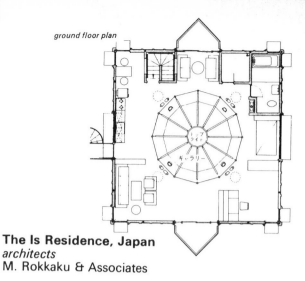

ground floor plan

The Is Residence, Japan
architects
M. Rokkaku & Associates

1 North side view from north-east
2 Drawing corner
3 Entrance
4 Living-room
5 Living corner, second floor gallery
6 Dome, second floor
7 Second floor gallery

photographs Shigeo Okamoto
courtesy Kenchiku Bunka

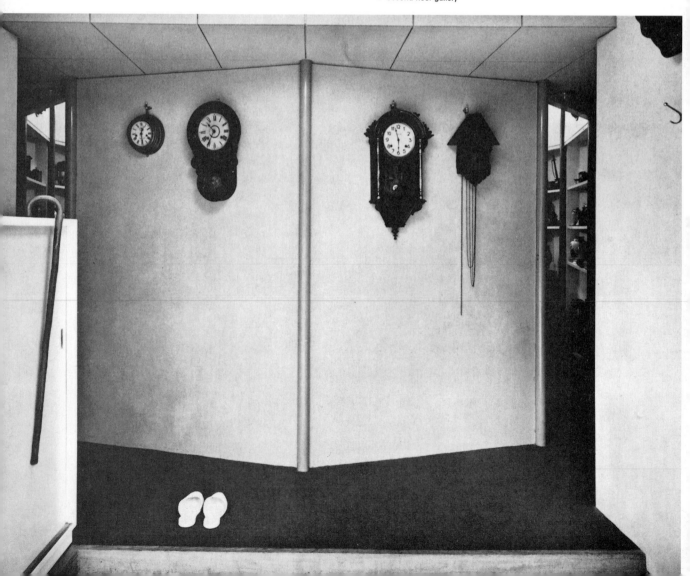

The Is Residence,
architects
M. Rokkaku
& Associates

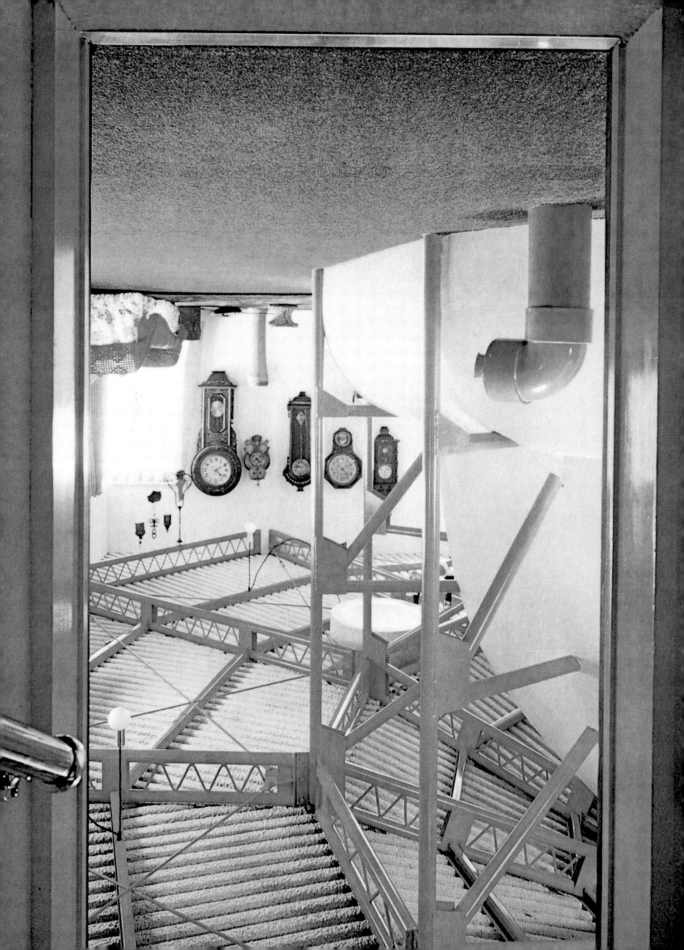

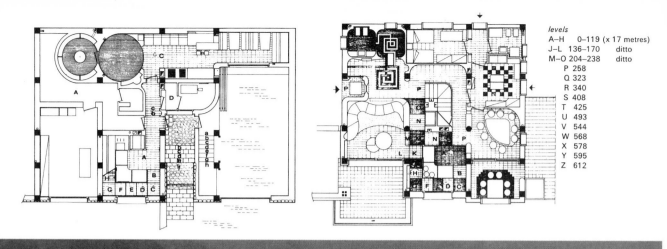

levels
A–H 0–119 (x 17 metres)
J–L 136–170 ditto
M–O 204–238 ditto
 P 258
 Q 323
 R 340
 S 408
 T 425
 U 493
 V 544
 W 568
 X 578
 Y 595
 Z 612

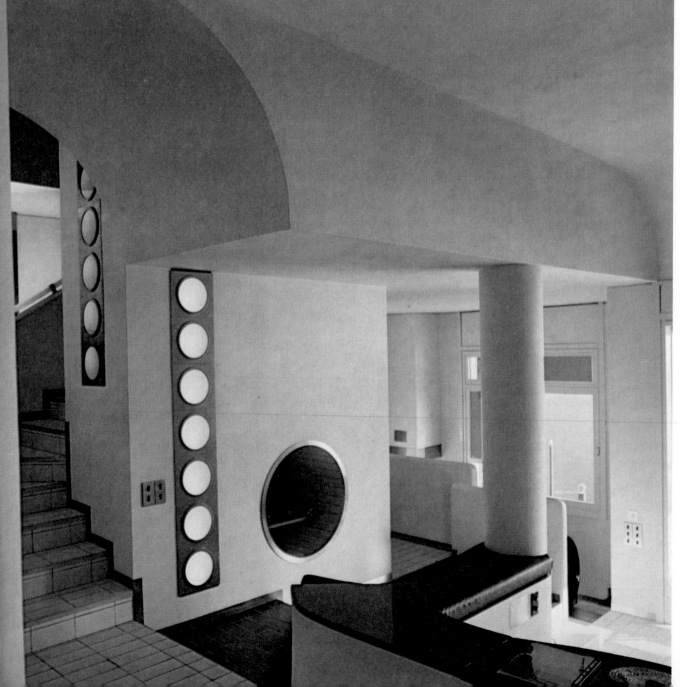

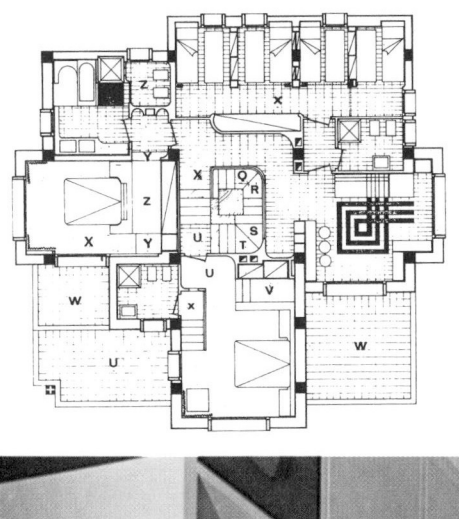

The Lenno House on Lake Como
architects Ico and Luisa Parisi

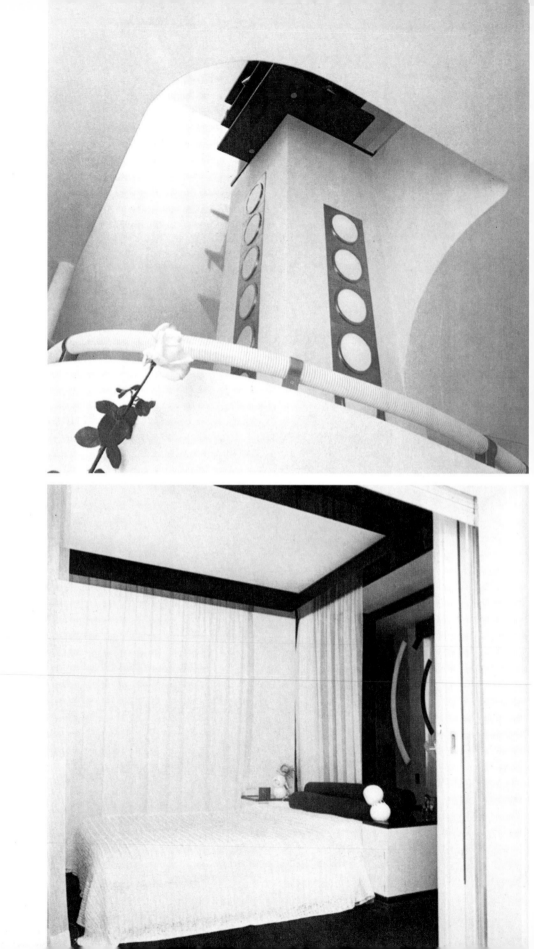

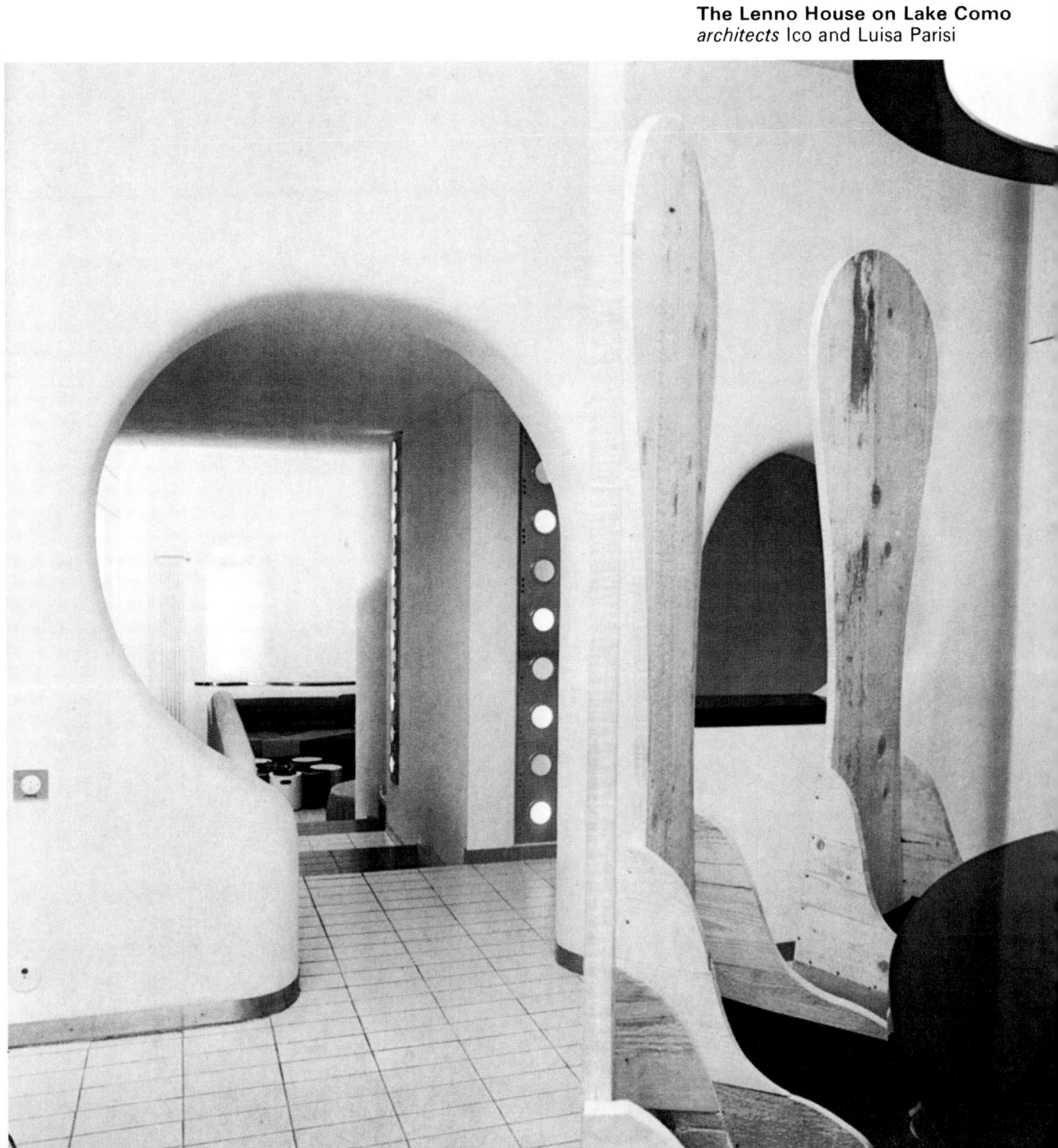

The Lenno House on Lake Como
architects Ico and Luisa Parisi

Built for a family this house offers the owners and their numerous friends an escape to tranquility from the exhausting atmosphere of city life.

It is thought of as a single volume wrapped around a spiral staircase with each of the internal spaces composing into a different form yet succeeding one another at different levels.

Externally, the structure reflects by colour the various areas of the interior.

Black-and-white is everywhere in the interior.

Black-and-white make the design of floors, walls, fabrics, household equipment.

The curves of walls and ceilings suggest the conformation of a carton-like structure.

Everything is lit by the colours of moving-art: each aesthetic addition was studied in collaboration with the architect at design stage, whether the revolving image of the Varisco, the kaleidoscopic projection of the Vecchi, the big chair-sculptures of Ceroli or the acrylic diagram of Degni.

The whole projects a type of habitation departing from the traditional.

It is a new search for a freer, more stimulating, more fantastic environment.

The Lenno House on Lake Como
architects Ico and Luisa Parisi

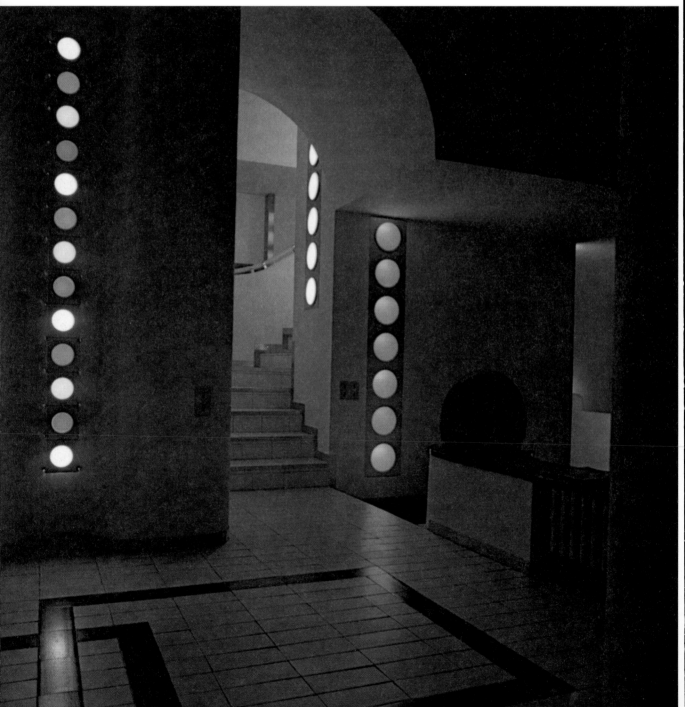

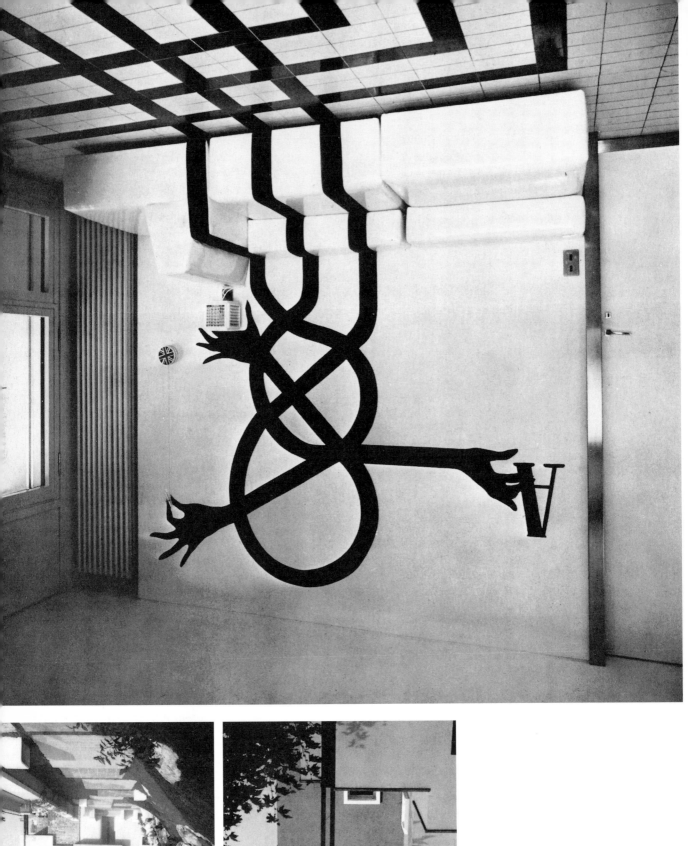
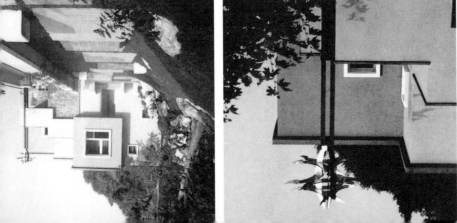

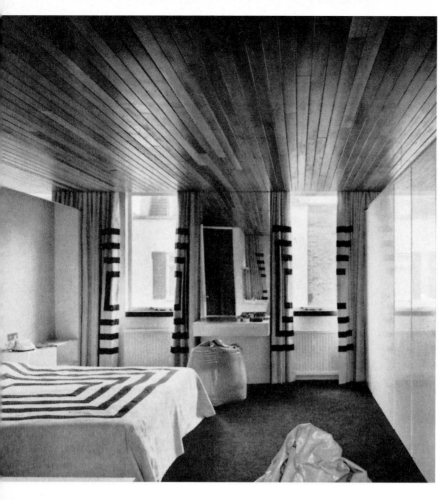

A Small Town House in London
architects Chilton Waters & Stutchbury

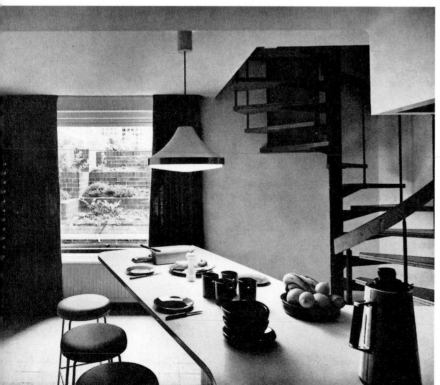

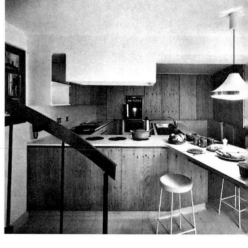

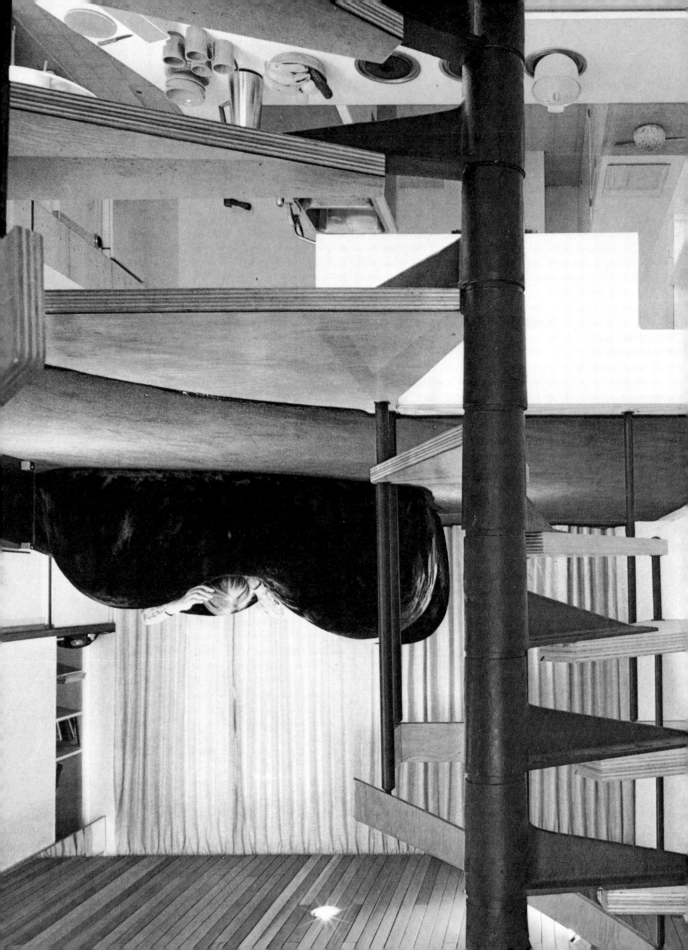

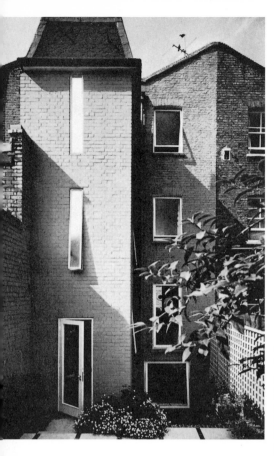

The basic structure of this small town house is the excavated shell of a mid-nineteenth century terraced workman's house in Chelsea.

It was designed to function efficiently yet comfortably as pied à terre for a London businessman and his family who have a country home.

The exterior rear view 5, reveals the partial reconstruction of the house.

On the left two identical bath-and-toilet rooms are above a utility room with door opening on to the small back garden.

To the right are, on the second floor, children's rooms at front and rear: below, parents' room: living room: kitchen-dining room with a picture-window revealing the terraced garden.

The pine timbering of the kitchen conceals capacious storage cupboards: the working counter branches to a dining counter reaching towards the window 2.

The bold use of this large continuous counter increases rather than diminishes the sense of space in an area of only 15 metres2.

The same largeness and positive approach to the design of the interior is repeated on each floor.

On the ground or street level, the living room 4, 7, has one big environmental seating 'shape' designed by R. W. Lloyd for Aerofoam (but made to each customer's specification).

Upholstered in fur-fabric it melts into the matching Africa-brown carpet.

Intervening walls were removed.

Chimney breasts and the spaces between are now filled by shelving and stereo-radio equipment to the left of the entrance.

The writing-table and chair are spatially-non-filling metal and acrylic.

The parents' room, again, suggests bigness in one simple appliquéd pattern of curtains and bedspread, specially designed and made by Fiona Campbell.

Here it is brown on oatmeal linen 1.

In the children's rooms the same motif is carried out in orange on oatmeal.

All the bedrooms and the bathrooms have the same Africa-brown carpeting as the living-room.

Well-considered structural details and decorative details (minimal for ease of maintainance) include the strips of mirror-glass the length of the living-room walls to add visual width to the room: the bathroom's casement windows which double as mirrors: Lyte-span track in the living-room carries high- and low-lighters operated by dimmers: they enable guests to see each other and a few carefully chosen pieces of art in the best possible light.

The nailie on the wall by the stairway (in close up on the jacket wrapper) is by David Partridge.

photographs Richard Einzig

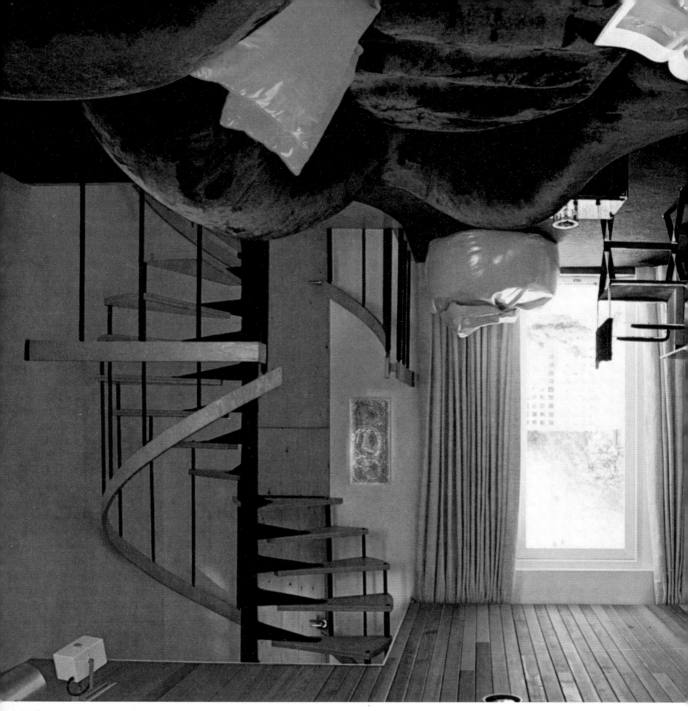

A Small Town House in London
architects Chilton Waters & Stutchbury

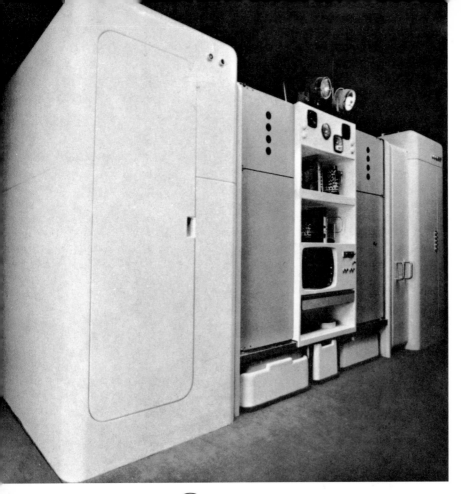

TOTAL FURNISHING UNIT
architect Joe Colombo

Project finalised posthumously, but very much in the line of development followed by Colombo from 1962 onwards. His researches in ecology and ergonomics led him increasingly to view the individual habitat as a microcosm, which should serve as the point of departure for a macrocosm attainable in the future by means of coordinated structures created through programmed systems of production.
Designed by Joe Colombo in collaboration with Ignazia Favata
Patrons: ANIC-Lanerossi
Producers: Elco-F I A R M, Boffi, Ideal-Standard, with the assistance of Sormani

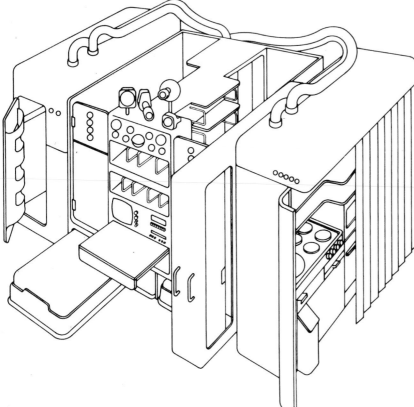

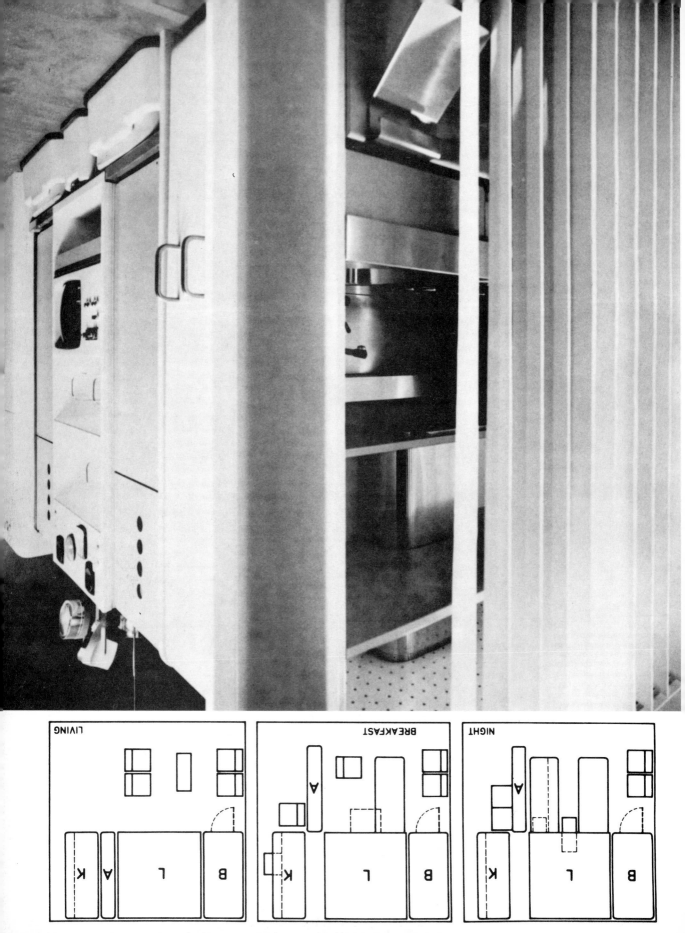

LIVING

BREAKFAST

NIGHT

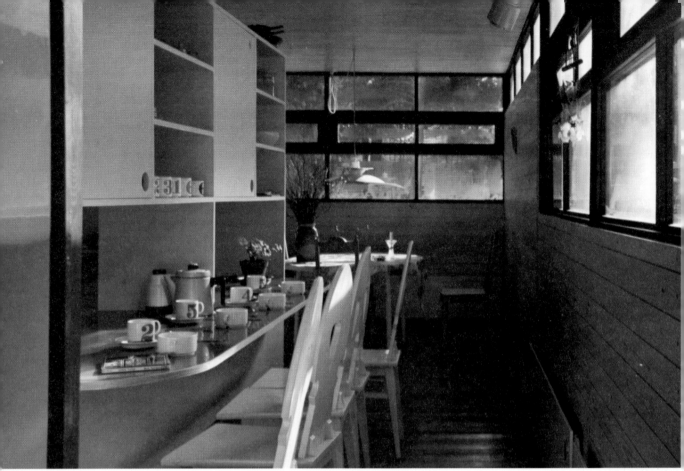

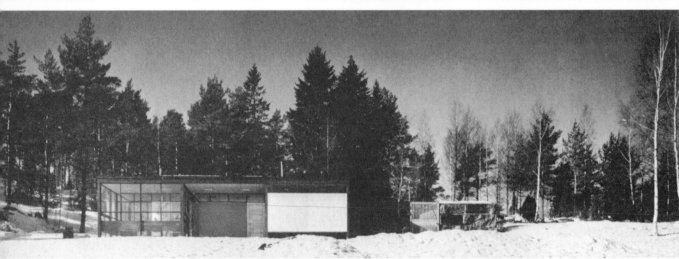

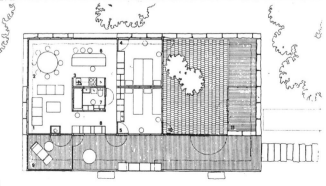

floor plan
1, living room
2, dining room
3, kitchen
4, parents' bedroom
5, children's bedroom
6, breakfast bar
7, bathroom
8, entrance
9, veranda
10, closed court
11, storage (reservation for a sauna)

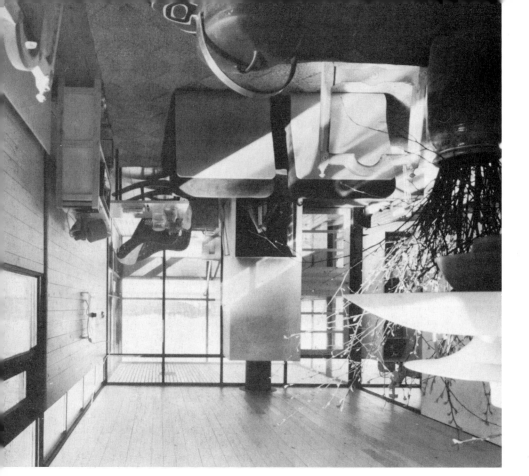

photographs *Richard Einzig*

Holiday House at Råmås, Siuntio, Finland
architect *Juhani Pallasmaa*

For summer sun and winter snow, this holiday home is near to one of the thousands of lakes which shimmer in the Finnish landscape.

Existing stone foundations of a former cow-shed together with its concrete floor, dictated the form of the rectangular plan of the house with its closed court. To achieve close contact to the terrain the house was in fact set lower, inside the stone foundations which now form a U-shaped wall, two metres high, cutting into the slope on which the house is located and opening to the view over the fields and lake.

The simple all-wooden construction was therefore placed directly on the original concrete floor. The common spaces and bedrooms are around a bathroom/kitchen core, the bedrooms opening also to the interior court.

Inner walls, ceilings and doors are all of white stained pine, floors and windows of the same wood stained grey and brown respectively.

A terrace, partially covered and closed, runs the whole length of the building, facing south.

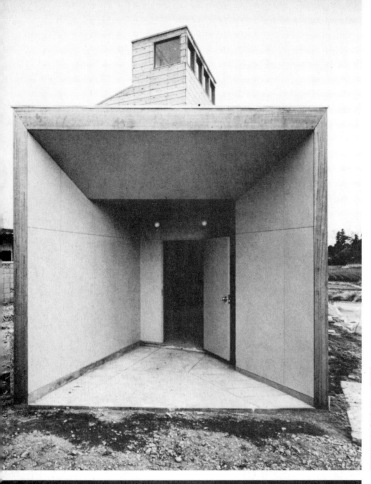

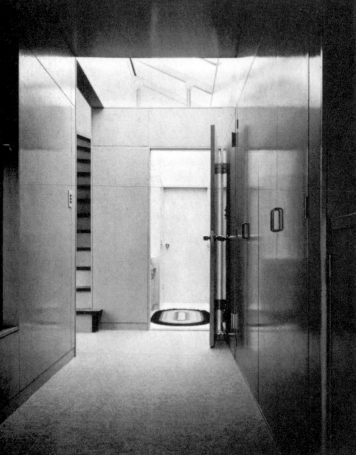

The Fu Residence, Japan
architect Kisaburo Kawakami

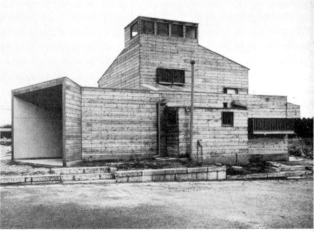

1 2 4
3

A Yellow Submarine of a house, floating calmly
where it finds itself.
The spirit with which the architect sought to
imbue it is expressed in some lines:

Glass Tower
A mass of houses this beautiful landscape
will one day be.
On a small part of it stands my glass tower.
Inside the glass tower there is no direction.
Light, wind, and blue sky are together in private space
It becomes the house of the moon and light.
Stand still for a while.
The white wall expands and contracts with light.
Corners disappear.
The front elevation becomes a plan.
and the plan hangs in the air.
Then geometry disappears.

Breathing
The house breathes.
Hard shell and soft spaces.
You feel the breath of the house in these spaces.
The house holds the wind and sun.
Then flies high in the sky with evidence of the earth.
When darkness dominates the world,
a streak of light breaks the darkness, and frees the earth
This is a lighthouse in the night sea.
A streak of light in the morning mist,
flows inside from without, and rushes out from within.
The King, called the Sun has just arrived.
The light fuses together with different direction
and amount.
From white to yellow, yellow to red.

The wall and the long tube.
The wall prevents a private space.
The wall opens itself to society.
A house is where men get together,
and walls get together. . . .
I want to walk there!

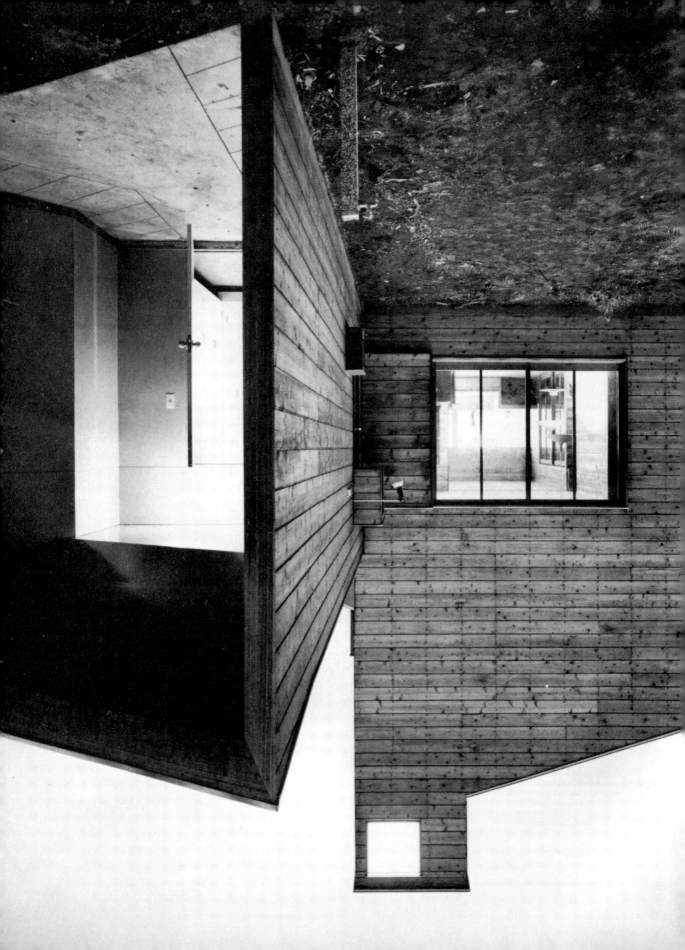

In and out, front and back, disappear.
Soon the wall changes to the tube. . . .
The long tube is the evidence of order.
The free expansion of light and wind.
Facilities which support the house. . . .
Locus of three: Man, Things, Nature.

Moving
It moves when you operate an image.
It easily moves here and there
into the sea, cloud, forest and desert.
Children, young man and a woman on board.
Lights appear one by one in the silhouette of the mass.
It breathes and floats by taking the length
and breadth of man's locus.
Suddenly, this mass might disappear.
Where are they going to sail?
Where?

The Fu Residence, Japan
architect Kisaburo Kawakami

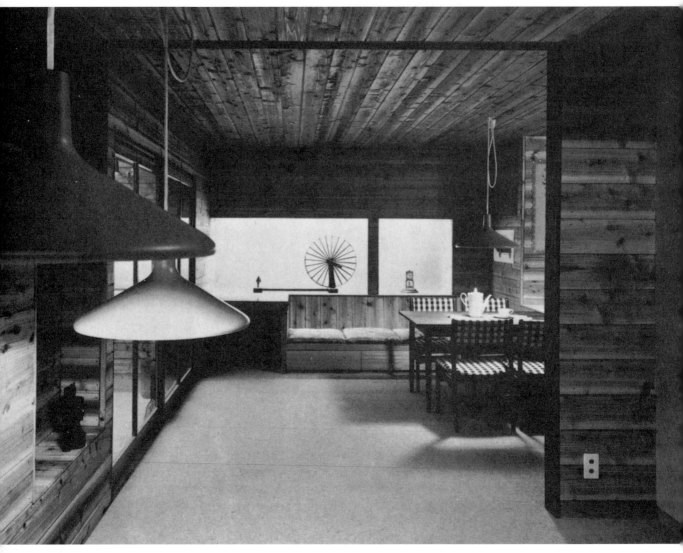

Yellow Submarine
Beatles. They sing.
I kept seeking for the place with traces of their songs.
I looked for the street which leads the children to heaven.
It was on the stairs.
I looked for blue sky, gentle breeze, green
sea in the big glass.
I looked for the sun on the white wall.
In the yellow world,
Pepperland and Yellow Submarine.
Yes, the Yellow Submarine with the group
of Sergeant Pepper's Lonely Hearts Club Band on board.

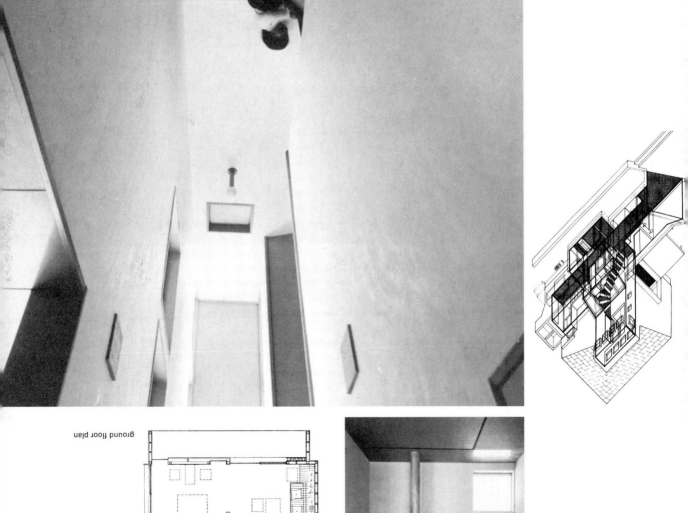

photographs Tohru Waki
courtesy Kenchiku Bunka

1, south entrance
2, north-east side view
3, entrance with toilet room
4, east side view
5, dining area of sitting room
6, tatami room
7, staircase

ground floor plan

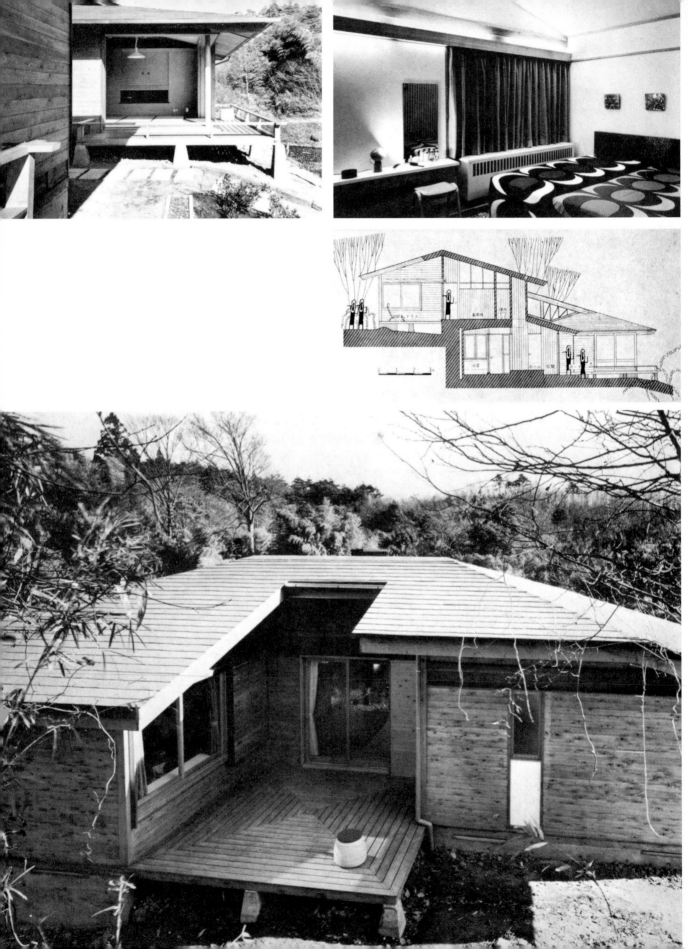

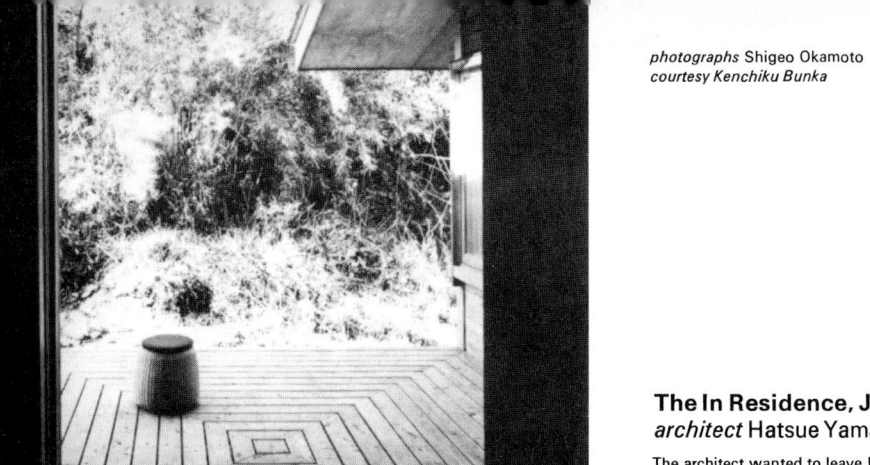

photographs Shigeo Okamoto
courtesy Kenchiku Bunka

The In Residence, Japan
architect Hatsue Yamada

The architect wanted to leave Nature as beautiful as it is.

Soon there will be other houses on the slopes of the still-wooded hill where this one is built.

How many can live in the wood and still be 'alone with Nature'?

It is a house for a family of eight. the oldest member of which is 88, the youngest 22.

For each individual the house provides an environment in which to be 'alone' and for each as member of a group an environment in which to be 'together'. Thus each generation group has its own level or its own terrace for its different way of life.

The sitting, or family, room is a contact point at which individuals unite.

Combined in it are the functions of eating and tea-ceremony in the tatami-mat space. The house is on the eastern slope of the hill and is designed in such a way that each room has equal benefits of sunshine and breeze and each an individuality to harmonise with its aspect.

1, east side deck
2, bedroom
3, west side
4, terrace
5, 7, living room
6. living room from entrance hall

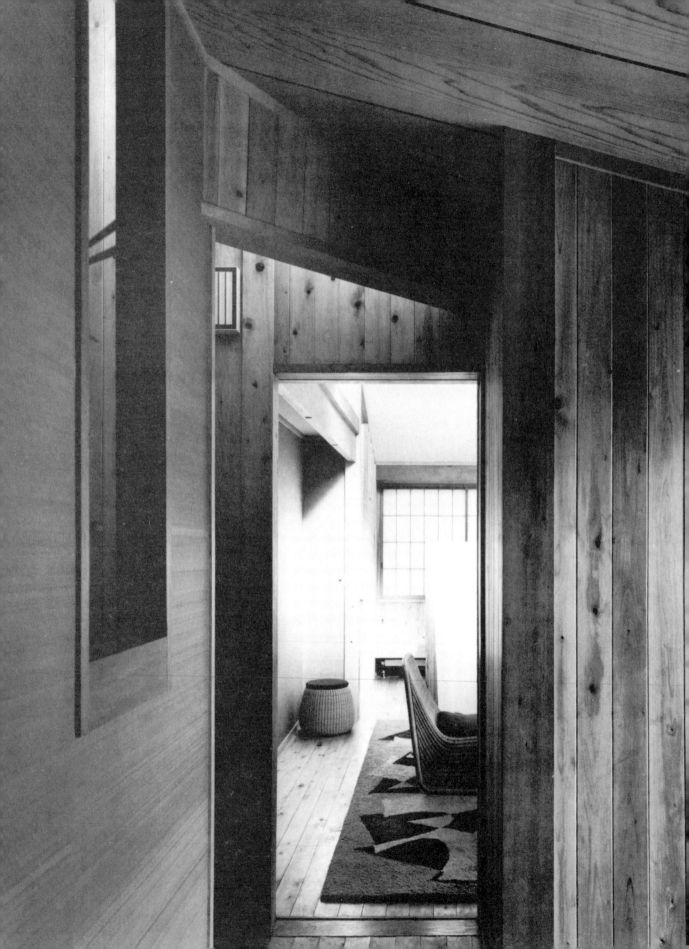

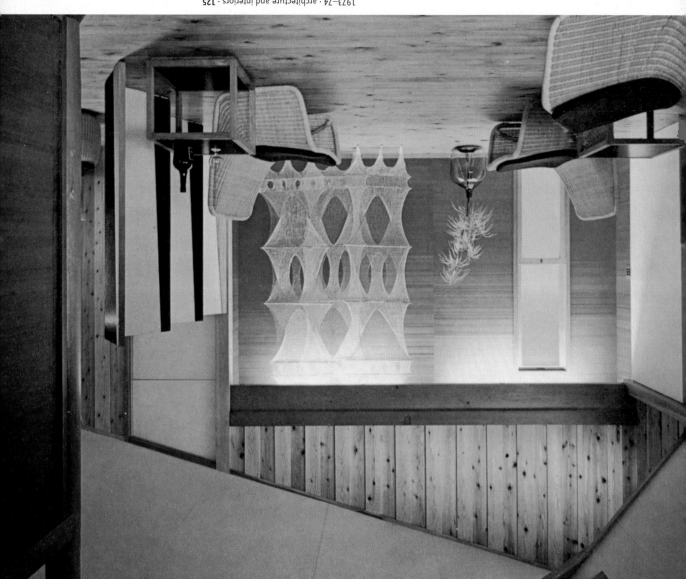

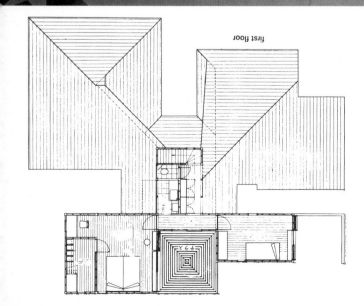

first floor

The In Residence, Japan
architect Hatsue Yamada

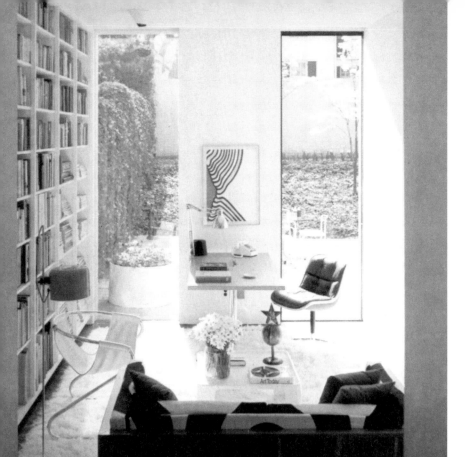

The Georgetown district of Washington dates from the very early 1800s and its buildings are subject to a preservation order: remodelling and additions must not be visible from the street.

This is an 1803 house with 1840 additions but remodelled and with further additions made recently for a client.

The architect, Hugh Jacobsen and his family moved into it only later: therefore, and fortunately, the house is less 'designed' than it might otherwise have been.

A flexible plan oriented to the exterior was achieved: for, surprising and refreshing to find in the city is the tiny garden with flowering peach between front and street, and the garden with terrace at the rear, 3 and 5.

To the effect of the gardens must be added the effect of light: 'even on the greyest day, light and colour range from good to dazzling'. The old and new buildings are linked by a bridge above which a round bubble skylight pulls light in and down into the front hall: functioning similarly a smaller bubble is above the boys' bathroom and a light well is in the master bathroom; on the ground floor windows were built, or lengthened, to the floor. All walls are pure white.

Easy circulation around the ground floor was achieved with two means of exit/entry to every space, so that none became a corridor to another. The clear view from the dining room through the living room to the back garden, 2, and the way through living room to library, 8.

5
6 7 8

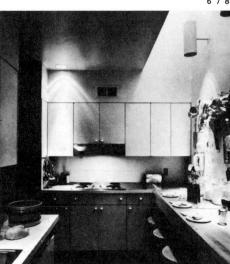

photographs Robert Lautman

The Washington home of the architect
architect Hugh Newell Jacobsen

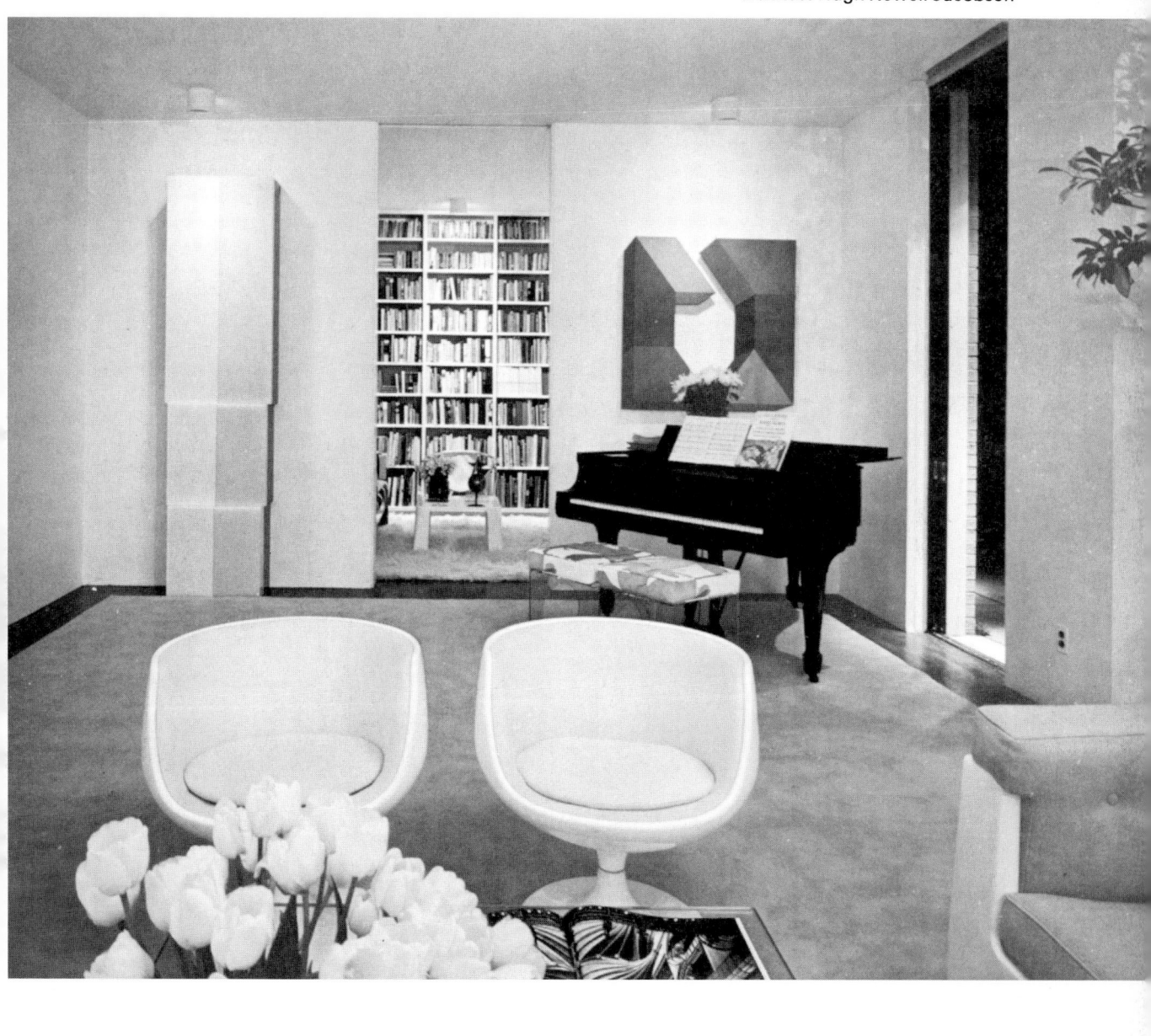

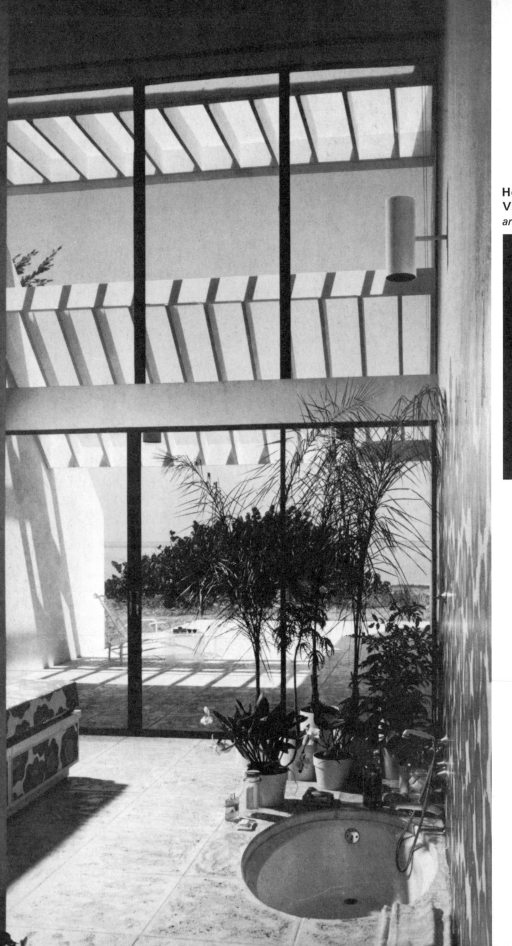

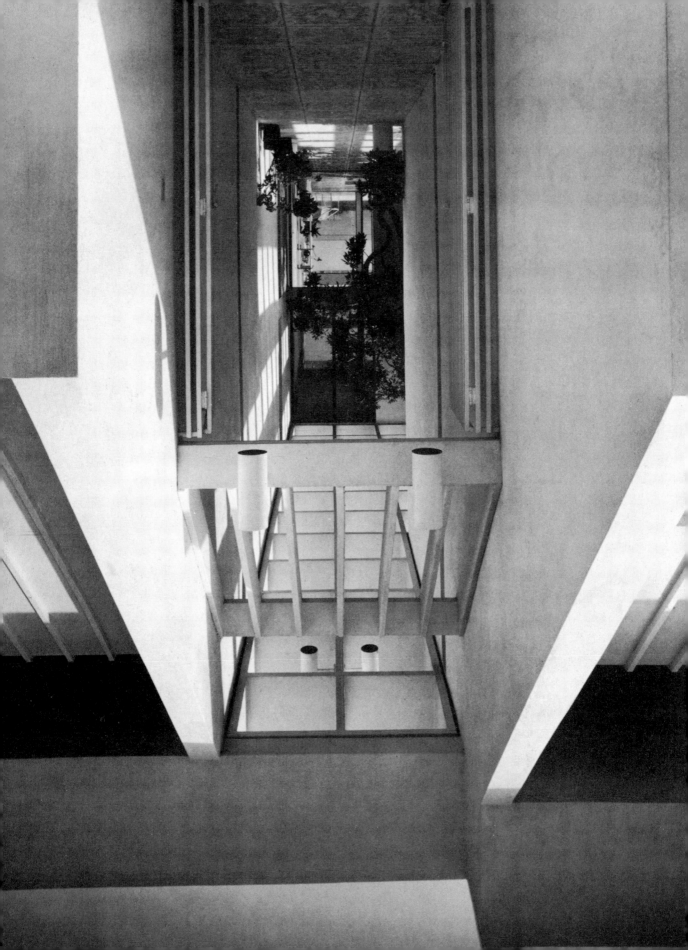

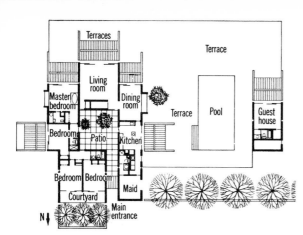

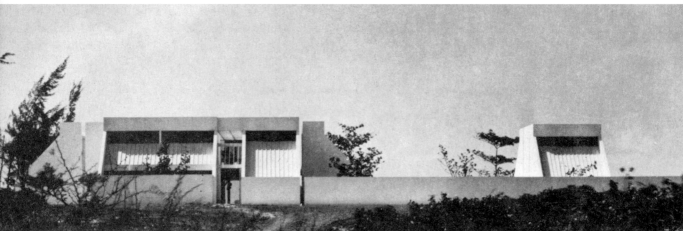

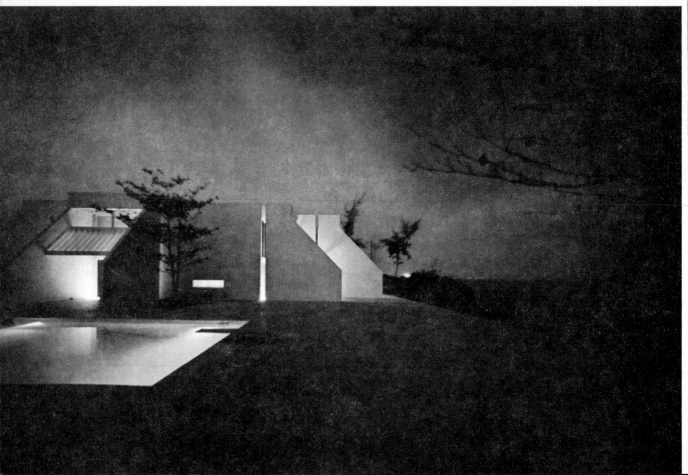

Holiday home on St Croix, Virgin Isles
architect Hugh Newell Jacobsen

photographs Robert Lautman

from pages 50/51

Scenically, the site for this house was idyllic but it offered challenging problems to the architect.

In solving them the form of the house took shape.

Flat roofs with deep parapets are designed to catch the rain, stored in an 85,000 gallon tank near the pool, for this is the only source of domestic water; and, because hurricanes can blow and 25-knot tradewinds are common, wind screens were necessary on all the terraces. To further deflect the air current exterior walls stand beside main steeply angled exterior walls create the walls to provide a slit between. These dramatic lines and light patterns of the structure, 4, 5.

The architect also used the house to screen from the approach side the ocean view, 4; to the right the pool and the guest house.

Only the slip of a door allows a glimpse of what is to come, 2, 3. It reveals itself as a great atrium 17 feet high and 22 feet square like a little town square' onto which open all the rooms including the kitchen.

The height of the structure and the open grid filter the sun, draw off from the surrounding interior spaces much of the hot air and create a breeze through the rooms even when there is none outside. Ventilation of the bedrooms can be further controlled: each has a louvered door above a solid door. The master bedroom opening to the terrace, 1, like the rest of the house, is floored with local, sealed cement tiles resembling travertine, and into it is set the sunken bath tub.

This family flat at Binningen, near Basle, is a
changing scene of pattern and shape: a
design laboratory where Verner Panton plans
fittings and furniture which are later on the
domestic market or are developed for special
'one-off' decorative schemes. Right, in his
studio with fabrics designed for Mira-X of
Suhr, and the dining room with spheres
designed especially for the Restaurant Varna
at Aarhus, Denmark.
Below, in the branches of the Pantower
now made by Fritz Hansen Eft under the
chandeliers designed for J. Luber of West
Germany
Below, right, a mirror wall decoration
designed and also produced in limited
edition by Verner Panton
photographs Werner Neumeister

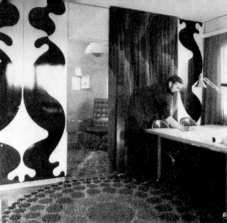

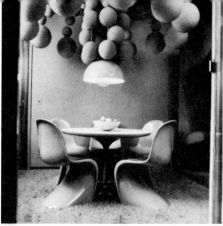

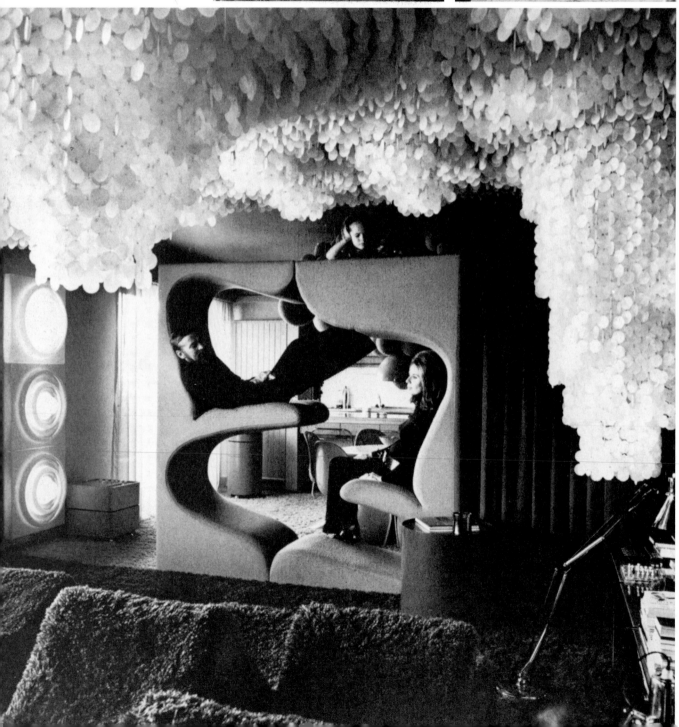

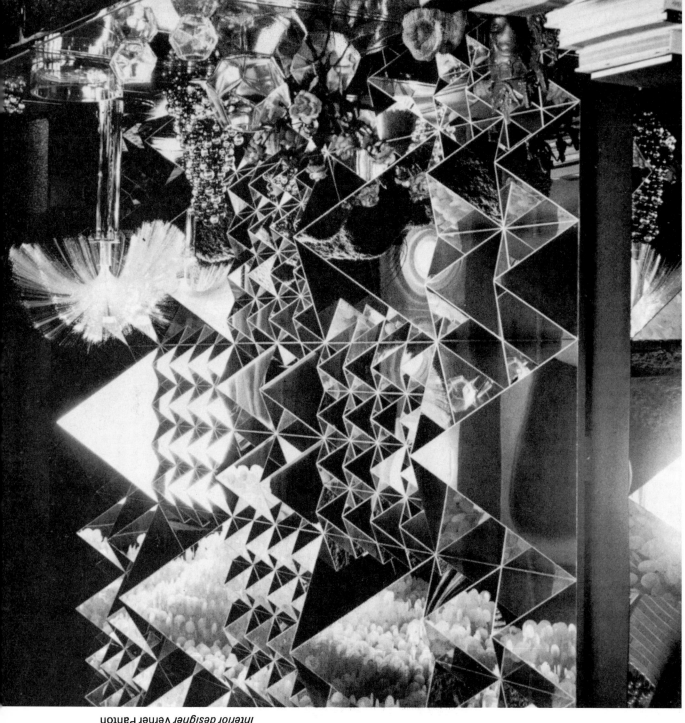

Verner Panton's Home in Switzerland
interior designer Verner Panton

The Barbican Complex, London

Architects
Chamberlin Powell & Bon
Photography by Sam Sawdon,
Richard Einzig, John Maltby

Conceived as an architectural complex of heroic proportions, on a site made available by the bombing of the City of London during World War II, the planning of the Barbican as a residential area has been conducted in full awareness that this was also a unique occasion for creating a cultural centre within the most ancient part of a great city, near one of the world's most established business institutions.

At the present stage of development, its powerful structures are pervaded by an atmosphere of strength and beauty. The remains of the Roman Wall and the Church of St Giles, testimony

Remains of the Roman Wall among new office blocks in the City of London

of great ages of the past, have been lovingly restored and surrounded by flowing water and open spaces. The banks of water basins, graced by waterlilies, are studded with old tombstones from St Giles' destroyed churchyard, and young girls attending the City of London School stroll among ancient columns at break time. No motor traffic is possible at pedestrian level, and the sound of water cascading into the lake overcomes at times the noise of traffic from the nearby streets, becoming more prominent as the day's activity ceases.

St Giles Church and the Barbican Towers; on the foreground the Roman Wall
Photography Sam Sawdon

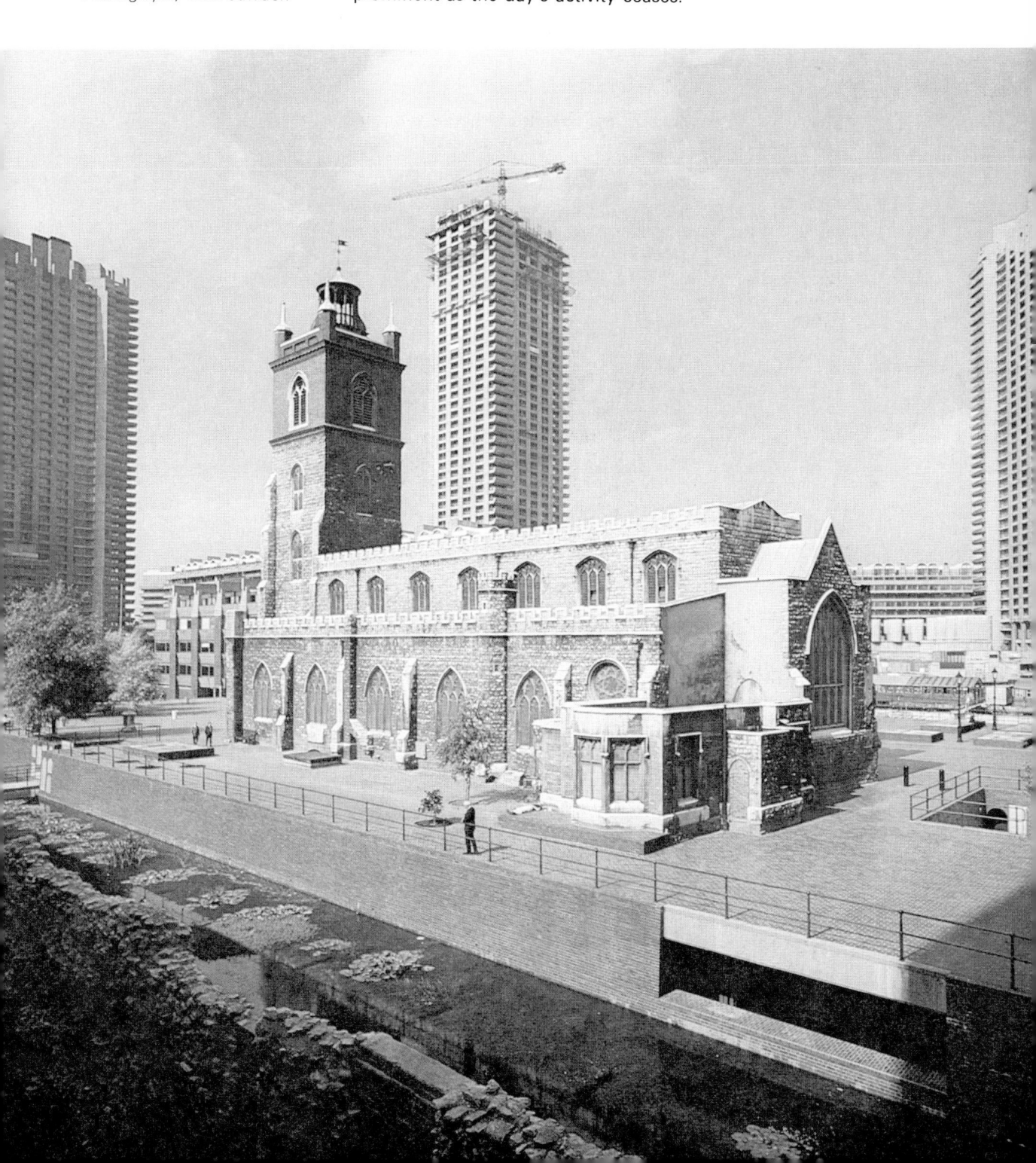

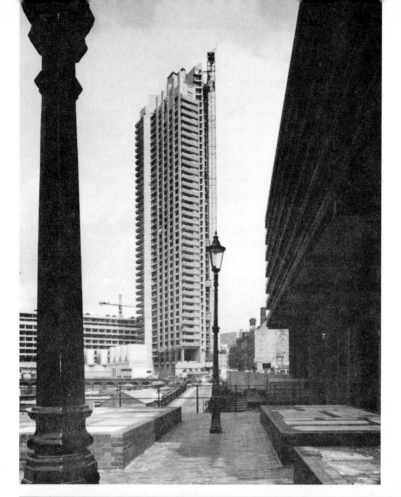

One of the residential
towers; Victorian street
lamps have been retained.
*Photography John Maltby
Ltd*

Entrance to underground
parking (right). On the left,
view over gardens; in the
foreground, communal area
and passage from where
motor traffic is excluded.
Photography Richard Einzig

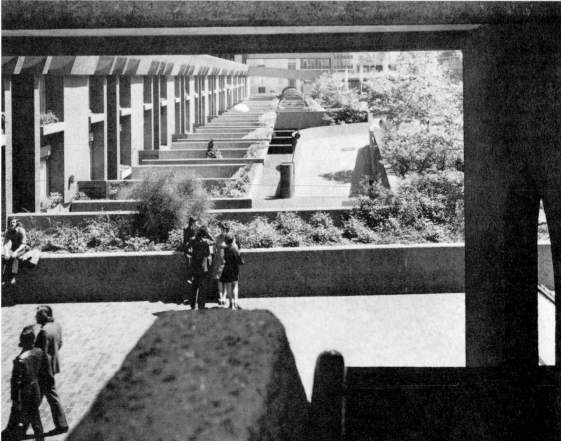

Page before
An overall view of the lake
as reflected in a town-house
window in the Barbican.
*Photography Richard
Einzig*

This particular atmosphere attracts many people to live in the Barbican and will probably be the basis for the establishment of a real community once the scheme is completed and the Arts Centre in full activity. Today one can only record the examples of individuality in the furnishing of homes by people who are already living there.

The living room of a one-bedroom flat (below, Fig. 6) contains numerous objects and rugs collected by the owners during their travels; here Japanese lamps, Mexican hangings, and bark paintings contibute to give the place an exotic and festive look.

In the two-bedroom house illustrated on page 22, red pinboard and white shelving cover one wall of the entrance hall, a landing-type passage leading to two bedrooms and the bathroom; from the hall an elegant spiral staircase leads down to the living/dining room and adjoining kitchen. The furnishing here is in calm, cool tones of oatmeal, white and green, but over the entire wall of the stairwell there is a huge hanging in bold checks of orange and pink which unifies the two floors and provides a contrast to the more restrained mood of the living room.

One of the garden flats:
living/dining room.
Photography Sam Sawdon

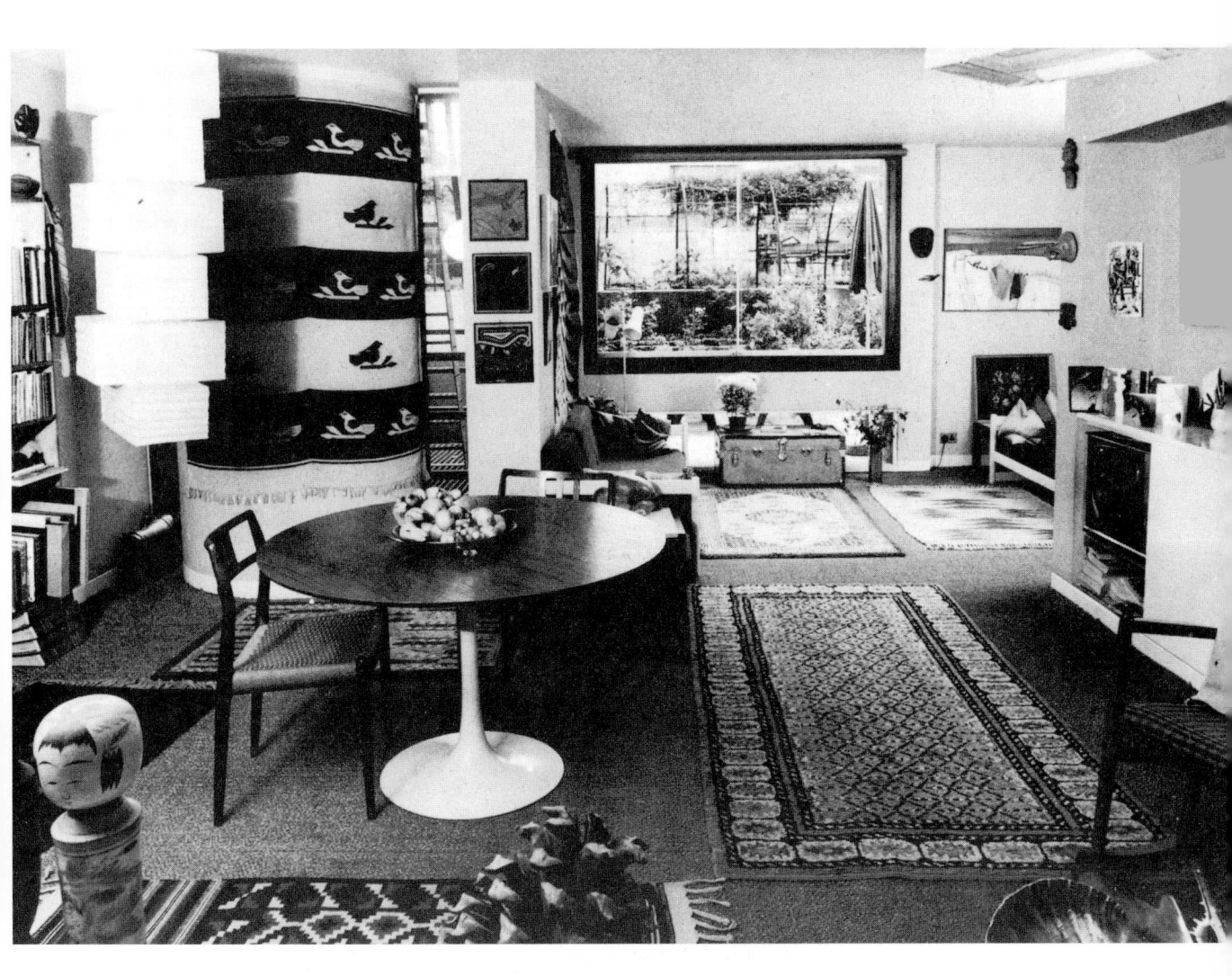

The BC25 Capsule, Japan

Architect Kisho N Kurokawa

This is an example of 'system building' at its most practical in a densely populated metropolis, intended to meet needs related to the normal running of everyday life, albeit a privileged, highly organized life.

The brief here was to build a 'businessman's hotel' in Ginza, one of Tokyo's most fashionable districts. The solution took the shape of two towers of steel and reinforced concrete, centred on a 'platform' composed of two floors and a basement. The basement is entirely occupied by a machine room, the ground floor consists of entrance hall and restaurant, and the first floor functions as an office, with ample facilities including a 24-hour secretary service. But it is from the second to the thirteenth floor where the break-through in building technique is to be found; a series of prefabricated, single 'capsules' can be grafted on to the central

Assembly of the BC25 capsules

The Nakagin Business Hotel completed

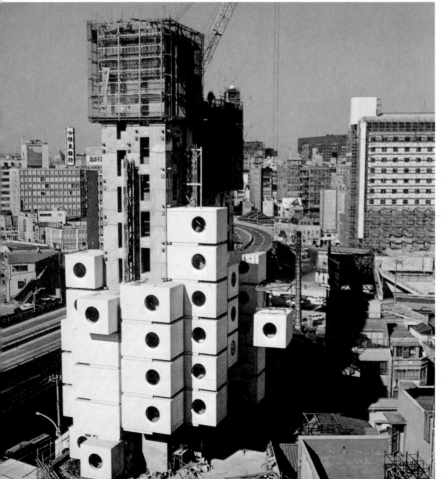

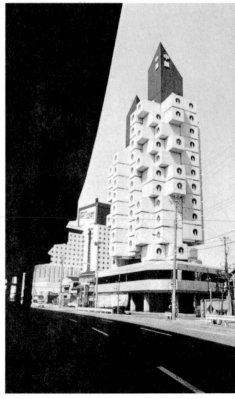

Mori-Izumikyo Model
House: detail

Outside view

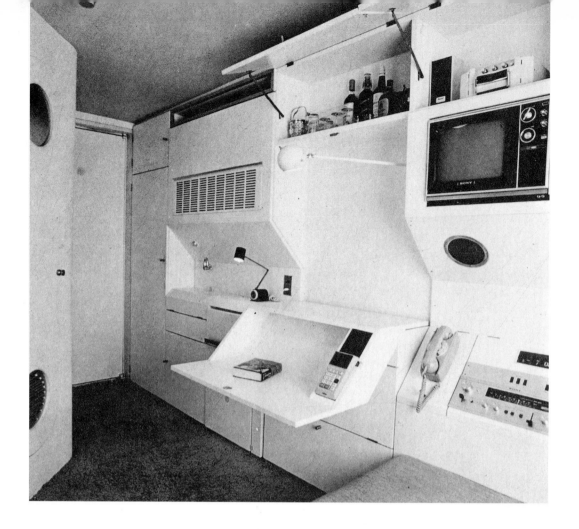

Business Capsule: interior

core in a countless number of ways. They consist of a lightweight steel frame structure with a 1·6mm-thick outer steel sheeting, protected by an undercoat of rust-preventive substance and spray-finished with Kenitex; the space available inside is 2·5m wide, 2·5m high and 4·0m deep (8'×8'×12'). In this particular building 140 capsules are located at each half-landing so that efficient use is made of vertical as well as horizontal space. Each capsule is provided with air conditioning unit and has facilities for the installation of air-cleaning devices, a small refrigerator and a sink. The furniture, from desk to bed to bath, is manufactured in specially designed integrated units. A 13" colour television set and a digital timer are part of standard equipment, but optional extras include a small electric desk calculator, amplifier, tape deck, speakers, and an automatic telephone answering device.

The remarkable versatility of this architectural 'cell' also permits its use in domestic architecture; thus a home can be extended according to need by the addition of extra capsules to the main structure, and the unobtrusive, clean lines of their design blend ideally with any landscape.

The Mori-Izumikyo Model House, the architect's own Summer house, is built on a slope in the holiday resort of Karuizawa. The main structure is of exposed concrete, on which four capsules are

Mori-Izumikyo Model
House: Tatami

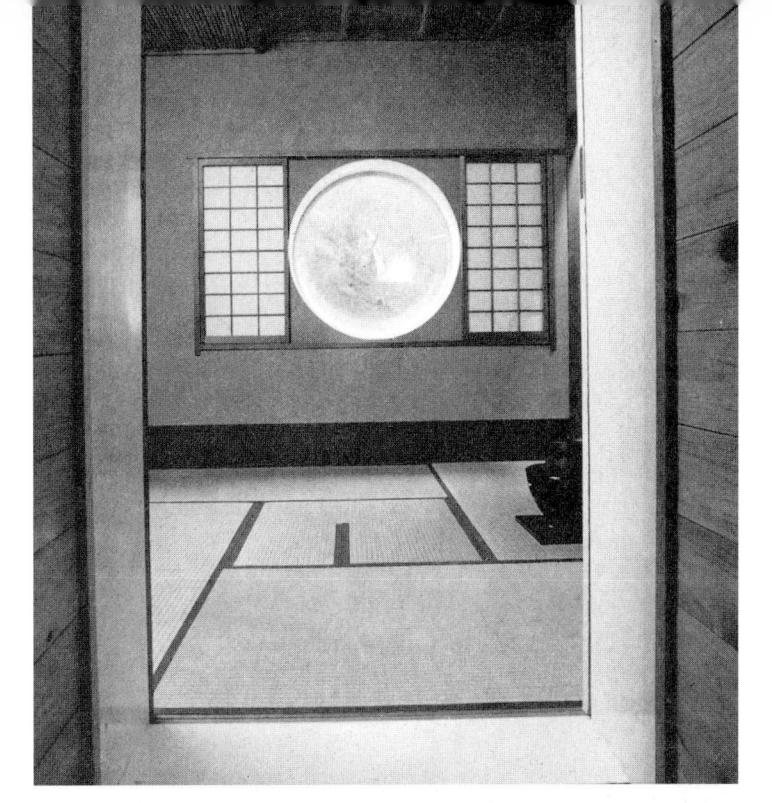

attached to provide two bedrooms, one kitchen/dining room and a Tatami. The exterior of the capsules is sprayed a rich mahogany colour, the interior is finished with marble floors; Japanese cypress board covers the walls throughout the house. The essential simplicity and elegant proportion of the capsules lend themselves to a remarkable freedom and variety of decor, from the traditional Japanese Tatami to the Scandinavian-inspired dining room setting.

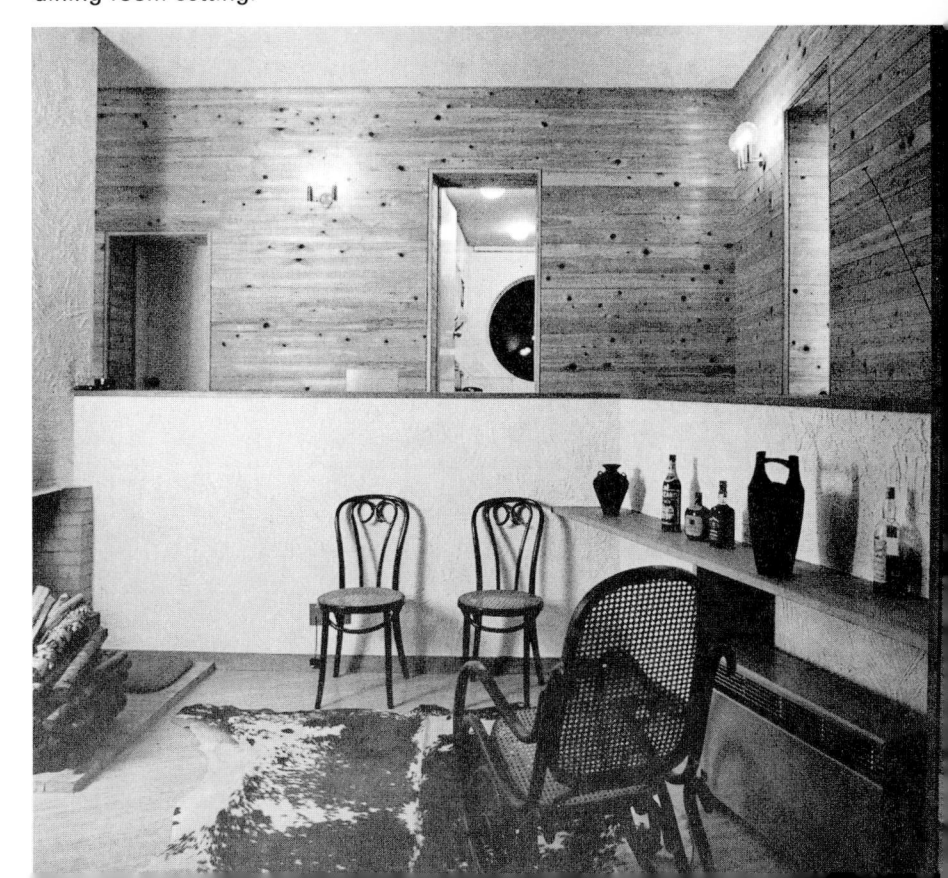

Living room

The Marano Shoe Shop in Milano

Architect Sergio Asti
Photography by Mario Carrieri

In designing this shop the architect exploited to the full the long and narrow space available by defining it lengthways into three distinct sections, one outside and two within the shop.

The first section, illustrated below, consists of six mobile, triangular display cabinets which seem to lead the eye to the entrance door.

Open display

Plan

Once inside, a second display area focuses on a rotating conical module, and some steps lead to a larger fitting area. This space is separated from the rest of the shop by a compact arrangement of modules, by a long seat running along the walls, and by a truncated-pyramid shaped ceiling with a mirror set on its end. The freshness and lightness of the colour scheme and of the materials, the imaginative use of mirrors, and the neat, geometrical lines of walls and ceiling are the most interesting and exciting features of this shop.

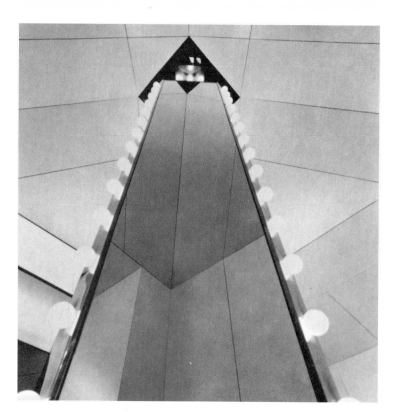

Square central structure of
mirrors, with light fittings
on its edges

Fitting area with mirror set
at an angle and reflecting
the ceiling lined with
purposely made white and
lilac Abet Print laminate.
Seating of raw buckskin.
On the display module
stands 'Open Lotus', a lamp
designed and produced by
Venini

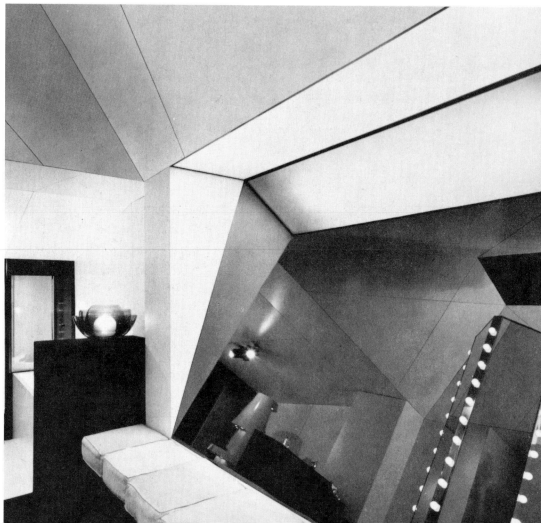

View from the back of the
shop: in the background
can be seen one of the
rotating yellow conic
modules used for display

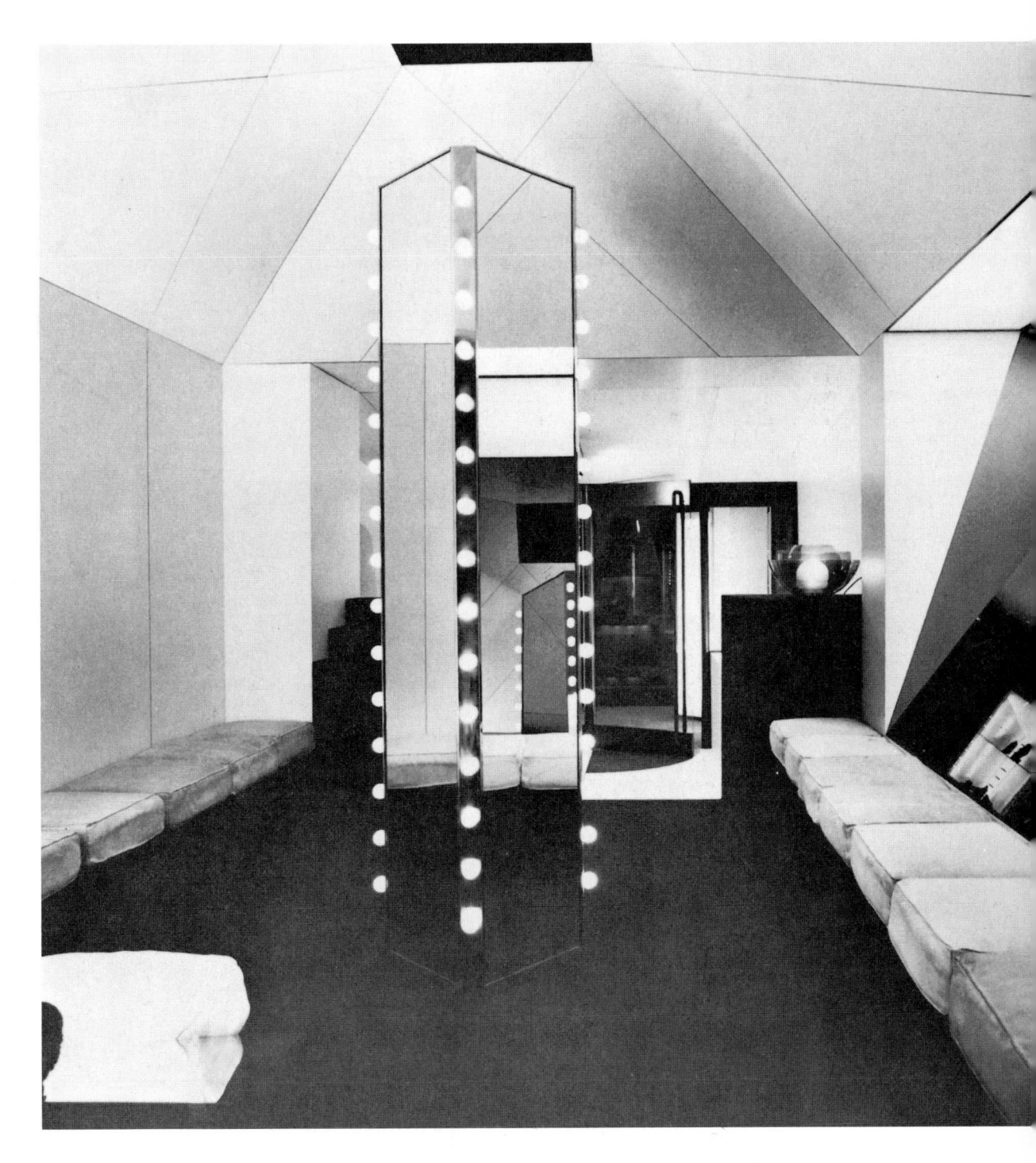

Villa on Lake Como, Italy

Architect and Interior Designer
Sergio Asti

Built on a steep slope on Lake Como, on three levels widening down to the water, this residence owes its character to the interplay of different architectural volumes alternating with open spaces. This plan allows for the numerous terraces to become closely related to the interior of the house and at the same time merge into lawns and grassy banks at various levels, so that the impression is one of living in total harmony with the surrounding landscape.

The entrance, at top level, leads immediately to the entertainment area. A spacious living/dining room, with sliding doors running along one entire wall, opens on to two large contiguous terraces overlooking the lake; the kitchen, scullery, shower room

General view across the water

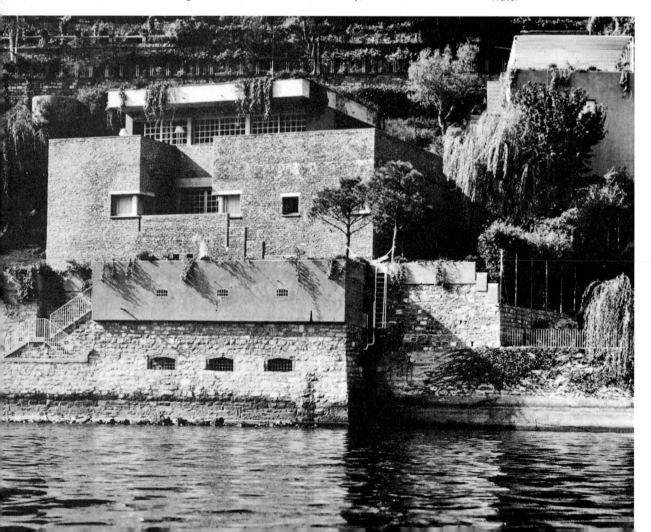

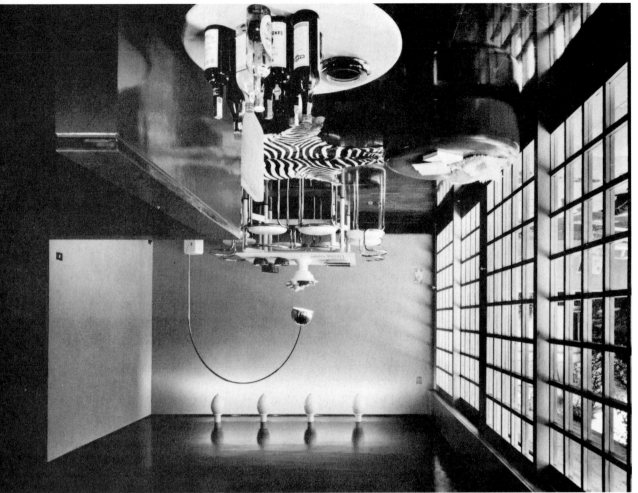

Upper Living room: dining area

The double terrace over the lake; on the left sliding doors to Living/Dining room

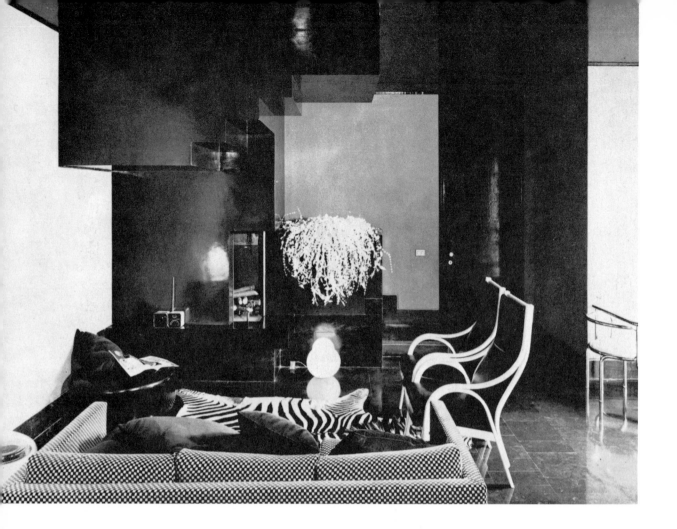

Lower Living room

and cloakroom are also included in this area. The middle level is devoted to family life; here too a small living/dining room opens on to a terrace, and the addition of a fireplace gives it a more intimate character. Here the provision of four bedrooms, two with breathtaking views over the lake, and of three bathrooms make a comfortable home of this house built on one of the most famous beauty spots of Italy; an alternative, not a complement to city dwelling. From the terrace adjoining the living room a staircase leads to the swimming pool and the boat-house below.

The interior decoration consists of a number of basic features adopted throughout. Black polished stone is used for the floors on the terraces and on the interior, with the exception of the bedrooms and of a raised area in the lower living room, fitted with honey-coloured, wall to wall carpet. Ochre-coloured plaster covers exterior and inside walls, again excepting the bedrooms where walls and ceilings are papered in white and brown checks, a pattern repeated on the velvet upholstery of the sofas in the living rooms. Everywhere else ceilings are of stucco painted a glossy shade of lobster pink. The wooden door fitments are painted silver. Most of the furniture, lighting and accessories were designed by Sergio Asti and produced industrially by Stilwood, Zanotta, Poltronova, Candle, Cedit and Salviati.

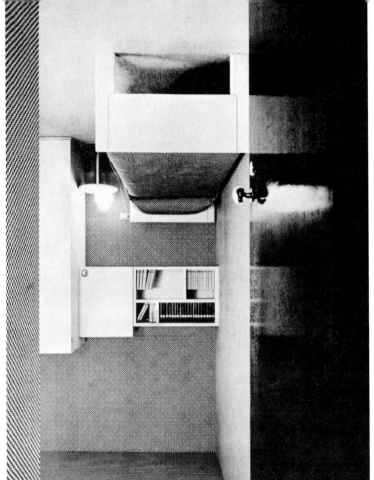

One of the lower bedrooms

Corner picture windows
from one of the bedrooms

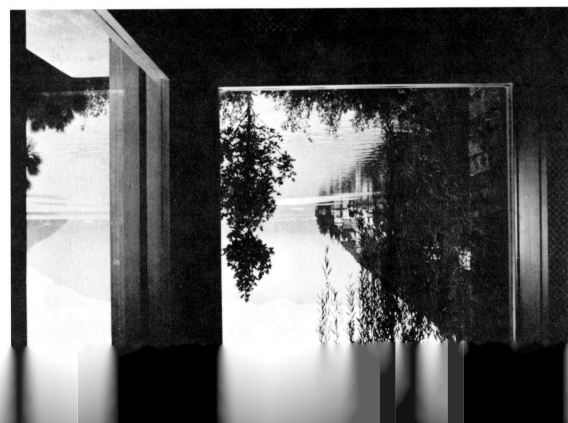

Plan

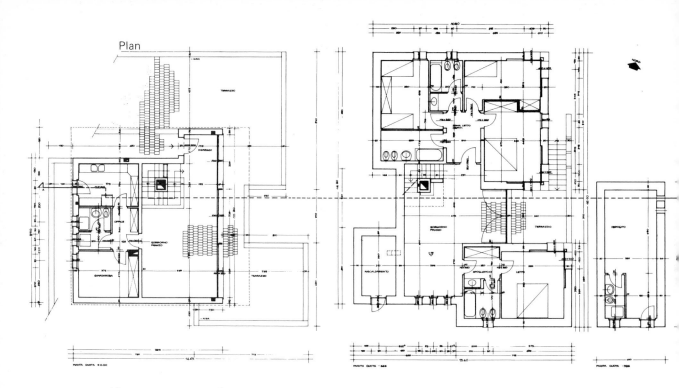

View over terrace and
garden levels from main
approach

Back entrance

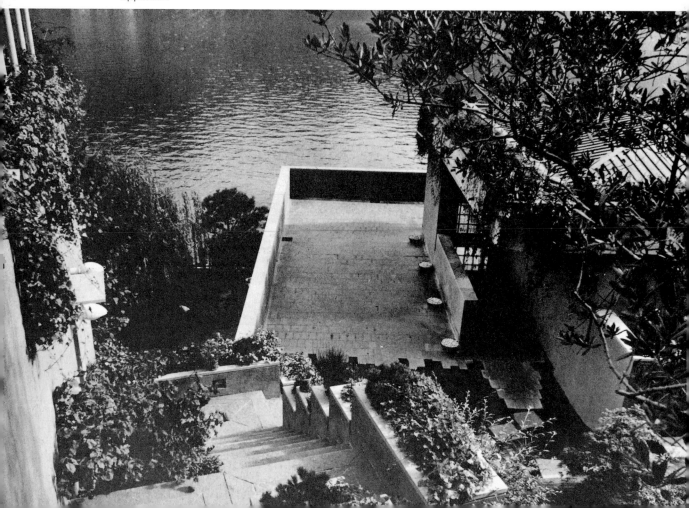

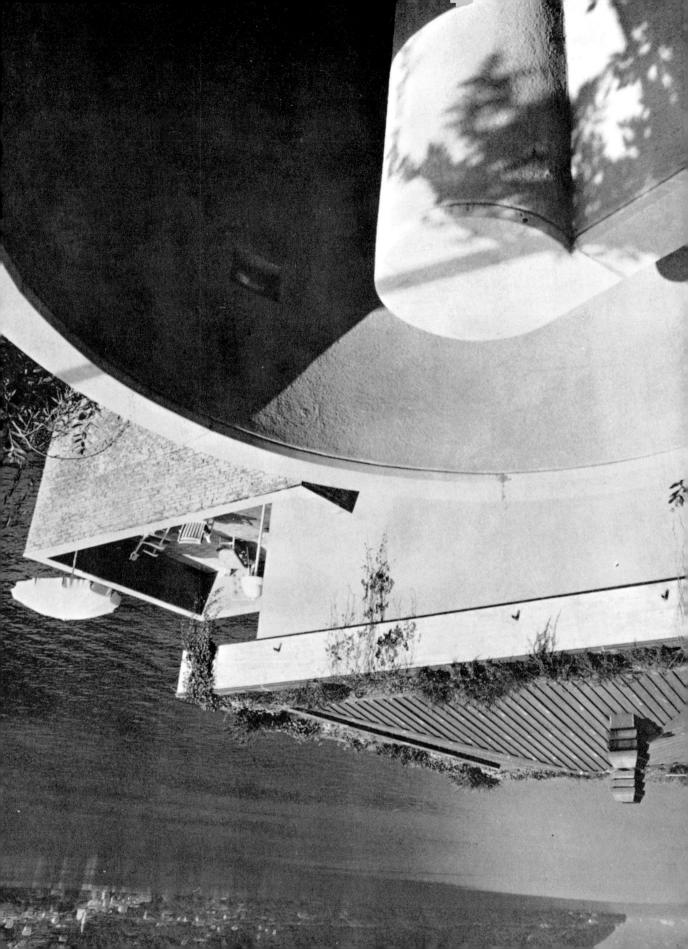

Family Holiday Home at Montorfano, Italy

Architect Ico Parisi
Photography by Giorgio Casali

Surrounded by beautiful woods, near Como, this holiday retreat was commissioned by its owner with the precise intent that it should become the meeting place for all the family, their children and friends, away from the constrictions of city life; a place where it would be possible 'to live together' in harmony with a natural environment.

The plan of the building is based on its gradual opening up on three sides towards the open countryside, from a cluster of three tiny bedrooms backing on to the woods to the three umbrella-shaped structures protecting the open-air living space.

The internal living area has dining/kitchen corner where stove adjoins dining table so that food preparation need not become a separate activity. A cylinder surmounted by a glass dome supplies natural and electric lighting and the mirrored table top, where the sky is reflected, increases the inside/outside relationship.

The furniture, designed by the architect, is of plastic laminates; sofas and beds are also upholstered in plastic. The floor is of ceramic tiles, walls and ceilings are painted. Dark grey, white and red form the colour scheme used throughout, inside and outside.

Outside view

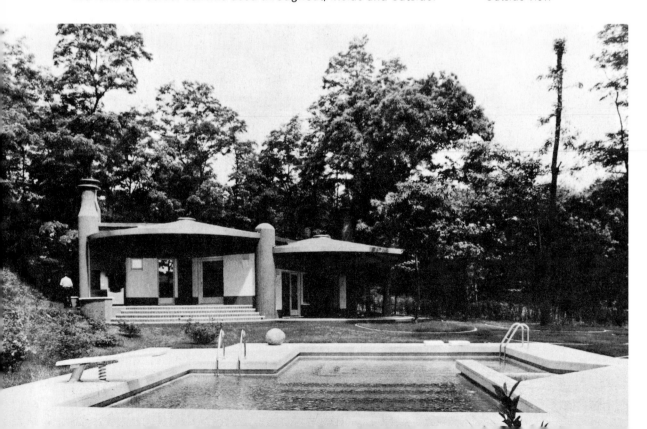

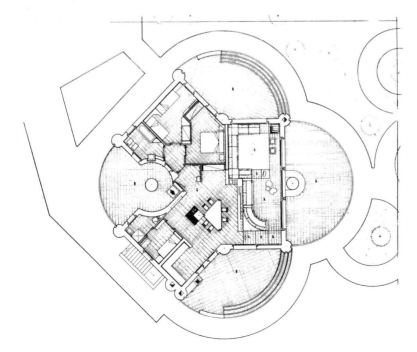

View of Family room from
Living area. In the fore-
ground two Perspex
sculptures.

Plan

Living area

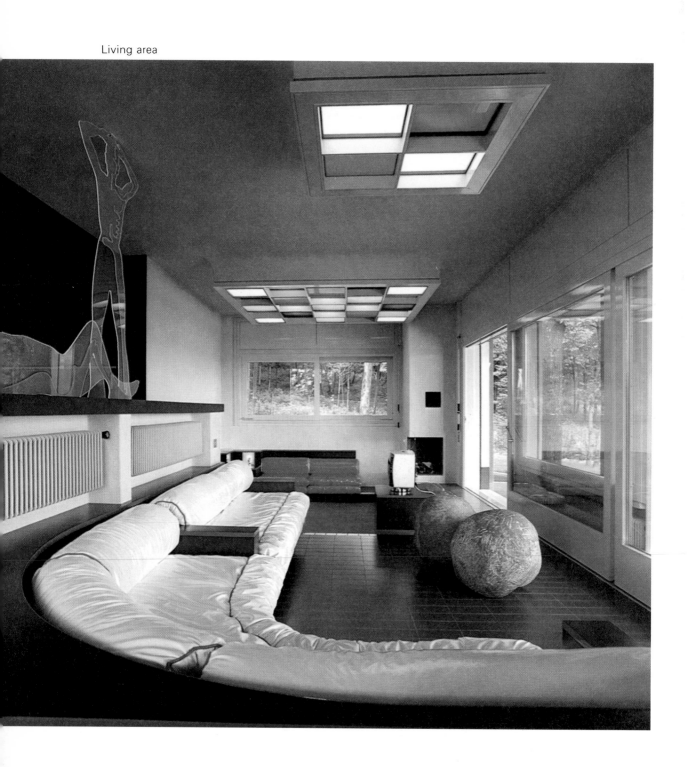

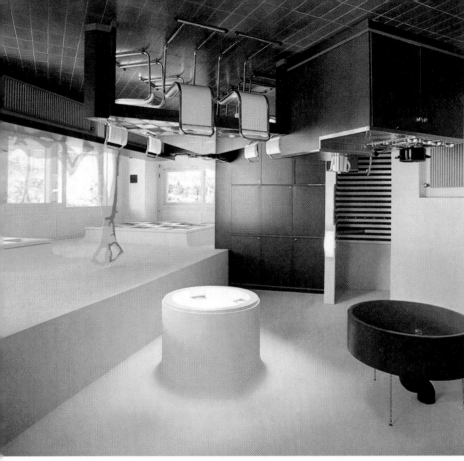

Dining/kitchen

Dining area showing
multi-coloured square light
fittings, reflected on the
mirrored table

Antidwelling Box, Japan

Architect Monta Mozuna
Photography by Shigeo Okamoto

Paradoxical as it might seem, this Antidwelling Box is to fulfil the needs of a contemporary dweller and his family!

The departure from traditional design originated from the architect's conviction that when planning a home, more often than not people get results opposite to those expected. This is mainly due to an architectural practice admitting in principle the adoption of duality of function, with parents/children, old/young users or communal/private, living/service requirements as determinant factors. By ignoring such preoccupations and basing the plan of a building on the designer's own concept there is a likelihood that the user will also benefit in the end.

The proposal illustrated consists of three cubes ('boxes') of reinforced concrete with a steel frame, one inside the other, connected by passages and stairs. Its striking appearance has an unexpected, perhaps unintended charm deriving from the uncompromising geometrical lines of its design. Viewed from the outside at night, the outer 'box' almost disappears from sight while the inner, brightly lit boxes appear to be floating in space.

The furniture is designed accordingly, with basic, simple lines enhanced by the use of contrasting colours, yellow and black for the wooden dining box, with blue walls, floors and ceiling. Storage facilities are offered by the stair-cupboard in the bedroom

General view

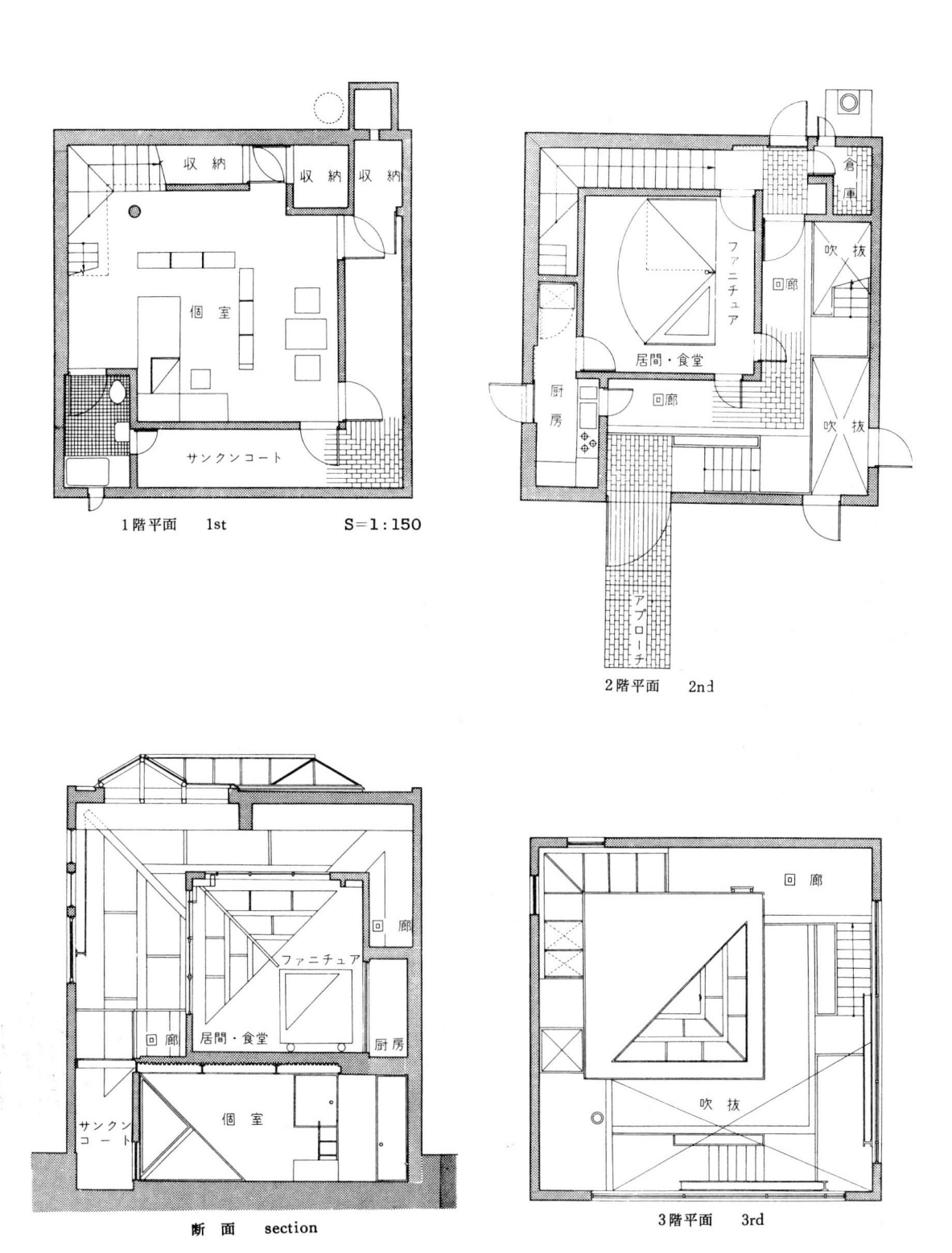

1階平面　1st　　　　　S＝1：150

収納　収納　収納

個室

サンクンコート

2階平面　2nd

倉庫

ファニチュア

居間・食堂

回廊

厨房

回廊

吹抜

吹抜

アプローチ

断面　section

回廊

ファニチュア

回廊　居間・食堂　厨房

サンクンコート　個室

3階平面　3rd

回廊

吹抜

Plans

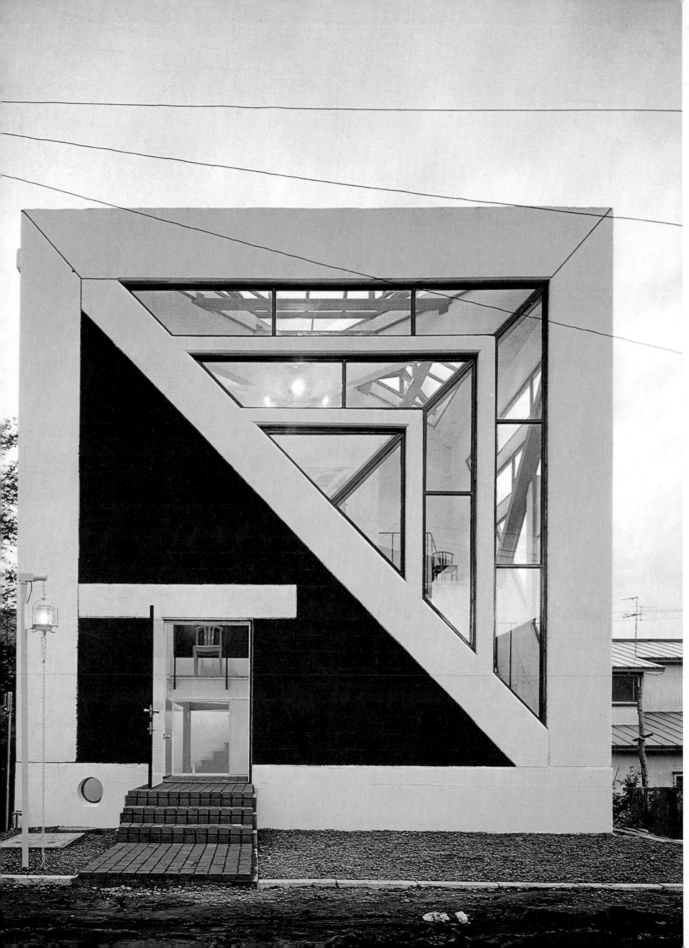

Outside view

Bedroom

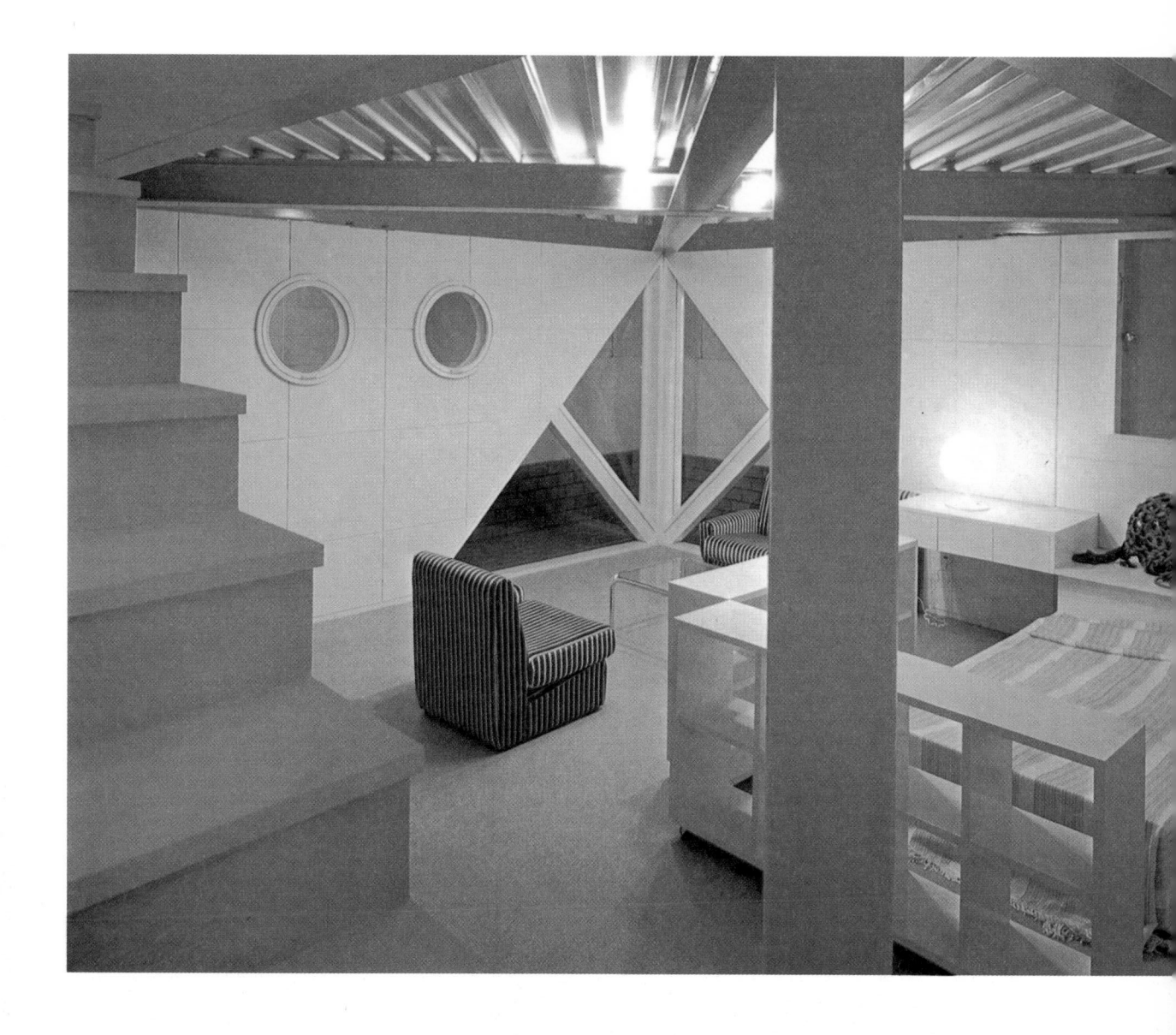

A Special Care Unit in London

Architects Foster Associates
Photography by
Tim Street-Porter

Flexibility was the keynote in the planning of this special care unit, at a time when change was foreseen in the schooling methods for the severely handicapped child.

The architects opted for a fixed central service core, flanked on both sides by two flexible areas defined by movable partitions and sliding screens. The central core is occupied by WC/changing and laundry facilities; it is fully glazed for efficient staff supervision and to allow the children to observe the activity area, thus relieving some of the unpleasant aspects of incontinence. Above the service area is a plant room housing heating and air-conditioning installations, with ducts hidden above the suspended ceiling throughout the building. Heating is radiated through the ceiling.

Great care has been taken to make the unit as inviting and reassuring as possible by a bold use of positive colours: orange for the wall to wall nylon carpet in the activity area, yellow and pink for the movable partitions and sliding screens, green for the sanitary fittings. The outside court is enclosed by a palisade of asbestos panels painted with swooping stripes of blue and yellow overflowing on the tarmac ground. A wide range of imaginative play equipment includes mobiles and special plastic inflatables designed at the Royal College of Art.

General view of play court

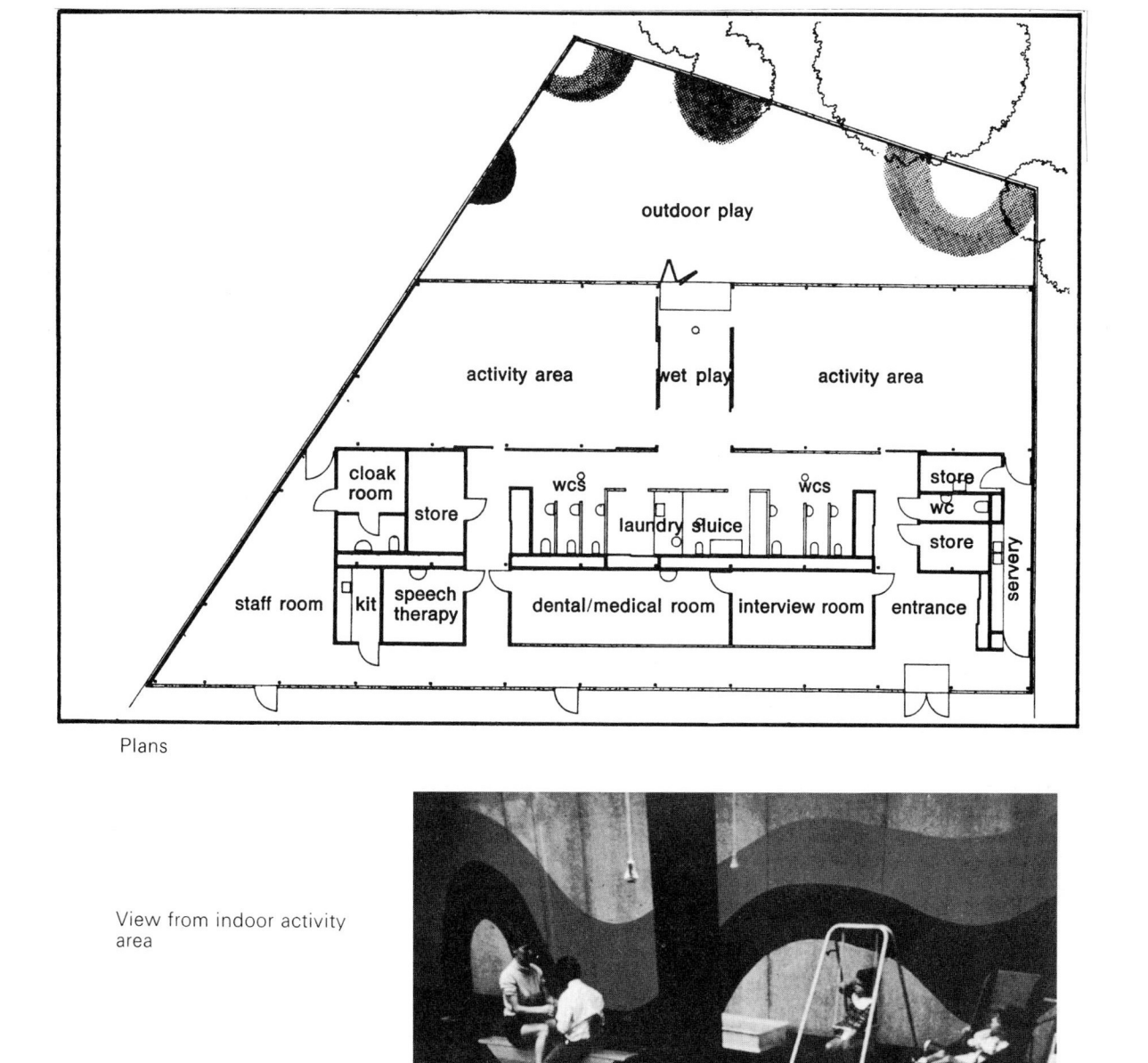

Plans

outdoor play

activity area — wet play — activity area

cloak room — store

staff room — kit — speech therapy

wcs — laundry sluice — wcs

dental/medical room — interview room

store — wc — store — servery

entrance

View from indoor activity area

Indoor activity
and specially designed play
equipment

Children at play on
inflatable plastic equipment

Service area

A Designer's Home and Studio, London

Designers Barbara Brown,
Ron Nixon
Photography by Sam Sawdon

An Edwardian house in South East London was bought by textiles designers Barbara Brown and Ron Nixon to become their home and studio.

No alterations were made to the existing layout, apart from demolishing half the wall between kitchen and dining room. Now pine boards line the dining area, and at the same time conceal the central heating pipes. The studio is also a living room where friends are entertained, and one of the three bedrooms is used as a workshop, its space taken up almost entirely by a huge loom where the beautiful wool hangings are made. Cork tiles cover floors and line the whole bathroom ('the cosiest place in the whole house!').

The furniture, with only one exception, was bought second hand or at the sales; surplus stores and junk shops were conscientiously raided to provide the accessories, one of the 'finds'

Dining area

Kitchen area

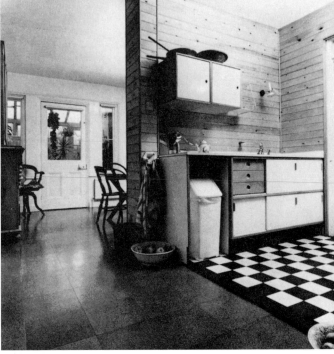

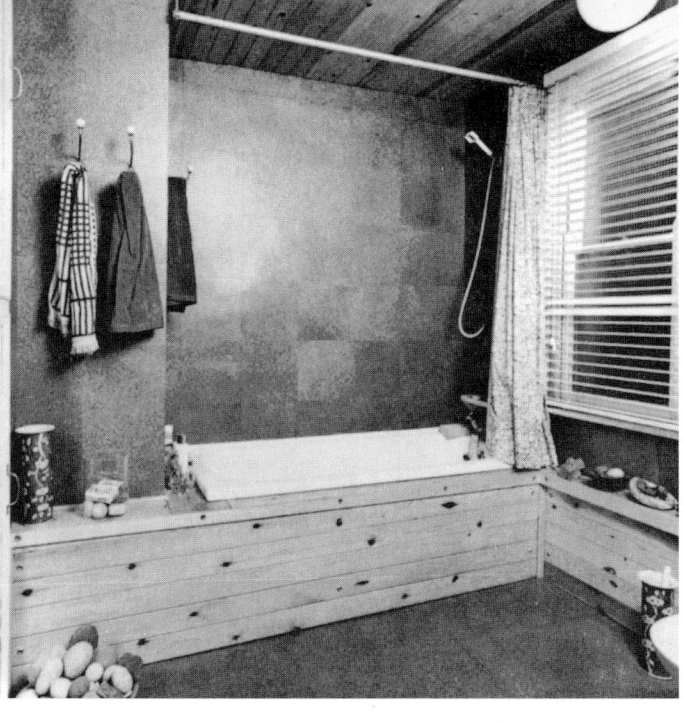
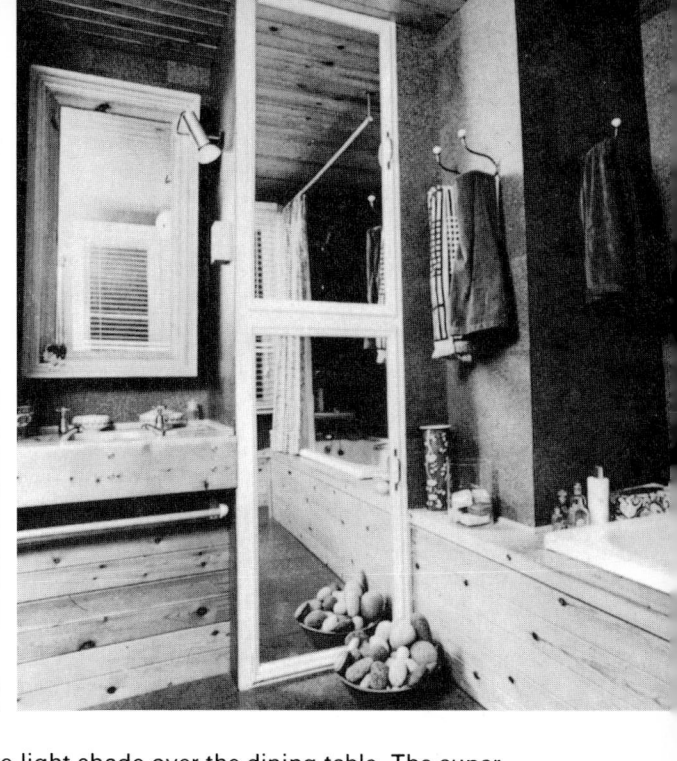

Bathroom

being the handsome light shade over the dining table. The super-ficial observer may be led to wonder how such high standards could be reached without the help of a qualified interior designer and a small team of specialized craftsmen. Perhaps the answer is a simple one: two artists, untrained in building techniques, wanted very much a place of their own for living and working. Being very gifted artists, and valuing most of all their work and their own way of life, they naturally and directly express these values in whatever activity they happen to be engaged. Food for thought in this consumer-orientated society of ours!

Bedroom

Workshop

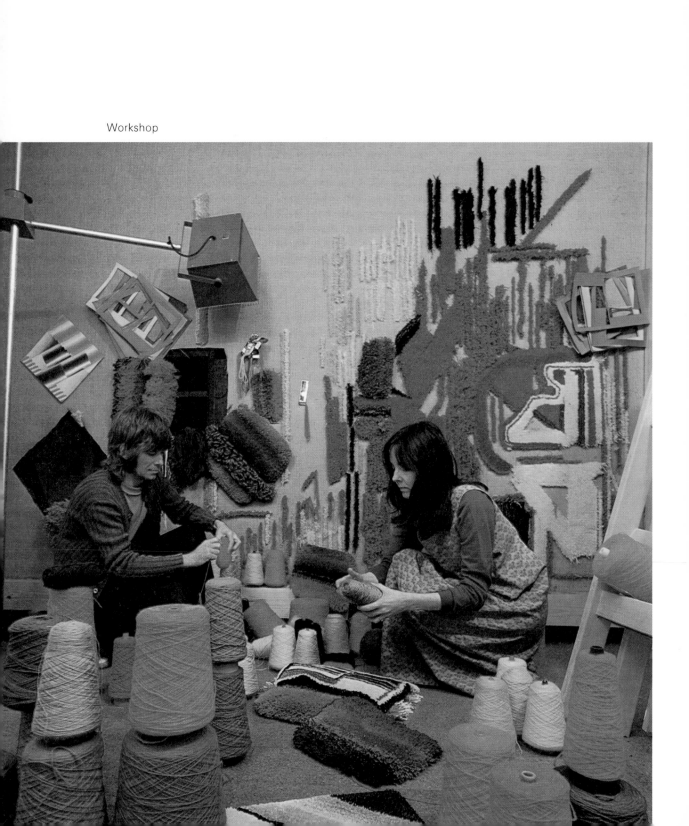

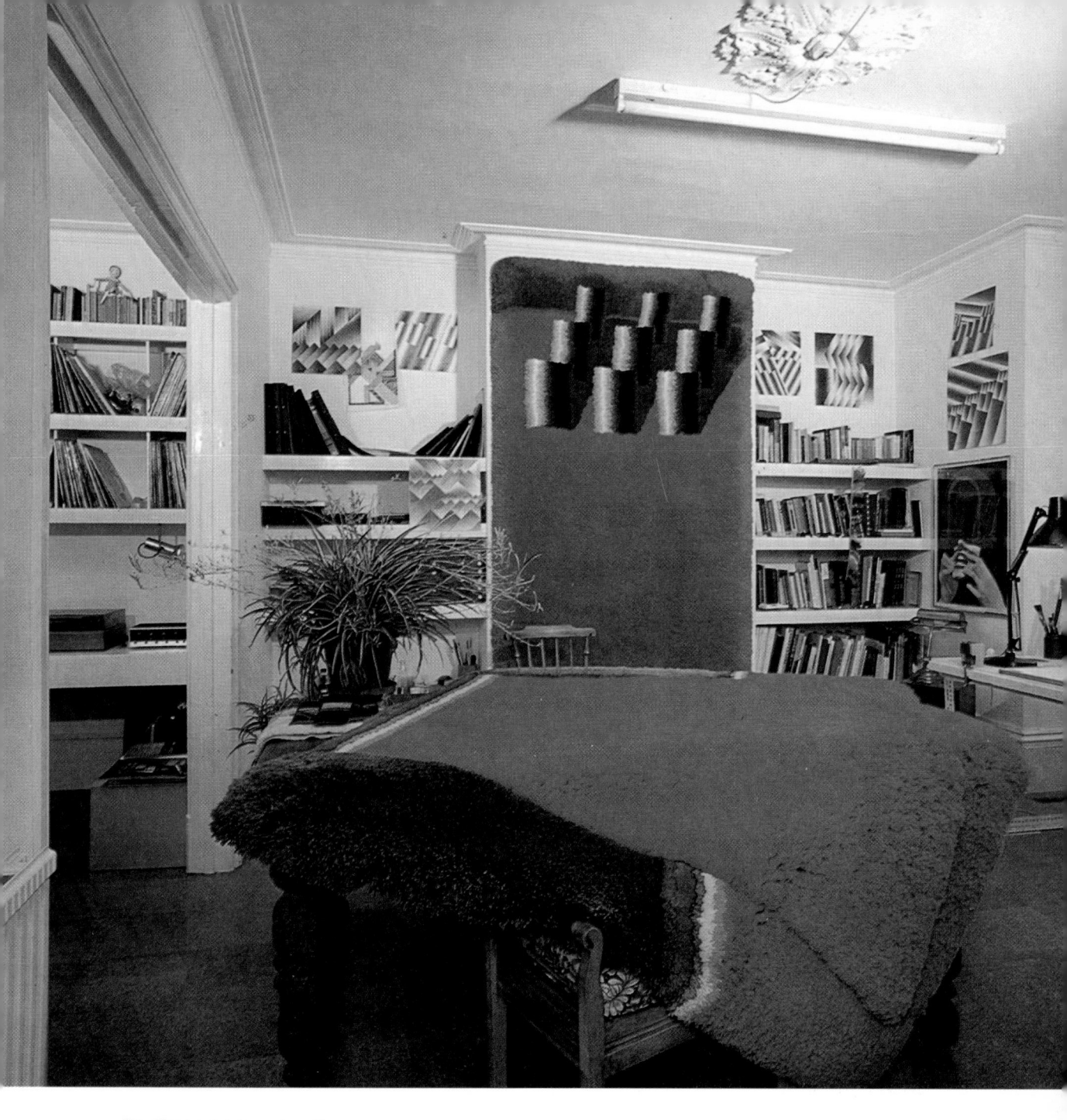

Studio; on table and wall,
hangings designed and
made by Barbara Brown
and Ron Nixon

A Hall of Wedding Ceremonies in Nagoya, Japan

Architects: Yasutaka Yamazaki
Architects & Associates +
Group System H
Photography by Yoshio Shiratori

'As long as human beings act under the influence of their spiritual nature, they have the power to change the environment completely through the accumulations of their acts.' This statement sums up Yasutaka Yamazaki's deep and complex professional commitment.

As an event that remains within the framework of daily life, yet is very extraordinary, a wedding is particularly related to the irrational side of human behaviour; it has dignity, happiness and embarrassment, the feeling of parting and of starting a new life; even perhaps a sense of envy is felt on such occasions. A building intended for wedding ceremonies, one of the very few surviving rituals that the individual can arrange and carry out for himself, cannot be planned on the basis of computerised calculations.

Looking down to the lobby; the ceremonial parade has just started

General view from the South; the box-like form on the roof garden, called the Shrine of Heaven, and the dome to the right, called the Shrine of Earth, are the two ceremony rooms

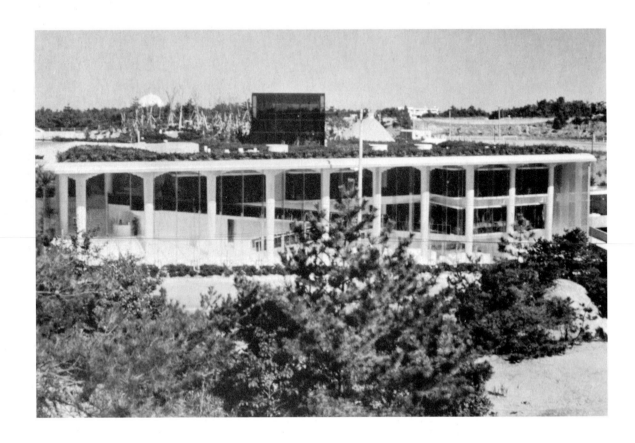

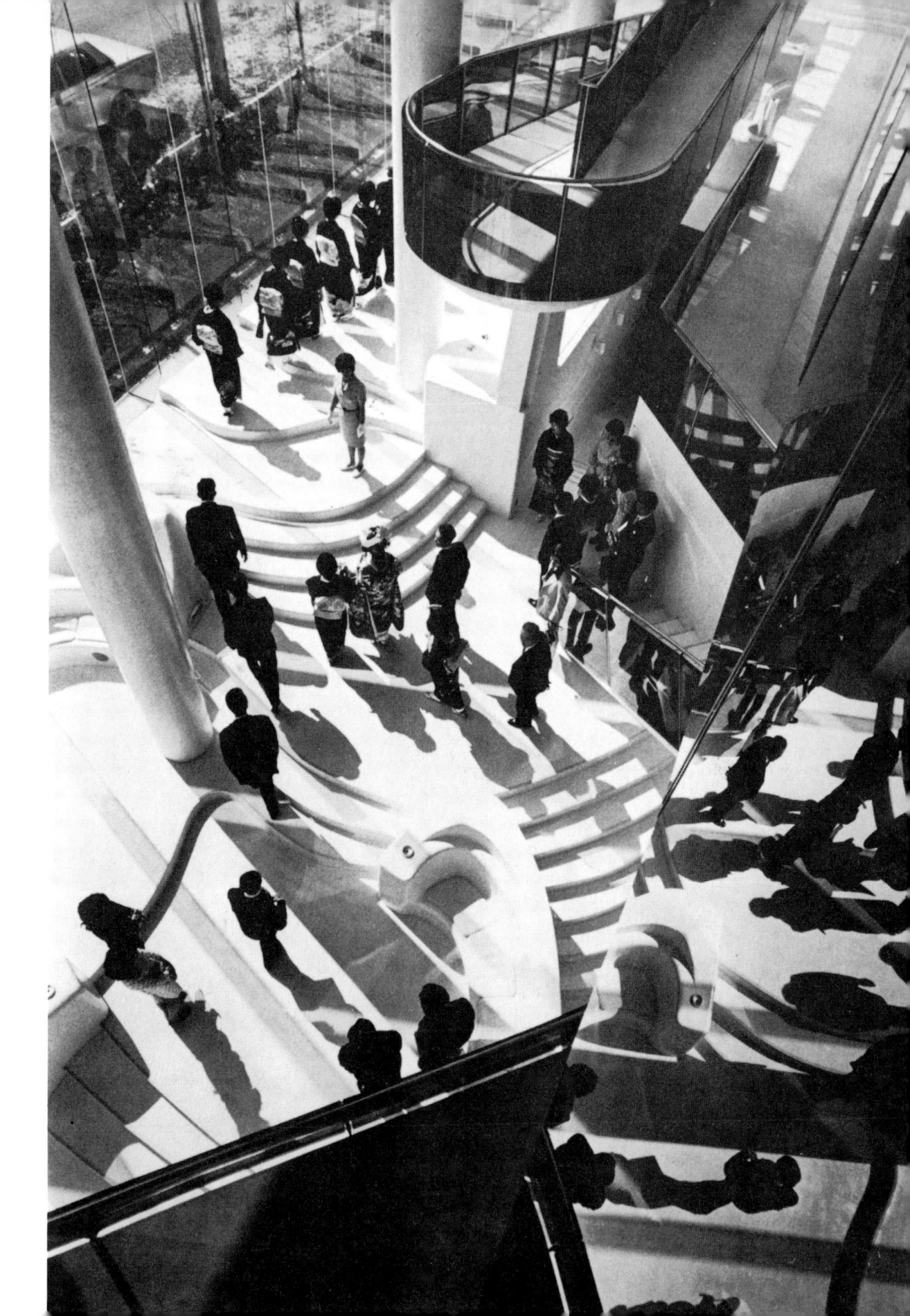

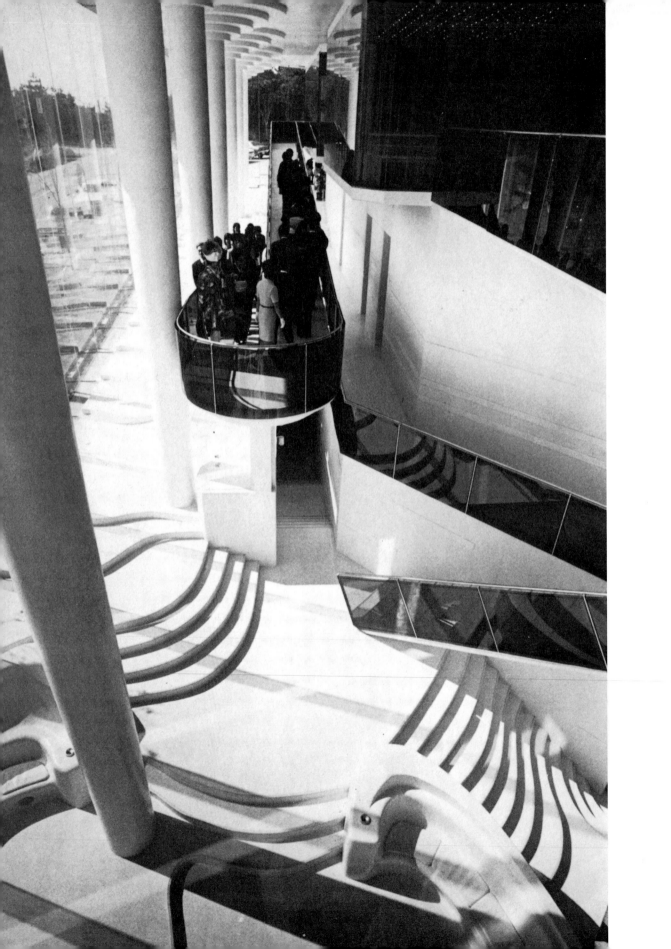

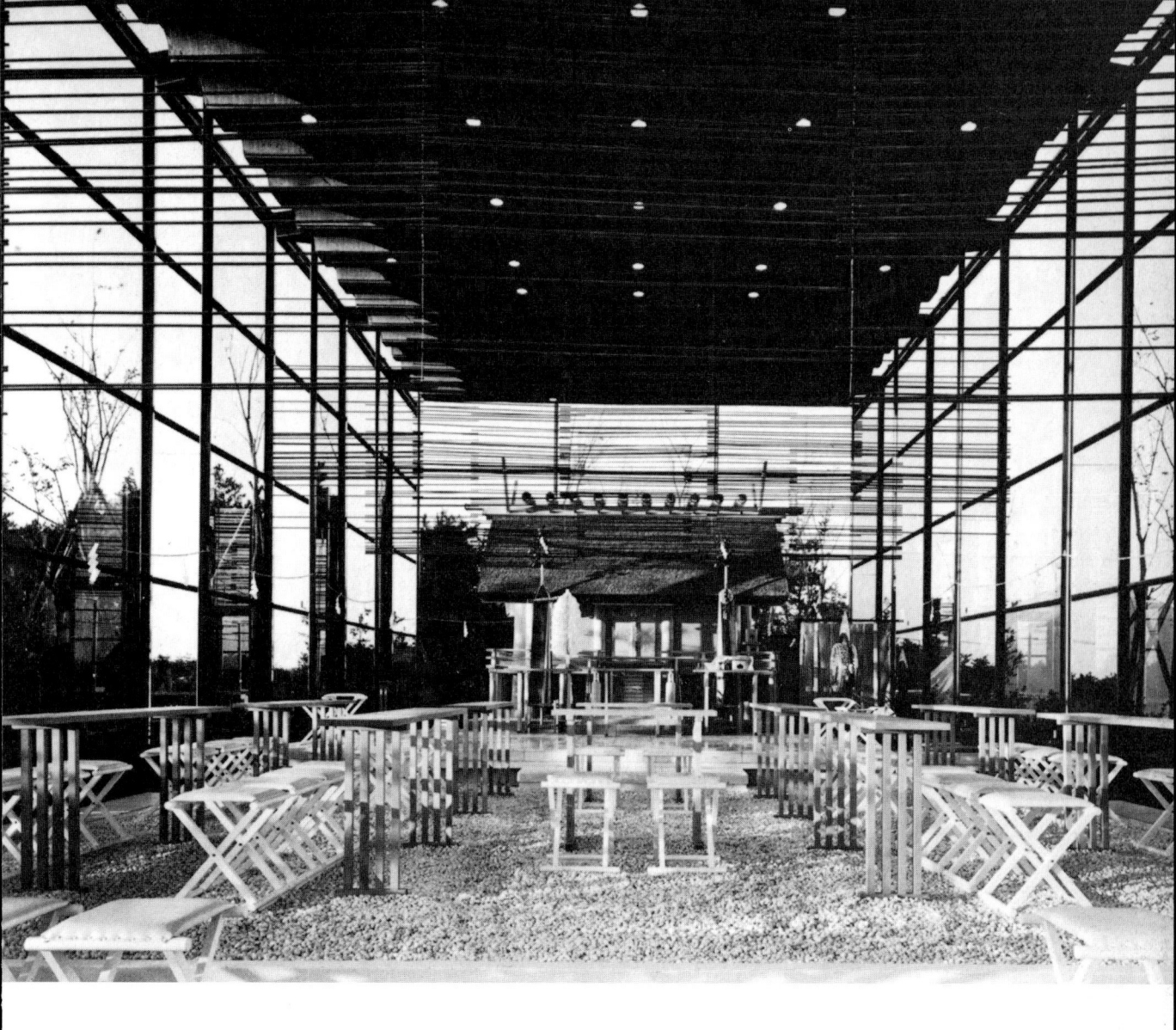

Inside the Shrine of Heaven; mirror facings seem to make the posts on the right and left sides disappear; in the background is a Shinto shrine in the Shinmei style

View of the Wedding Road

Yasutaka Yamazaki rented a flat in Nagoya so that he could live with the people who were to use and manage the completed building; he organised many meetings with people of different kinds who co-operated with him, and the resulting exchange of ideas led to the formation of 'Group System H', a one-time-only association of people who would disband once the task was completed, but whose core team lived under virtually dormitory conditions while the building was being planned.

The outline shape is a horseshoe, with the booking offices on the left and the ceremony rooms on the right. Spatially the building can be divided into two main zones: the lofty glass and white area that includes rooms for several functions, and the roof garden, which is on the level of a hill that stood on the site before construction. The pedestrian traffic pattern is based on the idea of the flow of water; the staircases leading right and left from the entrance seem to flow like a stream and guide the visitors to the lobby on the lower level. The shapes of the built-in benches and

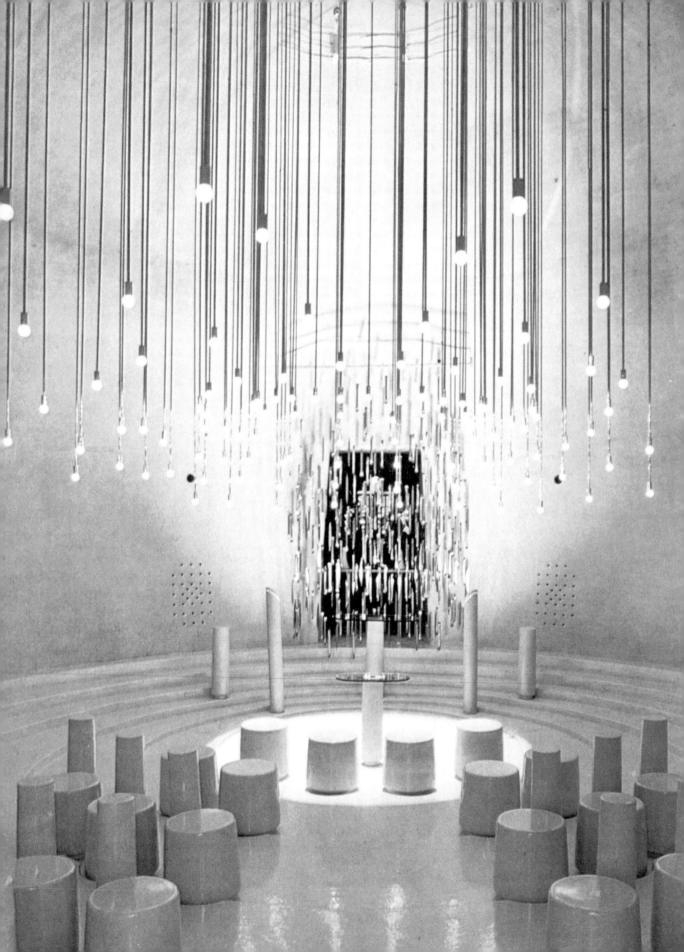

The Shrine of Earth; inside

chairs harmonise with this flowing image. When the party has assembled they proceed upwards along a ramp called the Wedding Road to the assembly room, where friends and family members are introduced to each other. Then the party moves on to one of the ceremony rooms: the Shrine of Earth or the Shrine of Heaven.

The Shrine of Earth is a circular, domed space, intimate and warm and enclosed to make possible complete artificial control of sound and light; but the Shrine of Heaven, a concrete and glass box, faces directly South amid the shrubs and trees of the roof garden. The glass walls and the white gravel on the floor establish connection with the exterior; the sense of space is reinforced by mirrors facing the interior side of the concrete posts and by the full views of the trees and red soil of the surrounding hills.

Plans

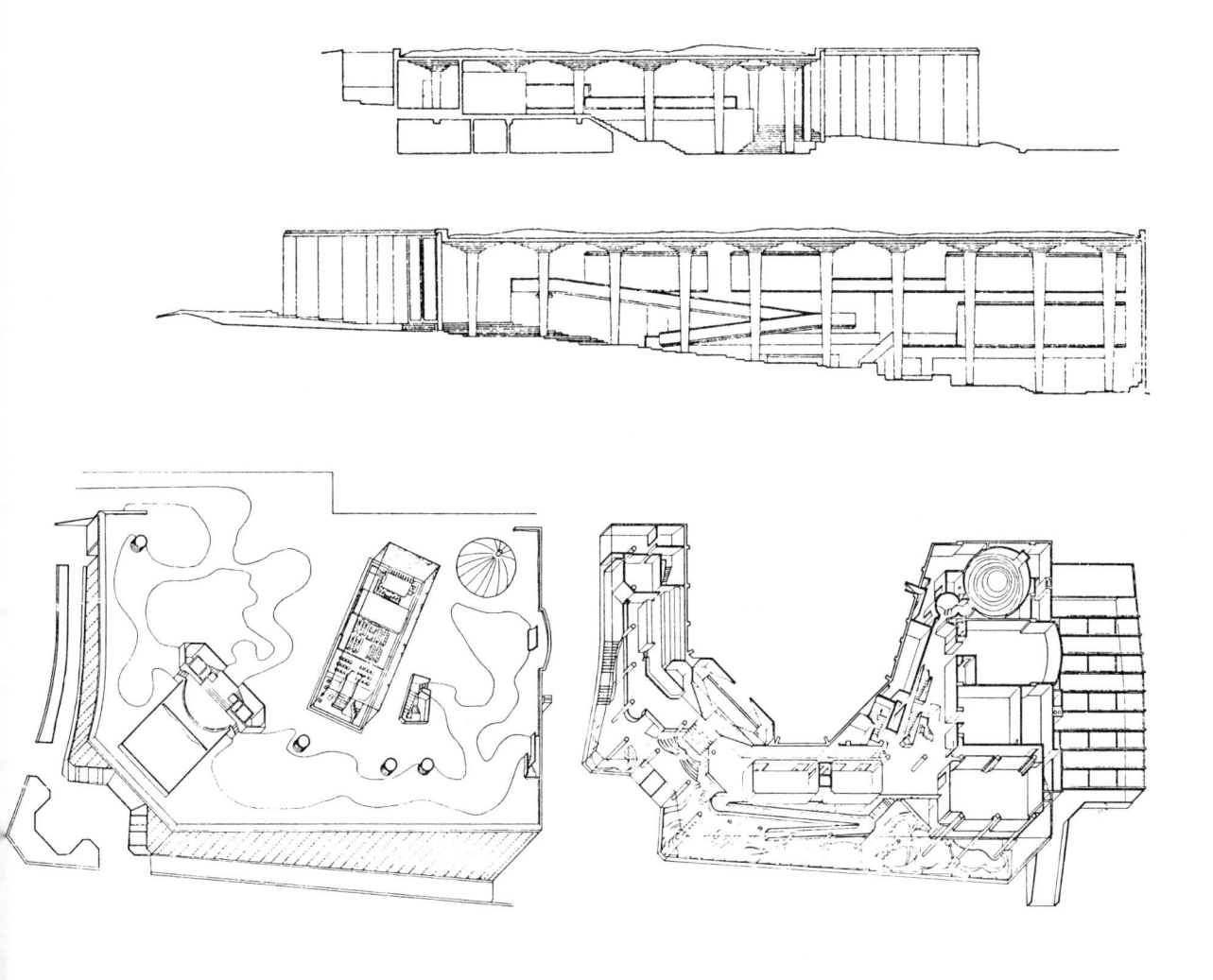

A Home on the Outskirts of London, England

Architects: Gerd Kaufmann
Associates
Photography by Heini Schneebeli

In designing this family house the architects exploited the natural characteristic of a site sloping southwards, with open views over London's 'green belt' to the north and east. The general composition is of a low, slightly spread building combining with very sharp, angular roof shapes and large areas of blank brickwork. Details were kept as simple as possible, with dark brown brick walls only relieved by the contrast of large and infrequent areas of aluminium-framed glazed doors and windows. Dark concrete coping and cills are externally flush with the brickwork, so that the main dynamic of the building is provided by sheer form. The overall effect is that of a somewhat sophisticated 'farmyard', which is not inappropriate to a house looking onto green fields from the edge of a vast city.

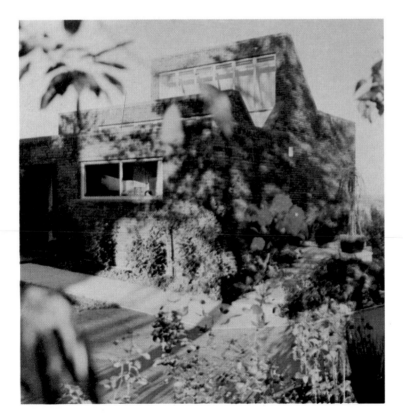

General view

Plans

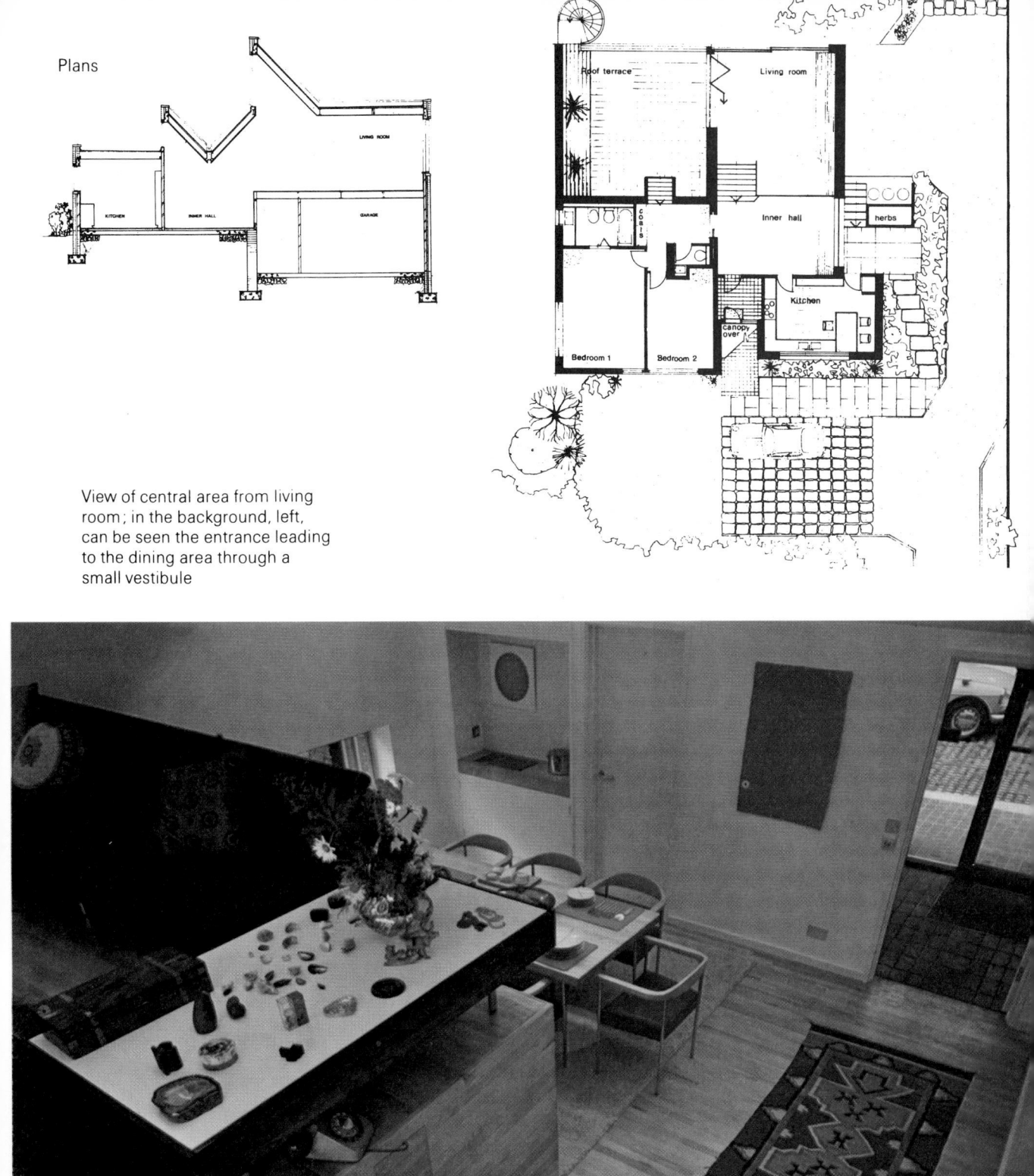

View of central area from living
room; in the background, left,
can be seen the entrance leading
to the dining area through a
small vestibule

Roof terrace

Living room

coals

Inner hall

herbs

Kitchen

canopy over

Bedroom 1

Bedroom 2

KITCHEN INNER HALL LIVING ROOM

GARAGE

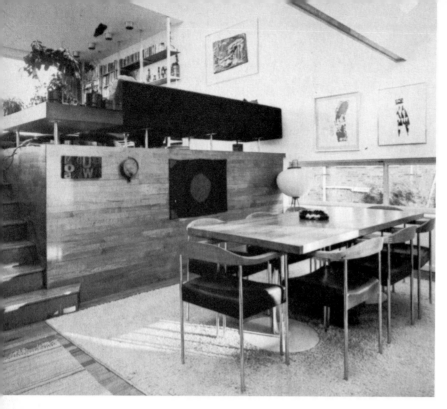

View from entrance towards split
level dining/living area

Upper level living area and roof
terrace

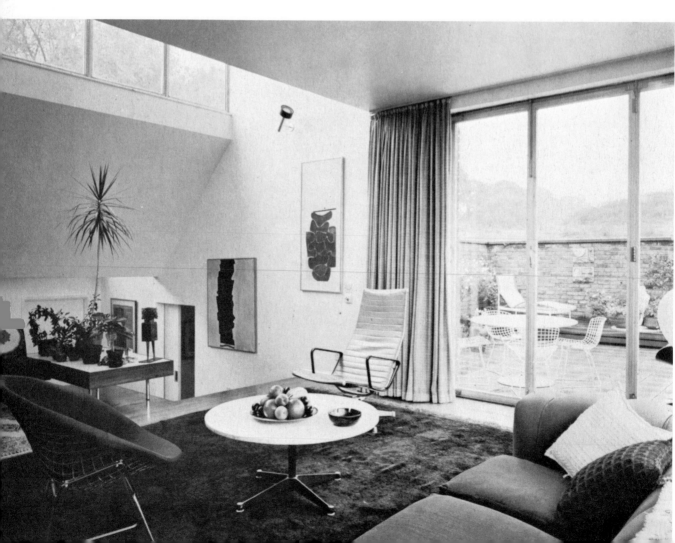

The interior plan, on split level, converges on the dining area, which placed in the centre of the house becomes the main circulating space, lit from the west by clerestory glazing. A short flight of steps leads from dining to living area and adjoining roof terrace; from the terrace an external circular staircase links the uppermost level of the house to the garden below. All the bedrooms are at ground level and have direct access to the garden.

View of terrace at tree top level

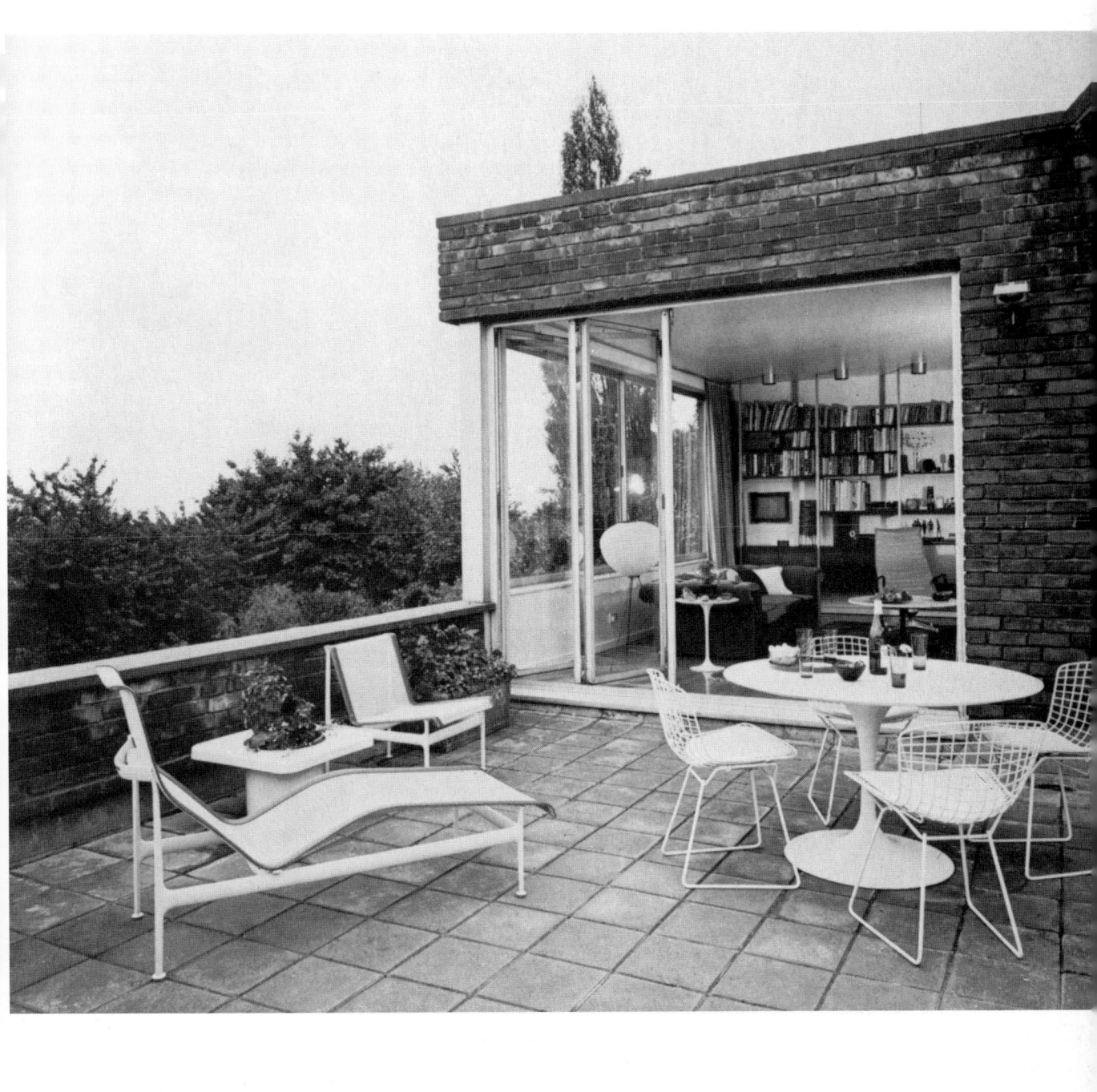

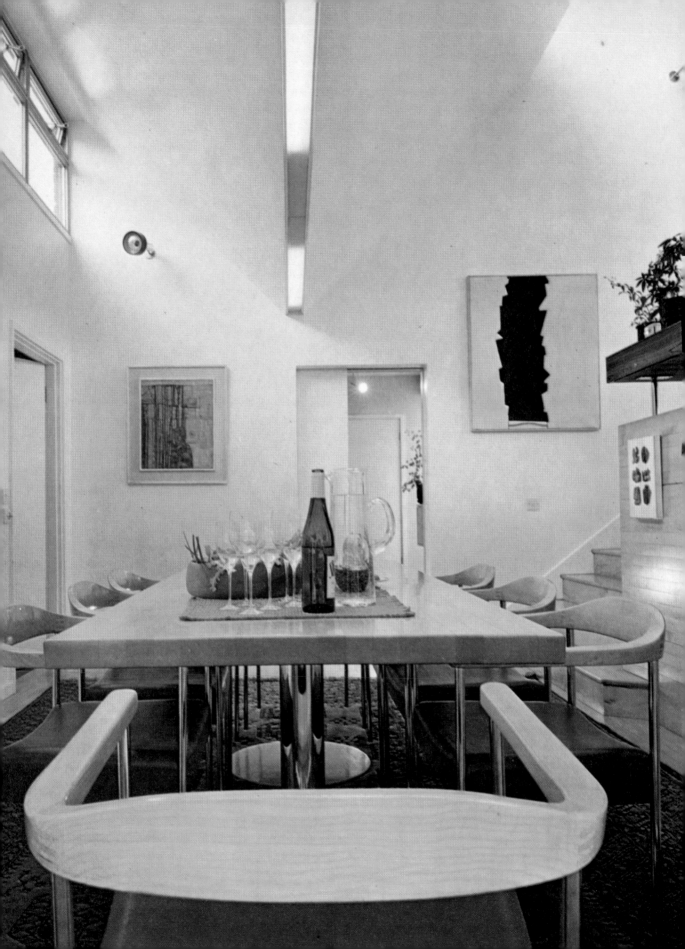

Children's bedroom

Close up of dining suite especially
designed by Robin Day and made
by Hille International. The
triangular trough over the dining
table functions as diffuser of
daylight coming through the
clerestory glazing, and houses
dimmer-controlled light fittings

The `Disk Union´ Record Shop in Tokyo, Japan

Designer: Katsuhiko Yamada
Photography by Eizabro Itara

A narrow and long basement area totalling 40 m² (120′ square approx) was recently converted into a shop specialising in the sale of jazz and rock music records. Katsuhiko Yamada chose black as the basic colour throughout, with variety of texture and glossy surfaces to add interest. The only exceptions are a touch of green paint on the shelves and back of the counter at the entrance, and the colours of the record sleeves on display.

The service counter and the furniture is black stove-enamelled steel. On both sides of the long walls the record racks are made of 3·2 mm steel sheets which arch over the whole ceiling area; they are also black stove-enamelled, but their edges were cut and ground to reveal the shiny metal underneath, in an irregular pattern derived from the section of a record groove. The whole ceiling reflected on the glossy surface of the service counter produces a space-less, eerie feeling.

Interior: the ceiling is reflected on the glossy stove-enamelled service counter

Reception counter

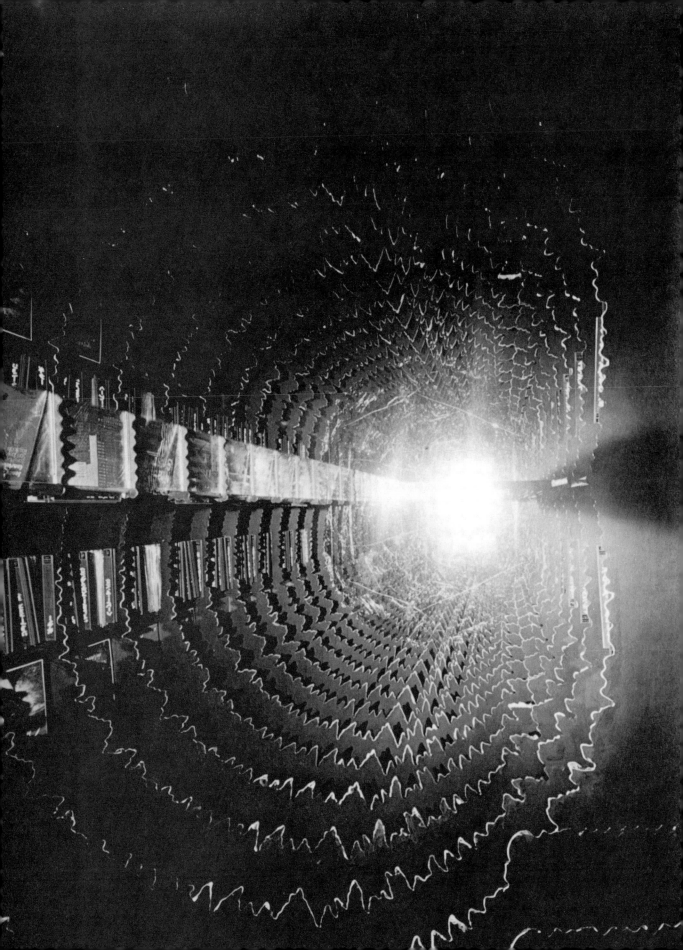

The `Shu-Pub´ Shoeshop in Tokyo, Japan

Designer: Minoru Takeyama
Photography by Yoshio Shiratori

Given the fact that a shoeshop will of necessity contain a fairly large number of shoeboxes, it seems unavoidable that the appearance of its interior will be determined by people handling them, rather than by the designer himself!

To control to some extent this situation, Minoru Takeyama based his plan on the module provided by the shoebox, and conceived the shelf space as an architectural element. Accordingly, the exterior of the shop is obviously modelled on a shoebox, and once inside shoeboxes supply the only note of colour in an all-black environment, and function as room dividers as well. Further, as long as the shop is doing good business, the walls are in constant movement; boxes and their contents are sold and depart, to be replaced by new ones; different colours show the sizes of the shoes they contain, so that the visual display presented by the wall communicates graphically the efficiency of stock selection and the sales turnover. And if stocks are low, the room dividers simply and discreetly vanish out of sight.

Inside; general view

Outside; general view

Overpage
Central display area showing arrangement of shelf space; lighting is also in box-like diffusers

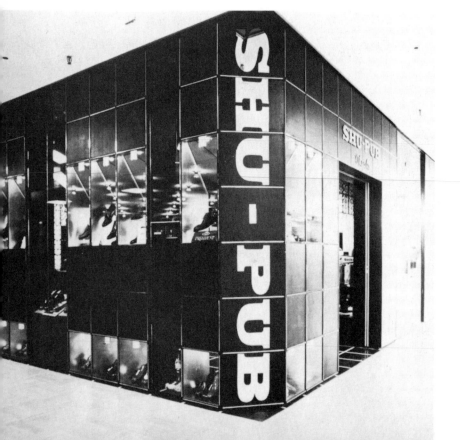

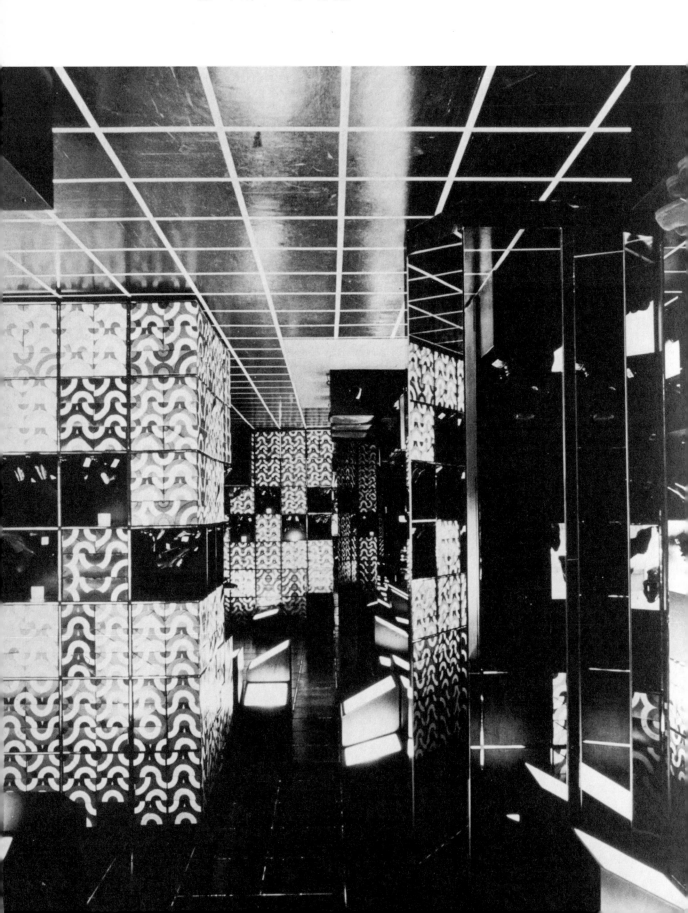

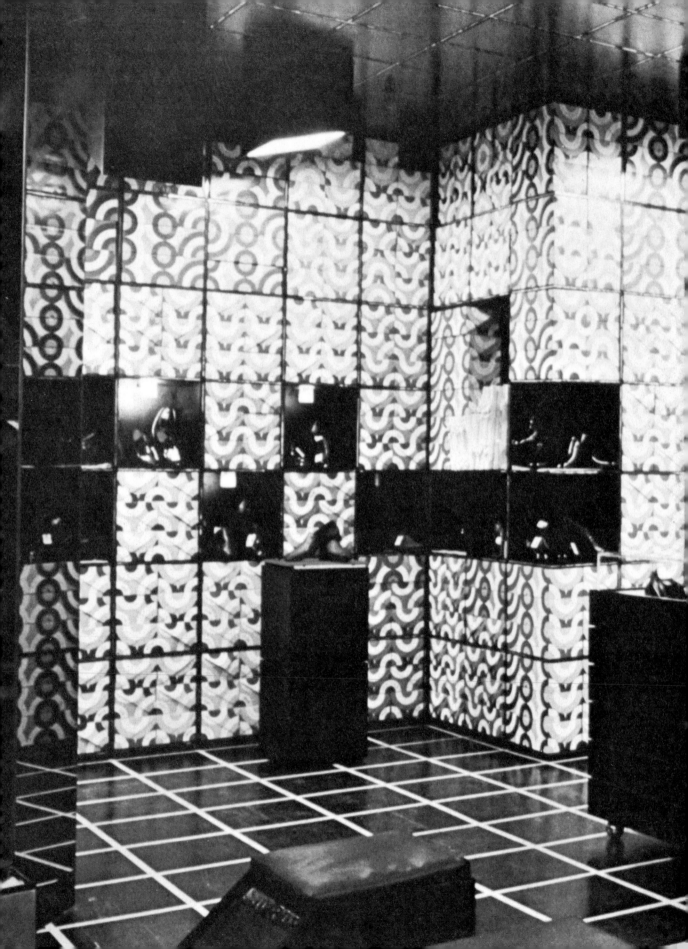

The Vacation House
of the Architect
on Crane Island, USA

Architect: Wendell H Lovett
Photography by Christian Staub

The site is called Wasp Passage, Crane Island, in the San Juan Islands group which lie at the extreme north-west corner of the United States. Set in a naturally sheltered position, these idyllic islands have a mild climate throughout the year. This summer weekend house for six was planned to provide the architect and his family the opportunity of a complete change from the urban experience; a small, 12' wide wooden cabin on the edge of the water, totally integrated to the beautiful site, with only essential plumbing, a compact kitchen, and an interior space put to multiple use. A lower room for relaxed sitting, eating and sleeping reaches with a simple ladder-stair to an upper sleeping loft.

General view of site

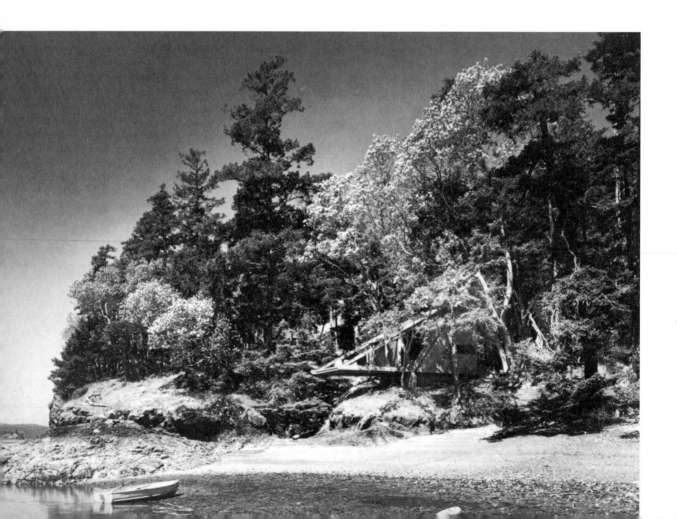

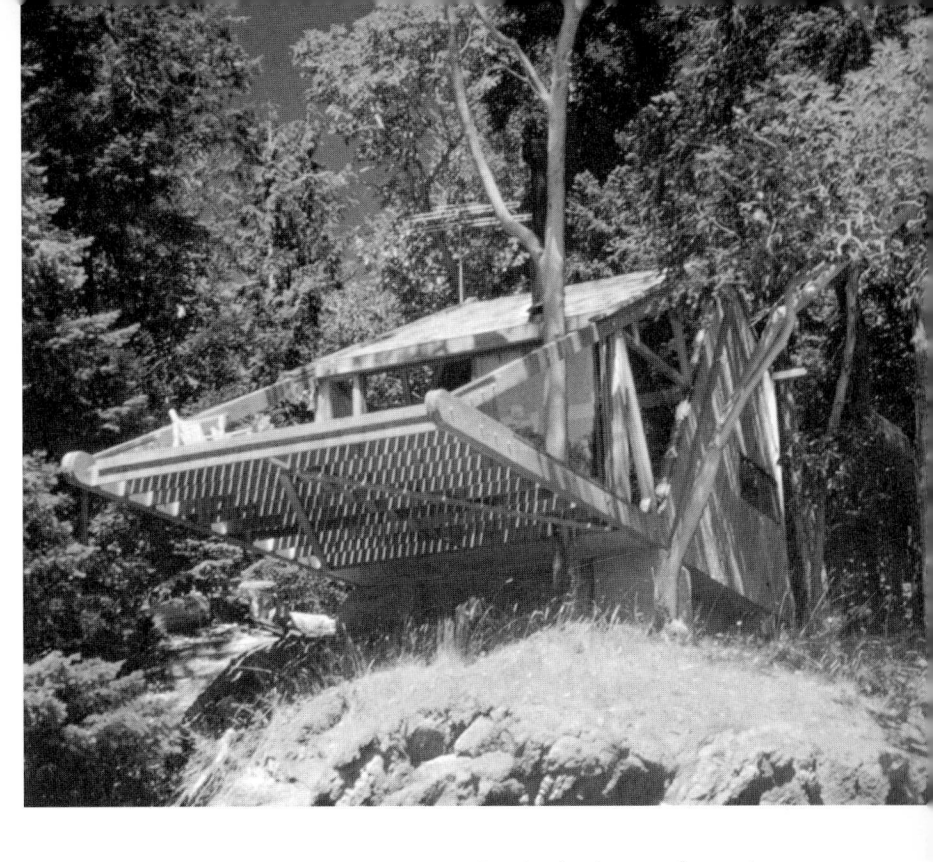

View from below deck level

The boldness of the resulting structure lies in the inverted wood trusses that cantilever 18' beyond the foundations to support the roof and suspend the sun deck. The floor of the major space lies one step below deck level (the depth of the joists) to accommodate the mattress for sitting and sleeping; the clutter of separate furniture pieces in a small space is thus neatly avoided. All structural elements and floor decking are Douglas fir; ceiling and walls inside and out are covered with rough-sawn cedar, stained to the colour of the bark of the surrounding trees.

47
Plans

Overpage
Outside: note how the trees are integrated to the sun deck

Inside: the metal fireplace, called the *Toetoaster,* was designed for series production by the architect, Wendell H Lovett

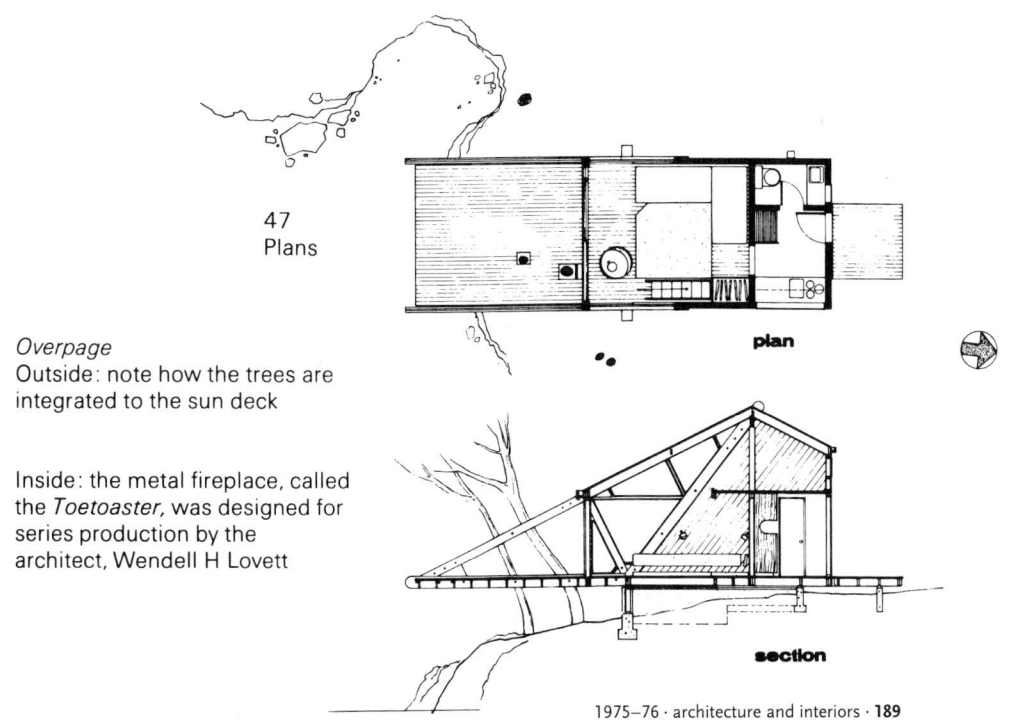

plan

section

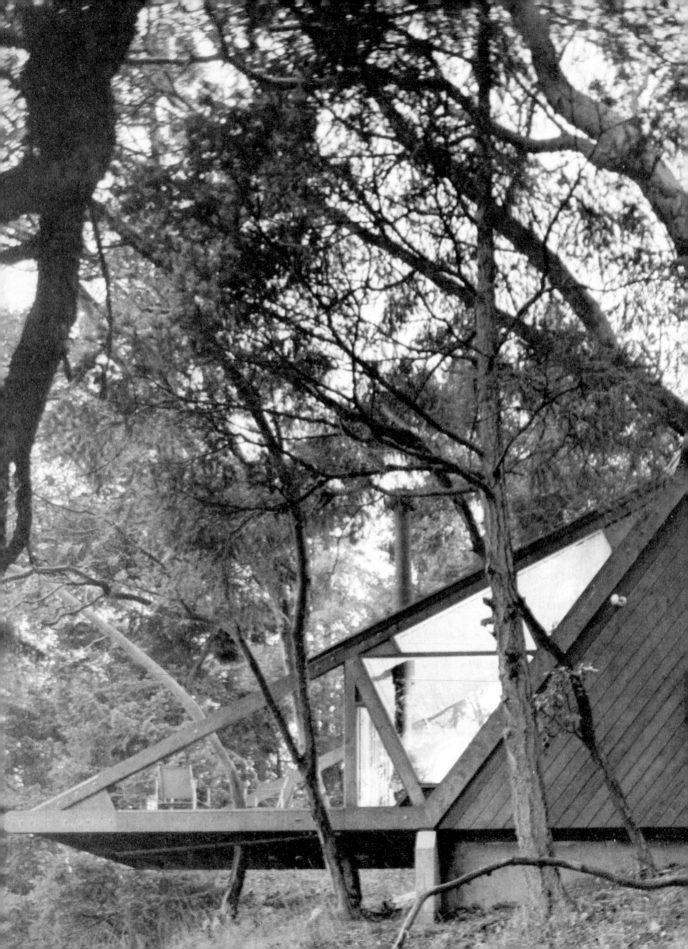

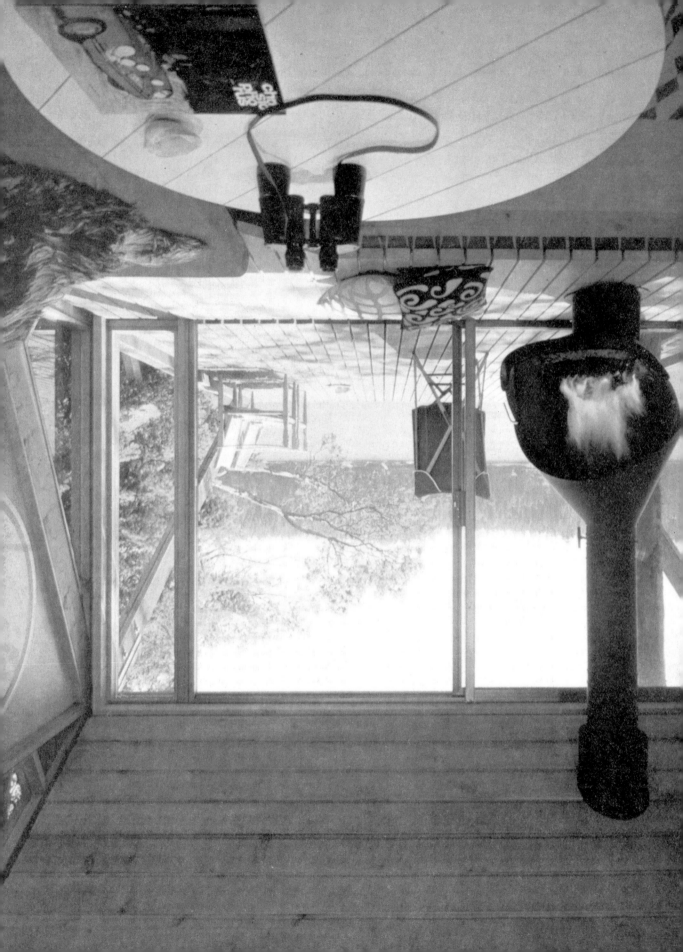

The Home of the Architect in Fukuoka, Japan

Architect: Shoei Yoh
Photography by Yoshio Shiratori

Having experienced himself the discomfort of living in a small apartment with his wife and their three children, the architect designed and built his own home 'to restore to its residents that individual freedom from restraint, which is the very nature of architecture'.

Set on a steep hill, the house consists of a raised concrete platform supporting two floors on a rigid steel frame. Inside, all areas have been designed to allow maximum flexibility of function. The outer walls are of plate glass with hinged, frameless windows; the inner partitions are movable units used as containers. Visual control is achieved by means of vertical and horizontal blinds. Ceilings house the light fittings, and floors become at times living or service areas, as in the round conversation pits or the acrylic bath unit.

Outside; general view

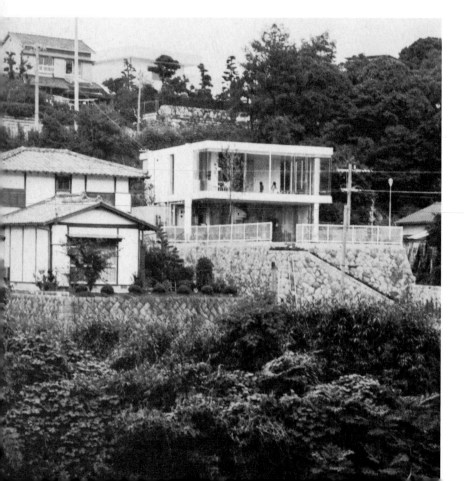

Plan

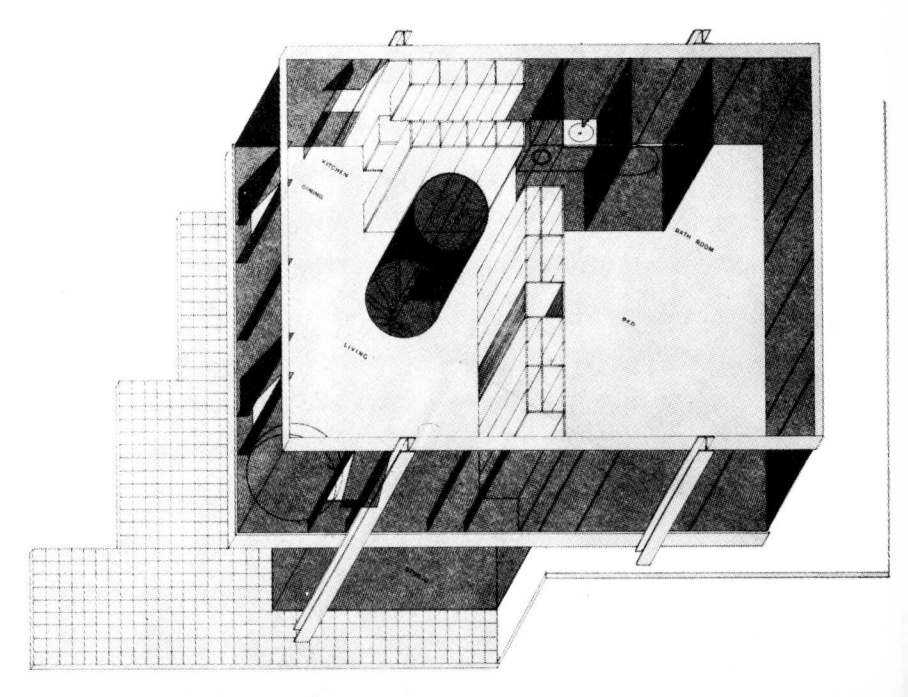

Detail showing hinged frameless window

View through one corner of the house

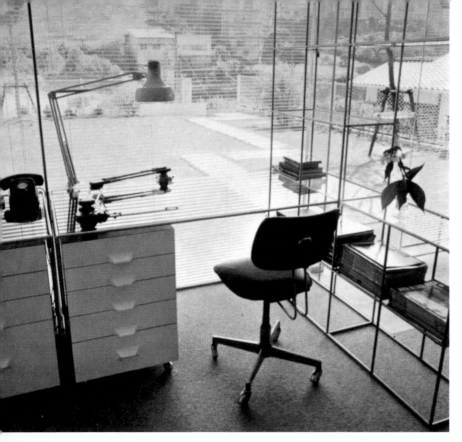

Detail of study with views over green space and hills

Opposite
Living area on upper floor; it is reached by spiral stairs within grey acrylic cylindrical form

Study area with blinds closed to show control of visual environment

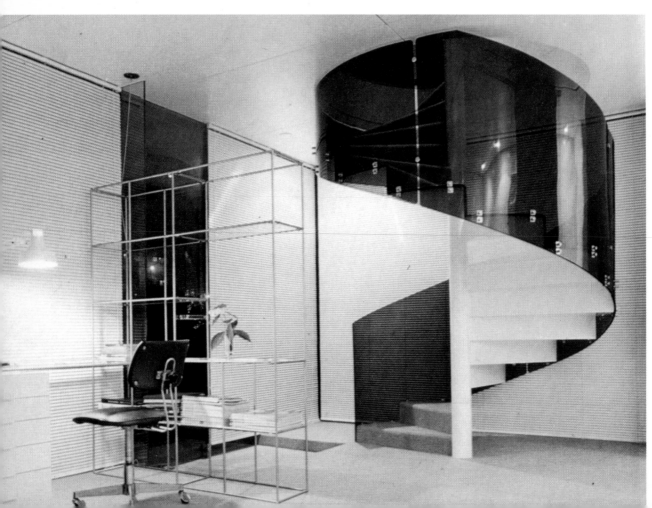

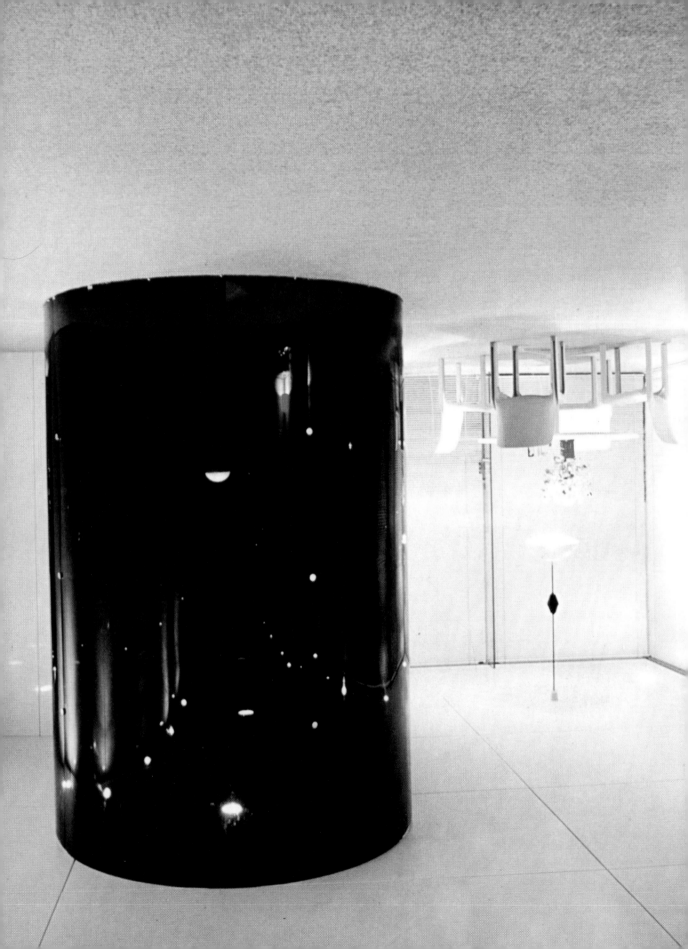

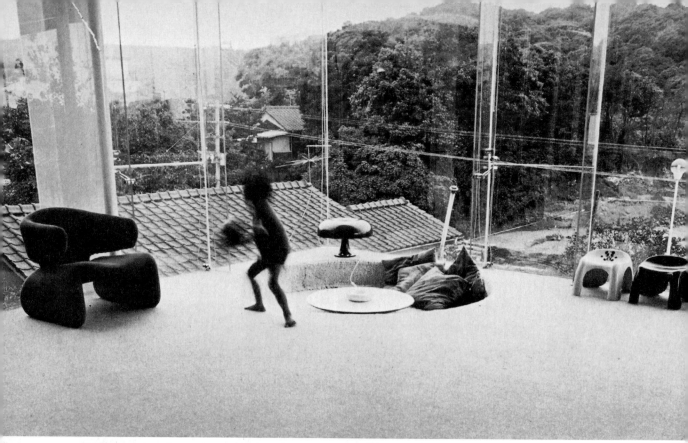

Living area

Detail of living area showing
sunken conversation pit

Minimum, compact furniture accentuates the freedom of open space, and the flexibility of design is epitomised in the graceful spiral staircase encircled in grey acrylic.

One important feature of this remarkable project is the rapidity of its completion: within three weeks from the erection the architect and his family were able to move in.

Kitchen; in the background, the dining corner

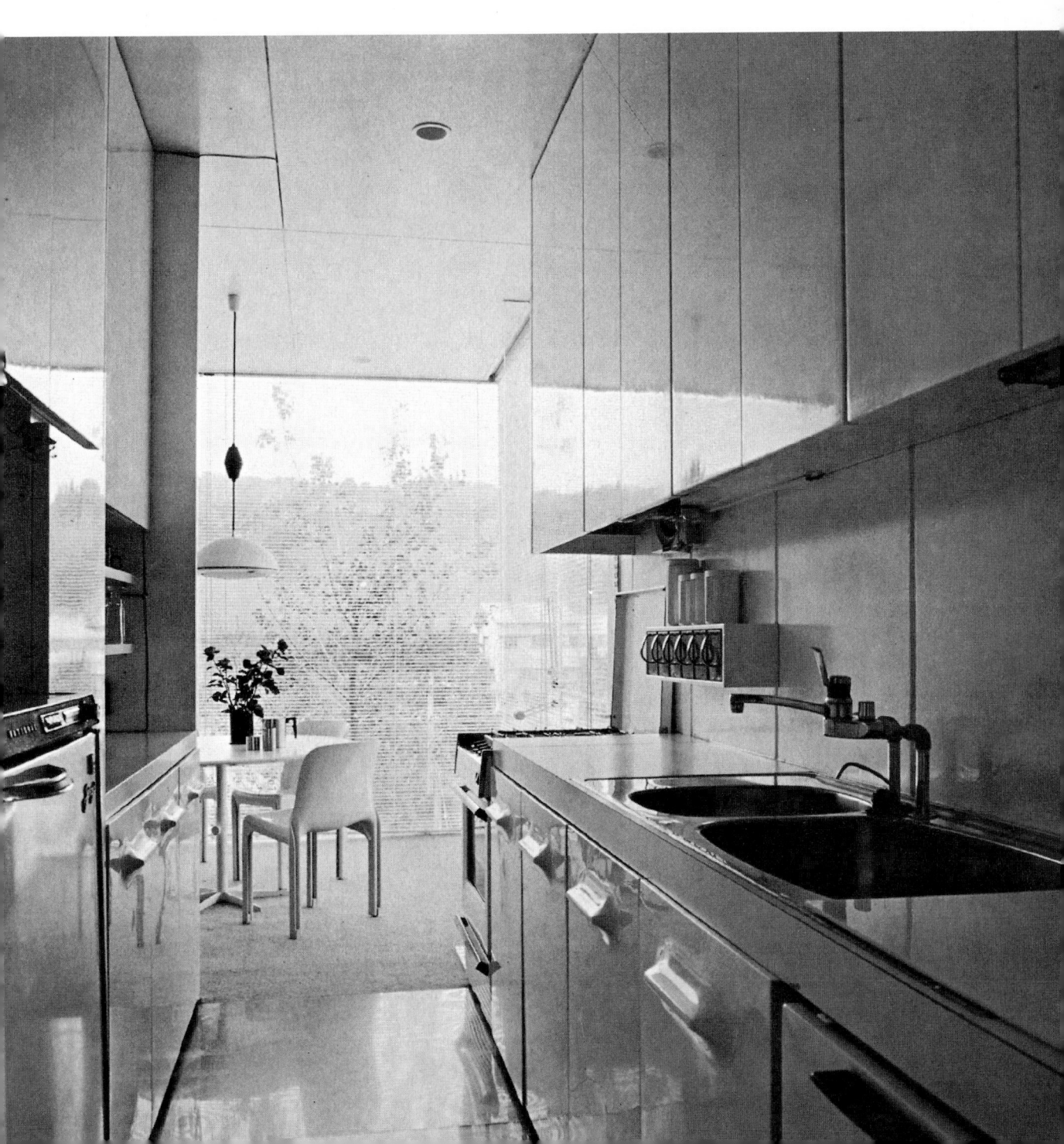

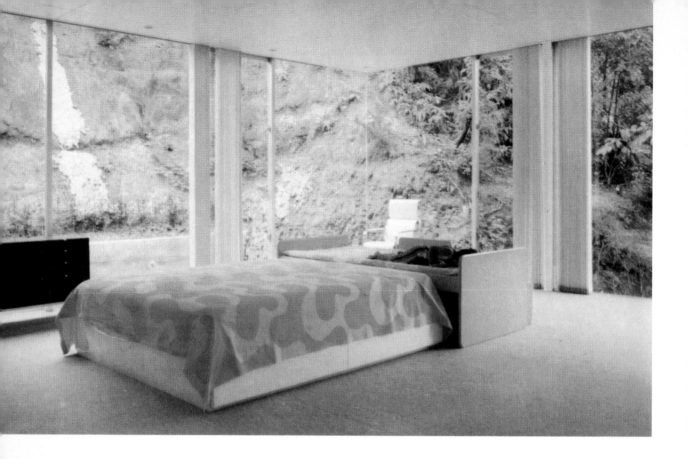

Bedroom

Opposite
Outside; general view at night

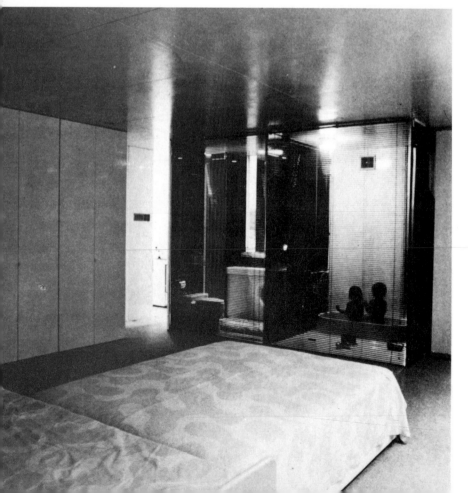

Detail of bedroom showing
integral bathroom (opposite
the bed)

A Retirement Home in Waiblingen, West Germany

Architects: Hans Kammerer and Walter Belz
Photography by Richard Einzig

The siting and planning of this retirement home was carefully considered by experts and eventually a sloping site adjoining another similar home was selected, on the outskirts of Waiblingen. The five storey building of reinforced concrete, designed in strong lines, is firmly planted on top of the slope, then steps down in various terraces and roof gardens. A natural spring of mineral water plays in the ground floor visiting area, cascading in a miniature water garden from where the central light shaft emerges. Reception, administrative offices and the chapel are located on this floor. Accommodation includes seventy-four single rooms, twelve double rooms and three apartments complemented by dining room, library, television room, hobby room, smoking room and services.

Outside view from the west

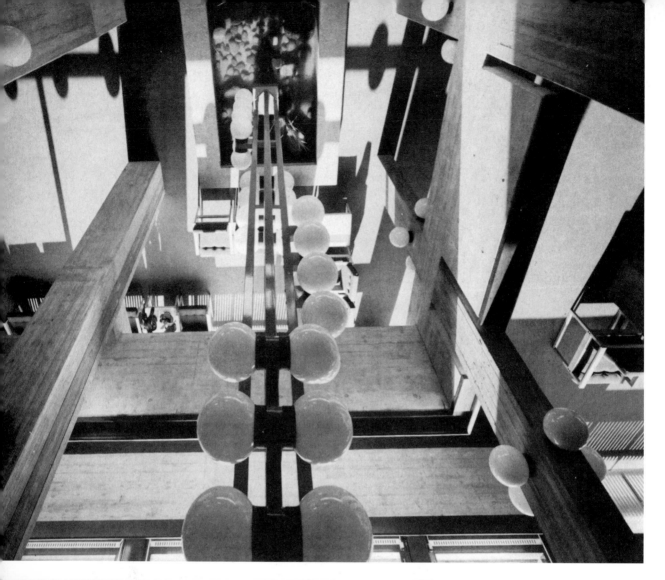

Looking down the light shaft and
stair well

Porter's lodge; to the right,
individual stainless steel
letter boxes

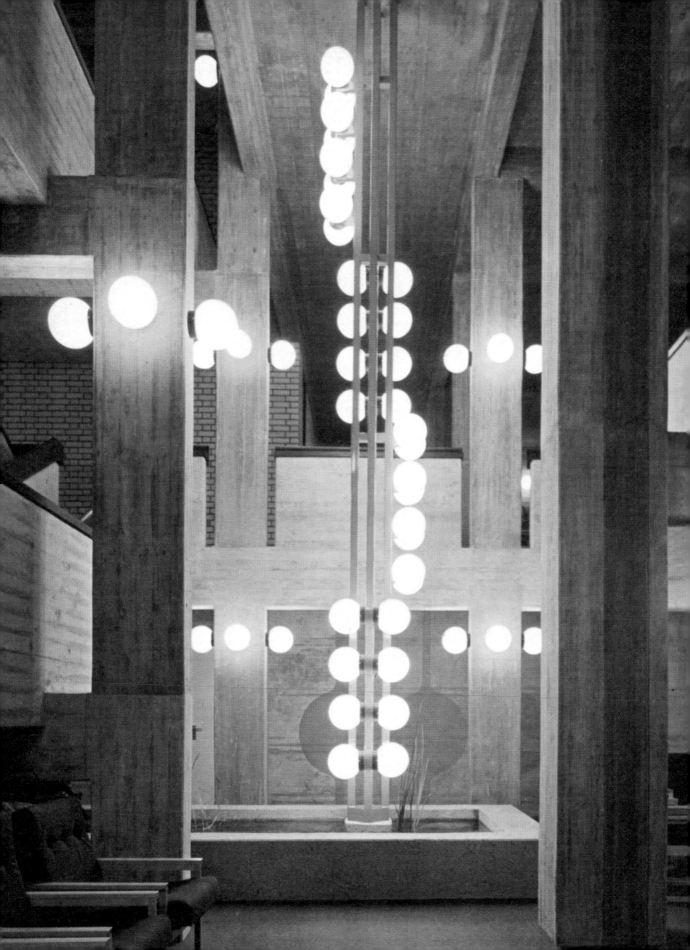

Dining room

The impressive hall/visiting area on ground floor with central light shaft

Materials are boarded concrete and limestone brick for walls, left exposed in the corridors, covered with hessian in the rooms. Linoleum and fitted needle felt carpet cover the floors. The colour scheme of all interior spaces and common rooms was devised in consultation with Heidi Kucher, who also designed the murals.

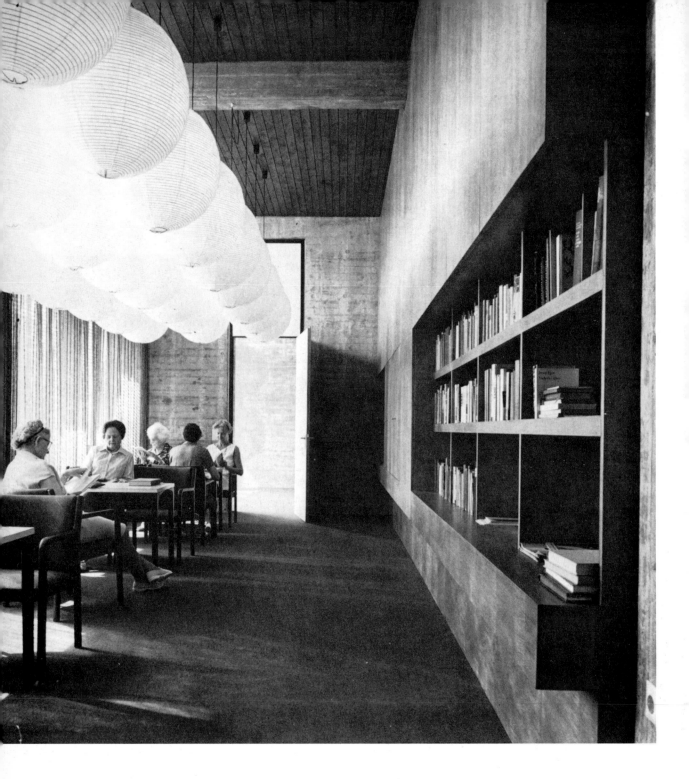

Common room

Ground floor; detail of water spring

View of landscaped terraces and balconies

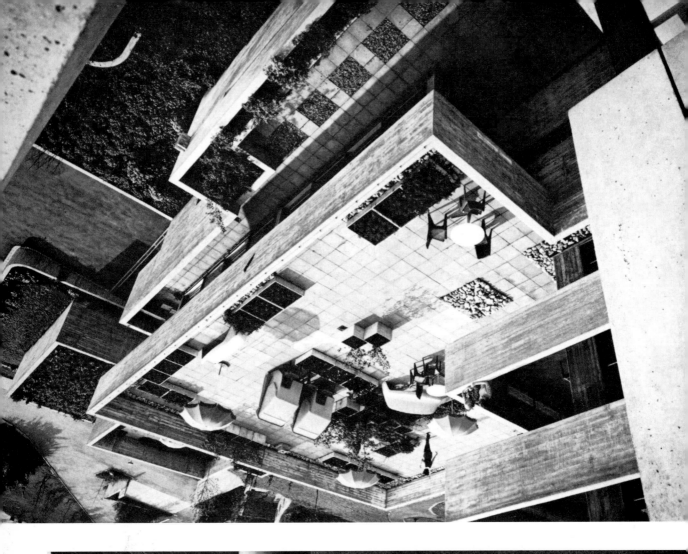

Alexander Boutique in Rome, Italy

Architects: Fratelli Bini
Photography by Giac Casale

The task of designing this fashion boutique in Piazza di Spagna, the smartest area of the city, was rendered particularly arduous by two main factors: the need to outshine strong competition from several other similar shops, while maintaining standards of excellency on a site surrounded by architectural masterpieces, and the necessity of working out an optimum of efficiency in a long and narrow interior with a floor area of only 75 m².

The solution centres on the interpretation of space as a mass, out of which is carved the actual shape of the interior: the approach of the sculptor rather than that of the architect. Every element serves a plurality of purposes: the masonry work includes two supporting arches, large display ledges, and a split level floor from where the display areas can be reached by additional steps; along the whole shop walls and ceiling, shelves run longitudinally in fluid curves combining decoration with function.

General view from inside

Plan

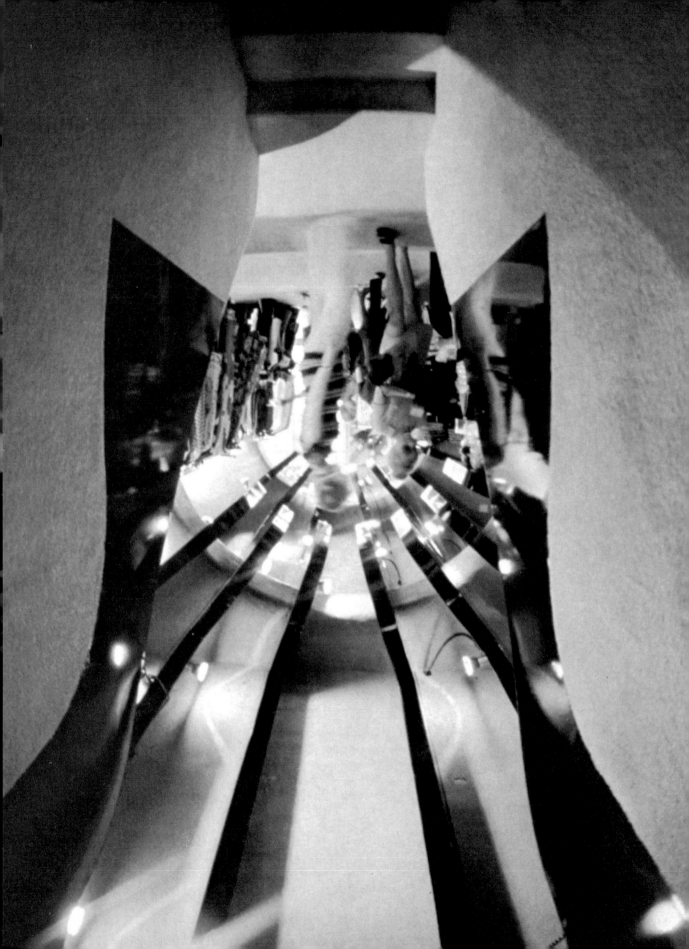

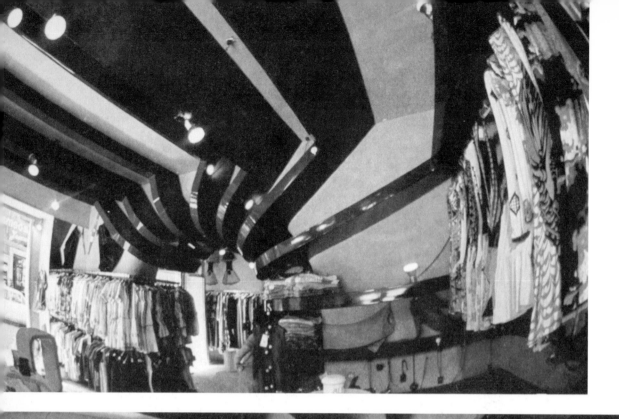

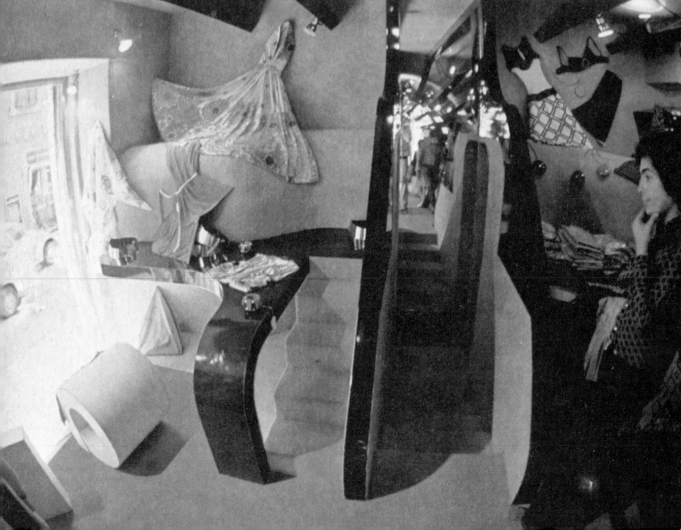

Detail of ceiling with shelves

The materials are wood, carpeting, and blue enamelled steel for the shelves. Lighting was the subject of particular study as it was intended to be directed to special display areas, the observer being always left in partial darkness. Mobile, medium intensity light fittings were chosen which adhere magnetically to the steel shelves.

Display area

Old palaces as reflected in the display window outside

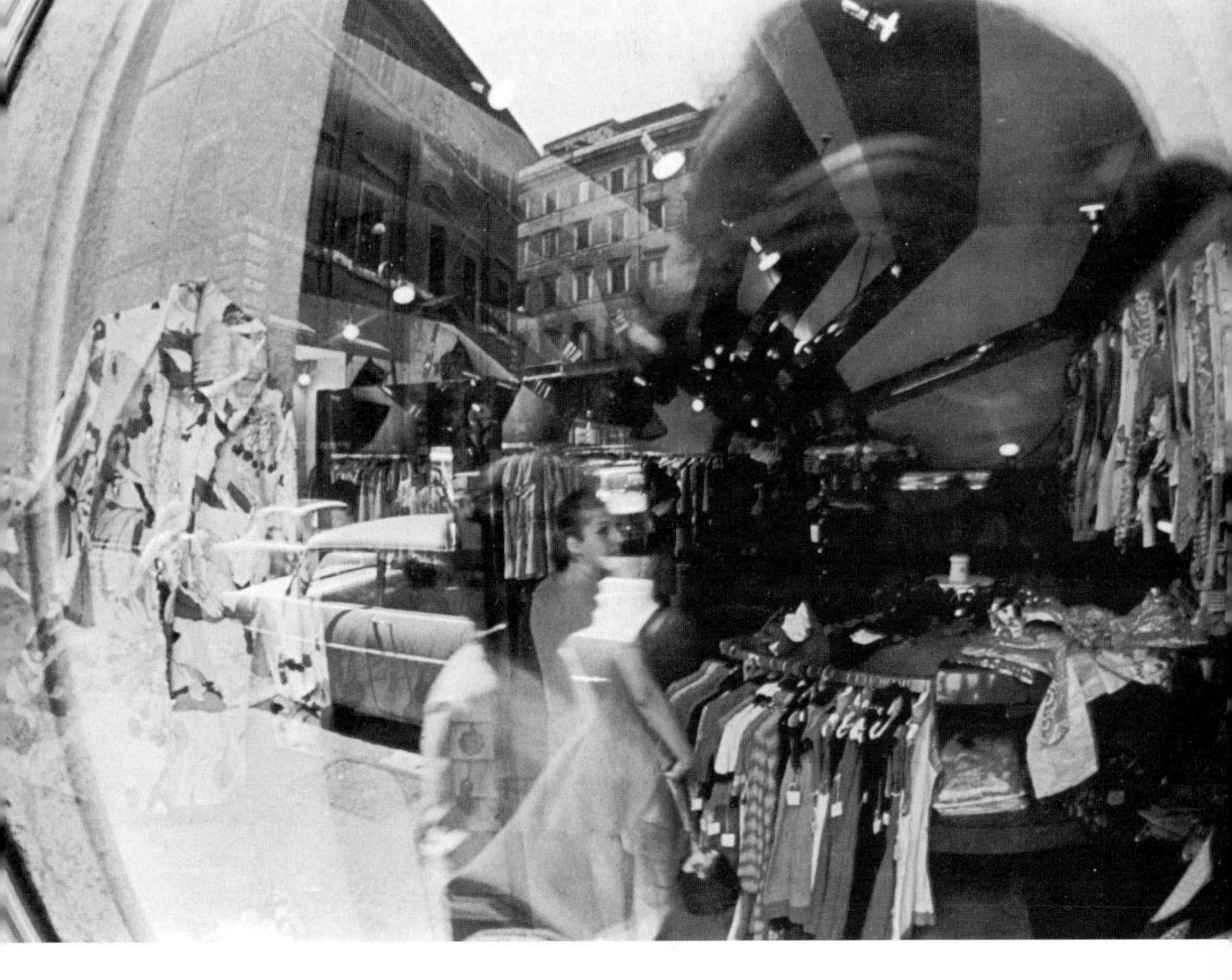

The Frey House in Bellevue, USA

Architect: Wendell H Lovett
Graphic Design by Alan Grainger
Photography by Christian Staub

Placed at the highest point of a site which slopes gently towards a private access road to the north, and rather steeply into a ravine to the south, this house overlooks dense woods of Douglas firs, Western hemlock and cedars in a protected area of Bellevue city. Its owners are a young couple without children who entertain frequently. The master of the house is interested in veteran cars, which he restores as a hobby. A large self-contained garage was needed, connected to the house by a utility link; the space between the two elements was conceived as an entry court, parking area for guests and a workyard in good weather. A view of the court and its interesting contents was desired from the interior, but the principal focus would be the ravine to the south.

Opposite
Main entrance to house

General view from entry court

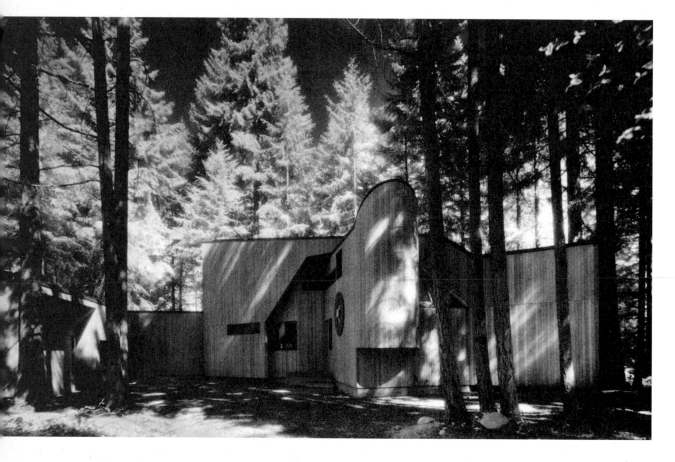

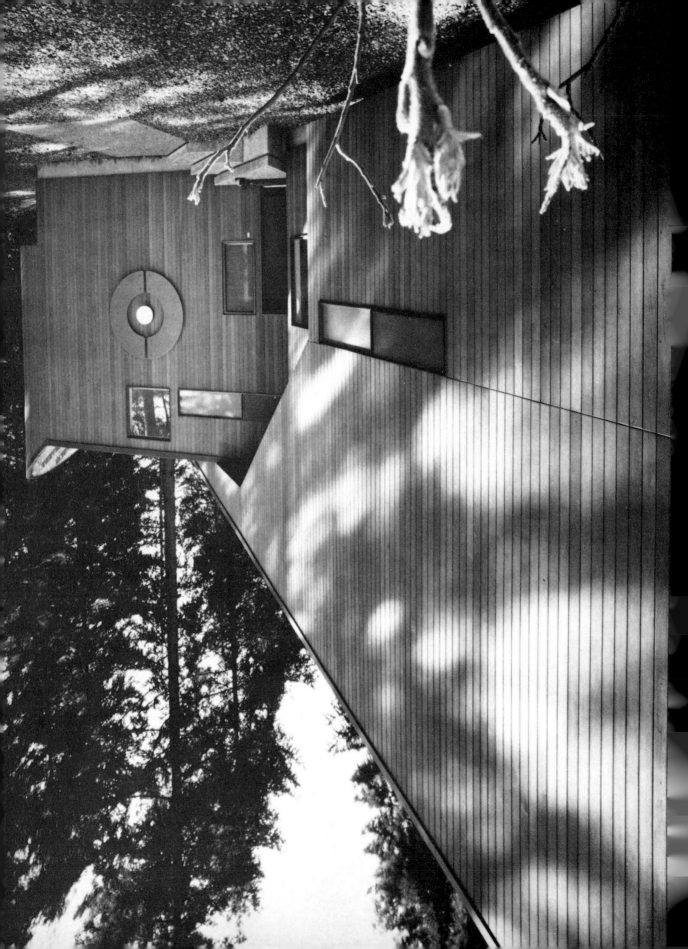

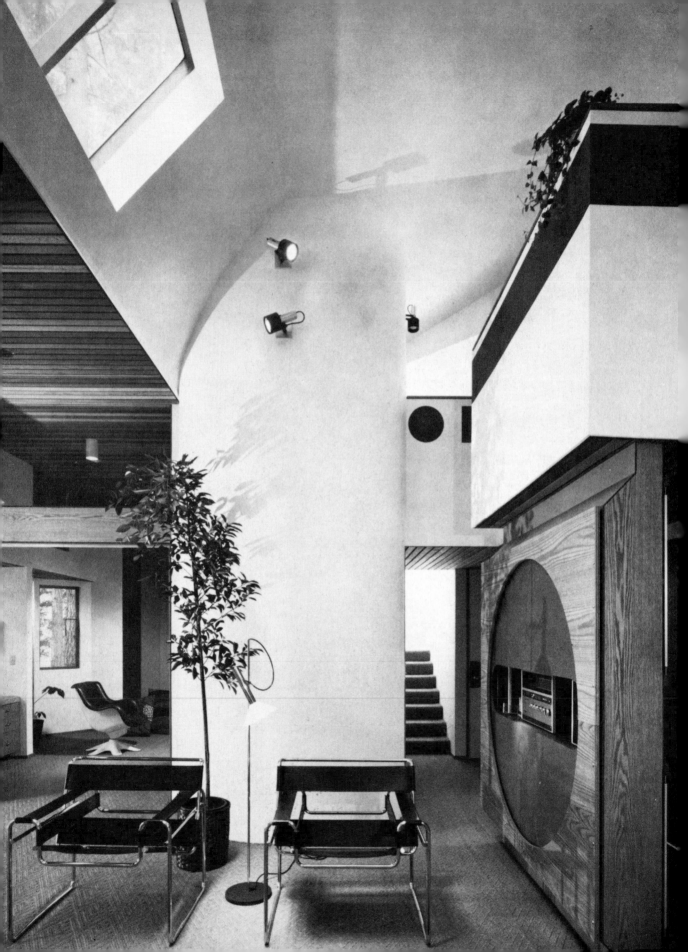

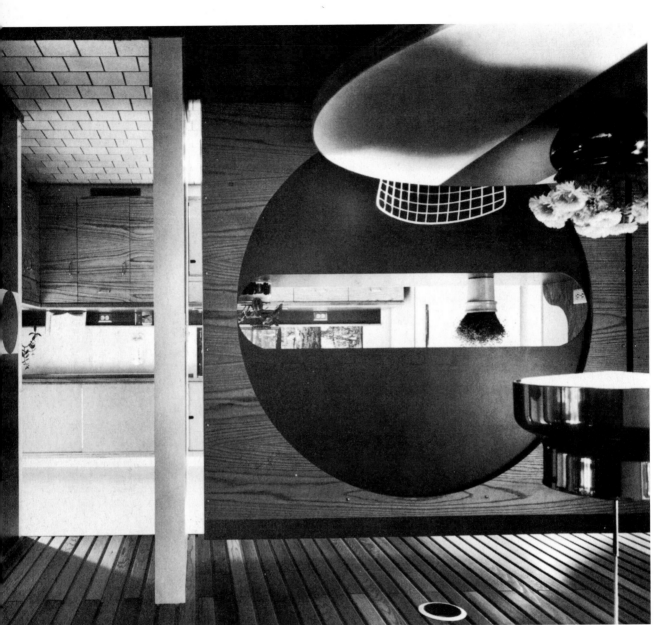

View from living area; to left, beyond folding doors, is a guest bedroom/study; the bathrooms are in the central cylindrical structure

Dining area; serving hatch and door to kitchen in the background

This brief was rendered mainly through spacial gestures. The composition of house, garage and utility link forms an entry 'harbour' for people and vehicles while the house itself, essentially triangular in plan, wedge-like in section, conveys a strong sense of containment and shelter. In contrast the principal circulating element, the sky-lit stair, projects assertively from under the sheltering form (Fig 113).

The house has a wooden frame of Douglas fir and hemlock, with plywood sheathing used structurally in several places. Vertical cedar siding is used for the whole exterior and on soffits and lower ceilings in the interior, while plaster board covers high ceilings and walls. Coir matting covers floors of principal spaces; a white, glazed quarry tile is used in kitchen, utility and bathrooms.

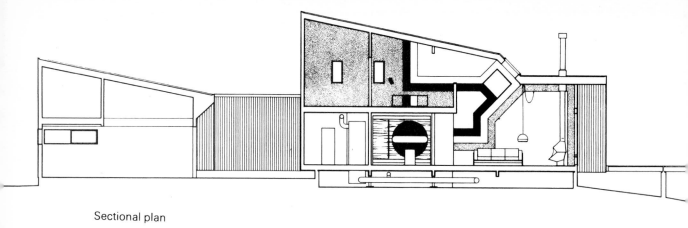

Sectional plan

Plan of house

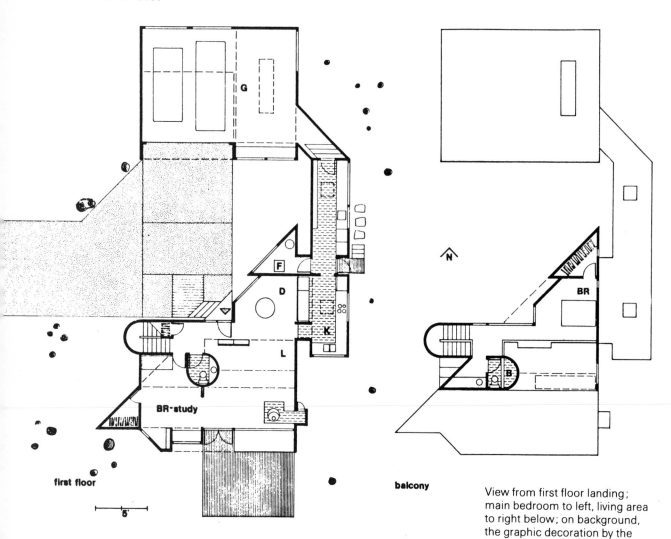

G

F

D

K

L

BR-study

first floor

5'

balcony

N

BR

B

View from first floor landing;
main bedroom to left, living area
to right below; on background,
the graphic decoration by the
English designer Alan Grainger is
carried on to the bedspread

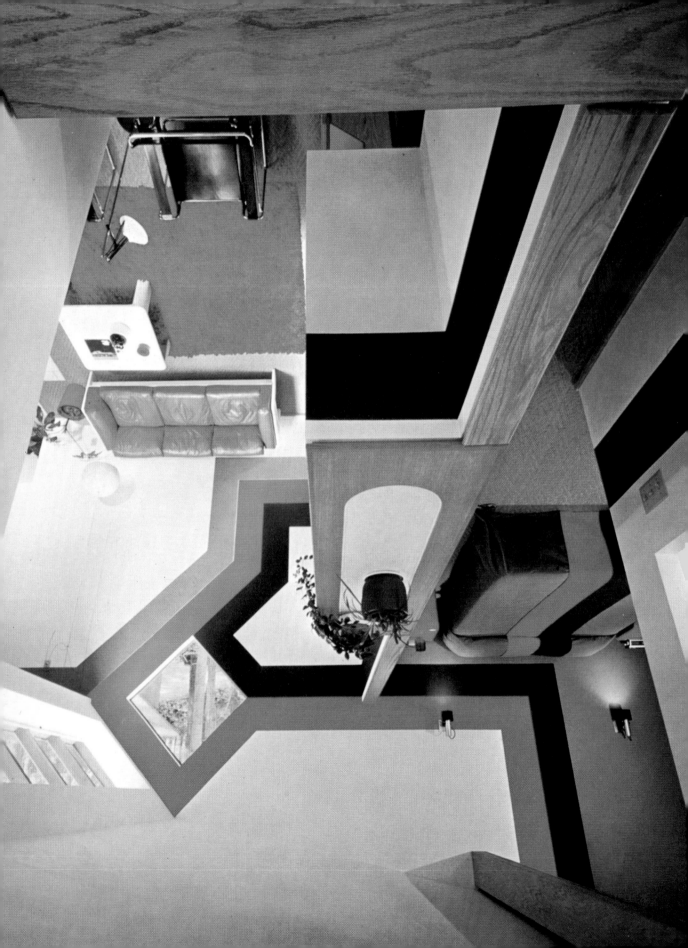

A Vacation House at Harbor Springs Michigan USA

Architects: William Kessler & Associates
Photography by Balthazar Korab

This year-round vacation house was designed on a site which faces west over Lake Michigan; it consisted of a small sand bowl surrounded by thickets of pine, spruce and birch trees. The house was designed to fill in the bowl and to echo the profile of the landscape which sweeps upwards from the water's edge to the tall trees behind. A desire to be in harmony with the natural setting without losing form and individual identity found expression in the architects' conception of an exceptionally well articulated and generous complex of communal and private interior spaces for the owners, their six children and their guests.

View looking south over primary sand dune to house

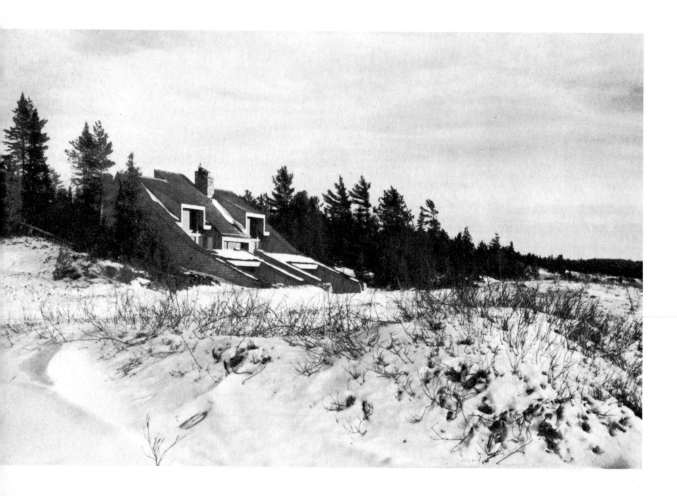

Site plan

Sectional plan

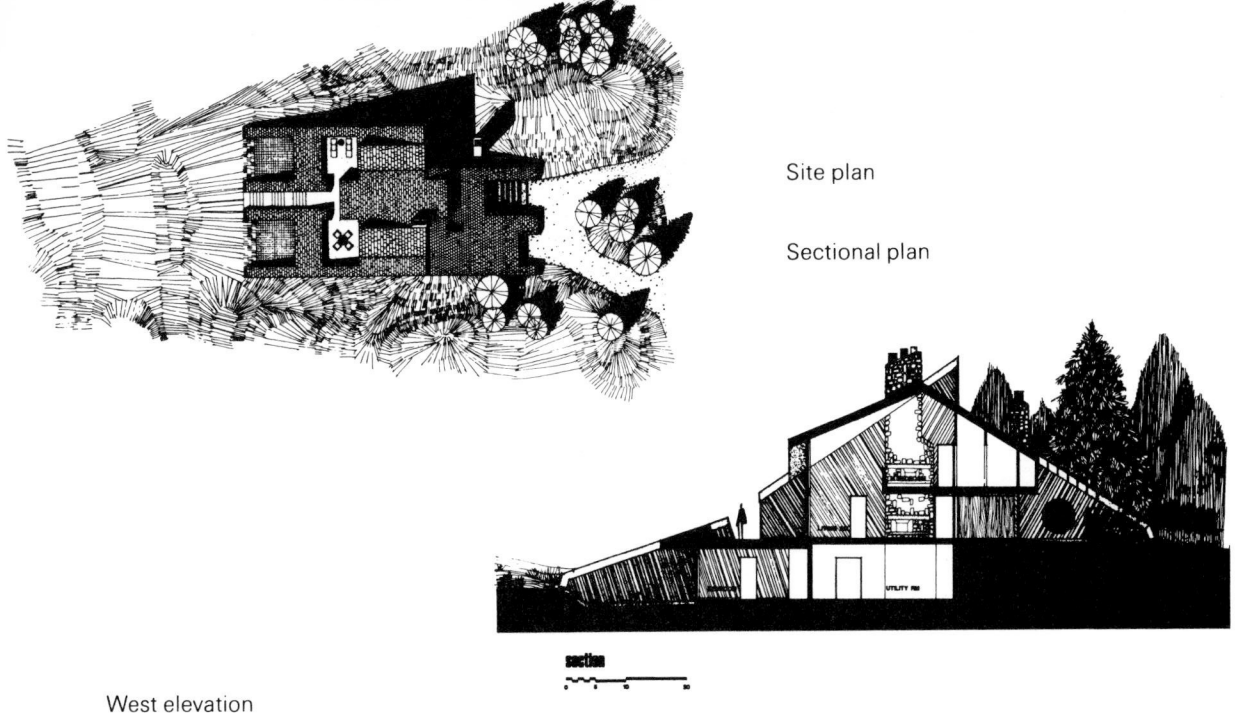

West elevation

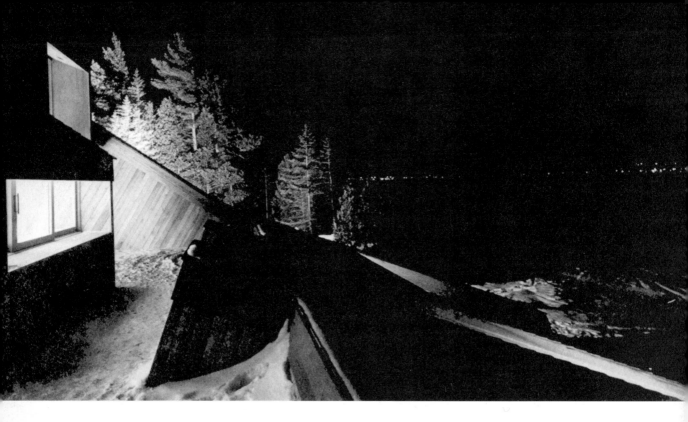

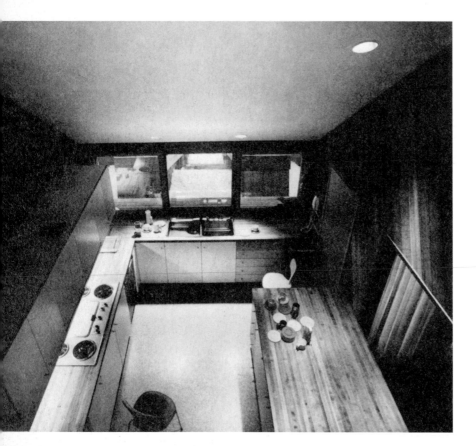

Night view showing balcony and windows off kitchen

Kitchen as seen from stair landing

Opposite
Activity room with guest room balcony at mid-level

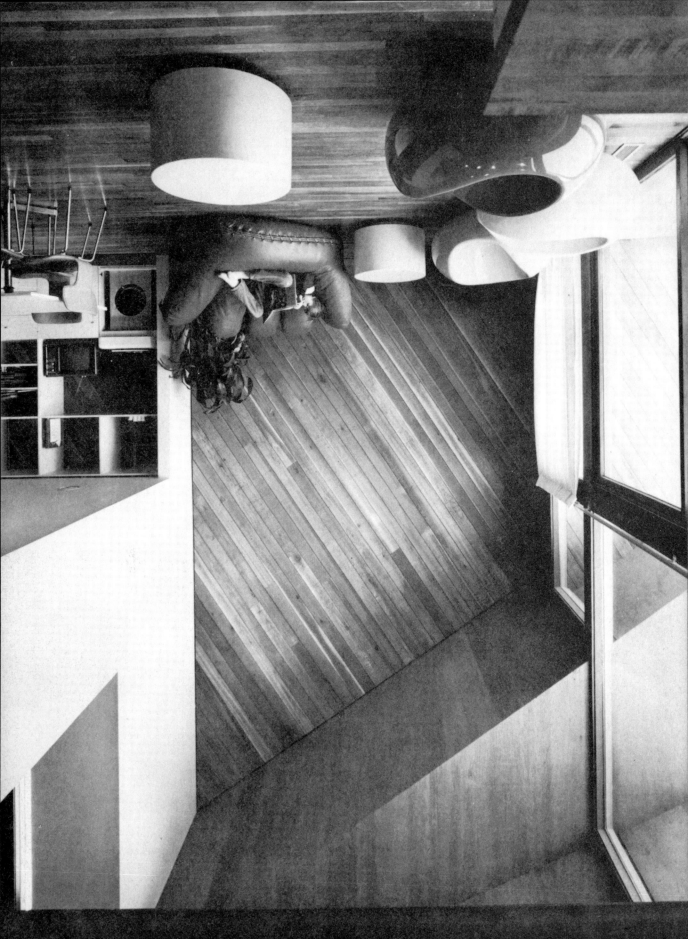

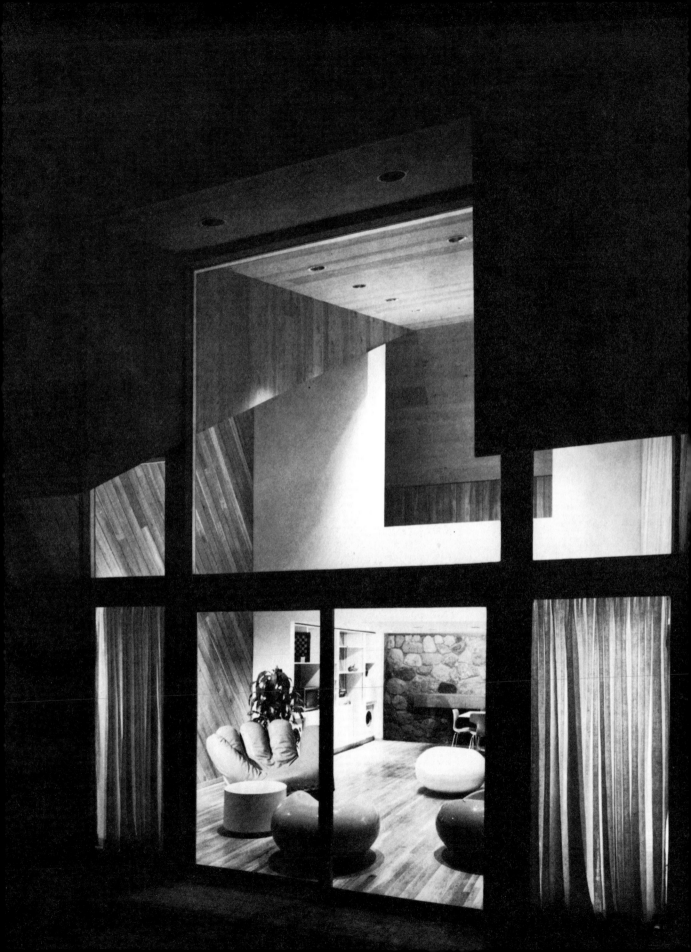

Opposite
Seating arrangement in activity room

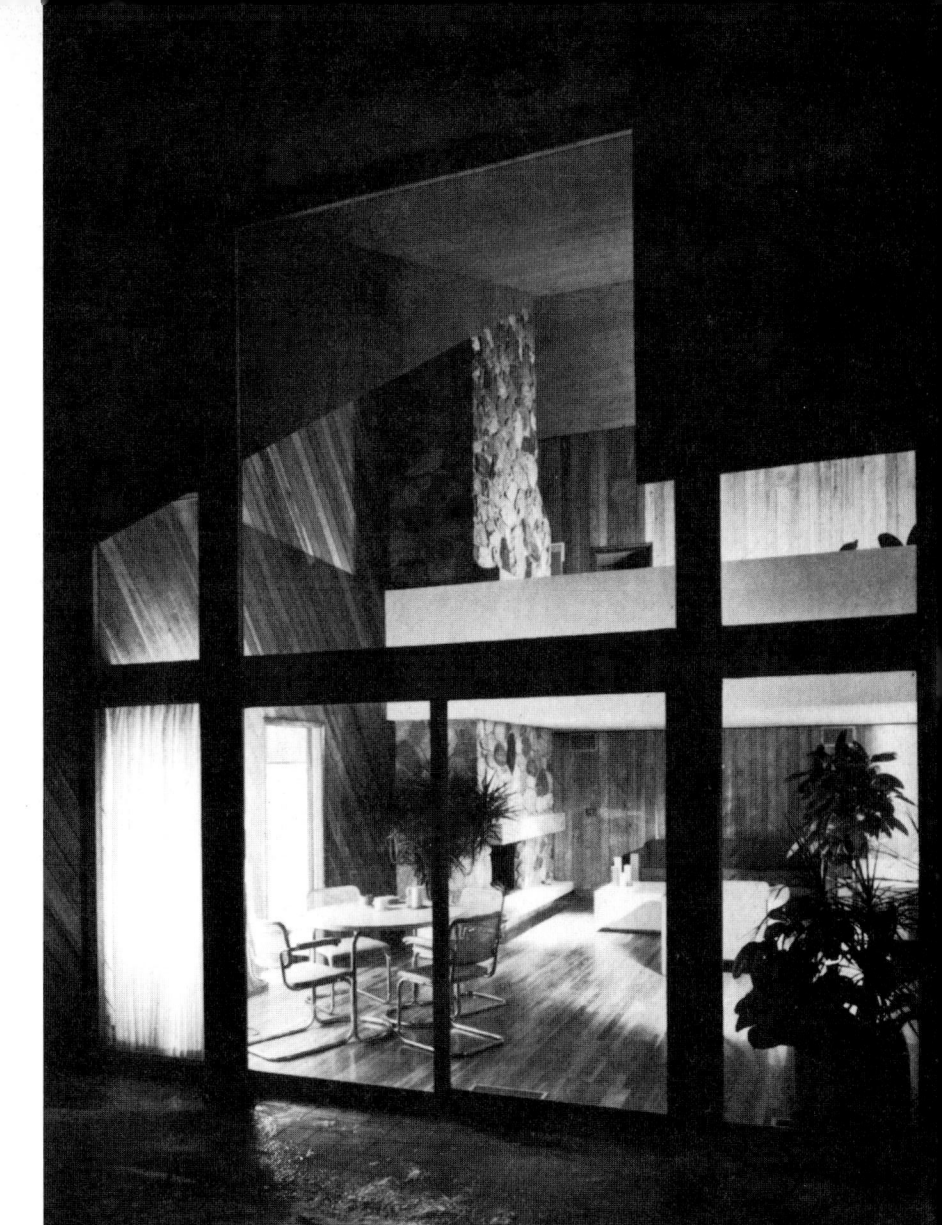

Dining/living room with main bedroom balcony at mid-level

The children's bedrooms (not shown) are dormitories placed on the lower floor with their own access to the beach. Above are the more public rooms; two living areas, a dining area, and a kitchen which is placed so that one can conveniently supply meals either indoors or outdoors. Special care was taken to give the occupants opportunities to enjoy the pleasures of the site and each other's company, while allowing individuals to retreat to their quarters for privacy by placing bedrooms on separate floors and by designing an open arrangement for the kitchen and the communal spaces. Materials were selected for their natural qualities and their ability to blend with the environment. Furniture used are standard available products. All built-in cabinets are custom designed.

General Plan

Kresge College in Santa Cruz
University of California

The University of California campuses are vast places: Berkeley has 27,000 students, Santa Barbara, among the smaller ones, counts as many as 9,000. Santa Cruz was conceived as a collection of individual colleges within a university campus, as a solution to the impersonal problem created by sheer number.

Kresge College was commissioned by a body comprising students and faculty members whose primary requirement was a non-institutional alternative to the usual classroom and residential designs often found in universities. State and Federal resources, plus

a gift from the Kresge family, provided funds for a residential college with accommodation for 325 of its 650 students.

The site, a densely wooded hill-top, overlooks Monterey Bay. Two sides are precipitous, the third slopes gently to the south. At the bottom of this slope a tight pedestrian street rises 45 ft from the access area (bottom left in plan) to the octagon at the top of the hill. The buildings arranged alongside the street have a central core flanked by an outer 'shell' punctured by a rhythmical sequence of irregular openings; this

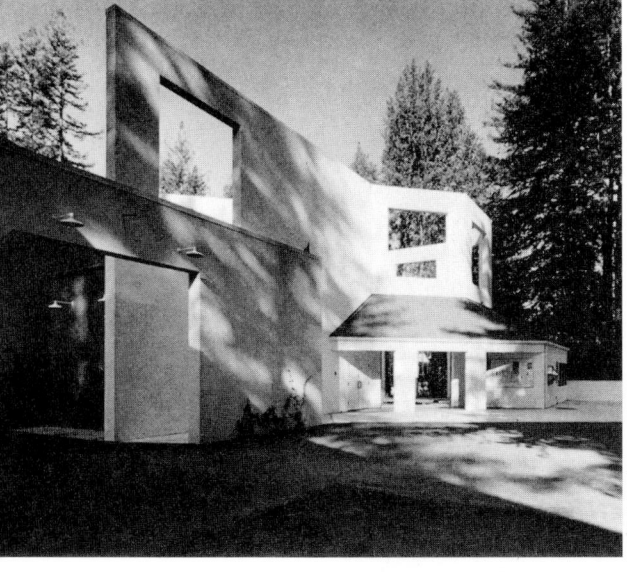

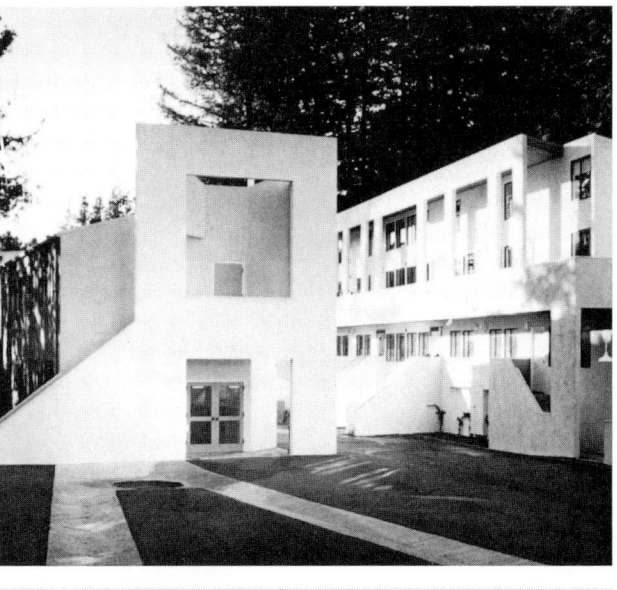

Main gate and commuter
student facilities

The laundry and, to the
right, a residential block

The middle courtyard, with
laundry to the left, dormitory in
centre and telephone arch
facing laundry

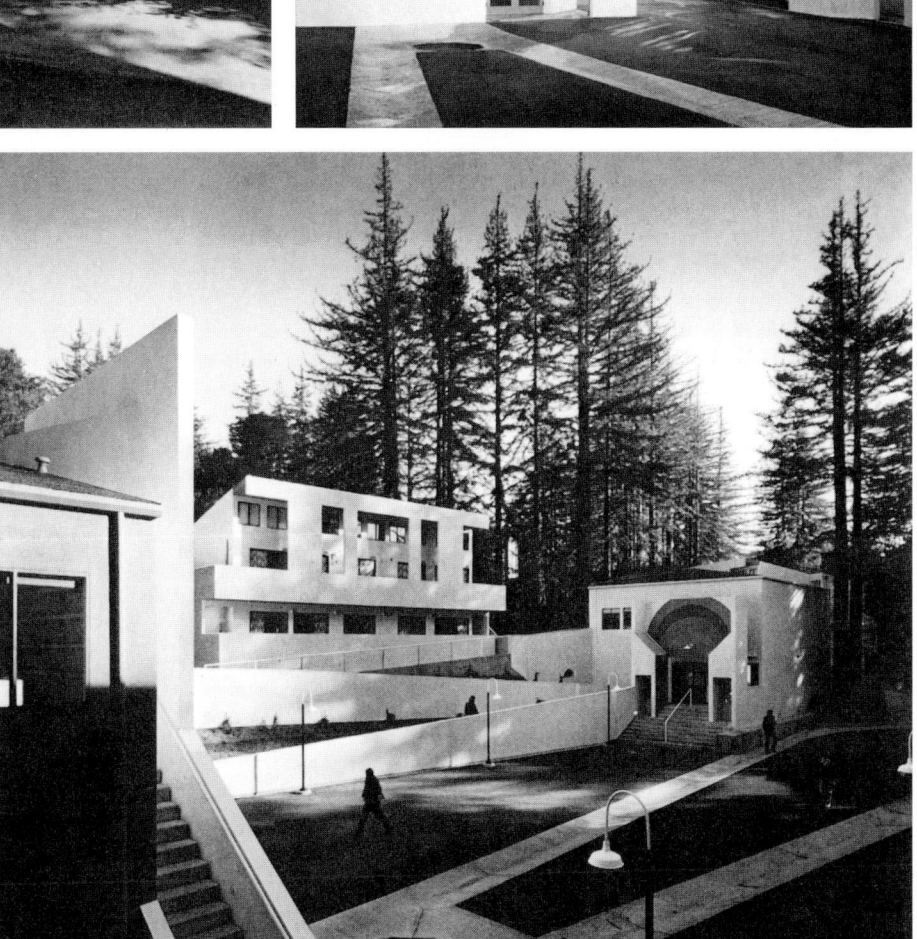

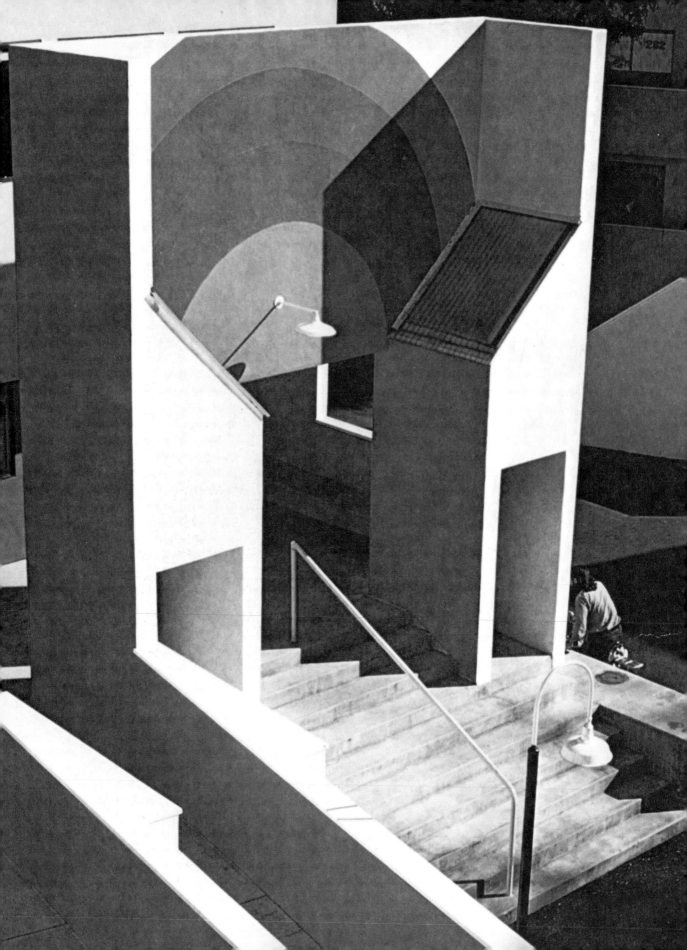

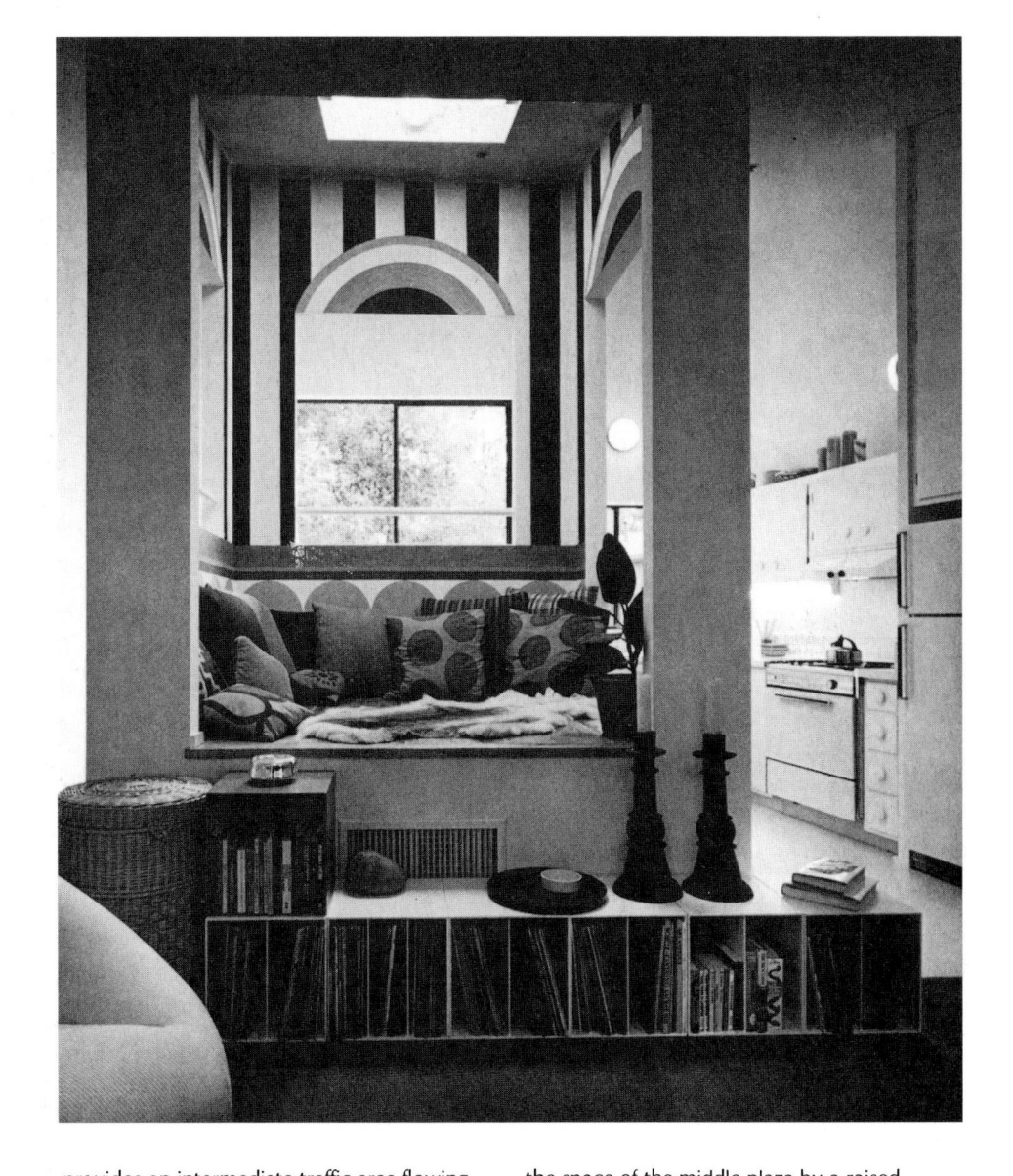

provides an intermediate traffic area flowing onto the street which thus becomes a centre for the college; a place where people meet as in the street of a Mediterranean village. This, the 'inside' of the college, is all white, though strikingly marked with primary colours to accentuate important landmarks. The exterior, on the forest side, is sienna brown. Structures for special functions act as markers in strategic positions along the street. The octagonal court at the upper end provides an entry to the town hall space and restaurant. The library has a two-storey gateway. The laundry, a symbolic town watering hole, is endowed with a triumphal arch, echoed across the space of the middle plaza by a raised podium, situated so as to conceal the trash box. Other important services, such as elephone booths, are emphasized as commentary on the importance of communications in student and faculty life.

The accommodation is planned in three different ways. The apartments contain a sleeping space for four people plus a combined kitchen, dining and living room. On the lower floor the sleeping space is divided into two double bedrooms facing out toward the privacy of the forest. The upper units have the advantage of extra ceiling height, and in these

The assembly hall

The fountain near the
cooperative store and coffee
house at topmost corner on
plan

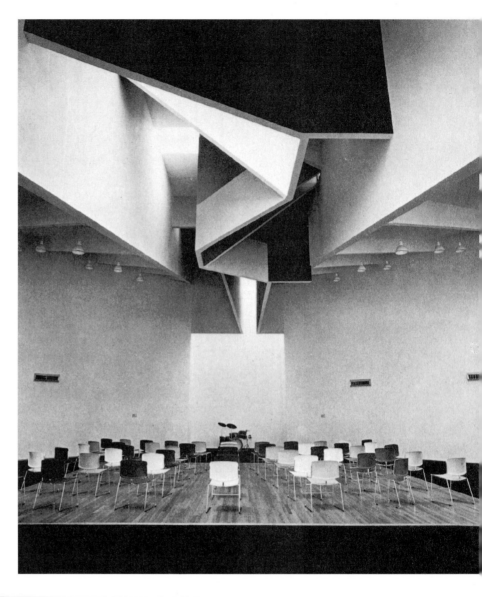

sleeping space is left for sub-division by the
occupant's furniture. These apartments provide
an answer to those who wish the more
unstructured life of off-campus living.

A second residential unit is the dormitory
suite. Two double rooms and four single rooms
are arranged along an exterior balcony, in
preference to the usual double-loaded corridor
systems. Entry to all rooms is from the street
side. Instead of combining all the student
common space into one or two rooms, each
dormitory has its own small living room and
kitchenette. The result is rather like a motel.

The last residential system was designed for
the more resourceful individual. Throughout
the University, students tend to move from
the campus to live in old Victorian houses in
downtown Santa Cruz or little redwood
summer shacks in the surrounding mountains.
Four units for eight people were built as an
'on campus' alternative. Each unit provides the
shell of the space, toilet facilities and kitchen.
The occupants, on moving in, decide on how
to subdivide the space and negotiate with
the University Fire Marshal for approval. They
are given materials (wood and sheetrock) and
use of the college tools to construct their
own living quarters. In choosing the furniture,

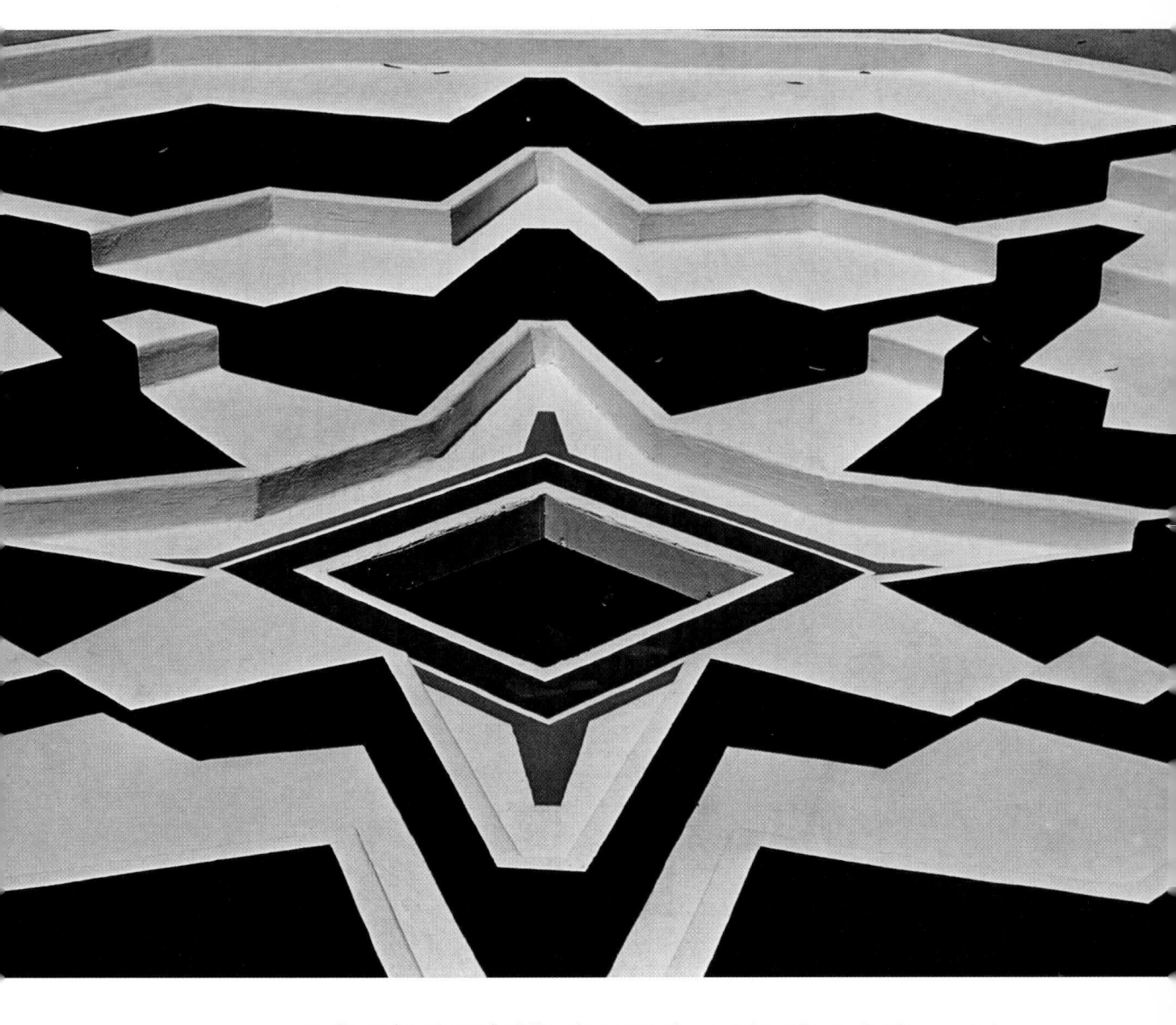

quality and maximum flexibility of use were of primary importance. The Finnish 'Palaset' plastic cube system, designed by Ristomatti Ratia, was eventually selected. Each student was given sixteen $13\frac{1}{2}''$ cubes, a desk top, a bed board, foam mattress and a director's chair, and left to his own resources.

Classroom furnishing ranges from the traditional to beech chairs on the floor or pillows on raised platforms. The student common became a 'crash pad' for commuters and the faculty common turned into a small formal living room for the entire college community. The library was looked upon as a space where one could

quietly read or work either at a desk or sprawled onto the floor. A fireplace provided an intimate focus and a large sunken bay looks out into the redwoods.

The effect of the college is one of an outdoor living room (the street) with the personal domain (student rooms) opening onto it. Semi-public spaces, classrooms, laundry, craft space, library, are extensions of the public street and are informal places for the exchange of ideas. Kresge's philosophy is that education takes place on all levels at all times and that stimulating environments are an asset to the process of learning.

Architect: Angelo Cortesi

Photography by Giovanna dal Magro and
Gianni Berengo-Gardin

Plan showing the
arrangement of the basic blocks

Outside view

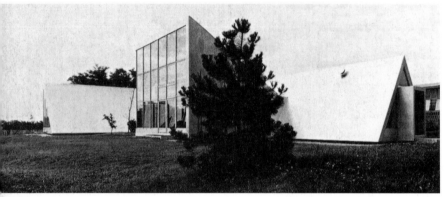

A Family House for a Doctor near Milan, Italy

There is a conceptual relationship between this house and Arata Isozaki's Museum in that its plan has an immediately recognizable geometrical formula. But the similarity ends there. In contrast with the Museum, where the cube frame is multiplied in accordance with its own rhythm, Cortesi's basic idea, binary in concept, is composed of a triangle and a rectangle. The juxtaposition of these two shapes intersecting each other, generating tensions that must be solved, leads eventually to a different type of harmony : a harmony through discord. The rectangular 'blocks' are cut on the slant, elevations have triangular sections; the conflicting shapes fuse together.

That Cortesi's idea should be embodied in a dwelling house is daring, since to express it fully, cold, unwielding materials had to be used inside and out; one does in effect flinch at the prospect of walking on a stainless steel floor. Yet a young doctor in general practice and his family live and work in this 'difficult' house on the outskirts of Milan. These primary forms that run into each other, then reassert their own identity, contain spaces that are unusual but undeniably stimulating. The large expanse of glass abolishes boundaries, introduces the landscape in the interior. Light creates unsuspected relationships. All tends to give the impression of a wider area than the

Plan of interior

1 Entrance
2 Gallery
3 Living
4 Surgery
5 Kitchen
6 Dining
7 Storage
8 Bedroom
9 Bathroom
10 Dressing room

View from the gallery; to
the left is the entrance door,
with living area beyond; to the
right is a wedge-shaped corner
nicknamed 'il pensatoio' (the
think-tank)

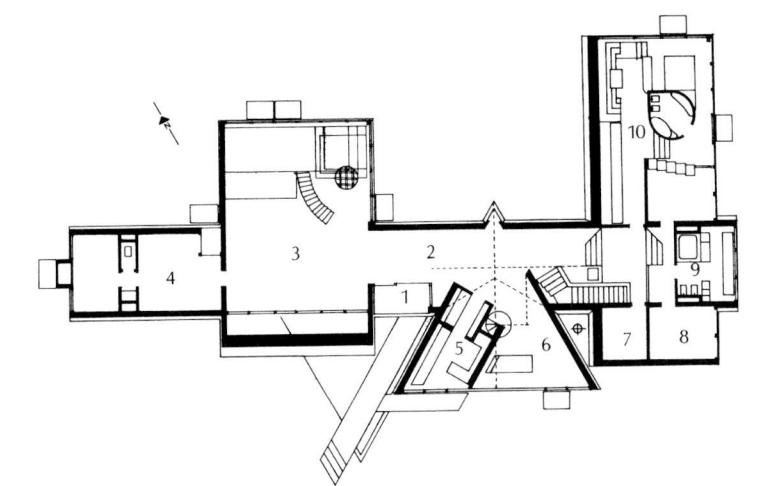

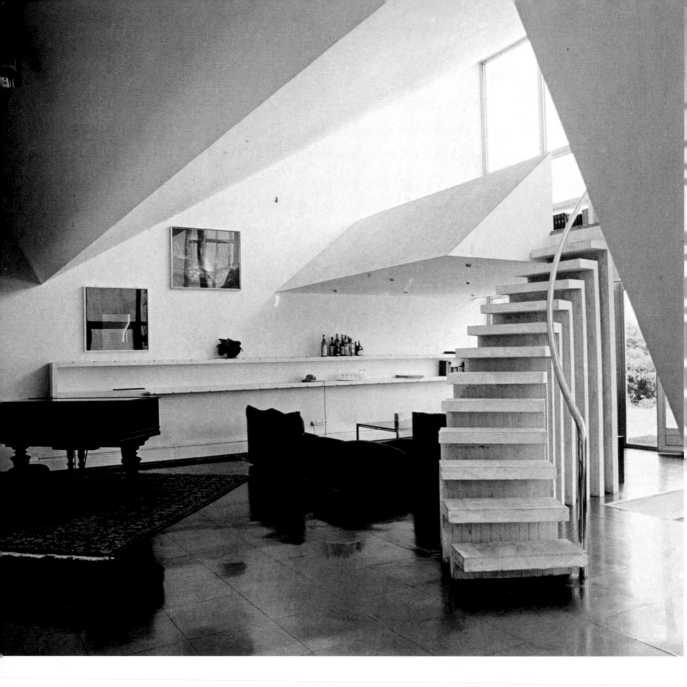

actual 300 sq m covered. Further, the logic of
this rigorous architectural idiom contains its
own reward in that it produces spaces of
unique character, 'adopted' by members of the
family as their preferred ones.

The house is planned as three main blocks
intersected by a long gallery that has an
independent waiting room and surgery at its
north-western end. A door leads to the wedge-
shaped living area on two levels; here the
north wall is entirely made of rectangular
panes of glass. The second block is an irregular
pyramid merging with the gallery; it faces
south with a triangular glazed front and contains

kitchen and dining area. The third block is
another wedge-shaped rectangle for the night
area. Although the gallery continues structurally
through this part, its presence is disguised by a
change in level that in one operation secures
privacy for the bedrooms, without an actual
separating wall, and provides underfloor
storage space. Furniture is mostly built-in,
designed by the architect. The main structure
is stainless steel on concrete block. Finishes
are white paint, plastic laminates, exposed
concrete slabs, stainless steel.

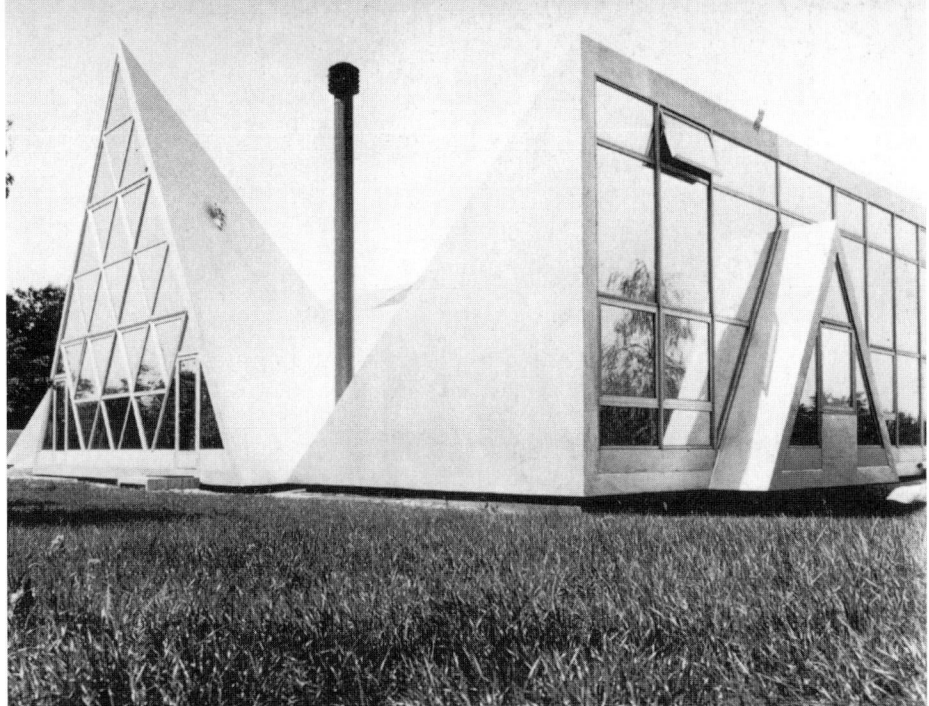

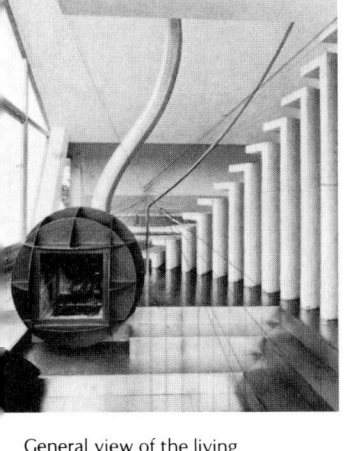

General view of the living area, with concrete steps leading to upper level

A corner in the living area; a segmented sphere fireplace, with its articulated steel flue, rests on a conversation pit under the upper level

Outside view; to the right is the bathroom wall, made of two-way mirror

Detail of bathroom.

Architects: Dufau et Briaudet
Interior Designer: Michel Boyer

Photography by Gerrard Guillat

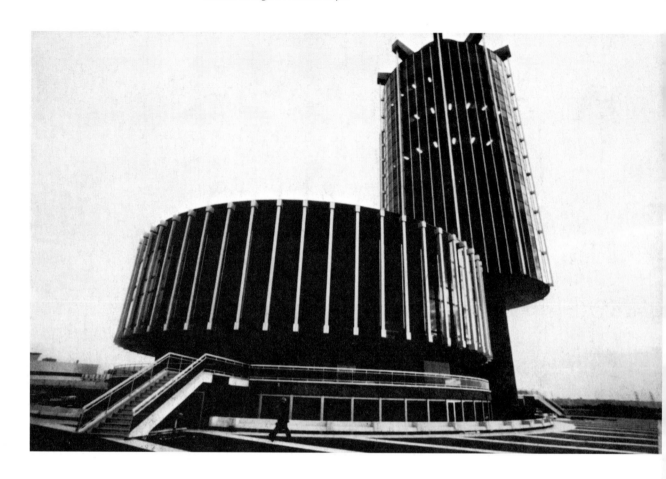

The Town Hall in Créteil, France

General view; the wide-
angle lens emphasizes the
round mass of the building

Créteil was, about thirty years ago, a rural
community of 12,000 inhabitants. It is today
part of a vast project of development in the
Paris region, realized by a team of urbanists,
architects, engineers, landscape and interior
designers, artists – a cooperation rarely found
on a more modest scale. The new town of
nearly 100,000 inhabitants is rapidly changing
into an important commercial and industrial
centre, with numerous factories; in the vicinity,
a landscaped regional park including an
artificial lake is being built.

The Town Hall is a distinctive landmark, with
its low circular building devoted to public
ceremonial spaces and the cylindrical tower
for the administrative offices. At the top of
this tower are the Mayor's private offices and
reception rooms.

In harmony with the general plan, radiating
from the centre, the interior design follows
the curving walls, adopts the circular shape
for the raised platforms of the ceremonial
rooms, the design of the suspended ceiling

The reception hall, at
ground floor level. The enquiry
desk rests on a large blue
circular carpet

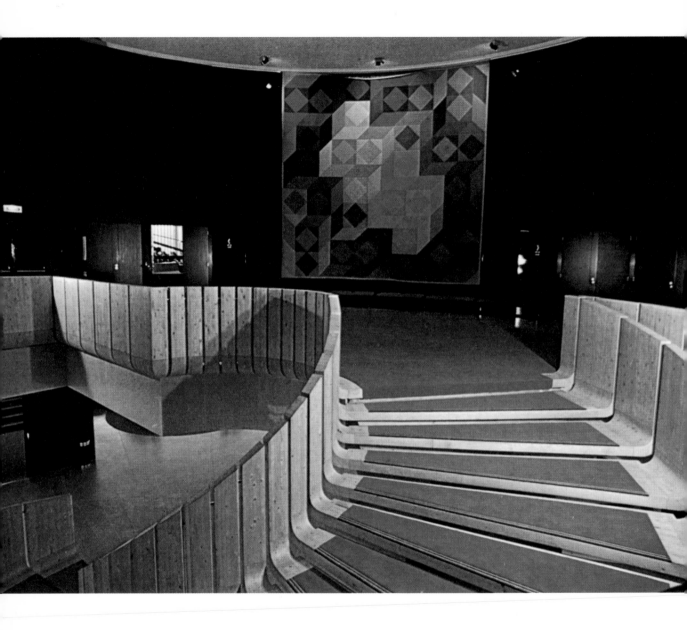

The stairs of laminated
wood, by Pierre Dufau,
leading
to the main reception hall
dominated by the tapestry
designed by Vasarely

and the fitted furniture in the Mayor's office.
Very subtle elements are however introduced
to avoid the monotony of reiteration; as an
example, the wooden wall panels in the
principal reception hall are stained matt and
lacquered black, with an effect of matt and
shining alternating areas. Focal points are
provided by numerous art pieces – a striking
hanging designed by Vasarely among them.
Large murals and decorative panels on sliding
doors by the painter Jean-Paul Derive
contribute dynamism to these opulent,
though generally neutral spaces.

Overall view of
Wedding Hall and detail
showing the Mayor's desk.

Exterior view

A Studio for a Sculptor in Tokyo, Japan

When planning this building the architect followed two guidelines. The first reflected his belief that the environment should become an active, working factor in relation to the new building. In this case the environment consists of crowded wooden houses, typical of a Japanese residential area, and nearby there is a railway. Paradoxically, in trying to apply his convictions to the interior, the architect used glass extensively so as to invite the outer view, and even the noise of passing electric trains, directly into the rooms.

The second factor was the architect's long-

nurtured concept of the 'box in a box' shape. Here one solid cubic box is contained by a larger, transparent, cube. The building is the studio of a sculptor as well as a gallery, so the inner shape has been devised for the display of art pieces and for work sessions. Occasionall the whole space becomes a salon for receiving friends and associates.

As an architectural idea this project is very exciting and should work well; provided of course that the social problems deriving from living in a glass house surrounded by wooden ones could be solved equally well.

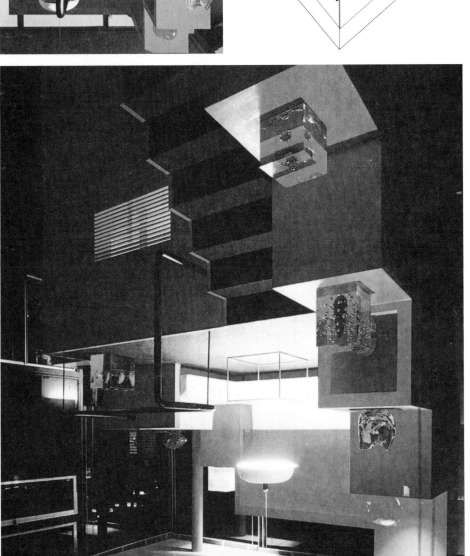

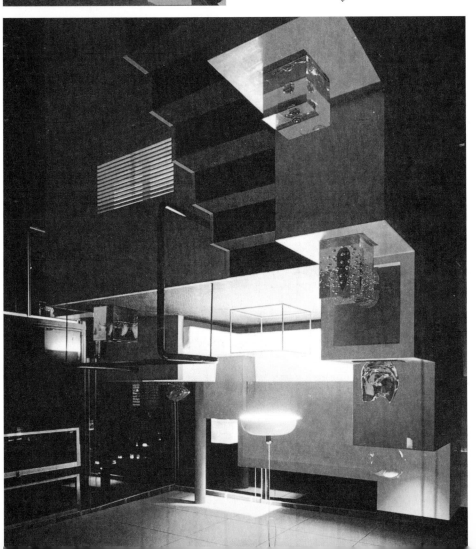

Interior, upper level

Isometric plan

Detail of display area

Ground plan

1 Entrance
2 Kitchen
3 Bathroom
4 Studio/office

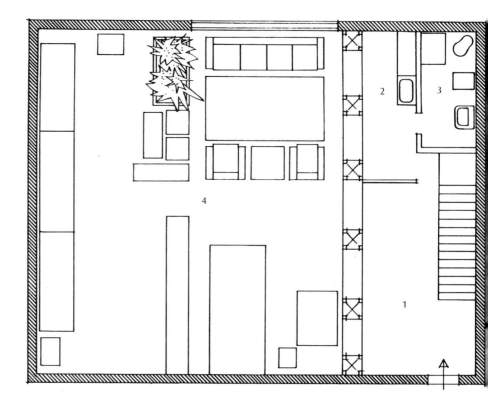

Studio for a Stage Designer in Rome, Italy

The steel structure; to the left, the mirror on the kitchen partition reflects the entrance door

The pleasing proportions of this century-old building allowed ample freedom of scope to an imaginative architect such as Pier Luigi Pizzi, who is also a stage designer. Located in that extraordinary area of Rome included between Piazza del Popolo and via del Babuino, this 8m × 10m × 8m cube was, a century ago, a studio for a sculptor and ceramist; then it was used as a ballet school. When the present owner found it he felt that his painstaking search for a studio of his own had come to an end. He was yet to enjoy an added bonus when the demolition of a badly damaged ceiling revealed the original roof beams and a very valuable skylight. This discovery gave Pizzi the idea of juxtaposing a stainless steel

grid, the shape that expresses so well much of the architecture of our time, to the splendid 19th century exposed wooden beams. Once this starting point was decided, the entire solution came as if of its own accord.

A steel structure, occupying one third of the whole width of the floor space, incorporates entrance hall, small kitchen, bathroom, and stairs leading to a rest area 3.50m above ground. A mirror covering the kitchen partition reflects the pattern of the grid, and adds both interest and visual depth. The remaining area is left open, with furniture arranged so as to define different areas of use. A writing table, drawing board and a large

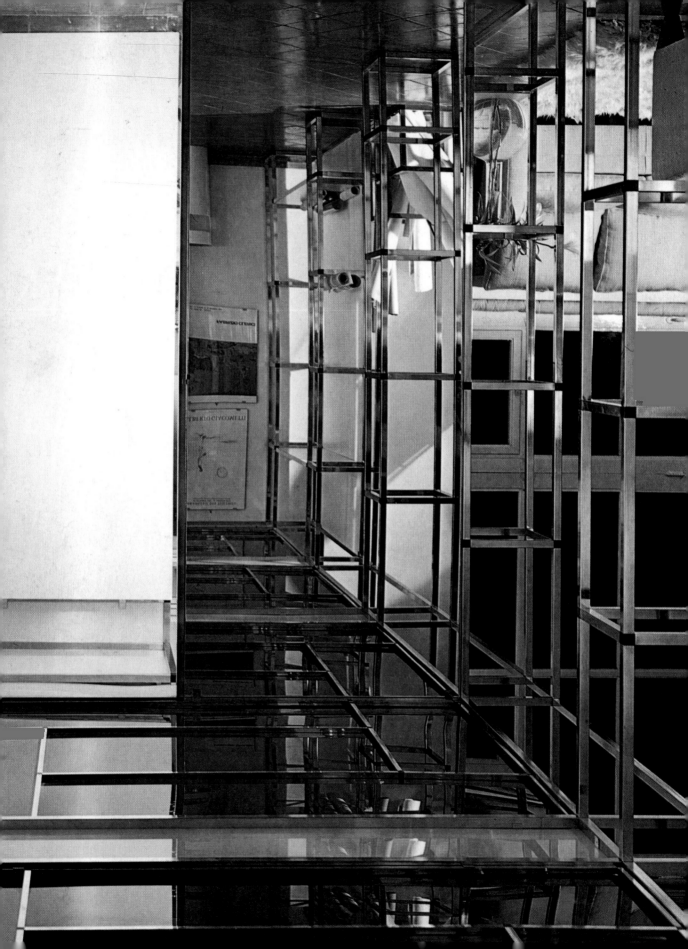

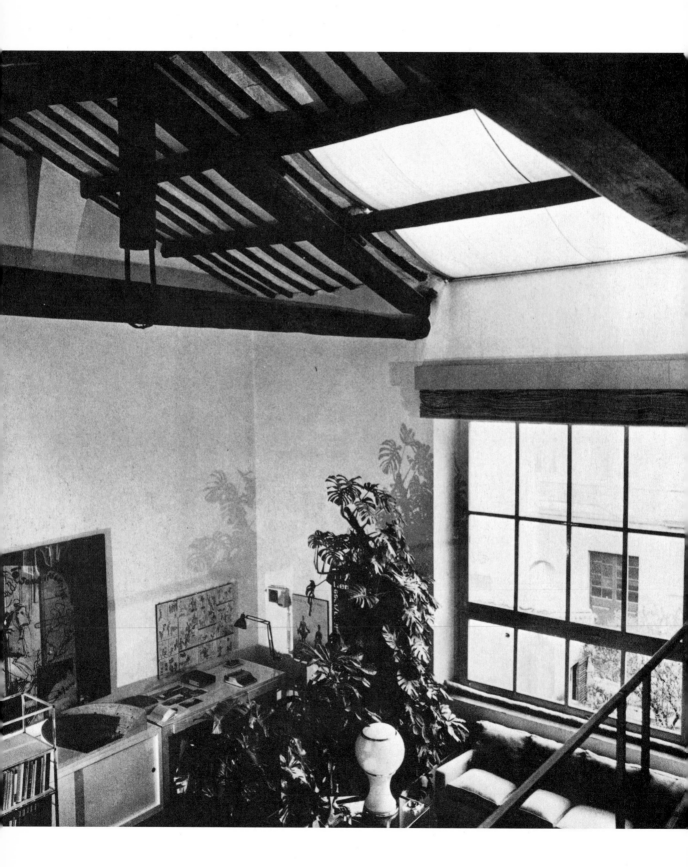

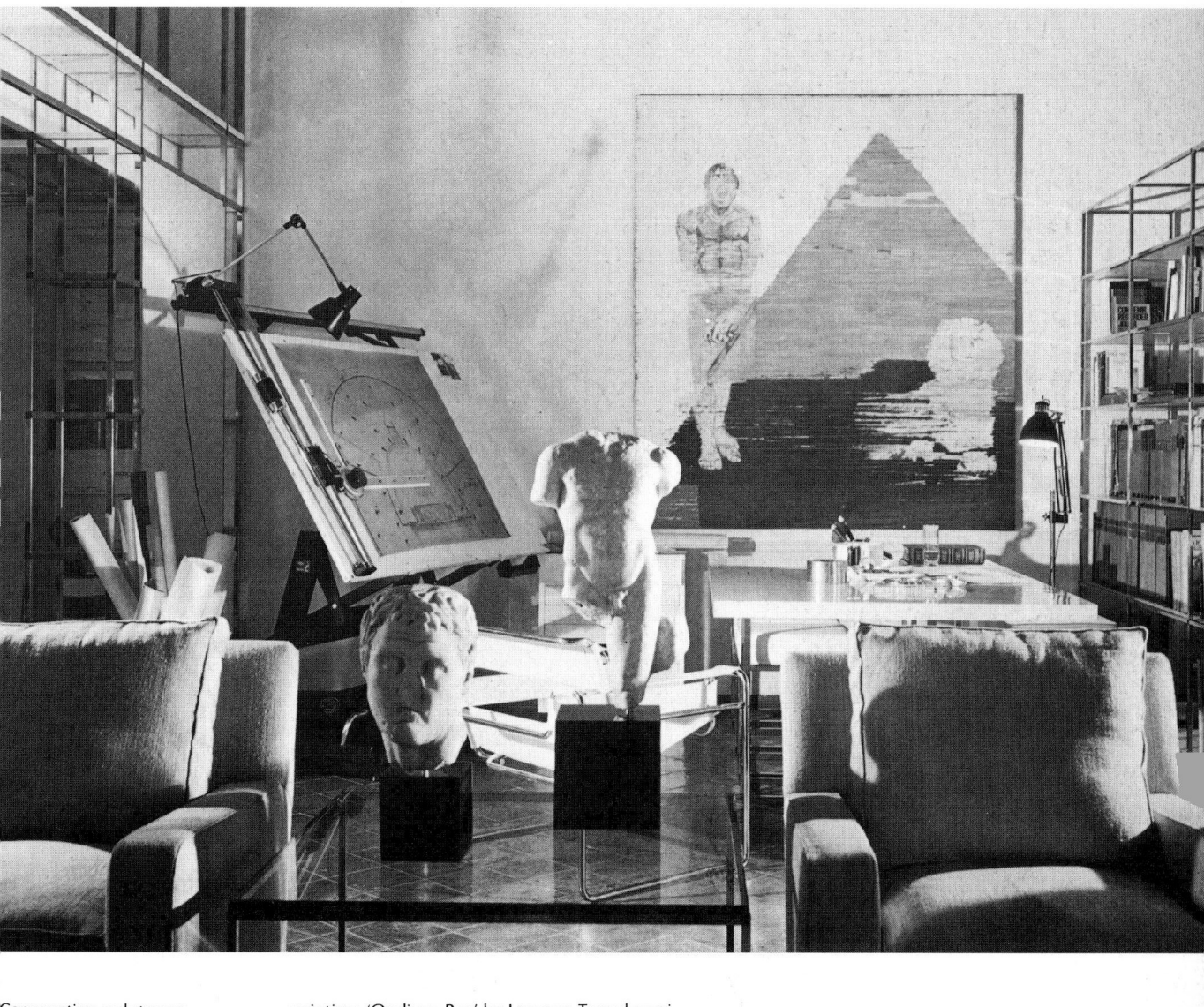

Conversation and storage
area as seen from the rest area
above

Study area as seen from
conversation area

Overpage

An overall view of the
studio from the rest area

painting, 'Oedipus Rex' by Lorenzo Tornabuoni,
for the study. The conversation area has simple,
unassuming armchair units, but on a glass
and steel table rest a head of Parian marble
(Greek art of 1st century BC) and a Roman
copy of a Greek torso (1st century AD). On the
wall facing the steel grid there is another
painting, by Mario Schifano. Steel and glass
bookshelves and a trough of green plants
partly hide the longe range of fitted filing
cabinets. White paint on the walls and the
original terracotta tiles on the floor harmonize
with the colour and texture of the roof beams,
emphasizing the simple elegance of this
outstanding conversion.

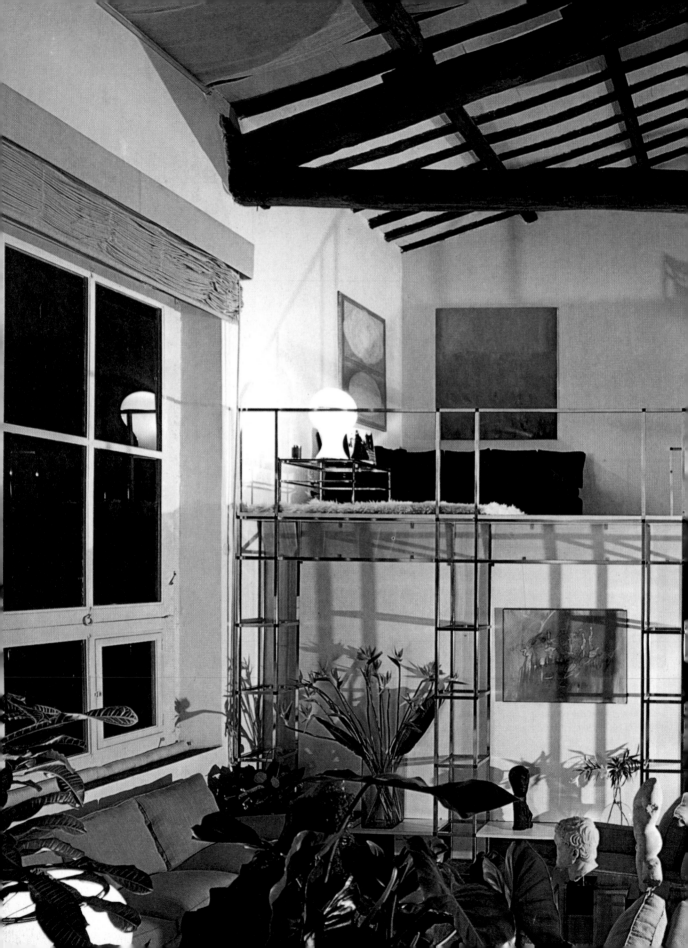

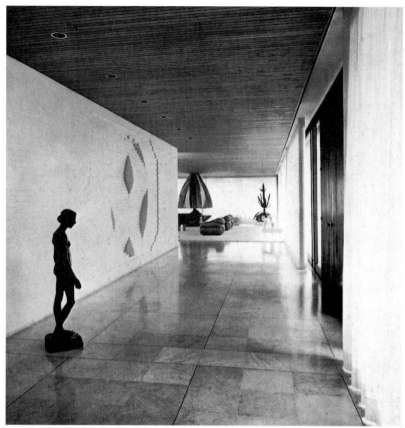

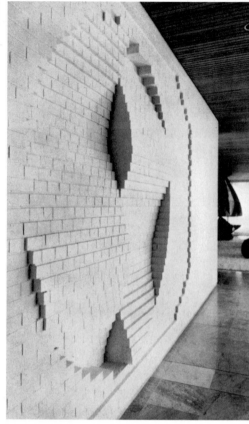

The Official Residence for the Prefect of the Essonne, France

Entrance hall, facing the
door is the brick mural by
Thomas Gleb

Detail of mural

The formal reception wing in the residence of one of France's chief civil administrators is L-shaped, with walls mainly of glass supported by slender concrete pillars. The basic structure demanded an open plan arrangement for the interior, with minimal brickwork to define private areas. A subtle interplay of different textures was essential to the scheme, to counteract both 'hard edge' materials such as glass, concrete, highly polished white marble, and the bleaching effect of stark daylight.

The designer kept the brickwork in evidence, but painted it white to exclude any 'rustic' undertones, which in this case would be

totally out of place. Just in front of the entrance, an integrated mural by Thomas Gleb exploits the pattern of brickwork and gives movement to the inner wall. The main reception is sub-divided by two large swivelling doors separating dining from conversation area. The dining room is dominated by the table, composed of square units of stainless steel which can be added to each other to accommodate up to 32 guests. The formal severity of this space is tempered by a large, thick white carpet and by the long and narrow trough containing a miniature indoor garden.

In the entertainment area light is controlled

Looking from conversation to dining area; the two spaces can be completely separated by two swivelling doors

by white curtains of Tergal and raw silk, which cover the entire glass walls, and by numerous dimmer-controlled lights set above the suspended ceiling of blonde Oregon pine. Here again, thick white carpets contrast with polished marble floor and with the steel and plate glass circular nests of tables. The only colour in the furnishing is given by the brandy-coloured leather covering sofas and armchairs. At the extreme end of the room, flanked by two long seats of natural leather, is the stainless steel open fireplace designed by the sculptor Philolaos. Its graceful convoluted form epitomizes the character of the whole scheme: direct, simple, yet supremely elegant.

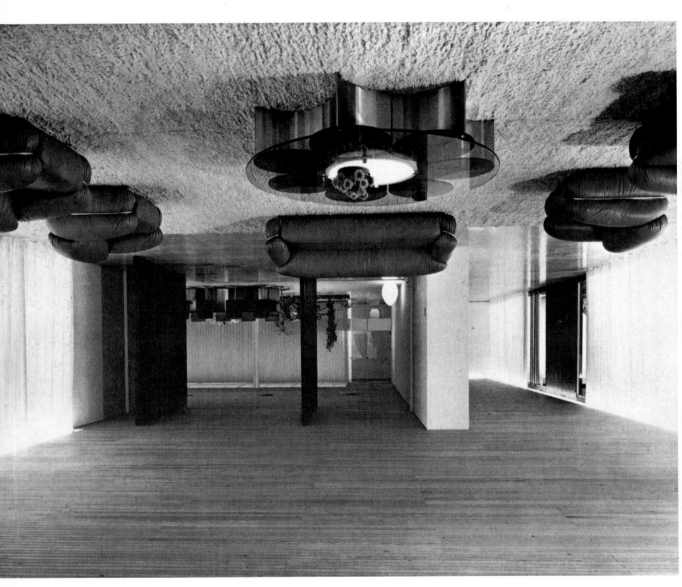

The modular dinner table,
a design by Pierre Guariche

Overall view of the
conversation space; the glass
and steel nest of tables is by the
designer, Pierre Guariche. In the
background can be seen the
steel fireplace by Philolaos

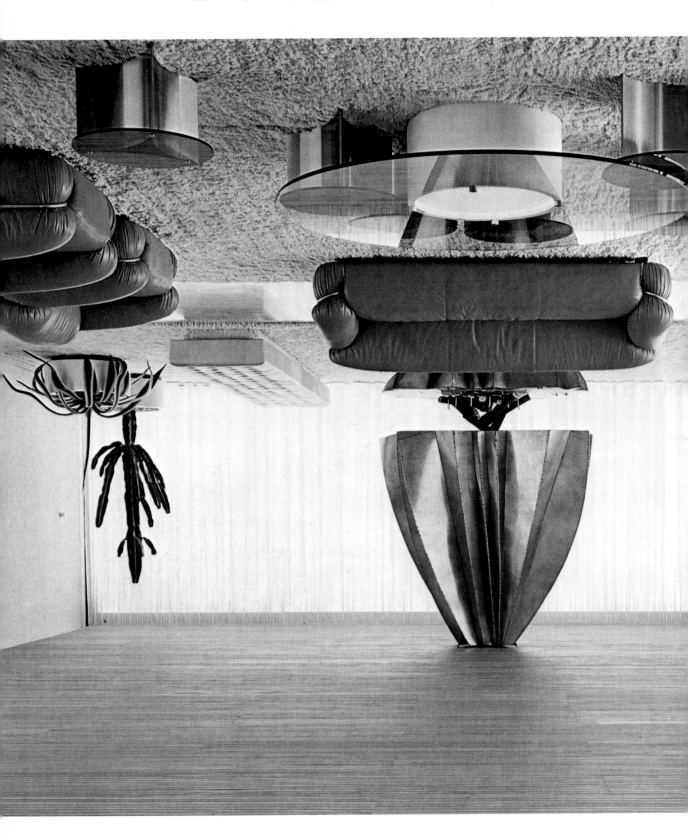

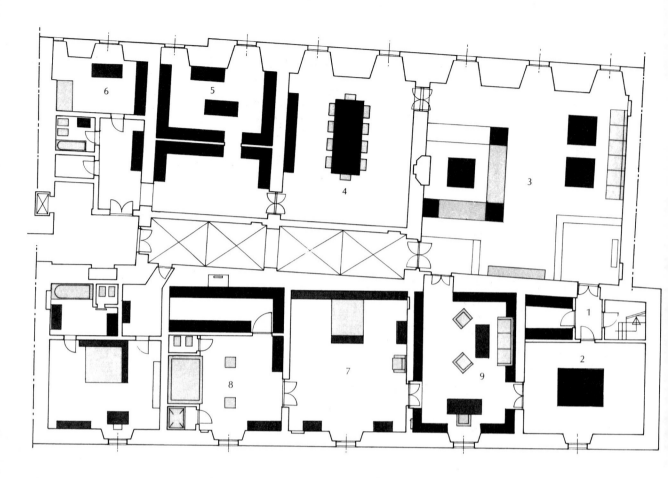

Plan

1 Entrance/gallery
2 Hall
3 Reception
4 Dining
5 Kitchen
6 Staff accommodation
7 Bedroom
8 Bathroom
9 Study

An Apartment for a Collector of Modern Art in Rome, Italy

The entrance gallery; on left foreground a Perspex sculpture, on the right a painting by Canaletto, in the background a sculpture by Trouva. Through the open door can be seen the reception room

The apartment occupies a wing of a 17th century palace, an important example of Roman Baroque architecture. This fact alone would tax the proven ability of any architect called upon to create an environment that would express trends, inclinations, the life of our times without losing sight of the grandiose scale of the Baroque setting. In this case the apartment is also the home of one of the most impressive collections of American modern art to be found in Europe. Nearly all contemporary artists are represented: works by Stella, Warhol, Wesselmann, Motherwell, Dine, are in every

room; they become part of the life of the house.

Whether the original architecture was left intact, as in the magnificent entrance hall, or whether spaces have been moulded into modern proportions by changes in floor levels, use of partitions, or by suspended ceilings, one is always aware of a breadth of vision that communicates to a seemingly unemotional interaction of architectural volumes a powerful, majestic rhythm. This is due to a felicitous combination of an infallible perception of space, an acute sensitivity to new materials

The dining room; on the
back wall a painting by Frank
Stella, to the right a piece by
Vasarely and to the left a 1963
painting by Tom Wesselmann.
The dining table is a design by
Beverly Pepper

Pages 254/255
The reception room as
seen from the conversation pit.
In the background, a painting by
Robert Motherwell is flanked by
two 18th century Venetian
sculptures. To the right, a piece
by Louise Nevelson

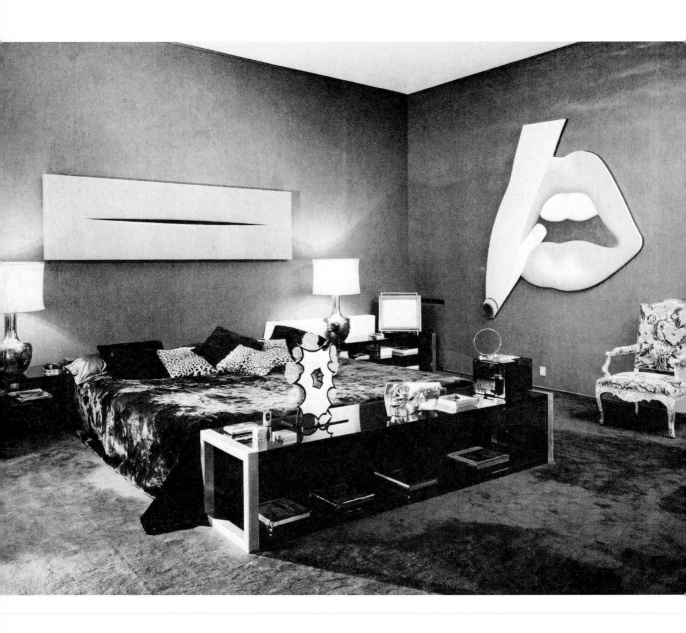

and colours and, above all, to a passionate love for art.

Walls and ceilings are white and glossy, reflections blur the boundaries of walls, reduced in size to harmonize with the scale of modern art pieces. The subtle arrangement of light is intended to create the exact atmosphere, never to project a crude spotlight on a particular painting or sculpture. A uniform, sand-coloured carpet covers reception and dining room floors – a subdued, soft texture contrasting with the polychromatic

marbles of the palatial hall. The doors between these rooms are by Jean Claude Fahi; made of brown Perspex with a sculpted motif of multilayered iridescent lamination, they seem to gather all the colours of the rainbow, and are works of art in their own right. The dining table of brown lacquer rests on an iron base designed by Beverly Pepper, the dining armchairs of brown suède and lacquered metal were especially designed by the architects. In this room striking multicolour light effects are produced by luminous bands running along floor and ceiling.

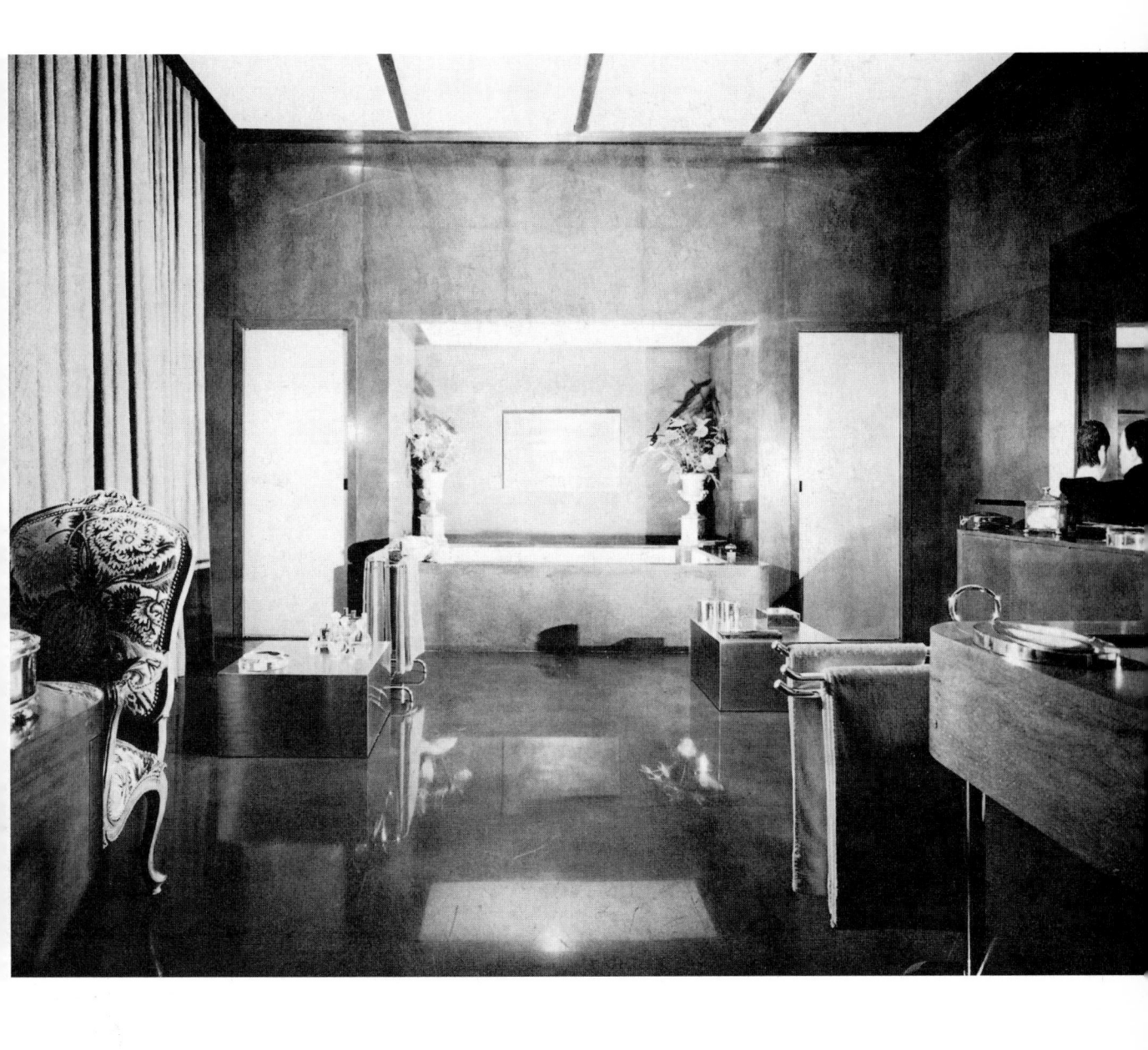

The master bedroom

The bathroom

The master bedroom is in various tonalities of brown, with light touches of white and yellow. On the walls, 'Mouth with Cigarette' by Tom Wesselmann and 'Red Cut' by Fontana. Adjacent to the bedroom is a vast bathroom of basaltic stone and steel. On the slate grey background, accents of vivid crimson and gold suggest an atmosphere of sumptuousness; unexpectedly in such surroundings, a Louis XV armchair with petit-point tapestry faces a piece by Michelangelo Pistoletto, 'Trompe l'Oeil'.

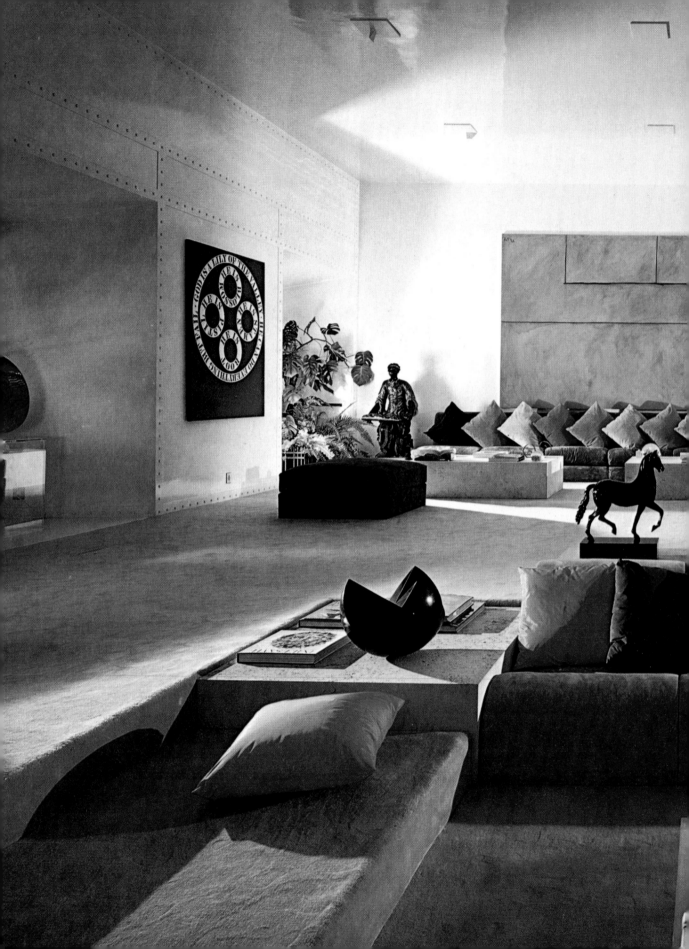

Architect: Arata Isozaki

Photography by Osamu Murai and Kuniharu Sakumoto

General view across the lawn from the Monroe Gate, whose shape is a symbolic celebration of the actress Marilyn Monroe

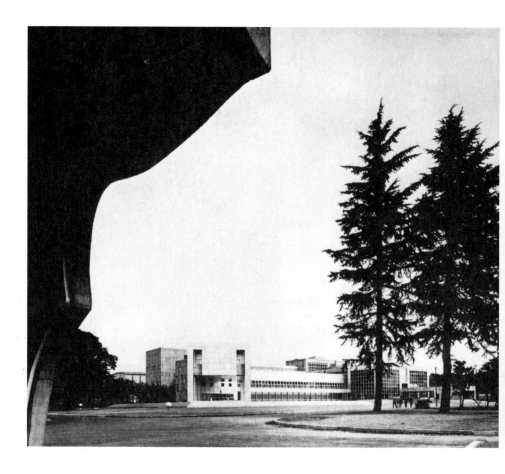

The Gumma Prefectural Museum of Modern Art in Takasaki, Japan

Arata Isozaki described the Gumma Prefectural Museum of Modern Art as 'cubic frames placed beyond a flat lawn as if they were thrown at random'. And this is exactly what the basic structure appears to be. But one must proceed further. The shadows cast by the cubic frames suggest the infinite aesthetic possibilities afforded by inserting more cubes of the same size into the existing ones, and symbolize the principle governing the expanding space. 'Cubic form is not only simple and clear,' continues Arata Isozaki, 'but is also the ultimate in terms of three-dimensional space, an absolute

form. It is coherent with the rigid-joint steel frame structure which supports from within the entire heritage of modern architecture since Louis Sullivan's time. Like the Greek order, the Roman arch, and the dome of the Renaissance, it is closely related to the style of the times with its proven universality. As an ornament, in this sense, the cubic frames adopted in the plan of this Museum emphasize its monumentality.

However, the nature of a Museum of Modern Art must need be ambivalent. One of its sections is used for the exhibition of the

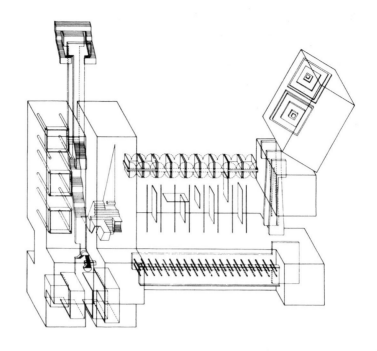

Basic structure

Supplemental structure

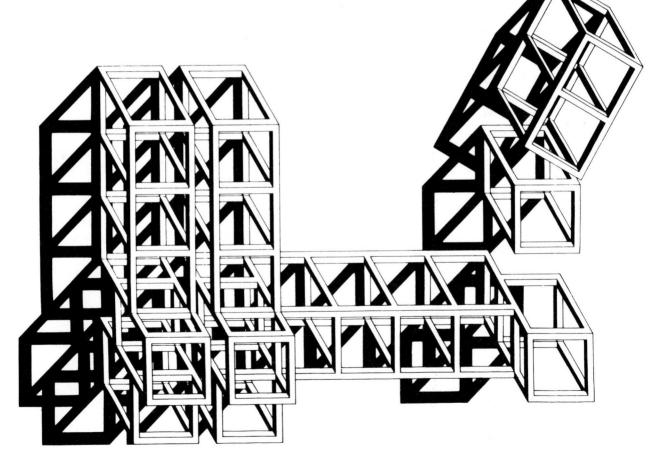

An angled view of main
staircase showing the effect of
reflection on highly polished
surfaces

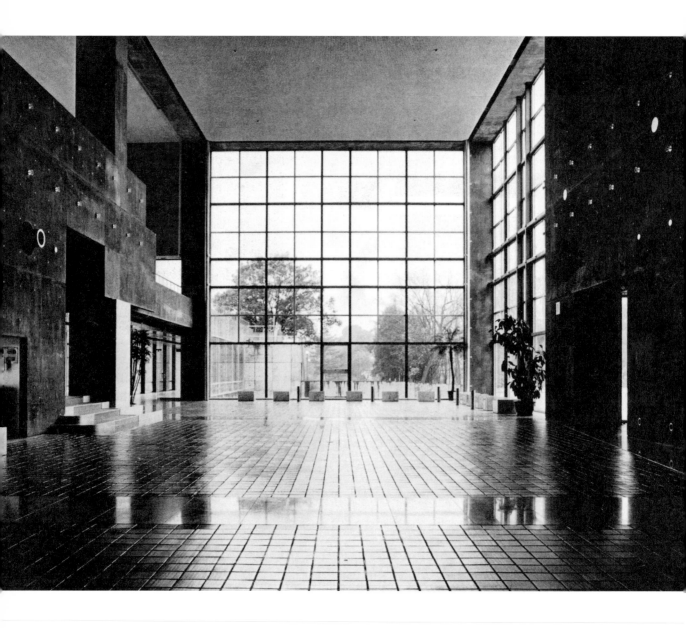

Main entrance hall as
seen from stairs to upper
gallery

permanent modern art collection, the other is
only a temporary abode for works of art
which, with frames and pedestals, are moving
throughout the world. In the first instance it is
possible to design the exhibition hall according
to its contents. One can create areas of
darkness with artificial lighting, or the skylight
can be used to dramatize impact. But a space
meant to exhibit ever changing, unpredictable
collections of objects, should be as neutral as
possible. Ideally, walls and ceilings should
become an even source of indirect light; then
the shadows from every exhibit would disappear,

and with them all feeling of material weight
would go. The visitor would behold the work of
art alone.

To pursue this ideal Arata Isozaki reacted
against the rigidity of the adopted modular
cubic structure. He used a floor surface that
is flat and smooth and extends to the front
lawn, where open air exhibitions are held:
boundaries begin to merge. A thin film of
translucent material lines walls and ceilings,
mirrors surfaces and outside trees in the
entrance hall. Indirect lighting blurs edges.

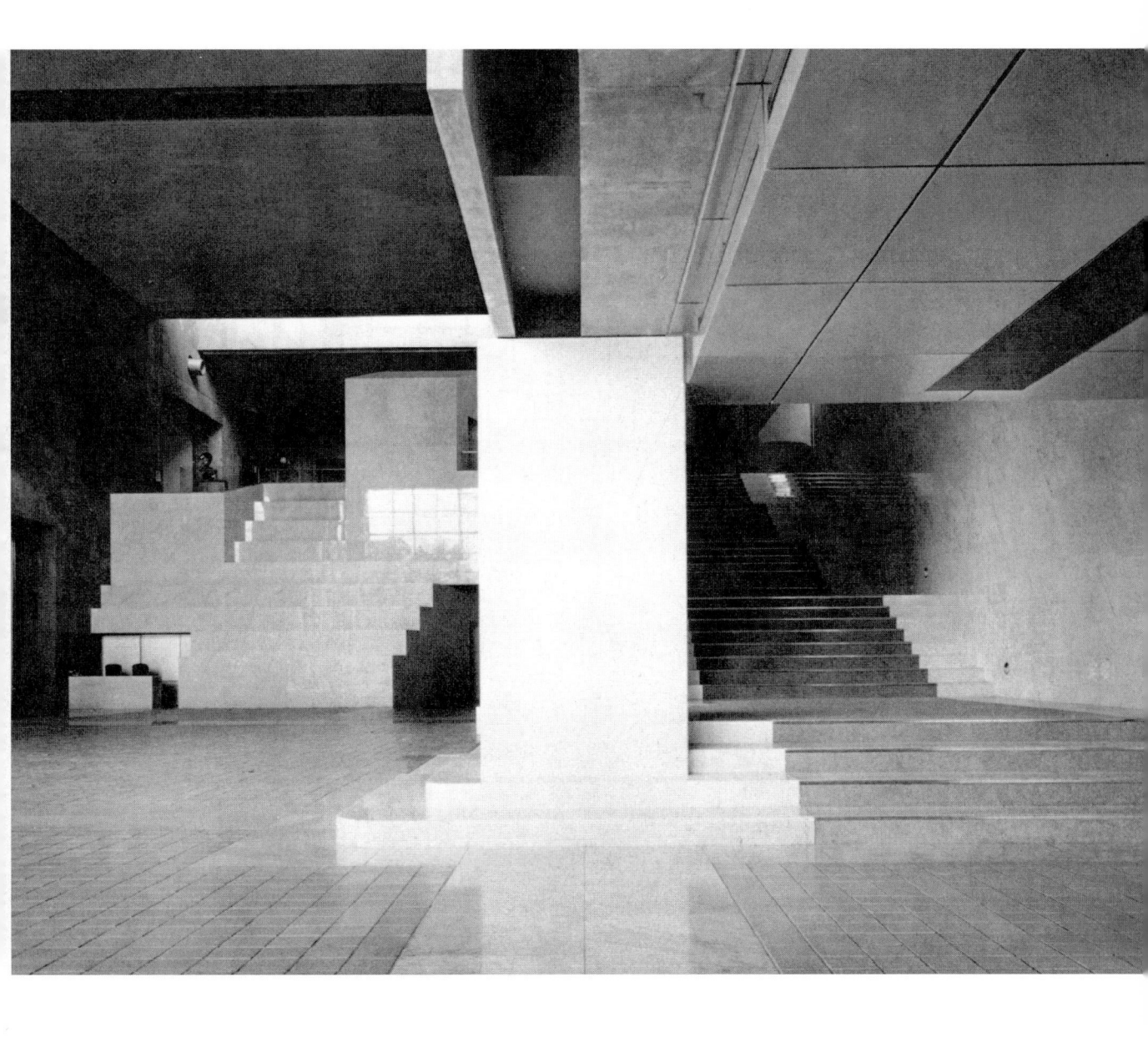

View of stairs from main
entrance

Significantly, the section containing the
permanent exhibition is projected diagonally,
at an angle of 22.5°, over the pond. Its reversed
image, distorted by the movement of the water,
becomes ambiguous. Unexpected relationships
develop.

The Caravelle Celine Boutique in Milan, Italy

architect:
Sergio Asti

photography:
Giorgio Casali

This boutique, in an area of Milan famous for its elegance and for many ancient buildings, occupies an irregular, deep, narrow space on three levels, opening onto a busy piazza near the Cathedral. Therefore, the architect's idea was to create an arresting, exciting design that would not be loud or pretentious.

The entire facade is glass, so that the whole interior can be seen from the street and the shop looks wider than the actual frontage size, a mere 10′ 5″. Inside, the traditional display window is replaced by a rotating conical stand with cut out recesses for exhibit-ing objects. The sale of dresses is handled on this floor. Full height shelves units are designed with an oblique forward slant for easier reach by the sales personnel.

The mezzanine, obtained by utilizing the upper part of the original, lofty rooms, has a display and sales counter for accessories and also a stock room at the far end. Heavier clothing is sold in the basement, which also functions as fitting room by means of movable screens. All service fittings are hidden within curvilinear fixtures that give this room a stage-like character.

View from the street of the entire shop frontage. Note the conical display unit and the mezzanine floor above

Axonometric showing all levels. The rear rooms, at an angle with the main areas, are used for stock keeping, service and additional fitting space

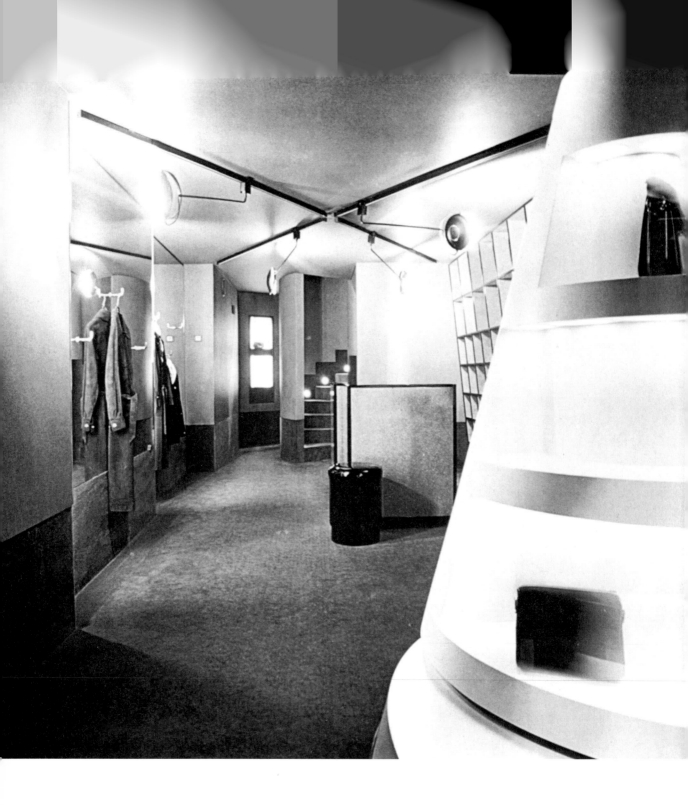

Interior at ground level.
Note how the staircase gives
privacy to a fitting area
beyond, without loss of visual
depth

Looking up to the mezzanine
level from the ground floor

Detail of spiral staircase

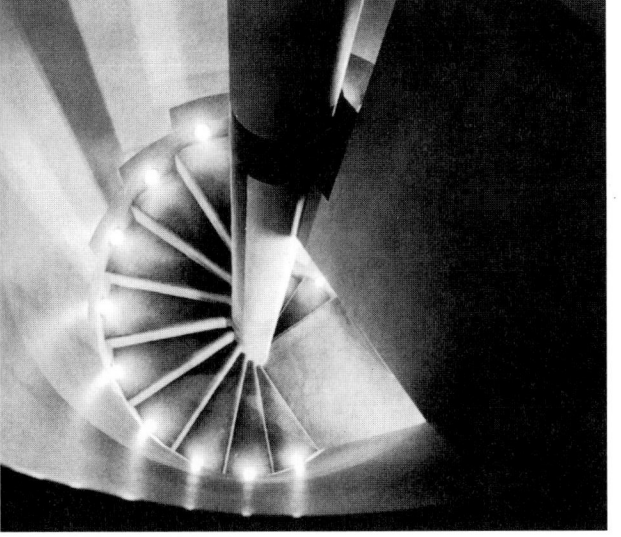

A spiral staircase of cast concrete links all levels and includes display and service space wherever possible. The materials employed throughout are blue paint for walls and ceilings, a moss green velvety carpet that partially covers the walls. The furniture is chipboard, clear varnished and trimmed with black edging for the shelves, lacquered white for the conical display unit. Lighting is by articulated spotlights running on electrified tracks, with halogen bulbs. All items are designed by Sergio Asti.

One of the fitting areas
in the basement

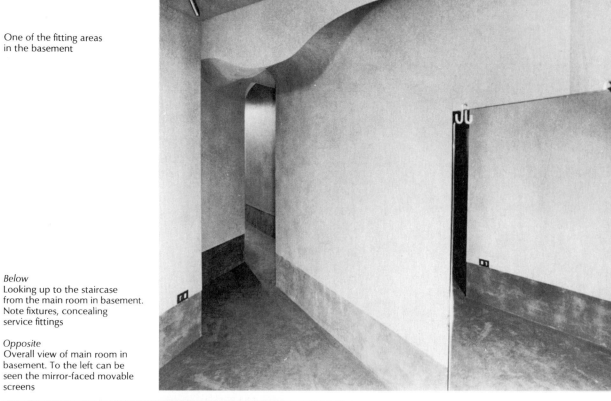

Below
Looking up to the staircase
from the main room in basement.
Note fixtures, concealing
service fittings

Opposite
Overall view of main room in
basement. To the left can be
seen the mirror-faced movable
screens

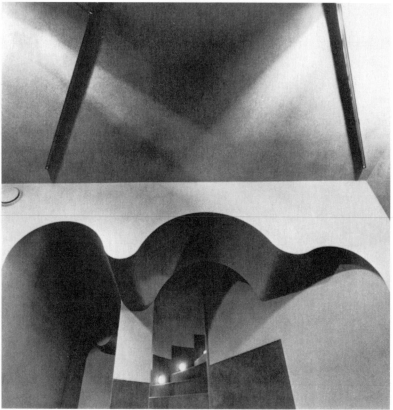

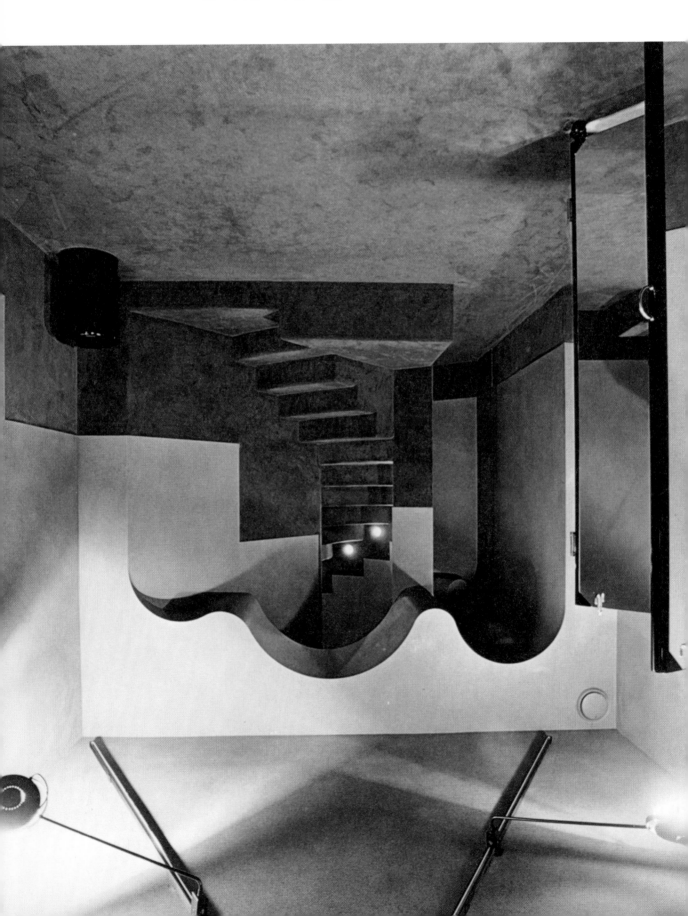

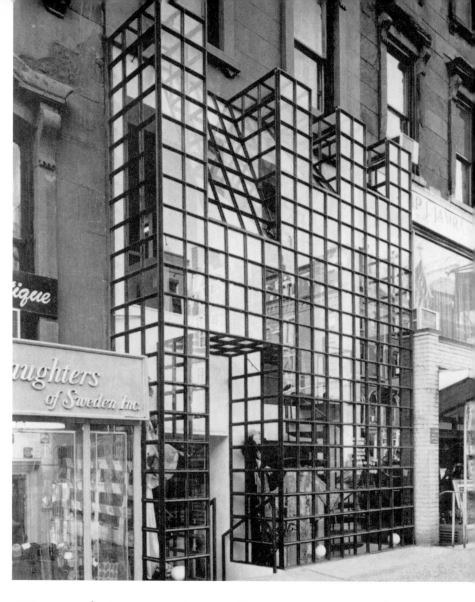

The structural grid, 'grafted' onto the old wall. The entrance returns and the three upper slopes strengthen the frame; the web of the tee section is used facing out, to ensure watertightness. The frame was prefabricated and erected in sections at the site

'First of August' – a Boutique and Beauty Salon in New York City, USA

architect:
George Ranalli

photography:
George Cserna

This project is the renovation of a woman's dress shop in an old building on Lexington Avenue, New York City. The clients, who had occupied the ground floor premises for some years, were offered an option to acquire the first floor. They decided then to restructure the business both in volume and in scope; the old shop was to include one half of the new space and a beauty care salon would be installed in the other half.

Two considerations were given priority when the new design was discussed: firstly, the architecture should contribute in a positive, meaningful way to the life on the street in New York, avoiding the brash, commercial solution that relies on loud neon graphics. Secondly, the space should be open, with maximum exposure to the street and with the vertical circulation occurring in the front of the shop.

The analysis of the streetscape revealed that it was perfectly legitimate to extend the shop area to the limit of the original stoop. This possibility,

Floor plan; the second floor
area measures 4·27 × 20·11m
(14' × 66')

Lateral view, showing the
architectural idea of 'layers'

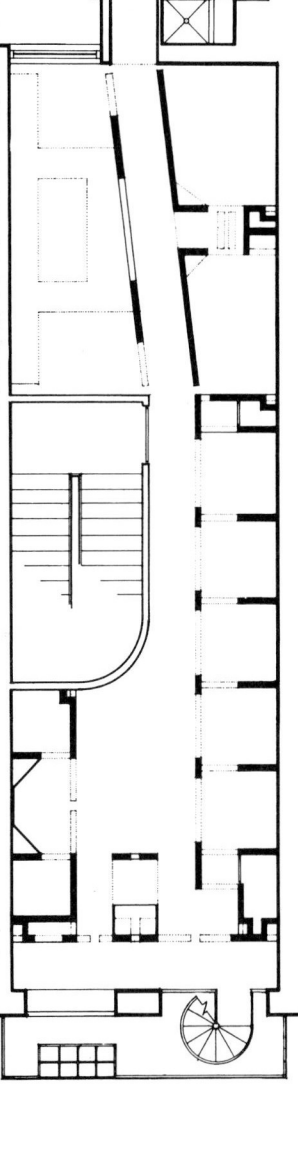

and the desire for maximum visual openness, suggested a formula that expresses both a reinterpretation of the brownstone wall of the original building and the notion of the shop window. The grid kept reappearing as the most basic idea from which the architecture could be generated, and from this the design developed into three sectional 'layers' and a 'skin'.

The grid frame sets up a strong visual and structural order which moves across the surface and then is sliced at the top to deny the complete rigidity of that order; it can take on the properties of being solid or completely spatial in a few minutes, as the light of day changes or when it turns into evening; it is structural, therefore functions as a wall, yet does not disagree with the old wall – it is both the first 'layer' and the 'skin' of the architectural concept.

The second layer is the old brownstone wall. The thickness and mass of the wall have been maintained, and brought down to the ground. As one moves first through the grid to enter,

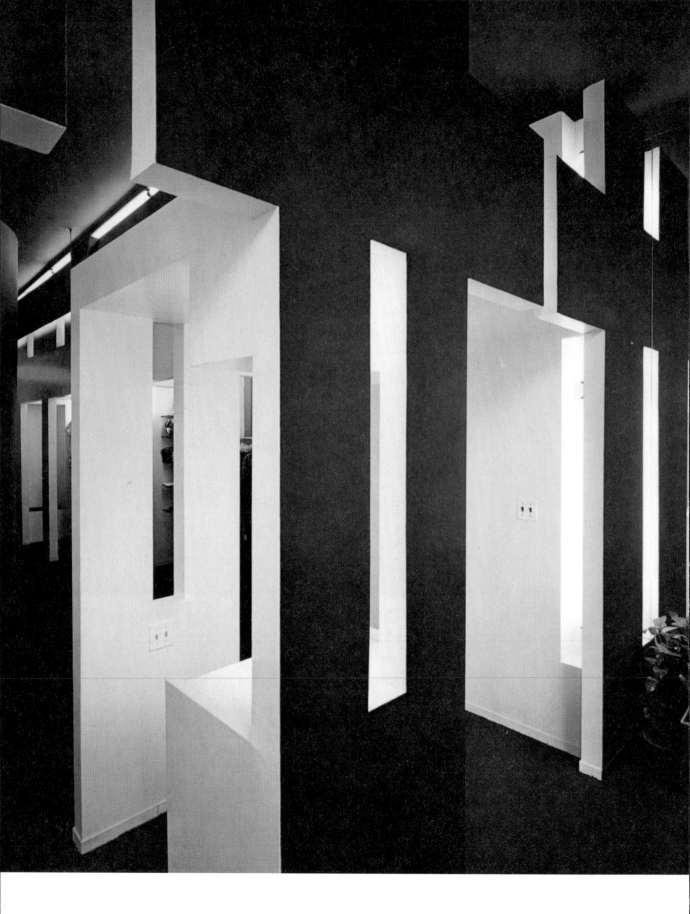

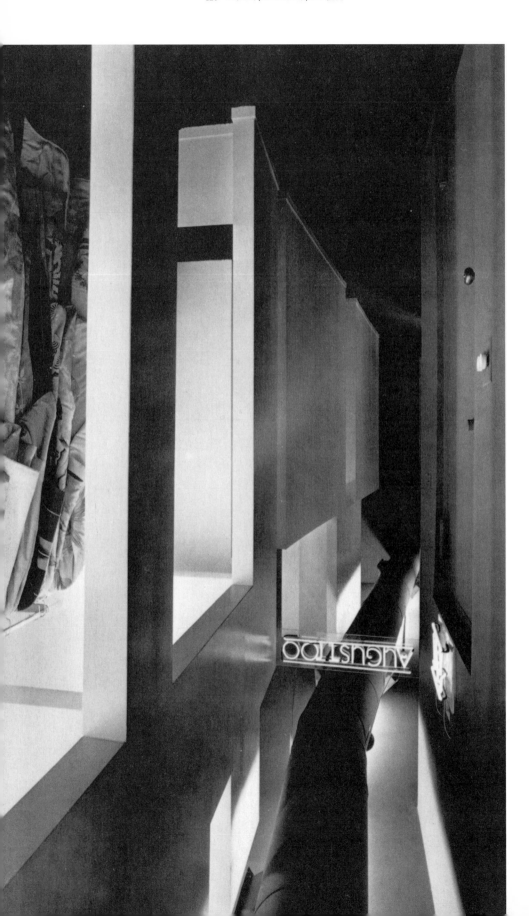

Entrance to the dress shop

Beginning of the beauty care
salon, at the back of the shop,
marked by a neon sign

Detail of the beauty care
area and, below, the manicure
area, defined by a freestanding
wall with large openings cut in it

Opposite
another view of the manicure
area; light and colour are used
to identify spaces and their
specific function

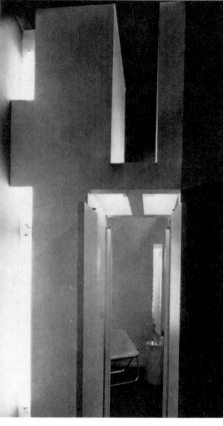

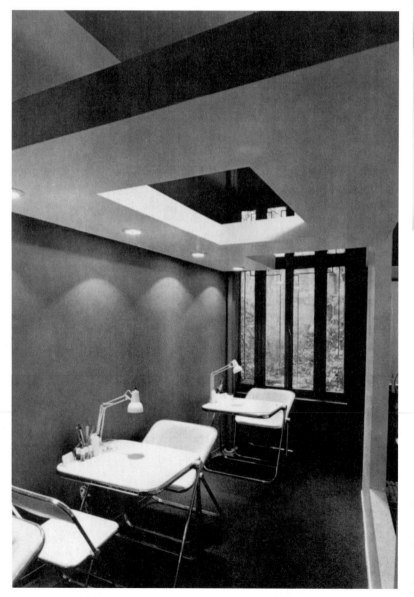

then up the stair inside the grid space, it
becomes apparent that the large openings cut
into the wall signify that this wall must be
penetrated to reach the upper floor.
The third layer is a large green plane which is
attached to 'objects'; sometimes these are solid
forms, sometimes they define spaces: the
dressing rooms, the desk at the front, or the
dress rack spaces for example. At the end of
the dress rack a change of function takes
place, marked by a neon sign: this is the
beginning of the beauty care salon. Between
the second and third layer there is a small

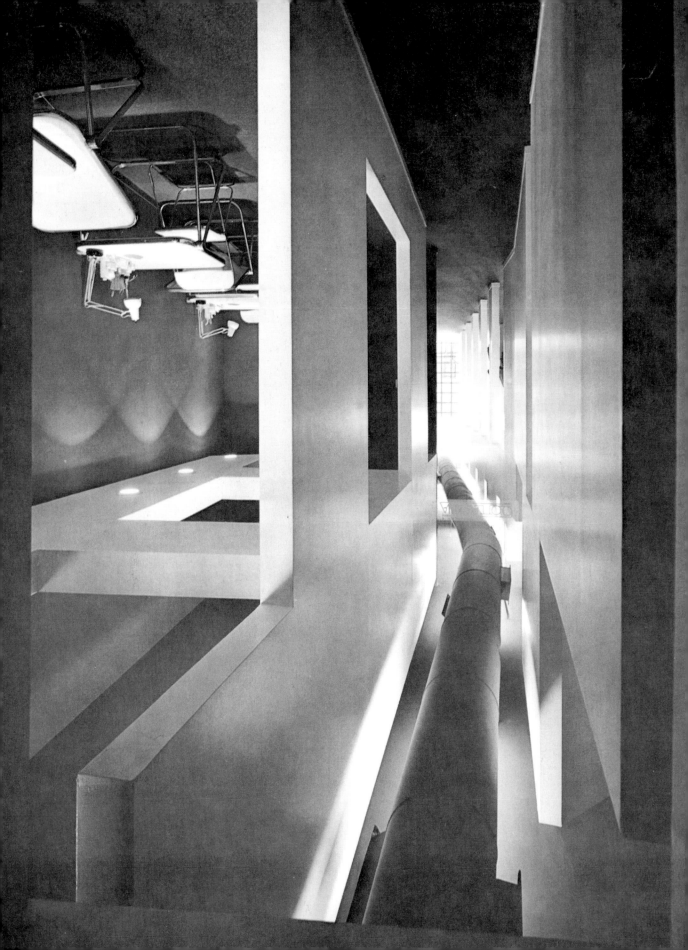

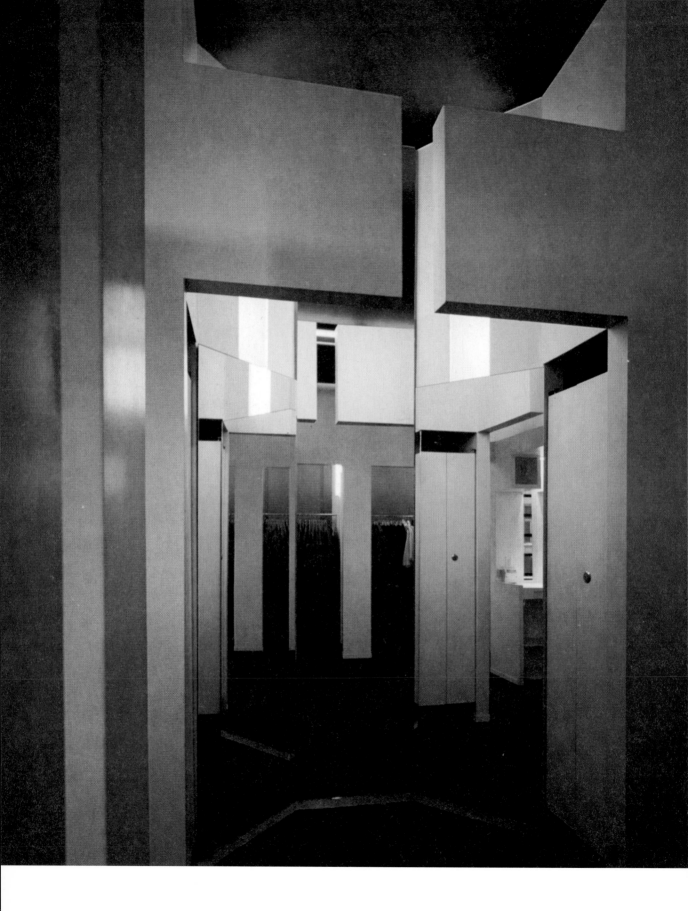

arrival space. It is narrow and thin, fitted with double mirrors, so that by standing at the top of the stair one sees the outside street moving by through the grid to an infinite horizon, and the interior, parallel with the street, also moves to infinity. This device allows the imagination to extend beyond the physical boundary of space, and recalls the function of the old mirrored waiting halls of Europe and America. The image at this point is of the three layers presented in infinity.

Left
Interplay of surfaces and reflections in the dress shop area

Looking back towards the front of the shop

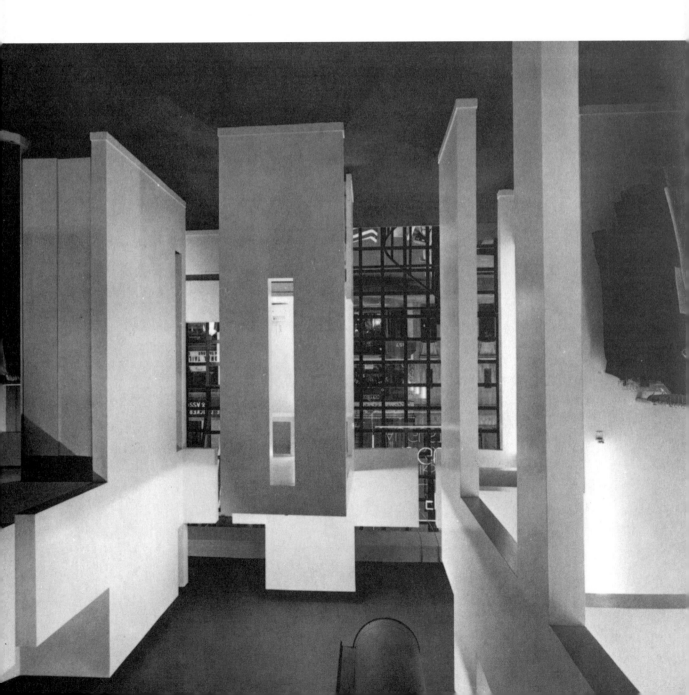

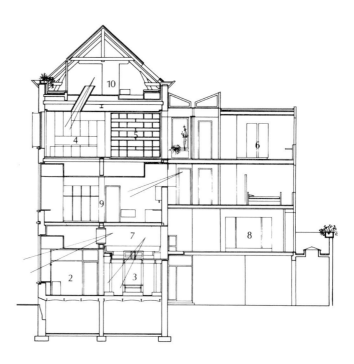

The Home of the Architect in Aalst, Belgium

architect:
Pieter de Bruyne

photography:
Gé Méijnen

A small, early 19th century terrace house was stripped of its original cladding during a conversion around 1950, and the delicate Neoclassical ornamentation of the facade was replaced by granite slabs. In 1974, Pieter de Bruyne remodelled the interior and designed an extension into the long and narrow back garden. He had two objectives in mind: to create areas with an individual atmosphere, intended for a precise, exclusive function, and to counteract the smallness of the house by visually disrupting the conventional idea of space. A study of the section will reveal the ingenuity of his approach. Rigorous economy of design uses all available space by changes in floor levels and use of integrated storage; mirror panels add visual depth; and a series of openings cut into floors and walls, sometimes even through specially designed pieces

of furniture, allows the passage of natural and artificial light to create new dimensions for the formal room shapes of the old house. It is here, in the original building, where the imagination has been spurred to the maximum.

A small, round mirror panel on the outside of the entrance door symbolizes the spatial manipulation to be found inside. From a small reception area one enters one of the front rooms, originally 4.29m high but now divided horizontally into a showroom, at the lower level, and a television room on the mezzanine above. The two spaces are visually connected through a round opening covered with glass in the ceiling of the showroom, and the floor joists of the upper level are left exposed. On the first floor are a study and the

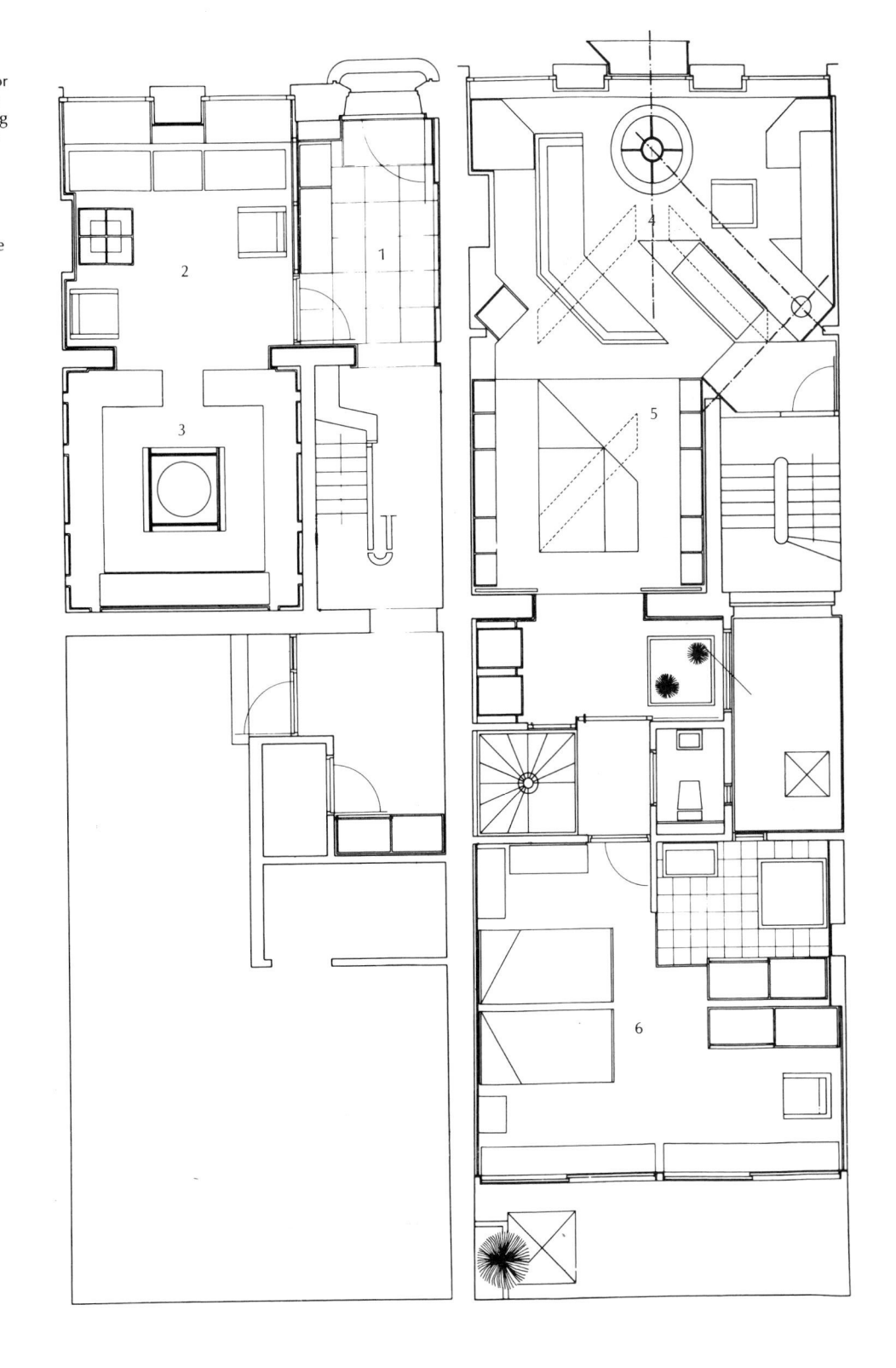

Left
Outside view; the alterations
to the original house, made in
1959, opened the way to the
changes carried out by Pieter
de Bruyne. Note the round mirror
panel on the front door and the
extension to a window belonging
to the blue room on the second
floor

Section showing the
position of the openings to
allow the passage of light and
the visual manipulation of space

Plans of ground floor and
second floor

1 Entrance hall
2 Reception room
3 Showroom
4 Blue room
5 Private studio
6 Master bedroom
7 Television room
8 Dining area
9 Office and studio
10 Guest room/recreation
 room

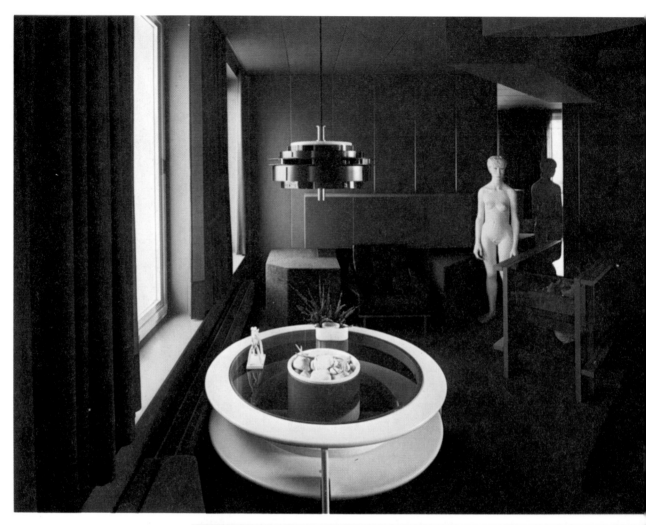

The private studio of the
architect is a windowless,
secluded room adjacent to the
blue room and opening, by
sliding doors, to the transitional
space between the house and
the new rooms

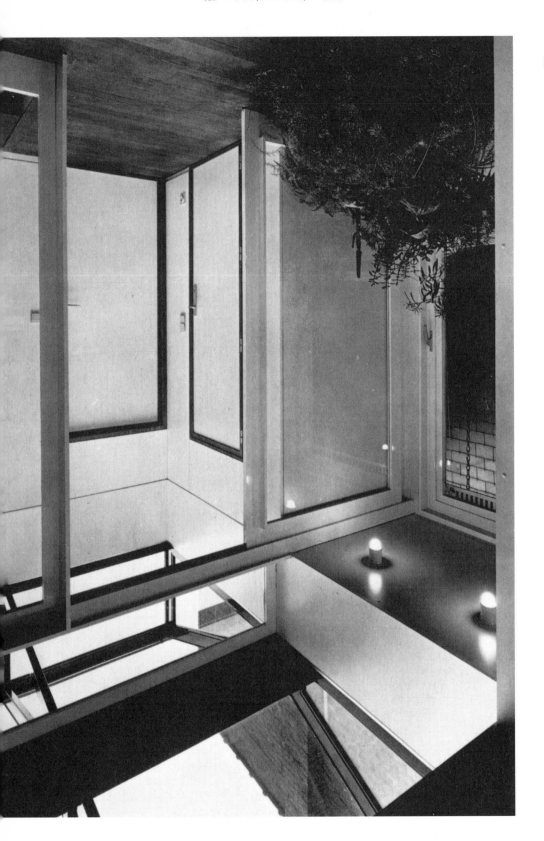

The 'nature' space that links old to new rooms. It is surmounted by a glass dome on which water is sprayed. To the right is the master bedroom, and a spiral staircase leads to the lower floors of the extension

The blue room, intended for relaxation and listening to music. All materials are in tones of blue: felt covers the walls, the windows are fitted with dark blue glass, carpet covers the floor and the plinths supporting the furniture, designed by the architect. The only natural daylight allowed in the room comes from the guest room above, through an opening in the ceiling. The light shaft falls onto the round table to the left

Showroom on ground floor;
note the exposed floor joists
of pine wood, belonging to the
mezzanine where is the tele-
vision room

Television room. The design
of this space is based on the
circle and the square – a formula
preferred by the architect.
Colours are in contrast with
each other: red felt covers
the walls, black leather for
the round bench, grey for the
carpet. The glass table is
placed on a round opening in
the floor, also covered with glass

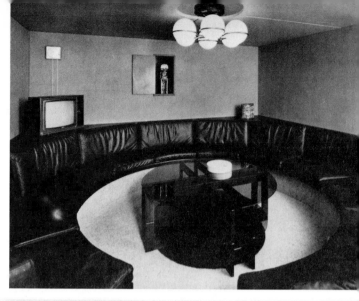

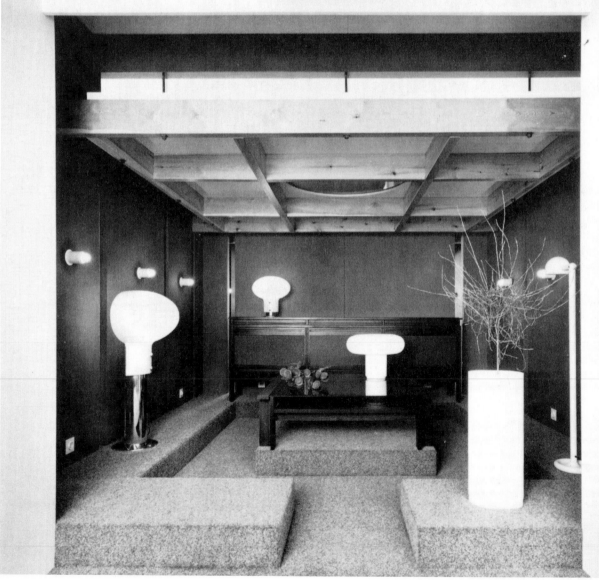

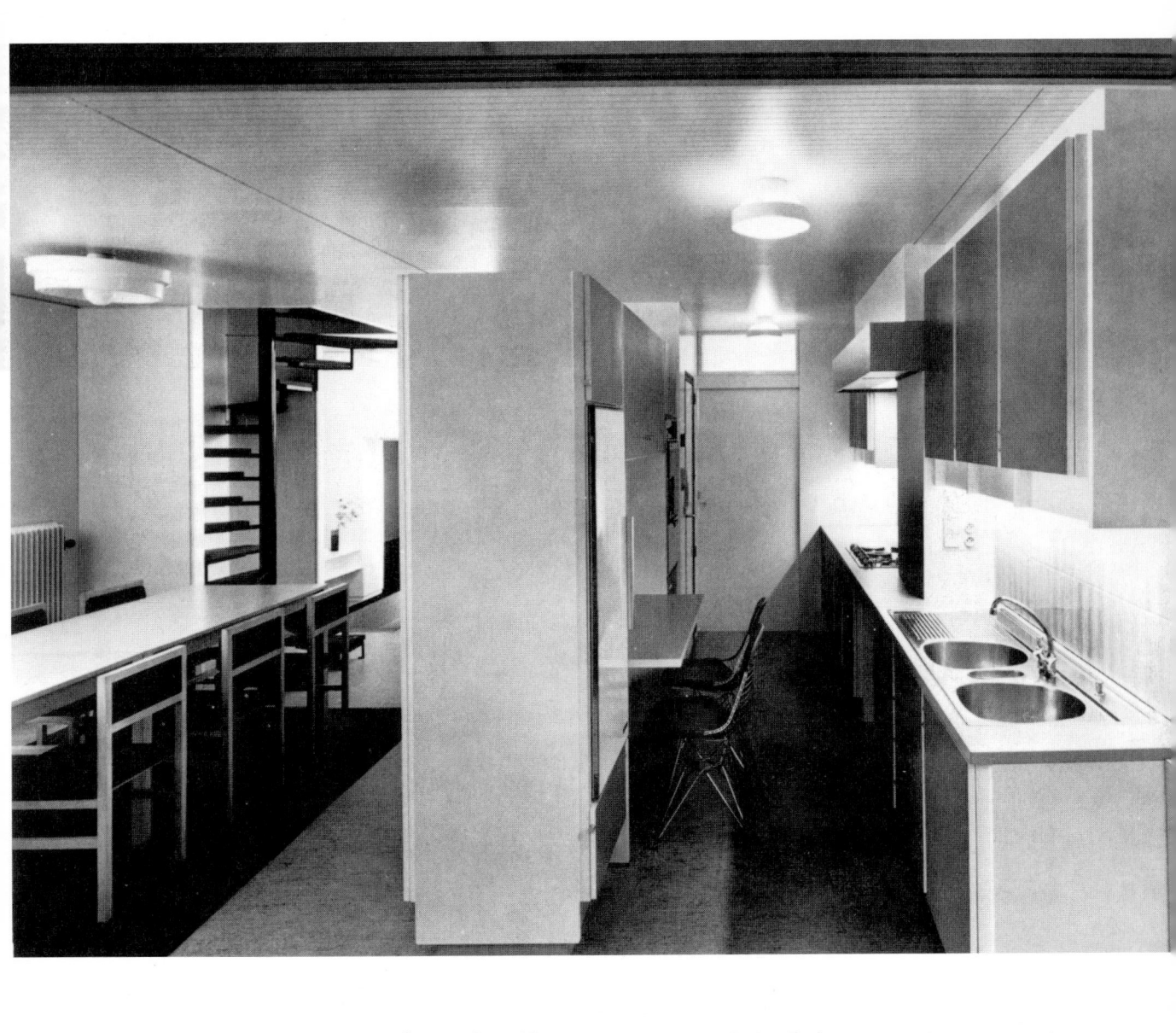

The dining/kitchen room is adjacent to the television room. Walls are covered with white laminate, and the floor is lino. The dining furniture is a 1958 design by the architect

secretary's office. Walls and furniture are faced with white laminate and the study has built-in storage. The ceiling was lowered and three window embrasures have been retained. The actual windows have been altered into three horizontal sections: the lower and upper panels are fixed, and made of frosted and dark blue glass respectively; the middle section – the proper window – is fitted with Venetian blinds.

The second floor contains the blue room and the private studio of the architect. The blue room functions as a barrier between the busy street and the studio, and is used for relaxation and listening to music. This is

undoubtedly the most significant space in the house; all materials are in tones of blue, from the felt covering the walls, to the furniture, the carpet and the windows, fitted with dark blue glass. A shaft of light from the guest room above penetrates this room through a specially designed piece of furniture: it is the only natural daylight allowed into a sombre, introverted space. The private studio is open to the blue room and, at the other end, communicates by sliding doors with a subsidiary staircase in the new extension, a luminous space containing plants and the sound of water given by an artificial 'rain' falling on a glass dome.

The master bedroom and bathroom. The furniture of rosewood and walnut is by the architect and the bathroom walls are covered with Italian ceramic tiles by Fausto Melotti

The roof space has been fitted as a recreation area and guest room: brick walls and old beams have been restored and the roof has been insulated and finished with white laminate panels. The room opens onto a terrace – the flat roof of the new extension – so that one can enjoy nature as far as this is still possible in a town house. The whole atmosphere is in total contrast with that of the blue room, which can nevertheless be seen through the hollow, glass-covered white table.

By comparison, the new addition looks extremely simple. Function here seems to replace the intense, emotional symbolism of the old house. The transition is carried out naturally: there is an evident enjoyment of the freedom to express in the same idiom a concept that includes both architecture and furnishing. In every respect the architect has indeed succeeded in creating spaces that possess a character of their own, to suit many different moods and inclinations.

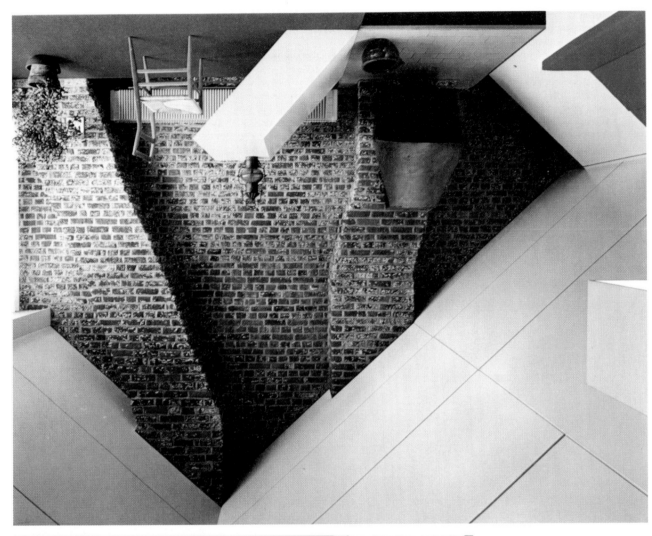

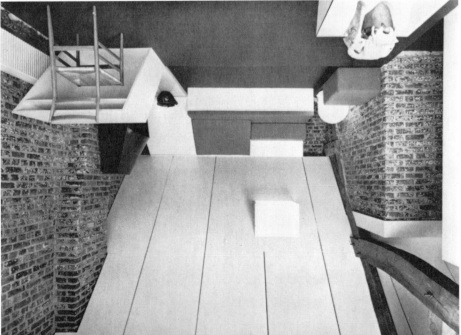

Two views of the recreation room, also used as guest room. Note how the white panels lining the roof set off the exposed bricks and old beams. The specially designed white table to the left is hollow, with a glass top, to allow light to penetrate in the blue room below. The chair is by Gio Ponti

The old premises shortly before being acquired by the architect (below), and the renovated building that is now the office of William Morgan

The Office of the Architect in Jacksonville, Florida, USA

architect:
William Morgan

photography:
Alexandre Georges and
Ronald Thomas

The mellow red brick building that is now the office of William Morgan Architects was erected in 1902 shortly after a major fire disaster that hit Jacksonville. First occupiers were a blacksmith, whose workshop was in the smaller premises to the left, and a livery stable. Later, the entire ground floor was used as a parking garage and the first floor became a printer's shop and press. The original blacksmith's shop is now the entrance stairwell leading to the office on the first floor, while the ground floor serves as a garage for 19 cars and as an additional office space.

The renovation work is a remarkable example of simplicity and restraint. The external brick wall was sandblasted and restored; wooden columns, beams and sash window frames were retained and restored, and a new roof was provided. Contained within the original shell is the new structure – a neat white post and beam construction with plasterboard partitions. The main space at the lower level is taken by the reception area and by a meeting room; above this is an open plan drawing office, brightly lit by skylights cut between the exposed roof joists. The walls were painted white on three sides, the floor was carpeted and a heating and an air conditioning system was installed. The effect is of a strong, pleasant contrast between the rugged brick wall and the sleek white structure.

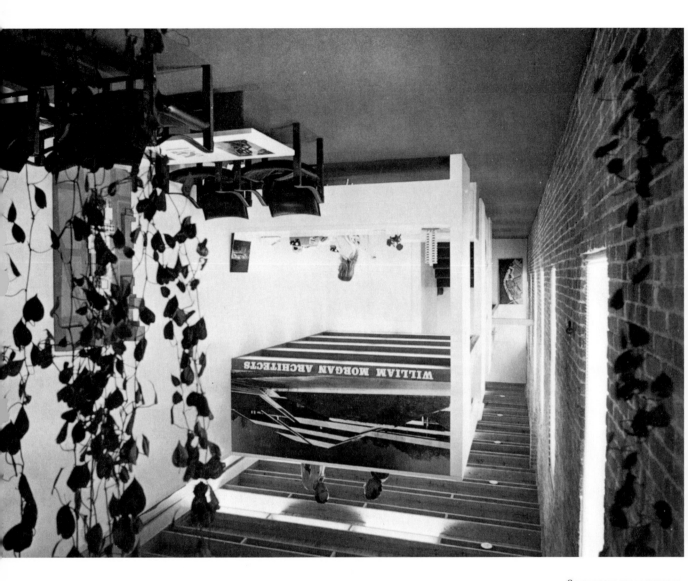

View of the reception area and of the white structure inserted in the old building

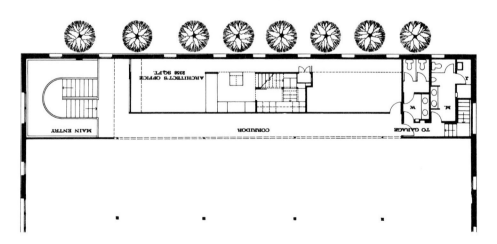

Plan of the office

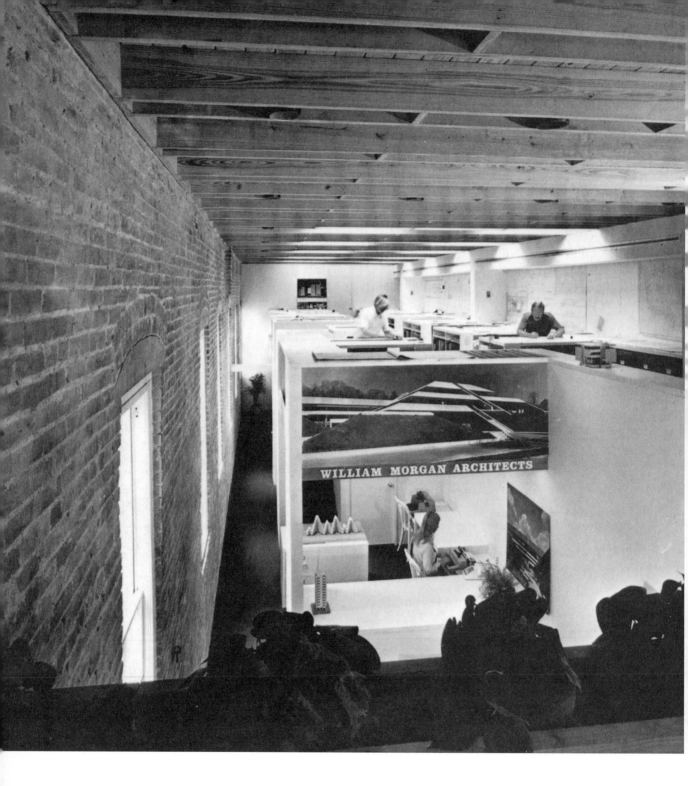

The drafting office on the
upper level

Looking towards the
reception area

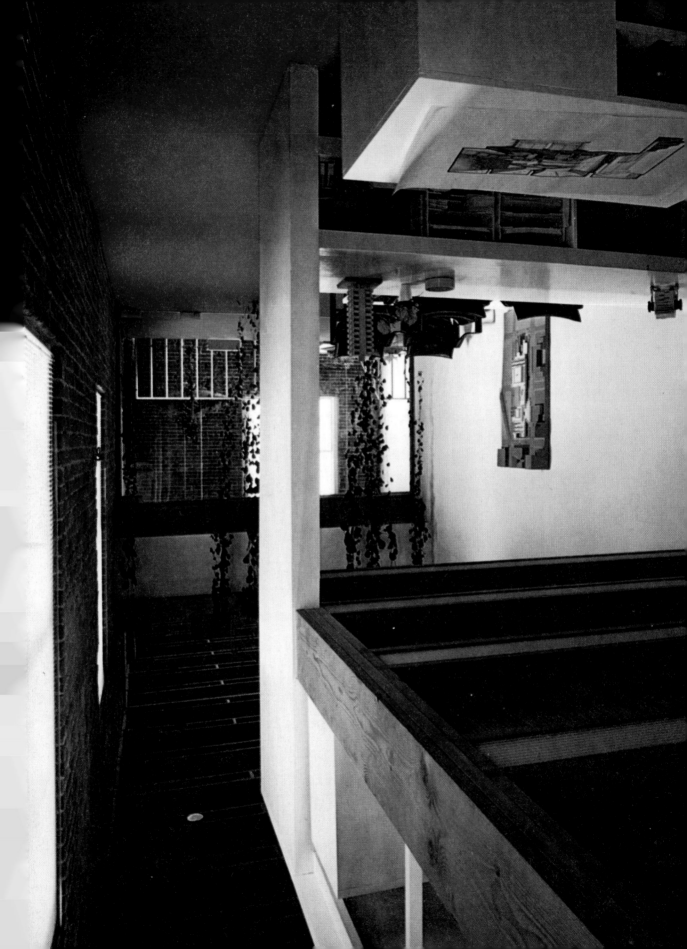

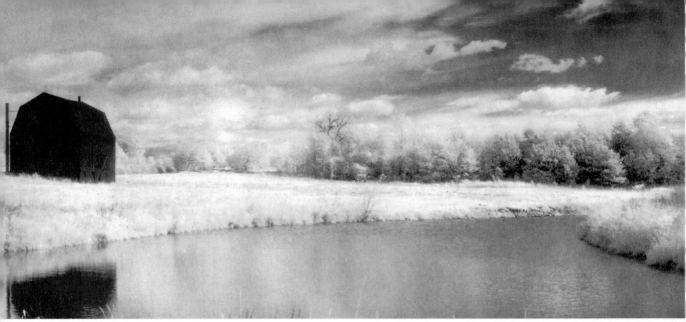

Black Barn – A Family House at Frog Hollow, South Michigan, USA

architect:
Stanley Tigerman

photography:
Philip Turner

The client had acquired a 150-acre farm on which stood a hundred year old barn, built in the style known in the profession as 'Pennsylvanian Dutch'. The mansard roof was in a state of disrepair, but the interior structure of heavy, hand-hewn beams was in good condition, so the owner decided to convert the barn as a home for himself, his wife and their three children.

The architect's brief was based more on a sympathetic understanding of the existing structure, than on strictly functional

considerations. However, as well as providing the usual family requirements, a studio for the lady of the house, who is a painter, and a music room that could contain a large theatre organ were needed. It was decided then to plan the whole interior as a series of galleries on different levels. The design utilizes the existing timber frame to support cedar veneer plywood panels that define the new spaces and also function as a bracing element. The different levels are served by a central helical staircase that continues up to the parents' bedroom under the mansard

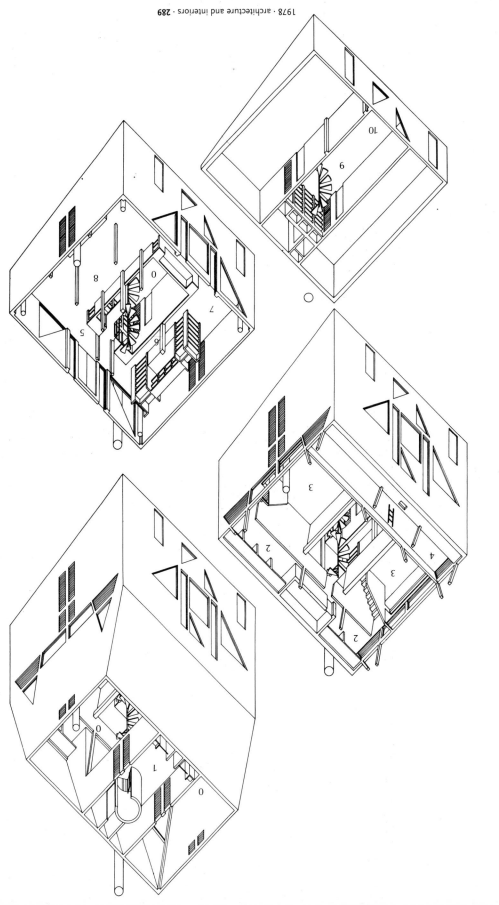

A wintry scene with the
black silhouette of the house
reflected in the nearby pond

The old barn: before and
after conversion. Note the
attractive design of the windows

Axonometric

0 Void
1 Master bedroom
2 Child study area
3 Child bedroom
4 Studio
5 Entrance
6 Kitchen
7 Dining area
8 Living area
9 Study
10 Organ pit

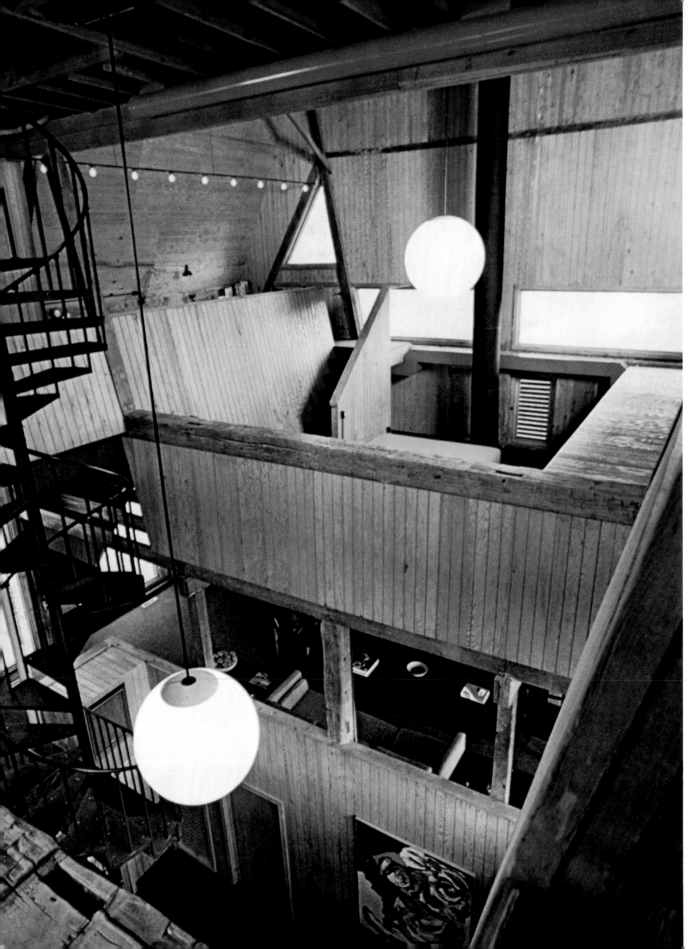

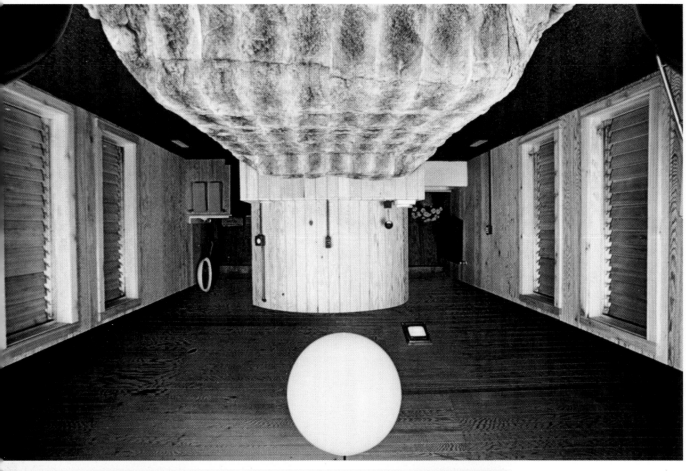

The parents' bedroom under
the roof. The curved partition
behind the bed conceals the
top of the staircase

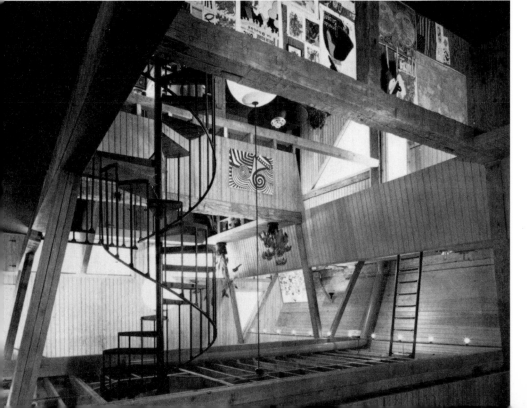

The studio, seen from the
children's area

Left
Looking from the painter's
studio to the children's
bedroom and study area, and
to the living room below

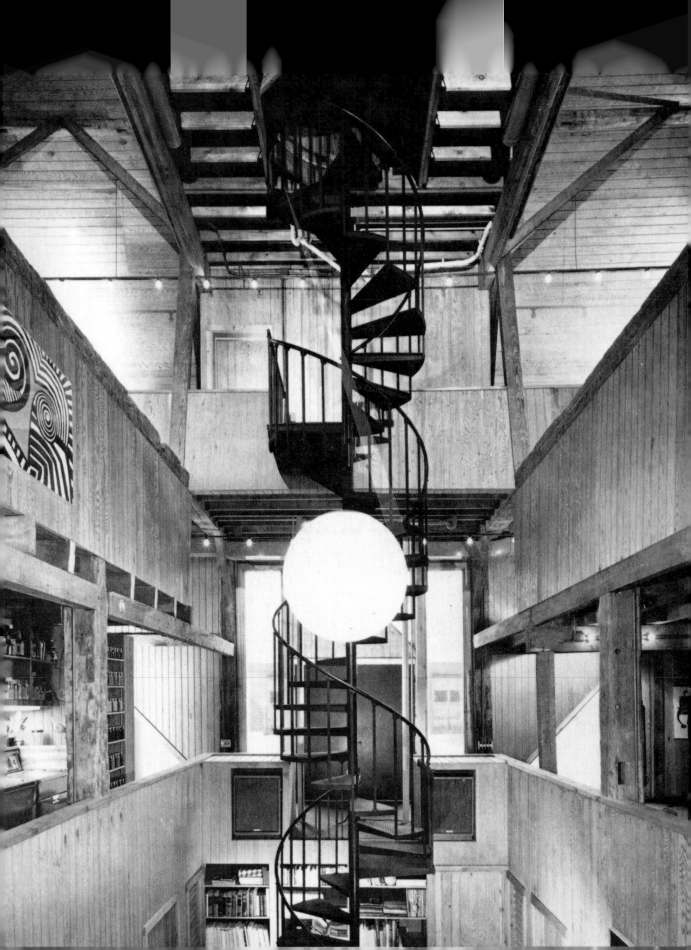

Left
View showing the general
layout of the galleries. The
entrance door is at the centre
back, the kitchen to the left
and, to the right, is part of
the living area. Main lighting
is by means of huge globes
hanging from the joists

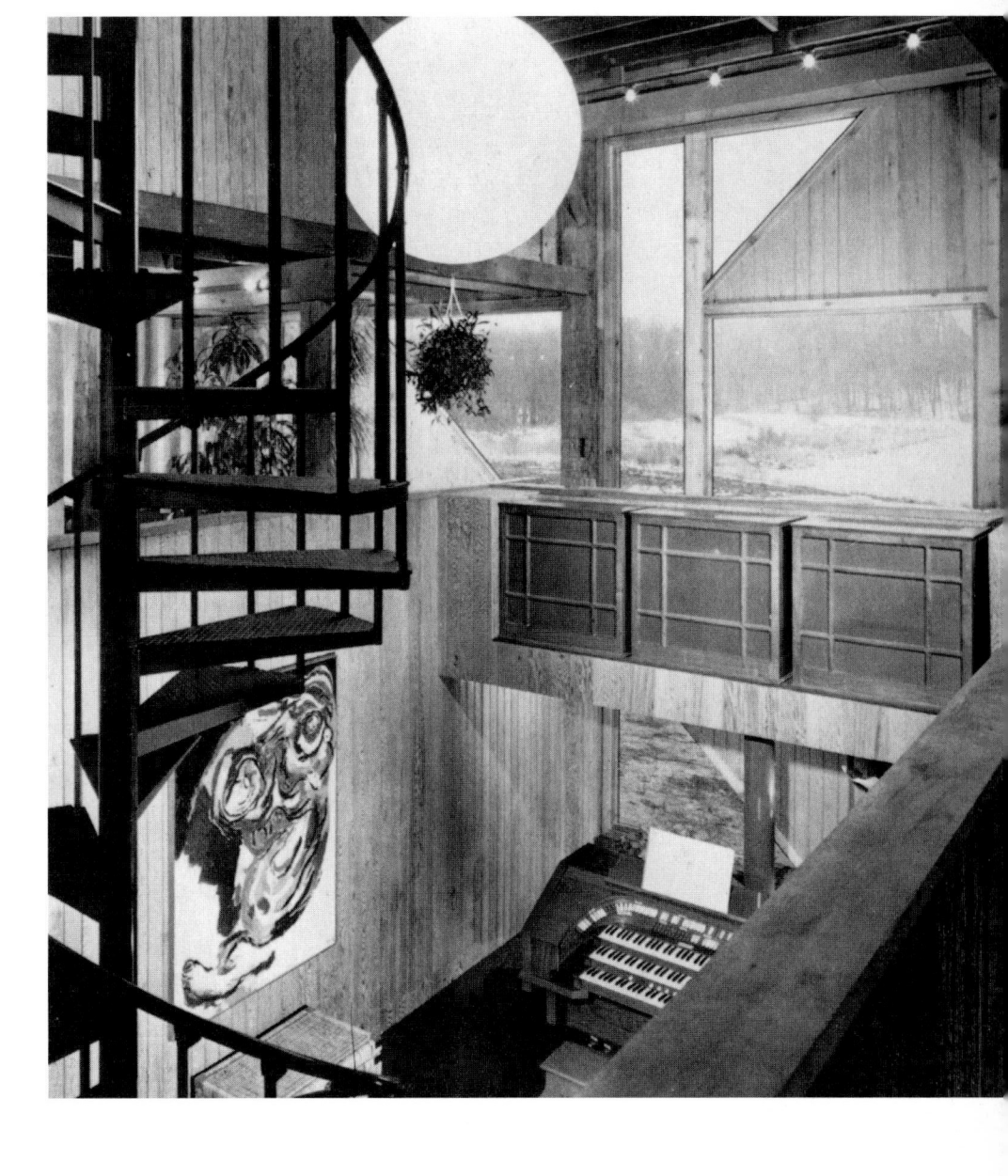

View from the kitchen
showing the music room below

root. This solution has many advantages: it
retains the quality of the barn, provides well-
defined, reasonably functional spaces and
allows visual communication without the
shortcomings of an open plan.

The entrance is at the first gallery level,
where are living room, dining room and kitchen.
The ground floor is used as a music and
reading room. On the gallery above the
living room is the children's area: bedrooms
and a study, reached by a small flight of
steps on a mezzanine level. Facing the
children's area is the painter's studio
and on the uppermost level is the parents'
bedroom.

All conduits, heating ducts and plumbing
are exposed and colour coded in blue, red
and yellow respectively. The outside has
been re-sheathed and then completely clad
with black asphalt shingles. The attractive
windows are fitted with grey tinted glass.

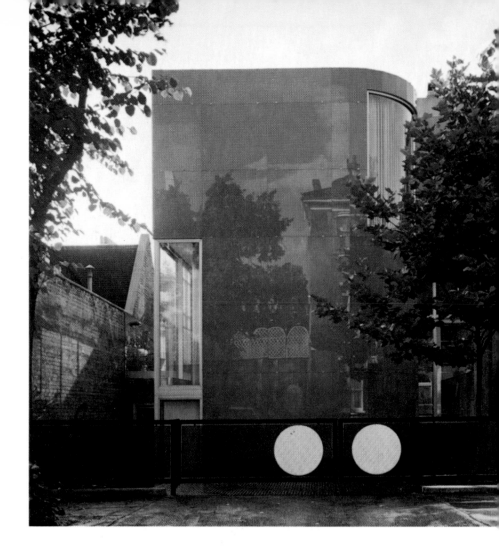

External view from South-East. The glass cladding is of 6mm toughened glass painted grey on the inside and subsequently fired to obtain a corrosion-resistant finish

The Home of the Architect in Kensington, London, England

architect:
John Guest

photography:
Richard Einzig

This project is an interesting example of urban development in South Kensington, London. The architect's former home was a studio/house with a long back garden, occupying a site between two parallel streets. When the house became inadequate for the needs of their growing family, the architect and his wife decided to divide the property in half, sell the old house and, on the remaining half, build a new home. This solution was hampered by some opposition at first, but permission was eventually given subject to building constraints that, as is often the case, ended by having a positive influence on the final result.

Set well back from the road, the house appears as a single volume rising to the height of the neighbouring two-storey brick houses, dating from 1950. The precise, clean lines of the front elevation curve gently to the East to join the adjacent house and the entire wall is clad in grey glass, reflecting the surrounding houses and trees. A long, narrow opening glazed on two sides pierces the South-West corner of the house and introduces a change of rhythm that anticipates the change of mood occurring at the back of the house. Here the space is articulated in terraces and paved areas that begin half a level below street and are then repeated throughout the three floors. Reflections continue to play an important role as the glass cladding covers the back of the house and the garden wall, full height glass

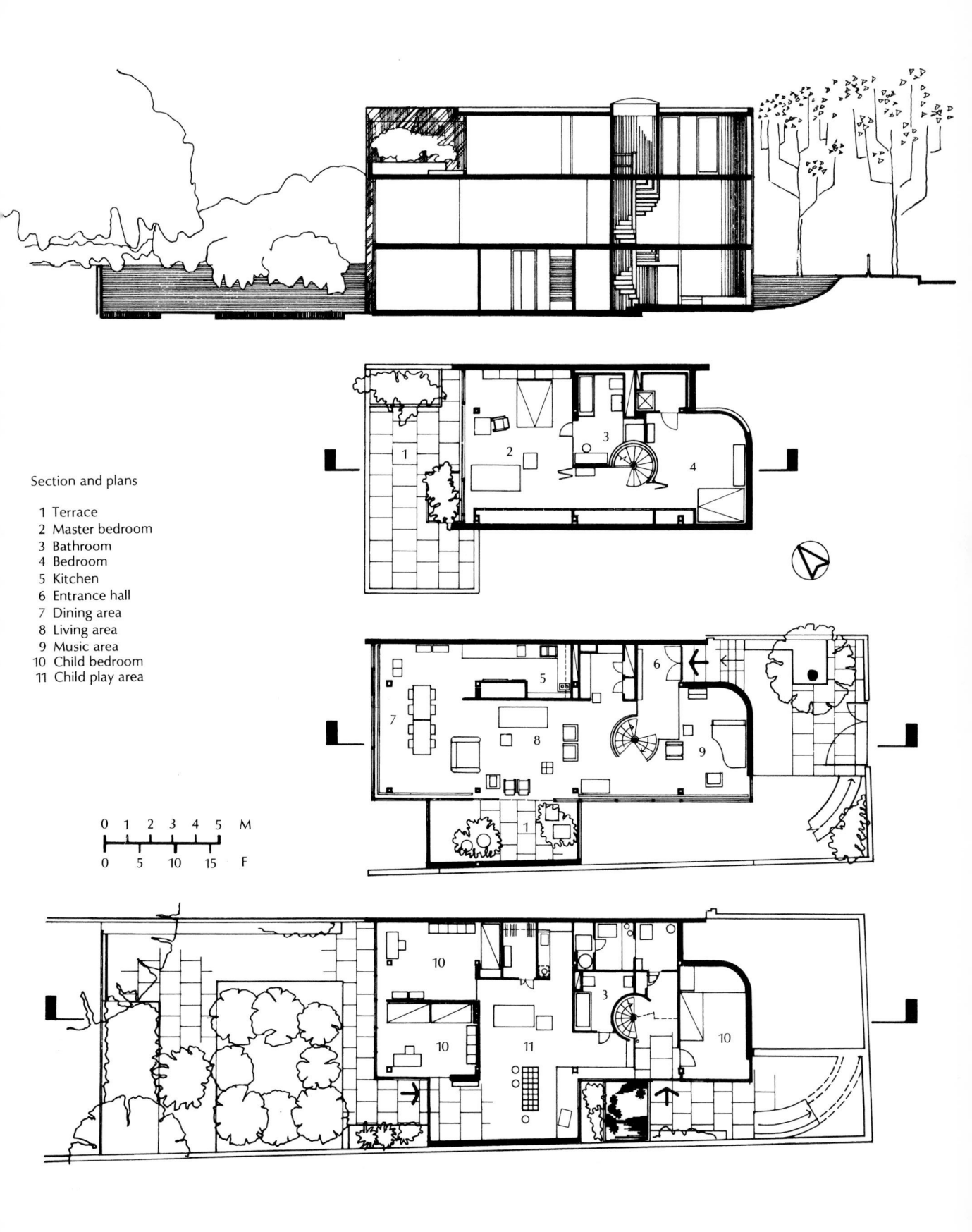

Section and plans

1 Terrace
2 Master bedroom
3 Bathroom
4 Bedroom
5 Kitchen
6 Entrance hall
7 Dining area
8 Living area
9 Music area
10 Child bedroom
11 Child play area

0 1 2 3 4 5 M

0 5 10 15 F

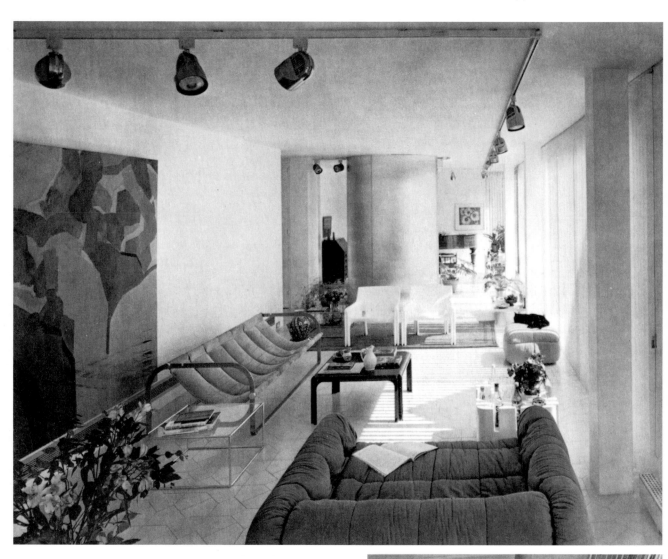

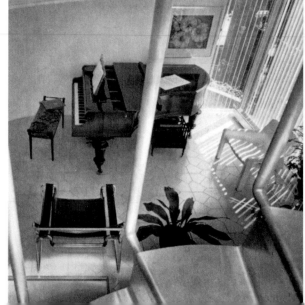

The living area on the second
level, above the children's zone.
The painting is by Mario Dubsky

Detail of the music area.
The grand piano is by Bechstein,
made in 1890

The South-West side of the house, with ramp leading to the children's zone

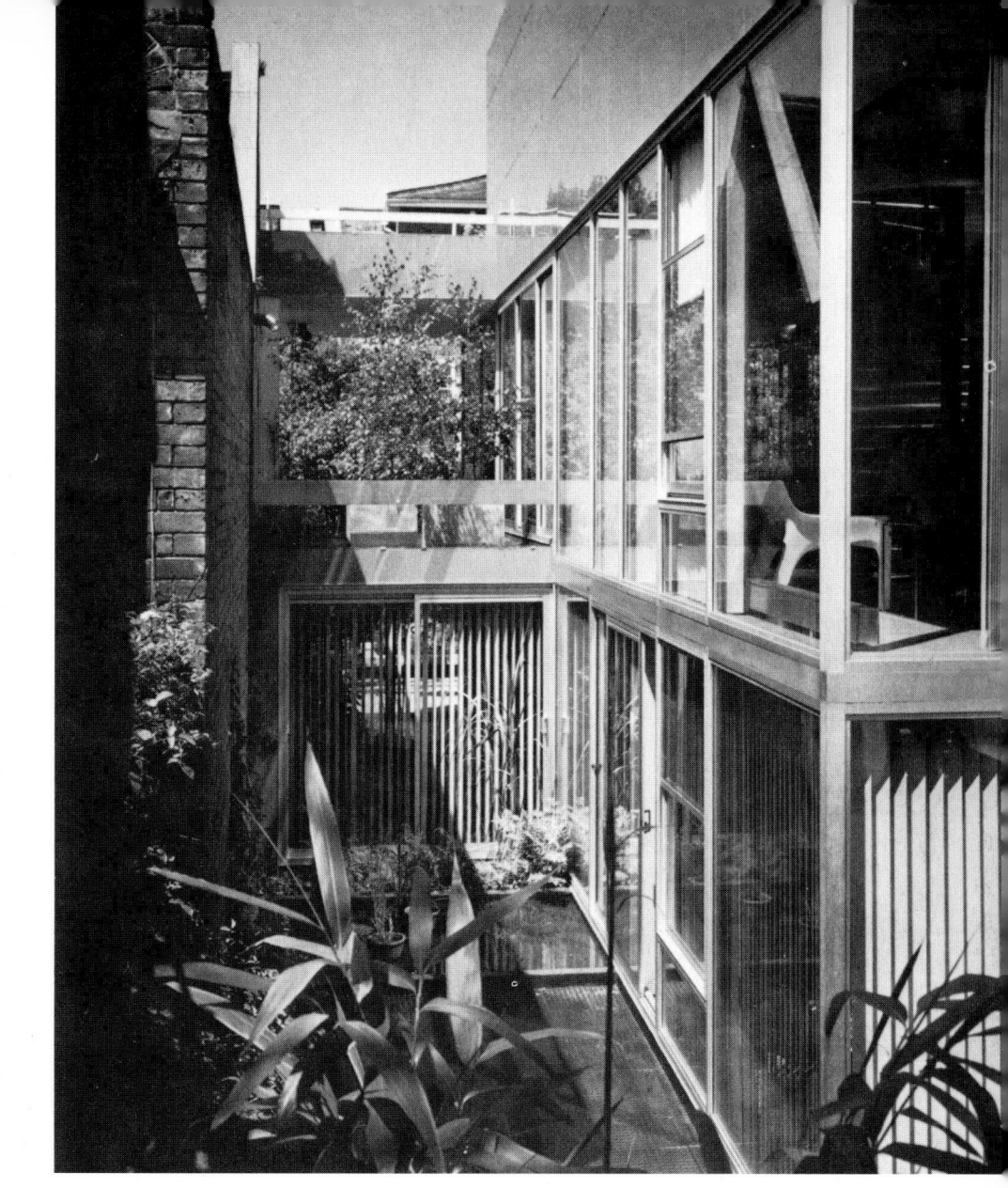

sliding doors provide direct access to the house from the garden, and a small square pool containing water plants occupies part of the open area that leads from the side to the street entrance, at the second level, by means of a curving ramp.

An atmosphere of spaciousness and light prevails inside. This is due to a combination of design and technical expertise. Reinforced concrete construction was chosen to obtain both clear uninterrupted spans and the possibility of building on three floors within the height of the two-storey surrounding houses. The frame rests on a concrete pad foundation; 200mm concrete block was used for external, 100mm for internal walls. Floors

are easily maintained white ceramic tiles from Italy, with some areas of 'Norament' rubber tiles on courtyard and in the playroom. The roofs are asphalt on reinforced concrete. All door and window frames are aluminium. The attractive spiral staircase linking the three levels, also of aluminium, is a design by the architect realized in close co-operation with the manufacturer.

Heating is provided by two gas-fired boilers, one supplying a ducted warm air system and the other perimeter units situated beneath the windows. The furniture, with the exception of the aluminium terrace chairs designed in the thirties by Hans Coray, is mostly of Italian design.

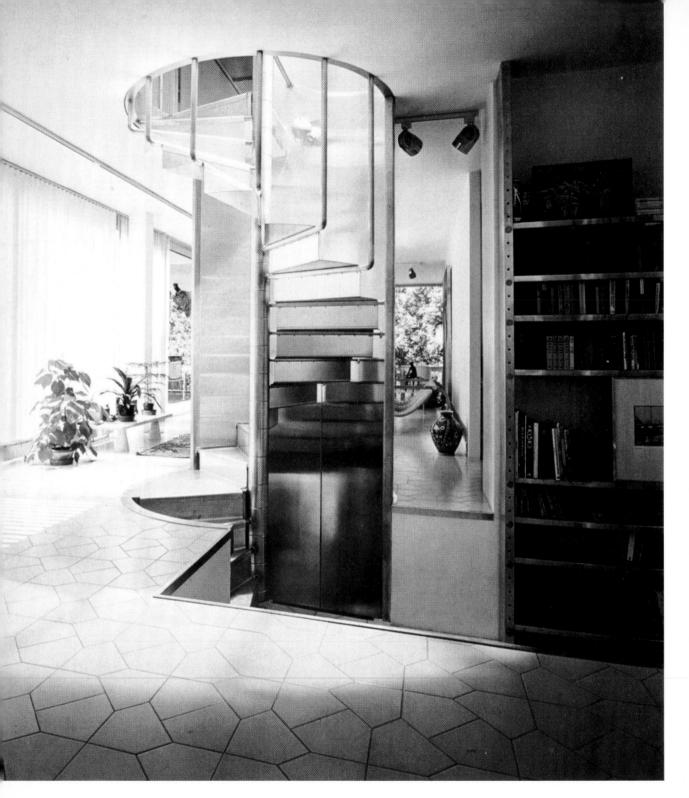

Main entrance at second
level. The staircase is surmounted
by a rooflight and was manu-
factured by John Desmond in
close cooperation with the
architect designer

The playroom in the
children's zone on the first level.
The full-height sliding doors to
the left open onto a paved area
with a small pool. The garden
can be seen in the background

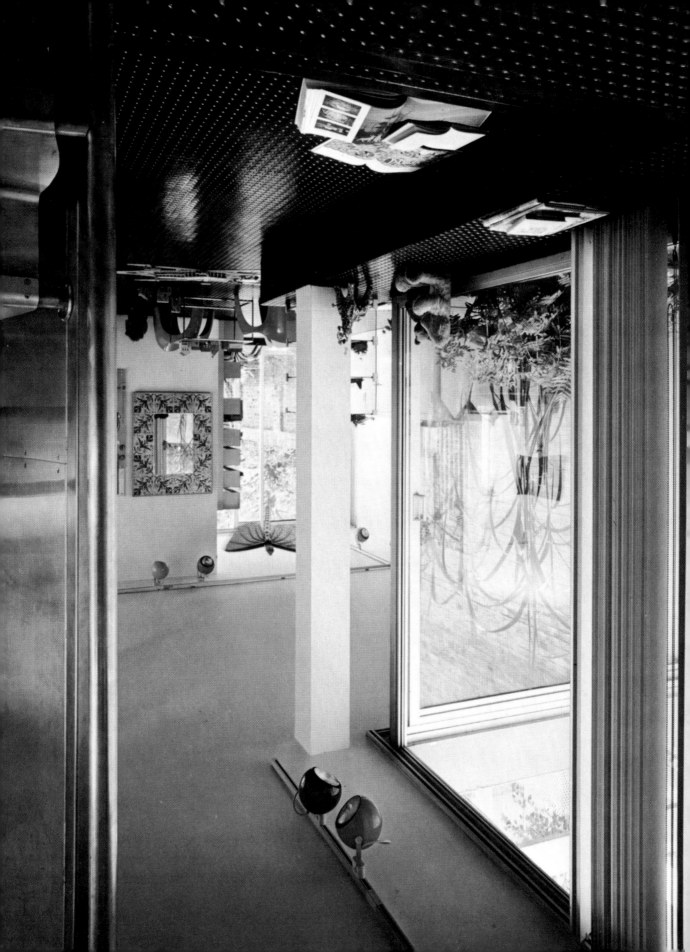

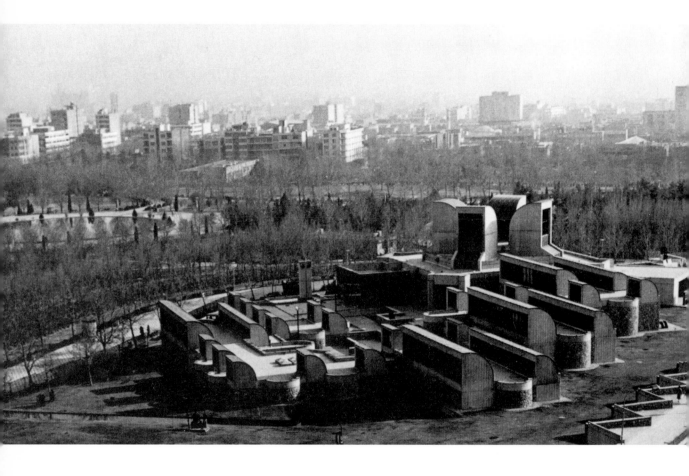

The Museum of Contemporary Art in Tehran, Iran

architects:
D.A.Z. Architects
Planners and Engineers
Design team: Kamran Diba,
Nader Ardlan

photography:
B Zohdi

The plan of this museum has a strong, graphic quality: it consists of a square element firmly wedged into a geometrical shape composed of two larger, interlocking squares. Six main blocks are asymmetrically placed around the edge of the basic shape, so as to face north-east. The rigidity of the square form is then tempered by semicircular accretions that offer the intimacy of secluded exhibition spaces within the large gallery blocks and, projecting into the central open space, contribute to the free form of the sculpture court.

The building is partly underground, on a sunken site at the western edge of Farah Park. When approaching from the north the above-ground structure is completely exposed, but from the southern approach the building is hidden by an artificial hill housing the auxiliary facilities around the main hall.

From the entrance lobby to the exhibition spaces the transition is immediate: a brief passage leads

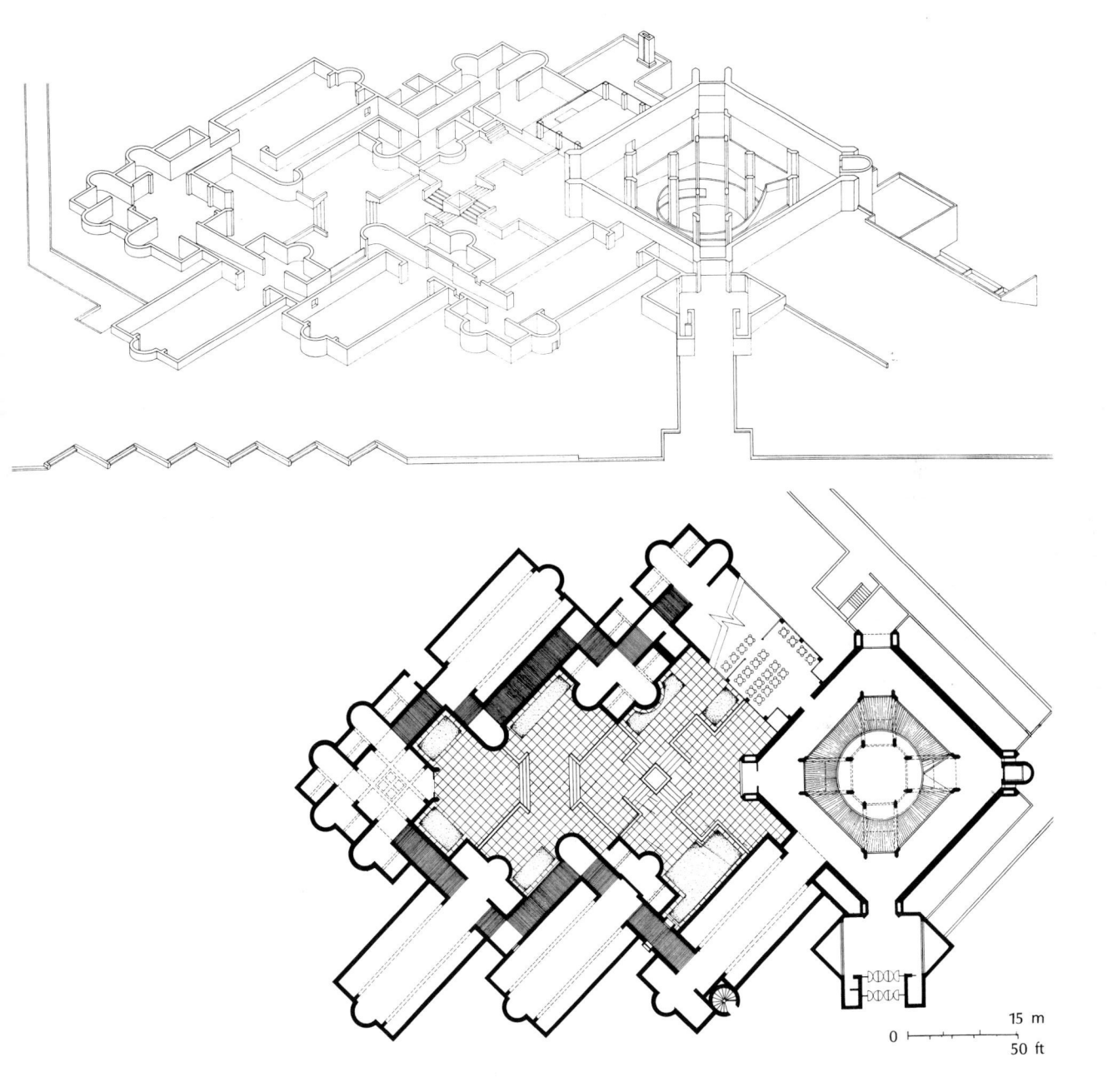

Aerial view of the Museum, clearly showing the characteristic fenestration oriented to the north-east

Axonometric and plan

to Gallery 1, which in turn communicates directly with Gallery 2 and, through glass doors, with the sculpture court. Gallery 1 is at the top level of a vertical element that plunges underground to the lowest gallery level and is the fulcrum of the building. The main circulation pattern begins at Gallery 2 with a system of low-gradient ramps forming a circuit that links the galleries, from the entrance level at Gallery 2 down to Gallery 9, then up again from Gallery 9

to Gallery 1 at main entrance level. This particular treatment recalls the Iranian bazaar which architecturally absorbs people into a sequence of unfolding large and small spaces in a continuous circulation system. A feeling of compulsion, inherent in such a pre-determined itinerary, is relieved by numerous openings in the walls, directed both inside and outside the building, and by connecting Gallery 5 to the central open court.

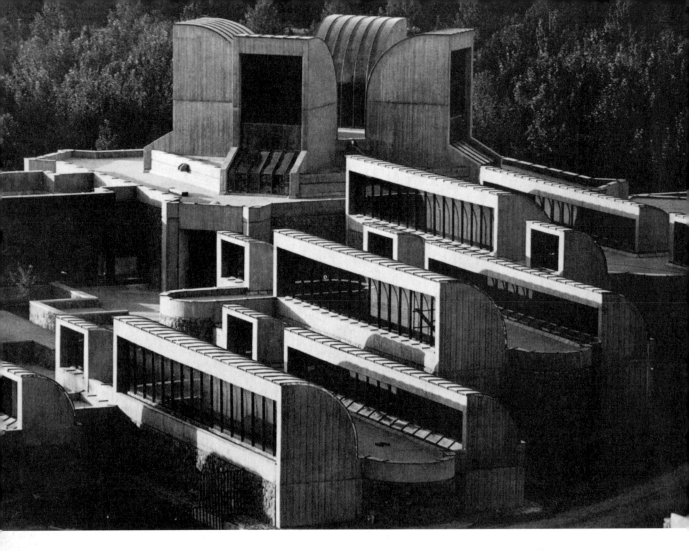

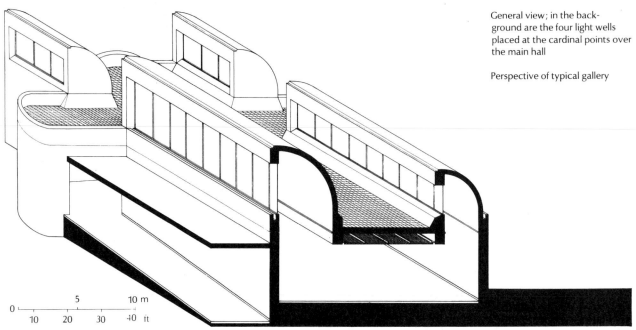

General view; in the background are the four light wells placed at the cardinal points over the main hall

Perspective of typical gallery

0 5 10 m
10 20 30 40 ft

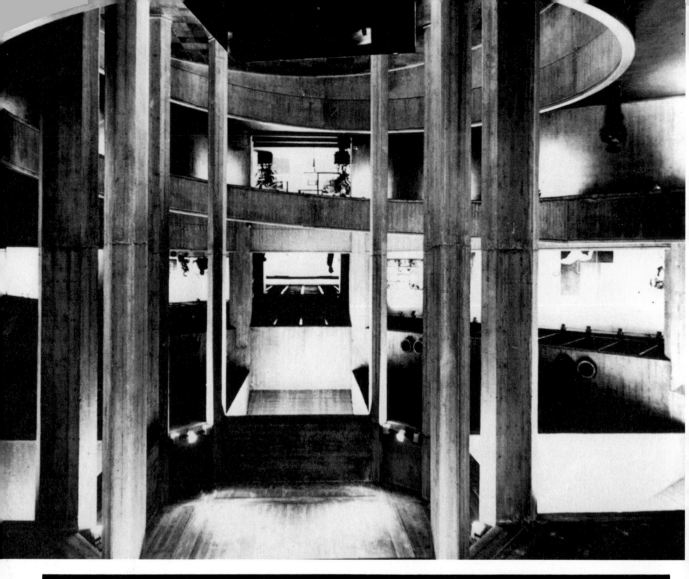

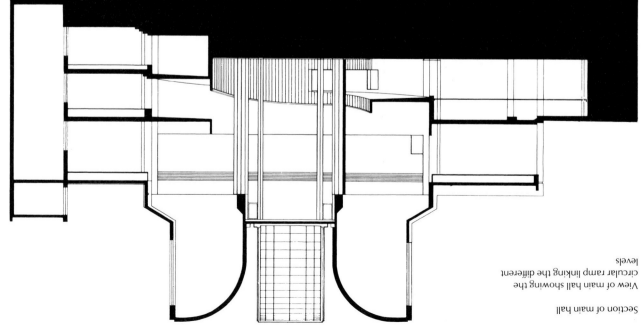

View of main hall showing the
circular ramp linking the different
levels

Section of main hall

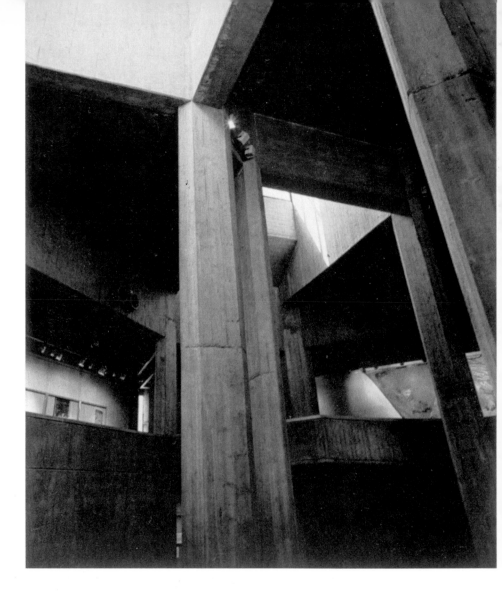

Looking upwards to the light wells

Fish-eye view from main hall; on foreground is the oil and steel sculpture by Haraguchi with reflections of the windows from the light wells above

The most important effect of this particular system of horizontal planes is the utilization of direct and reflected light coming from the same direction. Inspired by the characteristic ventilation towers of traditional local architecture, the 'baad-geers' (literally: 'wind-catchers') the designers created the architectural shape of the four light wells that are placed over the four corners of the vertical element of the building, symbolically facing the cardinal points. By repeating the basic shape on a smaller scale, and also by developing it into long galleries, the architects obtained a system of staggered fenestration based on a working principle similar to that of the 'baad-geers': the north-east light, 'caught' by means of the window, is directed by the curved shape of the light well inside the gallery, while the south-west light falling on the copper-clad light wells outside is reflected towards the windows. The quality of natural light in the galleries is therefore controlled as far as possible, but artificial lighting

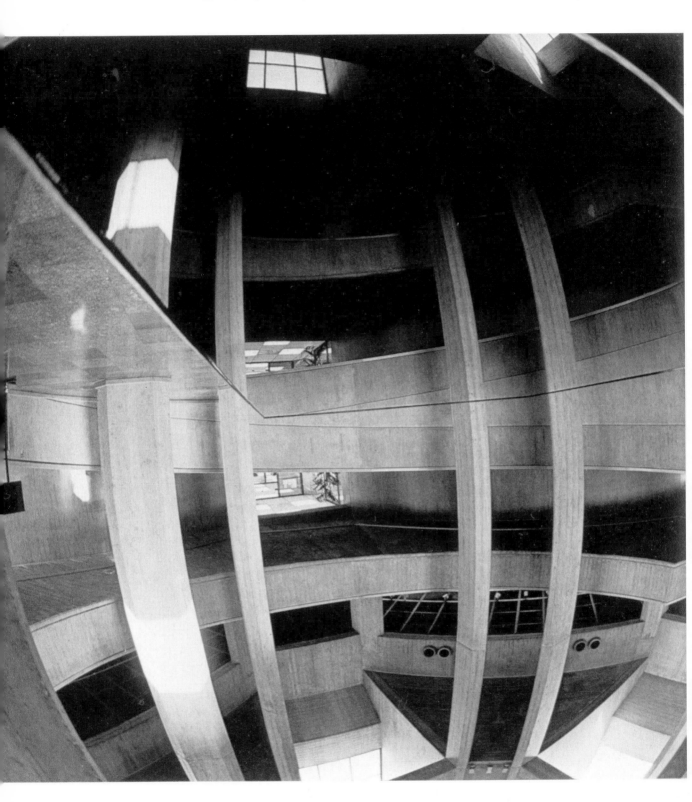

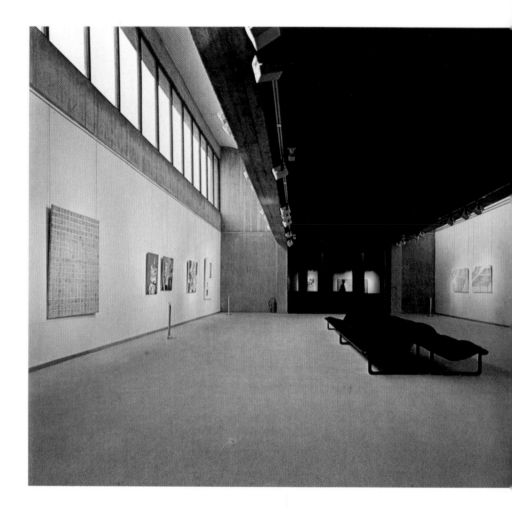

One of the exhibition galleries;
note the position of the windows
which guarantees that natural
light is reflected by the wall
above the low central ceiling

View from Gallery 5 across the
central court; in the background
are the four light towers

supplements and occasionally substitutes
natural light sources, as for example in Gallery 9.

The declivity of the central open space is
negotiated by a series of varying floor levels,
connected by a symmetrical pattern of steps.
The roofscape becomes available and accessible
at this point, and acquires a visual reference to
the vernacular roofscapes of traditional Iranian
architecture, translated into a functional and
contemporary idiom. As an open air transition

between Gallery 1 and the underground gallery
circuit, this space could be aptly described
as the lungs of the building. A permanent
collection of sculptures is exhibited there, and
open air festivals of theatre, dance and music
are also held. Construction is in situ concrete on
stone walling, complemented by plate and
mirror glass. All service ducts are placed above
metal tracking on ceilings. Total floor area is
7000m² (75,300 ft²) and exhibition wall space is
2,500m² (26,900 ft²).

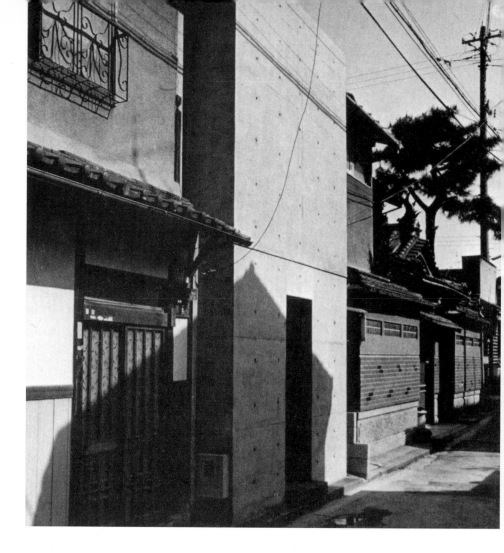

The Azuma Residence in Osaka, Japan

architect:
Tadao Ando

photography:
Tadao Ando Architect
and Associates

In an urban context, this house symbolises an isolated unit of the traditional timber row-house called 'nagaya', a comparatively low-cost urban housing form where a series of small dwellings, 3–5m × 15m on average, share common party walls and a continuous communal roof, but have individual entrances normally opening directly onto the street. A very popular form of housing in the past, the nagaya began to decline during the reconstruction period following the second World War and is now rapidly disappearing.

The plan of the old house that stood on the site before re-construction shows a cluster of rooms occupying the front portion of the first level, while an open court is left at the back of the house; on the second level, an open space is enclosed between two symmetrical rooms. In an attempt to express the spirit of the traditional concept in a modern house, architect Tadao Ando decided to emphasize the centrifugal effect of this inner open space, which now cuts through the entire section.

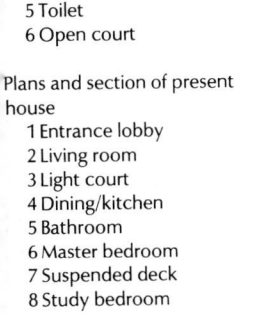

Outside view; the house re-
places the central section of a
three-dwellings nagaya, and
occupies a site of 57m² (610 ft.²)

Plans of the original house
1 Entrance
2 Dining/kitchen
3 Storage
4 Tatami
5 Toilet
6 Open court

Plans and section of present
house
1 Entrance lobby
2 Living room
3 Light court
4 Dining/kitchen
5 Bathroom
6 Master bedroom
7 Suspended deck
8 Study bedroom

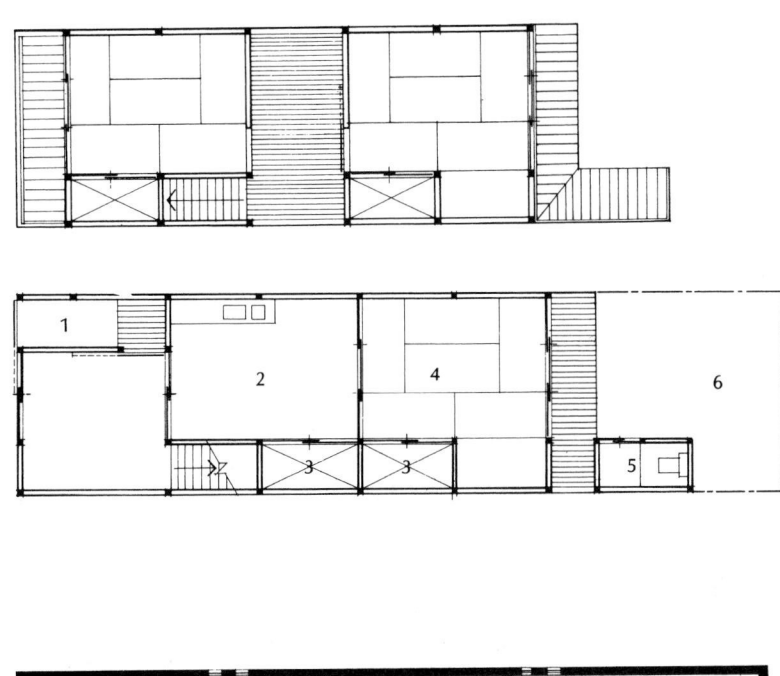

Looking towards the main entrance lobby from the living room

The first evident result of this decision is a clearer, more efficient plan: rooms are larger and better organized. But the effect of the change acquires a deeper significance when one considers its influence on the everyday activities of the inhabitants. The central court becomes an indispensable element of communication, linking directly the two living spaces at first level and, by means of a suspended deck, the master bedroom with the study bedroom at second level. In the total absence of windows on all external elevations, the open area acts as an intermediate space between interior and exterior and provides the only contact with the world of nature represented by air, light, wind and rain, which in turn play an important role in determining the use of the spaces opening onto the court. It is through this rather unique space that the elements of nature become part of the home and are inextricably bound with the ordinary acts of daily life.

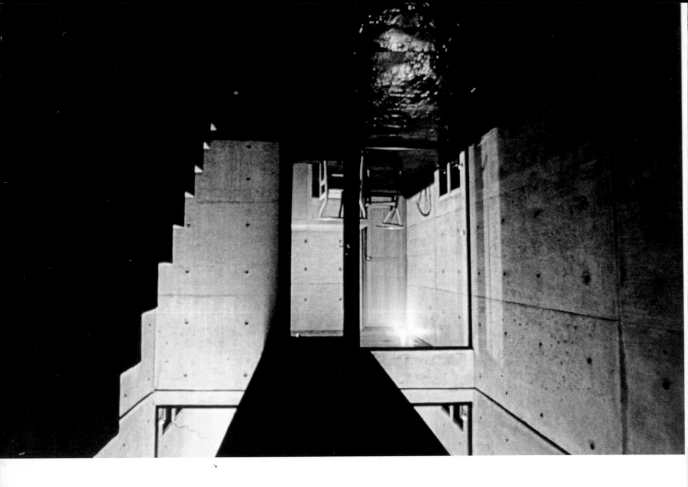

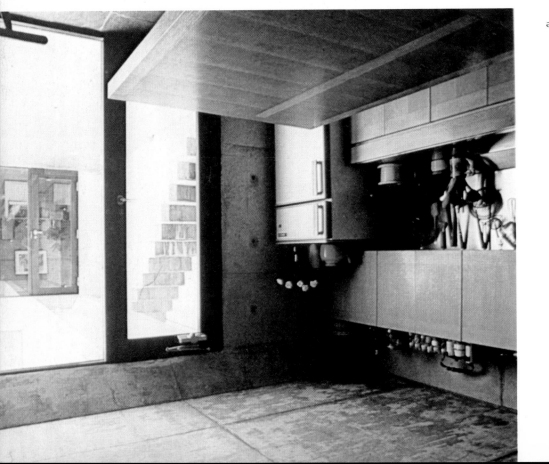

Looking towards the light court from the kitchen area

View of the dining area from the light court; note the suspended deck that provides shelter from the weather, and the stairs leading to the upper level

The master bedroom

View of the upper deck linking
the two bedrooms

The structure of the house is of site cast,

The expression of the architectural idea, however, is in marked contrast with tradition. The architect's main intention was for the solid mass of this enclosed building to stand in relation to the neighbouring nagaya as an example of conceptual art. It is meant to provoke fresh thinking in terms of urban living which, in the opinion of the architect, should be influenced by tradition but expressed in a direct, uncluttered manner suited to contemporary lifestyles.

reinforced concrete construction, with working seams and formwork bolt-holes left exposed, both outside and inside. Floors are covered with slate tiles, on the first level, and timber strips on the upper level. The choice of furniture reflects the same principle that inspired the architectural design: practical yet elegant. Solid wooden containers and tables are complemented by early dining chairs by Hans Wegner, a designer whose formative years were devoted to the study of the traditional furniture of rural Denmark. His chairs look in perfect harmony with the proportions of these Japanese spaces.

Looking from the master bedroom across the deck leading to the study bedroom

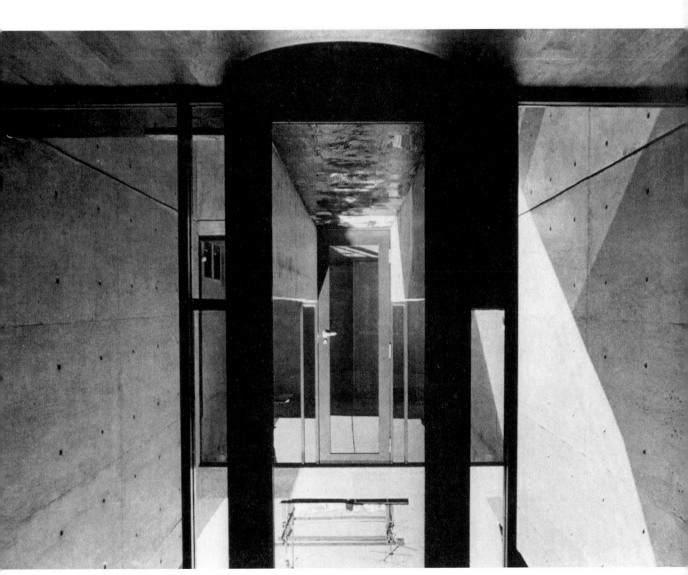

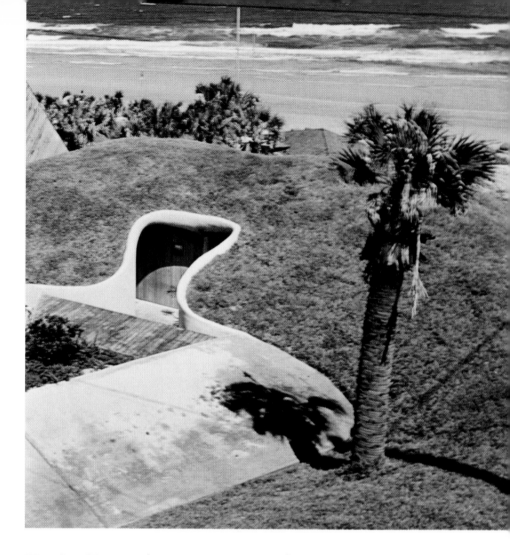

Twin Dunehouses at Atlantic Beach, Florida, USA

architect:
William Morgan Architects
photography:
Creative Photographic Service
Alexandre Georges

The idea of building underground dunehouses along the beach originated from a desire to preserve the characteristic landscape for the neighbouring houses, built above ground to the north and south. However, the outstanding solution reached by William Morgan offers fresh argument in favour of those architects and ecologists who, concerned with the preservation of our physical environment, question the assumption that all domestic architecture should be built above ground. Also, the extent of coastal dune formation in this particular area would permit a large scale development without detracting from the original nature of the terrain – an important consideration at a time of increasing density of land use.

Each apartment contains 70m² (750 ft²) of interior space within a shell of Gunite, a cement mixture without aggregates normally employed for building swimming pools. The shape of the shell was designed by computer on a three dimensional coordinate system, and relies on sand backfill to post-tension the concrete for structural strength and stability.

A concrete drive leads to entrance to both units, recessed into the earth

Site plan

Computer analysis of structural shell

Plan
1 Entrance
2 Bathroom
3 Sleeping balcony
4 Kitchen
5 Living area
6 Terrace

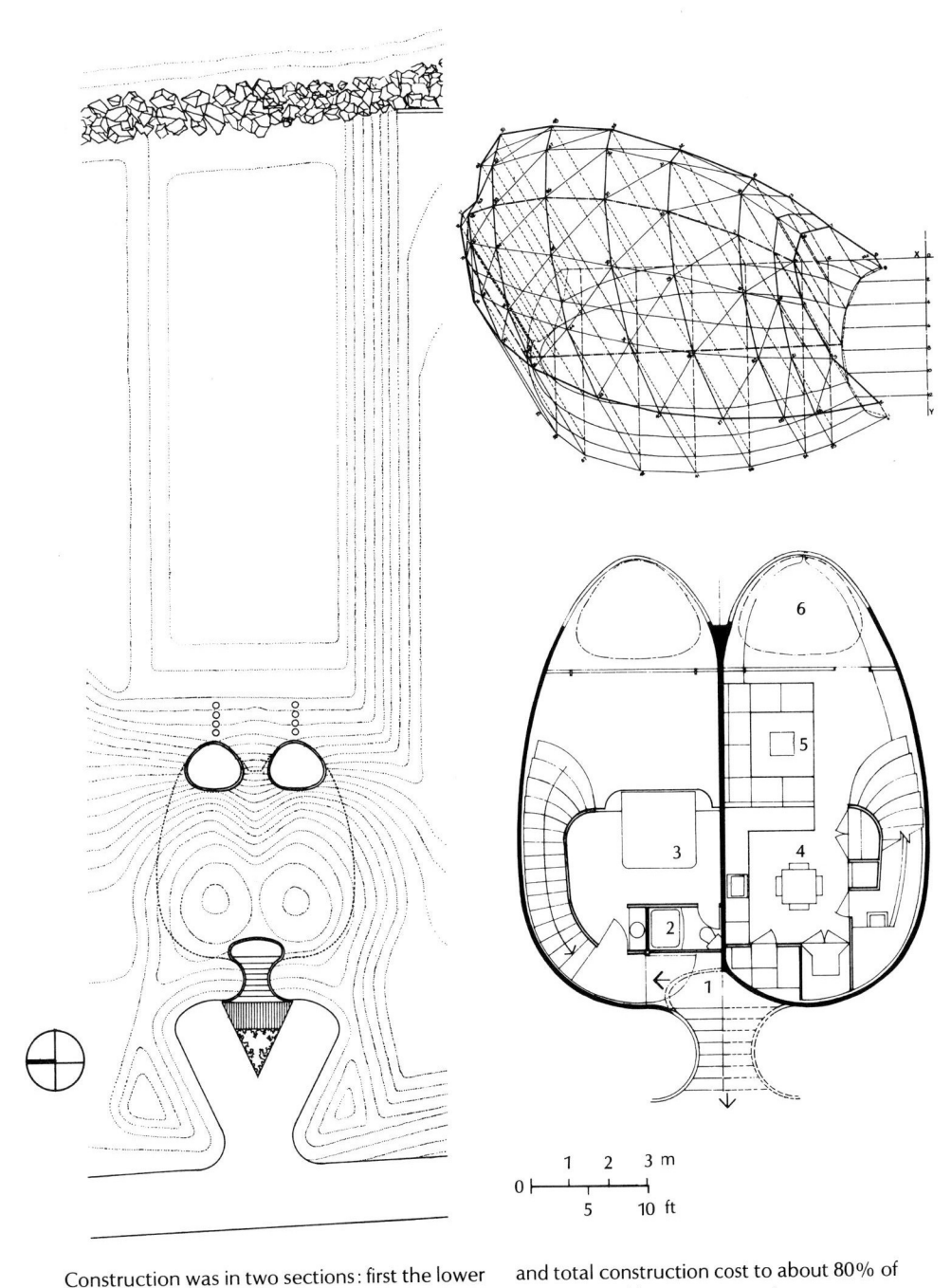

0 1 2 3 m
0 5 10 ft

Construction was in two sections: first the lower part of the shell was installed within the excavated dune; reinforcing steel rods, inserted in the shell, were bent to the shape of the roof; then the 100mm (4″) thick Gunite roof was applied over a plaster mesh. After two weeks the structure was waterproofed, the excavated sand replaced and green turf and vines were planted on top. Multiple shells could be built more economically by spraying a 60mm (2⅜″) fibre-glass reinforced Gunite on air-inflated form bags. This method would reduce shell construction time from six weeks to three days,

and total construction cost to about 80% of conventional frame construction.

The entrance to each apartment is reached from the west, 6m (20′) above sea-level, by a central staircase. From here a small lobby communicates with the sleeping balcony; then one descends a broad stair of increasing width, down to the single living space containing the kitchen and dining area, under the sleeping balcony, and the built-in seating in front of the glazed sliding door overlooking the sea. A small terrace provides shelter and at the same time

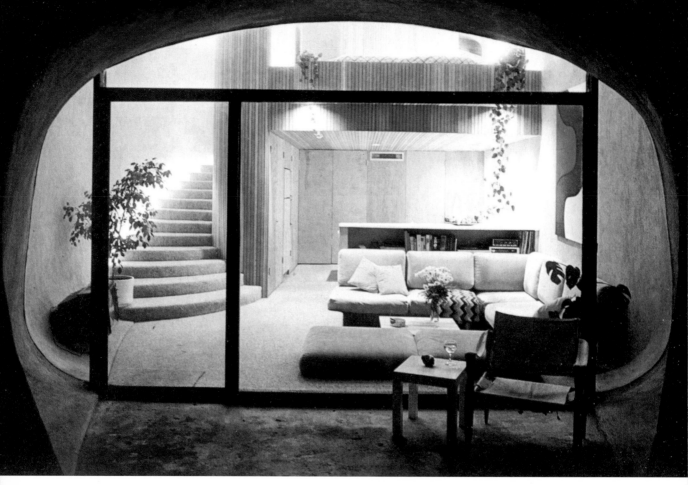

View of the two levels of one
unit

Section of the two units, facing
the ocean
 1 Storage
 2 Sleeping balcony
 3 Kitchen
 4 Living area

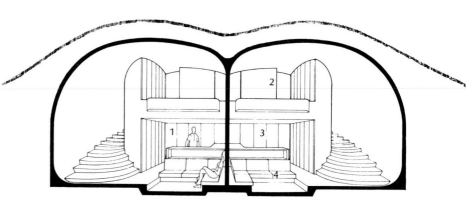

expresses the architect's intention of inviting the
sea as near the house as possible. From the
characteristic circular opening near the base of
the dune, stepping stones lead directly on to the
beach.

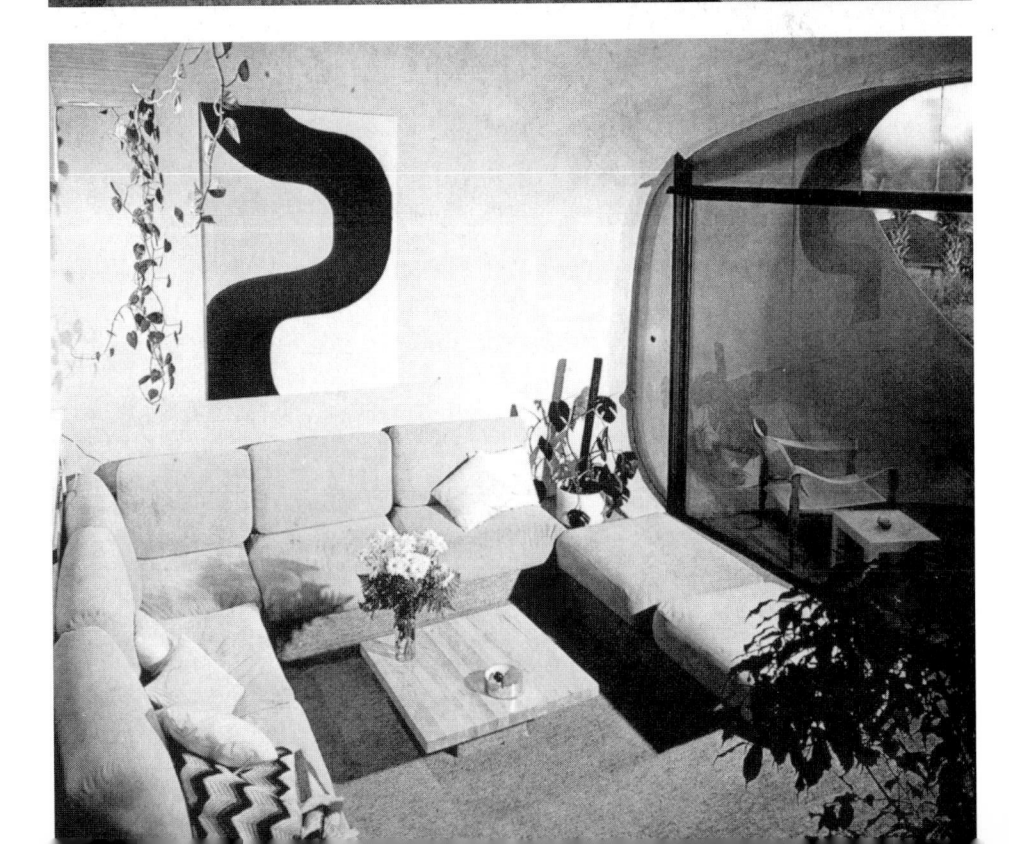

Detail of kitchen/dining area
beneath the sleeping balcony

The living area; to the right is
the glass door to the terrace

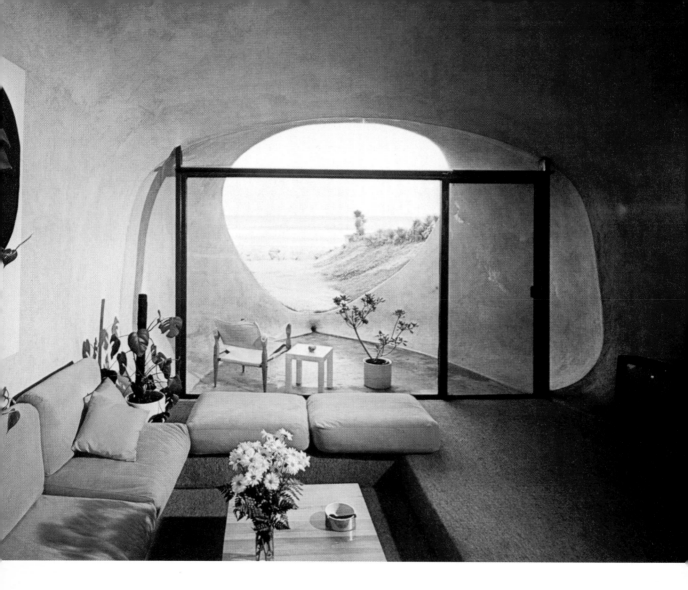

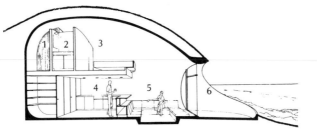

View from the sleeping balcony

Section of one unit
1 Entrance
2 Washing counter
3 Sleeping balcony
4 Kitchen
5 Seating area
6 Terrace

View of the twin terraces from the ocean side

The interiors express the contrast between the bearing concrete shell and the non-bearing timber structure. Wooden stair edges and partition tops are held away from the bearing shell to emphasise the architectural intent; this is further accentuated by concealed cove lighting. Such clarity of idiom plays a significant part in the feeling of openness that prevails in these structures built within the earth. The air conditioning and dehumidifying plant is operated by water cooled reverse cycle heat pumps. Fuel costs are about half those for conventional above-ground construction, due largely to the thick earth layer minimum 560mm (22″) insulating the concrete shells.

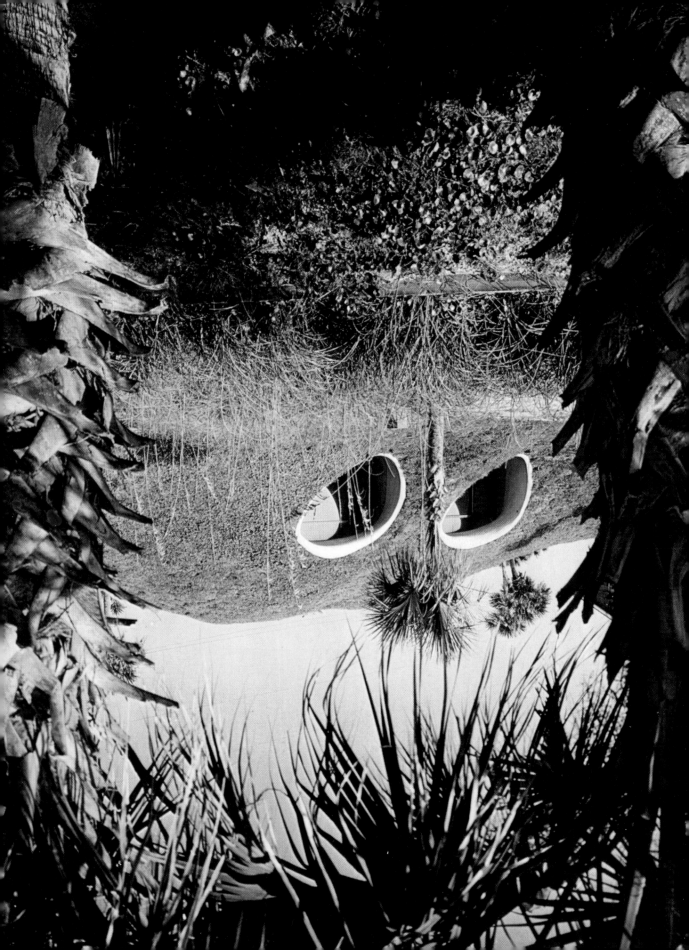

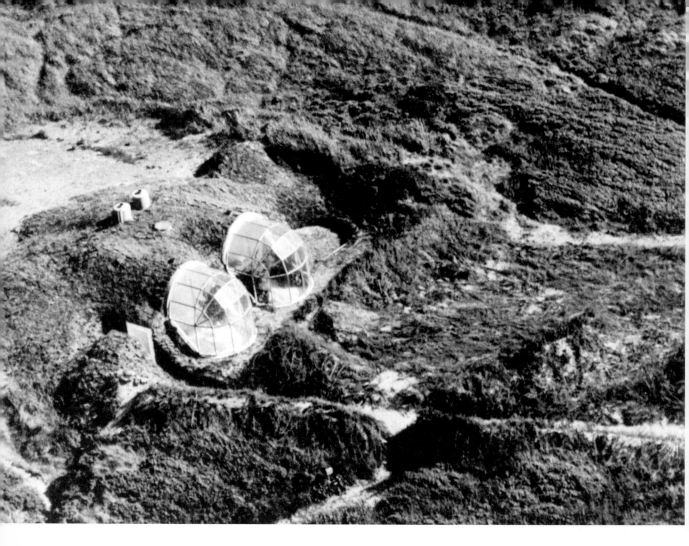

The Vacation House of the Architect in Blokhus, Jutland

architect:
Claus Bonderup
photography:
Hedin
Claus Bonderup

The house is partly built underground, in a remote area of the west coast of Jutland rich in sand dunes covered with thick scrub. The undulations of the terrain practically hide the house from view: only two protruding glass bays can be seen from the beach, like a pair of goggles set in the direction of the sea. A narrow path, leading to one of two entrance doors, and a semicircular terrace were excavated with considerable concern for the natural contour of the land, so as to disturb as little as possible the wild character of the place.

The formula of a twin space projecting from a structural shell – a favourite idea of Claus Bonderup – presents some interesting variations in this project. Firstly, the twin space is contained within the dune with the exception of the extreme tips emerging above ground. The plan is then intersected by the alignment of the two entrance doors with a small central lobby. This creates a circulation pattern that acquires somehow the function provided by the traditional corridor: the kitchen and the dining areas are clearly separated, although they are both part of a single space, and might well

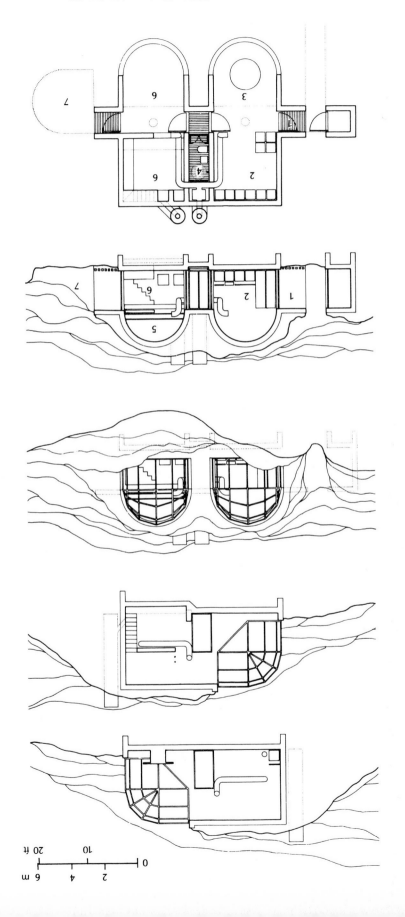

1 Entrance
2 Kitchen
3 Dining
4 Bathroom
5 Sleeping balcony
6 Living area
7 Terrace

Sections and plan

An aerial view of the dune-
house in its wild surrounding

0
10
20 ft

0
2
4
6 m

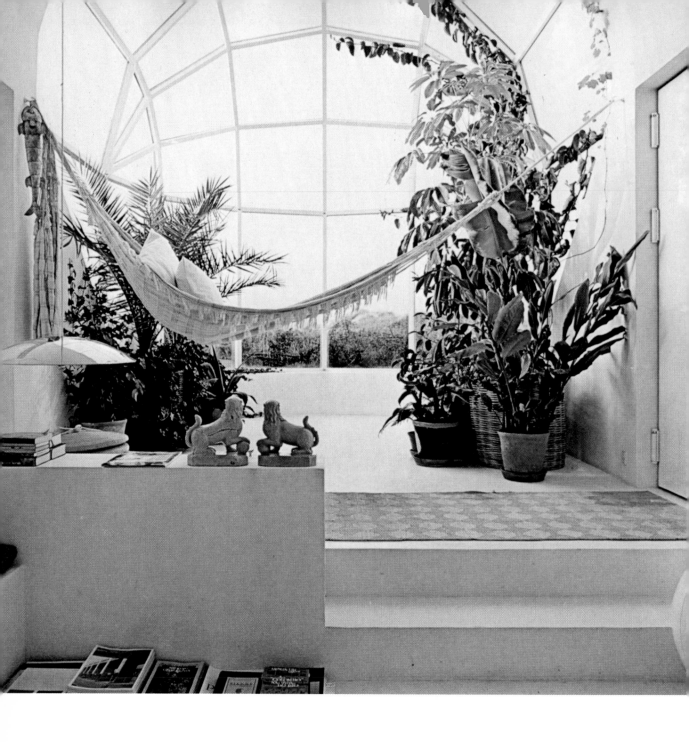

A view of the living area as seen from the sunken conversation area. The door to the left opens onto the terrace

be construed as an example of psychological space. When all doors are open one can walk across the entire house, from footpath to terrace; by closing the central lobby doors, the twin spaces become independent of each other.

The underground section of the building is a concrete shell with a vaulted roof to support the weight of the sand; the protruding bays are light structures of steel and glass. A central service core contains air conditioning and heating plant and the bathroom. In contrast with the kitchen and dining area, the lounging and sleeping areas were obtained with more structural means. By dropping the floor level at the back half of the space the architect obtained sufficient volume to construct a sleeping balcony over a sunken conversation area. Another structural element,

The conversation area and
the sleeping balcony as seen
from the glazed bay

A detail of the sunken conver-
sation area

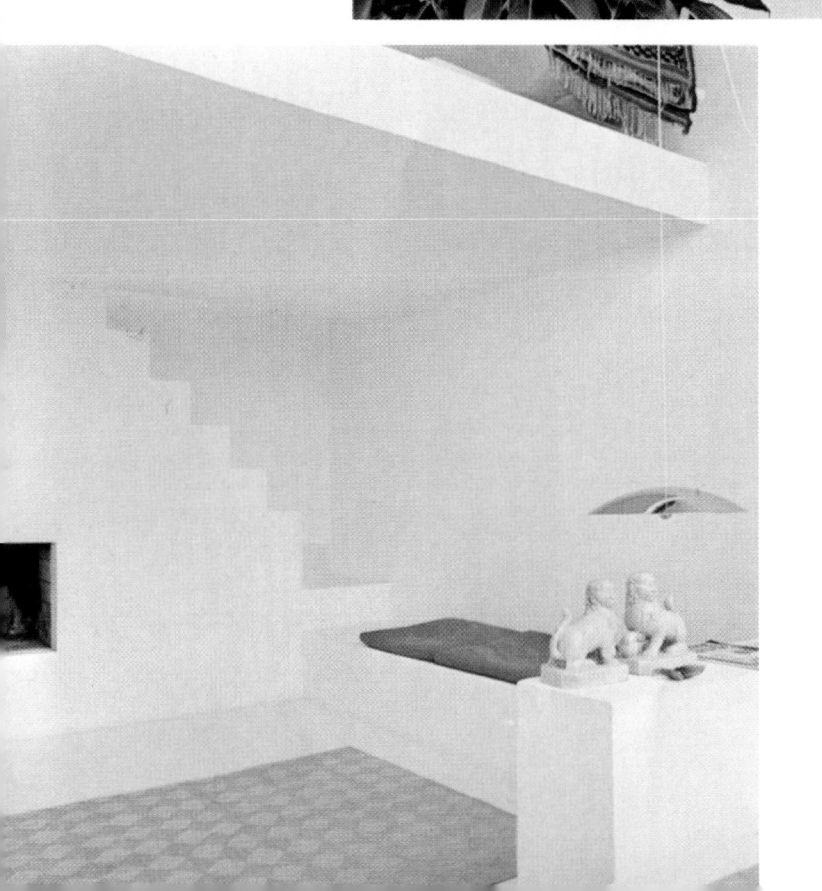

against the back wall, incorporates a neat
fireplace for the conversation corner and a flight
of steps leading to the sleeping balcony.

The furnishing is closely related to the
architectural space, and designed to focus
attention onto the landscape beyond the glass
bays. Note how a free standing cupboard placed
to the left of the entrance door helps to define
the kitchen area. A pale grass matting along the
passage way across the house emphasizes the
circulation pattern; and the built-in storage,
shelves and seating enclose the conversation
area. Furniture, walls and floors are painted
white, with a few vivid rugs to highlight the
calm, serene setting. A most important element
of decoration is given by the numerous semi-
tropical plants that thrive in the even northern
light, and in the heat provided by the ducted
warm air system. The contrast between the
luxuriant indoor vegetation and the wild scrub
outside enhances the originality of this project.

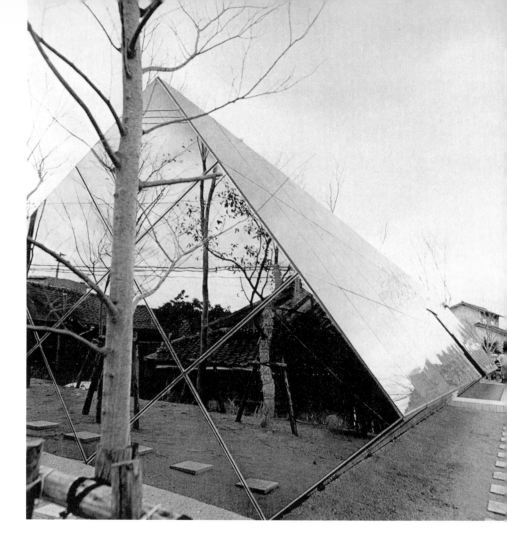

The Ingot – A Coffee Bar
in Kitakyushu, Japan

architect:
Shoei Yoh
photography:
Yoshio Shiratori

At first sight, the unusual appearance of this coffee bar leaves one rather perplexed. It looks like a scaled-down model of a skyscraper which, having been dropped on its side, had begun to sink slowly and inexorably into the earth until some mysterious underground obstacle arrested its progress, saving it from total burial. We are in effect observing the result of an ingenious combination of modern technology and basic engineering, that generates its own special type of beauty; an alluring beauty, deriving directly from the optical porperties of industrial glass.

A structural frame of 100mm × 30mm (4″ × 1¼″) steel joists on a concrete platform is entirely covered with Thermopane, a sandwich of two 5mm ($\frac{3}{16}$″) thick glass sheets with a 5mm ($\frac{3}{16}$″) air space fixed externally to the frame with a low modulus silicone mastic to allow for differential expansion and water-tightness. The inner sheet of glass is clear; the outer, a solar heat reducing mirror glass, has a chromium coating that gives it a highly polished and reflecting surface without complete loss of transparency.

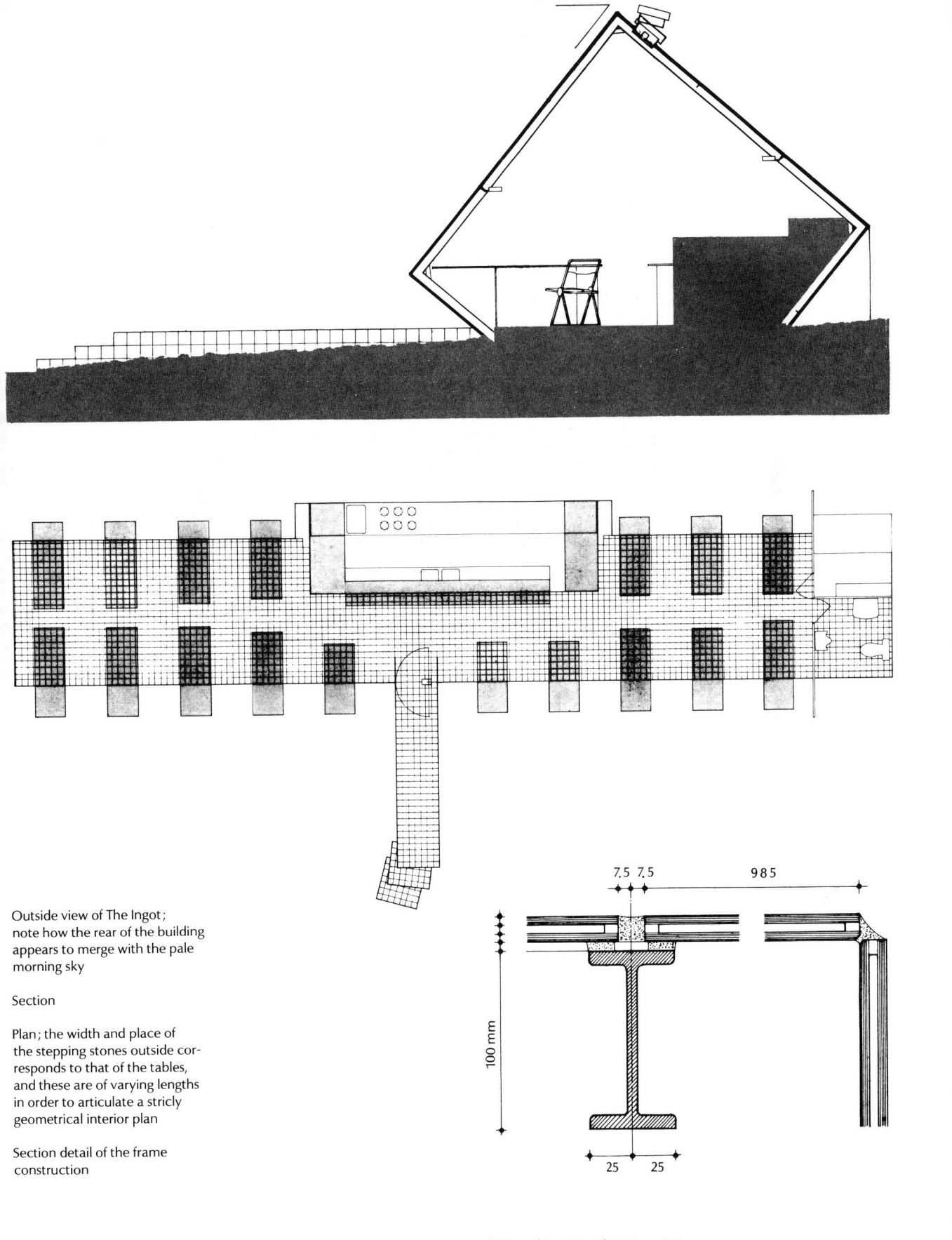

Outside view of The Ingot;
note how the rear of the building
appears to merge with the pale
morning sky

Section

Plan; the width and place of
the stepping stones outside cor-
responds to that of the tables,
and these are of varying lengths
in order to articulate a stricly
geometrical interior plan

Section detail of the frame
construction

7.5 7.5 985

100 mm

25 25

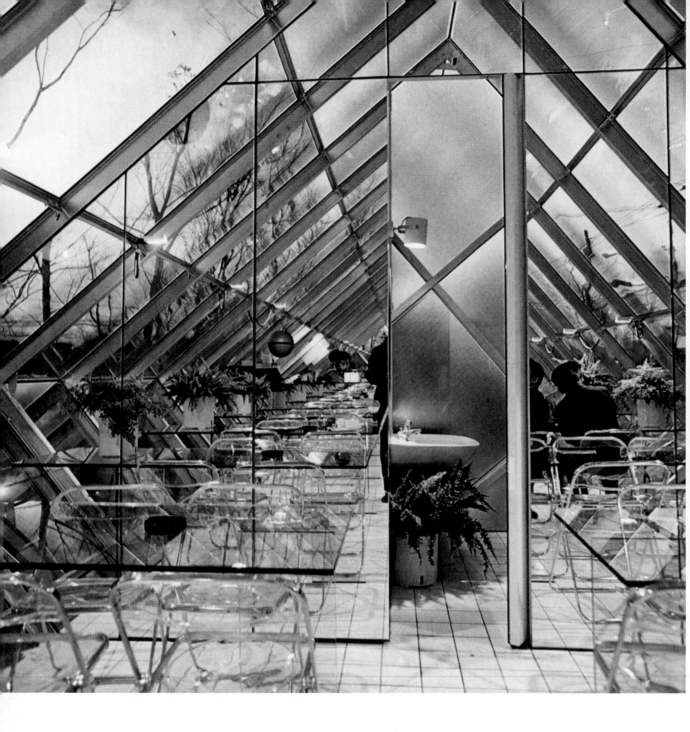

The open door to the cloak-room; the wall is chromium coated like the outside of the building, and reflects the entire length of the inner space

The most intriguing effect of this logical and efficient concept is that the building acquires an uncanny dynamism. During daytime it plays a passive role, giving no hint of activity behind its facade that, like a huge mirror, reflects the sky and the surrounding trees. But as night sets in the whole structure comes slowly to life and the bright interior shines with a soft glow through the glass. A strong blue light illuminates dramatically the tiled pathway leading from the

road to the entrance, and contrasts sharply with the white tiled floor and the glass interior.

The reverse seems to happen inside: the transparency is absolute during the day, but diminishes as darkness approaches. Only reflections are always present with endless variations, giving the illusion of new spatial dimensions as the pitched roof is reflected on the glass tables, or the Perspex and steel chairs

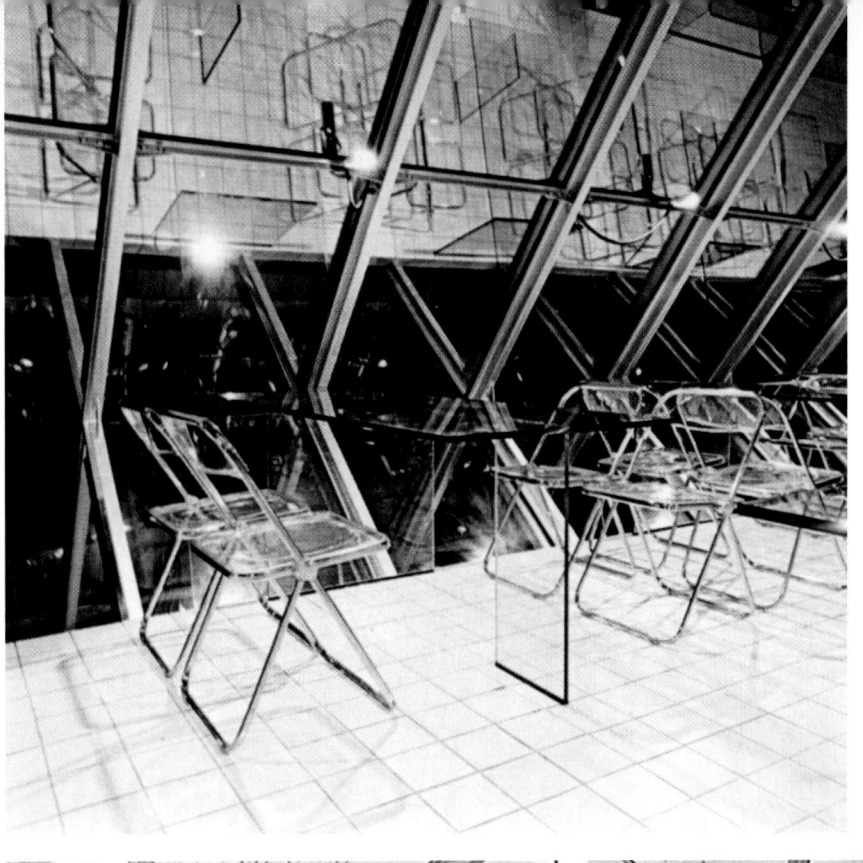

Detail of tables, made of plate
glass panes glued with a special
adhesive

The pitched roof mirrored
onto the glass tables

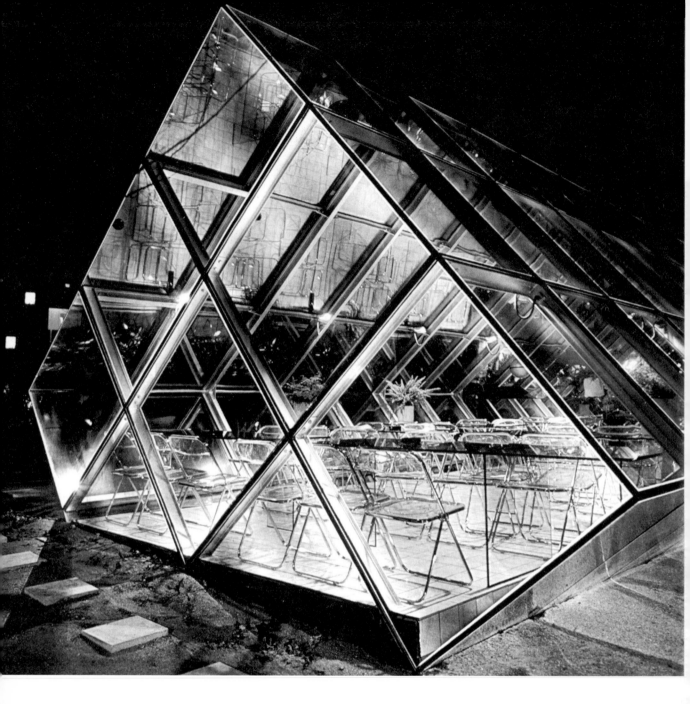

Detail of the building at night;
compare with illustration no. 80

Night view: contrasts of light
and colour

are repeated ad infinitum on the slanted wall
surfaces. Any artificial element of decoration
would be out of place in such an interior; but
series of delicate green ferns are arranged along
both sides of the long space, and pick up the
subtle shades of green and blue of the glass
planes. The tables, designed by the architect, are
glass panels fixed together with Photobond 100
adhesive, used experimentally by Shoei Yoh for
some time (see, among others, *Decorative Art
and Modern Interiors 1978*, pp. 178–179). The
Italian 'Plia' chairs designed by Giancarlo Piretti
for Castelli, look absolutely right in this setting.

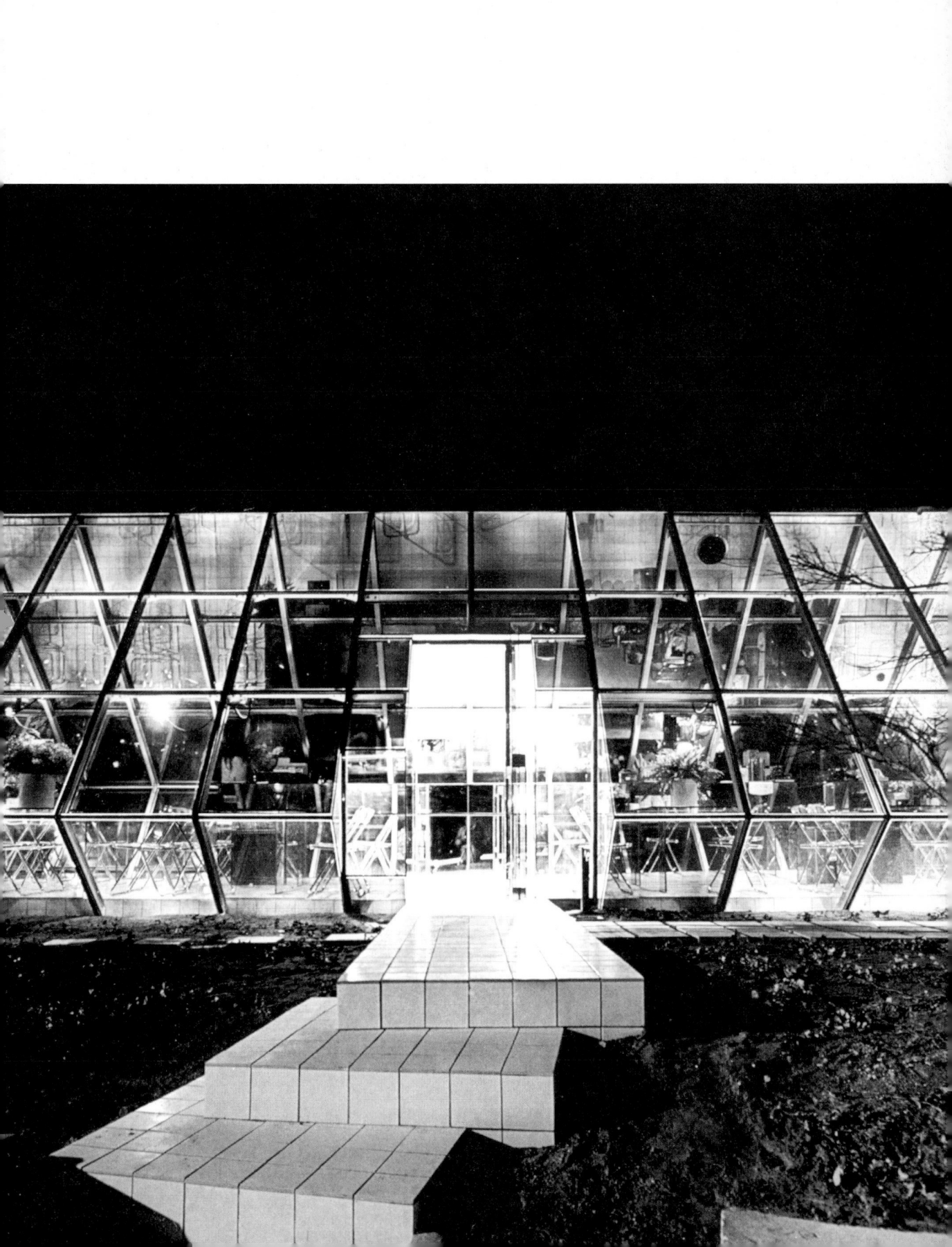

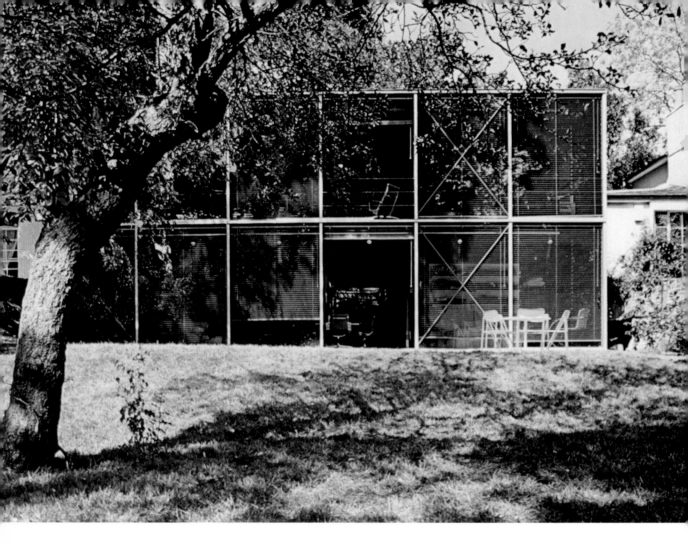

Hopkins House, Hampstead, London, England

architect:
Michael Hopkins
photography:
Tim Street-Porter
Michael Nicholson

An attempt by a property developer, to utilise commercially every square foot of an attractive site in the conservation area of Hampstead, was fortunately thwarted by one of those circumstances colloquially described as 'a down turn in the market': the developer had to sell the site, architects Michael and Patricia Hopkins bought it, and the planning authority, who regretted the previous consent to build two four-storey houses, gave eventually permission for a single, two-storey house of steel and glass.

The site, of 15m (49 ft) frontage with a deep garden, is in a comparatively low density street with graceful, early 19th century houses surrounded by trees – an improbable setting for a steel and glass building, one might suppose. But the architects took to their task with remarkable clarity of purpose, in a direct, uninhibited manner.

They wanted a house that could be occupied at minimum completion stage, so that details of the brief could be discovered while living in it. They needed a flexible house, that would respond to the

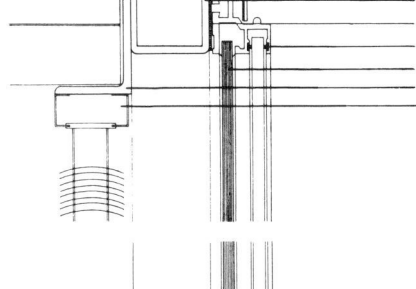

Glass wall head detail

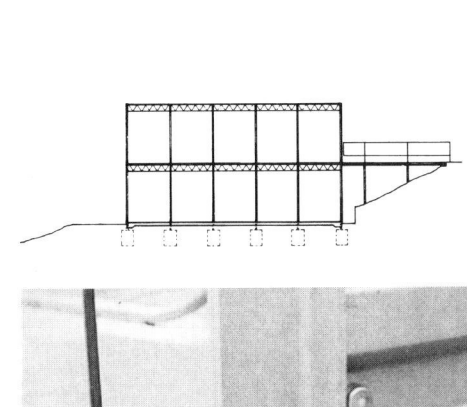

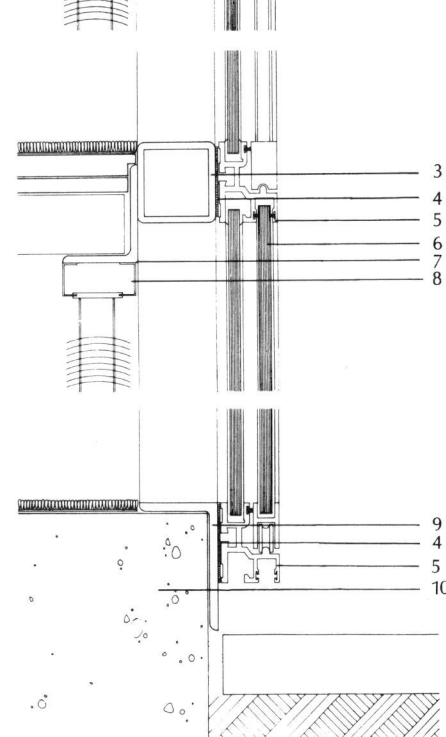

Glass wall intermediate cill

Glass wall base detail

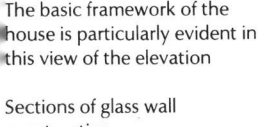
The basic framework of the house is particularly evident in this view of the elevation

Sections of glass wall construction

1 10 × 6mm aluminium plate
2 43 × 43mm aluminium angle
3 63.5 × 63.5 × 4.9mm Rolled hollow section
4 Isolating tape
5 Extruded aluminium glazing section
6 10mm toughened glass
7 80 × 60 × 6mm steel angle
8 Venetian blind
9 100 × 64 × 7mm Steel angle
10 Concrete base slab

Section A-A

Detail of frame construction at ground level

Detail of roof construction

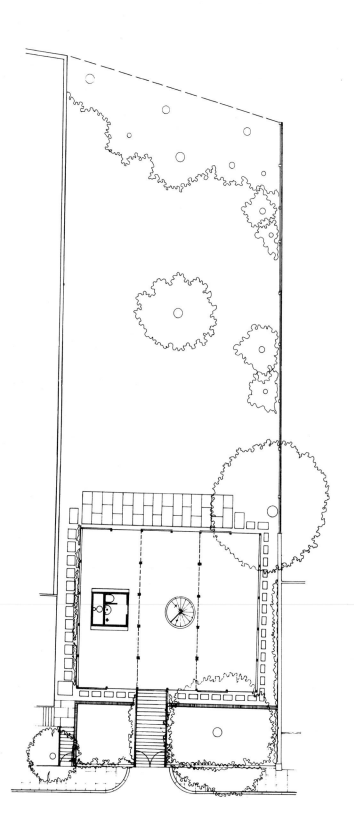

changing needs of two professional parents and their three young children. Thus the upper storey, at street level, would initially be used as a studio for the parents' architectural practice while the lower storey, opening onto the garden, would be the family home. As the children grew older, the studio could be moved somewhere else and the house would be separated into parents and children's flats.

As can be seen, a great deal of experimentation was an essential part of this approach. The architects carried this further when they decided to utilise components and technology developed for larger industrial buildings and reduce them to a domestic scale. Finally, by using very simple constructional details repetitively, and by managing the contract with direct labour and specialist subcontractors, they wanted to find out, in their own words, 'how much can we get for how little'. The cost, calculated at the rates current between August 1975, when work was started on site, and April 1976 when the house was first occupied, was just under £20,000 for a building area of 230m² (2,500 ft²) including all internal finishes and fittings.

The structure is a light steel frame on a 4m × 2m (13' 1" × 6' 6") grid with 63mm × 63mm (2½" × 2½") columns and 250 mm (10") deep lattice trusses supporting both the first floor and the roof. The frame is stiffened with 50mm (2") decking to the floor and roof. Apart from the flank walls, made of two skins of profiled metal cladding with fibreglass insulation infill, both the street and garden elevations are completely glazed in 2.7m × 2m (8' 10" × 6' 6") panes, with alternate fixed and sliding panes. A single aluminium section was specially designed to fulfill the different track conditions at eaves, first floor and ground sill levels.

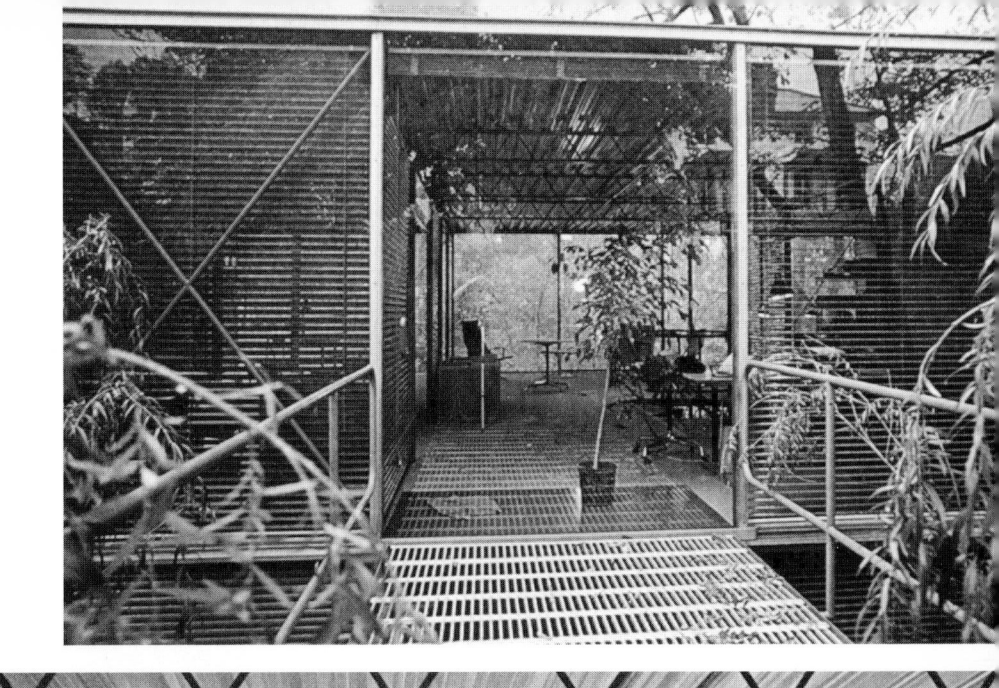

Plans at garden level and at
hill level, and side elevation

Entrance at street level

Light effects through venetian
blinds

A spiral staircase from main
entrance level leads to kitchen
and dining area

Another view of lower level
showing the function of venetian
blinds in relation to the entire
space

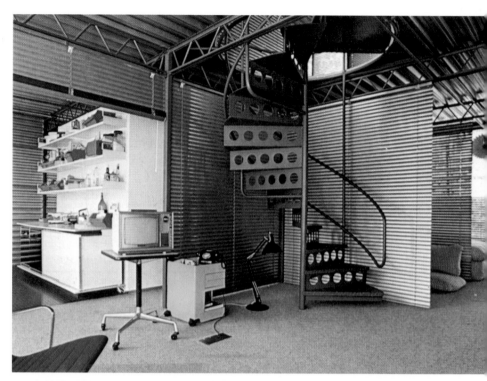

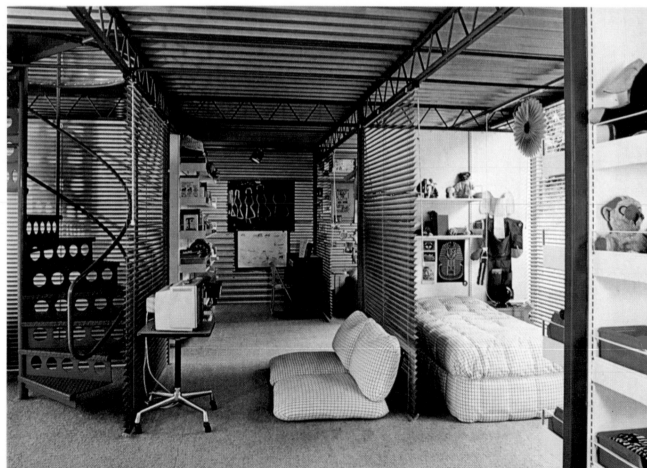

The main dining area

One of two identical bath/
shower rooms, built on a con-
crete platform; walls and ceiling
are of plastic laminate joined
with a silicone mixture; the
shower water comes from an
outlet on the ceiling

Detail of bedroom area

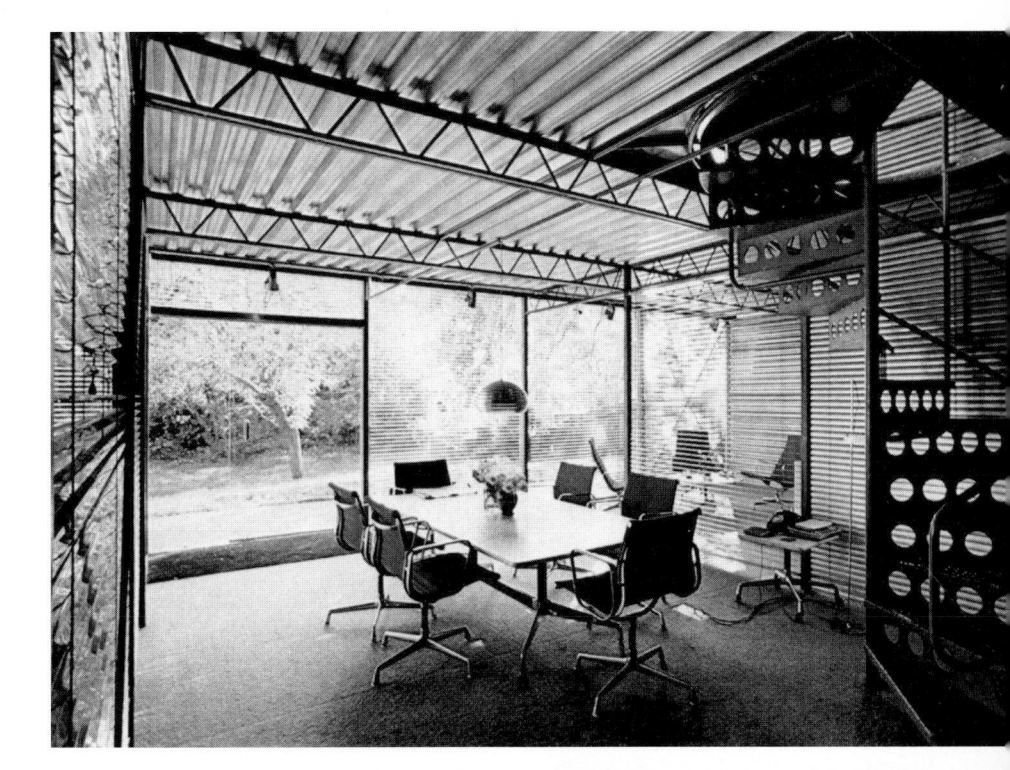

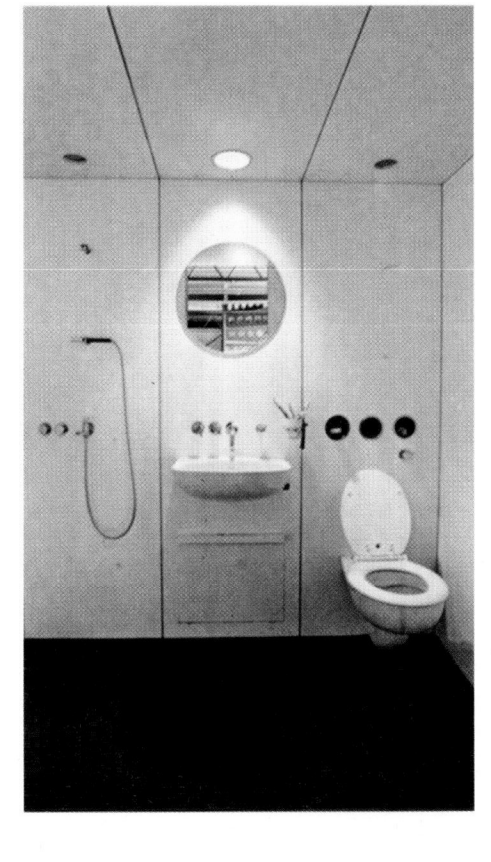

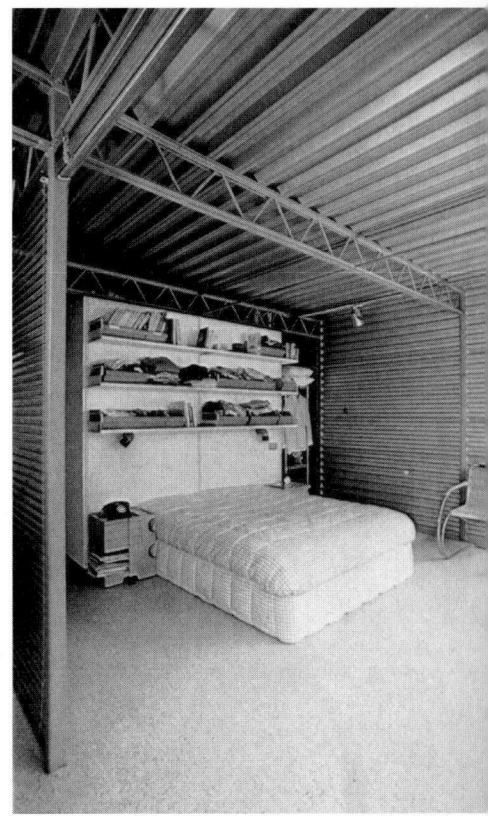

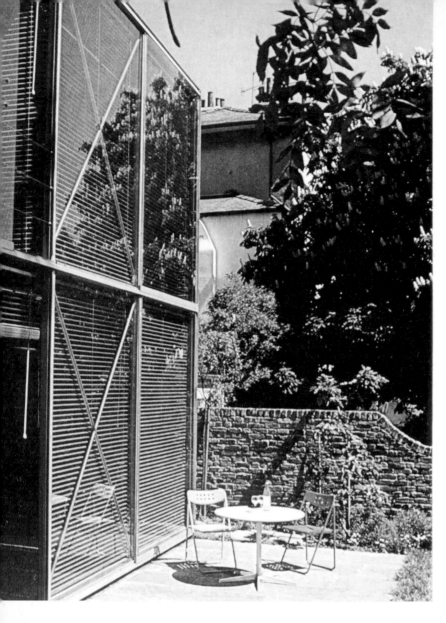

Two views of a paved
area at the back and side of the
house

Corner view showing con-
trasting effects of cladding
and glass wall

The street entrance is approached by a small
bridge over the garden, and opens directly into
the office at the upper floor. With the exception
of three non-structural enclosed spaces, for the
two bathrooms and the kitchen, both floors are
arranged as open plans. Interior finishes are
absolutely minimal: the industrial components
used for the structural grid have been left
exposed, and from the lattice trusses hang
venetian blinds which act as room dividers and
provide complete privacy. A uniform, grey fitted
carpet covers the floor. The furniture is
essentially functional: groups of good chairs and
tables help to define the use of space, but the
conventional wardrobes and cabinets have
been replaced by open shelves and by low
containers running on castors. Lighting is by
spot and floodlights on tracking, supplemented
by floor and table lamps.

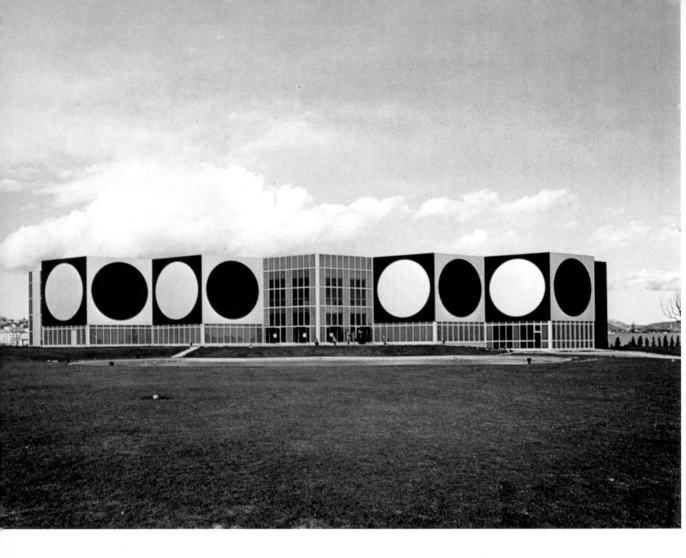

The Vasarely Foundation
near Aix-en-Provence, France

architects:
Jean Sonnier and
Dominique Ronsseray
photography:
Jean-Pierre Sudre
Fondation Vasarely

After searching for a suitable site for more than twenty years, Vasarely has, at last, built a centre for the study of his paintings in relation to architecture. He considered converting several historic buildings, but eventually decided that his avant-garde work would require a purpose-built, advanced building so that it could function with fewer constraints.

Vasarely's conception was to cover the facade of the Foundation with an alternating composition of black and white. The architects Jean Sonnier and Dominique Ronsseray turned this idea into reality. The Foundation stands on the crown of a smooth green mound near Aix-en-Provence. On the entrance front the building is reflected in an ornamental pond, while on the opposite side it is glimpsed through a screen of trees.

The building has to fulfil three main functions: firstly, to bring together forty-two monumental works

Section

Site plan

The front elevation of the
Foundation

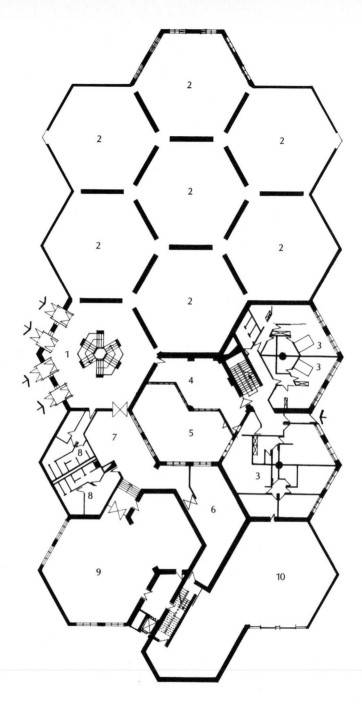

Plan
1 Entrance hall
2 Exhibition of paintings
 related to architecture
3 Staff lodgings
4 Bar
5 Patio
6 Library
7 Foyer
8 Cloakrooms
9 Seminar and lecture space
10 Maintenance workshops

View of the Foundation from
the approach path; the main en-
trance is to the left

in the same exhibition space; secondly, to
provide lecture rooms where the principles
deriving from Vasarely's idea of integrating
painting with architecture can be demonstrated
using models and other audio-visual techniques;
and thirdly, to collect and discuss research into
these principles at conferences and seminars.

The administration rooms, library, archives and
workrooms are all grouped around the
conference room. These, in turn, are closely
linked with the main exhibition hall and the

other public areas. A modular system of
interlocking hexagons expresses the unity of the
various functions of the building on plan.

The modular plan has lent itself well to
standardization of construction. The use of
prefabricated concrete elements greatly
shortened the time of erection. All the structural
framework was standardised and the floor was
constructed by the assembly of prefabricated
triangular units, which were then covered with
grey marble quarried in the Alps.

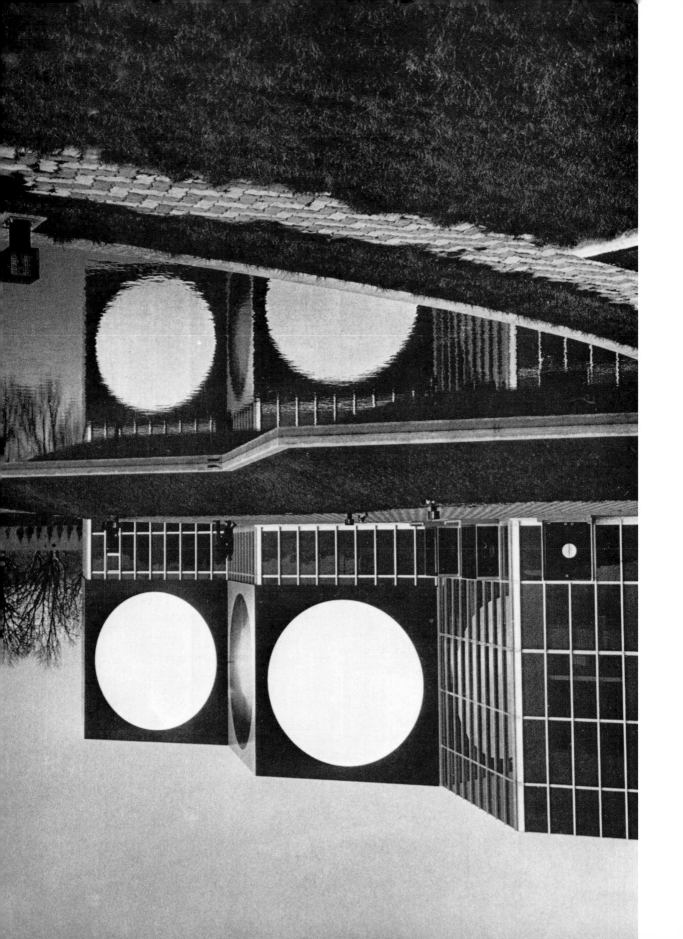

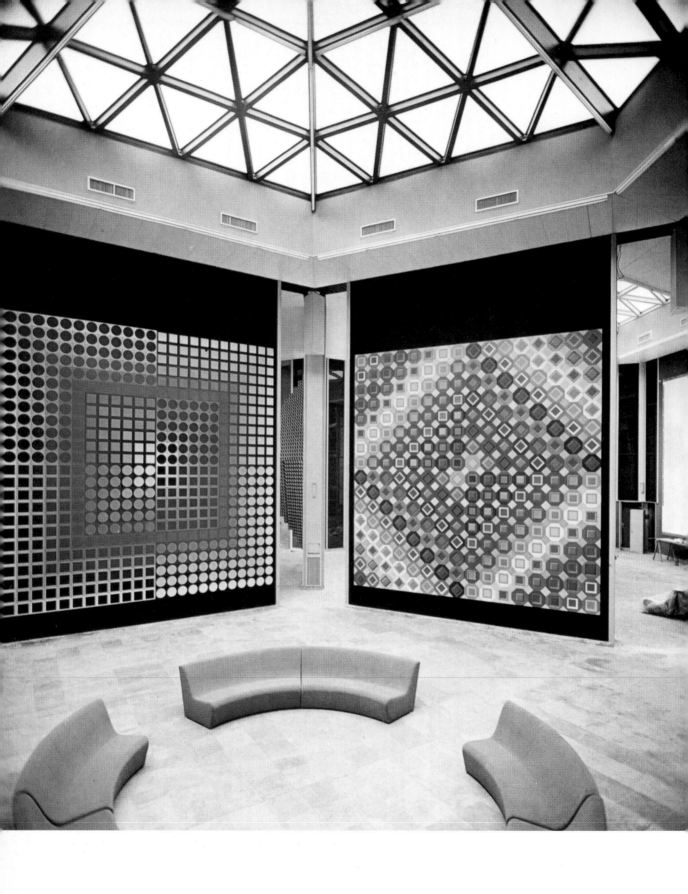

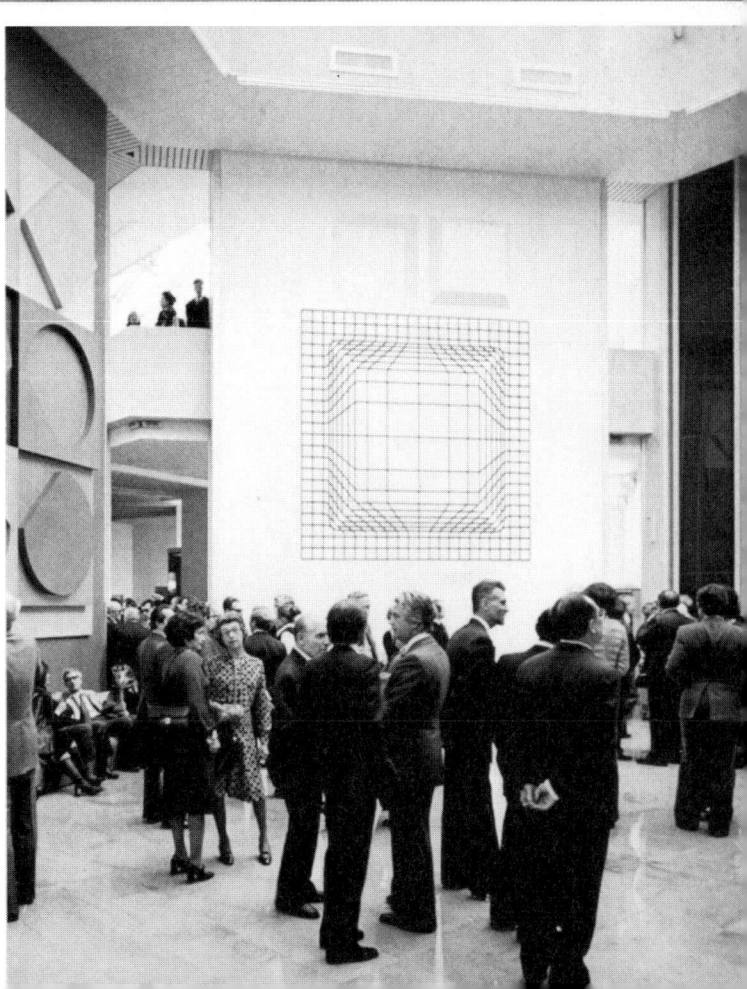

Three aspects of the exhibition space, showing details of the glass domes, left, and the spatial relationship between the cellular elements of the building. The seating system was especially designed by the Belgian designer Emile Veranneman

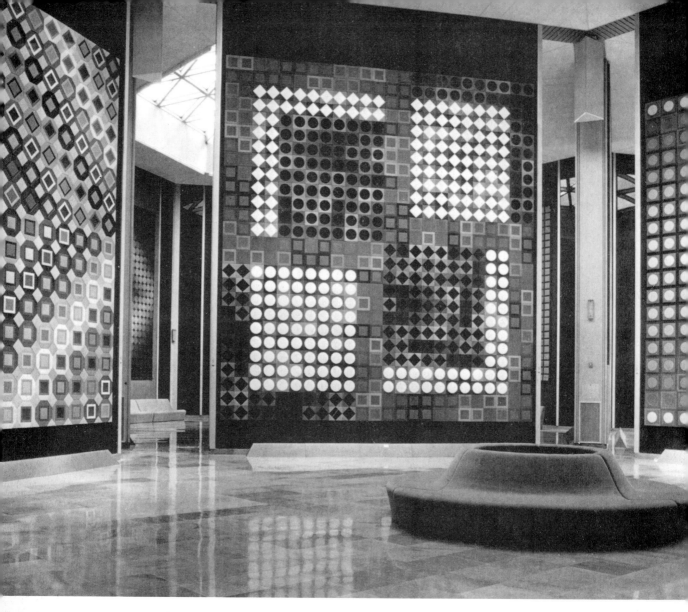

Some of the monumental
Vasarely paintings

Looking at the Foundation
through the trees at the back of
the building

The facade has been created by forming a framework of grey anodised aluminium members which runs right round the building and masks the roof structure. Depending on the function and requirements of the various interiors, it is either fully glazed or fixed to an insulated concrete wall and clad with aluminium. Each of the distinctive black and white panels is composed of 16 sheets of 6mm ($\frac{1}{4}$") gauge anodised aluminium. The panels seem to float above a strip of glazing, which is either opaque or transparent, with the exposed framework forming the mullions and transomes of the windows.

To achieve the required natural lighting the roof structure springs off the hexagons into a pyramidal shape using equilateral triangles of glass in a framework of laminated wood. Each triangle has a side of 1.45mm (4'9") and each dome is composed of 96 triangles, covering a

total area of 100m² (1076ft²). Overhead lighting brings with it the problem of excessive heat-gain from the sun. Therefore, a laminated glazing material was produced to counteract this: a layer of aluminium net between two sheets of toughened glass acts as a brise-soleil and reduces the amount of infra-red light entering the building. The laminated glass also suffuses the light to prevent direct sunlight from falling on the works of art.

The Foundation has a sophisticated, completely electric air-conditioning system which can either cool or heat the building. When necessary, heat pumps recycle waste heat extracted from the building. This type of air-conditioning system requires a highly insulated structure and the concrete wall construction includes a layer of glass fibre to this specific purpose.

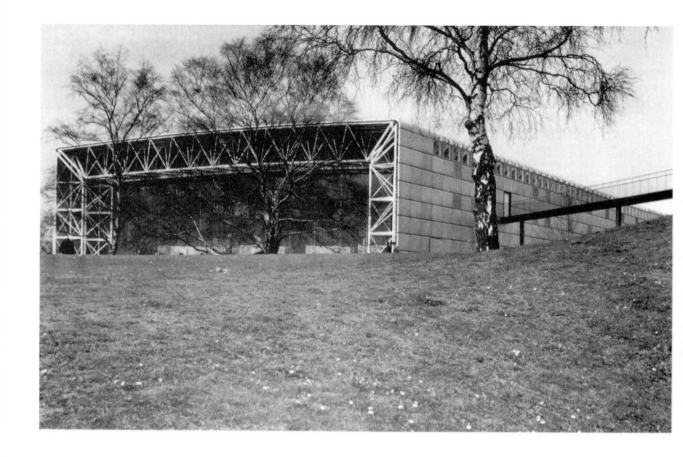

The Sainsbury Centre for Visual Arts
University of East Anglia, England

Architects
Foster Associates

Photography
Ken Kirkwood
John Donat

The brief for the Sainsbury Centre was developed in consultation with the University of East Anglia, the University Grants Committee and Sir Robert and Lady Sainsbury, who had decided to donate their large and varied collection of art to the University. The original buildings for the new university were designed by Sir Denys Lasdun and in his masterplan future growth was planned along the Yare Valley. A network of roads with drainage and services was already constructed in readiness.

The architects for the new building in consultation with Lasdun, decided to locate the centre along this planned line of growth. The fact that the

Centre would thus be next to the Science buildings was in sympathy with the Sainsbury's wish for their gift to be of benefit to the broadest cross-section of the student population. Preliminary research into gallery buildings in Europe and in the United States was widely conducted, particularly from the user viewpoint. As well as an Art Gallery, the new building had to contain the School of Fine Arts, the Senior Common Room and a new Restaurant open to the public as well as the university.

The various functions were all housed in one linear shed. In order to create an area completely free from columns, and thus a more flexible space,

The west elevation. Pene-
trating the building from
the right is the overhead
bridge linking the Centre
with the pedestrian spine
of the existing university
buildings.

North-south and east-west
sections.

Mezzanine and base-
ment plans.
Key to plans and
sections
1 Access road
2 Ramp
3 High level walkway
4 Entrance
5 Information desk
6 Special exhibition area
7 Terrace
8 Coffee area
9 Gallery lounge
10 School of Fine Art
11 Restaurant
12 Study area
13 Senior common room
14 Loading bay
15 Storage
16 Workshops

Concept sketch by
Norman Foster, 1975.

Detail of gable corner showing three of the four types of cladding panels: solid, glass and curved.

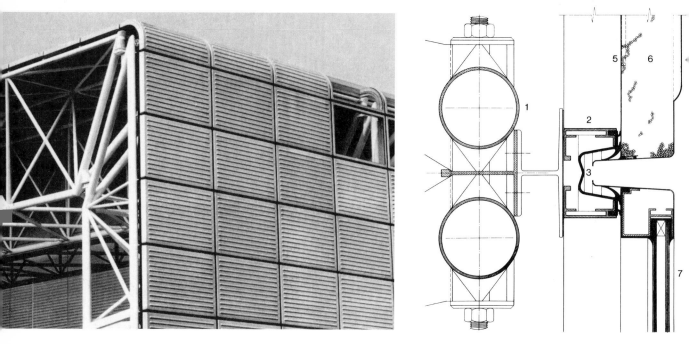

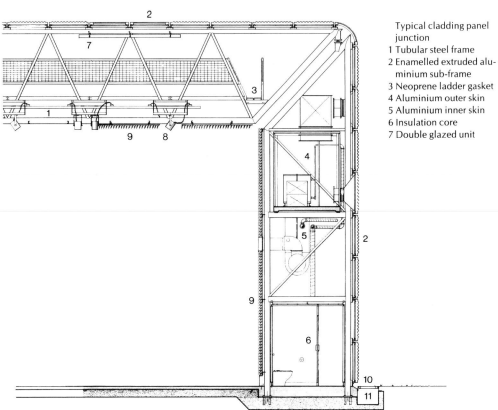

Section through external wall
1 Tubular steel truss
2 Interchangeable vacuum formed aluminium panels: glazed, solid or louvred
3 Access catwalk
4 Plant
5 Air distribution zone
6 Services: plant, darkroom, toilets, stores
7 Solar controlled aluminium louvres
8 Artificial lighting
9 Adjustable aluminium louvres
10 Cast aluminium perimeter grille
11 Gutter

Typical cladding panel junction
1 Tubular steel frame
2 Enamelled extruded aluminium sub-frame
3 Neoprene ladder gasket
4 Aluminium outer skin
5 Aluminium inner skin
6 Insulation core
7 Double glazed unit

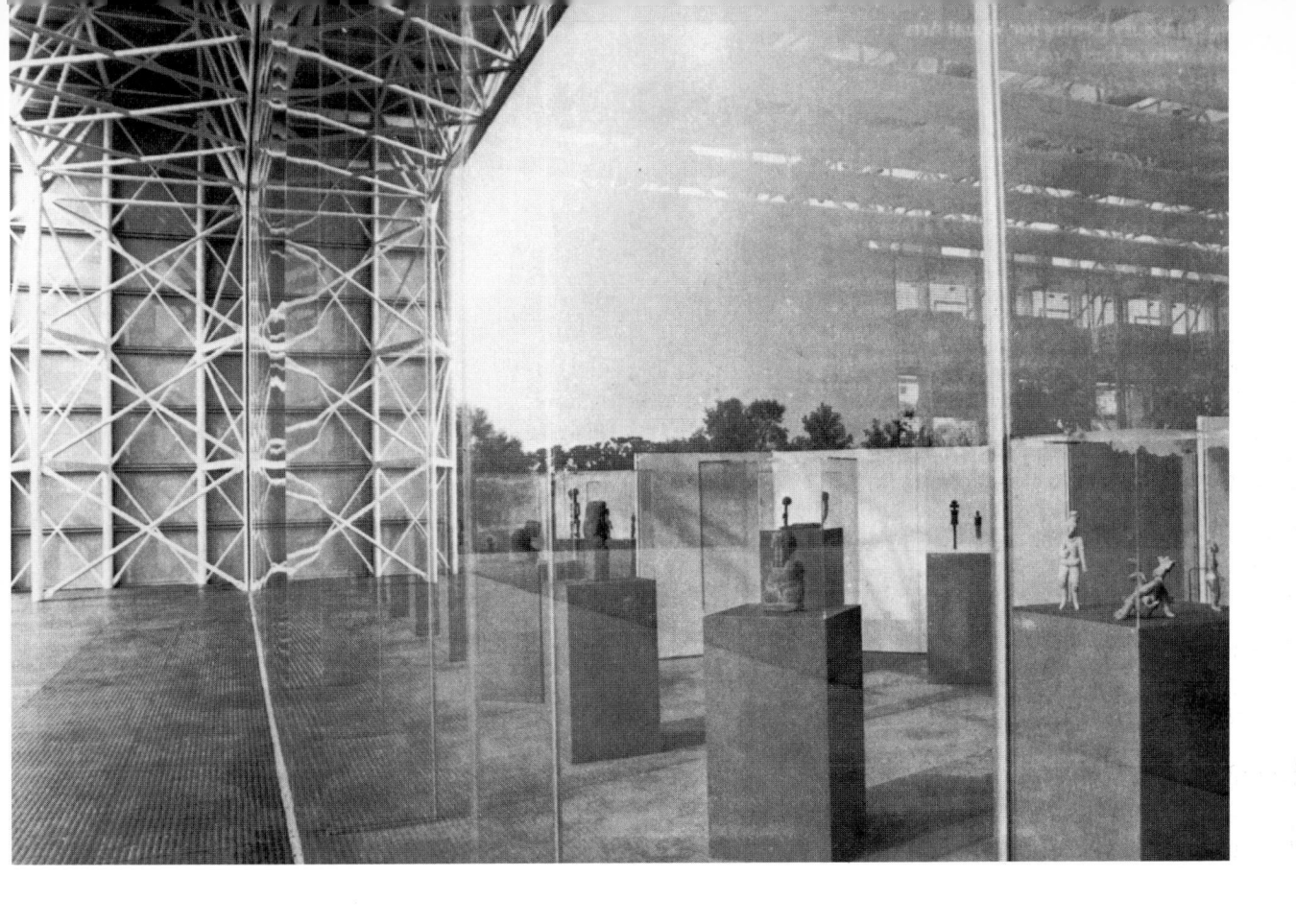

Detail of inner corner of
the west elevation. Note
the interplay of reflection
and transparency which
animates the rigid structure
of the building. Behind the
glass curtain wall is the
special exhibition area.

a skeleton frame 133m (436ft) long and spanning
35m (110ft) was constructed from thirty-seven
tubular steel trusses supported on similar lattice
towers. All building components were pre-
fabricated and assembled on site.

Internally the clear height is 7.7m (25ft), which
allows sufficient room for mezzanine floors and the
display of tall sculpture. The whole structure rests
on continuous concrete strip footings with an
integral floating ground slab. Extra foundation pads
are provided for the existing and for future internal
structures.

The outer cladding to the steel framework is
designed to be completely flexible. There are four
different types of panels: glass, solid, grilled, and a
curved panel to turn the corner between wall and
roof. The solid panels are a sandwich construction
with a vacuum-formed outer skin of highly reflec-
tive, superplastic anodised aluminium (the first
application of this material in the building industry)

and a foam filling 100mm (4in) thick, to give a high
insulation value. Each panel measures 2.4m (8ft)
wide by 1.2m (4ft) high and is locked into a
continuous net of neoprene gaskets by means of six
bolts. The panels can be easily interchanged in a
matter of minutes. The neoprene sections also
serve as rainwater channels, directing water into a
continuous cast-aluminium grille at the base of the
outer wall. Banks of perforated aluminium louvres,
backed with acoustic wadding where necessary,
form the internal lining to the structure. Louvres on
the ceiling are adjusted automatically to regulate
the internal lighting levels and, together with the
interchangeable external panels and a highly
flexible system of electric display lighting, create
what Norman Foster refers to as a 'highly tunable'
light control system.

At either end of the shed is a sheer glass curtain
wall of full height panels of glass with minimal
neoprene joints to allow completely unobstructed

The Sainsbury Centre for Visual Arts
University of East Anglia
Foster Associates

views of woods at one end and of a lake at the other.

The 2.4m (8ft) wide space created between the outer skin and the internal louvres is a service zone containing lobbies, cloakrooms, store rooms, photographic darkrooms, mechanical and electrical plant. This allows maintenance to take place without disturbing the internal areas, particularly in the ceiling zone where catwalks give access to the display lighting which can be adjusted independently of the exhibition below.

The design of internal spaces, the nature of the enclosing wall with its adjustable, highly reflective skin and its well insulated panels, combined with the design of the ventilation system, have created an alternative to air conditioning and its associated high installation and running costs. The building draws its main heat supply from the central high temperature water distribution system of the campus. This feeds a ducted warm air heating installation which has provision for fresh and recirculated air mixing and dust filtration. Air discharge is usually from long-throw side wall diffusers with individual room control by concealed thermostats. The decision not to use air conditioning was in keeping with the spirit of creating a relaxed environment rather than a hermetically sealed vault for works of art.

An overhead glass-sided bridge links the existing pedestrian spine of the university buildings with the new block. The bridge sails over the sloping lawns and penetrates the envelope at a 45 degree angle before culminating in a spiral staircase which brings the visitor down into the entrance conservatory, where are the main reception desk and a coffee bar. To one side is a special exhibition area overlooking the lake and to the other is the main exhibition area, which is referred to as the 'living area' because of its groups of easy chairs with low tables and books encouraging visitors to relax and talk amongst the exhibits; a major departure from the usual hushed atmosphere of art galleries. The

Interior of 'living area' looking west. Note the informal seating arrangement to the right, the coffee area in the conservatory in the background and the overhead bridge used as a surveillance point.

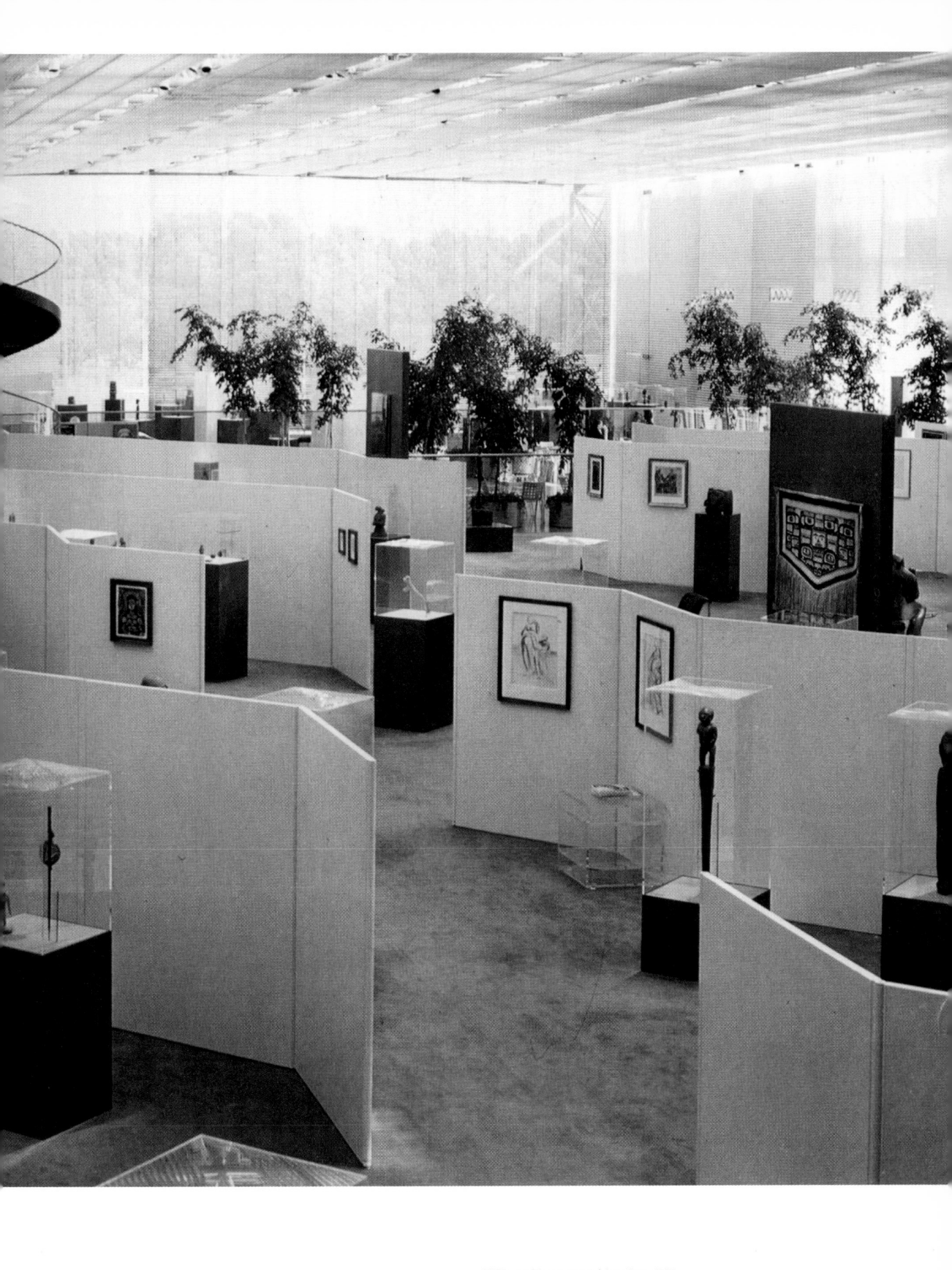

The Sainsbury Centre for Visual Arts
University of East Anglia
Foster Associates

View of the special exhi-
bition area from the ex-
terior terrace at night. The
linear rhythm of the exter-
nal blinds and the ceiling
blinds interlock to create
an insubstantial lacy effect
of shimmering light.

Details of roof construc-
tion: a network of catwalks
housed in the depth of the
steel trusses allows access
for changing the external
cladding panels and ad-
justing light fittings.

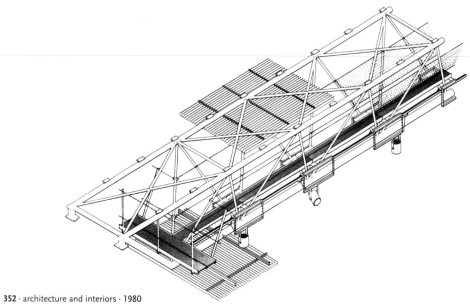

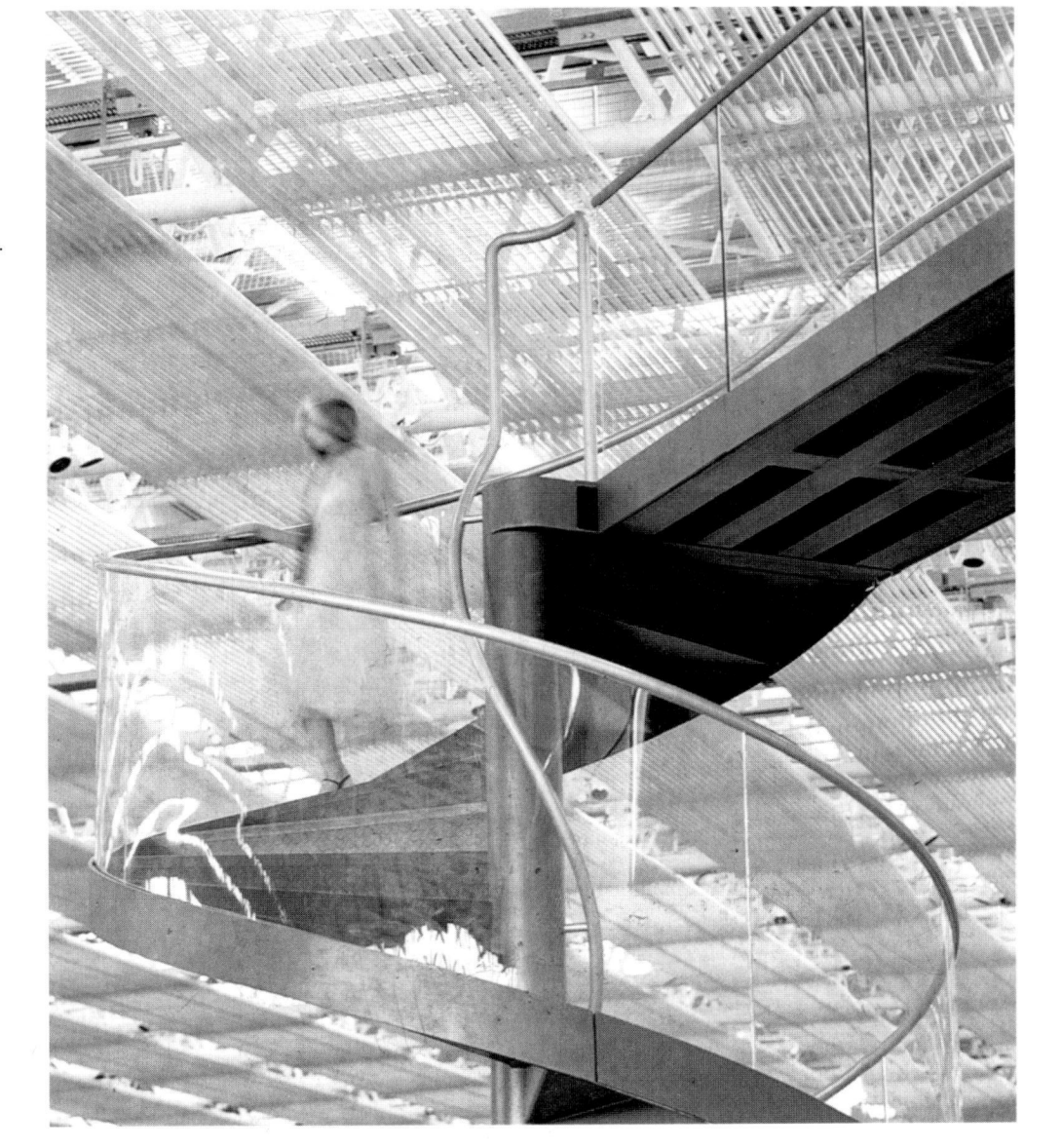

Detail of spiral staircase.

'living area' is separated from the School of Fine Arts by the reserve study area which has a mezzanine floor. Together with the entrance bridge, the use of mezzanine floors provides the security staff with convenient vantage points allowing surveillance of a wide area, thus reducing the number of staff required.

Another two-storey internal structure with kitchens on the ground level and the Senior Common Room at mezzanine level separates the school from the restaurant. All the internal spaces are connected by a passage which runs along the north side of the building and individual spaces can be closed off when necessary.

All the ground floor areas are served by a basement spine running the full length of the building. A ramp to the west connects underground loading docks to the access road. The basement contains store rooms for works of art and workshops and along its length are the staircases and lifts which connect all three levels. The plan is arranged so that the main gallery becomes a thoroughfare between the main university buildings and the School of Fine Arts, Restaurant and Senior Common Room.

There are five different types of display cases, which can be individually air conditioned. Each case has a 0.60m (2ft) square stove-enamelled steel base and a top of optically clear Perspex, which contains no colouring to filter out ultraviolet light as this function is provided by the building envelope.

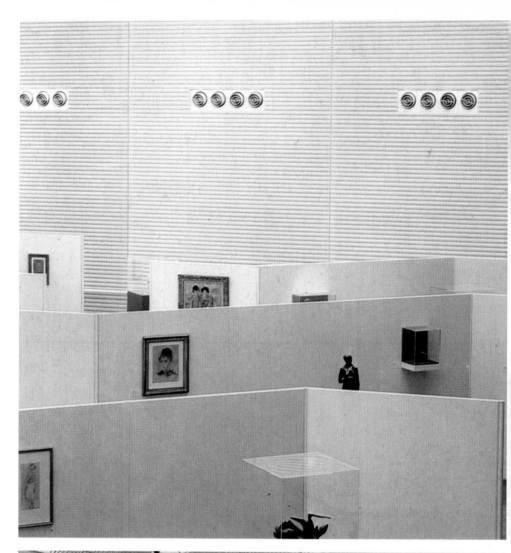

Detail of 'living area' with louvres closed. Note the adjustable nozzles supplying warm air.

The senior common room on the mezzanine; in the centre is the lift of toughened glass and tubular steel.

At night the exhibition area is more introspective, but the highly polished marble floor reflects individually lit display cases, continuing the main theme of the architectural concept, based on transparency and reflection.

Seating area in the 'living area'. Students and visitors are encouraged to linger and talk.

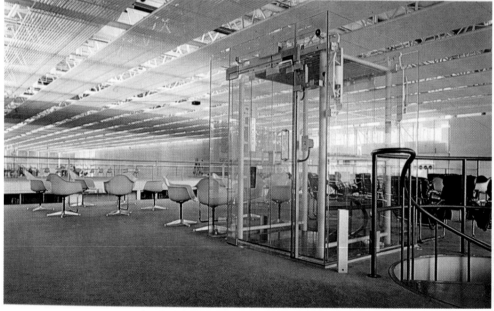

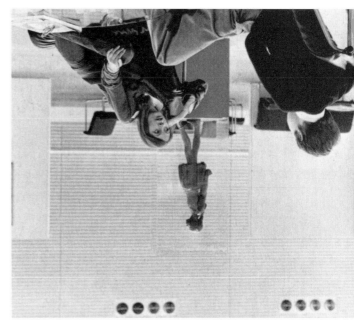

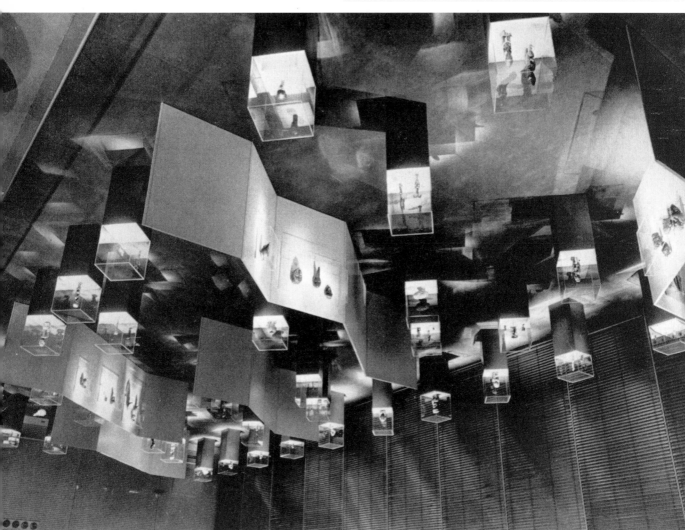

**The Sainsbury Centre for Visual Arts
University of East Anglia**
Foster Associates

The sleek north elevation.

View of the east elevation at night with the dramatically lit access ramp descending to the basement loading bay.

The two passenger lifts at the Sainsbury Centre represent a unique collaboration of Foster Associates, Marryat and Scott, lift manufacturers, James Clark and Eaton, glass specialists, and Tennant Panels Ltd, automobile manufacturers. The lift cars are constructed from welded tubular steel, complementing the space frame of the main structure, and both the car and the lift shaft enclosure are clad

with toughened glass, creating an almost transparent lift installation. An aluminium grille on top of the lift car with its own lift control panel simplifies cleaning the internal glass areas. Each lift is operated by a single hydraulic ram enclosed in a deep steel-lined bore hole below basement level, thus avoiding the need for lift plant at high level.

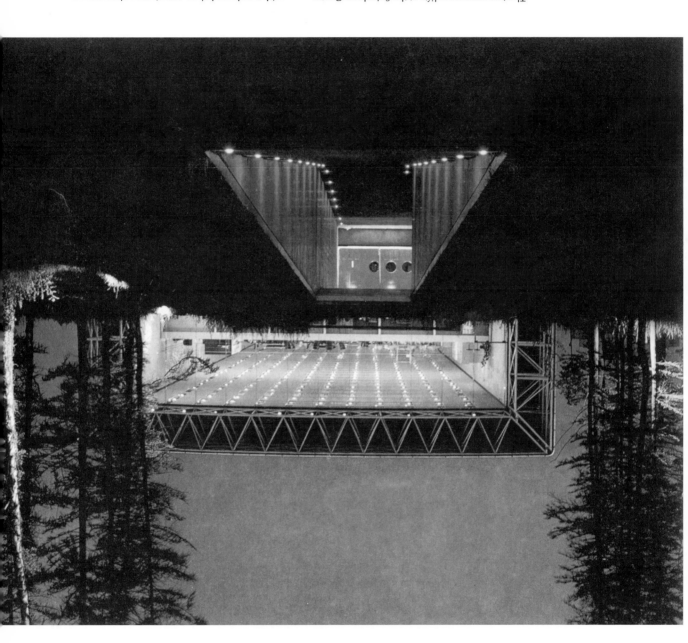

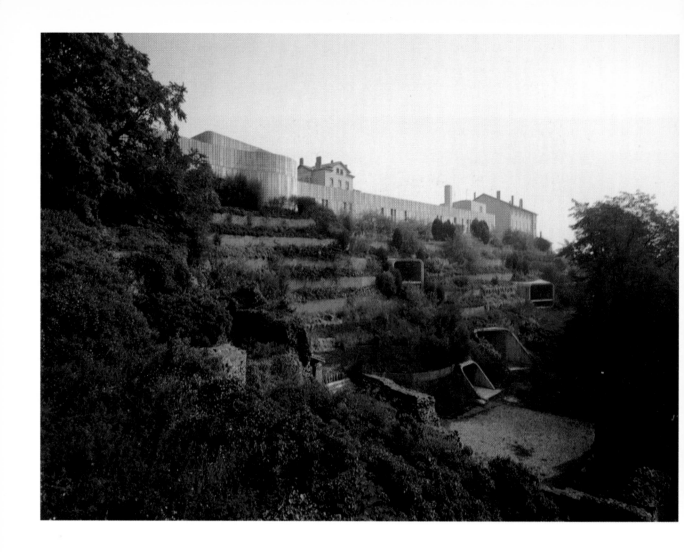

The Archaeological Museum
Lyon-Fourvière, France

Architect
Bernard Zehrfuss

Photography
Dahliette Sucheyre

An archaeological museum which would bring
together several scattered collections of Gallo-
Roman remains has been constructed in the Roman
forum on Fourvière Hill, Lyon, where two amphi-
theatres have been excavated. To reduce the
impact of a large new building on such a sensitive
area, the architect Bernard Zehrfuss decided to
construct the bulk of the 5000sq.m (54,300sq.ft) of
exhibition space underground.

From a storage area on the lowest level, the main
section of the building extends upwards through
two exhibition levels to emerge one storey above
ground, where the restoration workshops, plant

rooms and the curator's flat are situated. To the left
of the main block is a secondary section containing
lifts and stairs and exhibitions primarily of mosaics.
Its structure is traditional and comprises five levels,
three of which connect with the main museum. All
levels in the museum are linked by a continuous
ramp which is large enough and strong enough to
allow access on all floors for machinery used in
positioning the heavy stone exhibits.

The ground conditions made excavation a com-
paratively easy process. After the side of the hill
had been removed a 15m (49ft) high and 60cm (2ft)
thick retaining wall of in-situ concrete was erected

External view of museum.
The planted stepped tiers
cover the bulk of the
museum with only a few
windows and a single
storey structure visible.

Section showing the main
concrete structure.

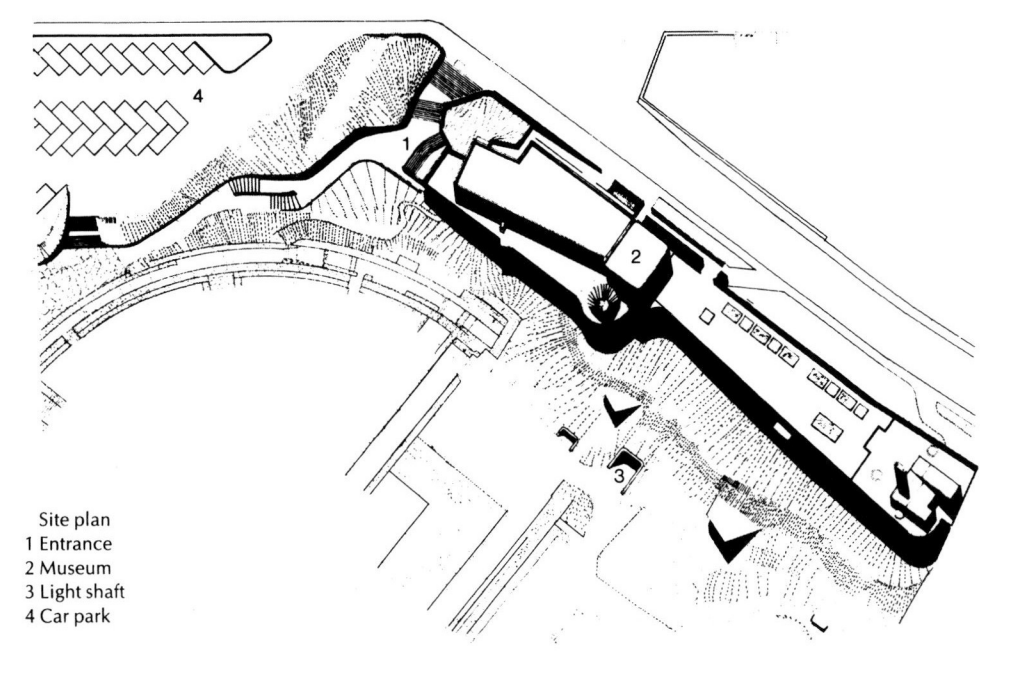

Site plan
1 Entrance
2 Museum
3 Light shaft
4 Car park

**The Archaeological Museum
Lyon-Fourvière, France**
Bernard Zehrfuss

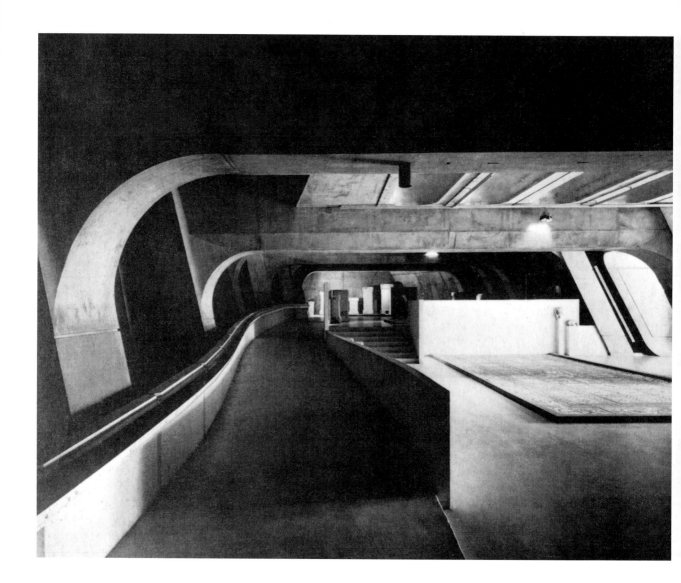

Exhibition hall with ramp
leading to a higher level.
Both exhibition floors
slope creating a flow of
space which is further lib-
erated by the absence of
load-bearing walls.

Plan of exhibition level
1 Ramp
2 Mosaic
3 Display case
4 Lifts
5 Void above mosaic floor
 below
6 Light shaft
7 Goods lift

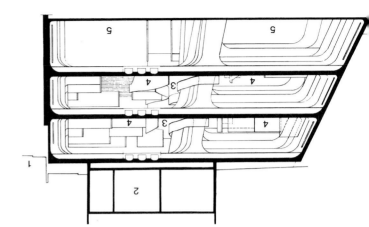

on three sides, and designed both to retain the earth and to release the build-up of water pressure by channelling ground water away into the Roman drain which once served the amphitheatres. The wall is in twenty-three 4.5m (15ft) wide sections; sixteen along the rear wall, three on the left hand side and four on the right, each anchored into the hillside with ties ranging from 12m (39ft) to 17m (56ft) in length. The structure incorporates concrete land drains, 50cm (1ft 8in) wide, a waterproof membrane of heat-bonded sheet plastic and an inspection gallery, 1.2m (4ft) wide, built along the

mosaic in exhibition hall. ach one of the portal ames had to be designed / computer because of e complexity of the struc-

ture. Columns along the back retaining wall are vertical but the inclination of the others varies; the outer columns incline to follow

the gradient of the hillside and the twin central columns are neither parallel to each other nor to those on the outer or inner walls.

Section
1 Street level
2 Conservation department
3 Ramp
4 Exhibition hall
5 Storage

**The Archaeological Museum
Lyon-Fourvière, France**
Bernard Zehrfuss

Spiral stair between exhibition levels.

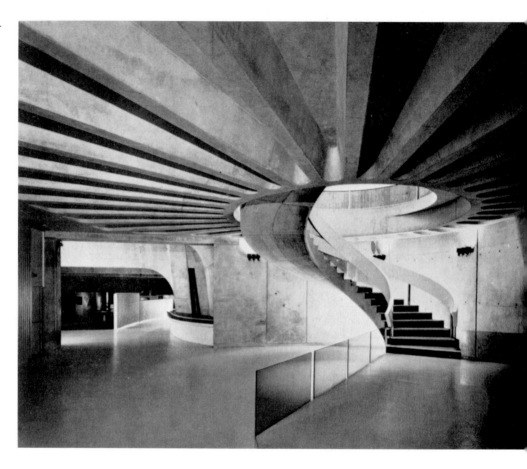

entire length of the retaining wall to give early warning of any failure in the construction.

Two rows of ten triple portal frames on a constant longitudinal grid of 6m (20ft) comprise the main structure. The rear wall is straight for seven sections of the grid and oblique for four and the external wall is cast in a series of horizontal steps following the natural contours of the hill, so that the width of the building varies along its length. The outer columns of the portal frames are set in from the retaining and from the outer wall. Short beams connect the twin columns in the centre and the outer columns with the walls, to take up horizontal stresses. Each column measures 1m × 35cm (3ft 3in × 1ft 2in) and continues down to a reinforced concrete foundation pad. Beams are a constant thickness of 80cm (2ft 7in) but vary in height from 1.35m (4ft 5in) to 2.25m (7ft 5in) to carry the exhibition floors of prefabricated rein-

forced concrete coffered sections 5.25m (17ft 3in) long and 1.49m (4ft 11in) wide covered with an in-situ screed.

The sloping ramp was cast in-situ while the reinforced concrete balustrade is prefabricated in adjustable formwork to allow for the differing gradients. The cavernous structure, while appropriate for an underground building, often appears oppressive; this is perhaps inevitable when the floors are required to support loads of up to 1500kg/sq.m (307lb/sq.ft). Air conditioning ducts are housed in the space between the central columns of the portal frames and between the outer columns and walls.

All internal surfaces are left in their natural state, so a high standard of workmanship was demanded on the concrete works, all concrete being pumped into the formwork, not poured, to achieve a greater degree of control.

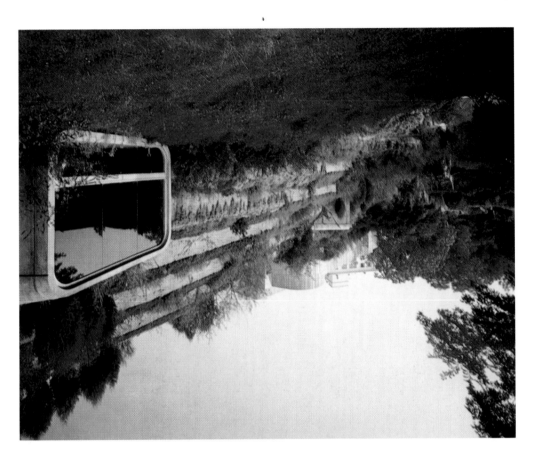

One of two laminated glass windows which allow dramatic views of the Roman amphitheatres. Natural light also penetrates the underground structure through several light shafts which are sealed by transparent plastic domes concealed in the external planting.

A gallery window from outside.

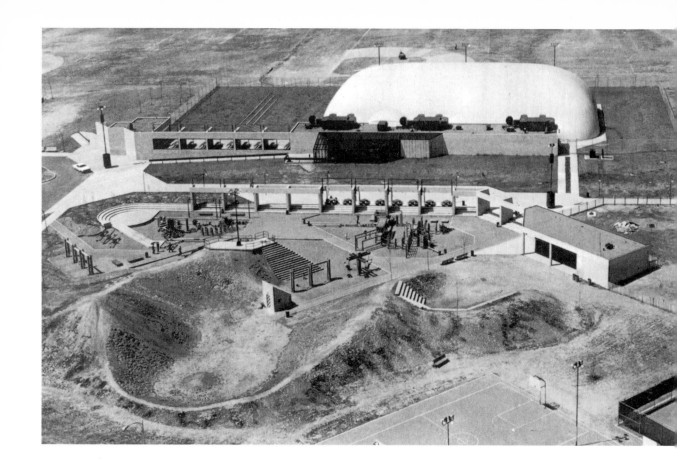

The Coal Street Park Swimming Centre
Wilkes-Barre, Pennsylvania, USA

Architects
Bohlin Powell Brown

Photography
Sandy Nixon
Mark Cohen

A city park has been created on what was formerly 32 acres of slag heaps. A 240m (800ft) long pedestrian spine, with car parks at either end, links two local neighbourhoods and connects with all the major functions within the park. These include playing fields for softball, baseball, American football, soccer and hockey, an ice-rink, children's play area and a swimming centre.

The swimming centre consists of a bath house containing changing rooms and toilets, a wading pool and a competition pool with a section for diving. The building complex also houses a snack bar, which serves the entire park. This is linked to

the bath house by an outdoor dining area which consists of a series of bays facing towards the pools but with openings in the rear wall overlooking the pedestrian spine and children's play area. The bays are separated by concrete block walls and can be sheltered from the sun by yellow canvas awnings slung from a steel frame. Materials used in the construction of the bath house are in-situ and pre-cast concrete, concrete blocks and steel. All concrete is left exposed and steelwork is painted.

The bath house is situated so that it shelters the pedestrian mall from the prevailing westerly winds. The visitor approaches the building up a long ramp,

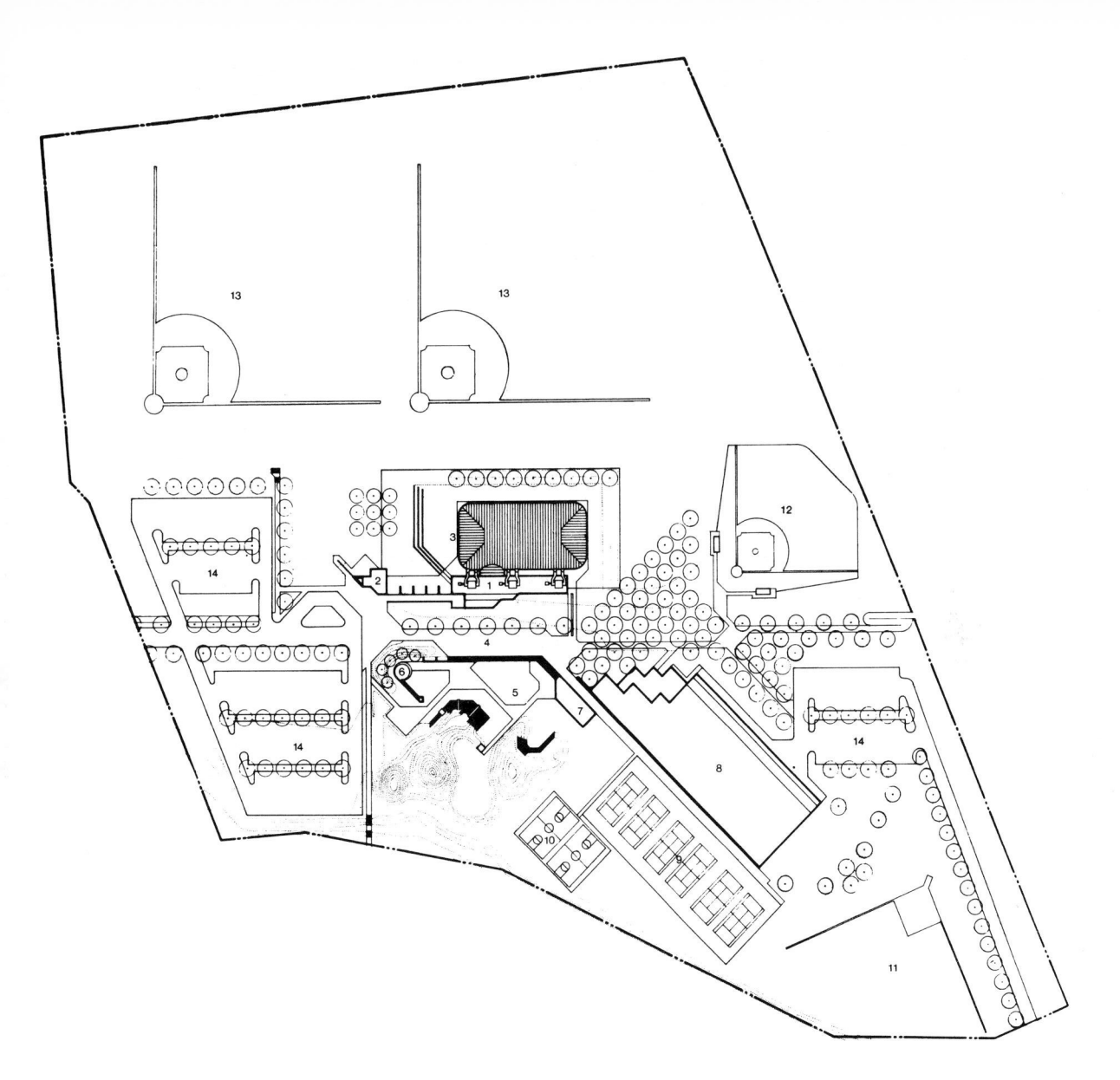

flanked on one side by a red and blue steel
handrail. This handrail passes into the fully-glazed
entrance hall and sweeps round the perimeter
before terminating on the face of the concrete
reception desk. Industrial lighting fixtures are par-
tially concealed by the profile of the rail and are
fixed at closer centres, to increase in rhythm as the
rail approaches the desk. Large-scale graphics
further help to emphasize the circulation pattern.

To increase the use of the centre from a possible
three months per year to all year round, an inflat-
able structure, 30m × 60m (100ft × 200ft) has been
designed to cover both pools.

The swimming centre seen
from the south-east with
the children's play area in
the foreground.

Master plan of the city
park
1 Bath house
2 Snack bar
3 Air dome over pool
4 Pedestrian spine
5 Children's play area

6 Spray pool
7 Shelter and toilets
8 Covered ice rink
9 Tennis courts
10 Basketball courts
11 Softball field
12 Junior baseball field
13 Baseball fields
14 Car parks

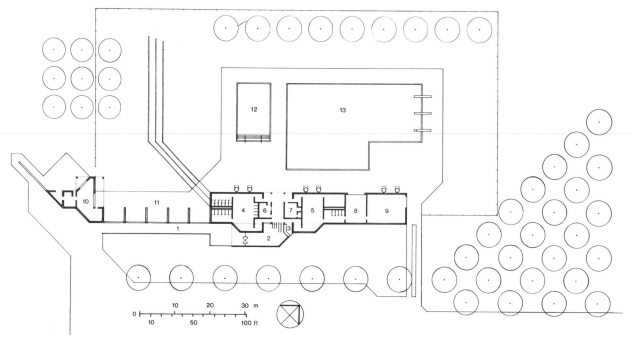

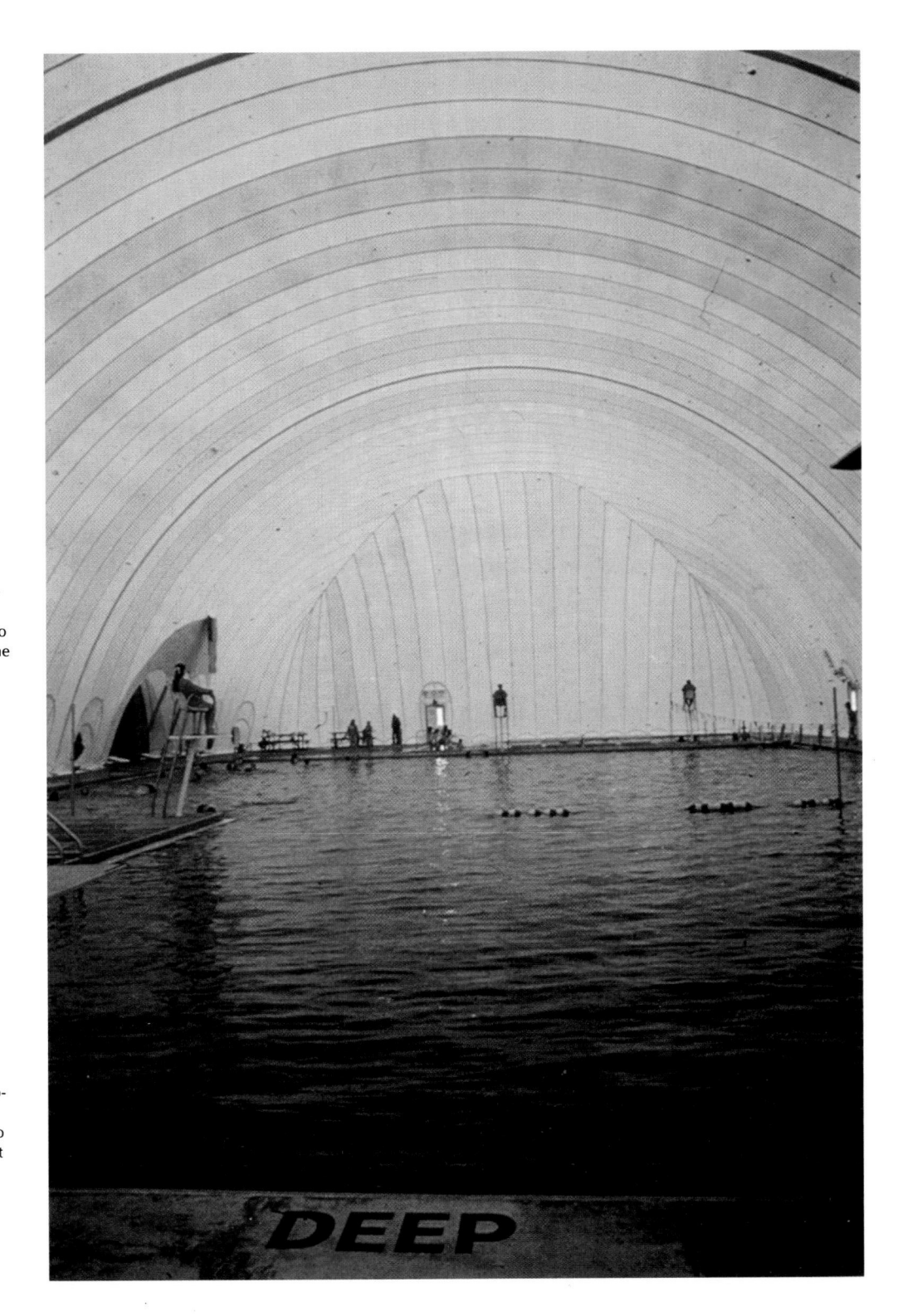

The entrance hall; the reception desk is in the centre and the entrance to the changing rooms on the left.

Plan of bath house and pool
1 Ramp
2 Entrance hall
3 Reception desk
4 Women's changing room
5 Men's changing room
6 Office
7 First aid
8 Dome storage
9 Pool equipment
10 Snack bar
11 Open-air eating area
12 Wading pool
13 Competition pool

The swimming pool is covered with a translucent air-supported structure to extend its use throughout the year.

Overpage

General view of the two pools.

The Coal Street Park Swimming Centre
Wilkes-Barre, Pennsylvania
Bohlin Powell Brown

Heating and pressurization equipment which serves both the air-supported structure and the bath house is placed on the bath house roof. Large round ducts, grouped in pairs of supply and return, swoop down to the pool surround to connect with the fabric of the air structure. Connection is made at the base to minimize the chances of the fabric tearing in a high wind. The interiors of the ducts are painted red and expanded metal screens are recessed into their openings to prevent children climbing up inside.

Two arcs of red steel, fixed to the concrete facade of the bath house, anchor the air structure to the bath house and, along with guy-ropes, form the catenary framed entrance to the covered pools.

The pressure in the bath house is equalized with that of the inflatable to avoid the formation of airlocks between the two structures. Thus, from the entrance lobby, the visitor can look straight into the pool enclosure.

The pools are surrounded by rising grass-covered banks which protect the bathers from winds in summer and provide inclined sun-bathing areas.

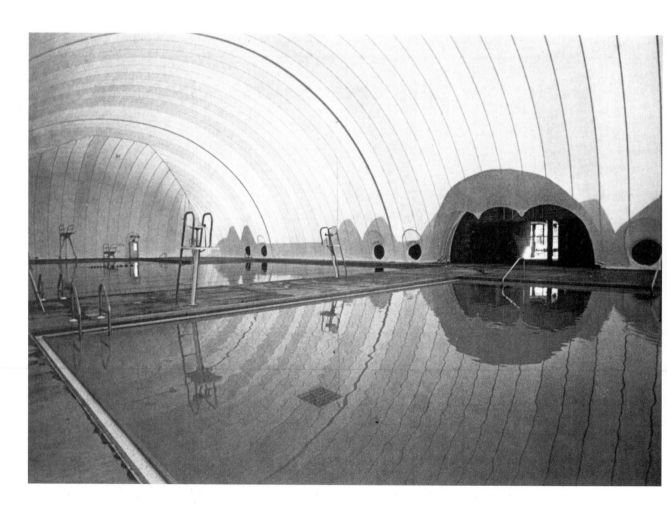

View of the pool looking towards the changing rooms. On the far side of the pool can be seen the duct openings and the entrance from the bath house.

Area between the wading pool and the main pool. The inflatable structure has a translucent elegance totally in harmony with its watery surroundings.

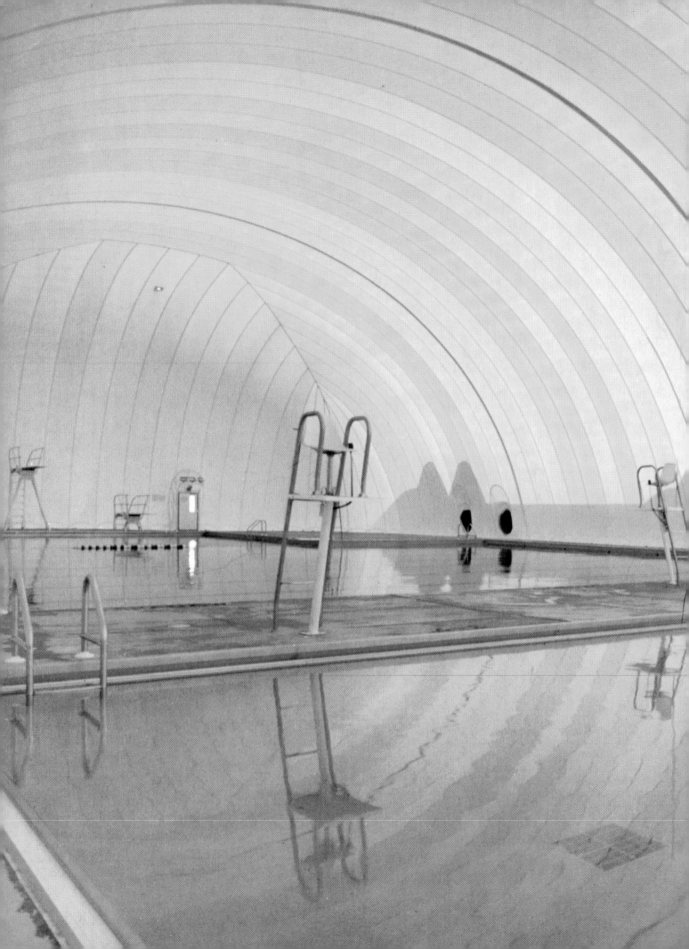

The Coal Street Park Swimming Centre
Wilkes-Barre, Pennsylvania
Bohlin Powell Brown

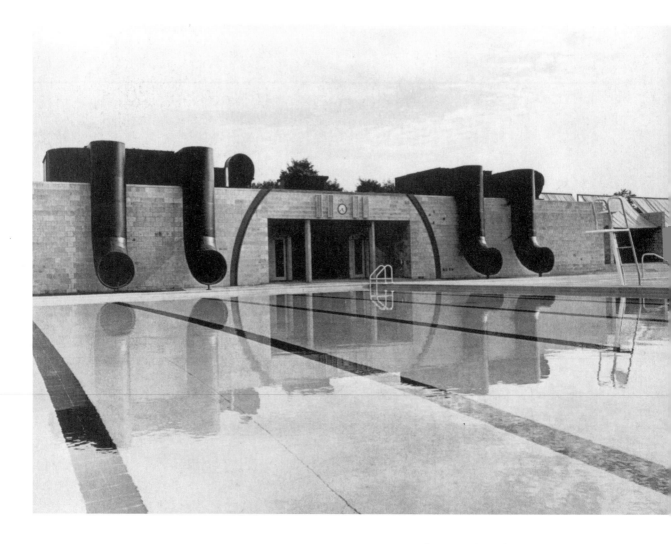

Looking across the pool to
the bath house; the open-
air eating area is on the
right.

The colourful supply and
return ducts acquire a
playful quality in the
months that the pool is
uncovered.

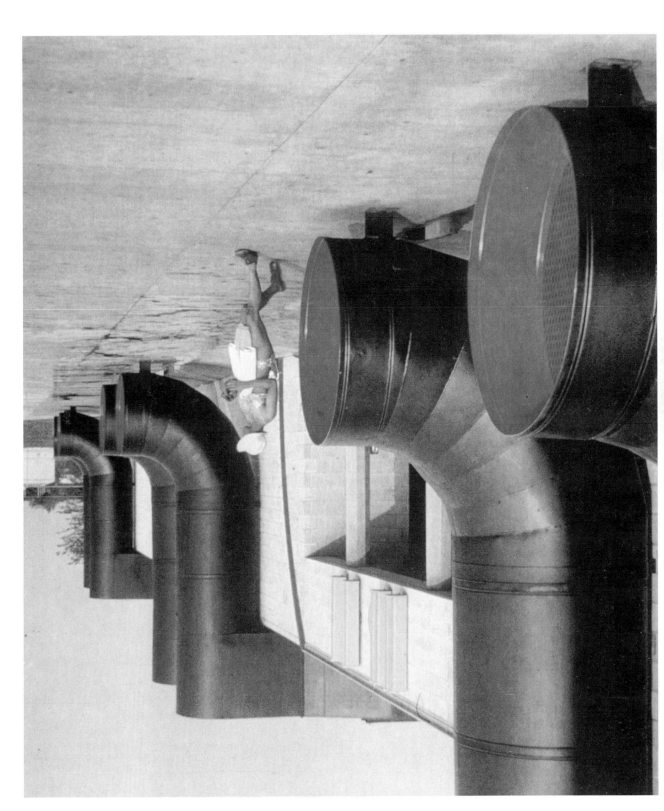

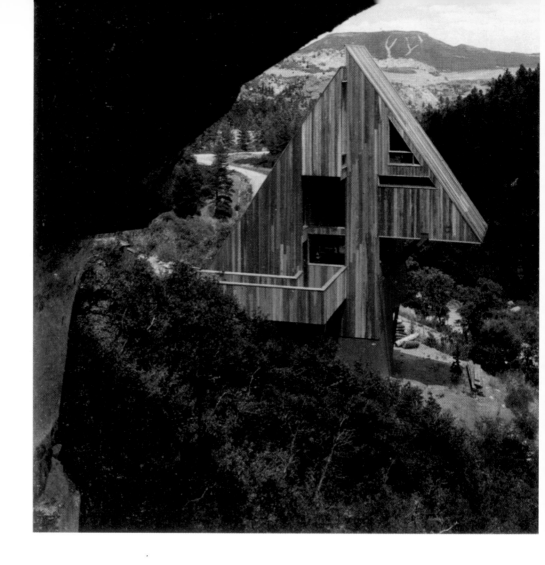

A Mountain Cabin
Perry Park, Colorado, USA

Architects
Arley Rinehart Associates

Photography
Richard Henri
Richard Springgate

The restrictions of a steeply sloping site with minimal support conditions, and a desire to disturb the landscape as little as possible, resulted in an award-winning design for a mountain cabin, by Arley Rinehart Associates.

Four 406mm (16in) diameter caissons, anchored 2.44m (8ft) into bedrock, support a central wedge form which contains a two-storey living area. Two smaller wedge forms are cantilevered from the main unit: their roof load and the floor cantilevers are supported by steel braces from the caissons.

A bridge gives access to a mezzanine in the main unit; opposite the entrance door are the kitchen and bathroom. From the mezzanine, a short flight of steps leads to the living area below and a central spiral staircase connects with three bedrooms, contained in the two upper levels of the house.

The house is constructed of 100mm × 150mm (4in × 6in) timber studs for the walls and 100mm × 200mm (4in × 8in) joists for the roof, with a 13mm (½in) plywood skin on both sides to form a stressed skin structure. Exterior roof and wall surfaces are clad in tongue-and-groove redwood boarding and the interior ply surface is left exposed and painted white. A thick fibreglass quilt between the two layers of plywood insulates the house. The

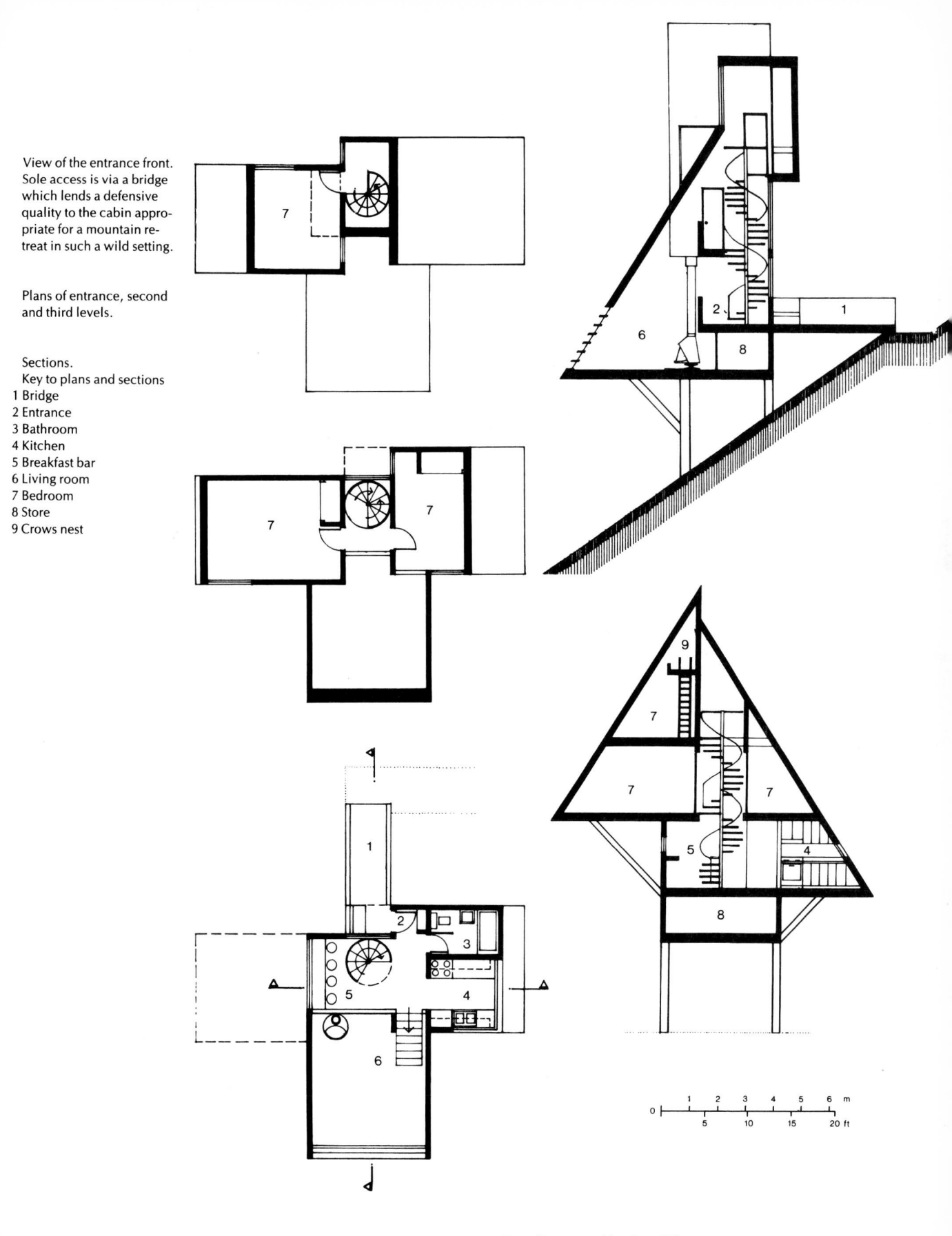

View of the entrance front. Sole access is via a bridge which lends a defensive quality to the cabin appropriate for a mountain retreat in such a wild setting.

Plans of entrance, second and third levels.

Sections.
Key to plans and sections
1 Bridge
2 Entrance
3 Bathroom
4 Kitchen
5 Breakfast bar
6 Living room
7 Bedroom
8 Store
9 Crows nest

A Mountain Cabin
Perry Park, Colorado, USA
Arley Rinehart Associates

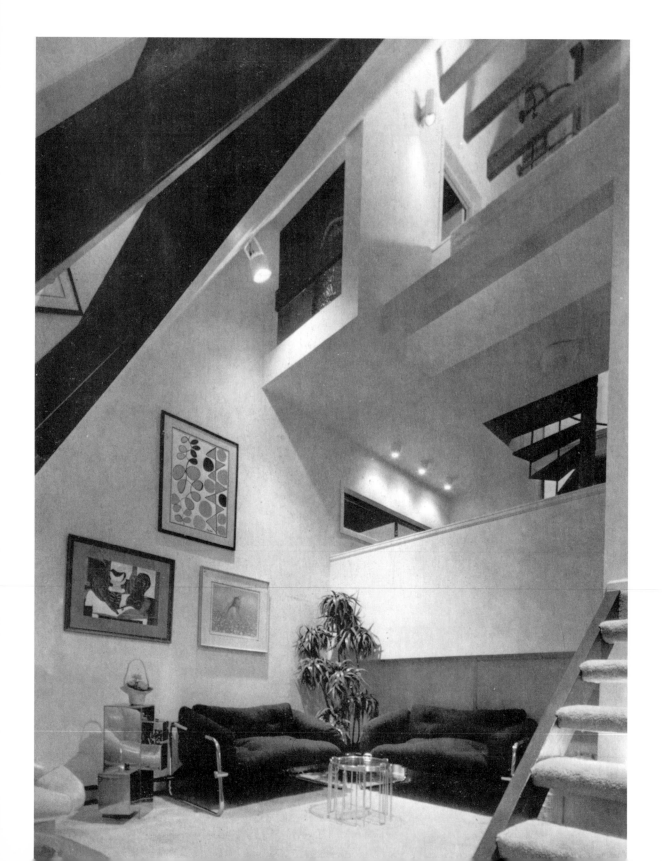

Looking up from the living area to the breakfast bar and entrance level and the bedrooms above. A dramatic soaring space has been created at the centre of the building where the cantilevered wedges intersect.

The cabin seen against the neighbouring crags almost appears to be part of the natural terrain.

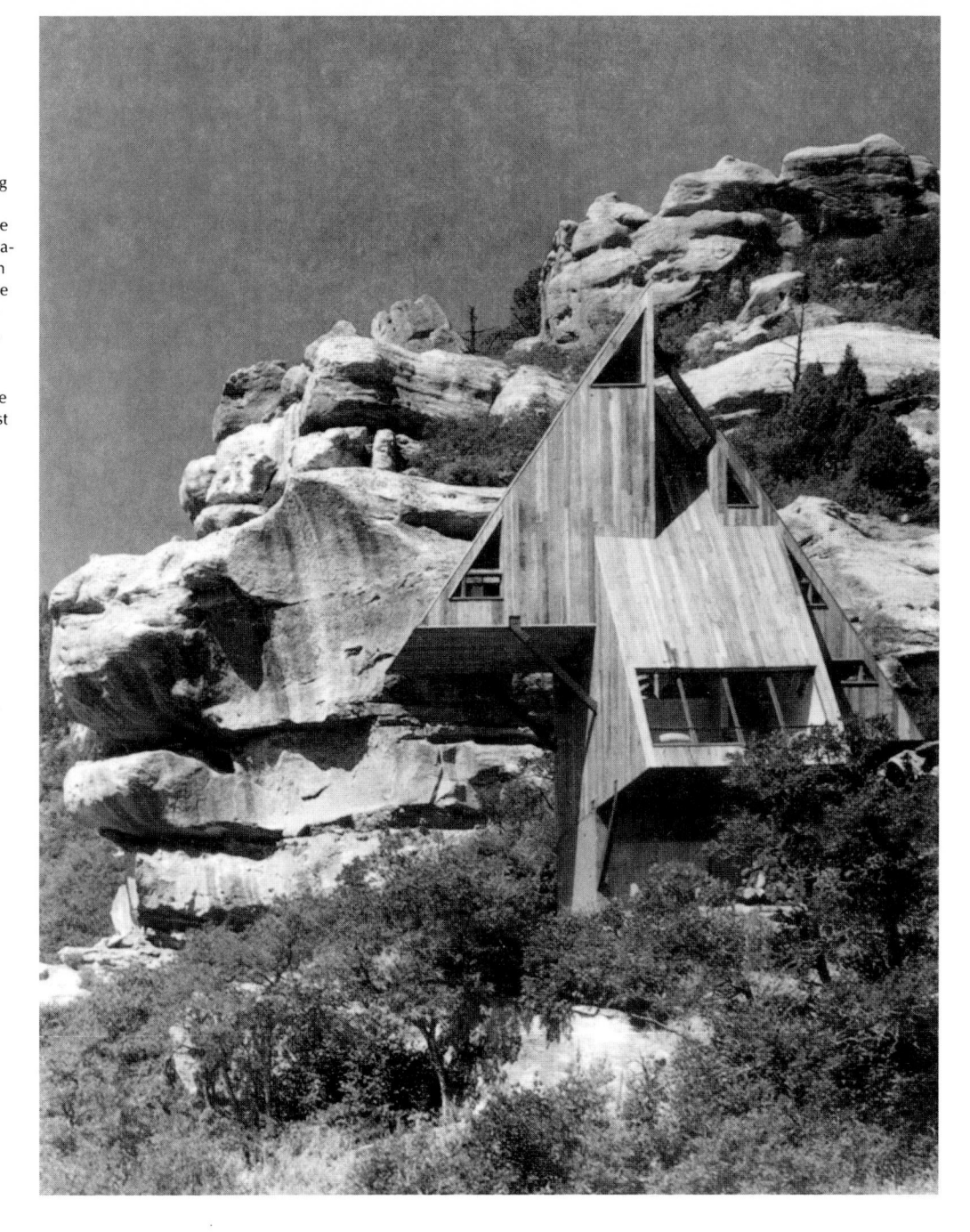

very nature of a stressed skin structure, where the entire wall area acts as a structural element, is compatible with the demands of a highly insulated structure with small windows. Electric underfloor heating is thermostatically controlled in each room to achieve further economy of energy in unoccupied spaces.

The West Office Building for Deere & Co
Moline, Illinois, USA

Architects
**Kevin Roche,
John Dinkeloo
and Associates**

Photography
Alexandre Georges

In the 1950s, both Kevin Roche and John Dinkeloo were closely involved with Eero Saarinen in the design of the Administrative Centre for Deere and Company, which was completed in 1964, three years after Saarinen's death. Saarinen ran his office on very liberal lines: he was prepared to delegate considerable responsibility, even to an active participation in the design process. It was therefore a great challenge to Kevin Roche and John Dinkeloo when they were asked to extend the Administrative Centre. Their brief was to add 20,000sq.m (200,000sq.ft) of office space for 900 employees to the original 30,000sq.m (300,000sq.ft).

Saarinen's original buildings comprise the main office building and, to the east, the Product Display building and the Auditorium. These two buildings are connected by an enclosed pedestrian bridge which leaves the main building at third floor level. Roche and Dinkeloo decided to position the new block to the west of the main building and connect it to the existing building by a similar footbridge, on the same axis and at the same level as the original bridge. It is not surprising that the new West Office building is in complete harmony with its neighbour. This is partly because they both utilise Corten steel, a material which eventually builds up a

The new office block seen
from the west. This is the
vehicular access and a
porte-cochere is provided
seen on the right.

Site plan
1 West office building
2 Main building

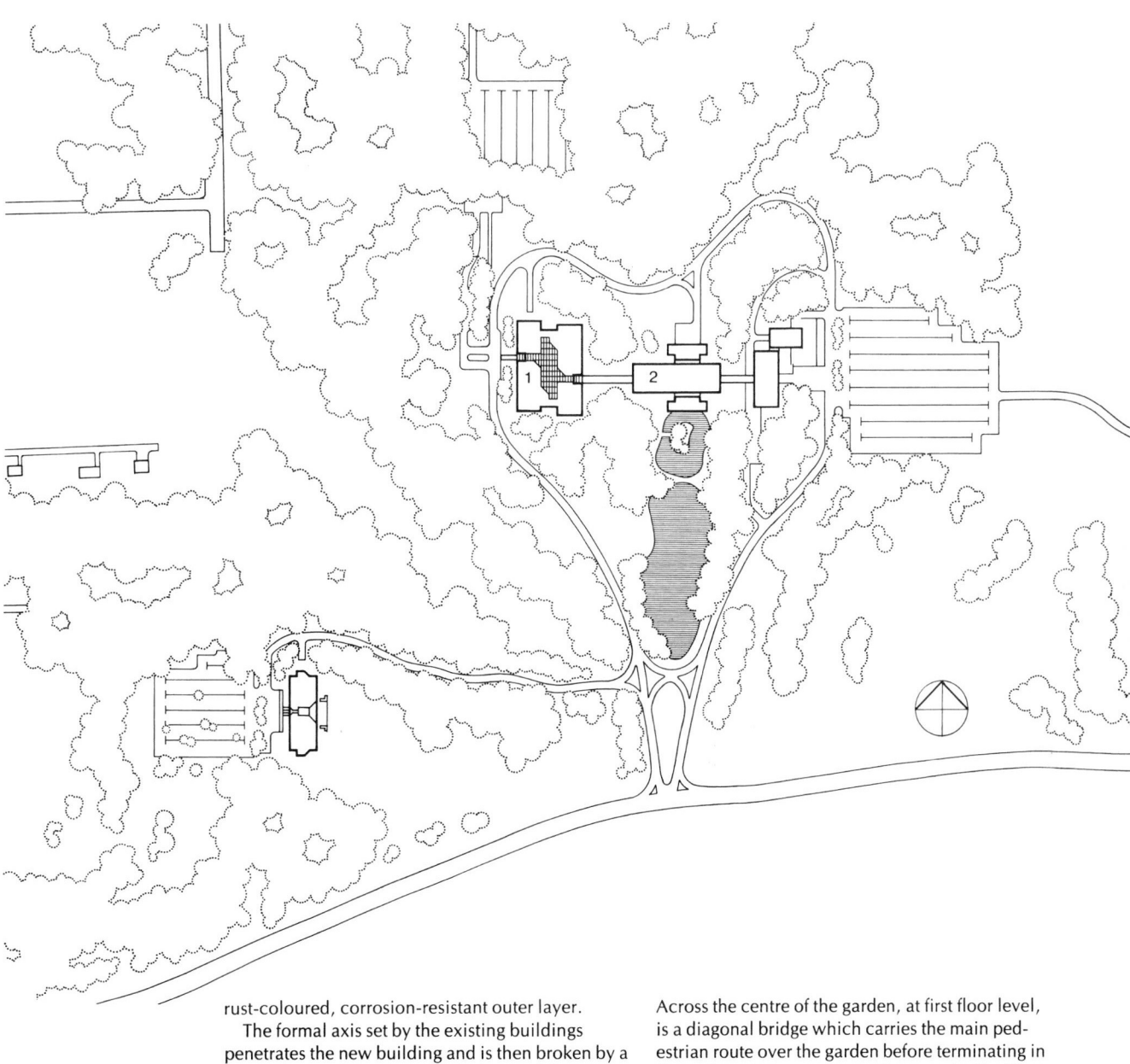

rust-coloured, corrosion-resistant outer layer.

The formal axis set by the existing buildings penetrates the new building and is then broken by a strong diagonal. It is here, in the heart of the new office, that one finds a remarkable contrast with the 1964 building. The rigid grid of the structure is prised apart to create a large indoor garden, approximately 1100sq.m (11,000sq.ft) in area, which extends upwards to the full three storeys of the building to finish in an arched roof, fully glazed with solar glass. The garden brings life and interest to the adjoining open plan office areas and, in one corner, the cafeteria flows out into the atrium.

Across the centre of the garden, at first floor level, is a diagonal bridge which carries the main pedestrian route over the garden before terminating in the main entrance and reception area for the West Office building. The architects took particular care over designing the planting layout of the garden. Trees such as weeping figs, coffee and southern yews, together with smaller shrubs and plants, form the permanent planting. The relatively low level of light in the atrium meant that the trees had to be gradually conditioned to their new environment before being finally introduced into the indoor garden.

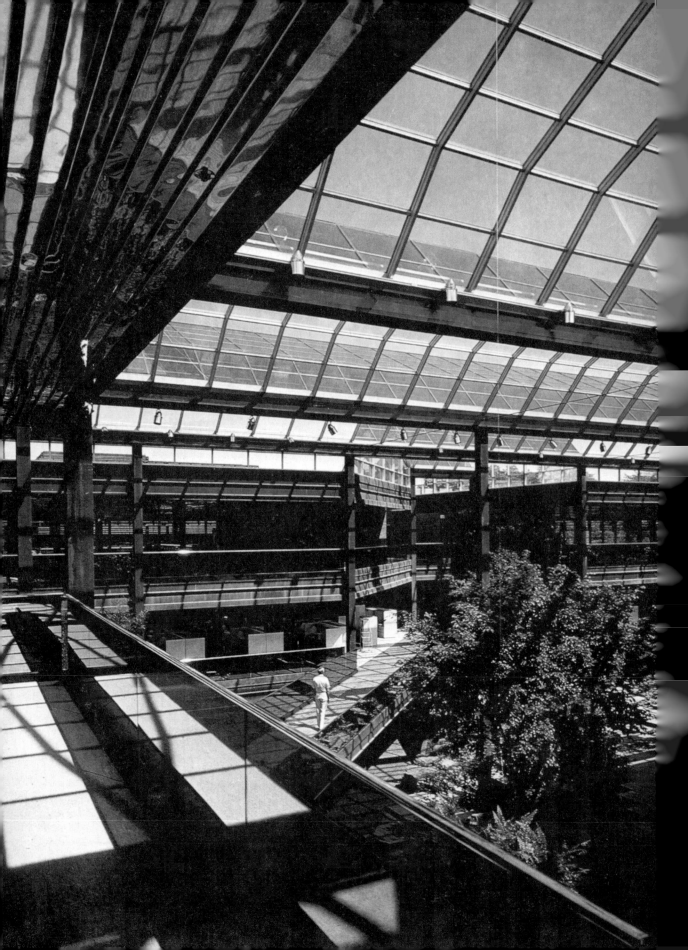

Looking down from the second level office area onto the bridge which crosses the atrium at the level of the link bridge with Saarinen's building and emerges on the west front at ground level due to the sloping site.

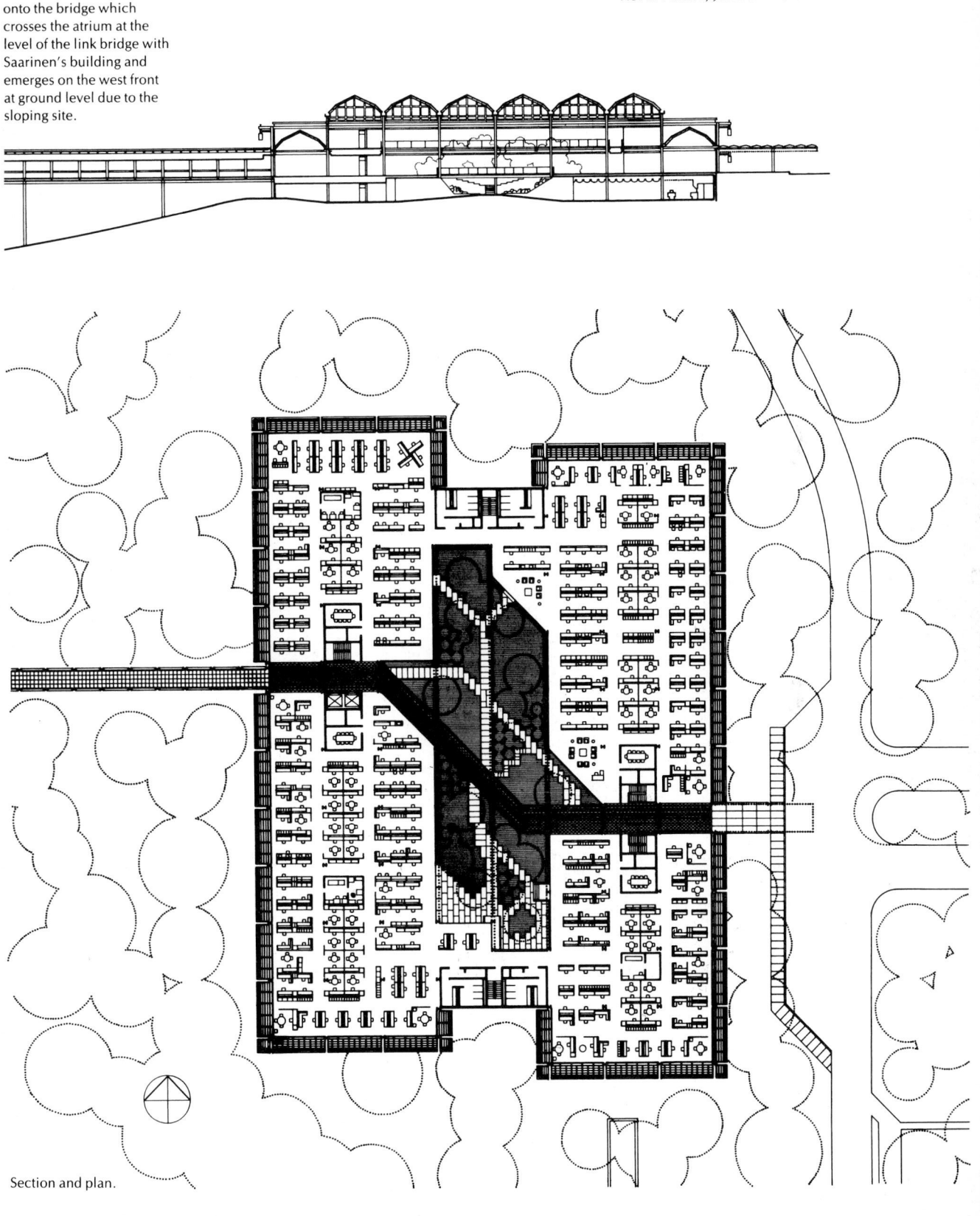

Section and plan.

The West Office Building for Deere & Co
Moline, Illinois, USA
Kevin Roche, John Dinkeloo and Associates

An office area directly adjoining the indoor garden. The illumination from natural daylight reflected onto the aluminium ceiling is maintained further into the office plan by artificial lights concealed in the top of the furniture.

A restaurant with seating for 300 people is situated at one end of the garden. Designed to give the company employees a wider selection of food, it includes a self-service bar, a sandwich bar and a grill.

The open plan office interior illustrates the latest development in lighting design: 'task lighting'. Rather than flood the entire floor area with a uniform high level of illumination, lighting is concentrated over desks, built-in to the furniture.

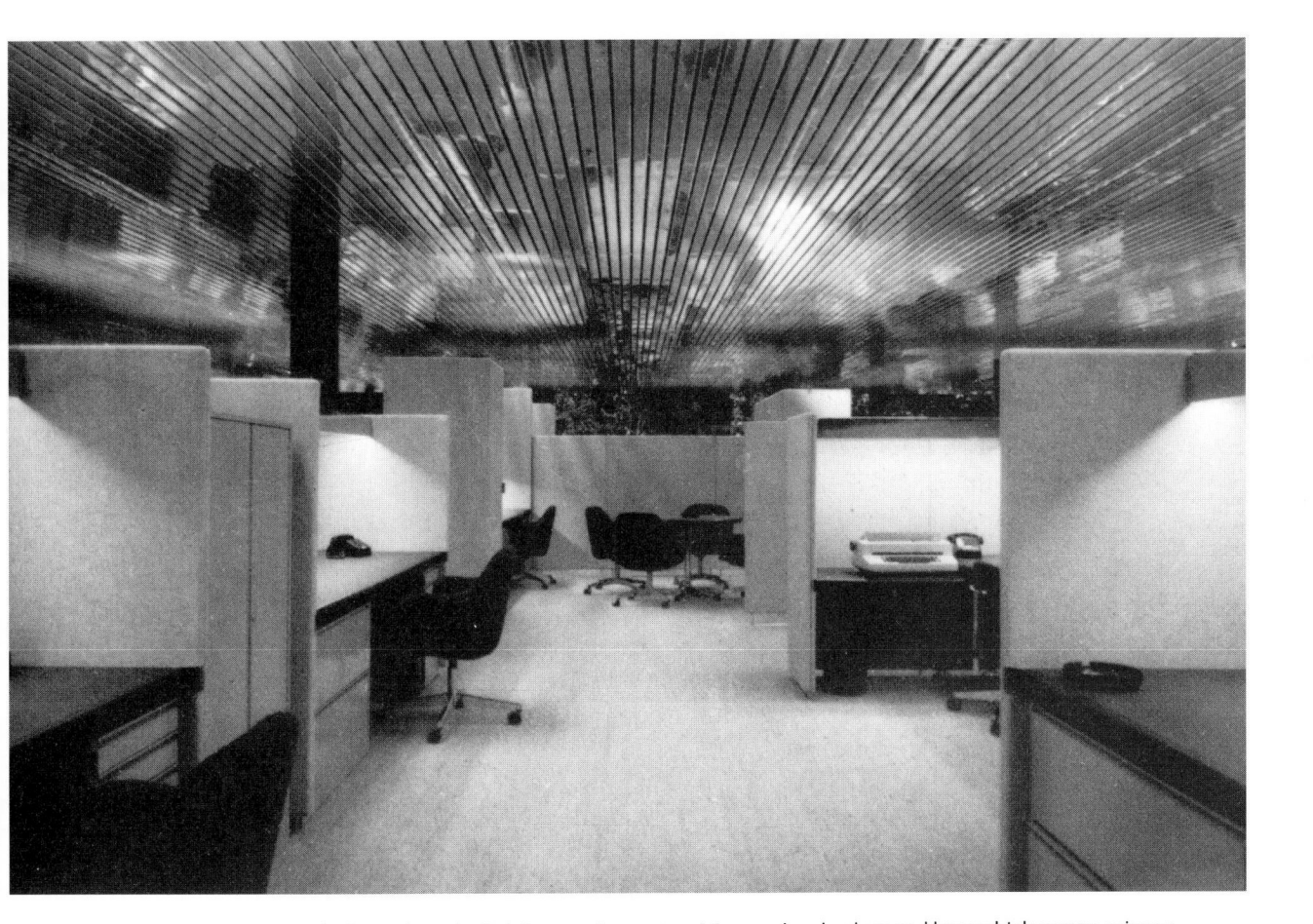

To further reduce the lighting requirement and thus save energy, a highly reflective aluminium ceiling has been used over the entire building. This creates interesting spatial effects and is used to brilliant results in the reflection of indirect lighting concealed in the top of office furniture. Such a reflective ceiling could create a serious problem with noise. However the acoustics are successfully controlled by using sound-absorbent carpet and furnishing and by the transmission of 'white noise', a low background hum which assures privacy.

One of the requirements of the brief was to provide a room to store and maintain the company's art collection which had been growing since the opening of the 1964 building. For display in the new building, the architects selected and acquired a collection of a hundred pieces of textile art of international significance. The textiles date from 1600 to the present day and represent a wide range of weaving and embroidery techniques.

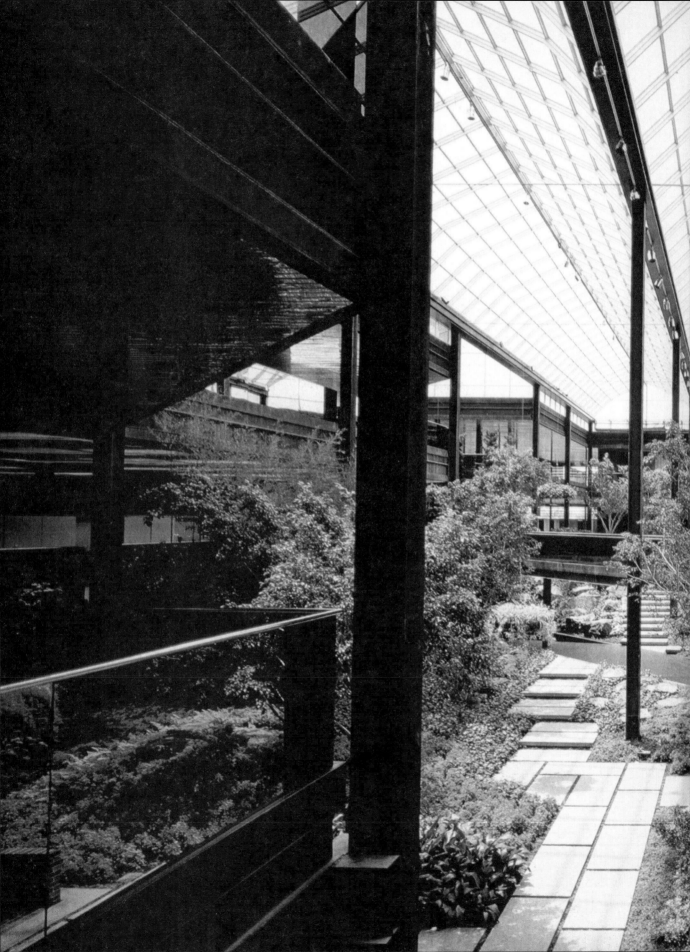

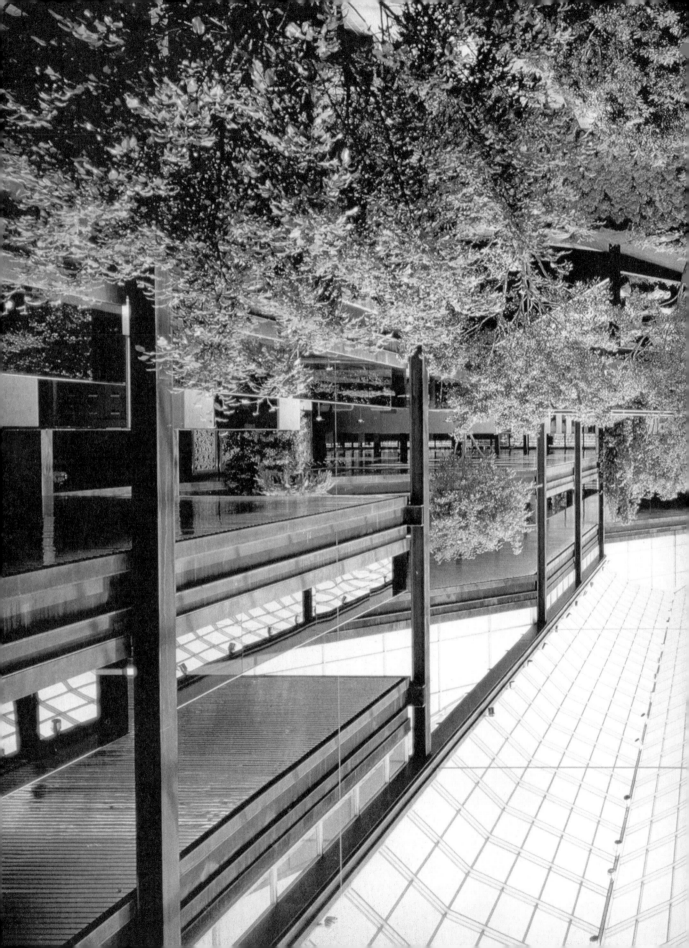

UP series polyurethane foam shapes
marked flat—released by removing the
plastic vacuum-packing
Designed by Gaetano Pesce for C & B, *Italy*

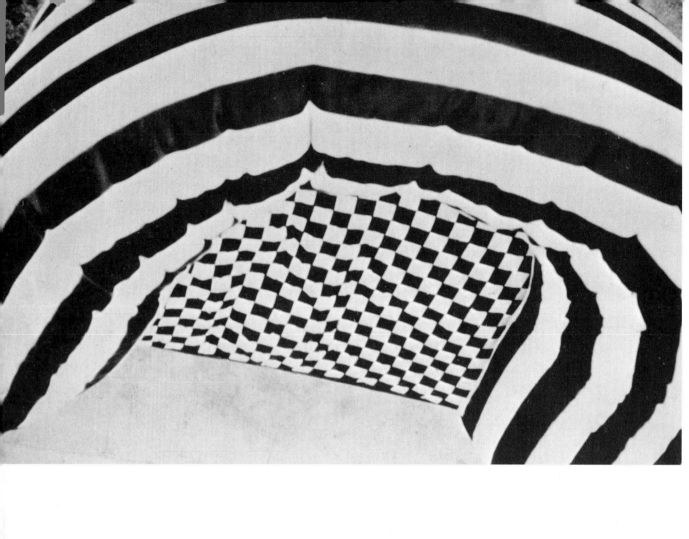

Sofa, part of an experimental environment; blue/white vinyl, foam-filled
Designed and made by Geraldine Ann Snyder, USA

Palla armchair and footstool, zipp-off stretch fabric over rigid polystyrene shapes
Designed by Claudio Salocchi for Sormani Spa, Italy

582 *Ribbon* lounge chair, jersey covered moulded foam rubber on patent frame
Designed by Pierre Paulin for Artifort Holland

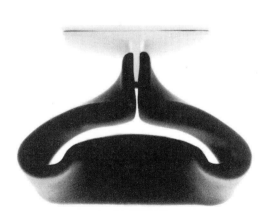

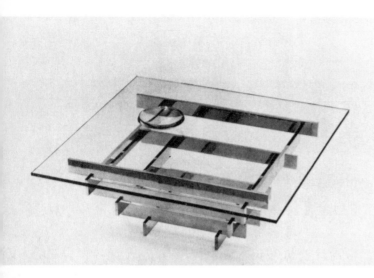

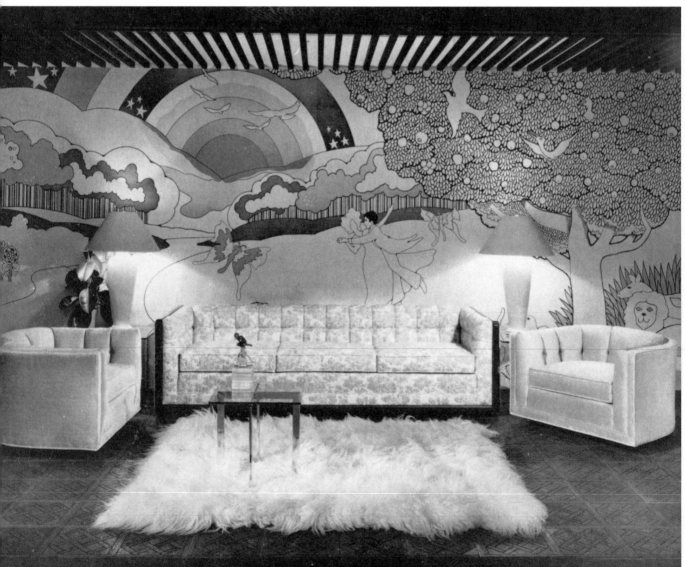

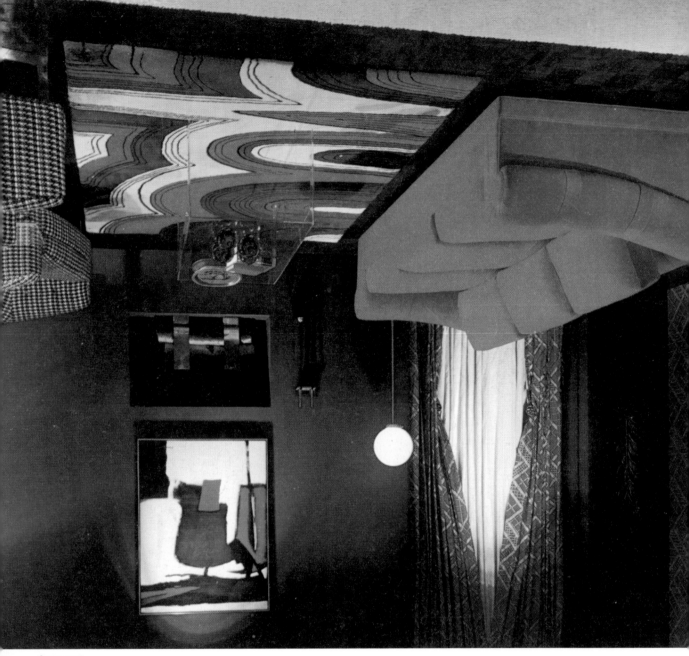

photo Selig

Pall Mall velvet-upholstered sofa: rug by Edward Fields, painting from Karl Mann Associates *USA* against a deep blue wall, in a setting designed by Elroy Edson All furniture designed and made by Selig Mfg. Company, *USA*

Cocktail table, plate glass on reflecting sections of solid brass or chrome steel cm 39·5 × 91·5/15¼ × 36 inches square Designed and made by Zaruch Limited, *England*

Chair with bolster back on polished aluminium frame Designed and made by Harvey Probber, Inc *USA*

Continental sofa wrapped in exposed elm: cm 234/92 inches wide: the barrel chairs incorporate swivel mechanism: Designed and made by Kroehler Mfg Company, *USA*

Rising Sun mural black and white with coloured sun, 12 panels = 2·6 × 6 metres made by Pandora Productions, Inc, *USA*

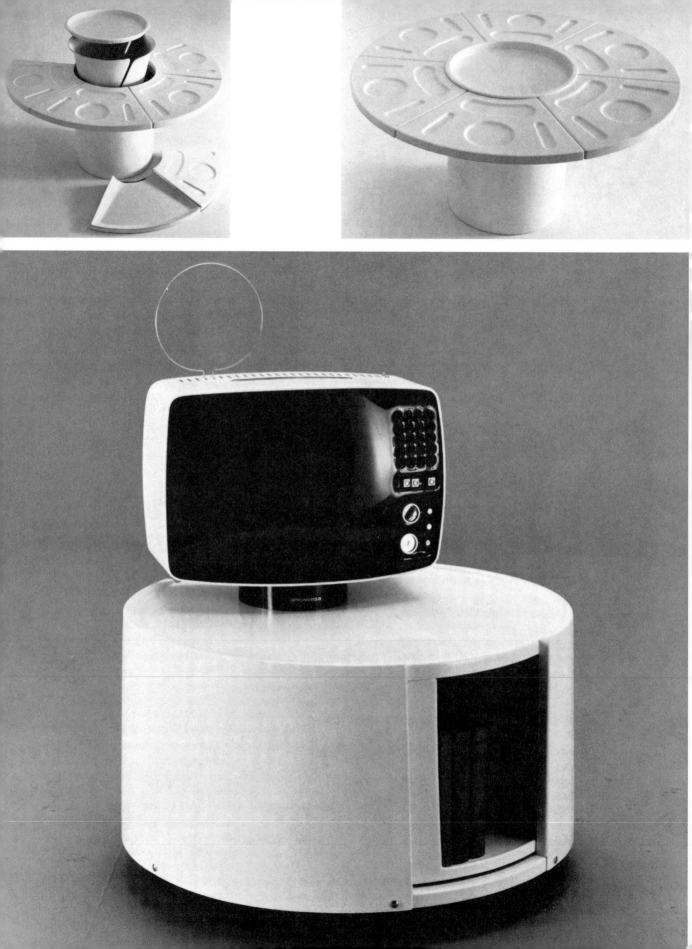

```
1 2
        4 5
3   6   8
    7
```

1,2
Series 230 segmented table with central
hollow support-cum-container for six
folded chairs, series 231, cm 152 × 73/
60 × 29 inches
Designed by Fabio Lenci for G. B. Bernini
& Figli, *Italy*
3
Drum table
Designed by E. Gerli for Tecno spa, *Italy*
4,8
Milieu swivel seat chair, all-white
polypropylene, or to order.

4–4000 chair, injection moulded ABS
buffalo brown or white, cushions covered
black or tan Ventrelle, or weaves.
Both designed by Robin Day for S. Hille
& Co, *England*
5
Oval table in reinforced polyester: cm 230/
92 inches maximum
Designed by Anna Castelli Ferrieri and
Ignazio Gardella for Kartell spa, *Italy*
6,7
Trentare occasional tables, moulded
fibreglass: cm 80 or 120 × 80 × 35 high/
31 or 46 × 31 × 14 inches high
Designed by Sergio Asti for Sintesis,
Italy
9
Chair 290 fibreglass reinforced polyamide,
red, white, green or blue
Designed by Steen Østergaard
for France & Son A/S, *Denmark*

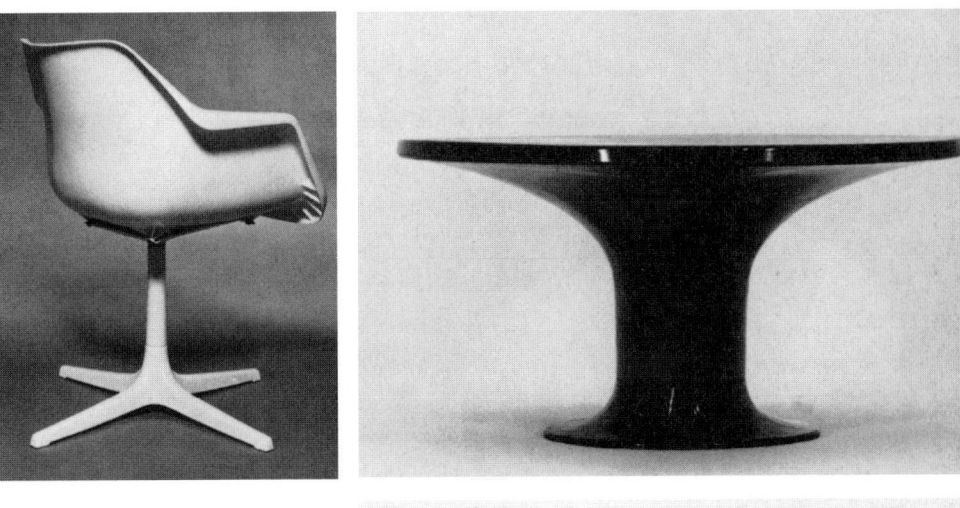

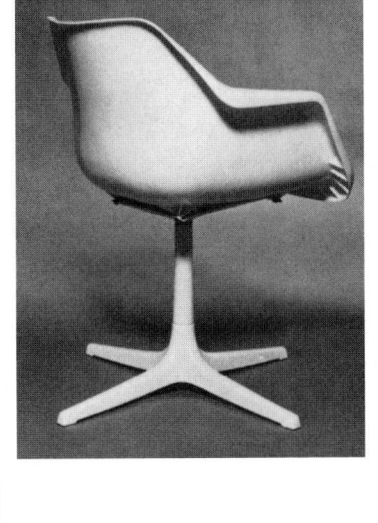

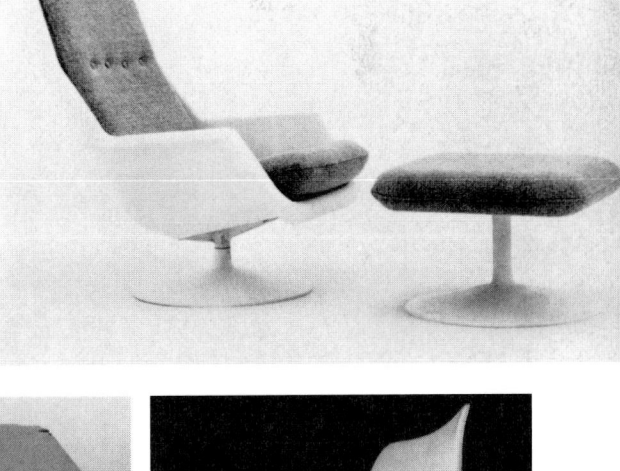

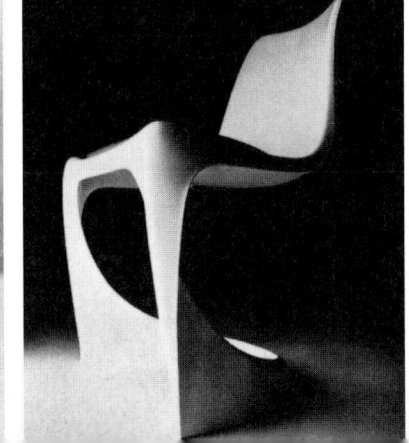

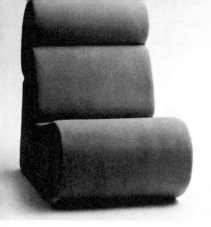

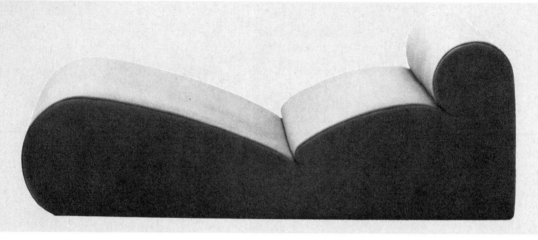

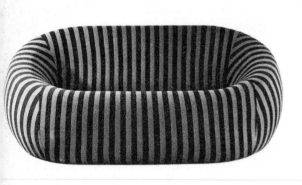

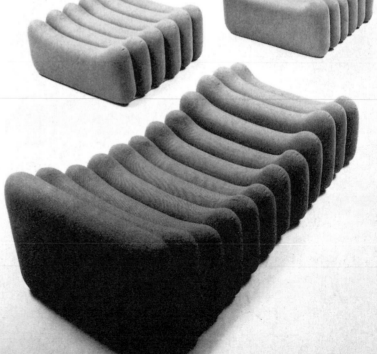

1,2
Boboalto and *Boboletto*
Designed by Cina Boeri for Arflex spa,
Italy
3
Sofa in the UP vacuum-packed series
Designed by Gaetano Pesce for C + B,
Italy
4
Additional system, builds into divans, sofas,
armchairs and stools
Designed by Joe Colombo for Sormani spa,
Italy
5,6
261/62/63 abcd – one, two or three-seat
units with or without right or left-hand
arm contour
Designed by Pierre Paulin for Artifort,
Holland

1 5
2
3 4 6

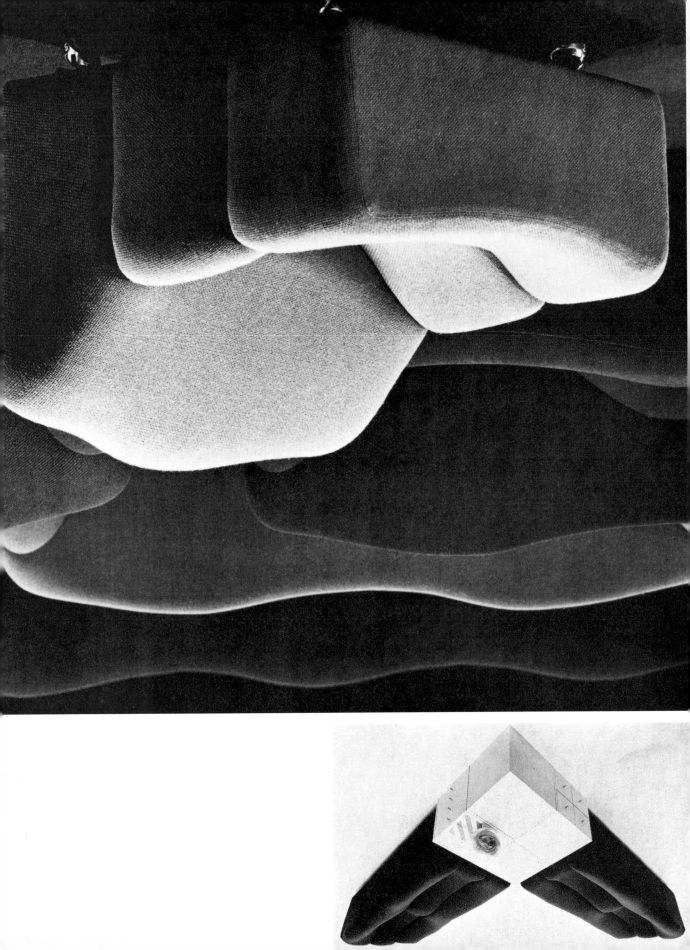

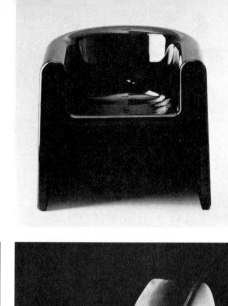

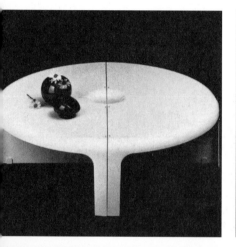

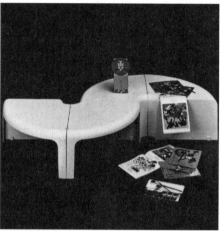

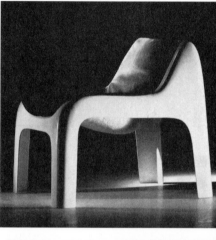

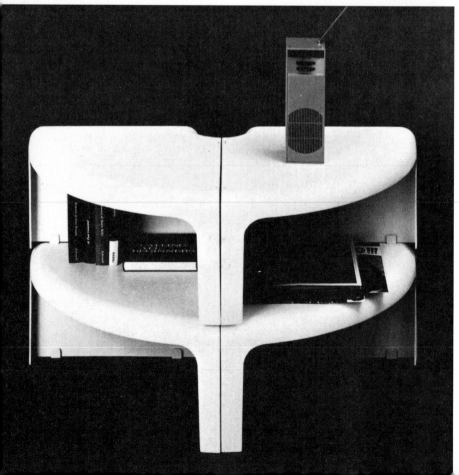

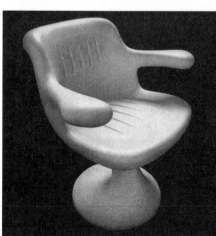

1,2,3
Quattroquarti table, ABS plastic, white,
beige, grey or orange: cm 100/39 inches
diameter
Designed by Rodolfo Bonetto for G. B.
Bernini & Figli, *Italy*
4
Fibreglass chair, black, brown, white,
red-wine
Designed by Rodolfo Bonetto for Driade,
Italy
5
Fibreglass chair, white, red, green, orange
or yellow
Designed by Ahti Kotikoski for Asko Oy,
Finland
6
Desk chair, high density polystyrene
Designed by Angelo Mangiarotti for
Zanotta, *Italy*

```
      4
1 2   5     8
  3 6   7 9
```

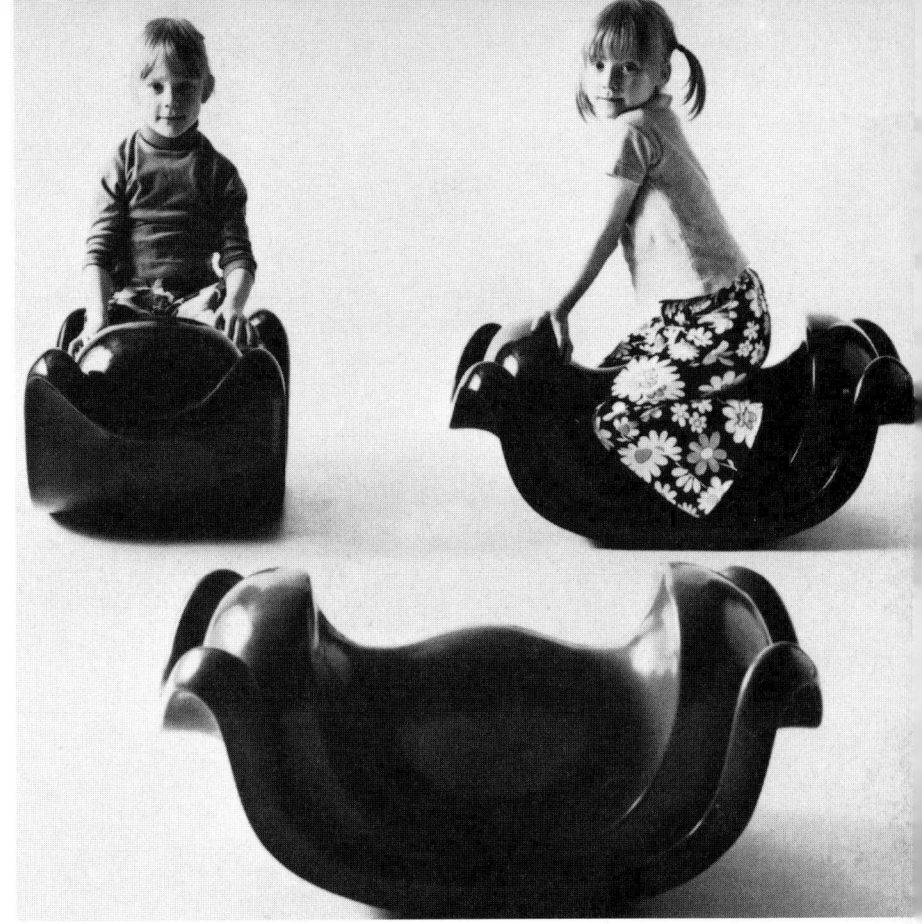

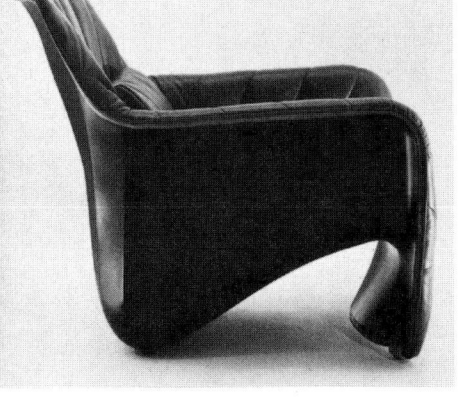

7
Bicia chair, charcoal fibreglass and
plastic shell, polyester foam padding
bonded to shell, loose cushions
Designed by Carlo Bartoli for Arflex spa,
Italy
8
Sculptural rocking-horse, vacuum-formed
polypropylene, red, green or blue
Project designed by P. Hiort-Lorentzen
All made by France & Son A/S, *Denmark*
9
Series 4953 storage units in Cycolac,
white, black, orange, red with black or
white lids/trays, with or without casters:
cm 230 or 380 × 420 diameter/
92 or 152 × 168 inches diameter
Designed by Anna Castelli Ferrier for
Kartell spa, *Italy*

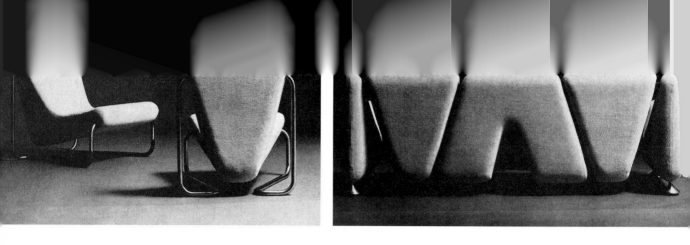

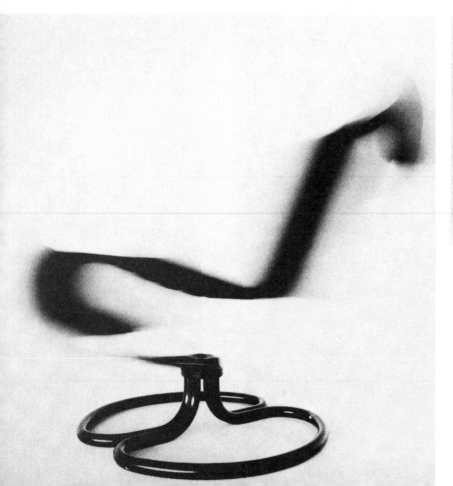

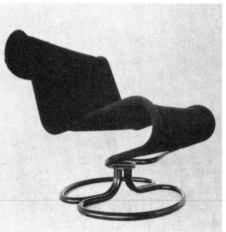

1,2
Model 2560 and sofa 2503, moulded foam rubber over a steel frame, covered textiles
Designed by Luigi Colani for Fritz Hansens Eft A/S, *Denmark*
3,4
Spaghetti chair, canvas over steel tube: black, red or yellow
Designed by Jan Dranger and Johan Huldt for Ulferts Fabriker Ab, *Sweden*

1 2 7 5
3 4 6
 8

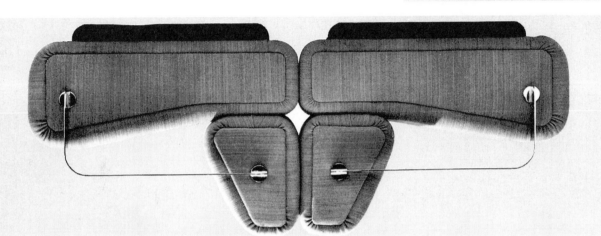

5,6
Chair 3108, moulded laminated wood on chrome-plated steel frames, colour-lacquered, upholstered in natural teak or oak. Designed by Arne Jacobson.
7
Dining chair, dull chromed steel and natural or black saddle leather: seat cm 39 or 42.5/15 1/2 or 17 inches high
Designed by Hans J. Wegner for Johannes Hansen Cabinetmaker, Inc, *Denmark*
8
Chair and stool, 8101 and 8110, moulded laminated wood, foam-rubber-covered on chrome-plated steel frame: cm 92/37 inches high overall
Designed by Jørn Utzon
All made by Fritz Hansens Eft A/S, *Denmark*
9,10
Scott Module Seating, polyether foam on Pirelli webbing, beech frame with optional chrome arms
Designed by Frederick Scott for S. Hille & Co. *England*

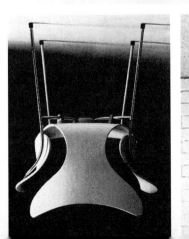

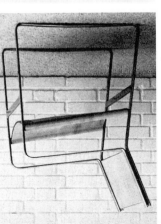

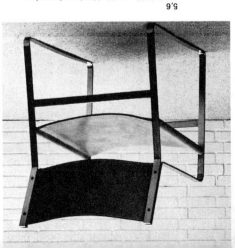

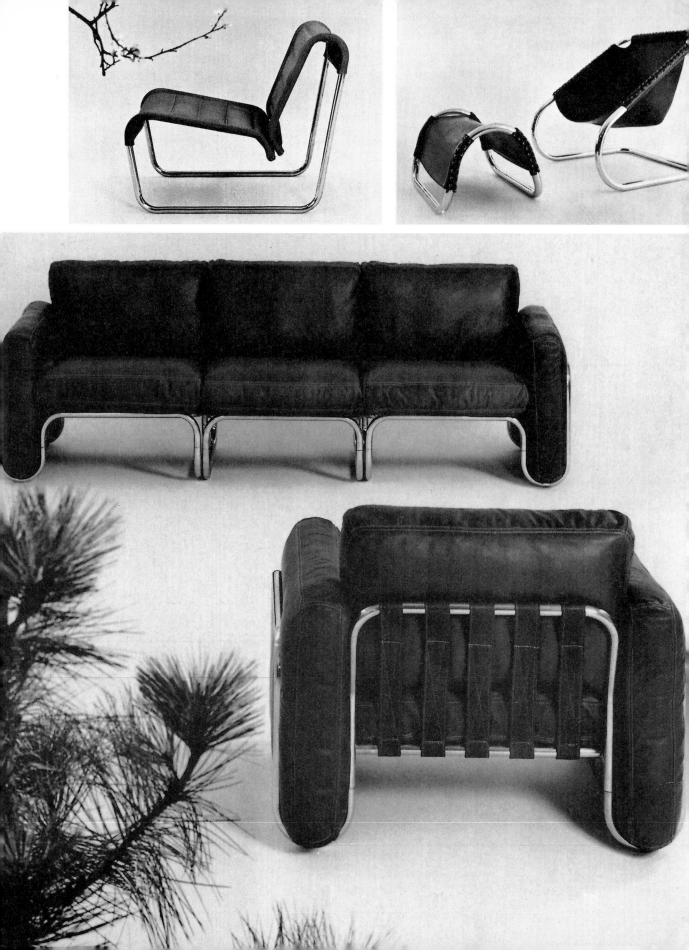

1 *Springer* steel tube chair with back/seat of ox-hide laminated to non-sag Dacron. Designed by Rud Thygesen and Johnny Sørensen for A/S Mogens Kold *Denmark*

2 Pony chair and foot-stool, chrome steel with black leather slings Designed by Alberto Colombi and G. P. Guzzetti for Alberto Bazzani *Italy*

3 Easy furniture system composed of chromium-plated steel tubes with loose hide-covered cushions on Pirelli suspension. Three-seat sofa or to custom width Designed by Lise and Hans Isbrand for A/S Mogens Kold *Denmark*

4 Easy chair 3400 chromium-plated steel tube with foam-upholstered back and seat rests Designed by Arne Jacobsen for Fritz Hansen Furniture *Denmark*

5 Lounge chair 603, polished chrome steel and black-stained mahogany frame with black heavy canvas sling: covered royal blue, black or natural linen or suedecloth Designed by Byron Betker and Jerry Johnson for Landes Manufacturing Co *USA*

6 *Blocco II* rectangular seating unit, wood frame, upholstered in polyurethane foam of different densities and Dacron, covered in fur fabric: cm 63/25 inches high Designed by Nanda Vigo for Driade *Italy*

1
Primate seat
Designed by Achille Castiglioni for
Zanotta, *Italy*
2
Joe armchair, moulded foam rubber
covered hide
Designed by De Pas, D'Urbino and
Lomazzi for Poltronova, *Italy*
3
Chair and stool from the *Epsom* range,
polished aluminium frames with pre-formed
plywood sections upholstered leather, vinyl
or woollen cloth over high density
polyether foam: the high-back working or
dining chair, cm 99/37 inches high overall
Designed and made by William Plunkett
Limited, *England*

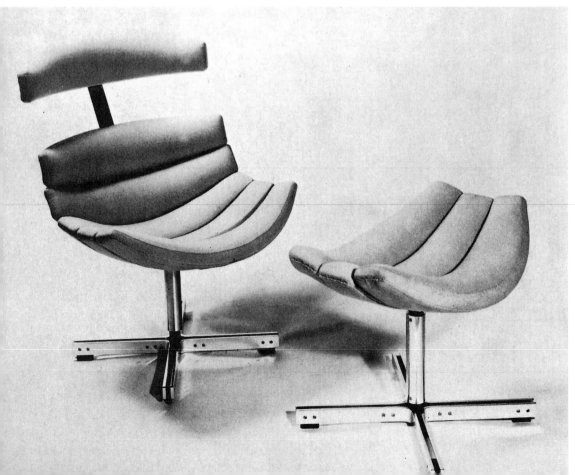

4
Saturnus chair, fibreglass frame black,
white, blue, red or beige with black leather
upholstery over foam rubber and dacron:
cm 74 high × 80 wide overall/30 high ×
32 inches wide overall. Sofa is assembled
from seat, base and armrest units
Designed by Yrjö Kukkapuro for Haimi Oy
Finland
5
Unit system chair and sofa, chromed steel
underframe, leather upholstery, three-seater
sofa: cm 225/90 inches wide
Designed by Michael A. Tyler for Collins
and Hayes Limited, *England*

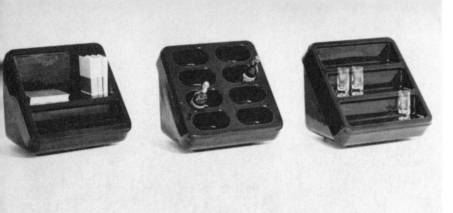 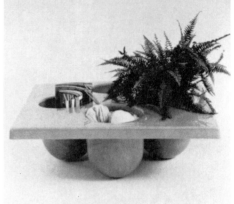

1
Tomorrow small storage unit, polystyrene
Designed by Cesare Casati and
Emanuele Ponzio for Sormani *Italy*

2
Vesuvio plant, newspaper, needlework
holder black, white or red polystyrene
Designed by Studio Tetrarch for Linea B
Italy

3
Marc Held high- and low-back chairs and
ottomans, white fibreglass shell bonded to
upholstered shell, rocks and rotates on its
counterweighted convex surface
Designed by Marc Held for Knoll
International *USA* and Form International
England

4
The Hump system single or modular
seat/table, glass fibre-reinforced plastic,
black, white and five high-gloss colours:
cm 60/24 inches square and cm 20, 40, 80
or 120/8, 16, 32 or 48 inches high:
nylon velvet covered cushion, choice of
five colours, cm 20/8 inches deep
Designed by Arthur Golding and Doug
Meyer for Architectural Fiberglass *USA*

5
Dining chair in glass fibre reinforced
polyester, white
Designed by Konrad Schafer for Firma
Lubke KG *W. Germany*

6
Lola chair in glass fibre reinforced polyester,
black, white and five deep jewel colours,
high gloss finish cm 73/29 inches
high overall
Designed by D. T. Chadwick for Arcon
Furniture *USA*

7
Bar stool, moulded glass fibre red, white,
turquoise or yellow with or without
upholstered seats: cm 70/29 inches high
Designed by Nanna Ditzel for Domus
Danica *Denmark*

8
Carrello Tondo bar table, Marbon ABS
white or red cm 51/20 inches diameter × cm
54/22 inches high
Designed by Giotto Stoppino for Kartell
SpA *Italy*

```
1 2
  4 6
  3 5 7 8
```

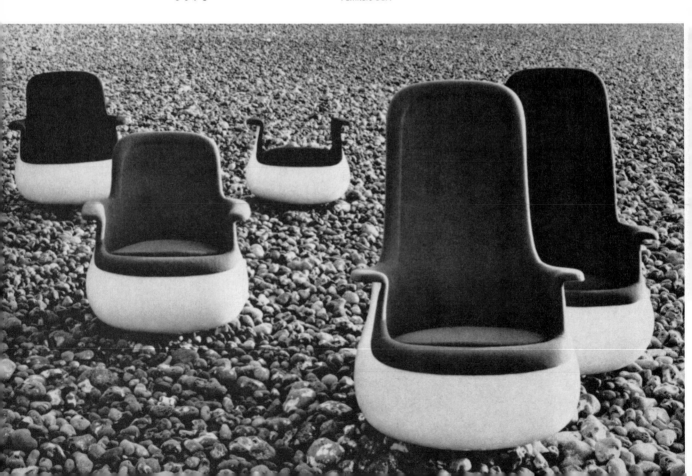

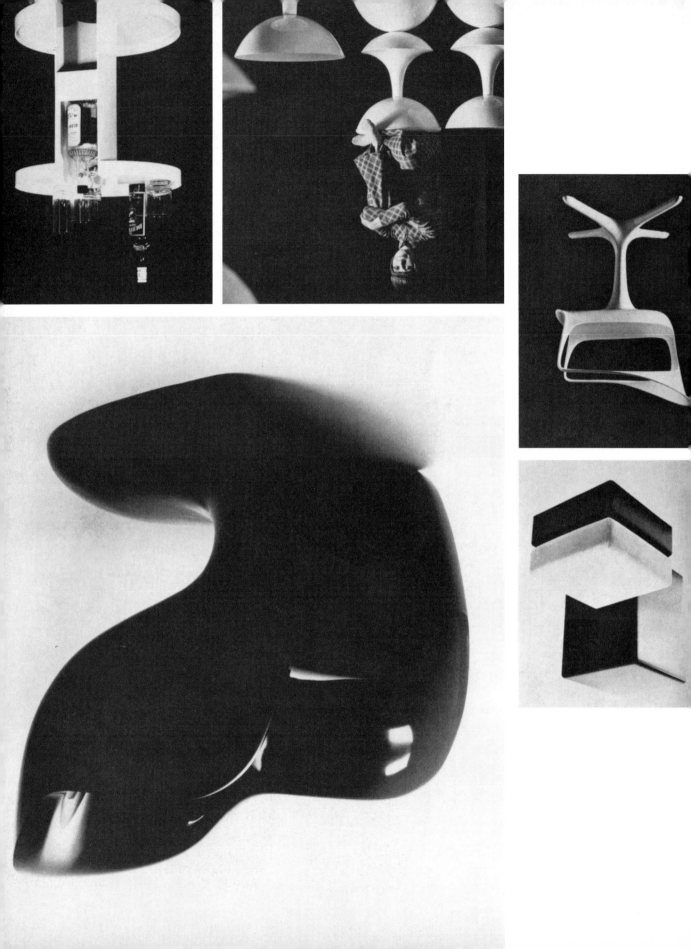

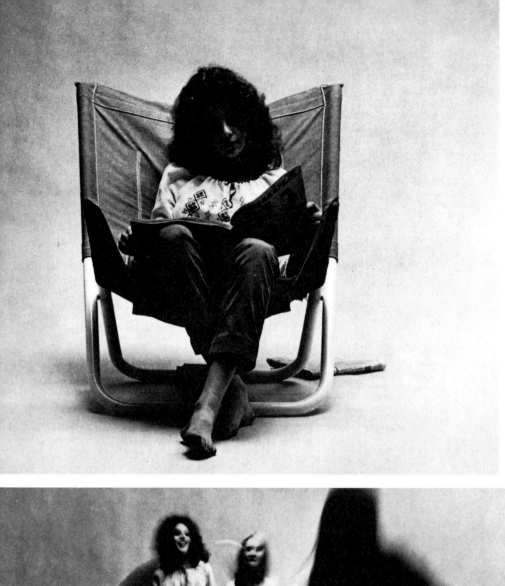
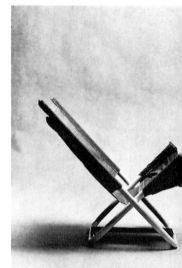

1-3
Ping-pong table and adjustable folding
chair in the S 70 series : table-top folds
and frame slides into dining size
Both on steel tube frames
Designed by Lindau and Lindecrantz for
Lammhults Mekaniska Verkstad Ab
Sweden

4
Series 177 chair and 2-, 3- or 4-seater sofa
all with or without arms, glass fibre-
reinforced polyester, white with
contrasting vinyl upholstery
Designed by Niels Jørgen Haugesen for
France & Son A/S *Denmark*

5, 6
Wave daybed or random seating : basic
form of glass fibre-reinforced polyester
upholstered in a range of fabrics
cm 200×140 · 61/80×56×24 inches
Designed by Susan Collingridge at the
Royal College of Art *England*

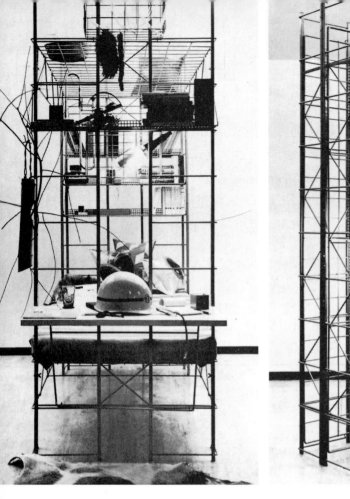

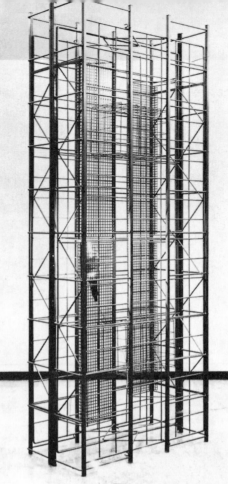

1, 2
Abitacolo welded steel structure, pale-grey epoxy resin-finished: basically four uprights/ladders on to which panels, adjustable table, baskets, 'almost anything' may be hooked: designed to a basic module of cm 20/8 inches, a cabin or cockpit in which to find isolation
Designed by Bruno Munari for Robots *Italy*

3
A more sophisticated, adult cage chromium steel tube
Designed by Alberto Massoni for Poltrona Frau, *Italy*

4, 5
Unigramma hanging cupboards, silk-screen decoration on white plastic laminate doors: m 6.2/236 inches high
Boys designed by Gallina and *Wave* designed by Michele Sfera for Stildomus *Italy*

6
Il Paravento screen red or white polystyrene
Designed by Alberto Colombi and G. Paolo Guzzetti for Linea B *Italy*

7
Sergesto bookshelving unit in Marbon ABS cycolac, red, white or orange
Designed by Sergio Mazza for Artemide *Italy*

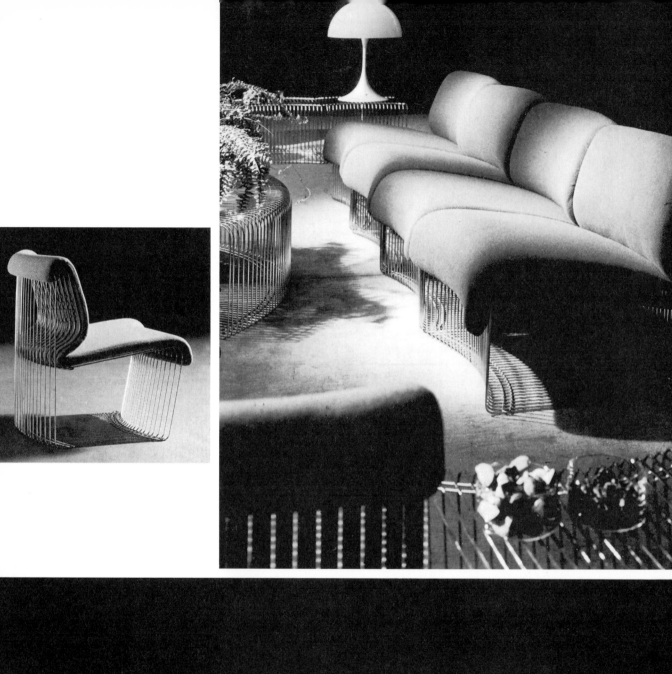

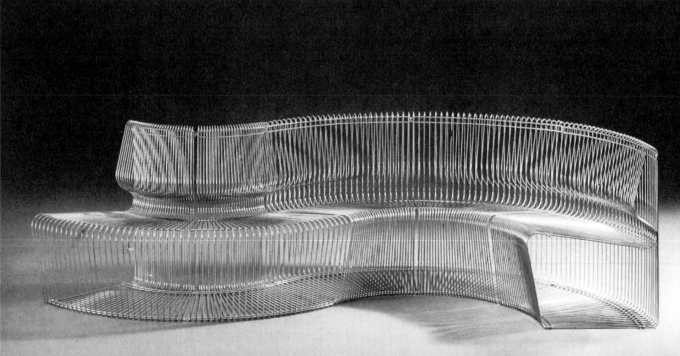

Pantonova series based on chromium-plated steel grid constructions: four basic chair shapes for straight, concave or convex seating with seat or seat-and-back cushion covered in Myralastic over form-cast plastic foam
The round table cm 120/47 inches diameter consists of six units bearing a glass top. Stools and storage units double as small tables
Designed by Verner Panton for Fritz Hansen Møbler A/S *Denmark*

Cabinet wall, with front finish in sand velour lacquer, from a range of wall storage units in two depths and three widths: cm 40 or 61 × 38, 54 or 90/15½ or 24 inches × 15, 21 or 35 inches: also finished in white-grey or black lacquer, larch, walnut, Rio rosewood or mahogany Designed by Walter Müller, Switzerland, in co-operation with, and for Interlübke *West Germany*

Blinds and upholstery fabrics from co-ordinating designs, including carpets, made especially for Interlübke Seating and table by COR-Sitzkomfort *West Germany*

Pendant lamp designed by Verner Panton and made by Louis Poulsen *Denmark*

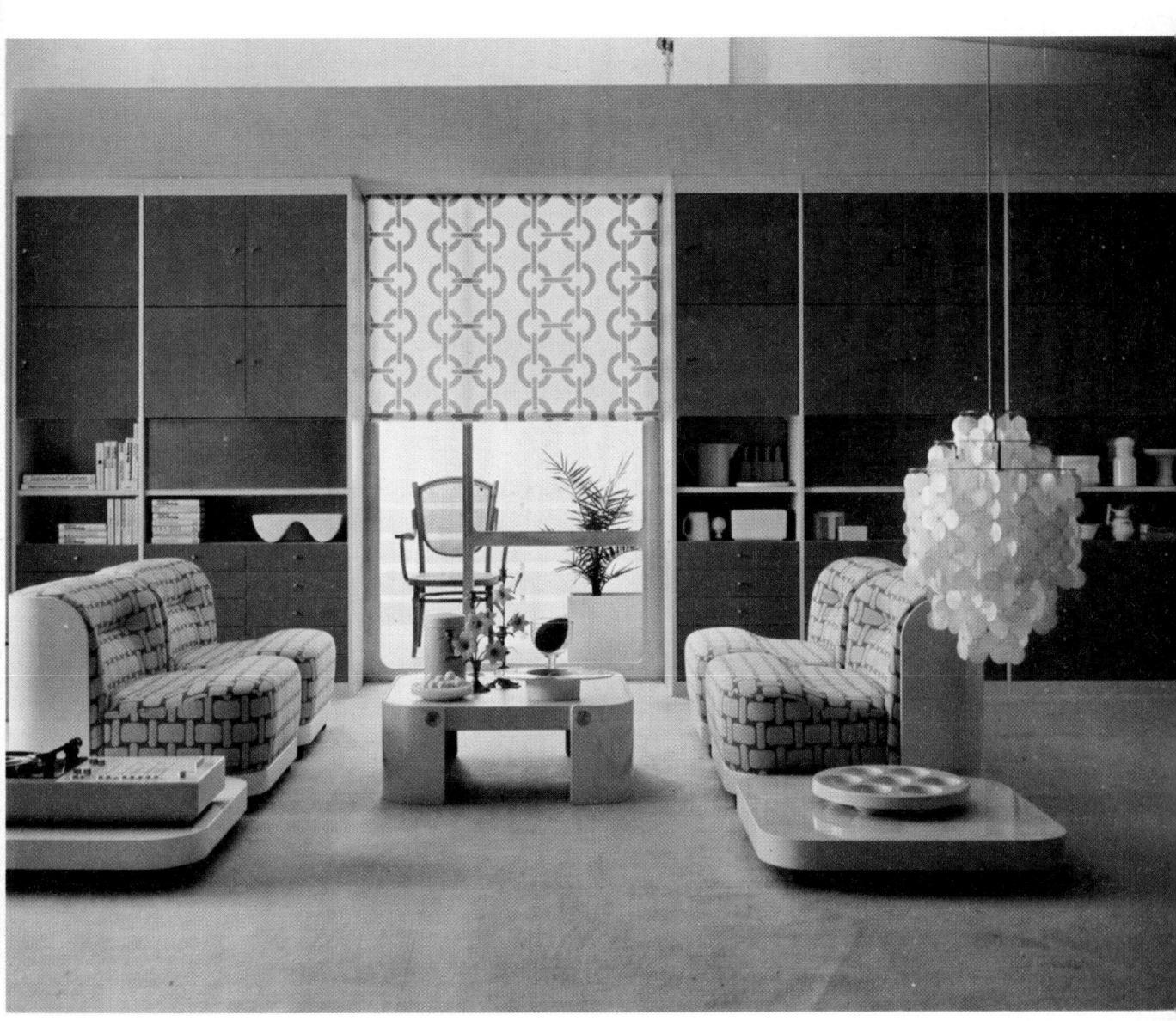

1
Stacking shelf units: ABS resin
yellow, red or white: each
cm 80×30×35/31½×12½×13¾ inches
Designed by Makoto Ookawa and
Sohsuke Shimazaki for Isetan Company
Limited *Japan*

2
Tyrol seat: white or orange vacuum-
formed polystyrene
Designed by Roth *Germany* for
Meurop NV/SA *Belgium*

3
Sauna stool: injection moulded
polyurethane, dark blue, dark green,
orange, yellow or brown
cm 38×27/15×10½ inches
Designed by Tammo Tarna for
Sarvis Oy *Finland*

4
Prototype table-system for rigid
polyurethane with sectional drums of
fibreglass or plywood
Designed by Jane Wright at the
Royal College of Art *England*

```
            4 7 5
            1 3  6
            2    8
```

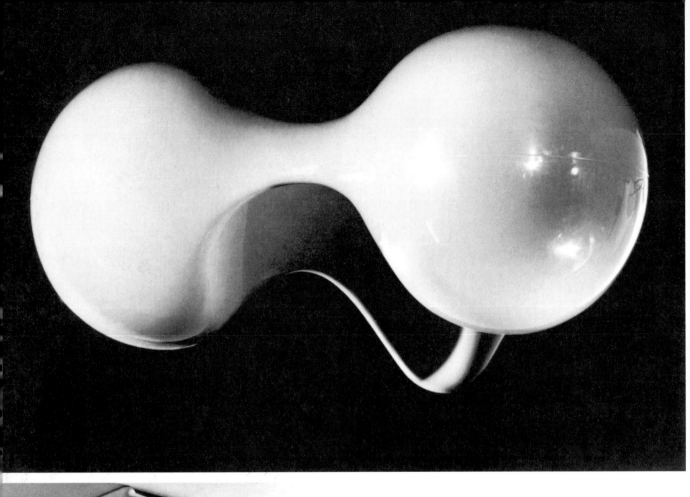

5

Castle chair: white, yellow, orange or red
fibreglass cm 56/22 inches high,
cm 119.5/47 inches wide
Designed by Wendell Castle for
Stendig Inc USA

6

Esther low- or high-backed chair:
polyether foam seats on white
polystyrene base: upholstered in wide
range of fabrics
Designed by J. P. Emonds-Alt for
Meurop NV/SA Belgium

7

Single beds linked as pair: fibreglass
white, green, red or yellow
cm 215×45/84×36 inches plus right- or
left-hand ledge
Designed and made by Sopenkorpi Finland

8

Tomaatti lounge chair: fibreglass
reinforced plastic white, red, yellow,
orange or green cm 140/54¾ inches wide,
cm 69.5/27½ inches high
Designed by Eero Aarnio for Asko Oy Finland

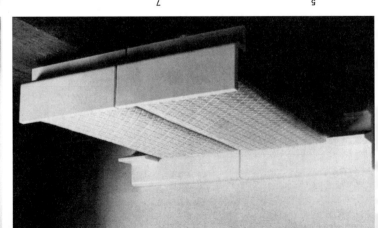

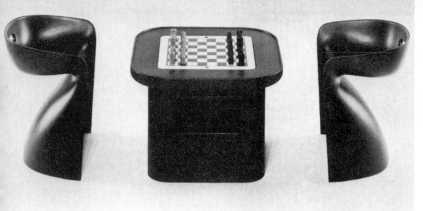

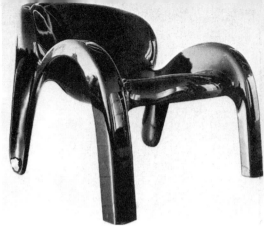

1, 2
Chess or drinks table *33 377*: smoked
glass top covers a central hold for
bottles, flowers, lighting, etc: black or
white polyurethane cm 70/27$\frac{1}{2}$ inches
square
Designed by Peter Ghyczy
Stool *11 104*: white, red or black
polyurethane cm 59/23 inches high
Designed by Winifred Staeb
Chair *29 252* white, red or black
cm 67/26$\frac{1}{2}$ inches high, moulded cushion
available
Designed by Peter Ghyczy
All from the Form + Life Collection
made by Reuter Produkt Design GmbH
West Germany

3, 4
Labia chair: from two injection moulded
Baydur sections: white, black, brown or
orange: cm 50 × 75/19$\frac{3}{4}$ × 29$\frac{1}{2}$ inches high
Appoggio support saddle: plastic with
metal base, adjustable height
Both designed by Claudio Salocchi
for Sormani SpA *Italy*

5
Wardrobe for production in rigid
polyurethane or vacuum-formed fibreglass
reinforced plastic, dark brown or colours,
cm 183/72 inches high cm 68$\frac{1}{2}$/27 inches
square
Designed and made by David Field
England

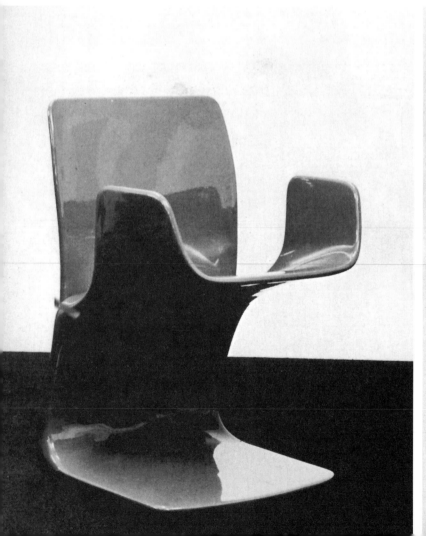

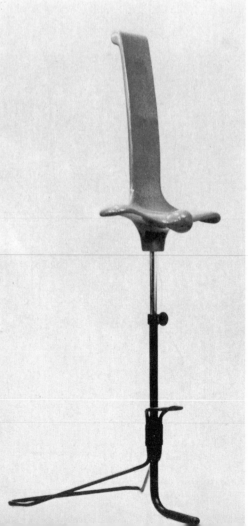

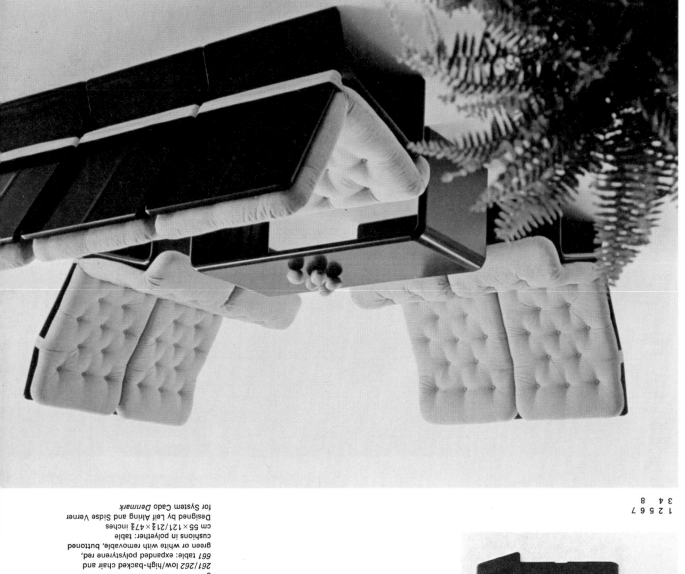

8
261/262 low/high-backed chair and
661 table: expanded polystyrene red,
green or white with removable, buttoned
cushions in polyether: table
cm 55 × 121/21⅔ × 47⅞ inches
Designed by Leif Alring and Sidse Verner
for System Cado *Denmark*

7
Garden Egg: the backrest/lid, closed,
protects the Egg from weather: white,
red or yellow polyurethane shell, matching
cushions covered with Bri-Nylon about
cm 84/33 inches at widest point
Designed by Peter Ghyczy for
Reuter Produkt Design GmbH *West Germany*

6
Occasional table of red, black or white
ABS resin: cm 70/27½ inches square
cm 30/11⅞ inches high
Designed by Makoto Ookawa for
Isetan Company Limited *Japan*

3 4 8
1 2 5 6 7

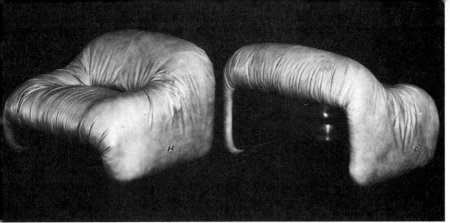

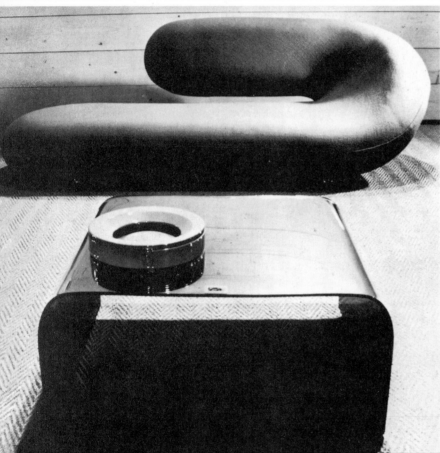

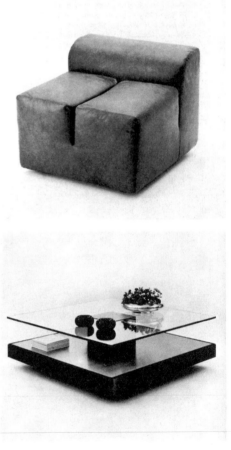

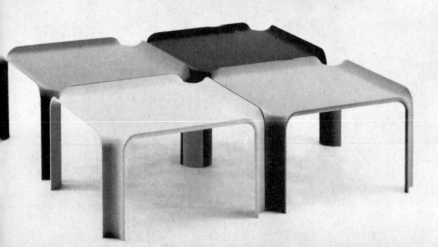

1
Bonanza chair: semi-rigid plastic shell
with Duraplum stratified foam 'mattress'
covered leather or weaves
Designed by Tobia Scarpa for C&B *Italy*

2, 6
Chaise Longue 248: moulded foam rubber
on steel and wood frame upholstered with
stretch fabric cm 63 × 190/24¾ × 71½ inches
overall
Chair 595: metal tube frame on cylinder
base upholstered ABS plastic
cm 86 × 85/34 × 33½ inches high
Both designed by Geoffrey D. Harcourt

3
Table 877: Nextel plastic available in
seven colours cm 50/19¾ inches square
cm 27/10½ inches high
Designed by Pierre Paulin
All made by Artifort *The Netherlands*

4
Ipercubo 200 armchair: weight displaces
seat/armrest in a predetermined way:
interior-sprung polyurethane and dacron,
covered leather or heavy blue denim
cm 83 × 73/32¾ × 28¾ high
Designed by De Pas, D'Urbino, Lomazzi
for Driade *Italy*

5
T147 two-tiered table: clear crystal top
centred on a cubic wooden block
lacquered black matt polyester: the lower
tier is brushed stainless steel and houses
eight drawers: cm 130/51 inches square,
cm 45/17¾ inches high
Designed by Marco Fantoni for Tecno SpA
Italy

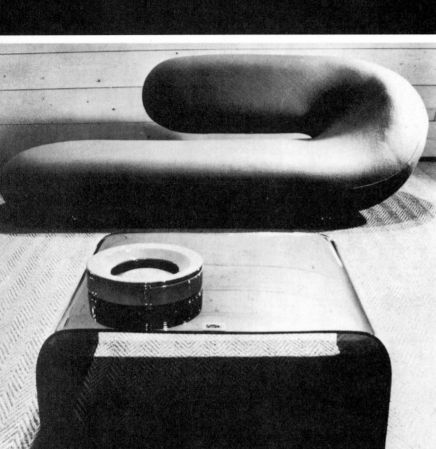

7, 8
Pianura seating units and table: solid
structured timber with expanded
polyurethane and Dacron Fiberfil cushions
covered with weaves cm $82 \times 63/32\frac{1}{2} \times 24\frac{1}{2}$
inches
Designed by Mario Bellini for C&B *Italy*

9
Chair, pouffe and table 656/856:
polished chrome tube frame with
polyurethane foam one piece back and
seat cushion covered fabrics: the table has
smoked Perspex top
Designed by Pierre Paulin
All made by Artifort *The Netherlands*

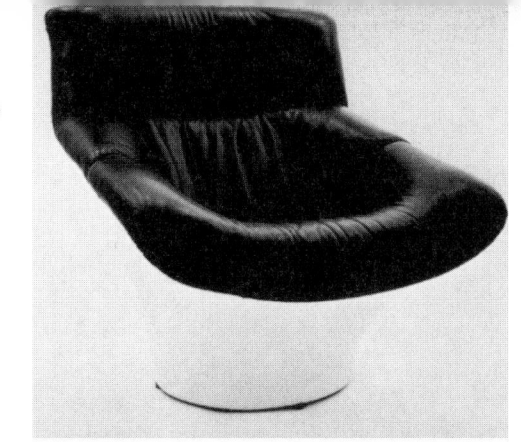

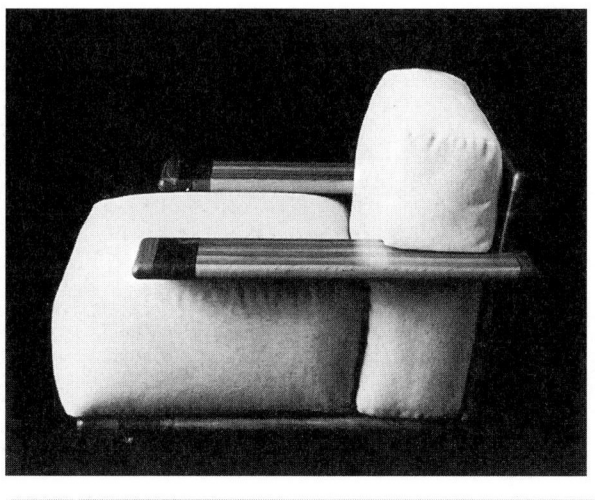

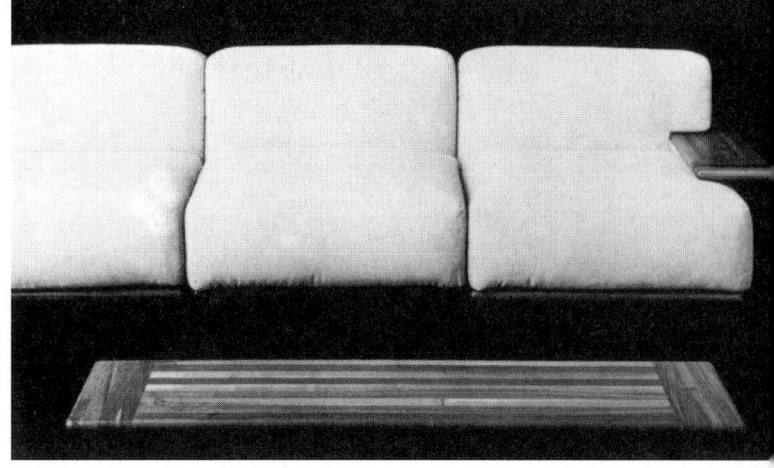

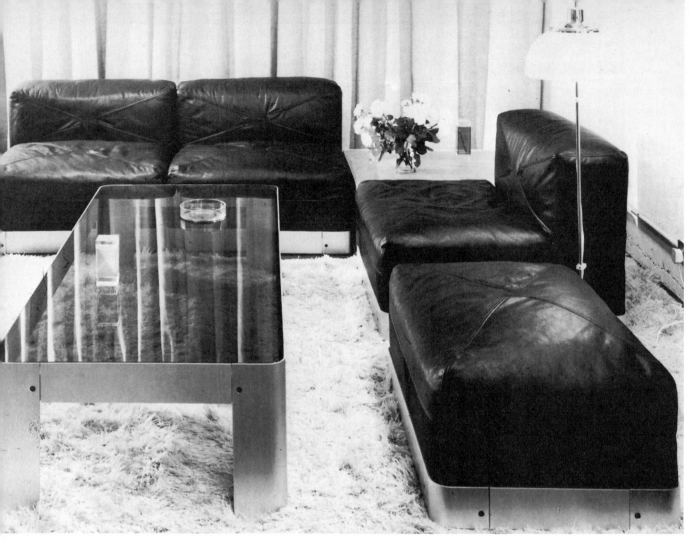

1
Single or combined seat unit: extruded aluminium frame with cushions of latex over pvc core, covered aniline hide: cm 86½/34 inches square
Matching coffee or dining table with smoked glass top, custom-made sizes
Designed by John Hardy and David Taylor for Design Workshop *England*

2, 3
Leg-set for self-assembly of plate-glass, slate or wood-topped table: chrome steel: cm 46/18 inches or cm 81·5/32 inches high
Designed and made by Atelier 'A' *France*

4
Nursery with wall storage units incorporating the revolving bed unit and built-in chest of drawers and shelves. The front finish is white-grey lacquer
Designed by Walter Müller, Switzerland, in co-operation with, and for Interlübke
West Germany

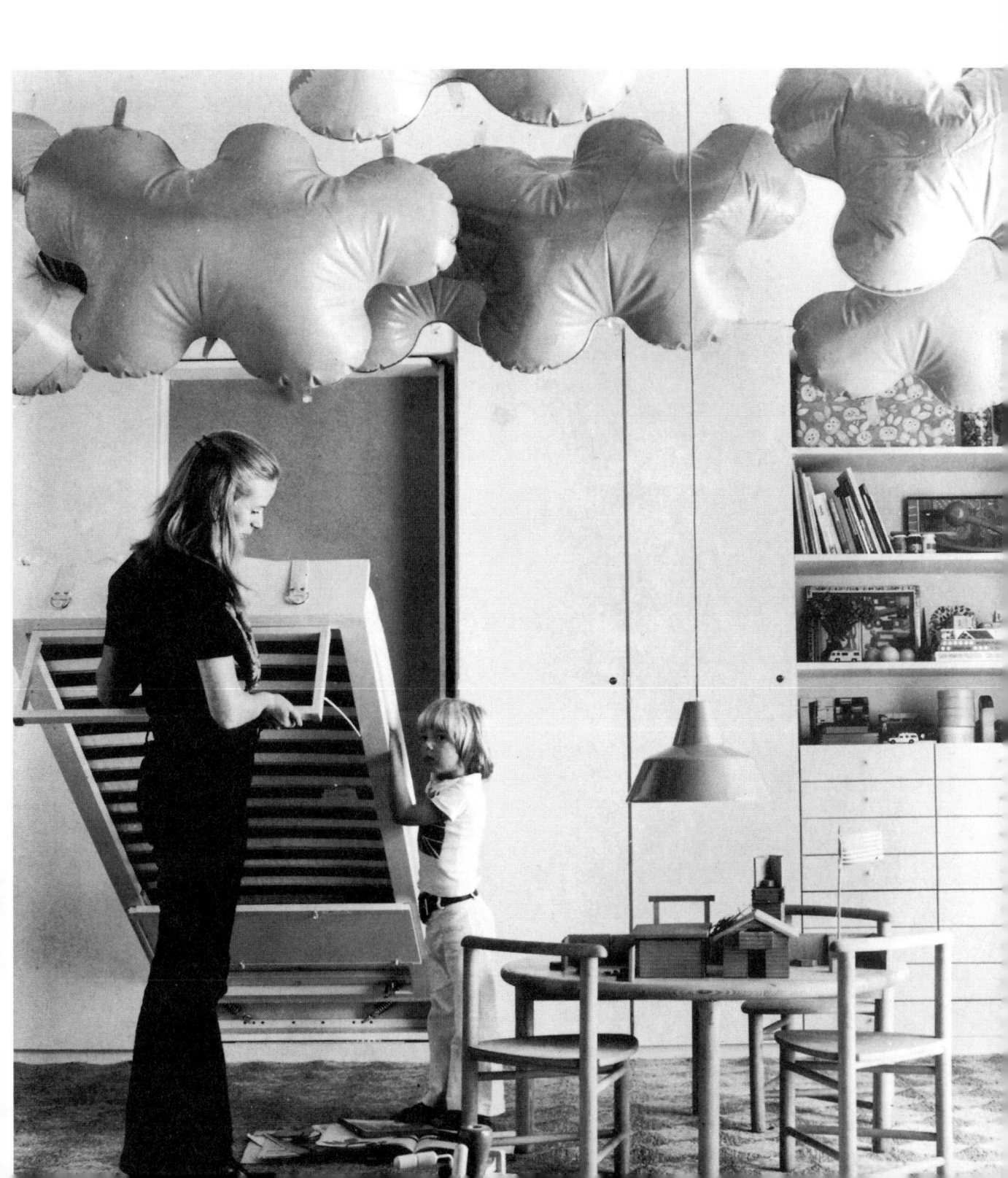

Opposite
'Podium 3' furniture programme;
plinths of various sizes and
heights, cabinets and special
'lamella' mattresses will
combine in different ways; ash
lacquered white/grey frames;
platforms and cabinets in sand
or green velour finish, yellow
or black stained
Designed and made by
Interlübke, West Germany

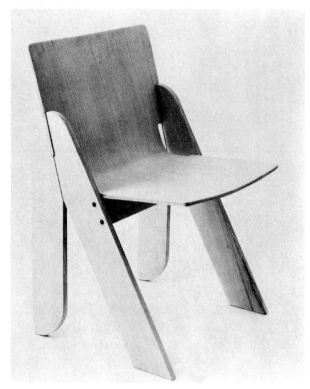

'Peota' chair, knockdown
construction, natural ash or
glossy black finish
Designed by Gigi Sabadin for
Stilwood, Italy

'Toco' bed, black or white
lacquered wood, chrome steel
support; 2 m × 1·70 m
(6′ 6″ × 5′ 7″)
Designed by Ennio Chiggio
for Zoarch, Italy

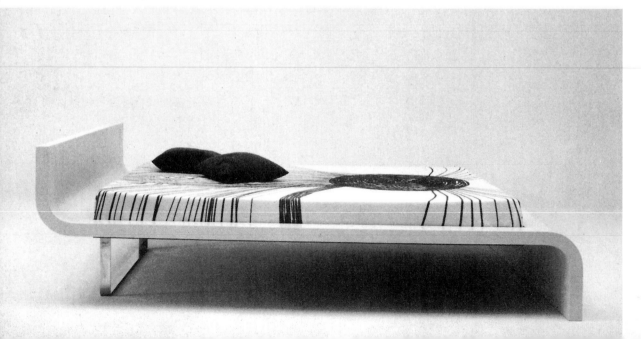

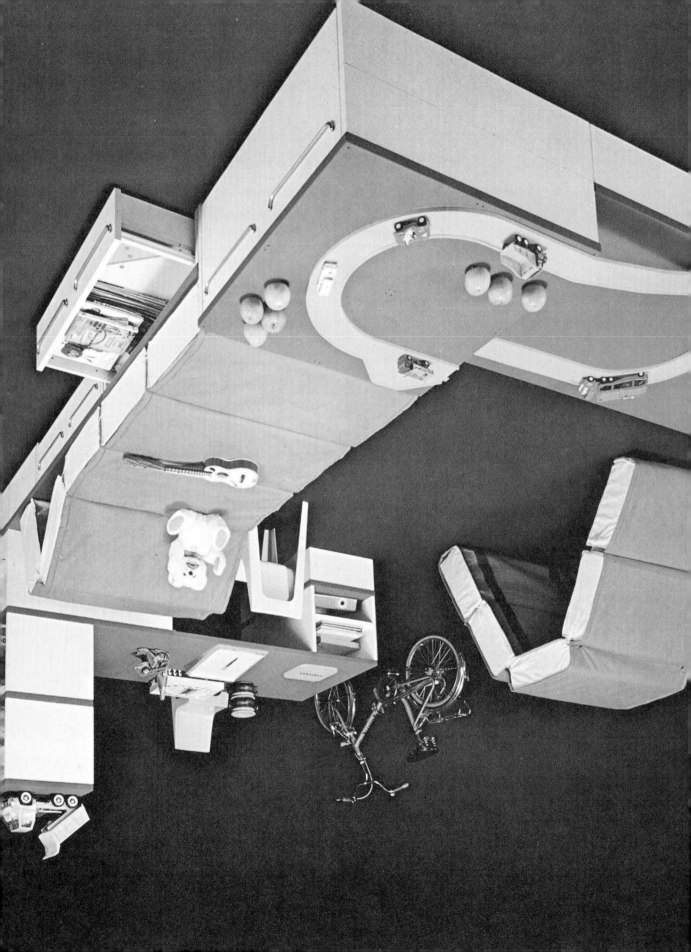

'Malibu' collection, waterproof
outdoor furniture; ABS
plumbing fittings, sling seats
with cushions covered of PVC
coated nylon, lemon, tangerine,
green or off-white
Designed by Heinz Meier for
Landes, USA

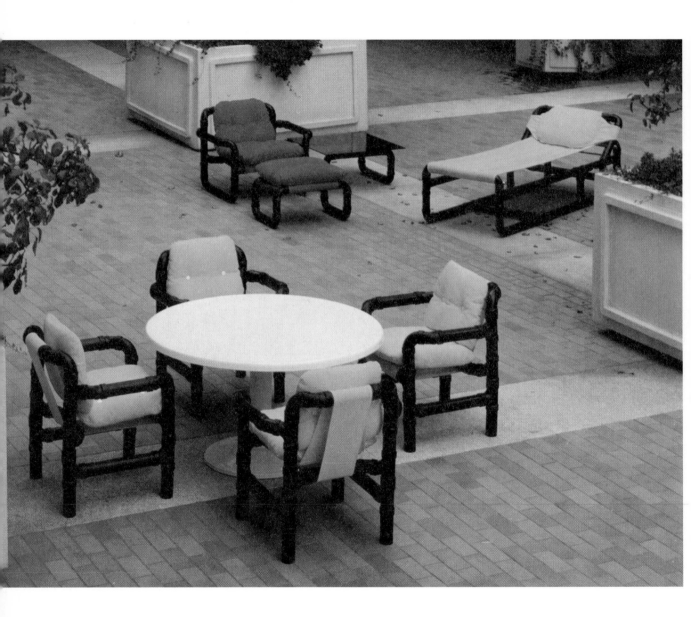

'Sunball', weatherproof sphere
houses folding seat, drinks shelf,
lighting and radio; can be
completely closed and locked
Designed by Günter Ferdinand
Ris for Rosenthal Einrichtung,
West Germany

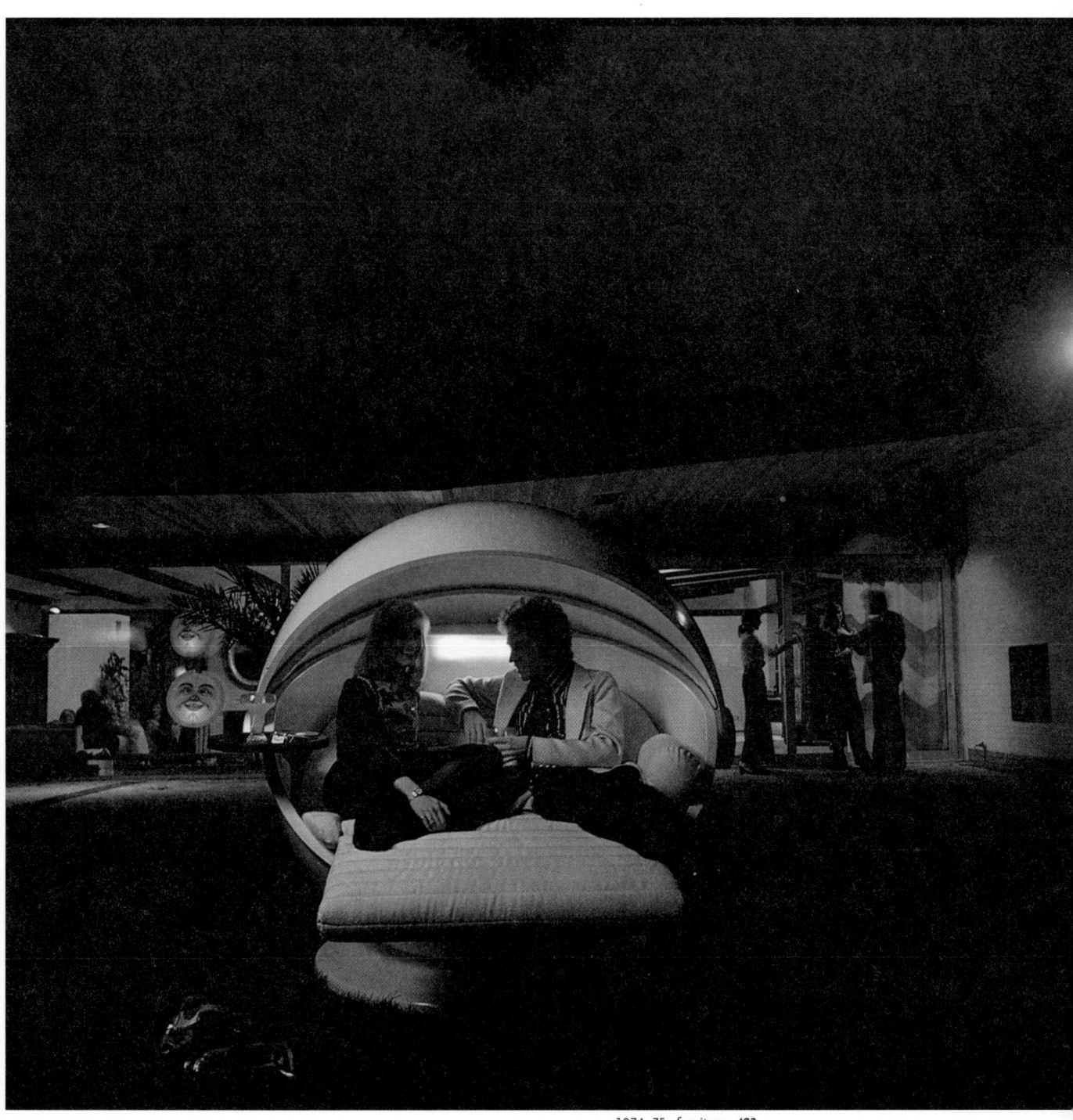

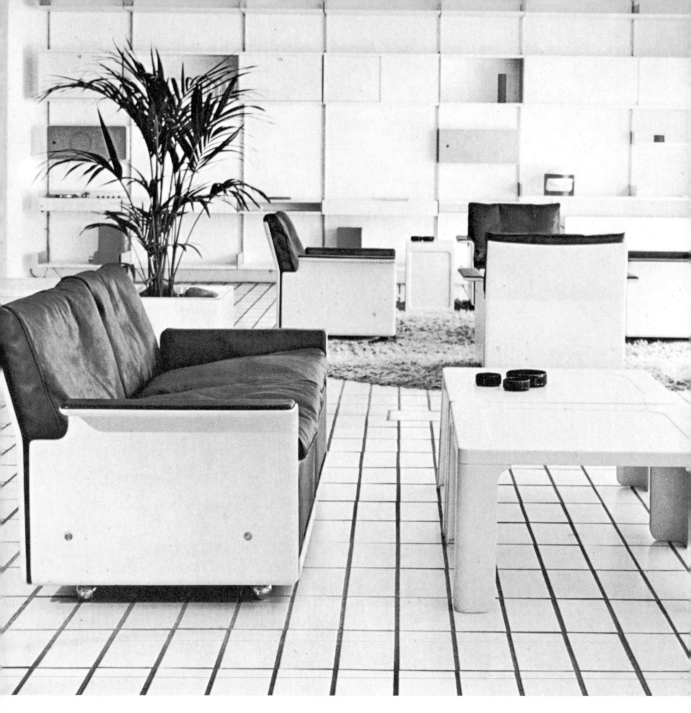

'Sesselprogramm 620', table,
containers and seating elements;
seating has low or high back
and can be used singly or in
combination of two or more by
means of a simple locking
device; tables and containers
are plastic, seating shells are
wood sprayed light grey, white
or black, with leather covered
cushions; excepting the tables
all components are fitted with
castors
Designed by Dieter Rams for
Wiese Vitsoe, West Germany

Table no. 66 and Chair no. 27,
laminated veneer maple clear
lacquered; table measures
1 m × 1 m × 30 (39¼″ × 39¼″ ×
11¾″), chair has metal and
rubber shock absorbing fitments
and is covered with leather,
seven colourways; 70 × 70 × 35
(27½″ × 27½″ × 13¾″)
Designed by Poul Kjaerholm for
E Kold Christensen A/S,
Denmark

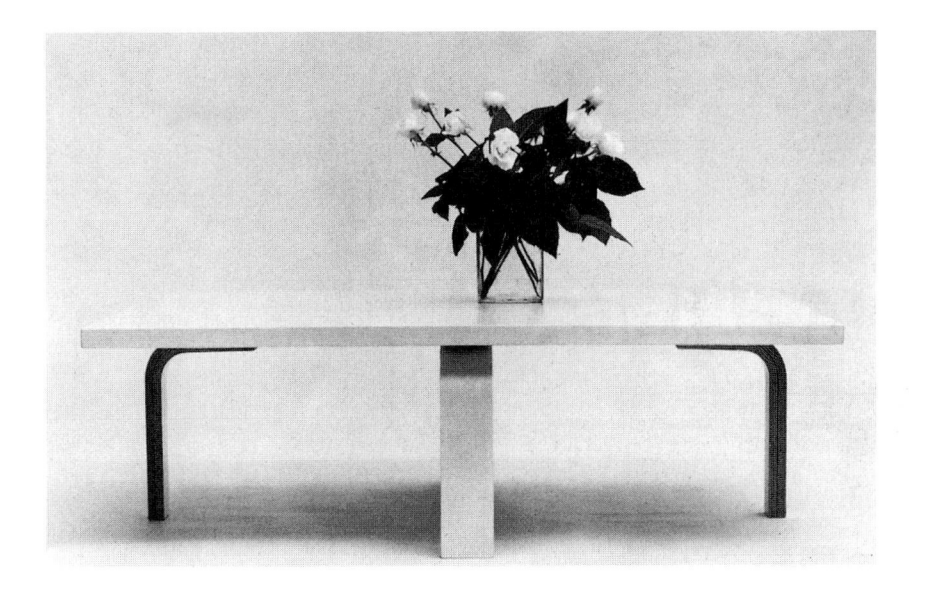

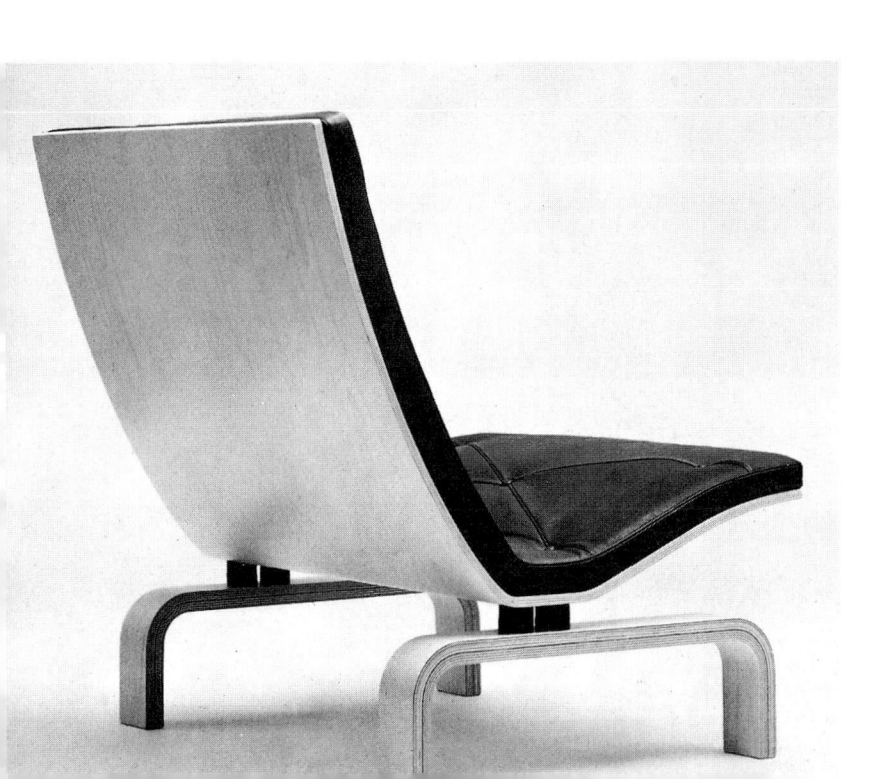

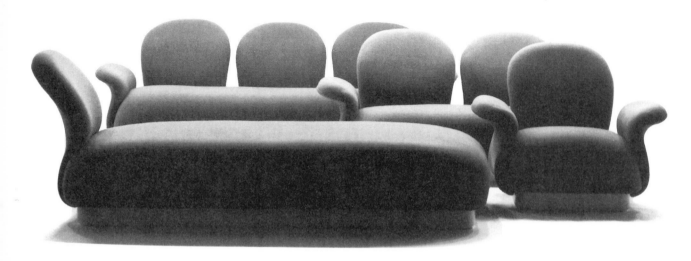

Stackable chair, injection
moulded glass fibre reinforced
polyamide, coloured throughout;
red, white or brown; 56·2 x 76·4
(22″ x 30″)
Designed by Eero Aarnio for
Upo Oy, Finland

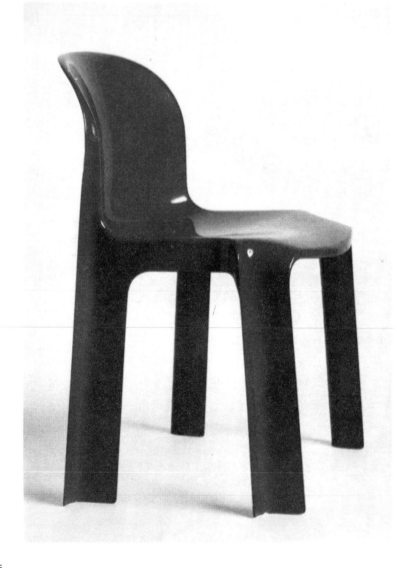

'Model 281–289', seating range
comprising chaise longue, sofa
and armchair with or without
armrest in various sizes; wood
and steel frame, foam body with
stretch fabric cover in eighteen
colour shades; 68–2·54 m wide,
72 high (26¾"–100" x 28¼")
Designed by Pierre Paulin for
Artifort, Holland

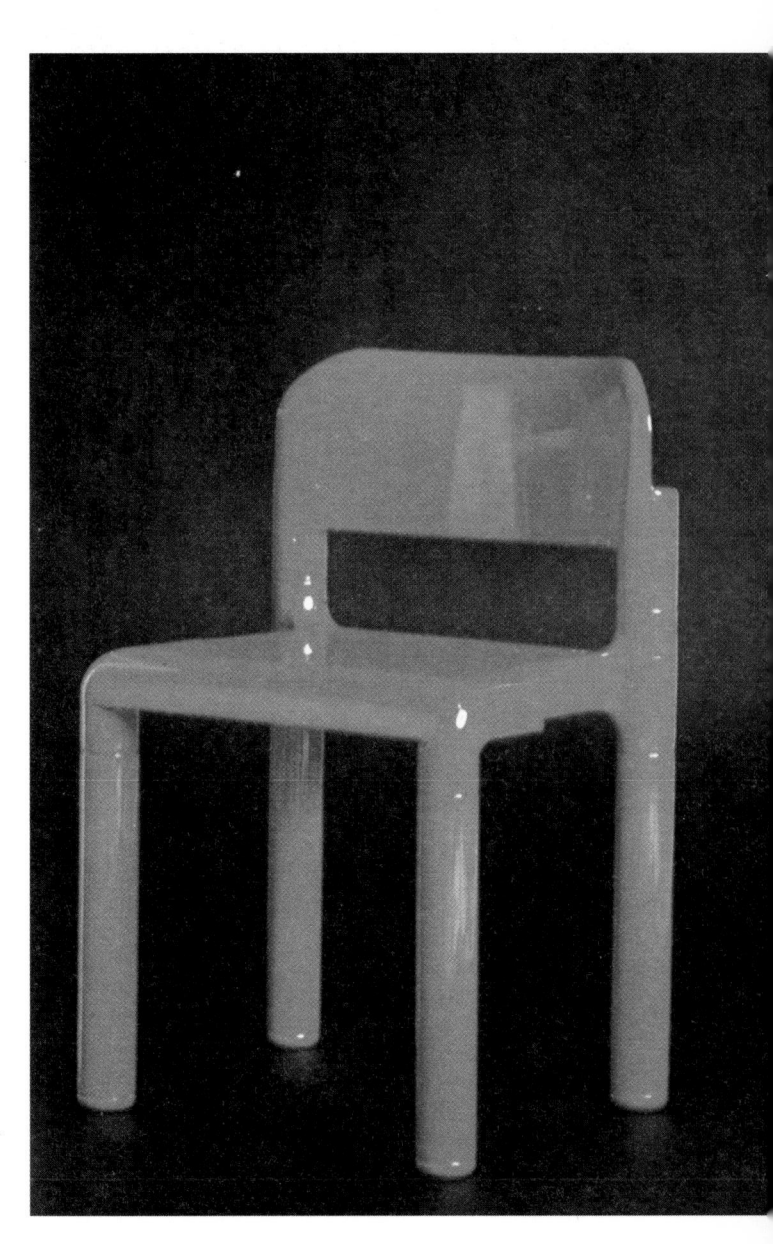

Knock-down chair, injection
moulded ABS plastic coloured
throughout, red, white or brown;
49·5 x 73·8 (19½" x 29")
Designed by Eero Aarnio for
Upo Oy, Finland

'Wigwam' modular range of children's furniture designed to encourage creative activity. Components include cubes in four sizes, tops, containers in two sizes, a bed and a cot with transparent acrylic sides to permit a wider visual field than the conventional cot allows.

Modules can be easily assembled by big plastic screws and nuts and can be fitted with castors to become playthings; frames of tubular steel, containers and shelves of timber finished with non-toxic, scratch resistant lacquer; the cubes are heavy-duty polystyrene. All

elements have rounded corners and edges and come in four colours: green, blue, orange or yellow

Designed and made by Poschinger Möbel, West Germany, and marketed in the UK by Concept Interiors

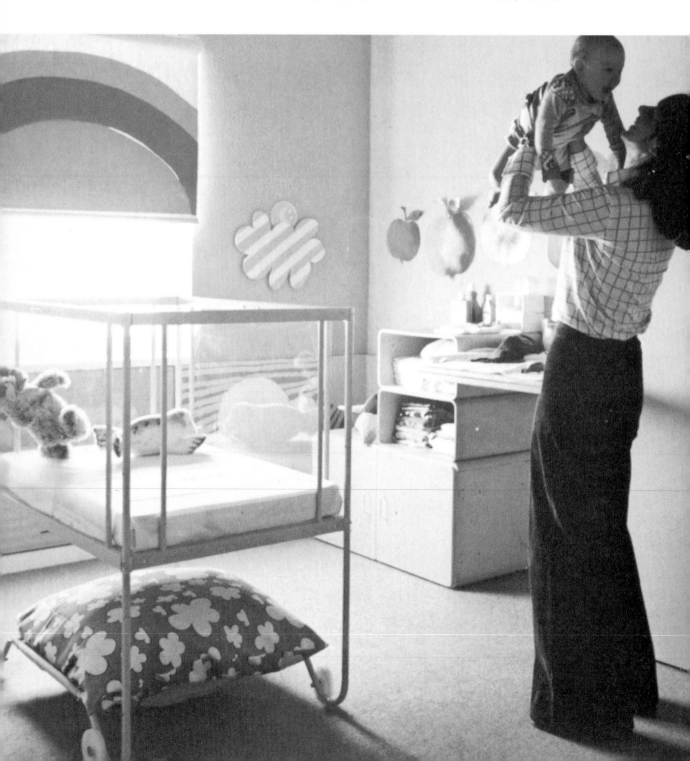

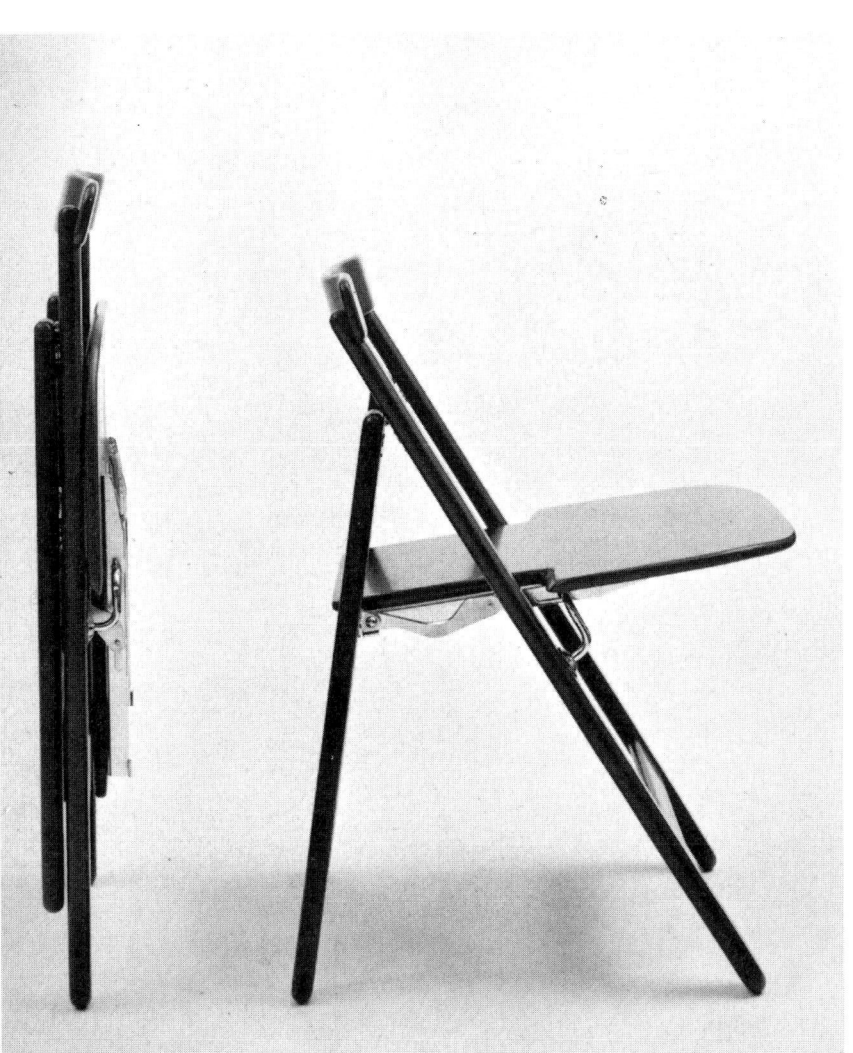

'Canossa' knock-down chair, a single length of industrial hose forms sides and back rest, steel rod ensures correct tension for adequate stability; natural ash seat and base
Designed by Gigi Sabadin for Stilwood, Italy

'Vivo' folding chair, lacquered beech in nine colours: ivory, black, red, orange, green, sepia ochre, violet or rose; 49 x 63 ($19\frac{1}{4}$" x $23\frac{3}{4}$") high
Designed by Kazuko Watanabe for Isetan Co Ltd, Japan

Chairs, from
the '2100 Thonet-Flex' range,
assembled from three main
interchangeable elements; the
exceptional versatility of this
design results from a synthesis
of function, material and
manufacturing techniques. A
plastic shell rests on two sturdy
wooden H frames; chairs can
be linked together or to various
accessories to the range. If the
wooden elements are changed
over and the frames face
inwards, a narrower and lighter
looking individual chair is
obtained. Black plastic shell or
with optional upholstery, beech
frame, clear varnished or
stained red, green or brown
Designed by Gerd Lange for
Gebrüder Thonet AG,
West Germany

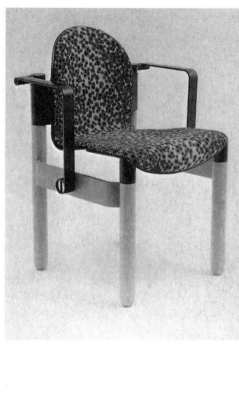

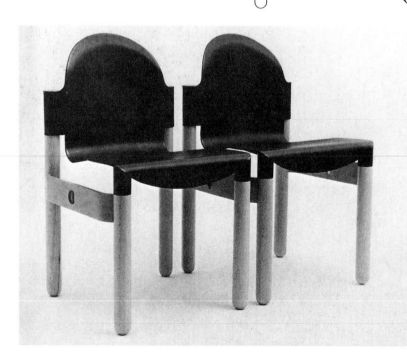

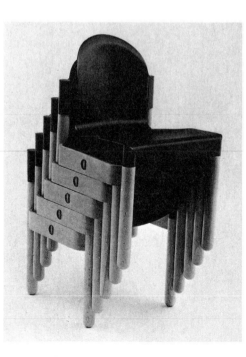

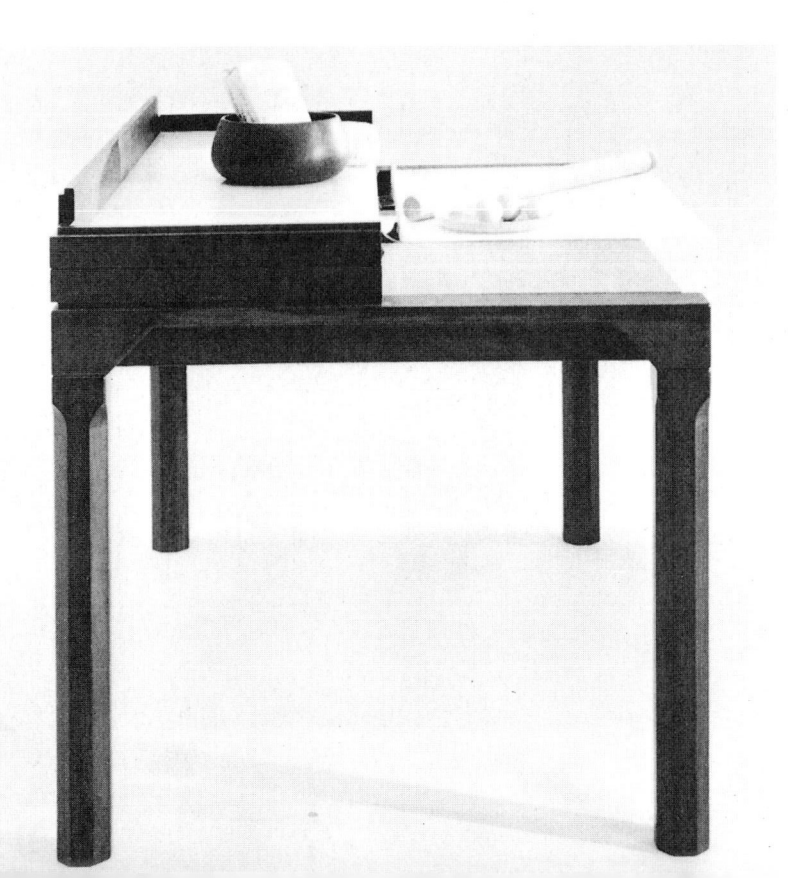

'Lunario', coffee table;
pressed steel base (weighted),
oval or round top of wood,
lacquered white or black; a
taller, dining version is also
available
Designed by Cini Boeri for
Gavina, Italy

'Madia', folding kitchen
table for bread making
Designed by Arch. Panelli for
Burelli Arredamenti, Italy

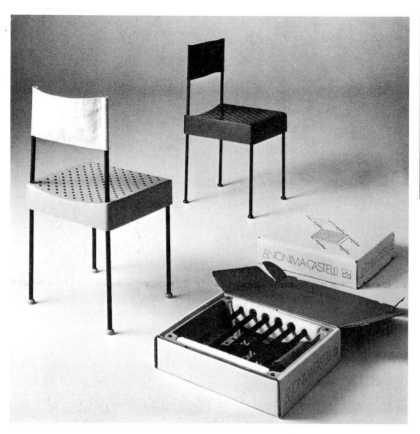

Chair for self-assembly;
the plastic seat is fixed on four
metal rods, the backrest is
canvas
Designed by Enzo Mari for
Anonima Castelli, Italy

'Table Range',
elements of various sizes are
assembled and held in position
by the triangular corner pieces
Designed by Paul Haigh at the
Royal College of Art, England

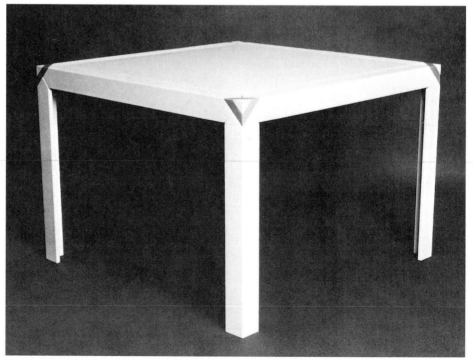

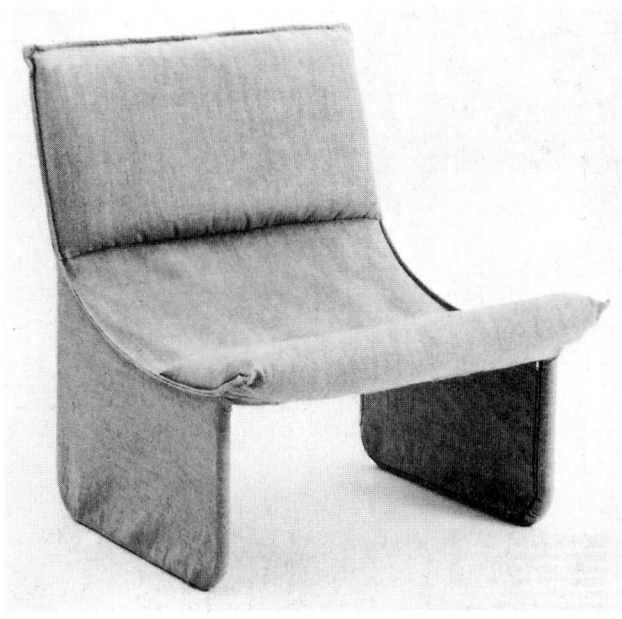

'Taboga', collapsible
chair in two sizes; lacquered
steel tubing, stuffed and zipped
canvas body
Designed and made by Arflex Spa,
Italy

'Flaps' large armchair that
converts into day bed or spare
bed; polyurethane structure,
Dacron filling
Designed by De Pas, D'Urbino,
Lomazzi for Bonacina Srl, Italy

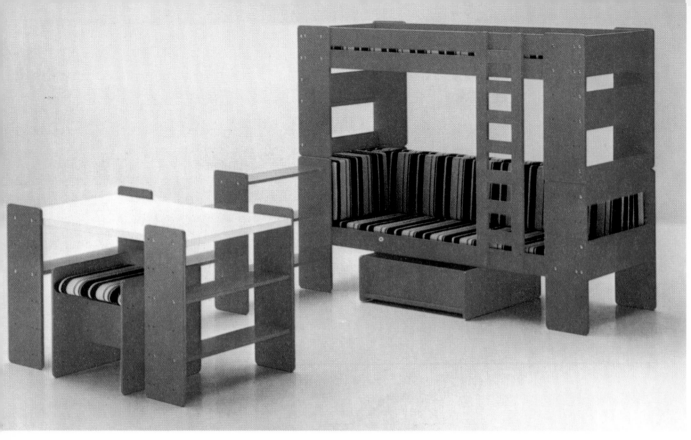

'Jyta', children's modular
furniture for self assembly;
units can be joined together
by metal pins to form tables
settees, cots, beds and shelving;
chipboard, lacquered red or
white
Designed by Jaakko Halko for
Lepokalusto Oy, Finland

Opposite
Toys of solid wood,
oiled and polished; hand formed
metal connectors; train 1·20m
long, 14 wide, 29 high (47″ ×
$5\frac{1}{2}″ × 9\frac{3}{4}″$); truck 10·5 × 16·5 × 25
($16″ × 6\frac{1}{2}″ × 9\frac{3}{4}″$)
Made by Michael Parker for
Columbia River Toy Works, USA

'Fabel' child's chair, with
playing/eating tray and seat
adjustable to eight heights;
laid on its side the chair
becomes a play horse or a
bench for two; two units linked
together form a cradle; natural,
red or green stained beech,
43 × 54 × 67·5 (2′ 3″ × 1′ 9″ ×
$2′ 2\frac{3}{4}″$)
Designed by J. Daae-Quale
for Westnofa, Norway

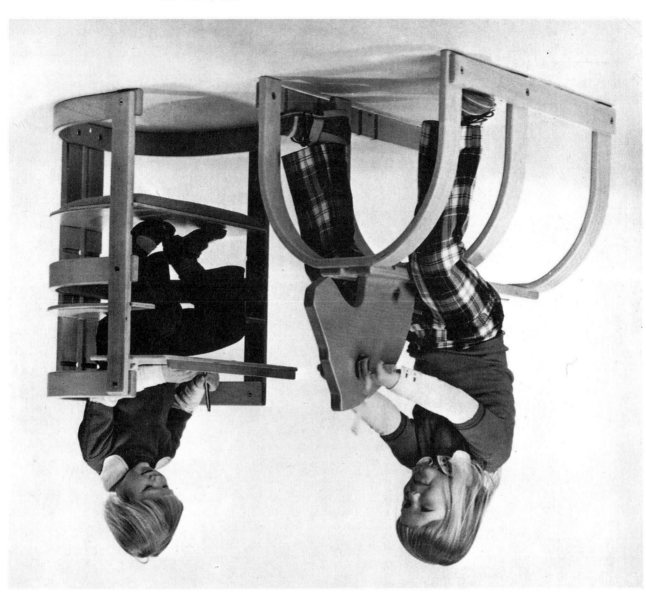

'Pinspot', from a range of
display light fittings; low
voltage, fully adjustable spot-
lamp available with bracket or
for use with a lighting track;
die cast synthetic material,
silver with black and red
trimmings
Designed by Roger Tallon for
ERCO, West Germany

'Talking Office', open plan
modular furniture; work tops
and storage units are fixed to die
cast aluminium frames; baize
covered screen on steel frames
can support vertical files; work
tops are faced with laminate,
1·30, 1·50, 1·80m (3′ 11″, 4′ 11″,
5′ 11″) long, 75 (2′ 6″) deep;
screens 75, 1·20, 1·50m (2′ 6″,
3′ 11″, 4′ 11″) long
Designed by Alberto Rosselli
for Facomet, Italy

'Baltic', open plan
office system; desks, cabinets
and storage units with suspended
filing (see detail); chipboard,
with crown oak veneer
Designed and made by Dodson
Bull, England

Opposite
'Dialogo' chair; natural ash
or leather covered body, fixed
to ash bearers or to chrome
finish steel frame
Designed by Afra and Tobia
Scarpa for B & B, Italy

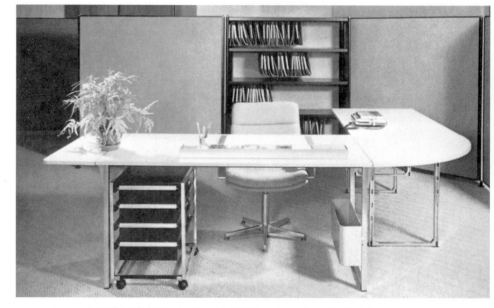

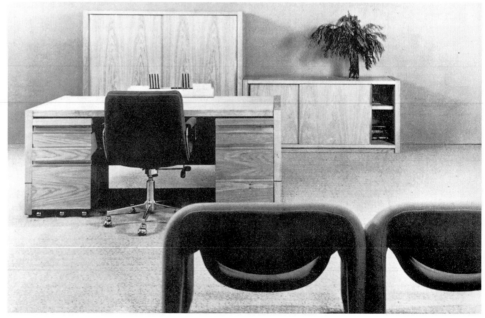

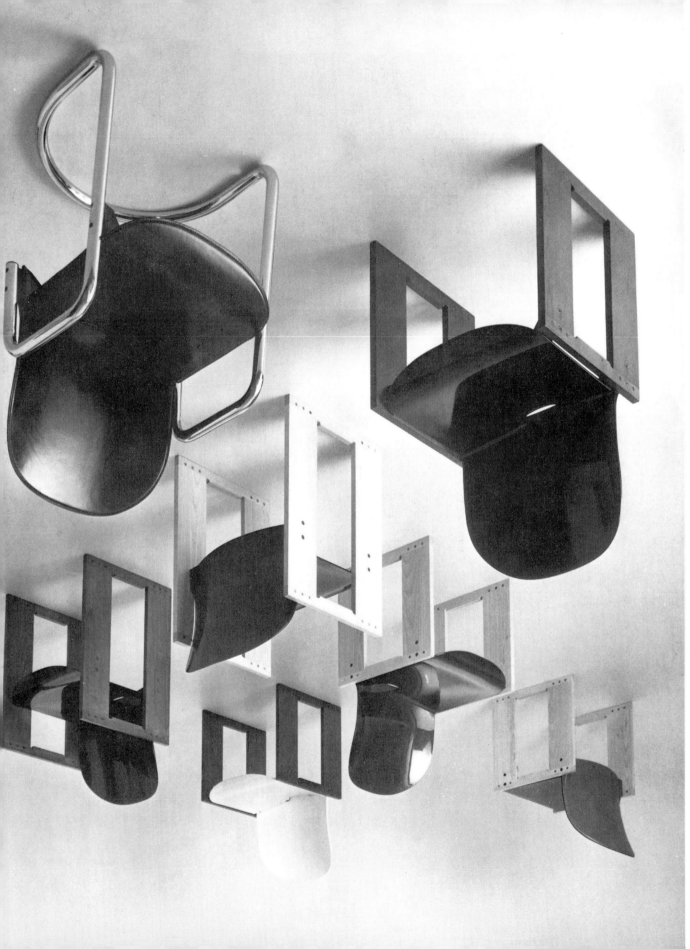

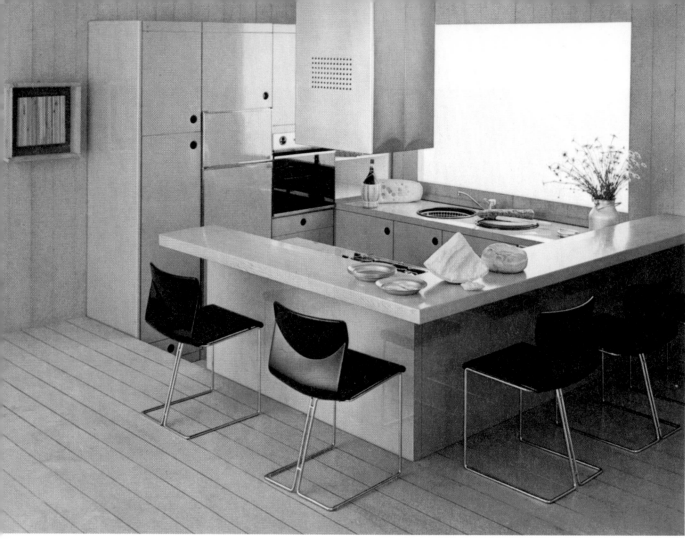

Left
'Polidada', integral kitchen
system; structure of upright and
horizontal panels. A series of
holes placed at 32mm intervals
along the lateral uprights allows
a flexible vertical adjustment of
horizontal planes; service units
include a range of coordinated
appliances such as sinks, stoves,
dishwashers and refrigerators;
30, 45, 60, 90 (1′ 0″, 1′ 6″,
2′ 0″, 3′ 0″) wide; 39·4, 58·6 (1′ 3″,
1′ 11″) deep; 85, 2·17, 2·69m (2′ 7″,
7′ 1″, 8′ 10″) high
Designed by George Coslin for
A Garavaglia Sas, Italy

Above
Range of demountable
dining furniture of various sizes,
comprising tables, chairs and
cabinets. A choice of finishes
includes solid wood or linoleum-
covered table tops; cord or
webbing woven seats, with
optional armrests for the chairs;
painted doors. The whole range
may be easily assembled without
the aid of tools; beech, oak
or mahogany
Designed by Dr. Bernt for
Kventy & Sønner, Denmark

Chair, 1975; note the twin
u-frame supporting the body;
laminated beech, woven jute
bands
Designed by Rud Thygesen and
Johnny Sørensen for Magnus
Olesen, Denmark

Lounging chair and foot-
stool, from a range that also
includes dining chairs and
settee; natural ash and French
cane
Designed by Rud Thygesen and
Johnny Sørensen for Christensen
and Larsen, Denmark

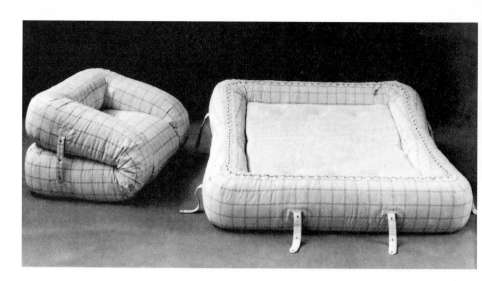

Desk Chair; the design is in-
spired by a traditional type of
ship captain's chair, and the back
is formed from twelve separate
pieces cut in the solid; mahogany
veneered with yew and inlaid
with ebony; 75 × 60 (2′6″ × 2′)
Designed and made by Rupert
Williamson, England

'Anfibio' sofa-bed; the straps,
held together by heavy duty
press-studs, undo to form a bed
base; steel frame in polyurethane
foam of various density, wrapped
in dacron quilting; leather or
woven upholstery; the model is
produced in three sized measur-
ing 65 × 98 × 1.10, 1.84 or 2.40m
(2′2″ × 3′3″ × 3′7″, 6′ or 7′10″)
when folded

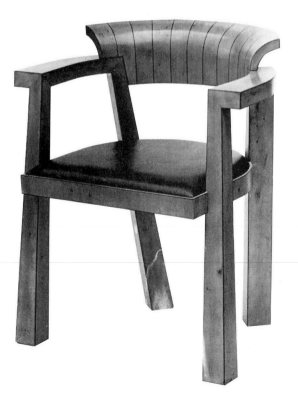

Writing table; Laminated
hardwood, carved, with inlaid top
Designed by Wendell Castle and
made in limited editions in the
Wendell Castle Workshop, USA

'Diletto' sofa-bed; by pushing the backrest towards the seat a locking mechanism is released and the sofa converts into a double bed; the covering unzips to reveal the mattress and doubles as a quilt; polyurethane foam on steel frame; 80 × 100 × 2.35m (2'7" × 3'3" × 7'8") when locked Both designed by Alessandro Becchi for Giovannetti, Italy

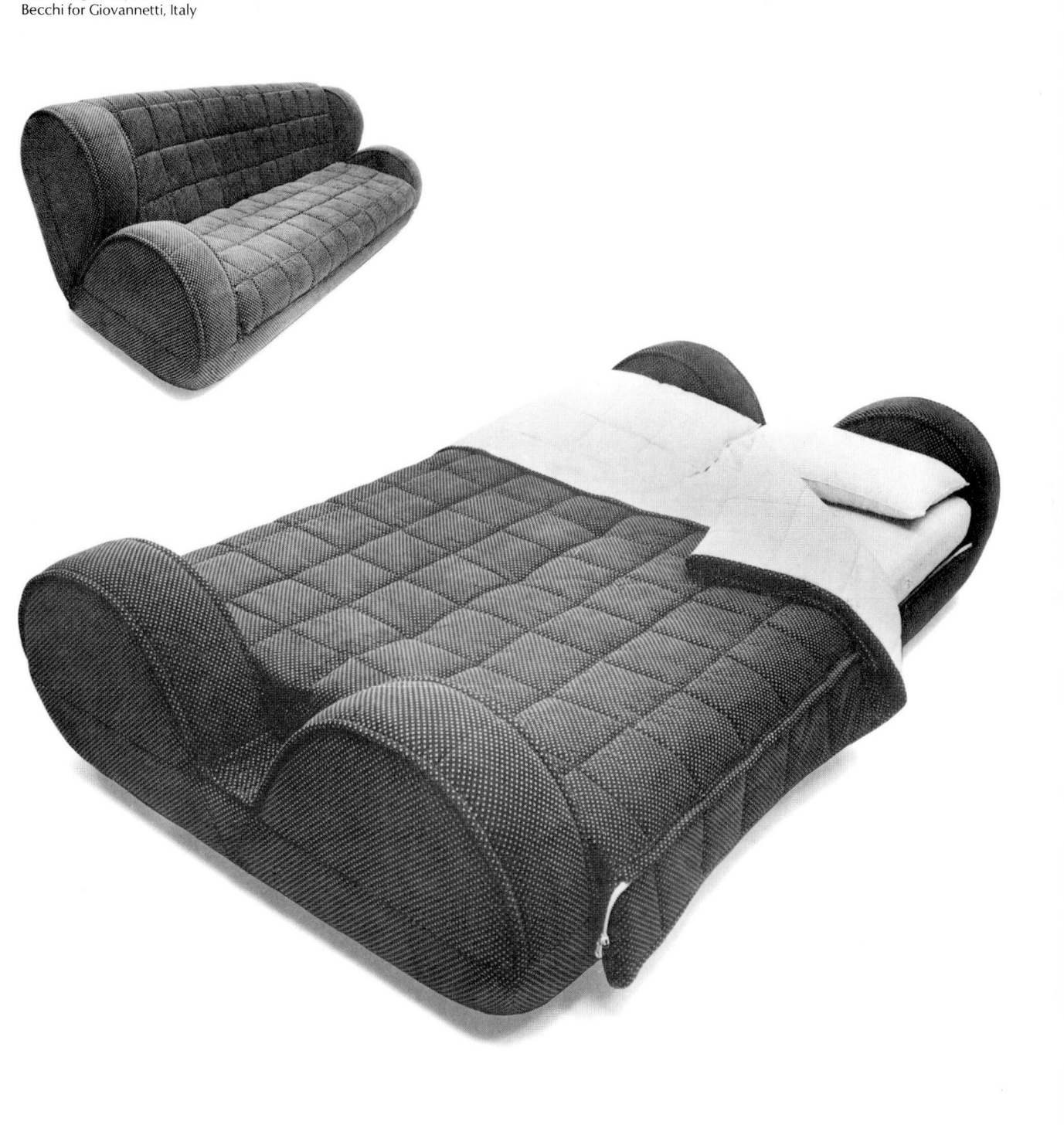

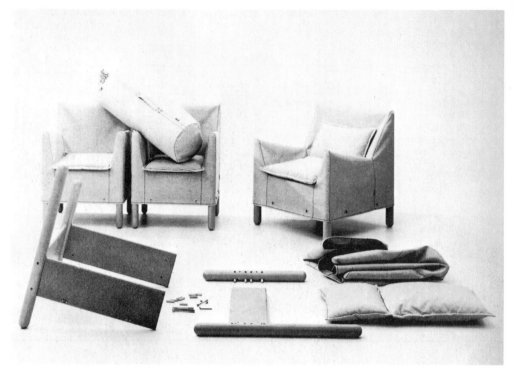

Avec chair: a demountable frame fitted with studs can be assembled in a few minutes. The canvas cover is attached to the frame by means of buttons, and cushions are filled with polyether wadding. The chair is also available packed in a special canvas sack.
Natural birch frame, black or natural canvas cover.
77cm × 84cm × 43cm (20¼″ × 33″ × 17″)
Designed by Eero Aarnio for Asko-Upo, Finland

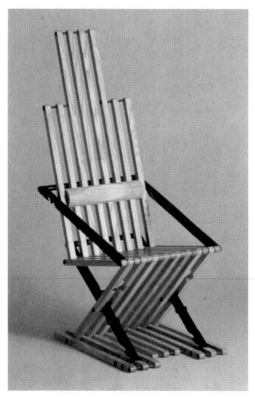

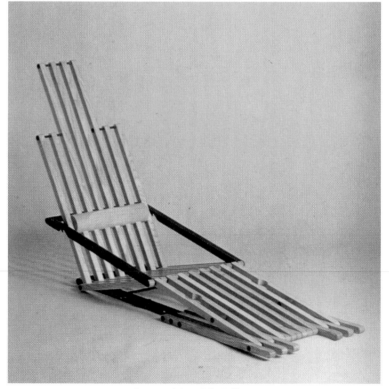

Body chair, 1979: adjusts to six upright and to four reclining positions. Used as an easy chair it can rock forwards. The lumbar support can slide upwards or downwards to suit the individual. Natural ash, with black lacquered metal parts.
Designed by Jim Warren for Pearl Dot Furniture Workshops, England

Table, Cogne 1976: the essentially geometrical shape of the piece, based on sections of a cube, is broken by the use of colour and by the reflections on the lacquer finish, symbolizing the subtle variations of natural elements.
50cm × 135cm × 135cm
(19¾″ × 53⅛″ × 53⅛″)

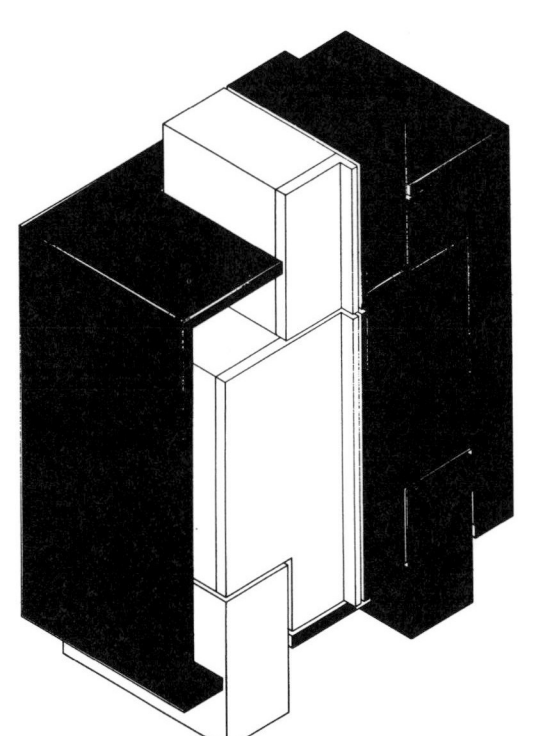

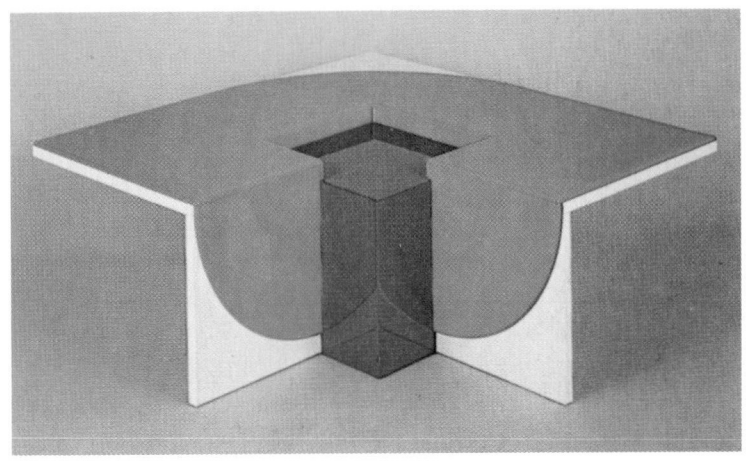

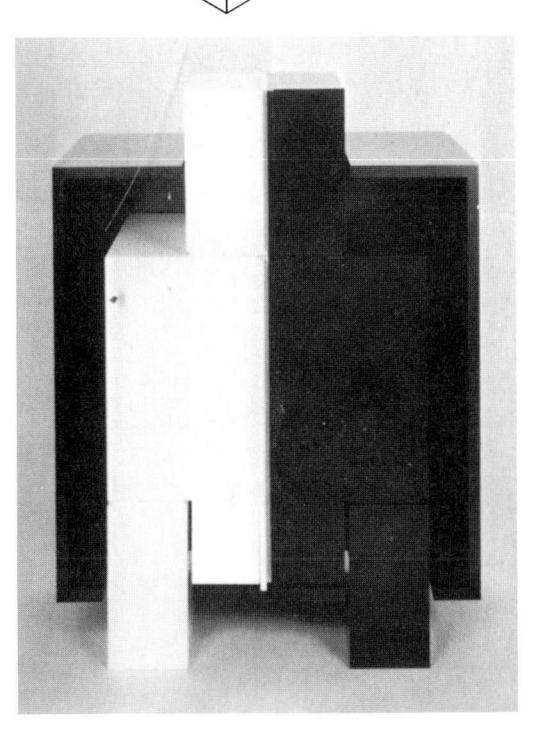

Container, 1978: the volume is symmetrically divided into a black and white, highly polished section and encased in a matt black 'container'. The container is divided by the supports in the upper part of the piece.
Black and white lacquer, 134cm × 100cm × 50cm
(52¾″ × 39⅜″ × 19¹¹⁄₁₆″)
All designed by Pieter de Bruyne, Belgium

Folding chair: ash frame
with canvas seat.
Designed by Steen
Østergaard and made by
Niels Roth Andersen,
Denmark

Chair: laminated ash or
beech frame with leather
seat and back.
Designed by Hans J.
Wegner for an organic fur-
niture competition in 1948
and produced in 1979 by
Johannes Hansen,
Denmark

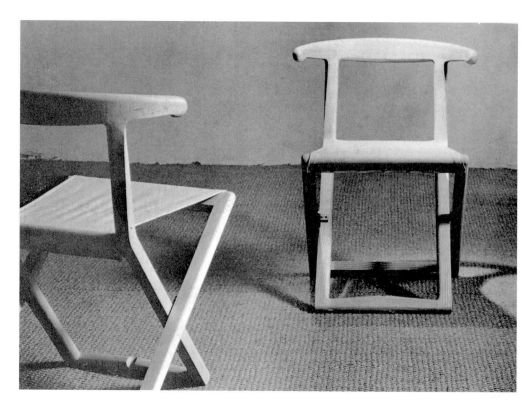

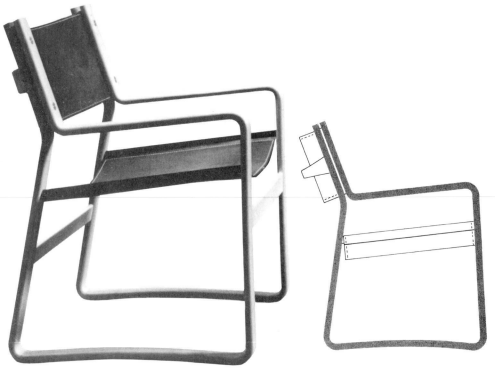

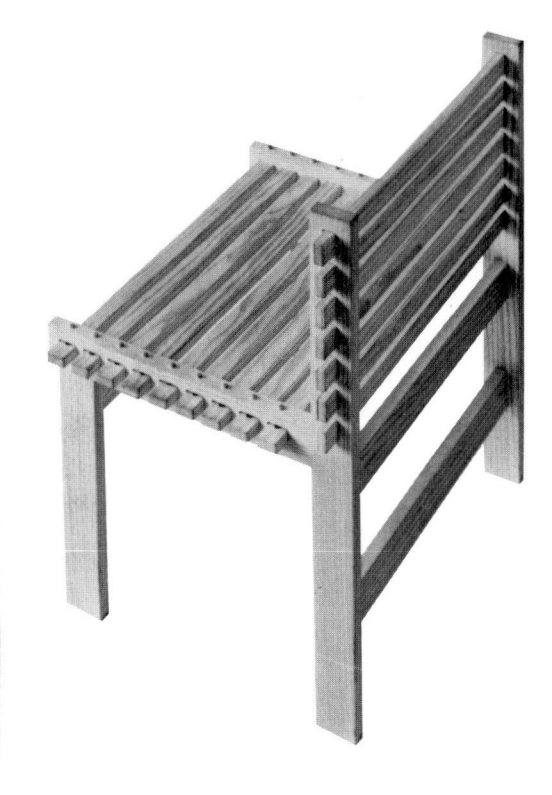

Bench: the semi-circular shape allows the bench to be formed from only the back sections on which it stands interlocking with the sections forming the cantilevered seat. Natural mahogany.
Designed by Per Borre and made by Wørts Møbelsnedkeri, Denmark

Chair: hardwood dowels expressed in the frame of the chair pass through oblong holes in the ends of the wooden slats which form the seat and back of the chair. The slats are solid ash thinly sliced and left unglued: the natural spring in the wood allows them to adapt to the shape of the human body.

Designed by Gunnar Aagaard Anderson and made by Søren Horn, Denmark

textiles and wallpapers | Stoffe und Tapeten | Textiles et papiers peints

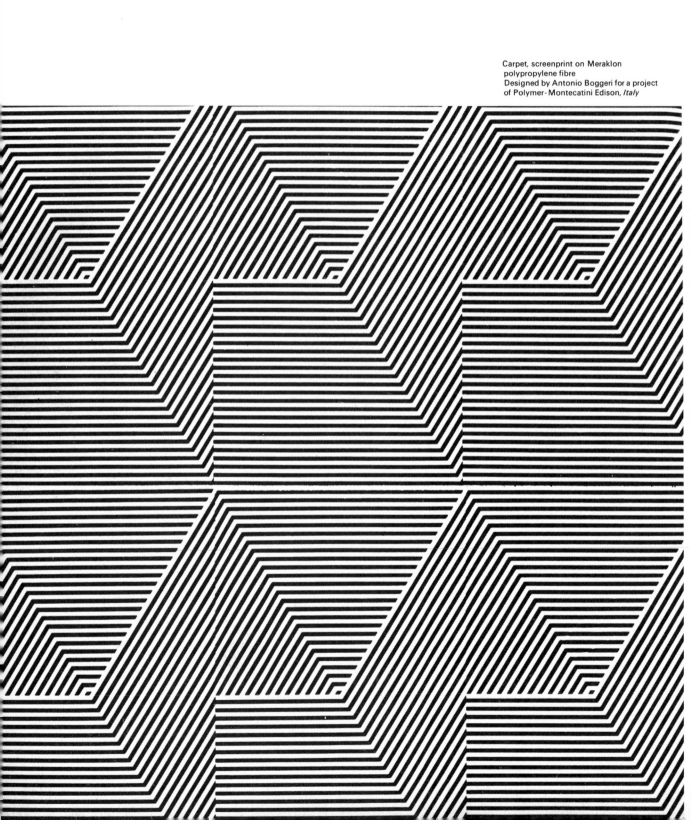

Carpet, screenprint on Meraklon
polypropylene fibre
Designed by Antonio Boggeri for a project
of Polymer-Montecatini Edison, *Italy*

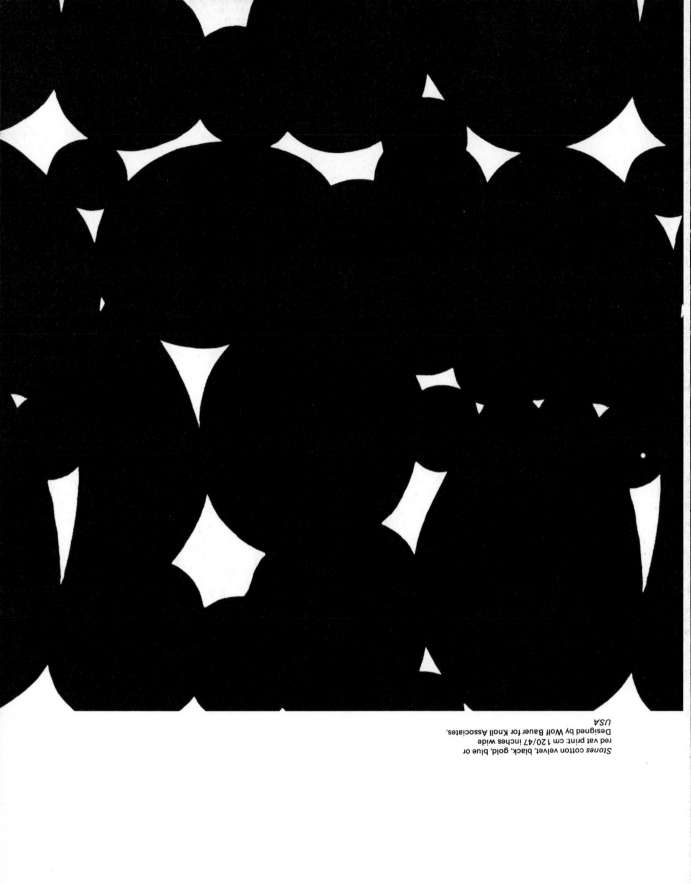

Stones cotton velvet, black, gold, blue or
red vat print: cm 120/47 inches wide
Designed by Wolf Bauer for Knoll Associates,
USA

1
Tempo paper-backed vinyl wallcovering,
2 colourways mist or oatmeal tones:
cm 39/21 inches wide
Designed by Robin Gregson-Brown for
ICI (Hyde) Ltd, *England*

2
SC 608 from the Scene range of Crown
wallpapers; 2 other colourways
Designed and made by the Wall Paper
Manufacturers Ltd, *England*
Mushroom table and chairs designed and
made by Arkana, *England*

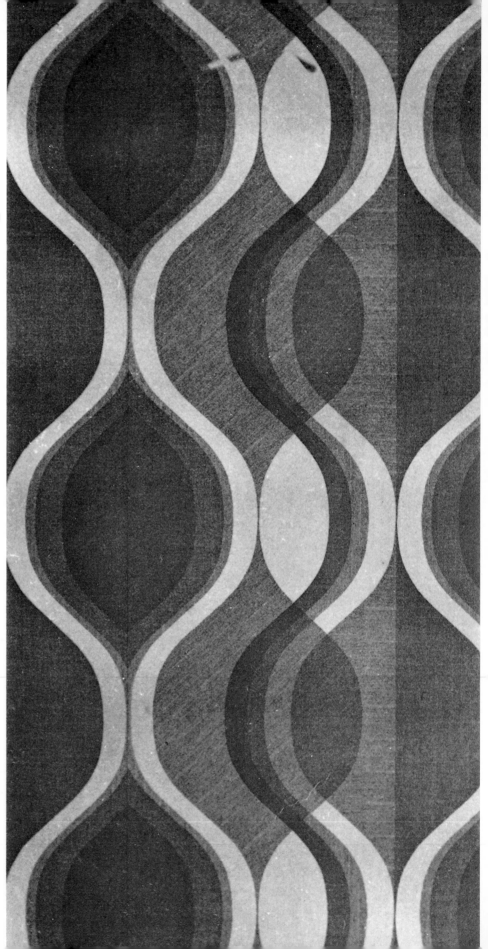

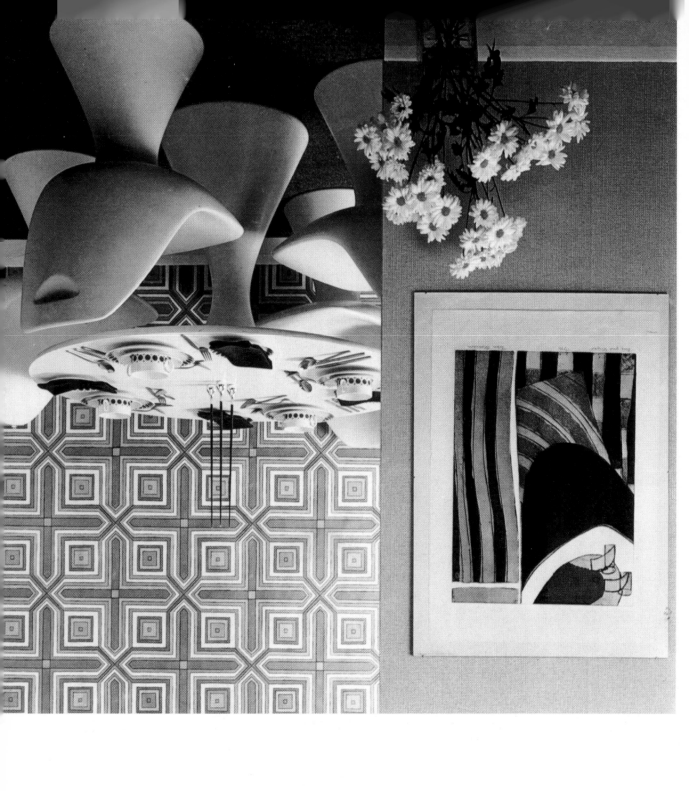

1
Hand-knotted rug, 100% wool: metres
1·85 × 1·75
Designed and made by Sandra Marconato,
Italy

2, 3
Corvara screenprinted cotton poplin, five
other colourways: cm 120/48 inches wide

Cristallo screenprinted cotton poplin, seven
other colourways: cm 120/48 inches wide
Both designed by Elsbeth Kupferoth for
Mech. Weberei Pausa AG, *W. Germany*

4
From the *Evolution Folio* series washable
wallpaper in squares cm 44/17 inches or
rectangles cm 54 × 36/21 × 14 inches
Designed and made by Evolution Folio,
Belgium

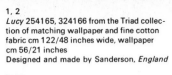

1, 2
Lucy 254165, 324166 from the Triad collection of matching wallpaper and fine cotton fabric cm 122/48 inches wide, wallpaper cm 56/21 inches
Designed and made by Sanderson, *England*

3, 10
3/46 *Count* Wilton carpet 80% wool/20% nylon: cm 17/6¾ inches repeat

6
10/25 Wilton carpet 80% wool/20% nylon: cm 34·5/13½ inches repeat
Designed and made by Brintons Limited, *England*

4
From the Boucle range of sisal carpeting: available ·7, 1·9 or 3·7 metres wide
Designed by Margaret Leischner for Tintawn Limited, *Republic of Ireland*

5
G.39395 (embossed) with 2 other colourways and L.46318 with 1 other colourway from the Crown collection
Designed and made by the Wall Paper Manufacturers Limited, *England*

7, 8, 9
Three colourways from *Lise, Hannibal, L'Oustau* ranges (see page 103)
Made by Boussac de Paris, *France*

1 5
2 6
3 7 8 9
4 10

opposite
Petit Point screenprint
on satin-cotton
6 colourways
cm 120/48 inches wide
Designed by James Morgan for Heal Fabrics Limited, *England*

1
Floral Tapestry, screen-printed spongeable wallpaper, one colourway, cm 67.5/27 inches wide
Designed and made by Albert Van Luit, *U.S.A.*
2,3
Muraweave wall covering: 100% jute laminated to heavy wallpaper, 33 colourways,
cm 80.5/36 inches wide
Designed by Mary Abbott
4
Pearl sisal-weave laminated to heavy paper, 11 other colourways, cm 80.5/36 inches wide
All made by Boyles of Leeds, *England*
5
Breton, one of a series of screen printed designs on semi-sheer Col'nova, 4 colourways, cm 118.5/47 inches wide
Designed by Adolf Felger
for Mech. Weberei Pausa AG, *W. Germany*
6,7
Cassandra (X31966) and *Hazel* (P.85794) linen-textured vinyl wall coverings,
6 colourways
Crown designs made by The Wall Paper Manufacturers Ltd, *England*
8,9
Stylon vinyl print on wallpaper-backed foil, three colourways, cm 68/27 inches wide
Designed and made by Wall Trends, Inc *U.S.A.*
10
Curtain Up screen print on plain cotton, 4 colourways, cm 121/48 inches wide
Designed by Shirley Craven for Hull Traders Limited, *England*
11,12
Softcord from 100% versatex fibre, 12 colourways, cm 67,5, 270 or 360/27, 108 or 144 inches wide
Designed by Irish Ropes Ltd for Tintawn Limited, *Ireland*

1	3	5		11
		4		
2	6	7		
8	9	10		12

1–4, 8 and 9 supplied by Edgar Brothers (London) Ltd

1,2,3
Red Herring, Fitzherbert, Minaret
hand-prints on heavy wallpaper, each 4
colourways cm 75.8/30 inches wide
Designed by Antony Little for Osborne &
Little Limited, *England*
4,5
Graphic 1 screenprint, four colourways
and black/white
Graphic 4 screenprint, six colourways:
both on 100% cotton, cm 120/48 inches
wide
Designed and made by Ryman Conran
Fabrics Ltd, *England*

1 2 3 6 7
4 5 8 9

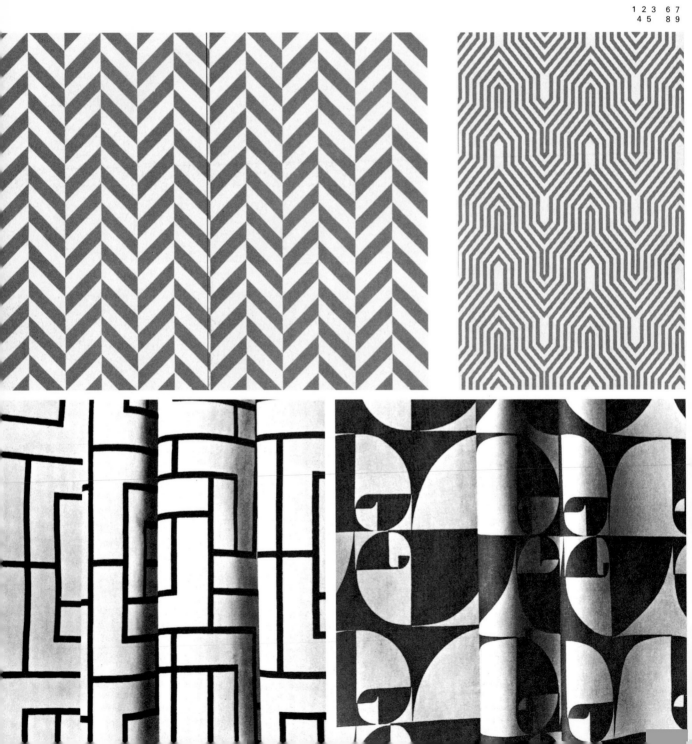

6,8
Kupla Neliö and *Kraklee* screenprints on
100% cotton, yellow, turquoise, green or
black with white, blue, violet or brown
with black, greens or reds, cm 140/56
inches wide
Designed by Studio Nurmesniemi for
Vuokko Fabrics, *Finland*
7
Uimari, screenprint on 100% cotton,
ten colourways: cm 140/56 inches wide
Designed by Maija Isola for Marimekko Oy,
Finland
9
Rolling Stones, screenprint on fine stain-
less hessian, three fade-resistant colour-
ways: cm 122/48 inches wide
Designed by John Wright for Fidelis Ltd,
England

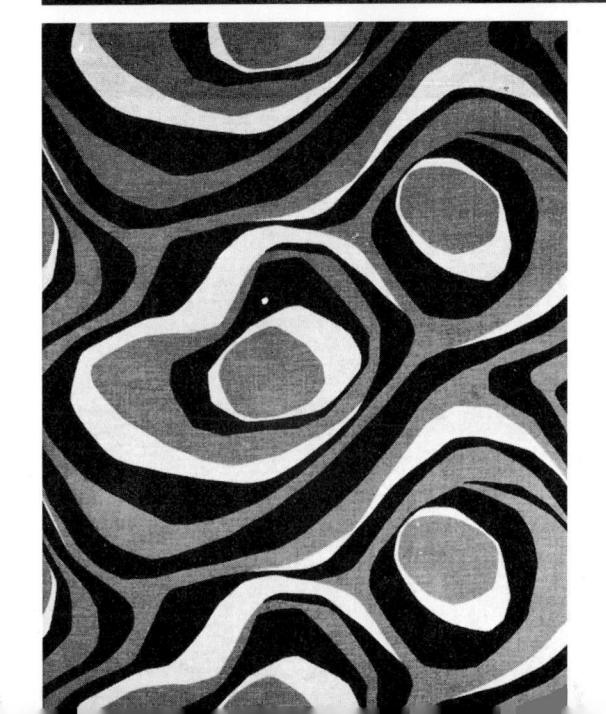

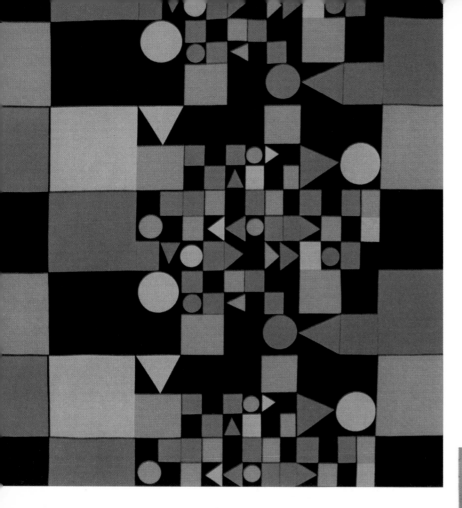

1
Screen-print 5031 on 84/16 cotton/rayon
cm 135/54 inches wide
Designed by Raili Konttinen for Porin
Puuvilla Oy *Finland*

2
Intermesh screen-print on cotton satin
orange/brown, turquoise/olive, purple/
burgundy, gold/mauve, grey/light blue
cm 122/48 inches wide
Designed by Barbara Brown for Heal
Fabrics Ltd *England*

3
Polypark plastic-impregnated wood
flooring tile, natural, olive, plum, cherry or
to order
Designed and made by Oy Fiskars Ab
Finland

4-6
Apollo I and *Chest of Drawers*,
screen-prints on 100% cotton cm 135/54
inches wide
Both designed by Riitta-Liisa Kuusiholma
Apollo I printed by Oy Finlayson Forssa Ab
Finland

7
Elmer was different nursery wall cupboard
(with 3-dimensional sun and strip-on
verse), pull-out drawer mounted on castors,
decal scratch-resistant transfer
colours, rosewood interior cm 180/72
inches wide cm 140/57 inches high
Designed and made by George Powers
England

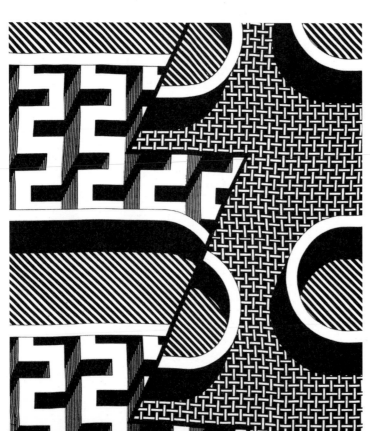

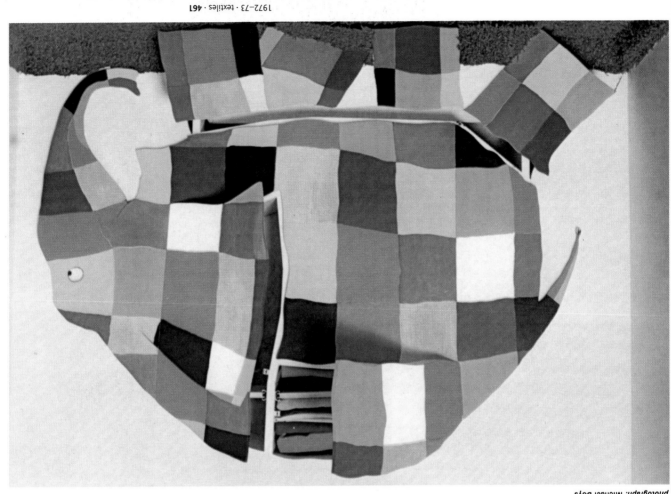

photograph: Michael Boys

LIIKKUVAT VIIVAT; DESIGN MAIJA LAVONEN

1
Stirring Lines screen-printed cotton,
black, brown or red, all on white
cm 140/54 inches wide

2
Interior I screen-printed cotton, black/
white only cm 140/54 inches wide
Both designed and printed by Maija
Lavonen
Interior I for Marimekko Oy *Finland*

3
Single-colour screen-print on 26/43/31
Trevira/Terylene/rayon, five colourways
Designed by Eine Ekroos

4
Six-colour screen-print on 100% cotton
Designed by Juhani Konttinen
both cm 140/54 inches wide
Porin Puuvilla Oy *Finland*

1
Space curtain, plasticised aluminium,
gold, silver, black, white or blue
Designed by Paco Rabanne and made by
Softwear Italy
for Baumann AG Switzerland

2
Unique rug, all wool red/blue/white/gold
m 2 × 3/6 × 10 feet
Designed and made by G. K. Pfahler for
Edition Kröner Galerie Germany

3
Paris tapestry, split technique
Designed and made by Hilde Fuchs
Germany

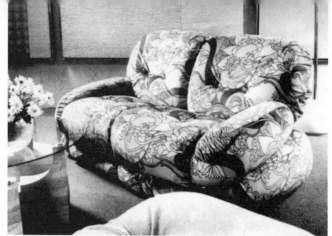

1
Jezebel handprint on cotton velvet on
Mobili Tre-D sofa: brilliant clear
yellows/tea rose/lavender
Designed and made by Jack Lenor Larsen
Inc *USA*

2
Brasilia all wool rya rug: two colourways
four sizes cm 95 × 160–250 × 350
Designed by Ib Antoni for Egetaepper
Denmark

3
Ophelia 105 wallpaper: red/orange/black on metallic gold and three other colourways
Designed by Antony Little for Osborne & Little Ltd *England*

4
Sibelia screenprint on 60/40 linen/cotton textured cloth: four colourways
Designed by Ulrike Rhomberg for Mech Weberei Pausa AG *West Germany*

overleaf

1
Screenprint on 100% acrilan semi-sheer cm 140/54 inches wide
Designed by Jukka Vesterinen for Porin Puuvilla Oy *Finland*

2
Screenprint 9919 on polyester slub muslin cm 263/104 inches wide including deep hem (width to hang): five other colourways
Designed by Herbert Jutzi for Ernest Schürpf & Co AG *Switzerland*

3
Terrazza designed by Peter Hall

4
Glentanna designed by Adrianne Morag Ferguson
Both screenprints on plain white cotton, each in four colourways, cm 122/48 inches wide
Made by Heal Fabrics *England*

front 5, 6
Data designed by Dorothy Carr in five colourways
Cantabrico in four colourways
Both screenprints on 100% cotton satin cm 122/48 inches wide
Made by Textra Furnishing Fabrics Ltd *England*

'Nut' print on 100% cotton,
orange or black; 1·20 m (48″) wide
Designed by Yuki Odawara for
Isetan Co Ltd, Japan

'Small Elephants' shrink resistant
100% cotton in four colourways:
red/blue checks, fawn/blue
checks, blue/red checks,
emerald/yellow checks; repeat
20 (8″); 1·22 m (48″) wide
Designed by Neil Bradburn for
Heal Fabrics, England
Courtesy of Heal and Son Ltd

'Elixir and the Dance', from
'Metamorphosis Twenty-One',
a collection of eleven murals
screen printed on white vinyl,
gold Mylar or clear Perspex
Designed by Jack Denst for
The Denst Designs Inc, USA

Furnishing fabric of pure
cotton
Designed by Hiroshi Awatsuji
for Fujie Textile Co Ltd, Japan

'Spatial Ikat', 1977; hand
woven ikat tapestry; wool and
jute weft, warp of expanded
polyurethane of varying thick-
ness 3·15 × 2·75m (10′6″ × 9′0″)
Made by Lia Cook, USA

'after "Flin Flon XIII" by
Frank Stella'; one of an edition
of seven tapestries; wool weft
on cotton warp; 2·68 × 2·68m
(8′ 10″ × 8′ 10″)
Produced and edited by Gloria F
Ross, New York
Made at the Pinton Atelier

glass | Glas | Verrerie

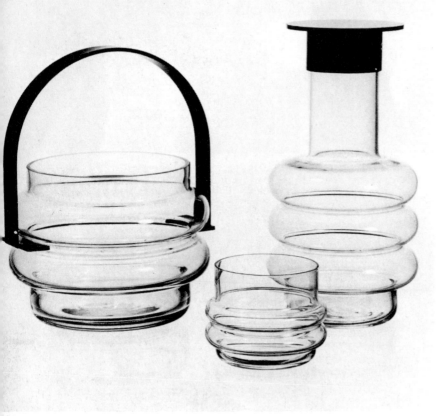

1
Cocktail glass, ice bucket and shaker,
clear crystal with red plastic handle and
stopper
Designed by Jan Johansson for Orrefors Ab,
Sweden

2
Decanter, glasses in handblown clear crystal
the decanter cl 55/18 oz capacity
Designed by Gunnar Cyren for Orrefors Ab,
Sweden

3-6
Bowl and vases in moulded and free blown
crystal: bowl cm 34/12½ inches diameter
Clear crystal wine glasses
Crystal decanter and glasses for 'snaps':
decanter cm 34/13 inches high
All designed by Bengt Orup for Johansfors Ab,
Sweden

1 3
2 4 5 6

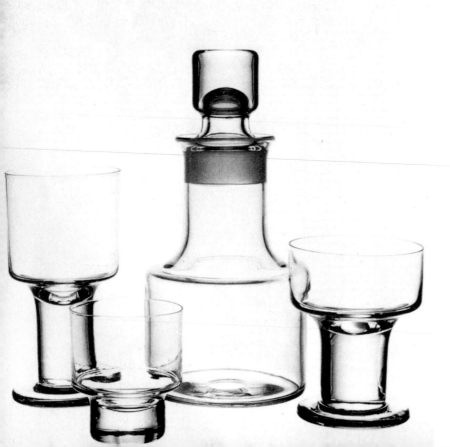

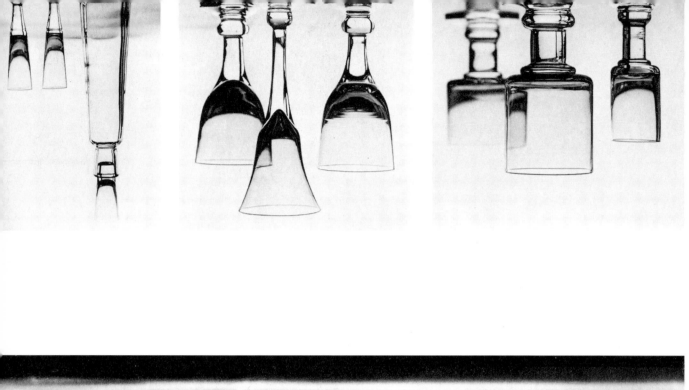

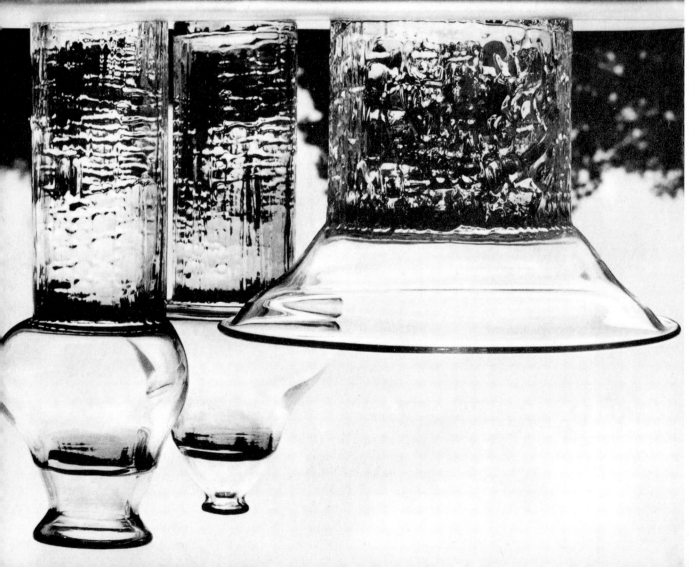

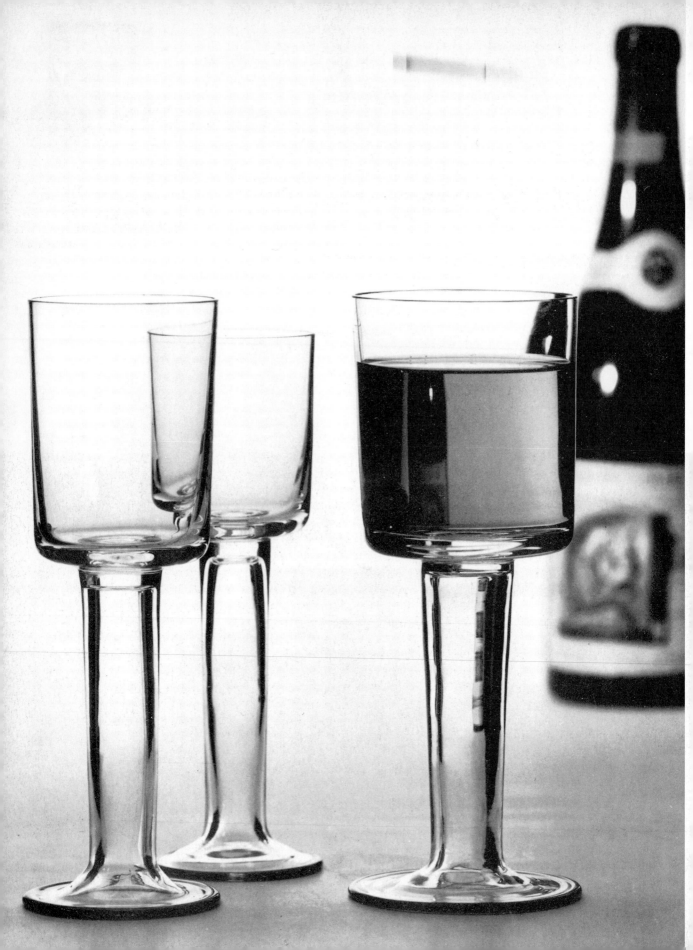

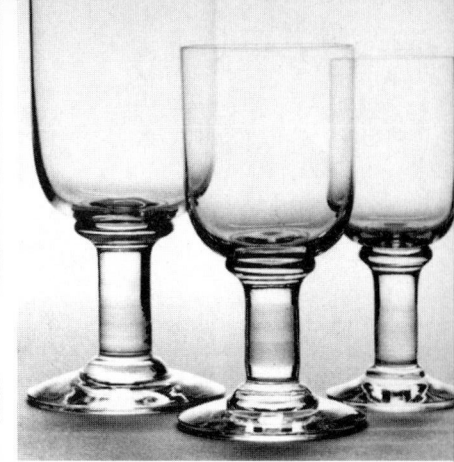

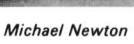*Michael Newton*

1
Venice series, tableglass, red, green, amber
or white inlay in foot for red, white or amber
wine or beer
Designed by Rosenthal Studio for
Rosenthal GmbH, *W. Germany*

2
Handblown clear crystal tumblers:
300 cc capacity
Designed by Yuji Takahashi for
Sasaki Glass Company Limited, *Japan*

3
Series of table glass, heavy based clear
crystal
Designed by Sergio Asti for Peruzzi & Bozzi,
Italy

4
Goblet, claret and sherry glasses,
handmade clear glass
Designed by Frank Thrower for Dartington
Glass, *England*

5
Ultima Thule series hand-blown clear
glass, five sizes 5 cl to 38 cl capacity
Designed by Tapio Wirkkala for Iittala
Glassworks, *Finland*

2 3 4
1 5

Sten Robert

Candlesticks cast in full lead clear crystal:
cm 25, 16 or 9/10, 6 or 3½ inches high

2
Dish in clear full lead crystal cast
and thrown: cm 23/9 inches diameter

3, 4
Glass water tower, clear crystal/amber/ blue/
green: cm 32/12½ inches high
All designed by Ann & Göran Wärff for
Kosta Glassworks Ab, *Sweden*

Ola Terje

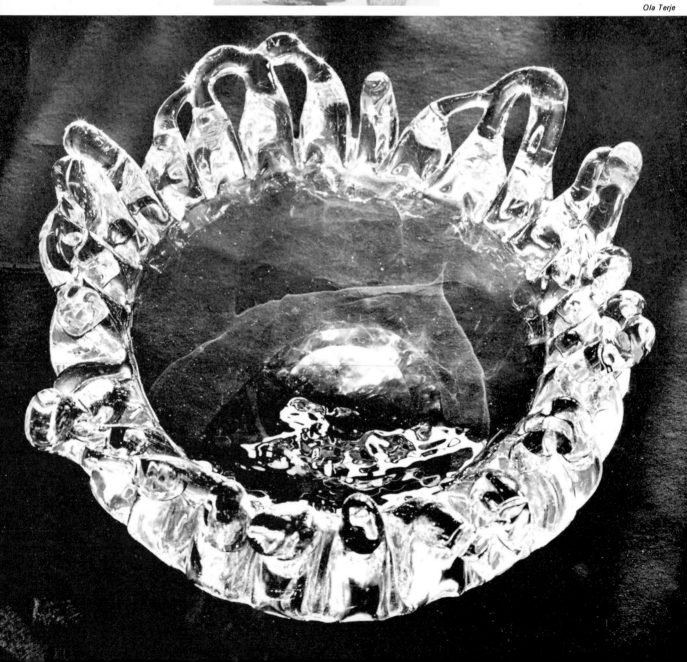

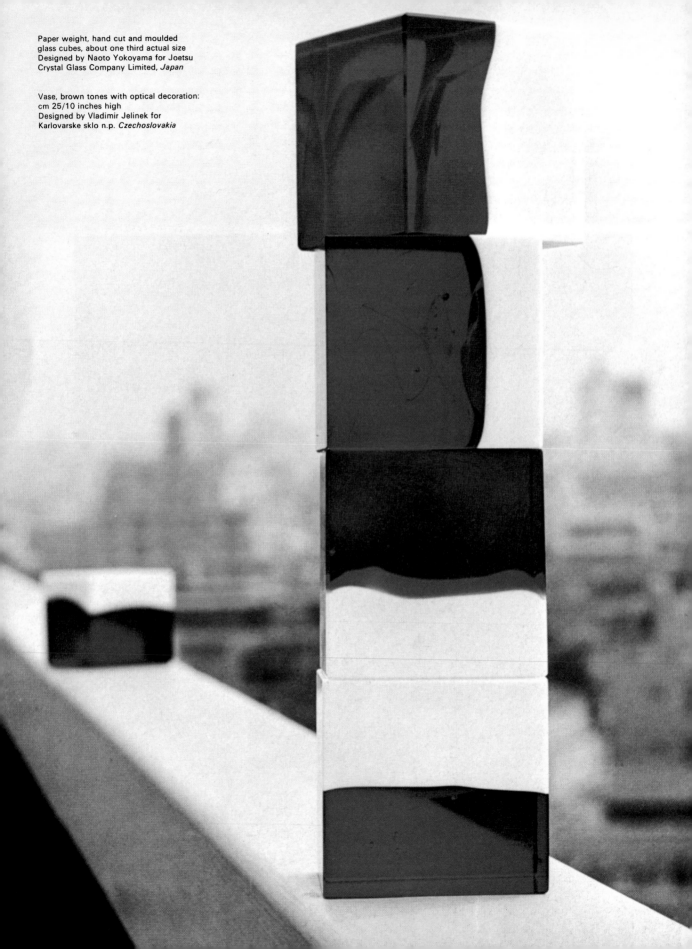

Paper weight, hand cut and moulded
glass cubes, about one third actual size
Designed by Naoto Yokoyama for Joetsu
Crystal Glass Company Limited, *Japan*

Vase, brown tones with optical decoration:
cm 25/10 inches high
Designed by Vladimir Jelinek for
Karlovarske sklo n.p. *Czechoslovakia*

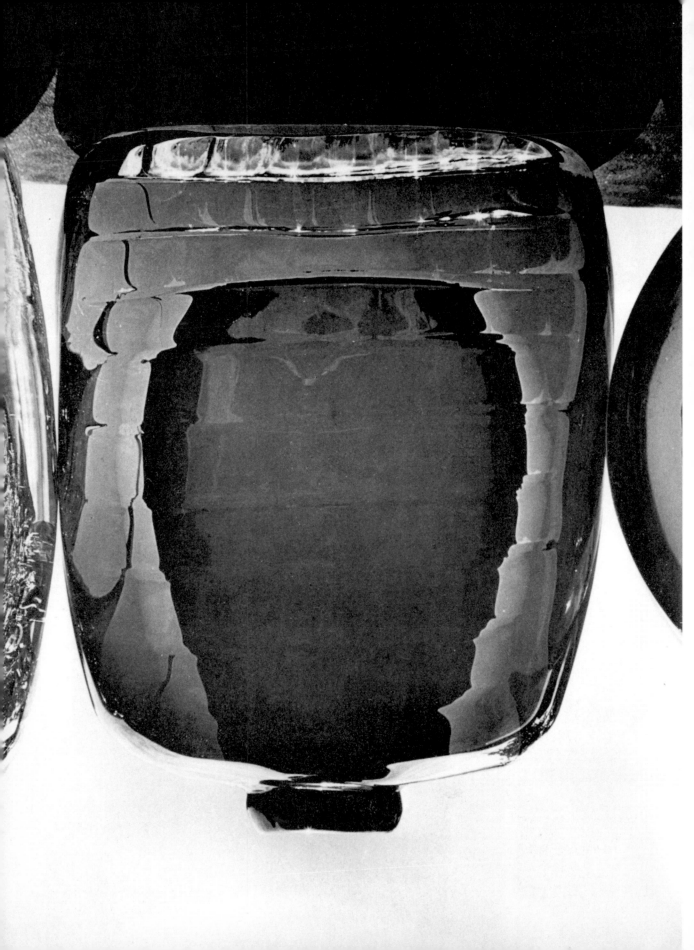

1
Sake carafe and glasses in
burnt-mould-blown crystal
Designed by Hiroyuki Kashiwabara for
Sasaki Glass Co Ltd *Japan*

2
Offa Rex clear glass tankard,
commemorates first English penny
cl .28/½ pint capacity
Limited edition designed by Frank Thrower
for Dartington Glass Ltd *England*

3
Whisky decanter and glass in clear lead
crystal cm 17/7 inches high
Designed by Takeo Yoshida for Kagami
Crystal Glass Works Ltd *Japan*

4
Crystal bowl cm 35/13 inches diameter
Designed by Bengt Edenfalk for Skrufs
Glasbruk Ab *Sweden*

5
Decanters and glasses in clear glass,
decanters cm 10/4 inches and
cm 14/5½ inches high
Designed by F. Meydam for NV Koninklijke
Nederlandsche Glasfabriek 'Leerdam'
Holland

```
1    4
   2
3    5
```

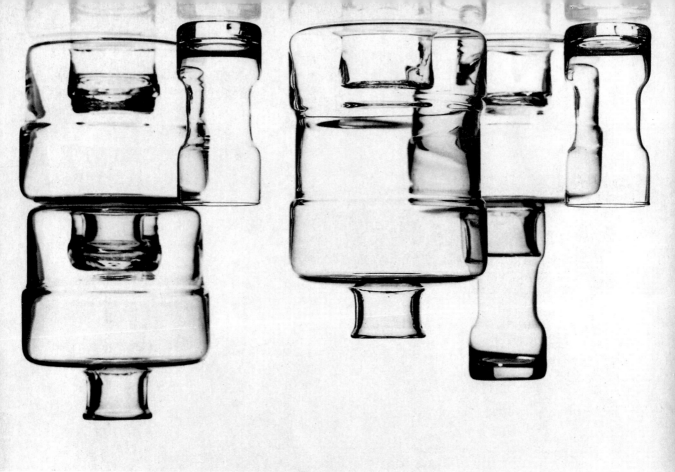

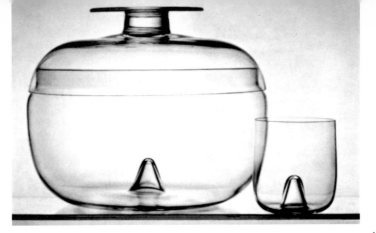

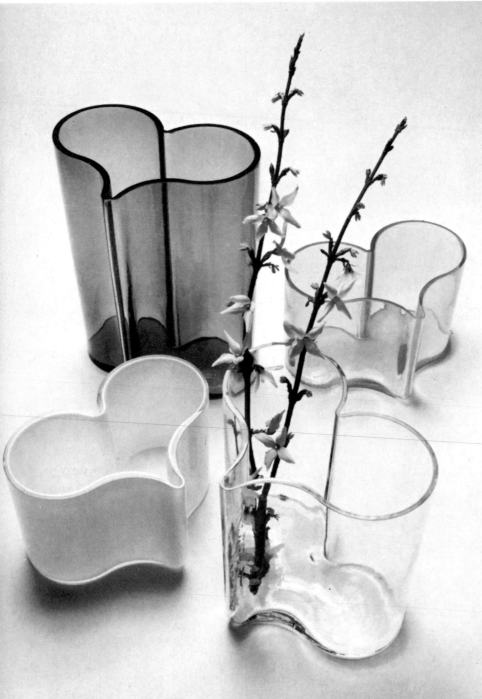

1, 5
Punch bowl, wine flask and glasses from
the *Capriccio 111* range
Designed by Claus J. Riedel for
Josef Riedel, Tiroler Glashütte *Austria*

2
Herzwasen heart-shaped flower bowls:
hand-made glass yellow, brown, clear or
opal cm 10, 16, 22/4, 6¼, 8¾ inches high
Designed by Sidse Werner for Kastrup og
Holmegaards Glasvaerker A/S *Denmark*

3
Rondo decanter and wine glass:
hand-blown clear glass
Designed by Ann and Göran Wärff for
Ab Kosta Glasbruk *Sweden*

4
Bowl and drinking glass from the
Mistretta 4019 range of decanter and
glasses
Designed by Giovanni Mistretta for
Josef Riedel Tiroler Glashütte *Austria*

6
Skittle bar set: carafe, shaker, ice bucket
and glasses in four sizes: handblown clear
glass
Designed by E. Kindt-Larsen for
Kastrup og Holmgaard Glasvaerker A/S
Denmark

1 4
2 3 5
 6

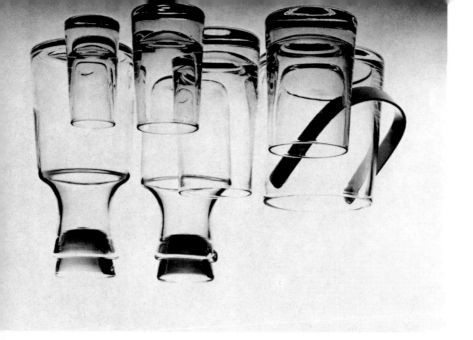

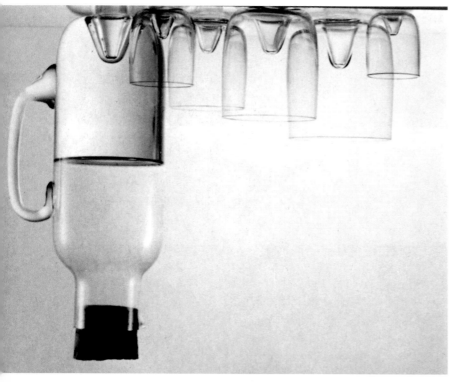

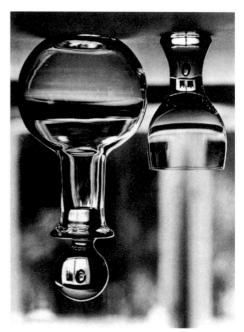

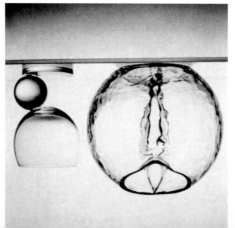

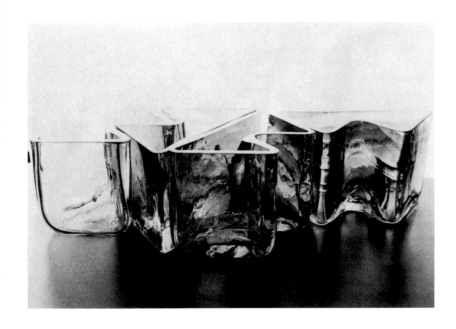

Drinking set, clear crystal
Designed by F Meydam for
Royal Leerdam, Holland

'A 200' series of drinking
glasses, clear crystal
Designed by Hans R Janssen
for Gral-Glashütte GmbH,
West Germany

'RH 478/7' candle holders,
clear crystal; 8 and 11 ($3\frac{1}{4}$"
and $4\frac{3}{8}$") high
Designed by Hans R Janssen
for Glashütte Leichlingen
GmbH, West Germany

'Shizuku Glass' mould blown
vases; blue/smoke or green/
smoke 14 ×9 ($5\frac{1}{2}$" ×$3\frac{1}{2}$")
Designed and made by
Masakichi Awashima, Japan

'Gaissa' hand-blown tumblers,
clear glass; five sizes
Designed by Tapio Wirkkala for
Iittala Glassworks, Finland

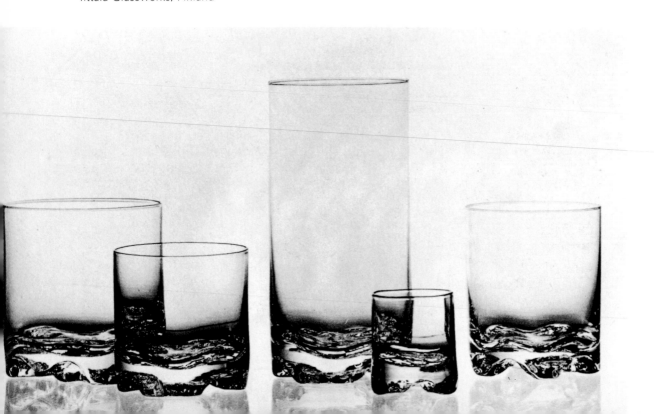

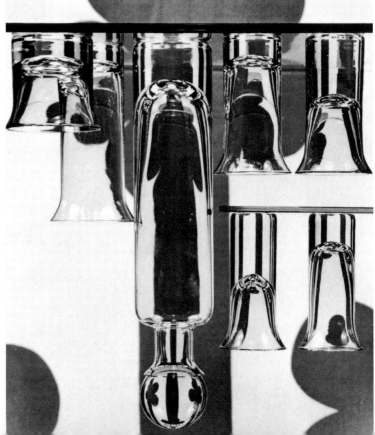

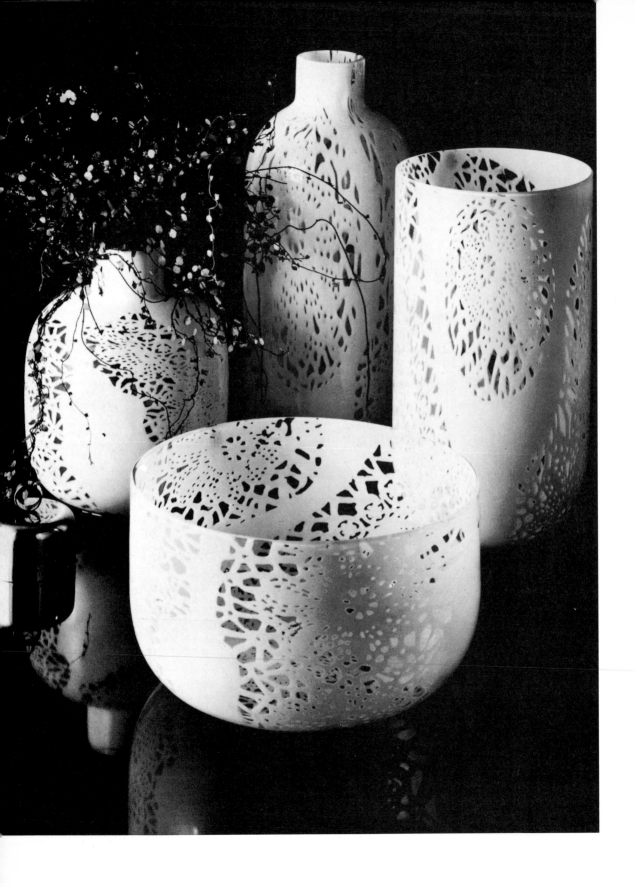

'Lace' bowls and containers,
opal and clear glass
Designed by Owe Thorssen and
Birgita Carlsson for Venini, Italy

Glass bowl from a series
of six
Designed by Sigurd Persson
for Kosta Glasbruk, Sweden

Bottle sculpture, hand blown,
with flame puncture decoration;
20 (8") high
Designed by Pavel Hlava and
made at the Včelnǐcka Works,
Ceský Křyšťál np, Czechoslo-
vakia

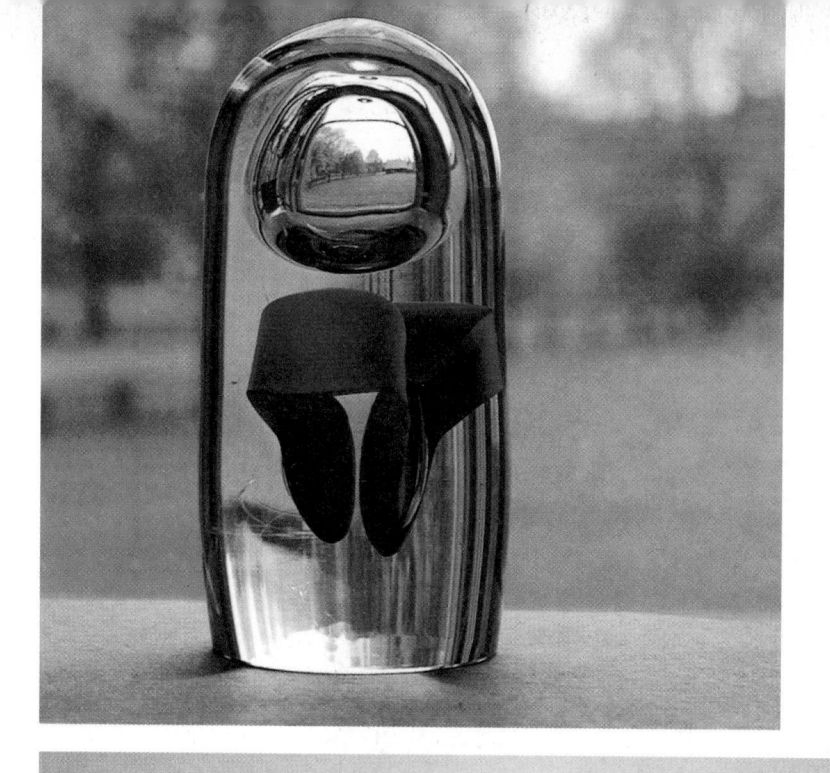

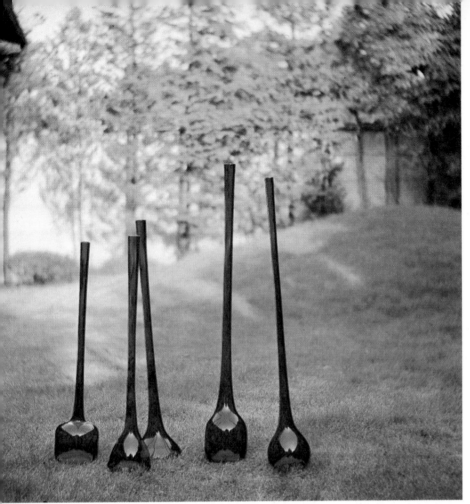

Decorative bottles, hand blown
Designed and made by
Masakichi Awashima, Japan

'Dawn' glass sculpture; detail,
40 (15¾") high
Designed by Oiva Toikka and
made at Oy Wärtsilä Ab,
Finland

Glass sculpture, clear and green
crystal with air bubbles
decoration; 18·5 (7¼") high
Designed by Wärff for Kosta
Boda Glasbruk, Sweden

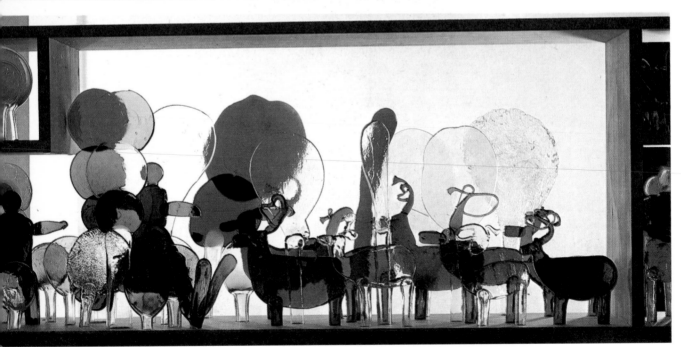

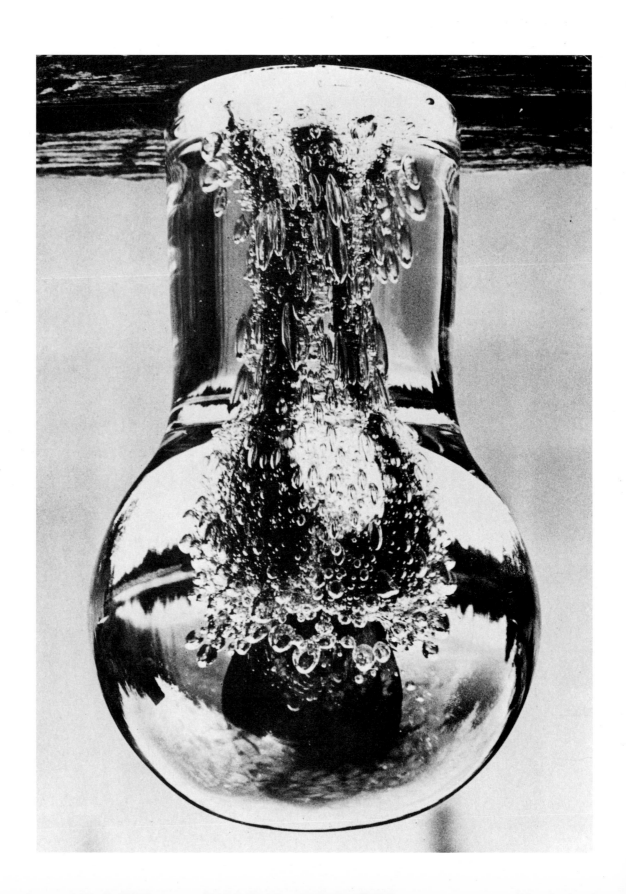

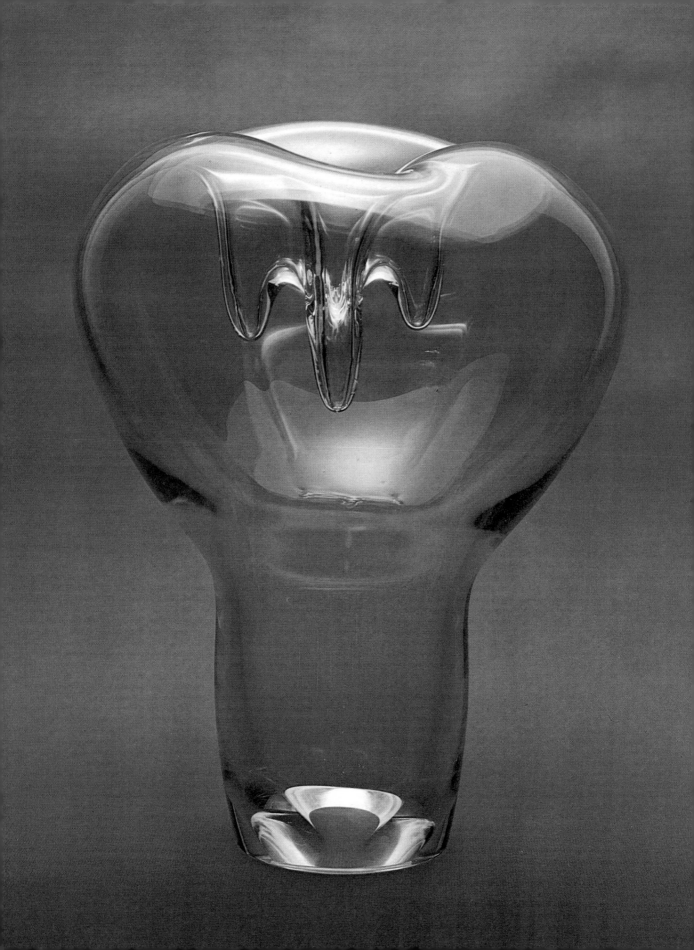

'Blue Sculpture', mould and
free blown
Designed and made by Kabey
Ashi, Japan

Plate, crystal glass with silver
chloride decoration; 35·5 (14")
diameter
Designed and made by Jane
Gilchrist at the Royal College
of Art, London

Plate; 91·5 (36") diameter
Designed and made by Sam
Herman at the Royal College of
Art, London

Containers, blown clear glass,
two sizes
Designed by Flavio Barbini for
Fratelli Barbini, Italy

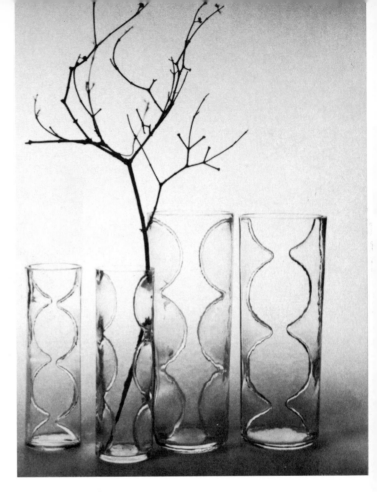

Left
'Roc 22' ashtray, mould blown
glass
Designed and made by
Daum & Cie, France

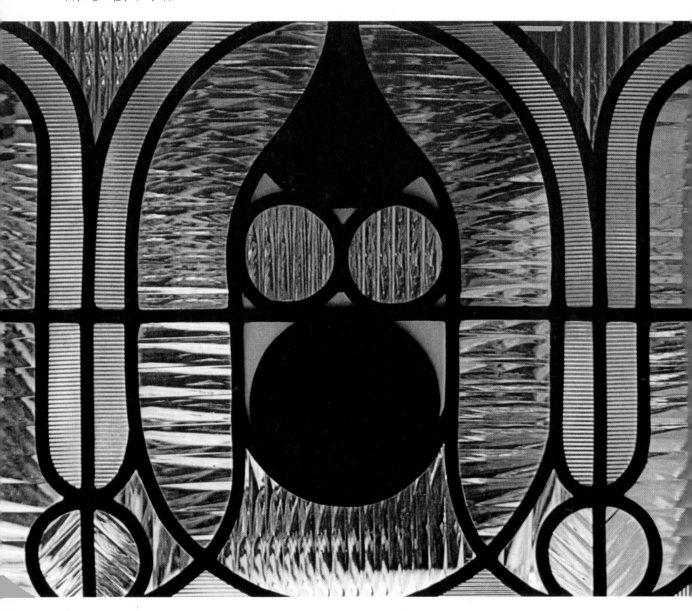

'Mechanical Glass Graphic',
lead channel, ridged clear glass,
opaque glass, mirror, wood;
86 (34¾") high
Made by Richard Millard, USA

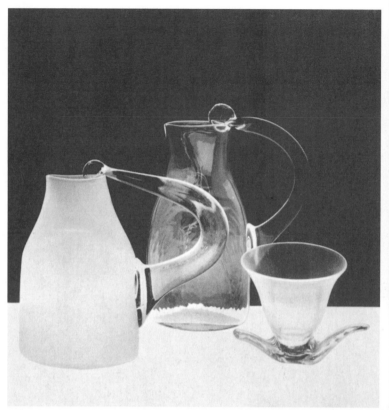

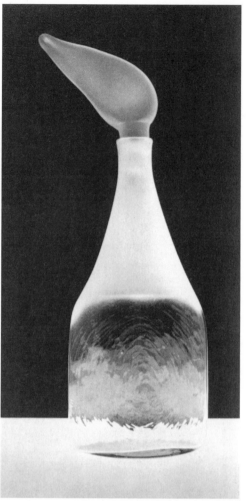

Flat jugs and winged cup.
Mould blown glass, hot
tooled handles and wings.
One of the jugs is sand-
blasted and measures
25cm (9⅞") the other,
clear, is 20cm (7⅞") high.
The cup is lustred and me-
asures 10cm (4") high.

Flat decanter, mould
blown and sandblasted,
35cm (13¾") high.

All made by Steven
Newell, England

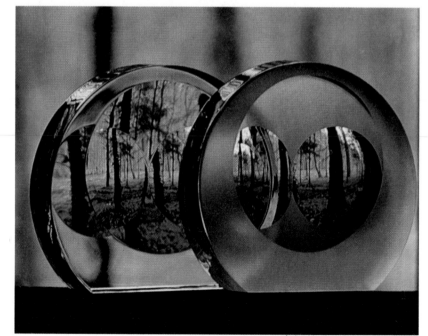

Variation Spatiale: two
blocks of crystal cut and
polished by hand, one par-
tially acid-etched. Each
6cm × 25cm (2" × 10")

Unlike the majority of contemporary glass artists, Yan Zoritchak does not work in a glass studio or workshop. The actual making of glass does not interest him: he uses the material as if it were stone or steel, in blocks which he cuts from the solid, acid etching and polishing them by hand afterwards. This is perhaps why his pieces have a distinct individuality, their heaviness expressing a controlled strength rather than the weighty quality of the original glass mass.

But where the artist depends on the characteristics of the material is in his need for light as an essential part of his work. Hence his preference for crystal and optical glass, partly etched to enhance textures and reflections.

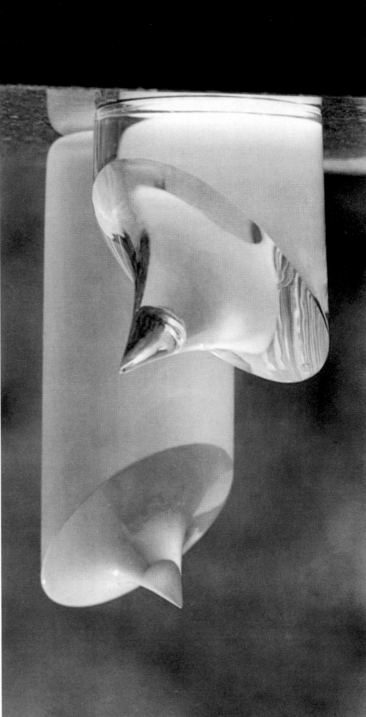

All made by
Yan Zoritchak, France

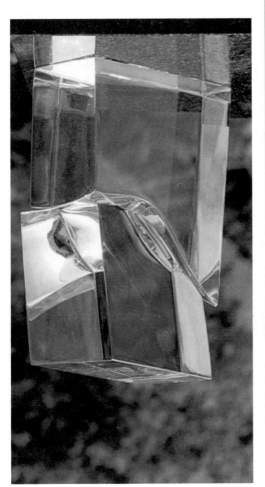

Stress: optical glass cut and polished by hand.
10cm × 10cm × 20cm
(8" × 4" × 8")

Relations: two blocks of crystal cut and polished by hand, one partially acid-etched. 25cm × 10cm (10" × 4") and 13cm × 12cm (5" × 5")

lighting | Lampen | Luminaires

1, 2
From a series of table/pendant fittings for
opal-glass globes: lacquered red, green,
or yellow or with polished chrome finish
Designed by Uno Dahlen for Aneta *Sweden*

3
Two series of tablelamps: ceramic bodies
glazed orange, yellow or white, white opal
globes: cm 15–23/6–9 inches high
Designed by Martin Hunt and James
Kirkwood for JRM Designs, *England*

4
Flexi table and standard lamps, flexible
hose on cast iron base vitreous enamelled
white, orange or matt black: polished
aluminium shade with plastic louvre
Designed by Robert Welch for Lumitron
Limited, *England*

5
Table (or pendant) lamp: metal shade
vitreous enamelled red, orange, turquoise,
blue or white: cm 21·5/8 inches diameter
Designed by Verner Panton for Louis Poulsen
& Company A/S, *Denmark*

1	2	4
3	5	

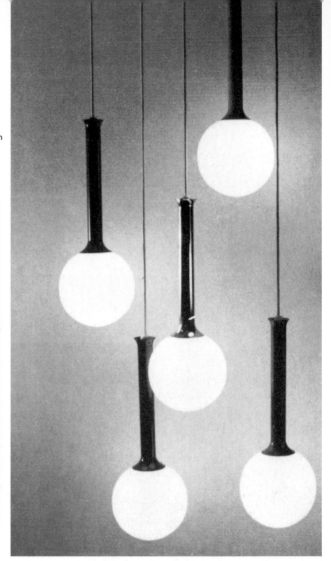

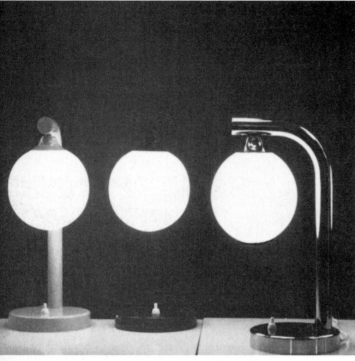

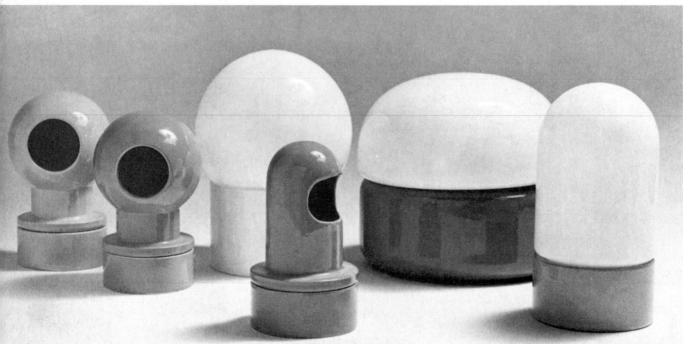

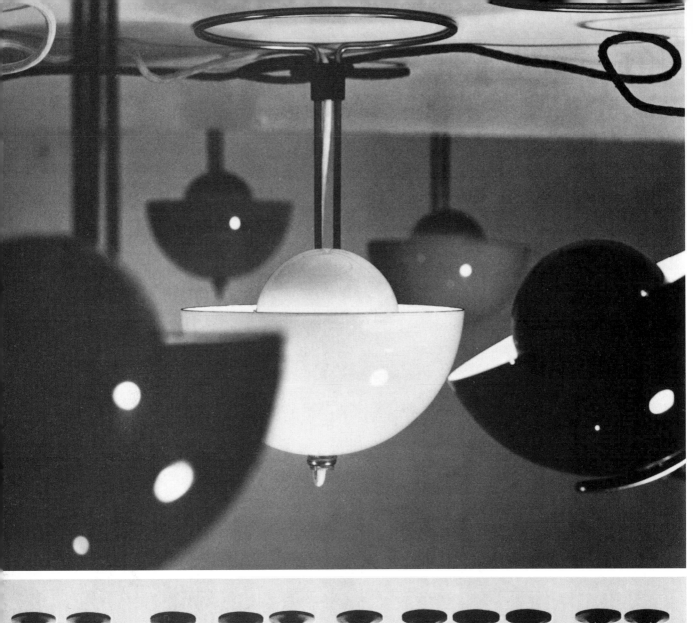

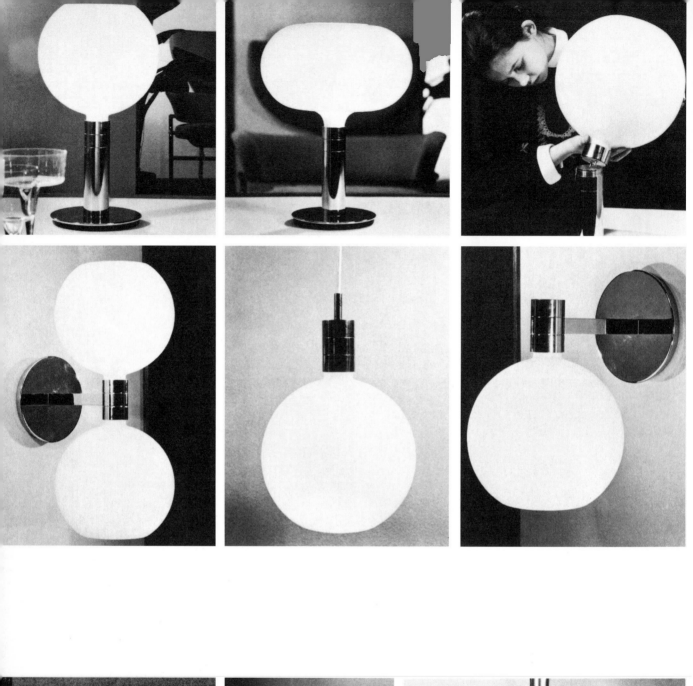

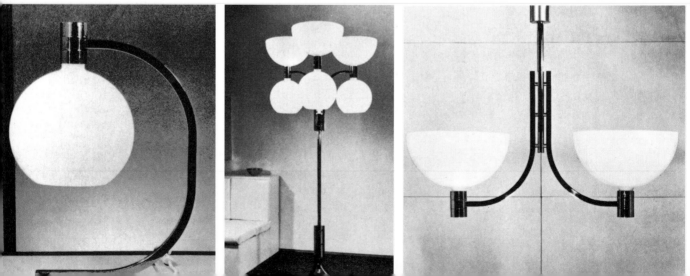

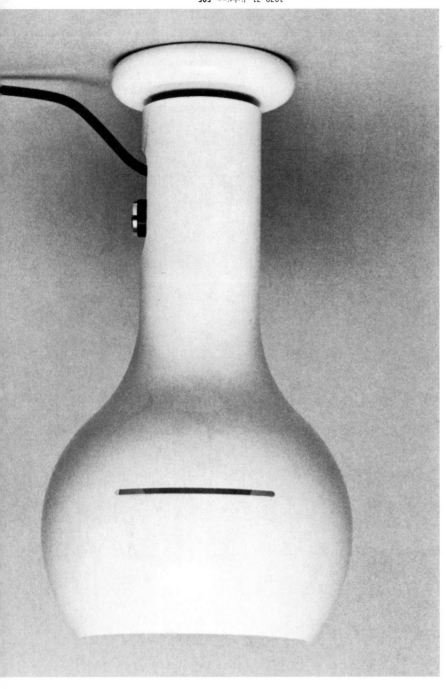

Flash set shade and base stove-enamelled
black or white, bracket anodized aluminium:
Also as floor, ceiling or wall fitting.
Designed by Joe Colombo for O-Luce, *Italy*

opposite
From a system series of lamps on low round
bases or longer square-section chromed-
steel branches, opal glass globes
Designed by Franco Albini, Franca Helg and
Antonio Piva for Sirrah, *Italy*

1,6
Wall-hung candleholder, brass
Designed by Aarikka Studio
Rotating colour whirl
Designed by Pauliaukusti Haapanen
Both made by Aarikka-Koru, Finland
2
Light panel 10451, opal glass held by
polished aluminium bands: shown are 16
units each with 4 fluorescent 60W
tubes, cm 50 × 50 × 8/20 × 20 × 3
inches overall
Designed by Ben Swildens for Verre
Lumière, France
3
Boalum light, designed by Livio Castiglioni
and Gianfranco Frattini for Artemide, Italy
4
Garden lamp, glassfibre reinforced
polyester with white opal glass globe,
cm 185/74 inches high
Designed by Annig Sarian for Kartell.s.r.l.,
Italy
5
Fluorescent light on white stove-enamelled
poles: with mount 2 metres/6ft high
Designed and made by Derek Jarman,
England
7
Luminous wall element: vacuum formed
Cellidor: shown are 16 units each with
2 light bulbs, cm 62.5 × 62.5/25 × 25
inches
Designed by Verner Panton for Bayer
Chemicals, W. Germany

1 2 6
5
3 4
7

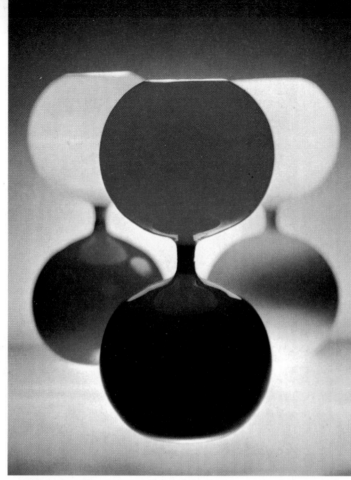

1
Ting table lamps, white, red or yellow
bone china
Designed by Stig Lindberg for
Gustavsberg Fabriker Ab, *Sweden*
2
Clustered ceiling or standard fitting, clear
or glass screens on bright-polished brass
stems, cm 75/30 inches diameter overall
Designed and made by Hans-Agne
Jakobsson Ab, *Sweden*
3,4
Standard lamp operating on 3-stage switch
and two lamps 25 and 40W: brass, alumin-
ium or coloured lacquer finishes: cm 19/
7 1/2 inches diameter
Ceiling lamp of crystal glass globes on
brass or chrome fitting, cm 32.5/13 inches
diameter
Both designed by Anders Pehrson for
Atelje Lyktan Ab, *Sweden*
5
Spectaculume lamp system: numerous
table, ceiling and floor lights may be
assembled from three shades and four
tubes with low-wattage lamps: clear
Plexiglas tubes with polished or colour
sprayed aluminium reflectors
Designed by Fini Bolbroe and Peter Karpf
for Dantek A/S, *Denmark*

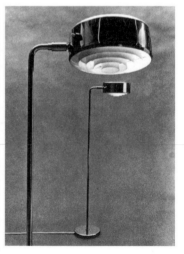

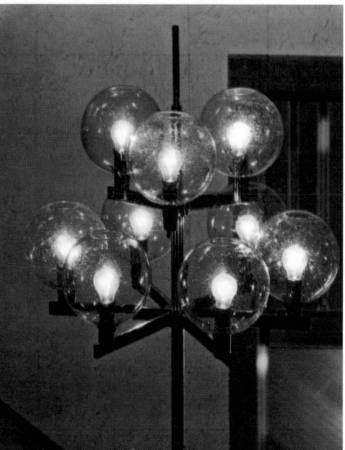

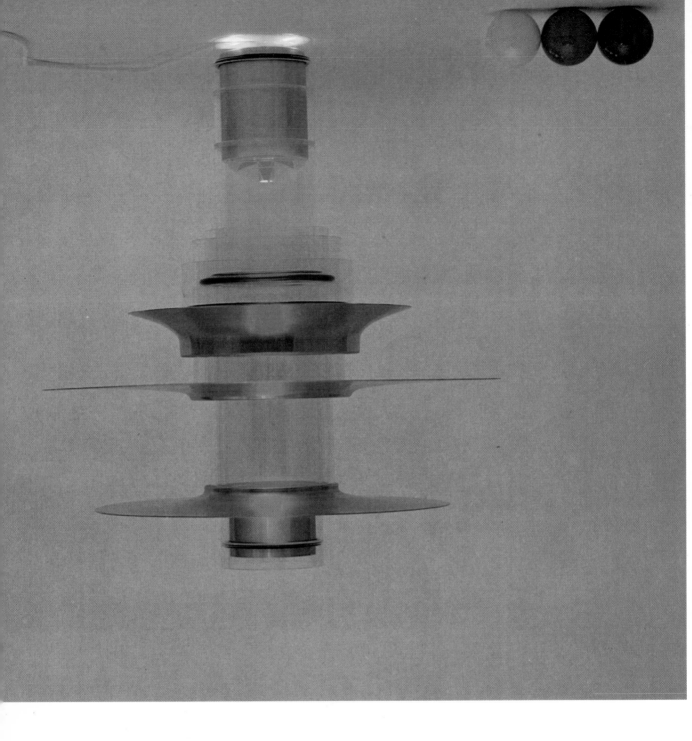

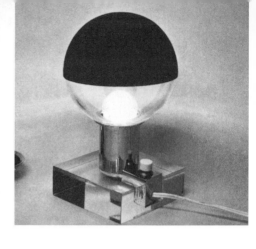

1,2
Cubic pillar and spherical table lamps, both clear glass and chrome steel, the sphere swivels under a chrome, red or green-lacquered hood, cm 25 and 27/10 and 11 inches high respectively
Designed by Yasushi Nakashima for the Nissin Denki Co Limited, *Japan*

3
Semi dining table pendant, matt white finished aluminium, cm 70/28 inches diameter
Designed by Claus Bonderup & Torsten Thorup for Fog and Mørup A/S, *Denmark*

4
Brillant table or ceiling lamp, socle and crown are polished aluminium cm 40/16 inches diameter

5,6
Mobile wall bracket and large ceiling fitting, white metal with pearl, red or orange glass balls, cm 25 and 110/10 and 43 inches high

7
Puck, single unit as small table lamp or wall bracket: ball and socle white, red or orange
All designed by E. R. Nele for Temde AG, *Switzerland*

```
1 2   5 7
    4
  3   6
```

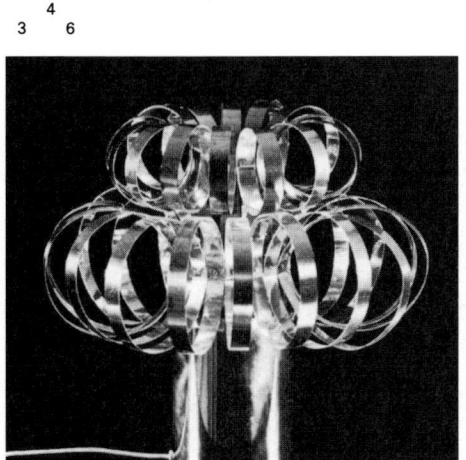

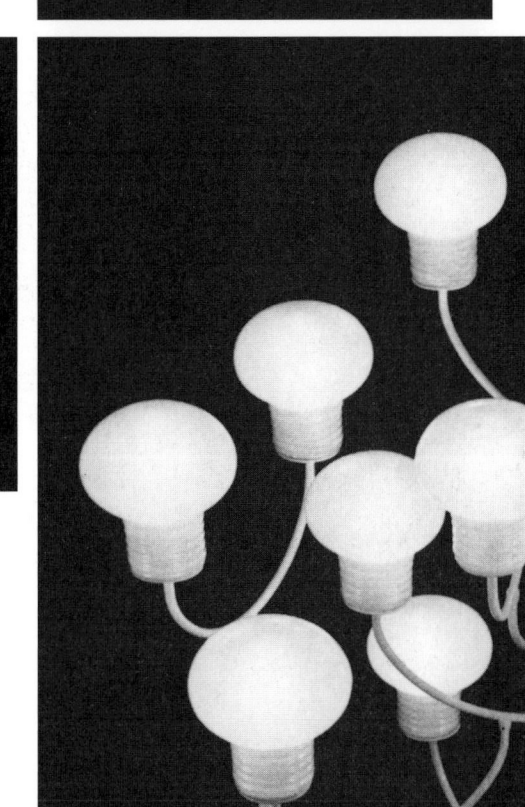

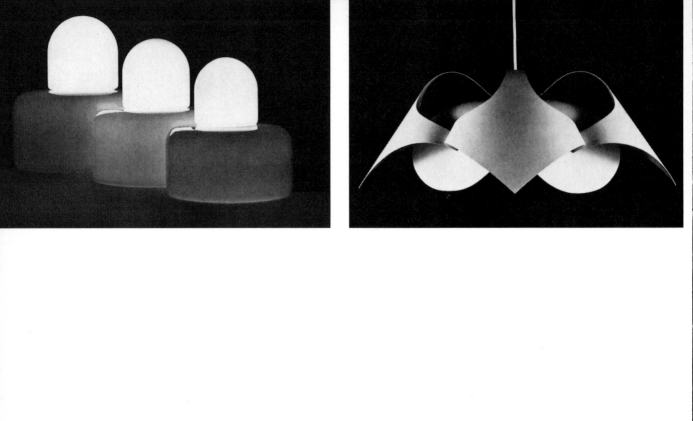

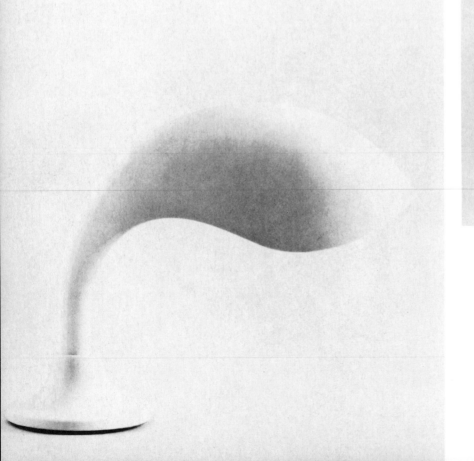

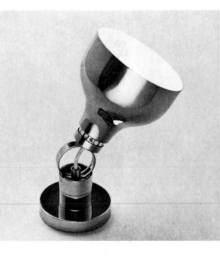

1
Table lamps, opaque glass, three sizes
Designed by Sergio Asti for Ve-Art *Italy*

2
Joker do-it-yourself pendant, Astralit
pvc plate, red, black, white, yellow, blue,
green or orange: sizes cm 65, 55, 50/
26, 22, 20 inches wide
Designed by Christian Raeder for
Le Klint Ltd *Denmark*

3
Rhea Minor table lamp vacuum formed
resin, red, white, yellow or violet,
cm 38/15 inches high
Designed by Marcello Cuneo for
Ampaglas SpA *Italy*

4
Table lamp AM6Bs, metal shade, chromium
plated or lacquered white, blue, red or
green: cm 35/14 inches high
Designed by Franco Albini, Franca Helg
and Antonio Piva for Sirrah *Italy*

5
Kerbstone glass table lamps
Designed by Sergio Asti for Bilumen *Italy*

6
Table lamps, glass, yellow, green, opal,
orange or black cm 20/8 inches high
Designed by Michael Baug for Kastrup og
Holmegaards Glasvaerker A/S *Denmark*

1 2 5
3 4 6

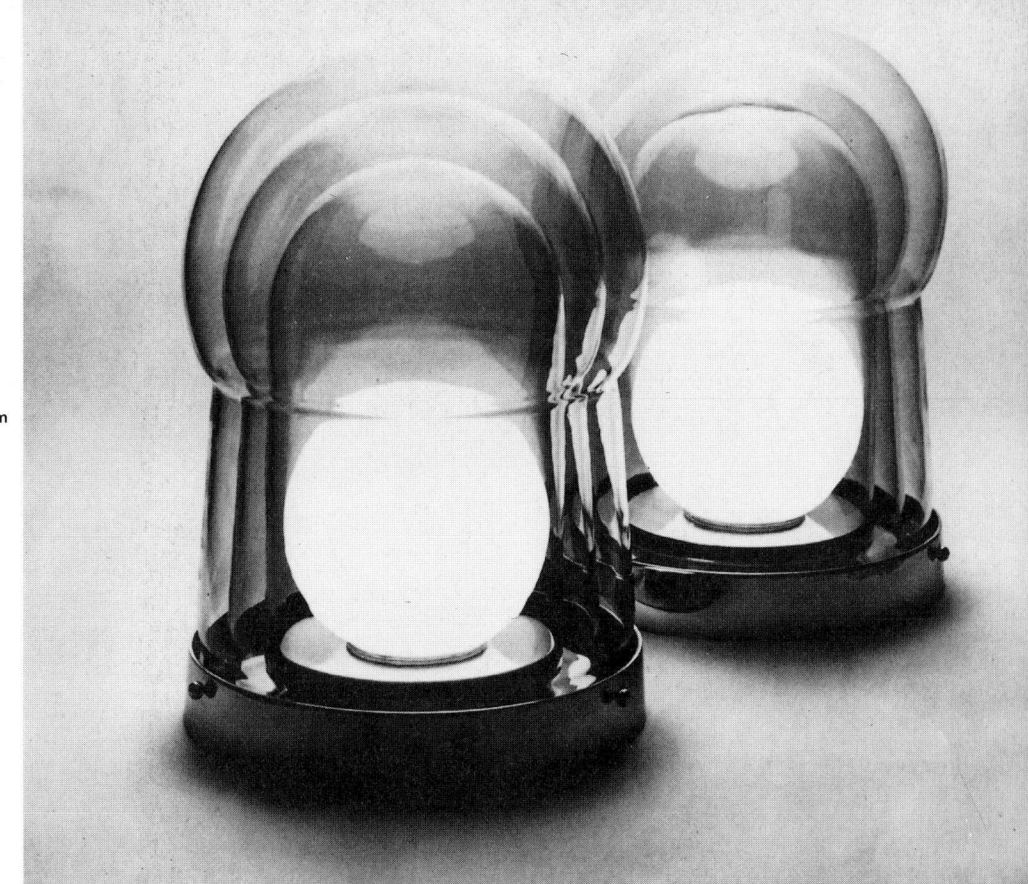

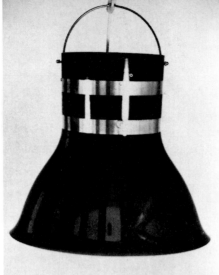

1
Pendants, white, yellow or orange Astralit
cm 90/36 inches high cm 42/16 inches
diameter
Designed by Thorsten Orrling, made by
Scan-Light Ab for Hans-Agne Jakobsson
Ab *Sweden*

2
Pendant, aluminium lacquered white,
black, brown or orange and silver
cm 40/16 inches diameter
Designed by Per Sundstedt for Kosta
Lampan Ab *Sweden*

3
Pendants matt aluminium, copper, or
brass shade cm 48/17 inches high
Designed by Thorsten Orrling for
Hans-Agne Jakobsson Ab *Sweden*

4
Zero pendant, white lacquered aluminium
cm 31/12½ inches high cm 41/16 inches
diameter
Designed by Jo. Hammerborg for
Fog & Mørup A/S *Denmark*

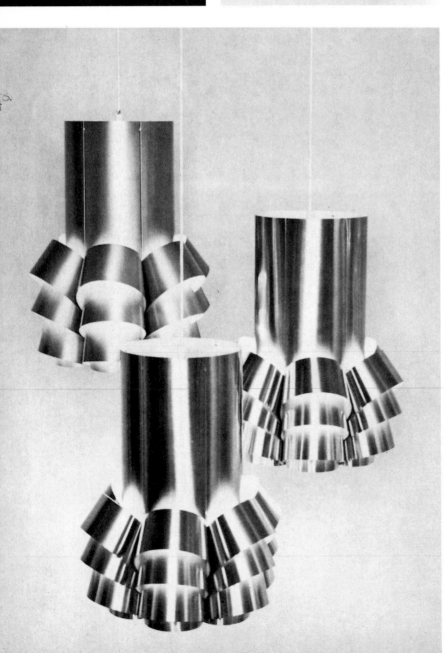
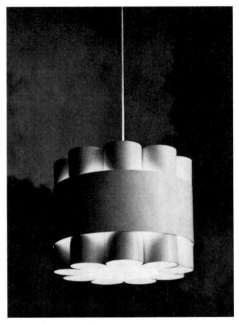

5
Space table lamp, clear glass globe on
white, black or nickel base matched by
edging round ventilation hole
Designed and made by A/S H. A. Gruberts
Sønner *Denmark*

6
Low voltage spot with integral transformer
26·018 for 12v 50w parabolic lamp:
cm 16·5/6½ inches high
Designed and made by Lumitron Ltd
England

7
Wall-lamp with natural pinewood or
white, orange or yellow Astralit shade
cm 25/10 inches high cm 13/5 inches wide
Designed by Hans-Agne Jakobsson for
Ab Ellyset *Sweden*

```
1 2    5 6
   4   7
  3
```

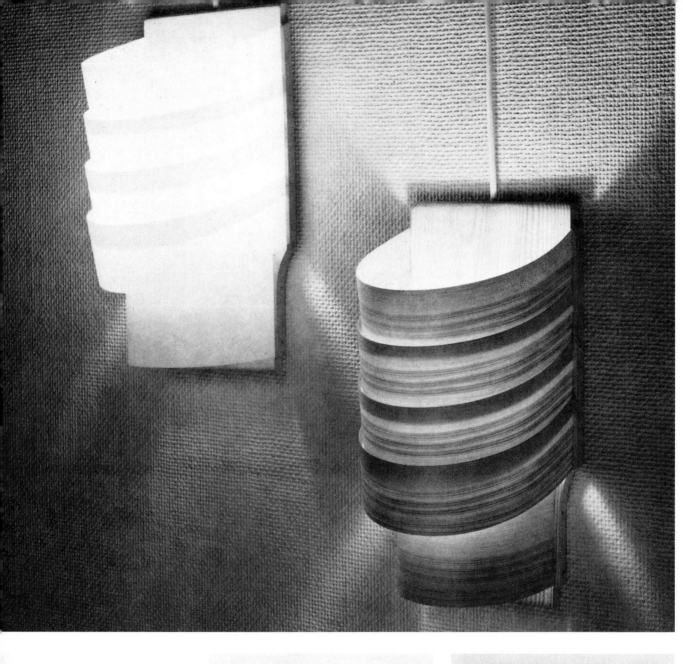

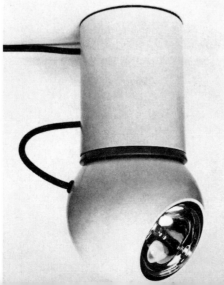

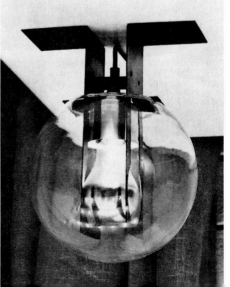

1
Recessed fitting from the *Oriel* range of
tungsten fittings, snap-fix attachment,
mirrored glass with clear glass tube and
silvered aluminium surround
Designed and made by Allom Heffer
England

2
Table or ceiling lamp with seven flexible
chromed arms, also available as standard
cm 78/32 inches high

3
Table lamp, metal frame covered on one
side in plexiglass, smoked, white, orange
or yellow cm 36 × 19/14 × 8 inches

4
Wall or table fitting, metal lacquered
white, red or yellow, cm 37/14½ inches high

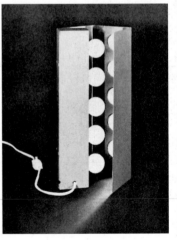

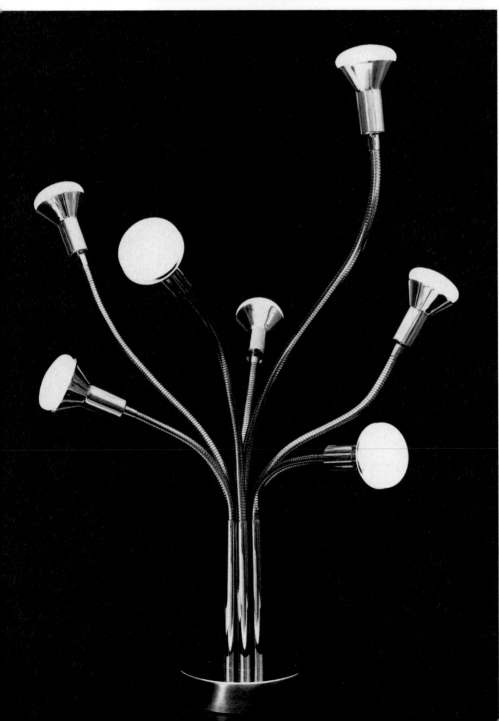

5
Wall lamp with swivel bracket, chromed,
white or red finishes cm 35/14 inches high

6
Mond standard with two lamps, chromed,
red or white finish cm 150/60 inches high

7
Visier table lamp, white, red or chromed
on black base cm 53/21 inches high, also
available as floor lamp
All designed by E. R. Nele for Temde AG
Switzerland

1	5	
	3	6 7
2 4		

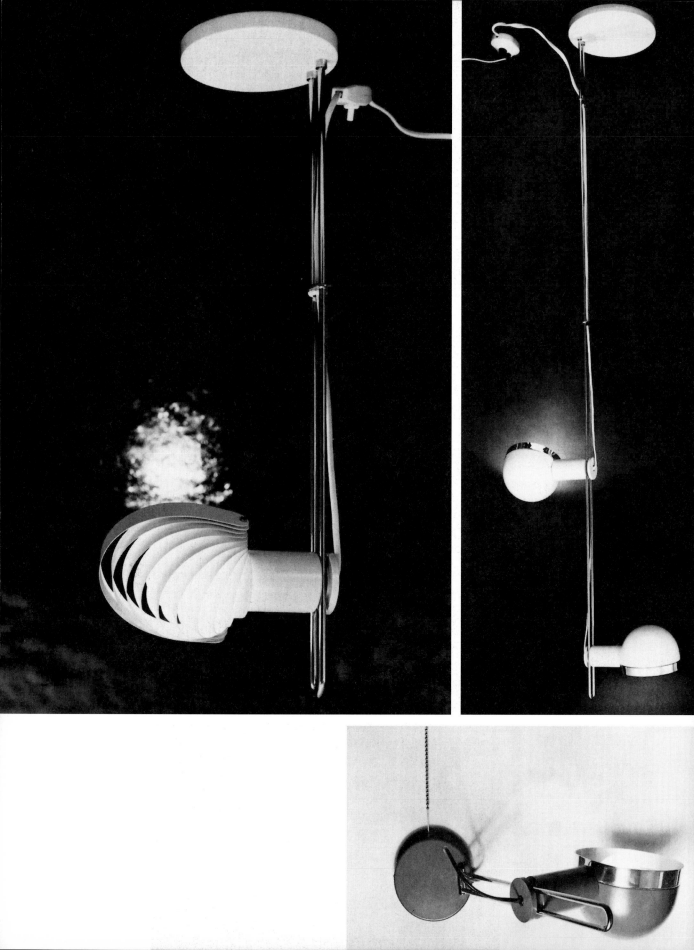

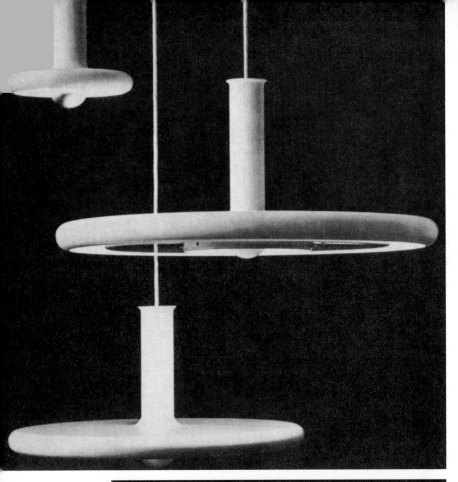

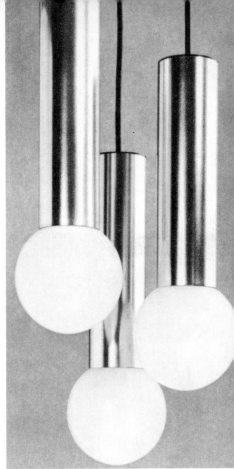

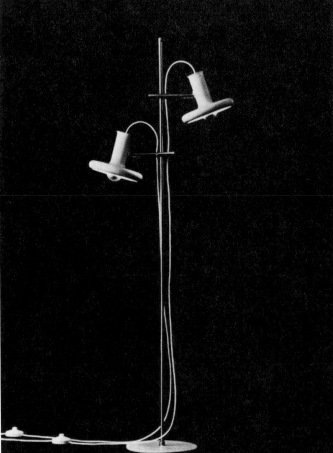

1, 3
Optima, range of floor, table, and pendant
lamps; aluminium painted matt white
Designed by Hans Due for
Fog & Mørup A/S *Denmark*

2
From the Mazda *Droplette* range, a triple
pendant lamp: chrome or matt-black
cylinders house standard lampholders
Designed and made by
Thorn Lighting Limited *England*

4
QC2 twin ceiling-mounted spotlight
with two independently adjustable
lamphouses: satin silver, white or brown
Designed and made by
Conelight Limited *England*

5
From the Mazda *Show-off* range of
wall- or ceiling-mounted pendant lamps:
spun aluminium with white, brown or
orange styrene cover: about cm
$16 \times 16/6\frac{1}{4} \times 6\frac{3}{4}$ inches
Designed by Alan Newark for
Thorn Lighting Limited *England*

6
Mazda *Pin-up* floor lamp: two fully
adjustable reflectors slide along chrome
tube on matt-black base
Designed and made by
Thorn Lighting Limited *England*

7
From the *Space Crystal* range:
clear, half-silvered or white opal glass
spheres mounted on chrome tubes of
varying lengths: the spheres house a
15 W or 25 W tubular bulb
Designed by Motoko Ishii for
Staff International *West Germany*

1	2	4	5
3		6	7

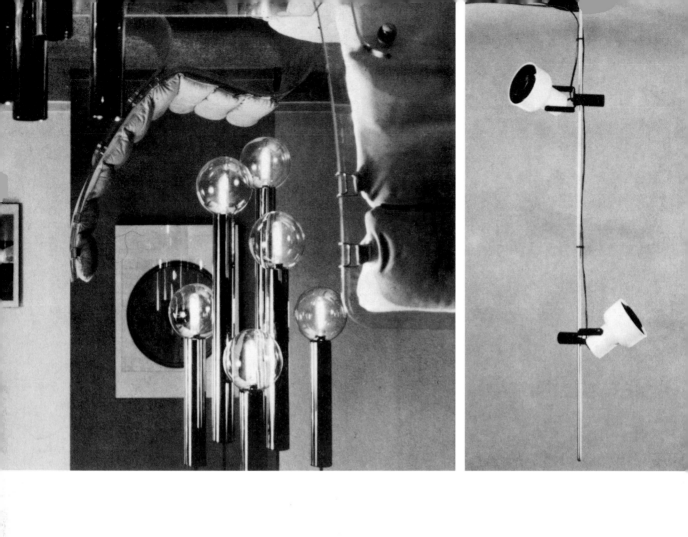

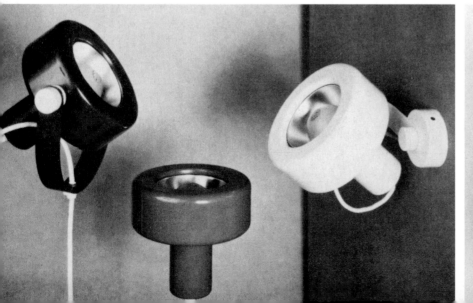

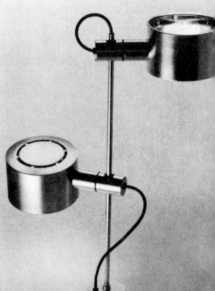

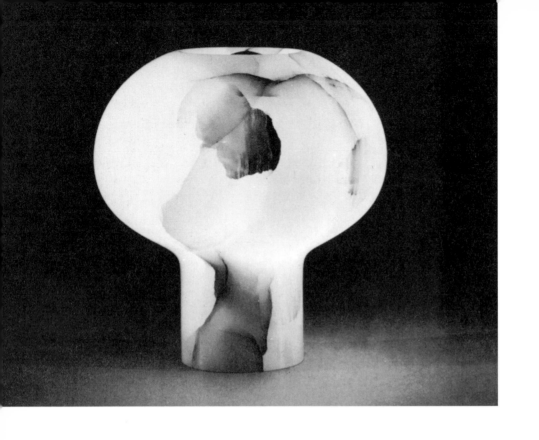

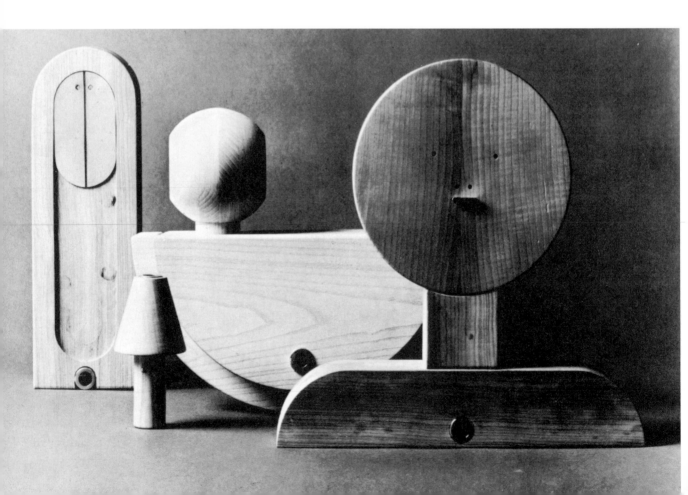

1
Onyx sculptured lamp fitted with silver
globe and integral dimming device
controlling the aquarium-like light effect
From a limited series designed by
Angelo Mangiarotti for
Iter Elettronica *Italy*

2
*The Monkey, the Bird, the Shape and
the Self,* reflected-light fittings
inspired by early mystical symbols
In wood or stone, Monkey with a brass
face
Designed by Luigi Massoni for
Iter Elettronica *Italy*

3
Il Cammino (The Road Ahead and The
Road Back) finger-tip control of the
chromium bars activates the light-cycle
from maximum intensity to darkness
Designed by Angelo Mangiarotti for
Iter Elettronica *Italy*

4, 5
Escargots floor lamp, dark amber/midnight
blue acrylic with lacquered ABS
synthetic resin, cm 40/16 inches high
Tree floor lamp, white glass,
grey lacquered base,
cm 170 and 60/66 and 24 inches high
Both designed by Naoto Yokoyama for
Joetsu Crystal Glass Co Ltd *Japan*

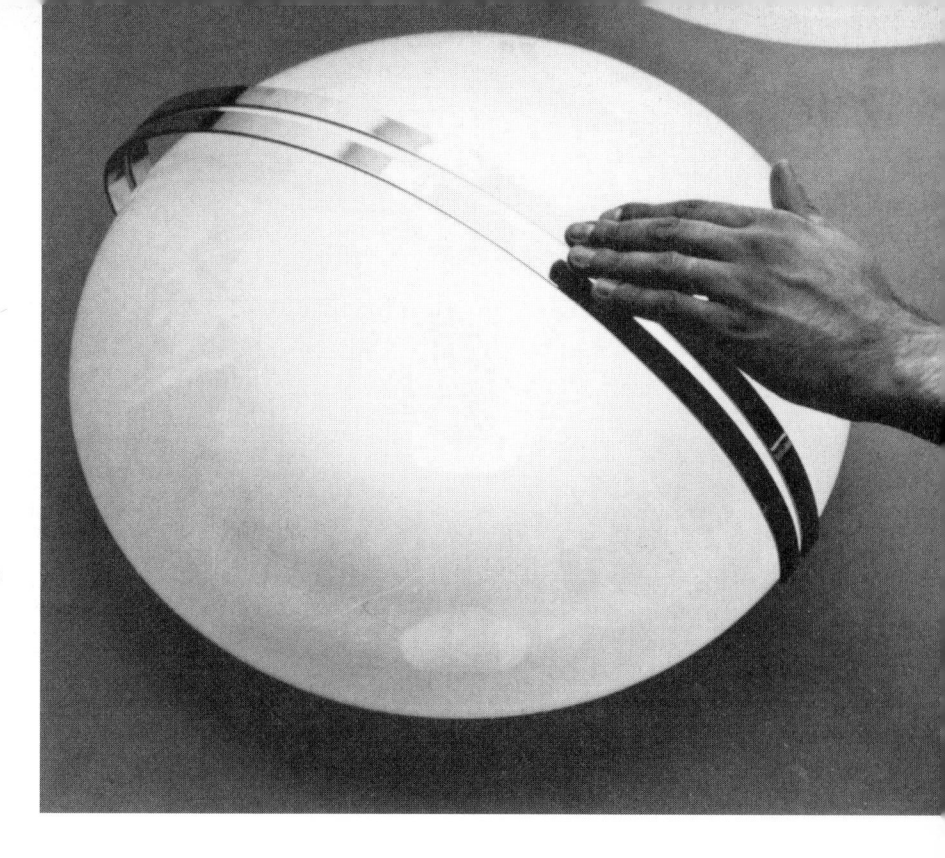

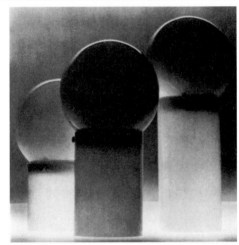

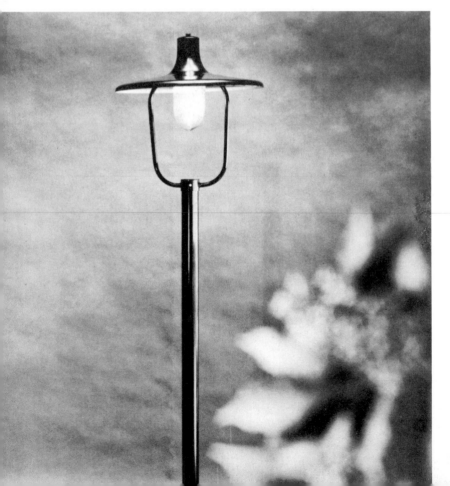

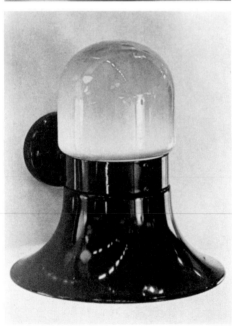

1 2 6
4
3 6 7 8

1
Pendant lamp: acrylic cylinder with
adjustable aluminium shade enamelled
white, orange, blue, green or brown
cm 45/18 inches diameter
Designed by Jan Wickelgren for
Ab Aneta Belysning *Sweden*

2, 3
Outdoor lamps in brown rust-proof-
enamelled metal and glass
cm 35 and 54/14 and 21¼ inches diameter
Designed by Bo Anås and Jan Wickelgren
for Ab Aneta Belysning *Sweden*

4
Free-standing globe lamps for diffused
general lighting: opal Perspex
Designed and made by Banks Heeley
Plastics Ltd *England*

5
13212 from a series of rust-proofed
outdoor lamps: brown-lacquered metal
with orange, opaline or bubbled clear glass,
cm 36 × 39/14 × 15½ inches wide
Designed by Monica Strandäng for
Ab Aneta Belysning *Sweden*

6
Terrace lamps: smoke grey reflector on
opal glass pillar, with chrome fittings,
cm 68–95·5/27–37½ inches high
Designed and made by
Peill & Putzler GmbH *West Germany*

7
Membrana co-ordinated series of floor,
table and pendant lamps: handblown
glass globe with self-coloured membrane
on lacquered metal tube: opal, antique red
or green
Designed by Toni Zuccheri for Venini SpA
Italy

8
Tumbo garden lamp
Designed by Piero Menichetti for
Ismosdesign *Italy*

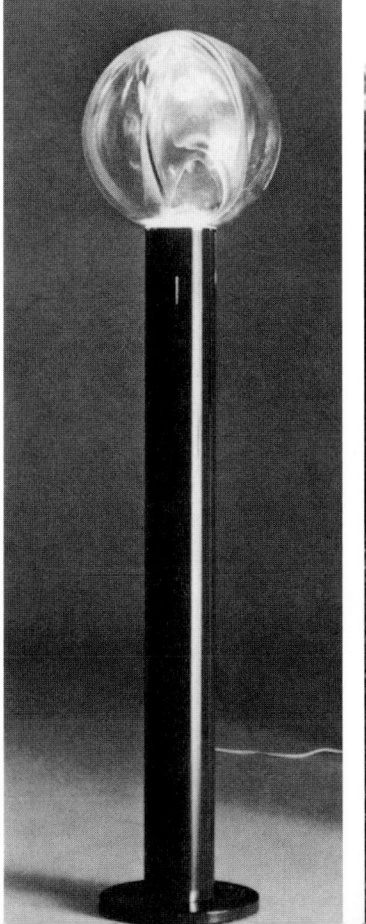

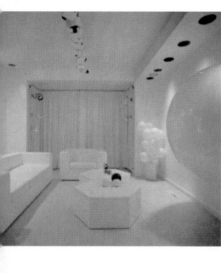

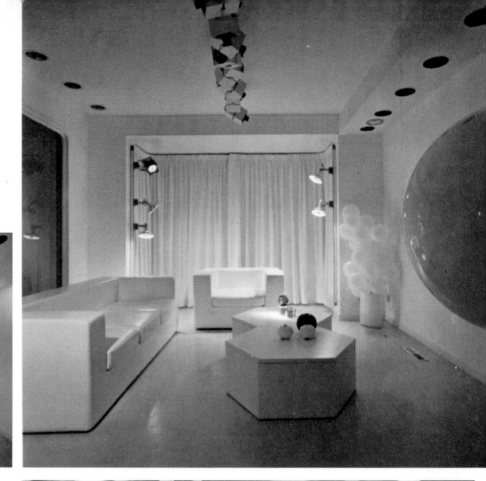

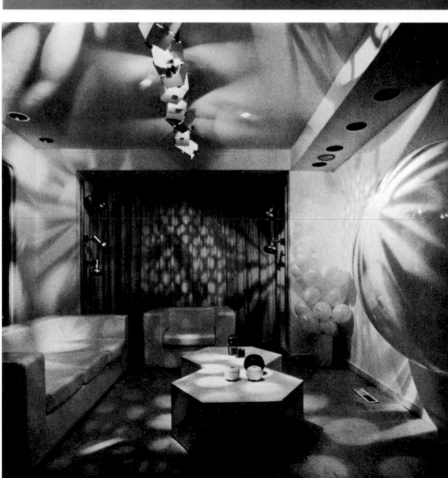

7
Custom-built table-light fitting in coloured glass and aluminium
Designed and made by Keith Cummings
England

8
Effect-lighting filament 6 P2: infinitely varied compositions result from rotation of the screen, through which prismatic spectrums are formed by refraction from curved- and flat-planed surfaces incorporated in the structure
Designed by Paolo Tilche for Sirrah *Italy*

6
Oil effect filter in Lumiere lens
All designed and made by Concord Lighting International Limited
England

5
Small tumbling glass spheres, kinetic effect *E 10715*, one of a range available for use with the Lumiere projector

1–4
Autofade light-programme modulator in an all-white interior furnishing scheme: the E10000 dimmer/cycling unit used singly or severally in conjunction with Lytespots produces strobe-type lighting through slow sunset/sunrise effects. Alternatively 'auto' may be switched off and the unit used as a conventional dimmer

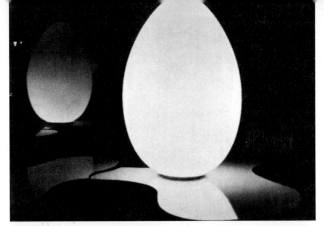

1
The Egg floor or table lamp, satin opaline
glass on concealed white-lacquered
steel base, cm 62/42½ inches high
Designed by Ben Swildens for
Verre Lumiere *France*

2
Pendant lamp in yellow, white or orange
Astralit, cm 38/15 inches diameter
Designed by Torsten Orrling for
Scan-Light *Sweden*

3, 4
Ceiling lamp with adjustable metal shade
cm 45/17½ inches diameter
Designed by Franco Albini, Franca Helg
and Antonio Piva for Sirrah *Italy*

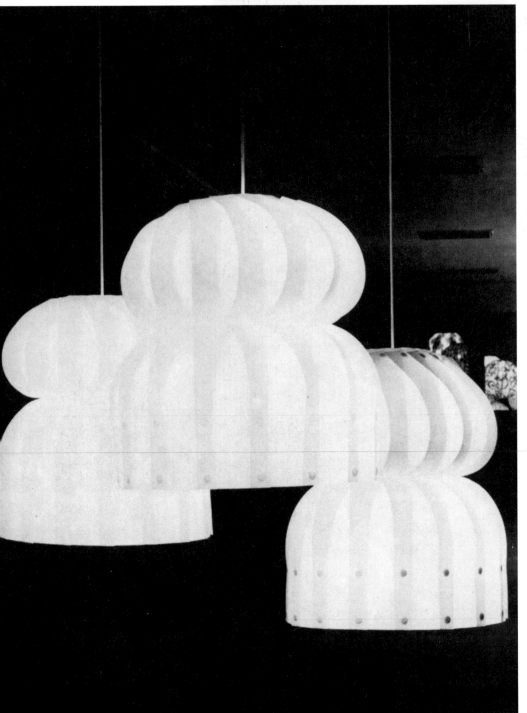

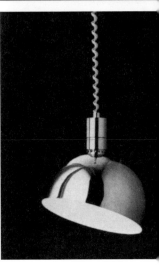

1 5
2 3 6 7
4 8

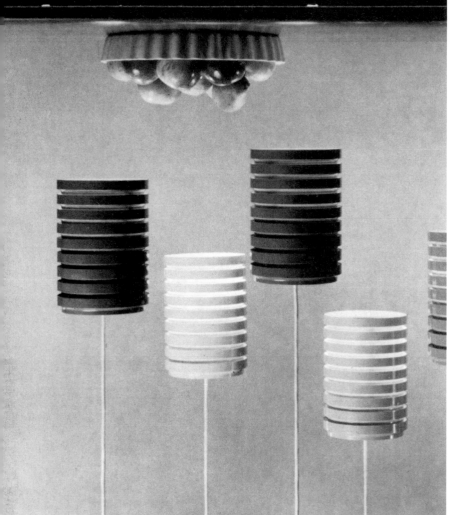

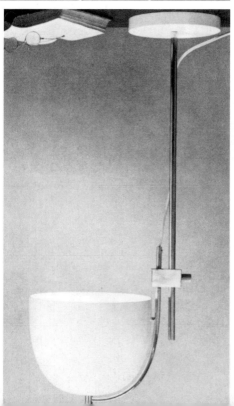

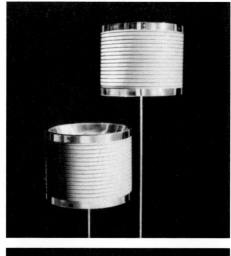

5
Mezzopileo lamp in white Makrolom
cm 45/17¾ inches high: a low,
white-lacquered metal *Pileino* and a
pillar version, *Pileo*, are available
Designed by Gae Aulenti for
Artemide *Italy*

6
Pendant lamp, grey plastic edged with
polished aluminium, cm 26/10¼ inches
diameter
Designed and made by Hans-Agne
Jakobsson *Sweden*

7
Super Egg, table lamp: chrome aluminium
stem, adjustable shade and base finished
matt white, cm 95/37¼ inches high
cm 25/10 inches diameter
Designed by Piet Hein for Lyfa *Denmark*

8
From the *Ringline* series: pendant lamps
spill lighting through a series of precision
moulded plastic rings together with full
downward illumination. White, yellow,
orange, green or purple, cm 21/8¼ inches
high. A deep drum pendant for high
mounting and a wall fitting are available
Designed by P. Boissevain for Merchant
Adventurers *England*

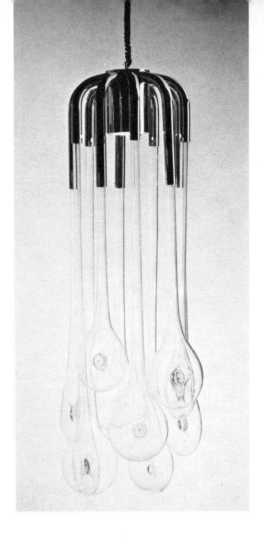

L/110 Ceiling lamp, structure of chromium plated steel tube houses bulbs, pendants of blown glass with 'murrina' decoration
Designed by Lino Tagliapietra for La Murrina, Italy

'Lola' wall lamp, translucent white polycarbonate components; a ceiling version is also produced
Designed by Sergio Mazza for Quattrifolio Design, Italy

'Tiptop' ceiling lamp, six
aluminium shades suspended
around a single light source,
various colours; 35 (13¾") high
20 (8") diameter
Designed by Jørgen Gammelgård
for Design Forum A/S, Denmark

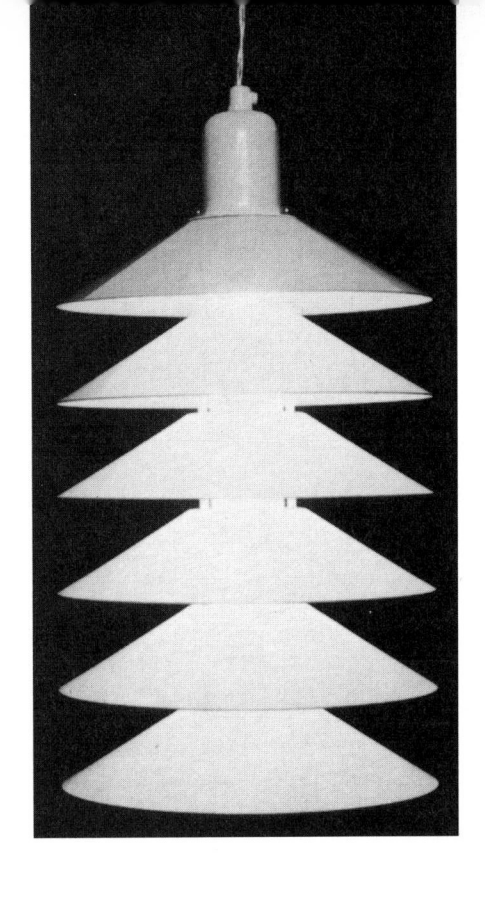

'Blitz' table lamp, aluminium alloy
painted white, green or yellow;
37·5 x 24·5 (14¾" x 9½")
Designed by F Trabucco
M Vecchi D. Volpi for Stilnovo,
Italy

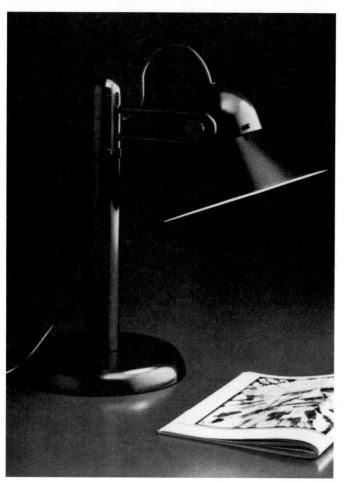

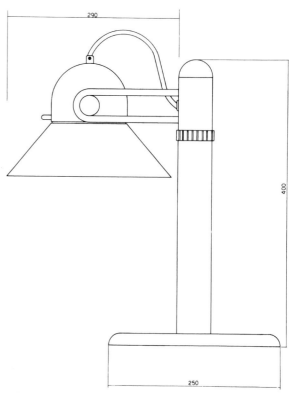

228 Adjustable reading lamp: the
top section of the lamp can
swivel through 360 degrees and
the shade itself can be adjusted;
metal lacquered maroon or dark
green; 40 (15″) high
Designed by Gae Aulenti for
Stilnovo, Italy

'Pinspot', from a range of
display light fittings; low
voltage, fully adjustable spot-
lamp available with bracket or
for use with a lighting track;
die cast synthetic material,
silver with black and red
trimmings
Designed by Roger Tallon for
ERCO, West Germany

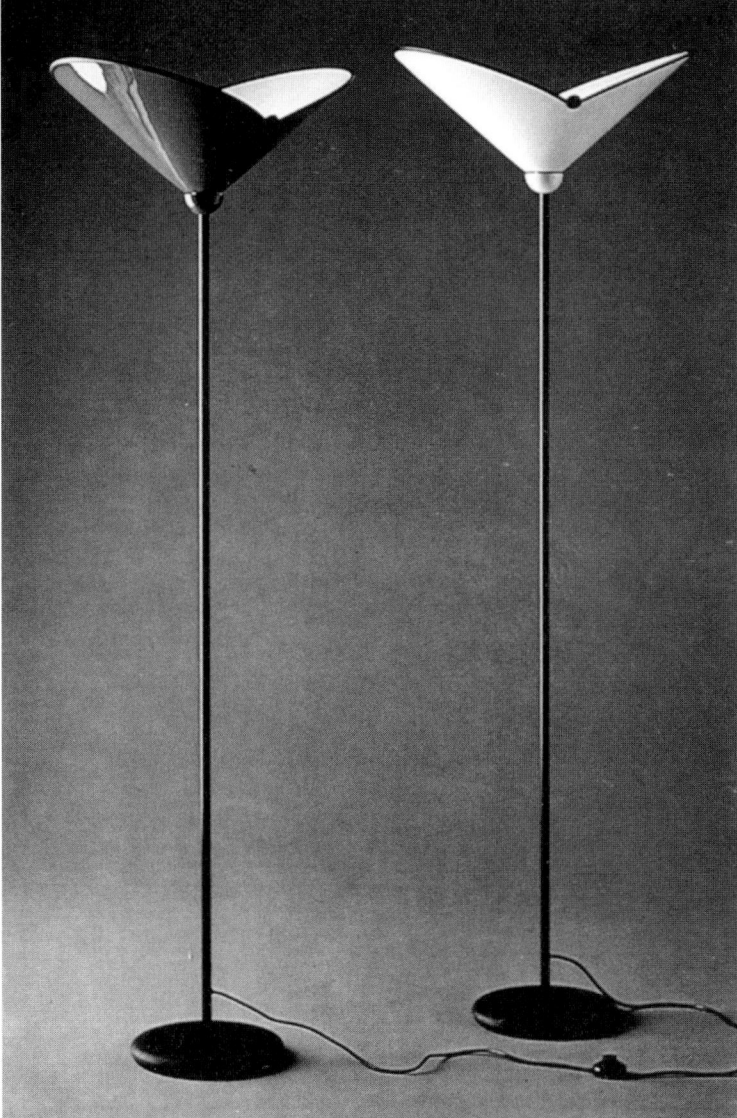

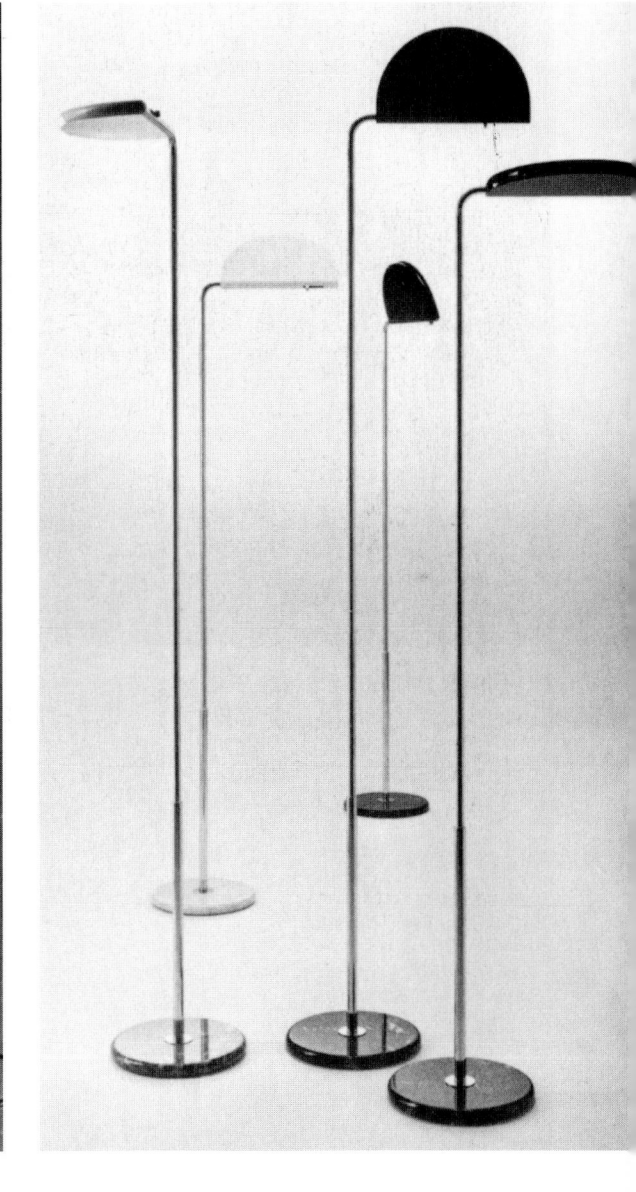

Fiore, Mod. 3603: floor lamp. Steel plate reflector lacquered white, green or maroon; black lacquered stem. 184cm (72″) high 60cm (23⅝″) diameter. Designed by Adalberto Dal Lago for Stilnovo, Italy

Mezzaluna: series of floor, wall and ceiling lamps. The lighting units, adjustable on 180 degrees, have a protecting glass on the side not shown by the illustration. Semicircular diffusors of pressed steel, stove enamelled black or white, hold halogen bulbs of 250 or 500 Watts, 110 or 220 Volts, which can be electronically controlled in the floor and wall models. The stems of chrome tubing adjust telescopically in height and rotate on a base of white, grey or black marble. Designed by Bruno Gecchelin for Skipper, Italy

silver and tableware | Silber und Geschirr | Argenterie et arts de la table

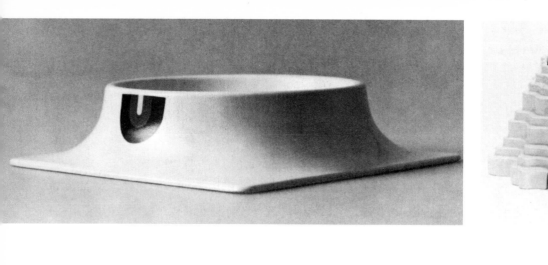

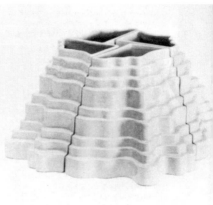

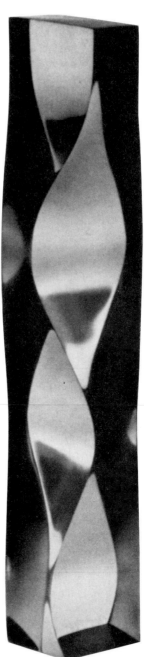

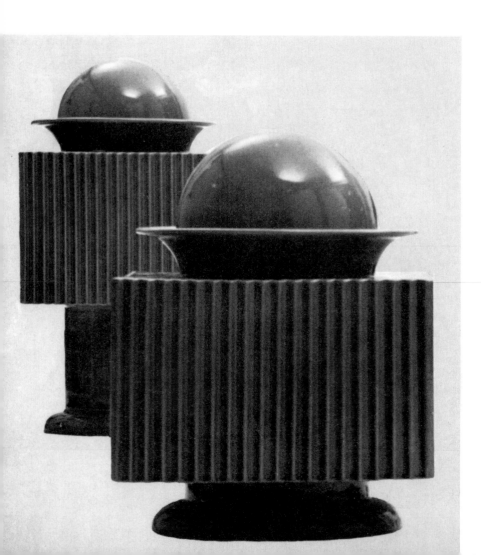

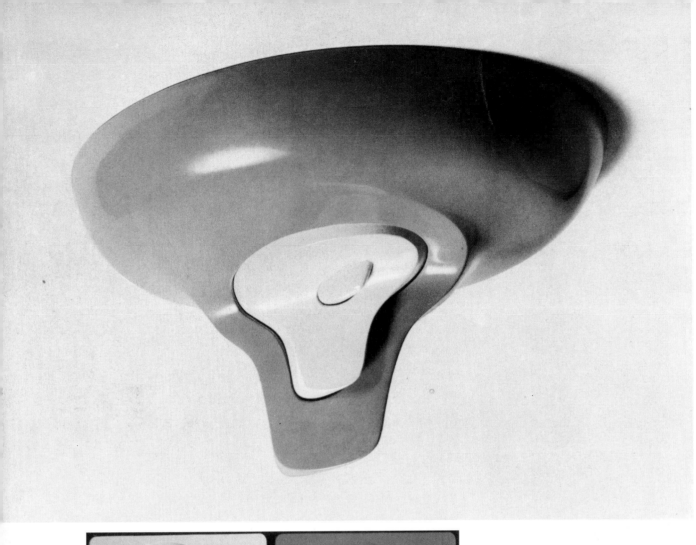

1
Ashtray, moulded Melamine: several colours:
cm 15×15/6 × 6 inches
Designed by Sergio Asti for Mebel, Italy
Aldo Ballo

2
Collina group of moulded ceramic vases,
white, black or orange:
cm 28/11 inches high
Designed by Sergio Asti for Gabbianelli, Italy

3
Mysterious Boxes white or red ceramic:
cm 25·5–35·5/10–14 inches high
Designed by Sergio Asti for Cedit, Italy

4
He Loves me, He Loves Me Not
water clear polyester cast with pink or
green tones: cm 45·5/18 inches high
Designed and made by Freda Coffing
Tschumy, USA

5
Spyros ashtrays red, gold, white and
olive green Melamine: cm 21·5 × 21·5/
8¼ × 8¼ inches
Designed by Eleonore Peduzzi Riva for
Artemide Spa, Italy

6
Nesting shapes, resin-impregnated plaster:
cm 36/14 inches diameter
Designed and made by Keith Walker at the
Royal College of Art England

Toni R. Lutz

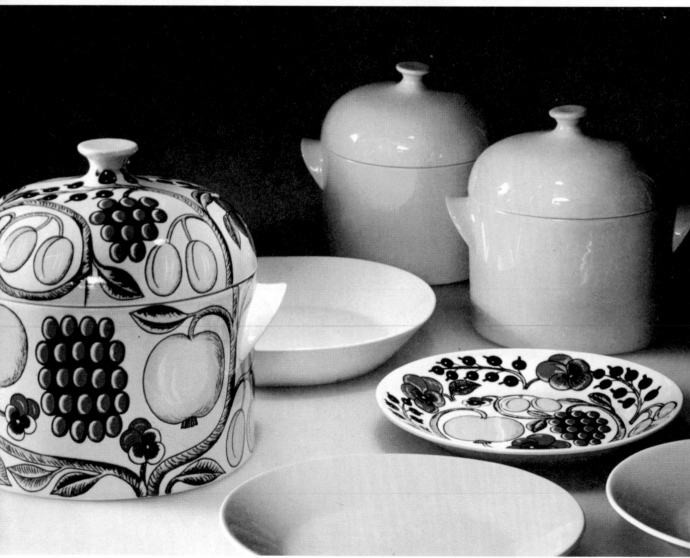

1
City stackable tableware, glossy white
feldspathic porcelain or with bright decor:
large platter cm 38 × 23·5/15 × 9 inches
Designed by Pierre Renfer for
Porzellanfabrik Langenthal AG, *Switzerland*

2
Transition range of tableware, plain white or
with circular coloured motif
Designed by Gerald Gulotta for Porzellan-
fabrik Langenthal AG, *Switzerland*

3, 4, 5
Yellow *Adam*, plain white *Eve*, and rich fruit
decor *Paradise* related series of nearly oval
shapes, hard glazed earthenware
Designed by Birger Kaipiainen

Spice jars, earthenware, white with black
decor
Designed by Ulla Procopé and Esteri Tomula
background: Liekki range of oven-to-table-
ware brown ceramic Designed by Ulla
Procopé

Milton dinner and tea service with under-
glaze decor, grey or brown-green
Designed by Anja Jaatinen
All manufactured by Oy Wärtsilä Ab Arabia,
Finland

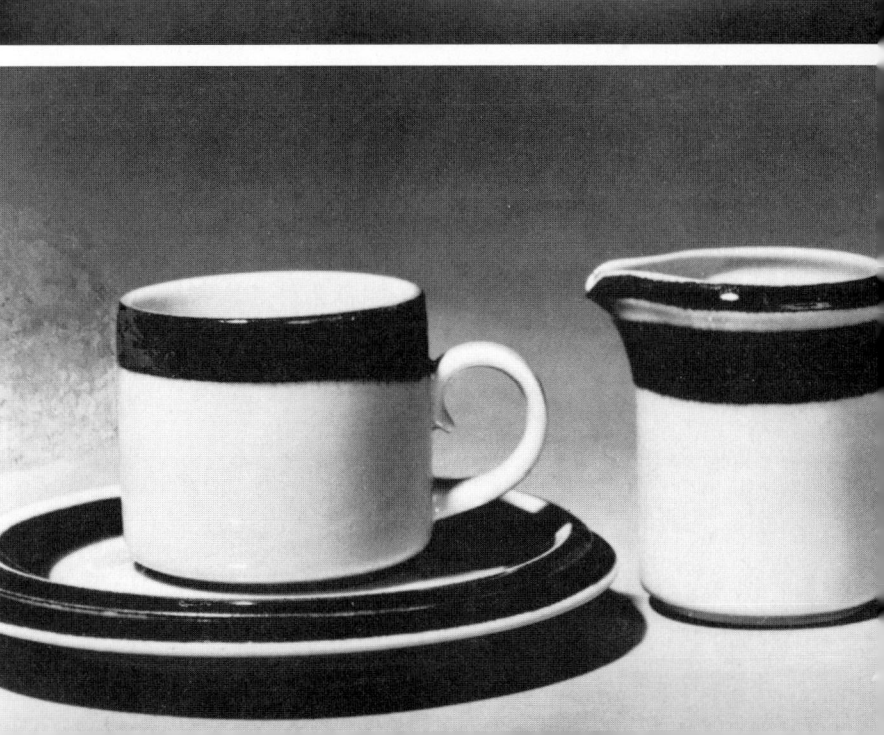

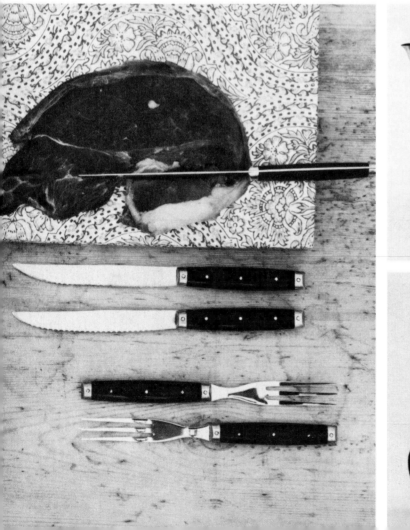

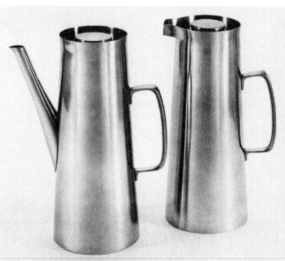

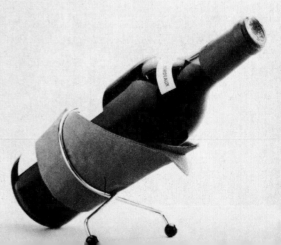

1
Cruet set, solid silver and ebony
Designed and made by Gordon Hodgson,
England

2
Glacer ice/nuts box
Designed and made by Luigi Massoni, *Italy*

3
From the *Bistro* range of cutlery, stainless
steel with black or orange Melamine handles,
finished brass
Designed and made by APA, *France*
Courtesy Danasco, *London*

4
779/780 Vacuum jug with removable liner,
and coffee pot, stainless steel satin-finished
cm 27/10$\frac{1}{2}$ inches high
Designed by Robert Welch for Old Hall
Tableware Limited, *England*

5
Wine stand, chrome steel or silver with
black plastic feet

6, 7
Hot-plate/flower-holder, crystal thermoplast
and steel: cm 16×16×7/6$\frac{1}{4}$×6$\frac{1}{4}$×2$\frac{3}{4}$ inches
All designed by Devico Design AG for
Womar AG, *Switzerland*

8
Alfresco garden grill, aluminium grid
in bowl on one or more rings:
cm 45/17$\frac{1}{2}$ inches diameter
Designed by Jørgen Høj for Ivan Schlechter,
Denmark

9
Palisander range of cutlery stainless steel
with rosewood handles
Designed by Don Wallace for H. E. Lauffer
Company Inc, *USA*

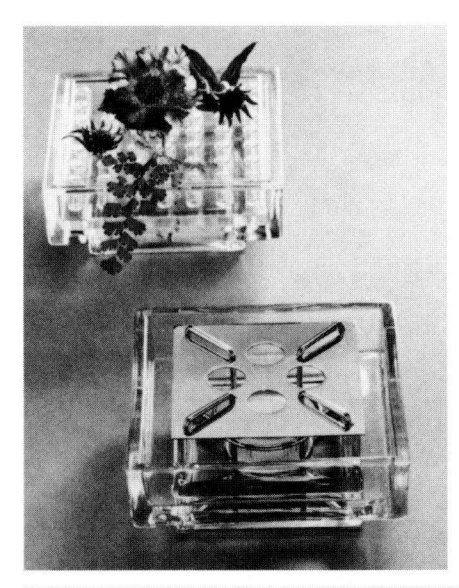
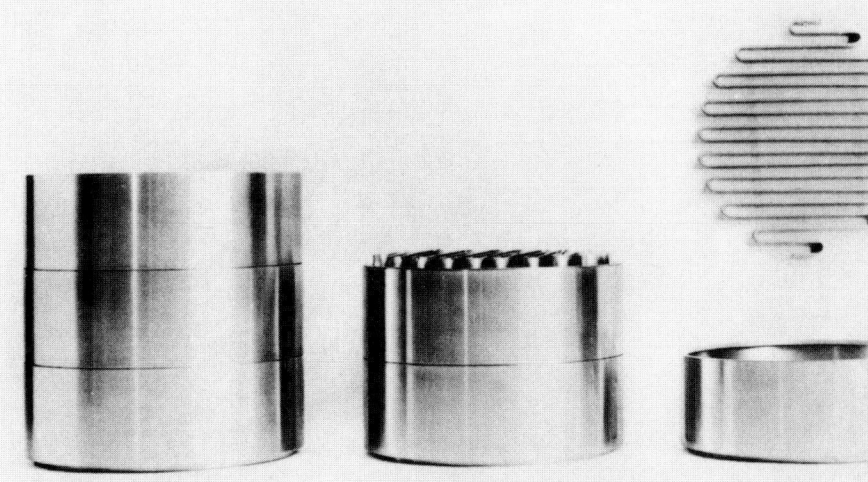

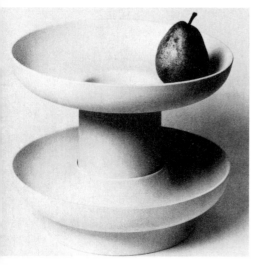

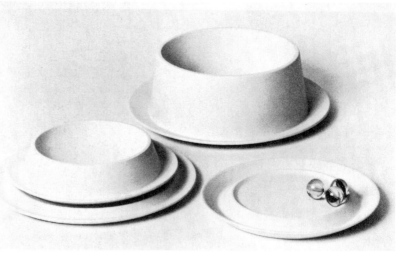

1 2
4 3
 5 8
6 7

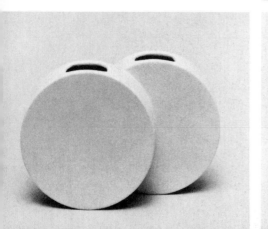

1,2
Games, Fort Apache and Dominoes,
designed by Studio Angeretti
3,8
From ranges of ergonomic tableware
Designed by Joe Colombo
4
Tiered dish designed by Doppio
Scomponibile
5
Sectional ashtray, black, red, orange, yellow
or white, cm 15 × 15/6 × 6 inches
Designed by Jean Pierre Garrault (France)
6,7
Vase, tempest blue, black or white
20.5 cm high/8 inches
Ashtray, yellow, red, black, orange or
white: both designed by Ambrogio Pozzi
All made by Ceramica Franco Pozzi, *Italy*

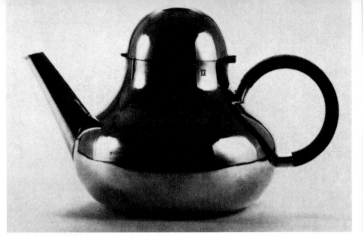

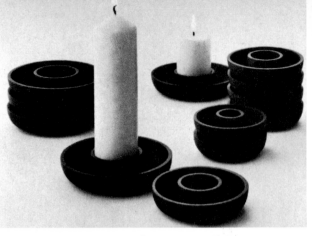

1
Tea pot, sterling silver with rosewood
handle, cm 20/8 inches diameter
Designed and made by Robert Welch,
England
2
Candlesticks, cast iron vitreous-enamelled
matt black: for candles cm 2.5, 3.75, 5/
1, 1 $1/2$, 2 inches diameter
Designed and made by David Mellor,
England

1 2 7
3 4 8
5 6

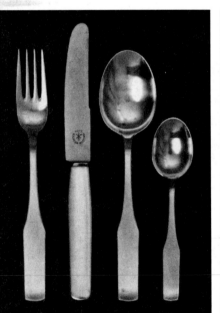

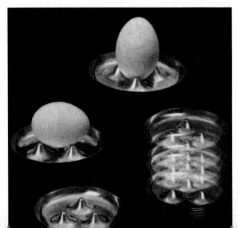

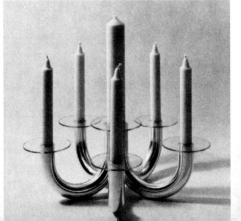

3
Cutlery from the 2789 range of tableware,
sterling silver, alpaka or chromed steel
Designed by Alexander Schaffner for
C. Hugo Pott, *W. Germany*
4,6
Teapot, saucepan and chafing dish, sterling
silver, cm 13/5 inches diameter
Candelabra 1175A, sterling silver, with
candles cm 38/15 inches high
Both designed and made by Søren Georg
Jensen for Georg Jensen Solvsmedie A/S,
Denmark
5
Eggstand 1115 DBGM, 18/8 chrome-
nickel steel
Designed by Friedrich Becker for C. Hugo
Pott, *W. Germany*

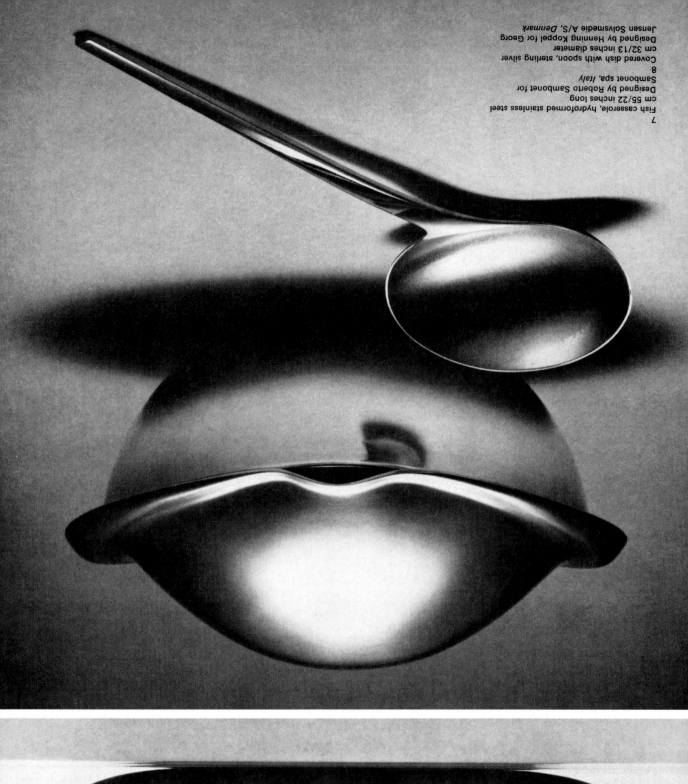

7
Fish casserole, hydroformed stainless steel
cm 55/22 inches long
Designed by Roberto Sambonet for
Sambonet spa, Italy

8
Covered dish with spoon, sterling silver
cm 32/13 inches diameter
Designed by Henning Koppel for Georg
Jensen Sølvsmedie A/S, Denmark

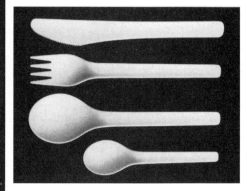

1
Wall panels, white or aluminium vacuum-
formed polystyrene: cm 200 × 100/
80 × 40 inches
Designed by Guy Bernard for Meurop NV,
Belgium
2
Mirror: vacuum-formed polystyrene in
white, blue, green, orange or red surround
cm 50 × 50/20 × 20 inches
Designed by Guy Bernard for Meurop NV,
Belgium
3
Ashtrays A2/A3, melamine, choice of
colours
Designed and made by Sergio Asti, *Italy*

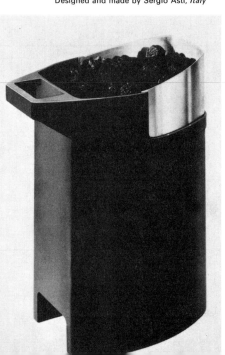

4
Disposable cutlery: injection-moulded
polystyrene, white
Designed by David Mellor
for Cross Paperware Ltd, *England*

5
Scuttle: black polypropylene and stainless
steel, capacity kg 10/22 lbs
Designed by J. P. Emonds-Alt
for Overpelt – Plascobel, *Belgium*

6
Thermos bowl: ABS plastic, carrot, scarlet
or sea-green
Designed by Gino Colombini for Kartell
s.r.l., *Italy*

7
Acrylic penholder
Designed by Aarikka-studio for Aarikka-
Koru, *Finland*

1 2
3 7
4
6 5

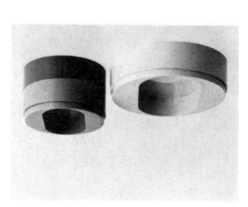

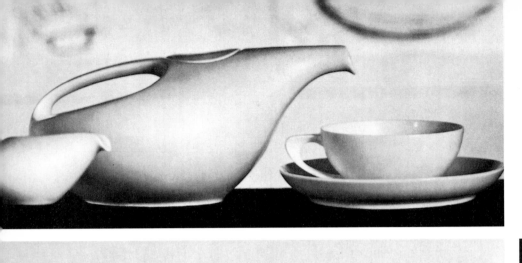

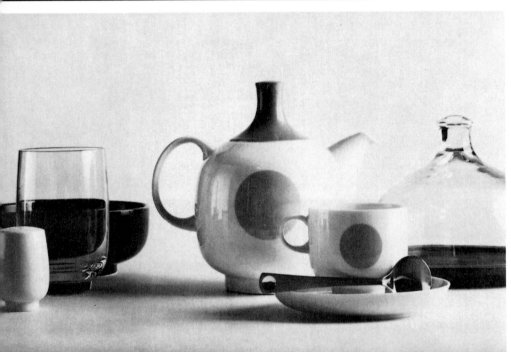

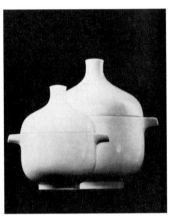

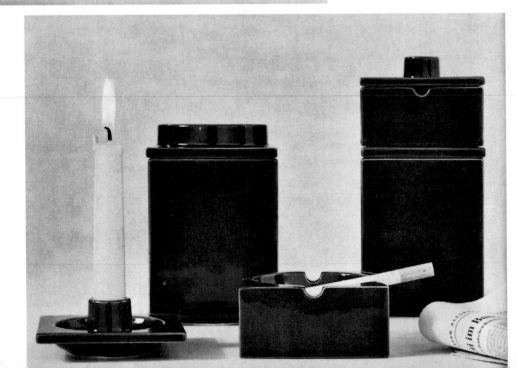

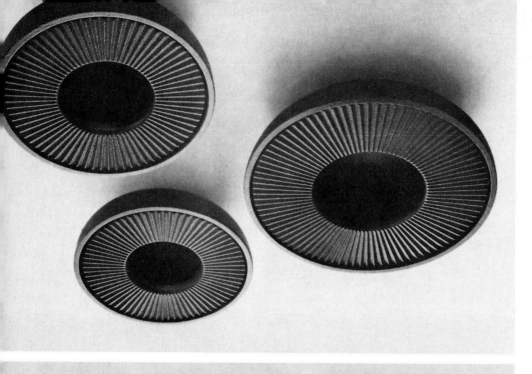

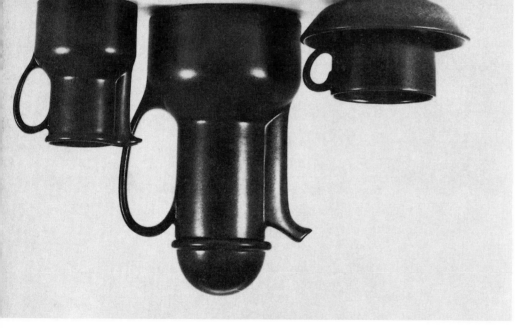

1
Streamlined tableware: white, blue,
black or gold porcelain
Designed by Luigi Colani

2, 3
From the *Plus range* of co-ordinating
cutlery, glass and oven-to-tableware
Designed by Wolf Karnagel

4
Stacking smoking set of cigarette box,
ashtray and candlestick, ceramic
Designed by Wolf Karnagel
All for Rosenthal AG *Germany*

5
Teapot, white porcelain, extra large
Designed by Edith Sonne Bruun for
Bing & Grøndahl Ltd *Denmark*

6
Brixham Stoneware, from a complete
range of tableware, mottled chestnut
high-fired Tamooko glaze
Designed by Robert Welch for Brixham
Pottery *England*

7
Cast iron bowls with cover, matt black
vitreous enamelled, cm 16/6 inches and
cm 13/5 inches diameter
Designed and made by David Mellor
England

1 4
2 3 6 7
5 7

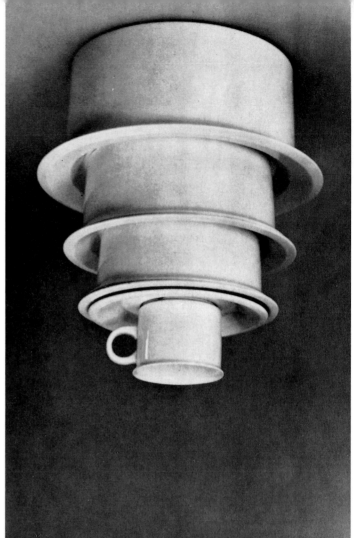

1
Tilted soup bowls

2
Stacking table service
All matt white majolica glazed
Designed and made by Ceramiche Sartori
Italy

3
Serving dish, cruet and soup bowl from
an Air-force blue range
Designed by Pompeo Pianezzola for
Appiani SpA *Italy*

4
Fondue set, white and brown earthenware
Designed and made by Luciano Mancioli
Italy

EH stacking dinner service, fine white
earthenware
Prototype designed by Peter Winquist

6, 7
Sunday and *Aprila*, new patterns on the
BK range of oval shapes : both yellow decal
transfer patterns on white earthenware
Designed by Birger Kaipiainen
All for Oy Wärtsilä Ab Arabia *Finland*

1	3	4
2	6	
5	7	

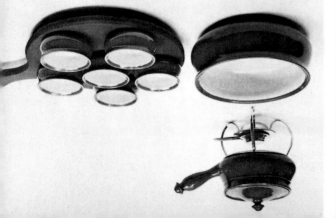

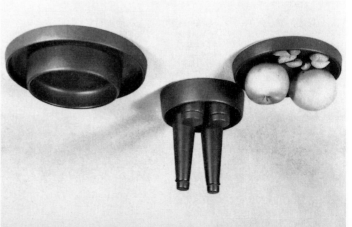

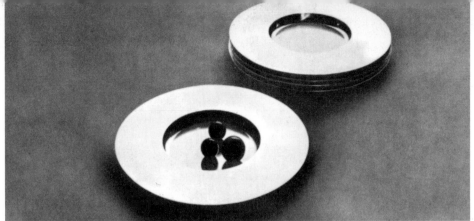

1
Pilon stackable plates of stainless steel
cm 40/16 inches diameter
Designed by Giuliana Gramigna and
Sergio Mazza for Argenteria Krupp SpA
Italy

2
Bar set in ribbed and polished silver
Designed by Massimo Vignelli for
San Lorenzo *Italy*

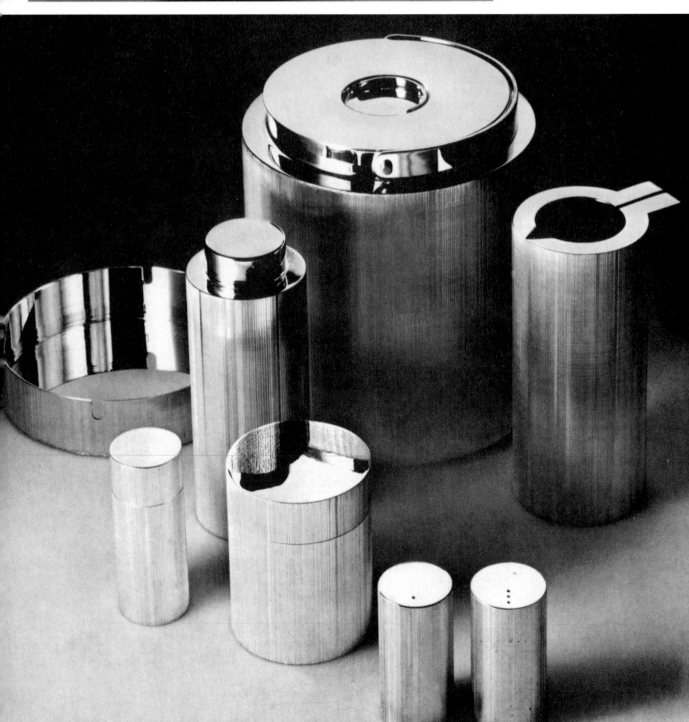

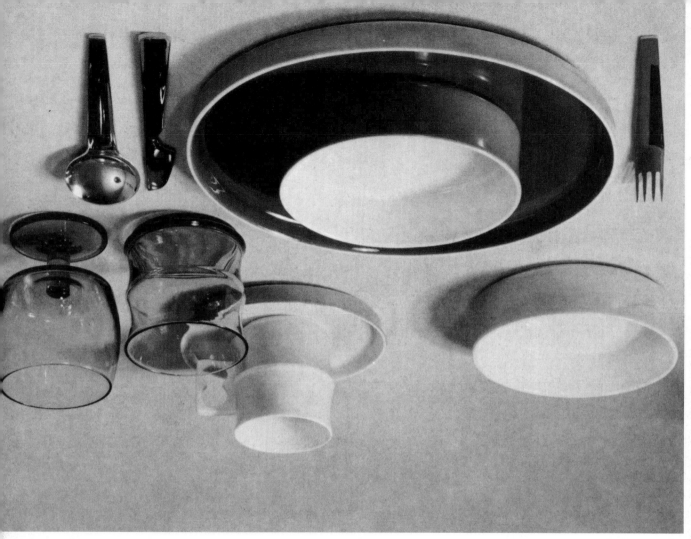

3
Place setting in heavy silver-plated
metal and crystal,
cm 35 × 39/14 × 16 inches overall
Designed by Lino Sabattini for
Argenteria Sabattini *Italy*

4
Russian tea-glass and holder, 18/8 steel,
Designed and made by Bruckmann
Bestecke Silberwaren *West Germany*

5
1000 Chromatics porcelain ware in ten
tones of gold-brown, pink-lavender or
grey-beige complemented by drinking
glasses and cutlery
Designed by Gerald Gulotta and
Jack Prince for
Porzellanfabrik Arzberg *West Germany*

1
Table set of stoneware with hand-painted underglaze decoration: white with bands of shades of blue
Designed by Marianne Westman for
Ab Rörstrands Porslinfabriker *Sweden*

2
Casserole from the *Tree of Life* range comprising dinner, tea or coffee sets: earthenware with two-tone colour scheme: Wicklow, dark/light greens, and Kerry, amber/dark browns
Designed by Don McDonagh and Pat McElheron for
Arklow Pottery Limited *Republic of Ireland*

3
Ts-210 fondue pot and burner of burnished stainless steel: bottom of pot is aluminium sprayed for better heat conduction
Designed by Timo Sarpaneva for
Opa Oy *Finland*

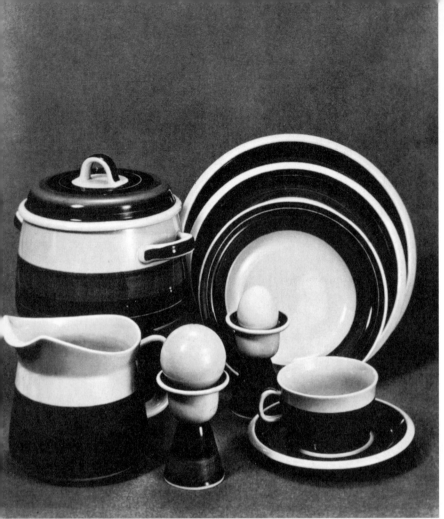

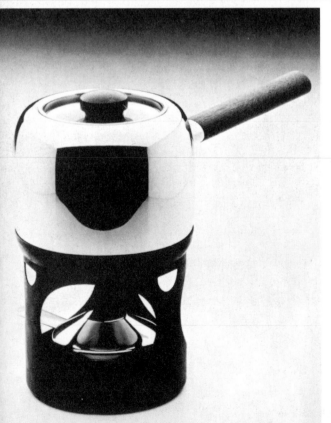

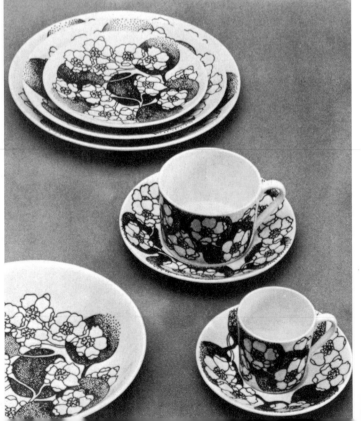

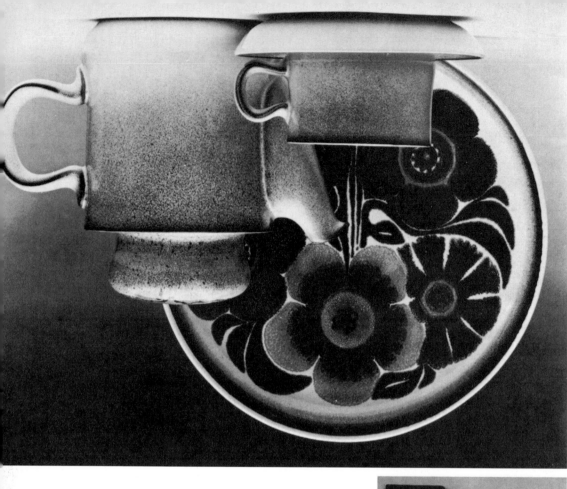

4
Emma bone china tableware: brown or
green decorations
Designed by Paul Hoff for
Ab Gustavsbergs Fabriker *Sweden*

5
Eystein range of tableware: high-fired
Feldspar porcelain with hand-painted
underglaze decoration: white background
with blue and brown bands
Designed by Eystein Sandnes for
Porsgrunds Porselaenfabrik & Egersunds
Fayancefabriks Co A/S *Norway*

6
Candleholders of black wrought iron,
hand-cut circles,
cm 9, 12 or 27/3½, 5 or 10 inches
Designed by Henrik + Jette Nevers for
Henrik Nevers *Denmark*

7
Table set of stoneware clay: brown
flowers orange-centred on mottled
grey/brown background
Designed by Gill Pemberton for
Langley Pottery *England*

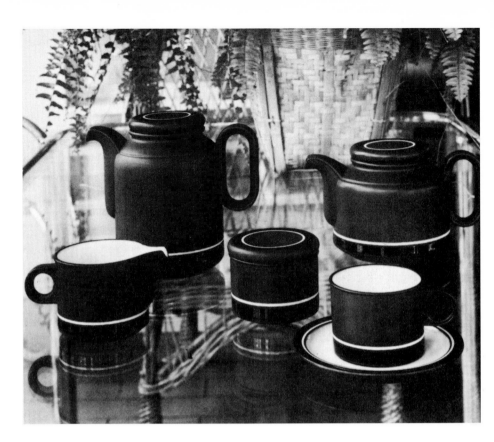

Right
'Lancaster' range of tableware,
vitramic body, partially glazed;
dark chocolate, black and white
Designed by Martin Hunt for
Hornsea Pottery Co Ltd, England

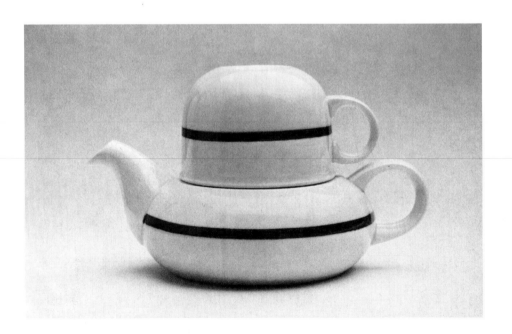

'Tea for one', set of tea-pot and
cup, white porcelain, brown
band decoration; 11·5 (4½")
overall size
Designed by M R Hunt for
Bing & Grondahl Ltd, Denmark

'Chinese Ivory', stainless
steel, dish-washer proof
cutlery
Designed by David Mellor for
David Mellor Cutlery, England

Bar set; stainless steel
with satin finish
Designed by Salvatore Gregorietti
for Coppola & Parodi, Italy

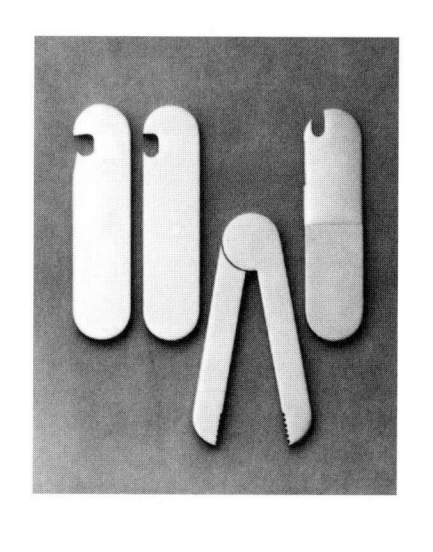

Carving set and two cheese
knives from a range of table
accessories
Designed by OPI Milano for
Cini & Nils, Italy

Place setting for airline
passengers; melamine tray,
china, glass, stainless steel
Designed by Joe Colombo and
Ambrogio Pozzi for Alitalia,
Italy

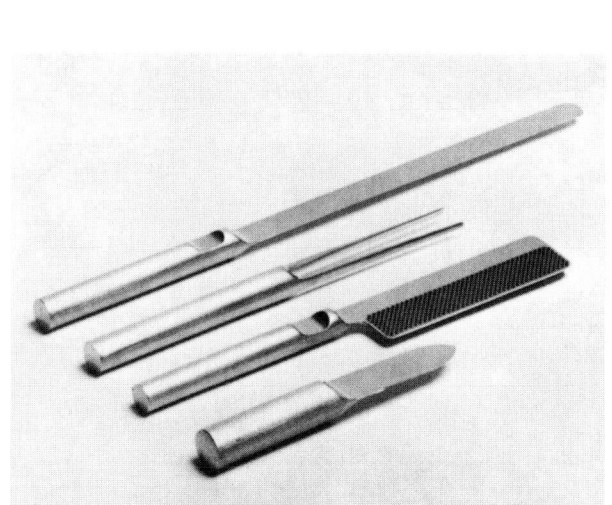

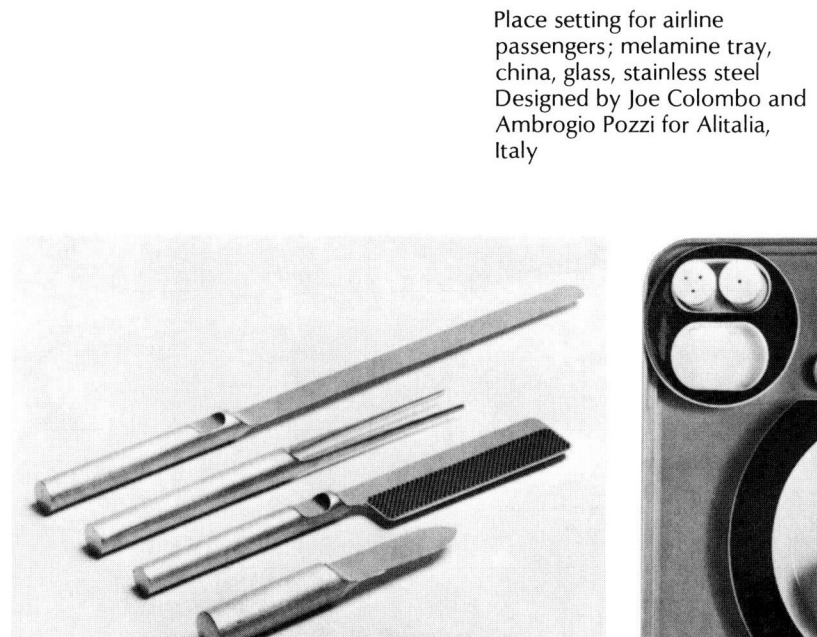

ceramics | Keramik | Céramiques

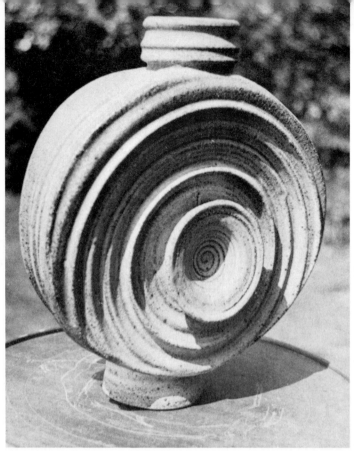

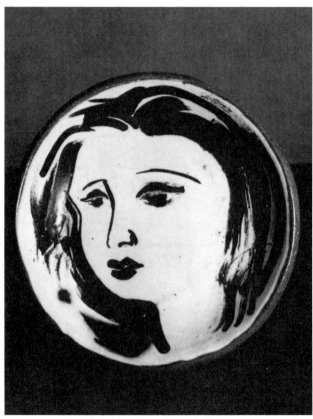

Bellwood

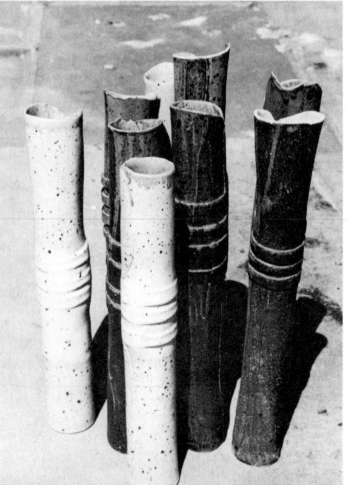

1
Flat jar, thrown and built stoneware,
speckled white: cm 30.5/12 inches
Designed and made by Elizabeth Rompala,
England

2
Rolled-slab pots, speckled matt white
or dark brown) with yellow ash glaze:
cm 38/15 inches high
Designed and made by James Campbell,
England

3
Stoneware dish, black and rust iron on white
slip: cm 18/7 inchs diameter
Designed and made by Francis G. Cooper,
England

4
Wall decoration: cm 150×240/59×94
inches
Designed and made by Elisabeth
Aerni-Langsch, *Switzerland*

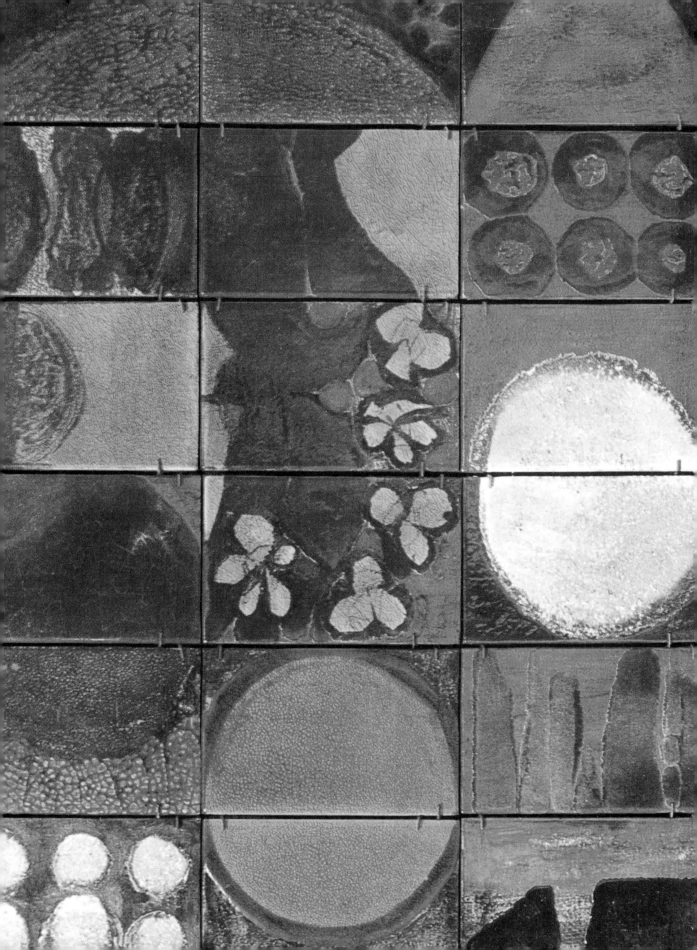

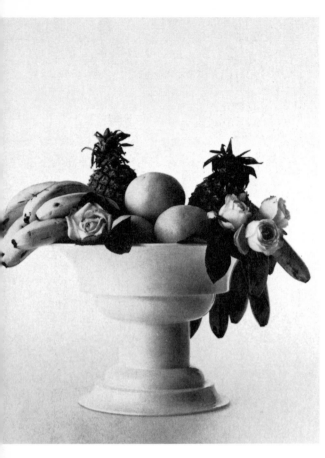

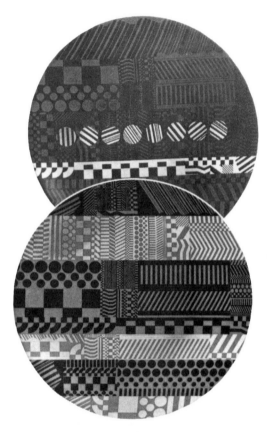

1,2
Vitruvio flower vase/fruit bowl, white,
rose pink or green porcelain
Designed by Sergio Asti for Cedit, *Italy*
3
Variations on a Geometric Theme from a set
of six plates, bone china, cm 26.5/10 1/2
inches diameter. Limited edition
Designed by Eduardo Paolozzi for Josiah
Wedgwood & Sons Ltd, *England*
4
Shapes in black glazed porcelain cm 24,
10/9 1/2, 4 inches high
Designed by Tapio Wirkkala for
Rosenthal AG, *W. Germany*
5–7
Umbrella stand, *Bambu* and *Tortiglione*
vases, all from ABS plastic, the vases
cm 34 and 45/13 1/2 and 18 inches high
respectively
All designed by Enzo Mari for Danese, *Italy*
8
Periscopio battery-run timepiece red, white,
silver, pluin, grey or black ceramic
Designed by Ennio Lucini for Italora con

		8		Designed by Ennio Lucini for Italora con
1	3		6	Quadrante Ridisegnato
2	4	5	7	Made by Gabbianelli, *Italy*

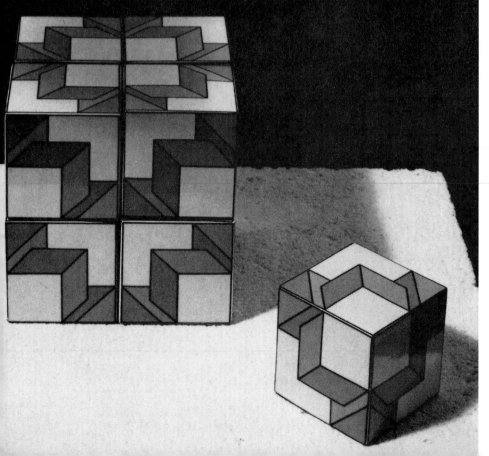

1
From a series of vases, white porcelain with flat and metallic colour or gold effect
Designed and made by Hutschenreuther AG Germany

2
Relief, from a series of multiples, white and black or sharp colours assembled from cm 10×10/4×4 inch units in metal frame, each in limited edition, designed by Victor Vasarely for Rosenthal AG Germany

3, 4
Graphic permutations upon precision cubes, primary colours on white
Designed and made by Glenys Barton at the Royal College of Art England

5
Cast forms, white bone china or earthenware glazed matt white, matt black, purple, yellow or orange cm 13-23/5-9 inches high
Designed and made by Pauline Zelinski England

6
Cigarette boxes, cast earthenware black, white or cream cm² 7·5/3 inches²
Designed and made by Margaret Stout at the Royal College of Art England

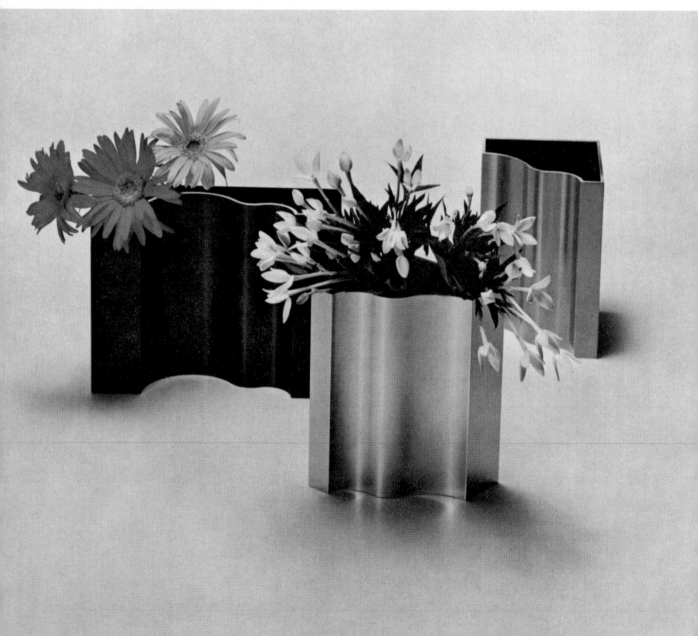

1
Flower vases, silver or lacquered finish
aluminium : cm 15/6 inches high

2
Desk set, ashtray and cigarette, data and
letter-cases orange, blue, milk or
yellow-ochre Melamine : largest (data
case) cm 37.5 × 25 × 3/15 × 10 ×
1¼ inches
All designed by Makoto Ookawa and
Sohsuke Shimazaki for the Isetan
Company Ltd *Japan*

Electro porcelain (automatic-machine-
made) candlesticks unglazed, vitreous,
slate blue
Designed by Martin Hunt for JRM Design
Sales Ltd *England*

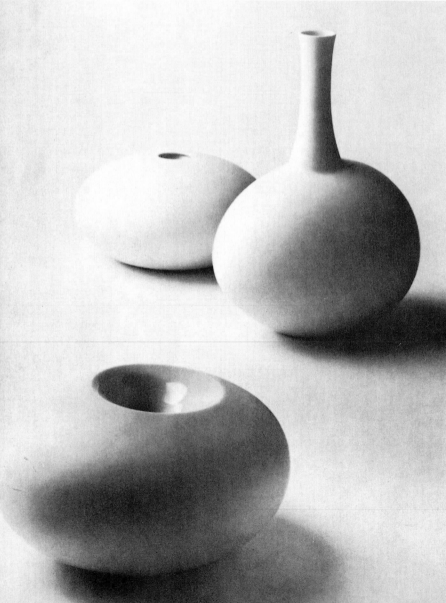

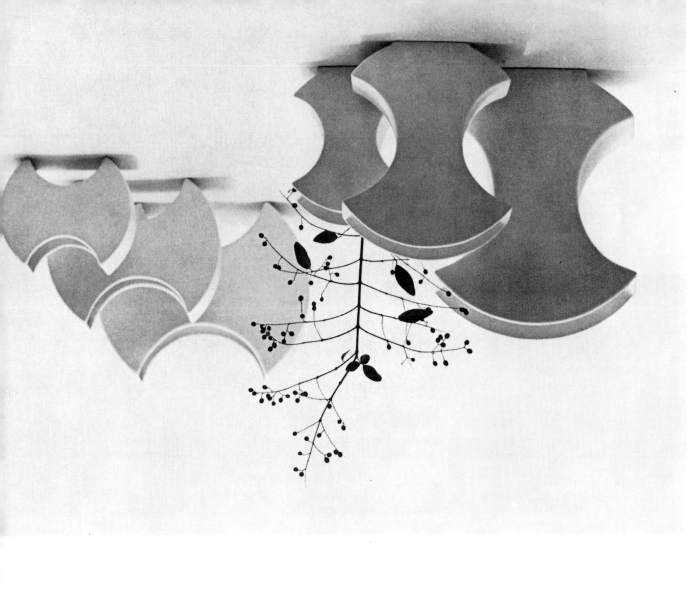

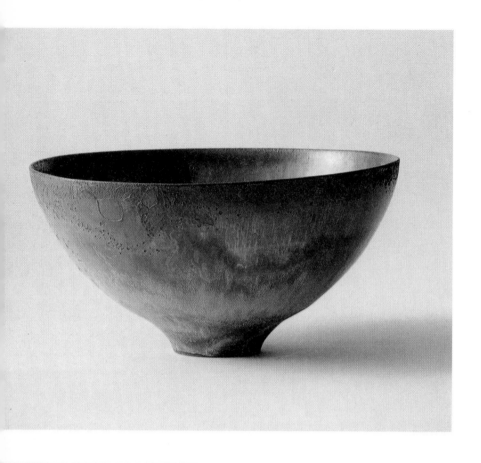

Bowl no. 0461, clay, apple
green reduction glaze with fire
marks and red iridescence;
21·5×10·5 (8½″×4⅛″)
Made by Gertrud and Otto
Natzler, USA
*Max Yavno photograph;
courtesy of the Renwick Gallery,
National Collection of Fine Arts,
Smithsonian Institution*

Closed Form no. 0428, clay,
dark green reduction glaze with
melt fissures and fire marks;
20×14 (7⅞″×5½″)
Made by Gertrud and Otto
Natzler, USA
*Max Yavno photograph;
courtesy of the Renwick Gallery,
National Collection of Fine Arts,
Smithsonian Institution*

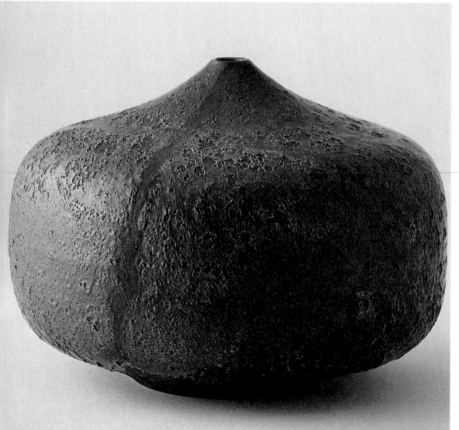

Bowl, bone china, mould cast in
two layers, violet and white;
the decoration is hand carved
through the white to the violet
layer; 12 (4¾″) diameter
Designed and made by
Jacqueline Poncelet, England

'Goose Bowl', cast bone china,
hand-shaped and decorated,
transparent glaze; 6×12×6
(2⅜″×4¾″×2⅜″)
Designed and made by
Jacqueline Poncelet, England
*Public collection: Veslandski
Kunstindustri Museum, Bergen*

'Cylindrical Forms', hand thrown
glazed stoneware
Designed and made by Cyril
Smith for Doulton Studios,
Australia

Credits
Bildnachweis
Crédits

Bayer, Cologne: 8
Bonham's, London; 9 left, 9 right
Christie's Images, London: 20
Fiell International Ltd., London: 4, 23
(photos: Paul Chave) 10 right, 11, 14 left,
16, 17, 18, 22
Gufram, Balangero: 15
Kartell, Milan: 24, 25
Sotheby's, London: 5
Stelton, Copenhagen: 10 left

DECORATIVE ART SERIES

More titles on architecture & design from TASCHEN

Decorative Art – 1950s
Ed. Charlotte & Peter Fiell
576 pages
3–8228–6619–9
[ENGLISH/GERMAN/FRENCH]

Design of the 20th Century
Charlotte & Peter Fiell
768 pages
3–8228–7039–0 [ENGLISH]
3–8228–0813–X [GERMAN]
3–8228–6348–3 [FRENCH]

1000 Chairs
Charlotte & Peter Fiell
768 pages
3–8228–7965–7
[ENGLISH/GERMAN/FRENCH]

Decorative Art – 1960s
Ed. Charlotte & Peter Fiell
576 pages
3–8228–6405–6
[ENGLISH/GERMAN/FRENCH]

sixties design
Philippe Garner
176 pages
3–8228–8934–2
[ENGLISH/GERMAN/FRENCH]

The Rudi Gernreich Book
Peggy Moffitt, William Claxton
256 pages
3–8228–7197–4
[ENGLISH/GERMAN/FRENCH]

Decorative Art – 1970s
Ed. Charlotte & Peter Fiell
576 pages
3–8228–6406–4
[ENGLISH/GERMAN/FRENCH]

Furniture Design
Sembach/Leuthäuser/Gössel
256 pages
3–8228–0276–X [ENGLISH]
3–8228–0097–X [GERMAN]
3–8228–0163–1 [FRENCH]

Julius Shulman
Architecture and its Photography
Ed. Peter Gössel
300 pages
3–8228–7204–0 [ENGLISH]
3–8228–7305–5 [GERMAN]
3–8228–7334–9 [FRENCH]

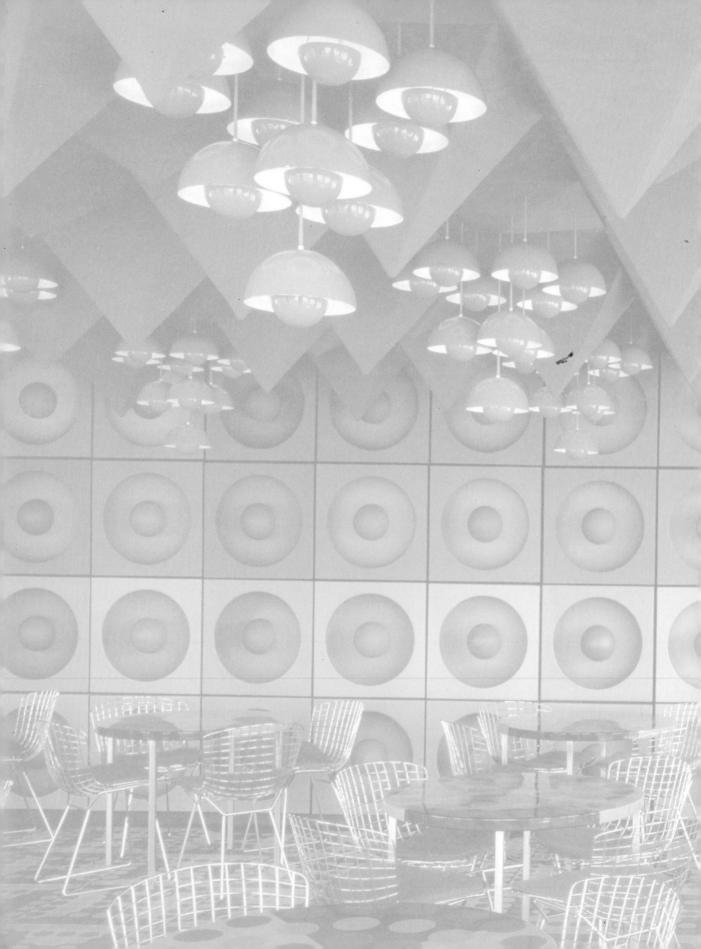